MONSTER!

MONSTER! #32 is dedicated to the one person in my life who is solely responsible for my turning out the way I am today. It may sound cliché to dedicate a book to your mother, but in this case she's the primary reason why you are holding this magazine. My mother grew up going to movie theaters in the 1930s and '40s watching Universal monster movies, and she collected comics when it was uncool for a young woman to do so. She also read all sorts of esoteric texts, and loved fantastic literature. She encouraged the study and admiration of the odd and unusual in her children, and introduced me to the likes of Ray Bradbury, L. Frank Baum, Lovecraft, Lon Chaney, Sr., and other such folks. She also bought me my very first issue of *Famous Monsters* (#51), as well as a subscription to *Heavy Metal*. Mom passed away on December 26th, 2016 at the age of 89.

~ **Tim Paxton** *[R.I.P., Mrs. Paxton! – SF.]*

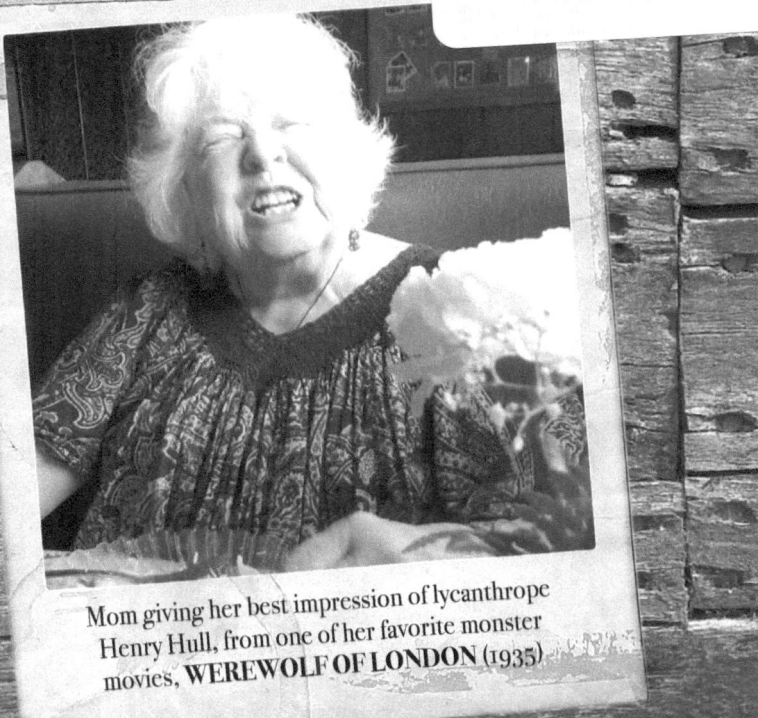

Mom giving her best impression of lycanthrope Henry Hull, from one of her favorite monster movies, **WEREWOLF OF LONDON** (1935)

MONSTER!

ISSUE 32 / JANUARY-FEBRUARY 2017

EDITORIALIZING! .. 4

ANARCHY & MONSTERS: ... 6
An Interview with Brett Piper! (Pt. 1)

MOONLIGHT MASK a.k.a. GEKKŌ KAMEN, 40
The Ally of Justice!

ALL YOUR PRAYERS ARE ANSWERED! 68
That Great, Glowering Giant God-Monster Known as
Majin Stomps Evil Bastards!

FLY, DARNA, FLY! ... 88
Mars Ravelo's *Pilipina* Wonder Woman Takes to the Skies!

THE CHILDREN OF THE NIGHT: ... 106
Reassessing Tod Browning & Béla Lugosi's Vampire Movies!

NEW TO REVIEW: Horror Cinema from India! (Pt. 1) 120

H.P. LOVECRAFT & THE LOVECRAFTIAN in Japanese Cinema! 136

DÉLIRE ET DÉSIR: The Dreamworld of Jean Rollin! 154

THE NAKED & THE DEAD: ... 203
Monster! (*International*) Meets Jean Rollin! (1993 Interview Reprint)

CÉRÉBRÉS AU GRATIN: ... 217
N.G. Mount's *Trepanator* (starring Jean Rollin)!

GARGANTUS Comic! (Pt. 2) .. 228

MONSTER MOVIE REVIEWS, Pt. 1: .. 229
including *Island of Terror, The Cross of Seven Jewels, Lake of Dracula, Blood of the Virgins, Kraa! The Sea Monster, Unhuman, The 7th Curse* & *The Brainiac*!

MY DINNER WITH *EL BARÓN*: ... 239
Classic '90s Brainiac Comic Reprint!

MONSTER MOVIE REVIEWS, Pt. 2: .. 257

MONSTERS! An Illustrated Movie History! (Pt. 4) 315

***MONSTER!* BOOKSHELF:** Reviews of 2 Wayne Kinsey Works!......... 319

CULT MOVIE COMICS: *THE FLESH EATERS!*................................... 324

***MONSTER!* #32 MOVIE CHECKLIST:** .. 327
Video Availability Info!

Additional information on page 361

EDITORIALIZING

For those of you who may justifiably be wondering what's been going on with our far-more-erratic publishing sked here at *M!* lately—well, let's just say that (*um*) "life" gets in the way sometimes... I would love to go back to the old monthly schedule but, seriously, it's simply *NOT* an option at this point. The good news is, we've got an *ultramega*-issue for you, with 360 pages of densely-packed eye (and brain!) candy that'll hopefully keep you occupied for days and help make up for the *Monster!*less past couple of months somewhat. Besides the usual Indian horror films—which I (biased as I am!) think are always deserving of some coverage—this truly MASSIVE issue also swings wildly from classic '30s Hollywood horror, to erotic French monster flicks, to Japanese fantasy epics...and (just about) everything in-between. So, despite the book's lateness (and I *do* mean *BOOK*!) Steve and I—with an invaluable assist from our ever-reliable talent pool!—have delivered our most diverse issue yet!

I'm sure most of you reading this ish have seen many of the films our *Monster!* contributors have written about herein; some of my all-time favorites being those in the *Daimajin* trilogy. My early recollection of seeing at least one of the films came about purely as a happy accident. As an early teen in Junior High, I had a paper route *[Me too!* ☺ *- SF]*, and busted my ass to make it back from school to deliver all 100+ papers, then get home in time to catch whatever afternoon movie was playing on TV. Ch.11 out of Toledo (Ohio) occasionally aired some cool flicks, and I would tune-in to watch them whenever the reception was just right...or even remotely bearable, for that matter. Once, during a particularly bad snowstorm, I didn't make it home until late, and what little I did get to see of that day's feature came c/o about the only time (at least that I know of) when one of the Majin movies was televised in our area. I caught roughly the last fifteen minutes of rampaging-stone-god insanity, and the sight of the striding, stomping giant was instantly imprinted (make that *stomped*!) into my gray matter for decades thereafter. It wasn't until the early 1990s that I managed to acquire murky, reddened 16mm-to-VHS copies of the films from Greg Luce's pioneering PD/gray

Even Swiftly-Sprouting Li'l Monsters Like Daigoro "Dai" Geddes Luv *Monster!*

Now rapidly approaching his first b-day (which is actually more like his *second* one, if you think about it ☺) since we last saw him in these pages early last April, even fast-growing li'l monsters like "Sasha" Theodore Daigoro Geddes (affectionately a.k.a. "Dai" for short) love *Monster!*—even if about all he can pretty much do with it yet is look at the pictures and maybe chew on the corners of it now and again. (But considering this issue is our [*ahem*] raciest one yet by far, what with all Jean Rollin's tastefully undraped vampire babes prowling through our pages, his folks might perhaps want to place some—*um*—strict "parental controls" on it until he's at least old enough for high school! [Or maybe even of college-age...?]). Here's wishing you a Happy 1st Birthday in advance, Dai! ~ SF *[Photo by his daddy, Colin "TIFF's Midnight Madness/ex-*Asian Eye *zine guy" Geddes]*

Left: Big daddy Itto Ogami and his son Daigoro; panels from Kazuo Koike & Goseki Kojima's manga *Lone Wolf with Cub*

market outfit Sinister Cinema. This was followed by legit VHS releases in the '90s, then—at long last!—came the *sweeeeet* BD editions we have today. Oh, how I dearly love these films!

Incidentally, in 2009, I visited Japan, where I saw some very cool Haniwa (埴輪) statues (see also p.71) at the Tokyo National Museum; then, later that year, I received a letter from a friend in Kyoto which came with postage stamps featuring one of the more famous such figurines. I still have those stamps (see facing page) today... *that* is how much I love the Giant Majin! As a matter of fact, I love fantasy films (etc.) in general, no matter their country of origin. "Fantasy" being such a very broad genre with so many subgenres, so far as I know every country that has any sort of film industry produces fantastical fare. Now, not *every* nation has produced monster movies as a result, but a great many of them have: which is why I keep on searching for the new and unusual in movies and popular culture, as well as frequently revisiting past favorites.

And this massively monstersome issue is the ideal end-result of the passion I have to see as many of these as I possibly can, and so much more besides...
~ Tim

Give Us A Kiss! *El Brainiac* sticks his licker out, ready to slurp up all the yummy brainy goodness to be found in this ultramega-XL feast of an ish of *M!*

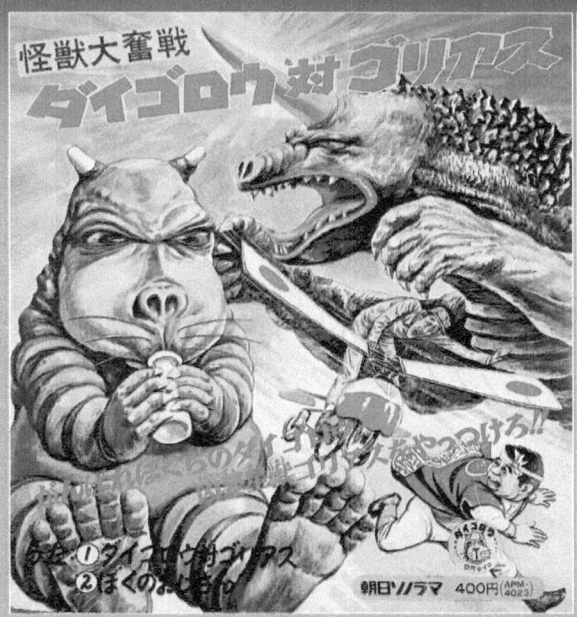

Above: Japanese tie-in sonoroma *[left]* for 1972's **DAIGORO VS. GOLIATH** (ダイゴロウ対ゴリアス), plus some contemporaneous press-hype for the film from Japan's *Weekly Film Focus* mag

5

ANARCHY & MONSTERS

An Interview with
BRETT PIPER
Part 1
by Stephen R. Bissette

Brett Piper's first-ever onscreen stop-motion monster: the double-header beach pulmonate gastropod of **MYSTERIOUS PLANET** (1982)

> *"I'll tell you what the 'Brett Piper Universe' is about: anarchy and monsters. In all my movies the characters find themselves in situations, large or small, where they're on their own with no support from any kind of social structure... And there's monsters."*
>
> — Brett Piper[1]

Every few years, an animated puppet film is completed with big Hollywood money, mobilizing an army of animators, production assistants, voice talents, and creative talents—**THE NIGHTMARE BEFORE CHRISTMAS** (1993), **JAMES AND THE GIANT PEACH** (1996), **CHICKEN RUN** (2000), **WALLACE & GROMIT: THE CURSE OF THE WERE-RABBIT**, **CORPSE BRIDE** (both 2005), **CORALINE**, **FANTASTIC MR. FOX** (both 2009), **ANOMALISA** (2015), **KUBO AND THE TWO STRINGS** (2016)—and a flurry of articles and reviews note how these puppet films are carrying on a grand cinema tradition, resurrecting an almost lost artform.

Every time, *every* writer, *every* review, handily ignores the fact that one man has been humbly carrying on that tradition—with the kind of live-action-and-stop-motion-effects-creature-filled SF/fantasy/adventures which Willis O'Brien and Ray Harryhausen used to make—with almost *every* film he's made since 1982.

He's done so without major studio money or support—or, actually, *any* Hollywood studio money or support whatsoever—working as he has in New Hampshire, Vermont, New Jersey, and now Pennsylvania. He's done so without name stars (well, there was *one*, long ago: Cameron Mitchell), without teams of animators, without any assistants or gofers, without CGI enhancements, without spending (squandering?) the gross national product of many small industrialized nations on single feature films. He's most often done so as a one-man producer / writer / director / cinematographer / editor / special-effects expert, though he has enjoyed a few creative collaborative partnerships along the way, some of which were indeed fruitful (if only fleetingly so).

That one man—Brett Piper—has made his kind of movie steadily since the early 1980s, fusing live-action and stop-motion-animated models in the manner of his stop-motion precursors before him. They are, to a film, *monster movies*— and despite Hollywood having finally honored and lionized forefathers like O'Brien and Harryhausen (and the likes of Roger Corman too), mere "monster movies" are still obviously beneath the radar. This is particularly true of *low-budget* monster movies.

Brett Piper has done so steadily, quietly, and modestly, with scant recognition, for nigh-on four decades now; certainly, he's done so without the accolades showered on his more prominent, better-bankrolled, and far-less-prolific and -productive contemporaries. But what does *that* matter? Piper can't do much of anything about it, save get to work on the feature film now being shot, now in post-production, now in the planning stages—in Brett Piper's world, it's the work at hand, not the lack of money or partners or fame, that counts. In the grand scheme of things, neither fame, nor infamy, nor lack of fame or infamy has either bankrolled or crushed his dreams or projects. Given the systems and sharks we laughingly call "distribution" and "distributors", Brett has little choice when he's done with each movie: he entrusts each completed brainchild to whatever best-case-today agent, broker,

1 Email from Brett Piper to the author, September 3, 2016; the full context of this quote is in Part 2 of this interview (the section on **DARK FORTRESS**), in the next issue of *Monster!*

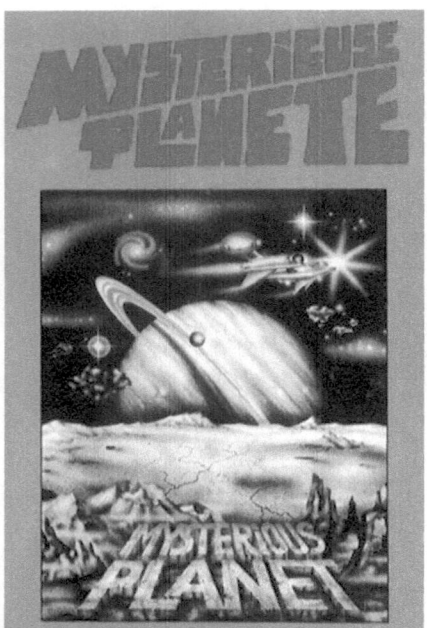

French VHS box art for the 1980s release of **MYSTERIEUSE PLANETE / MYSTERIOUS PLANET**, using the splashy painted cover art used on the US release (see p.25)

Though Brett Piper has never found his perfect production partner and/or advocate—the kind of long-term relationship emulating that which Ray Harryhausen enjoyed with producer Charles H. Schneer, say—it must be noted that Piper has quite effectively and efficiently forged his own distinctive body of work as a writer/producer/director/visual effects creator. That he has done so while still freelancing as a special effects "pinch-hitter", if you will, is even more remarkable. This is something that Harryhausen deliberately chose *not* to do, based in part on what Harryhausen saw happen to and with his mentor Willis O'Brien.[2]

Though it's his distinctive stop-motion animation creations that endear his films to many—what current collaborative partner Mark Polonia has lovingly dubbed "Pipermation"—Piper is, in fact, arguably the *last living practitioner* of the kind of hands-on expertise practiced by the great Mario Bava, working movie magic and near-miracles with modest (often meager) means. He even comes across in interviews much like Bava did, in his day: Piper is unfailingly candid, straightforward, self-effacing, has a sense of humor about even the worst circumstances he's labored under, lacks any pretensions about the nature of his films or his work, praises those who have done their best working with him, is diplomatic as he can be about those who have dropped the ball or (to be frank) given him the shaft, and is self-deprecating to a fault. Like Bava, Piper prides himself on his reliance on hand-crafting visual "tricks" using techniques that date all the way back to the silent era. He has learned his craft and learned it well, improving with every shot, every film; learning by doing. What most uninformed and oblivious viewers and critics erroneously presume to be CGI effects are actually carefully-orchestrated combinations of live-action with foreground miniatures,

dealer, or distributor might be interested or within reach, signs on those dotted lines, hopes for the best, and moves on to spawning the next beastly brood. Best to persevere and soldier on with the work at hand, and get to work on the *next* feature film as soon as possible.

To be blunt, I love unpretentious monster movies. I love Brett's films, and in the course of this lengthy conversation, I've come to quite like Brett Piper, the man.

While Piper has rigorously maintained his private life as *private*—a philosophy and path this interview doesn't challenge—it's a matter of public record that he completed his first feature film **MYSTERIOUS PLANET** (1982, USA) at age 27, and he has worked steadily as an independent filmmaker ever since.

Piper completes entire features for less than most contemporary Hollywood features blow on catering alone—and he does so with wit, energy, passion, and a potpourri of "old-school" special effects ingenuity, including (in almost every single film) stop-motion animation in the style of his heroes: Willis H. "Obie" O'Brien, Ray Harryhausen, James Danforth, and Phil Tippett.

2 After the landmark achievements of **THE LOST WORLD** (1925) and **KING KONG** (1933)—with the distinctive exception of **MIGHTY JOE YOUNG** (1949), on which Harryhausen assisted—O'Brien spent the bulk of his career and lifetime frustratingly juggling freelance effects work on various films not of his conception (**SHE**, **THE LAST DAYS OF POMPEII** [both 1935], etc.) with ambitious projects that were near-and-dear to his heart, almost all of which either imploded (i.e., "WAR EAGLES", "GWANGI") or never even got off the ground. After successful completion of **MIGHTY JOE YOUNG**, in his last decade of life and work, O'Brien worked with Harryhausen on the opening dinosaur sequence of Irwin Allen's **THE ANIMAL WORLD** (1956), and finally with animator Pete Peterson on **THE BLACK SCORPION** (1957) and—more ignobly—subcontracting stop-motion animation effects work under Willis DeWitt and Jack Rabin for **BEHEMOTH THE SEA MONSTER** (a.k.a. **THE GIANT BEHEMOTH**, 1958); see "Beasts & Behemoths: The Lourié Menagerie", my article on that production backstory in *Monster!* #12 (pp.79-100).

animation, makeup effects created with available materials, man-in-suit creatures, and all manner of in-camera practical effects, blended and/or enhanced using rudimentary post-production tools (including, yes, some digital manipulation, but *never* CGI per se) supplanting the kind of optical effects work that used to exist.

As we shall see, he has also had a hand in helping numerous filmmakers finish their films, too, pitching-in to create otherwise impossible effects, applying his unusual skillset to long-delayed (and, by any other means, costly) post-production, often completing unfinished sequences or entire features. Thus—as I've already asserted—Piper has juggled *two* career arcs: nurturing, developing, and completing *his own* films *and* fulfilling a role traditionally filled by effects specialists since the beginning of industrialized cinema production itself. While neither revenue stream has been particularly lucrative, this *has* been a means toward sustaining ongoing filmmaking and film work over decades. As I wrote in *Monster!* #30:

"An aspect of Brett Piper's career rarely-discussed, and never chronicled or analyzed, is his special effects creative work for feature films that aren't his own productions. Since the 1980s and his affiliation with Troma, and thereafter his tenures (however brief) with Edgewood Productions, E.I. Independent, and more recently the Polonia Brothers, Piper has quietly fulfilled the role classical motion picture industry effects experts like Irving Block, Jack Rabin, Louis DeWitt, Gene Warren, Wah Chang, Jim Danforth, and others sustained throughout American cinema history, creating effective and often impressive special effects work (including miniatures, environment illusions [i.e., what were called matte paintings and the like, pre-CGI era; Brett still does 'em old-school fashion], creature and character creation/animation, etc.) on thin-to-nil budgets. Piper has now served the East Coast low-budget genre for decades in this capacity, often in association with producers Piper has been able to complete some of his personal pet projects for. This body of work deserves a full accounting...and it should be

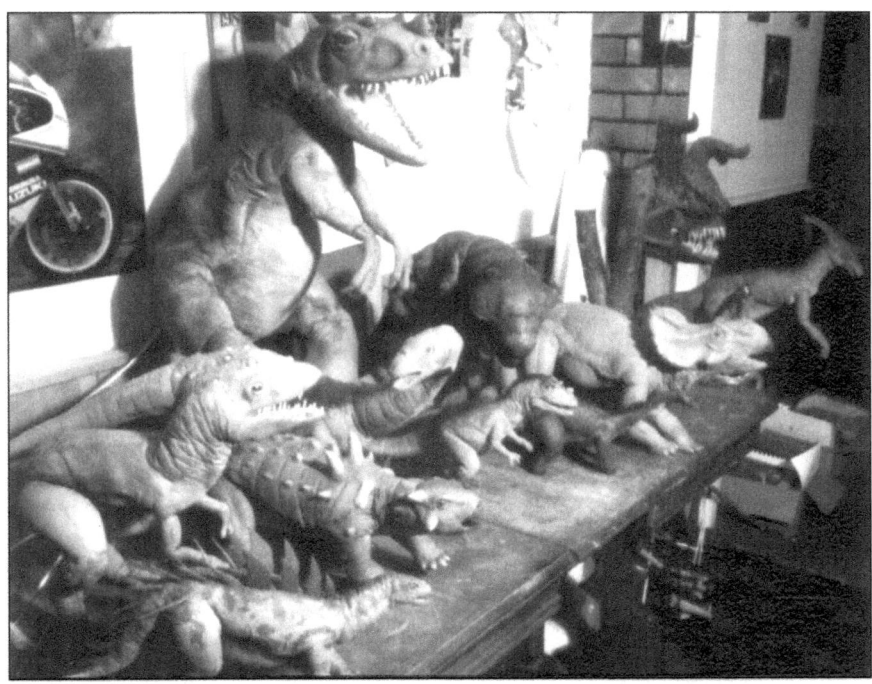

When Dinosaurs Ruled The Tabletop: A workbench in one of Brett Piper's past (humble) apartment/studio spaces, showcasing a menagerie of Piper's stop-motion and live-action (i.e., those larger carnosaur) puppets: *"They were all built for movies that looked like they were going to get made, but never were. I keep them because I may still get a chance to do those projects someday"*. All shall be revealed, as we'll be discussing Piper's saurian cinema in later instalments of this career-spanning interview

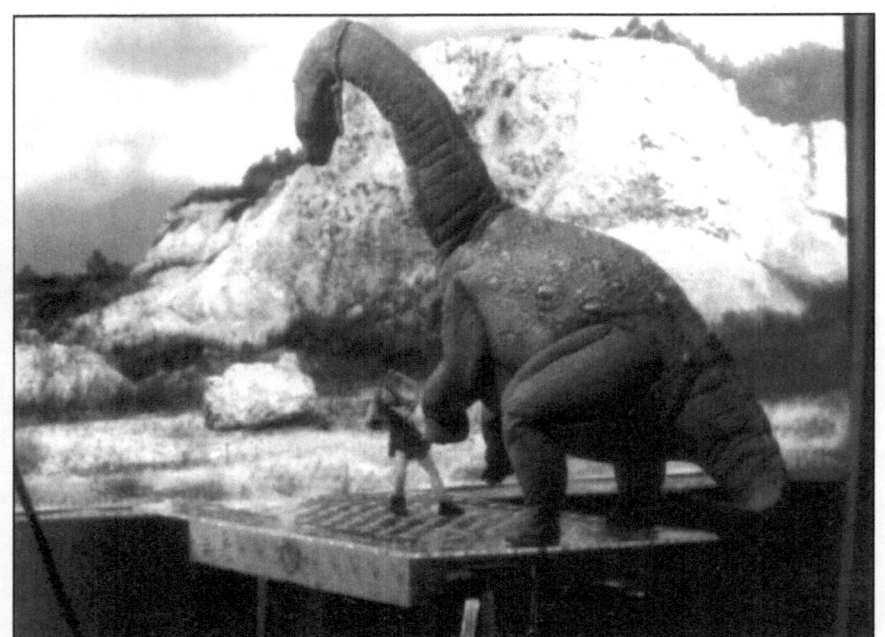

One of Brett's tabletop animation setups—a stop-motion sauropod model stomps a caveman character model against a painted background—for the sole completed (by the producers) feature to date which Brett Piper has disowned: **DINOSAUR BABES** (1996).

duly noted that Piper's IMDb listing doesn't adequately cover this entire filmography."[3]

Despite often insurmountable odds, Piper's films have landed distribution and are *seen*. He has abandoned a few unsold projects (i.e., a planned 1980s horror anthology feature, **DINOSAUR KID**) and totally disowned only *one* completed feature (i.e., **DINOSAUR BABES**) along the way; we'll get into those in due course. True, some of Piper's films are essentially orphaned "lost films" at this point, having been released once on videocassette back in the 1980s and 1990s and never again subsequently—and Piper makes it clear he's just as happy they're no longer available, however frustrating that may be to his fans. Nevertheless, in an era of ever-changing release formats and platforms, almost all of Piper's productions *have* seen distribution, including even international distribution (in two cases, they were released *exclusively* overseas), and a couple have enjoyed remarkably long shelf-lives.

Piper doesn't seem to care, actually. As reflected in the following conversations, Brett is too concerned with the current and *next* production to fret over the fate of his past creations, most of which were sold outright to distributors or manhandled by business partners who were less than honorable. It matters little, it seems, to the maker of these sometimes remarkable low-budget gems: their eventual marketplace success or failure neither fuels nor impedes Piper's current undertaking. You win a few, you lose a few; just get back to work.

He has maintained a formidable momentum, completing a steady procession of science-fiction/fantasy/horror films over the decades without losing steam over the kinds of upsets that have stopped other filmmakers in their tracks. You name it, Piper has experienced it—shady business partners, short-sighted producers, broken promises, shaky deals, botched releases, shoddy handling of prints and video/DVD transfers—but he never gives up, and he still gives his all to every production. It's more a matter of absolute pragmatism than anything else, grounded in Piper's extensive knowledge of filmmaking and exploitation and genre film history. For every genre filmmaker who

3 Bissette, "Surf 'n' Turf with Brett Piper: Up From the Deep with **QUEEN CRAB!** and **SNOW SHARK**" (*Monster!* #30, Summer 2016, p.20). Please note that any errors (of presumption, specifically about Brett Piper's role in **SNOW SHARK**'s post-production) made in that article/review will be corrected in these interviews.

retained the rights to their work and was able to ensure some measure of profitability—or at least revenue—from their creations (e.g., David Lynch, **ERASERHEAD** [1977, USA]), there are dozens upon dozens of others who got taken to the cleaners by unscrupulous producers, distributors, and con-artists.

Lest you think otherwise, consider the history of the independent genre film, producers, distributors, and money. For our purposes here, it's sufficient to note how George Romero was quoted in 1969, talking about Walter Reade's Continental Films release of **NIGHT OF THE LIVING DEAD** (1968, USA), as saying, *"We have a very good arrangement with Walter Reade. I've heard bad things about them but we can't complain. I'm sure they're taking something somewhere but we are getting more than a fair share."*[4] They sure were *"taking something somewhere"*...right to the bank! Romero and his Image Ten partners were fleeced for millions of dollars before filing suit in 1972 *"in Pittsburgh Common Pleas Court for the return of LIVING DEAD from Walter Reade, along with some $1.3 million in arrears."*[5] The four-year legal proceedings culminated in a $3-million Pennsylvania Supreme Court judgment against Continental/Walter Reade. Alas, Continental filed bankruptcy papers in January 1977—with Image Ten reaping only $500,000 of what they were due—by which time the filmmakers behind Tobe Hooper's **THE TEXAS CHAIN SAW MASSACRE** (1974, USA) had been similarly taken to the cleaners by the Mob connections behind Bryanston, who'd folded Bryanston operations in May 1976 after bilking tens of millions from the collaborative team behind that surprise international smash-hit.

Though he has never enjoyed the kind of breakthrough hit which filmmakers like Romero and Hooper have (nor been fleeced for those kinds of vast revenue streams either, for that matter), Brett Piper has had his share of midadventures as well—including his own lawsuit filed against one of the studios he'd worked with—some of which

4 Romero, interviewed by William Terry Ork and George Abagnalo, *Inter/VIEW*, Vol. 1, No. 4, 1969, p.21.

5 Christopher T. Koetting, *Retro Horror: Terror in the New Millennium* (Hemlock Books, 2012), p.167, though this has been covered in detail in numerous articles and books. Koetting offers a succinct overview of **THE TEXAS CHAIN SAW MASSACRE** fleecing on pp.239-240; though that, too, has been covered in excruciating detail in other articles, interviews, and books, Koetting proffers a succinct summary.

There's All Kinds Of Action In A Brett Piper Movie! Actress Alison Whitney (as Billie Mulligan) and Brett Piper (director / co-screenwriter / special effects tech), with Anju McIntyre ([a.k.a. A.J. Khan] as Asia Buchanan, the villainess who'll do *anything* for reality show ratings), as seen on the Pennsylvanian backwoods shoot of Piper's and Mark Polonia's **MUCKMAN** (2009)—no relation to the *Teenage Mutant Ninja Turtles* character or the same-named fanfiction author either!

he candidly discusses in this comprehensive interview. Taking a long-overdue serious look at his filmography, one notices Piper is often able to see through two-to-three productions with a given producer before moving on, which is more than most filmmakers are capable of managing in any era of independent American filmmaking. Piper also finishes what he starts, whatever the means (or lack of means) at his disposal.

What defines his path, career and creative life is Piper's extraordinary work ethic, his unflagging tenacity, inventiveness, and imagination. He is a seasoned pro, dedicated and experienced, who has surmounted all obstacles that have defeated countless filmmakers over generations. Like one of his heroes, Ray Harryhausen, Piper has continued to make *his* kinds of films, despite all the odds: genre films spiced with lively stop-motion creatures and sequences, working "old school" when most others have abandoned such hands-on techniques to pour millions upon millions into expensive CGI showcases, even at the lowest end of the production spectrum (e.g., SyFy Channel mockbusters).

Piper has done so steadily, without slacking, since 1982.

The lifeline and wellspring for countless aspiring genre creators of Brett Piper's generation: Forrest J. Ackerman & James Warren's seminal newsstand monster magazine *Famous Monsters of Filmland* (pictured here is *FM* #44, May 1967, with **KING KONG** cover art by Dan Adkins)

It is a track record precious few other living writer/director/effects artist monster-movie-makers can or ever will hold a candle to.

It's this—and, of course, his monsters—that makes Piper a *Monster!* favorite filmmaker.

Ladies and gentlemen: *BRETT PIPER!*

BACKGROUND & BEGINNINGS

SRB: When I first saw your films, you were making them in New Hampshire (I grew up in the neighboring New England state of Vermont—born in 1955, we're of the same generation, I believe—so my own background shapes these initial questions). Were you born and raised in NH? What was your family background?

BRETT PIPER: Yep, we're pretty much the same age. I was born in a smallish town just over the border from Massachusetts, with the McCarthy-ite/totalitarian mindset typical of that time and that place. It was *not* conducive to creativity. My fairly large family, three generations living in the same house, were like a cross between Archie Bunker and the Costanzas from *Seinfeld*, and considered my interest in art and movies a form of mental illness. "Why can't you be *normal???*" they'd shout, only they were New Englanders so it came out *"Naw-mull!"*

SRB: Living in rural New England in the 1960s, we were utterly dependent upon what was in local libraries, sold at local newsstands, and on broadcast TV for access to media. What were your first and most formative experiences of horror, fantasy, and science-fiction? Were they shared, or were you initially alone in your interests?

BP: My area wasn't particularly rural, but there was still the same lack of access to material, although I suppose that was true everywhere at the time unless you lived in or near Los Angeles, where the industry made things more movie-centric. I'd seen enough old monster movies on TV (three—count 'em!—*three* channels back then, so pickings were sparse) to develop an interest, so I'd scour the library and our set of Colliers Encyclopedias for anything I could find on movies.

SRB: What three channels did you get on TV as a kid, and what films were in broadcast rotation? (I know for me, certain films would pop-up again and again, and that was my first "storytelling class", so to speak...)

BP: The three main stations were WBZ (NBC), WHDH (ABC) and WNAC (CBS), all out of Boston. The New Hampshire station, WMUR, was only half as far away, but the reception was so bad you couldn't watch it. There were also two PBS stations, WENH in NH and WGBH out of Boston, but they didn't count—they were "educational TV", so no one watched them. Which to a degree was understandable. Back then there was no *Masterpiece Theater* or *Nova* or *Dr. Who*. It was guys in suits standing in front of blackboards doing math problems.

Movies were shown more or less at random. You just scanned the listings each week to see if anything good was coming up. Later we got *Chillerama*, a sort of *Shock Theater* knock-off, on Saturday nights. And WNAC later came out with *Fantasmic Features* in primetime on Monday evenings, hosted by a little alien character named Feep and showing Allied Artists and AIP pictures. I finally got to see **ATTACK OF THE CRAB MONSTERS** and **AMAZING COLOSSAL MAN**!

As with many of our generation, my real education began with *Famous Monsters* magazine, although it could be hard to get because the local newsstand for some reason stocked them in the "adult" section along with *Playboy* and such, so when I tried to buy them I'd get chased out of the store. I once attempted to explain to the store owner that FM wasn't actually a girly mag. "Don't gimme none of your lip!" he snarled and I was out on the street. Ah, I'm getting all nostalgic just thinking about it!

SRB: When you could get your hands on FM, were there any articles or issues you found useful in your own formative filmmaking pursuits? Did the Dick Smith makeup one-shot ever fall into your hands, or did you use mail-order to obtain back issues at some point?

BP: *Famous Monsters*, as I mentioned, was my primary source of movie information in the early years. **KING KONG** was my inspiration for wanting to make movies (that and the old Universal horror movies), so I would scour the pages for pictures and info on Kong and other stop-motion monsters. If they ran a photo of one of the Kong armatures, I would study it under a magnifying glass to see how the joints were

Cover of *Television Week* (for July 1963): *"Who's FEEP? Frankly, we're not sure. Says he's from Outer Cosmos and that his being here, in atmosphere, is pure accident..."* [quoted from Channel 7's "Feep" debut ad). From June 17th, 1963 to January 4th, 1965, Boston's WNAC-TV Channel 7's *Fantasmic Features* horror host Feep was played by Ed McDonnell, whom Channel 7 viewers also saw as Saturday morning *Jungle Adventure* host Lord Harold Harvey Bumblebrook, and as weekly kid-show host Major Mudd. *Fantasmic Features* continued without Feep for another Season (1964-65). [See more @ http://monsterkidclassichorrorforum.yuku.com/ topic/25578/Fantasmic-Features-with-Feep-Boston39s-Horror-Host#.WLLINjKZPUo]

designed and such. And I did have the Dick Smith makeup magazine, which was extremely helpful. Of course, I had to learn what I could from these magazines as quickly as possible before they were discovered and thrown away.

SRB: Many of us had issues with parents and adults considering our interests abnormal; I certainly did. Was there a point where they were supportive, or a turning point later in life where that changed for you and your immediate family?

BP: Hah! *Supportive?!* Oh, I love your sense of humor. No, no such thing. As I said, they thought I was crazy. My father actually thought

my unusual interests were an offense to society. "This is a democracy!" he'd shout. "You have no right to be different!" On one occasion I wanted to build part of a set in the basement and I was refused before I could finish asking the question.

"Can I—?"
"*No!!!*"

End of discussion.

SRB: *For our readers, we must emphasize how access to filmmaking materials was so limited back then (video was completely inaccessible, save at some schools, and then tightly controlled by administration and staff). Home-movie cameras—silent 8mm—were the standard, and Super 8 was introduced in 1965-66 (when I was 10 years of age—how old were you?!), albeit still silent. You could buy and watch 8mm/Super 8 "cutdowns" (short, silent 50' or 200' reels) of genre films from outfits like Castle Films and Ken Films, but there weren't any publications or books like Don Dohler's* Cinemagic *around until the 1970s; there were only home-movie filmmaking "tips" publications, like the Amateur Cinema League's* Movie Makers. *Brett, what was your introduction to making your own movies, and what was your first hands-on experience with amateur filmmaking?*

BP: When I was around eleven, a local department store (Zayre's) advertised a complete Kodak moviemaking kit (spring-driven 8mm camera, how-to manual, and a roll of film) on sale, so a friend of mine and I pooled our resources and bought one. I can't remember how much it cost, but certainly less than $15-20. My friend soon lost interest, so I had the camera pretty much to myself. I began experimenting with clay animation (disastrously—what did *I* know about focus or depth of field?!) then tried to make a three-minute version of *The Lost World*, which got nowhere. So very slowly and laboriously, over the next decade or so, I taught myself the basics of filmmaking. By the time I was in high school, occasional books on moviemaking became available and I practically memorized them. I never did complete an entire film at that time. I'd shoot a few scenes then toss them out and start over again as my "skills" improved. In fact, a friend of mine made a bet with me that I could never finish a movie. He won, but was gracious enough not to make me pay up.

SRB: *Respect and all due kudos to you. Having done my own experiments with clay animation, sporadic makeup effects, and filming and trying to edit spastic "action" sequences, I've nothing but admiration for your sticking with it as you did. I recall the grueling disappointment of working for* days *on a clay-animation thing, waiting for the Kodak film to be developed, and then screening the resulting atrocity! What was the first work you did that felt like "success", or close enough to your aspirations to inspire you to carry on?*

BP: It came so gradually, I couldn't point to any one "*Aha!*" moment. I remember animating a dimetrodon on a ledge and thinking "This looks pretty good, this motion is kind of smooth", but even at the time it seemed like no big deal. It was really just a matter of practicing and practicing and getting a little better each time. Which I'm still in the process of doing.

SRB: *I only got away with drawing my own comics and such because drawing took up no space in the house, required no involvement or permission from others; I can imagine some of what you went through, but only because I so rigorously avoided such issues to forge my own creative paths with as few obstacles as possible. At some point, though, you obviously had a breakthrough; how old were you, and did it have to wait until you had the autonomy of your own living space, Brett?*

BP: There was an empty room in the family house that I more or less took over and turned into a workshop. Every now and then someone

Most of us had a Ray Harryhausen movie that changed our lives, some more than others—and for Brett Piper, it was the life-altering **MYSTERIOUS ISLAND** (1961); pictured here is the cover art for the Dutch 8mm 400-foot [roughly just-under-a half-hour] color-and-sound "cutdown" reel)

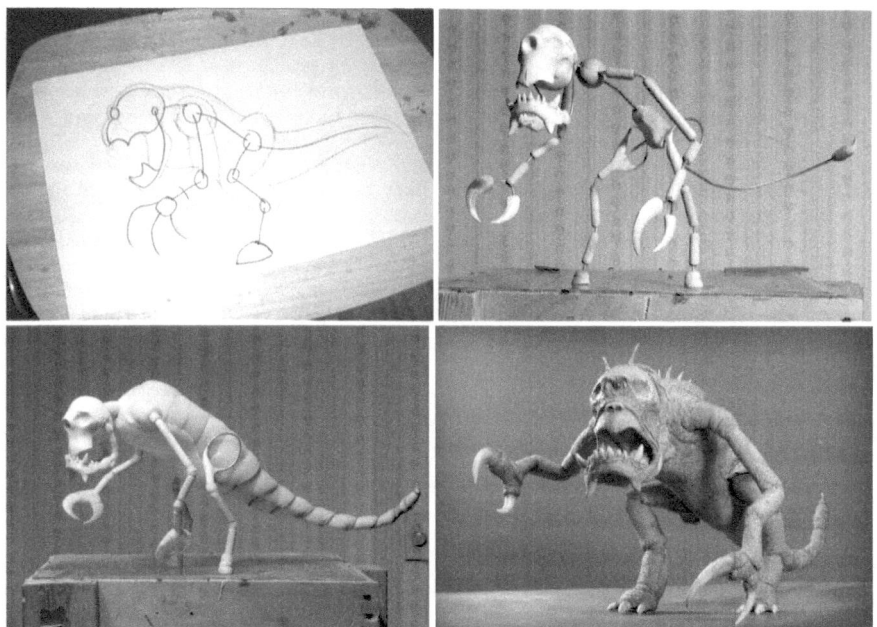

How To Make A Monster: Brett Piper's step-by-step chronicle of his model-making process, from conception sketch art, to articulated skeletal armature, to under-the-skin foam-and-latex musculature, to the fully-textured/detailed and finished stop-motion animation model. *"The one eyed creature was for an idea I was toying with last year, a movie I thought I might be able to shoot over the winter,"* Brett explained (personal email to the author, February 2017, quoted with permission). *"It never amounted to anything, but I got two creatures made"*

would notice the mess and give me hell and tell me to get rid of all the junk, which I would do. Then I'd lie low for a while, and gradually begin resuming my work again. Fortunately my family had short memories.

By the way, it's interesting that you did experiments with stop-motion and makeup when you were young, because for a while I wanted to be a comic book artist. Unfortunately, while I can draw reasonably well, it's a very laborious process for me, and I don't think I'd have ever been able to keep up the pace, even if my work had become good enough. And eventually I realized that I saw comic books as a more low-cost substitute for making movies, so I abandoned the idea. We each have our own *métier*!

SRB: What was the closest you got to a completed film (of any length) before MYSTERIOUS PLANET? When and where and what year did that happen?

BP: When I was just out of high school I started a version of *Frankenstein*. It had an interesting hook—in my version, Elizabeth was the main character. It was like "*Frankenstein* meets *Jane Eyre*". This was before things like **MARY REILLY** *[1996, USA/UK, D: Stephen Frears]* took a similar approach. It was silent, 8mm *(not Super 8)*, and after maybe a year of work and going through three different monsters, I finally finished it. It ran about 45 minutes. Several years later I looked at it and said, "This is crap" and threw it in the garbage along with everything else I'd shot to that date. I'm not very sentimental about my early work.

SRB: Out of curiosity: in that 45-minute featurette, did you work with actors your age or older? Did you do the Frankenstein monster with makeup, or with stop-motion animation—and did you incorporate (in nascent form) any of the kinds of scenic effects we've since seen you master (i.e., miniatures, split-screen, matte paintings, etc.)?

BP: The actors were around my age. The monster was a guy (actually *three* different guys) in makeup. I did build a miniature of a tower, and

animated a small wire-framed figure climbing it. I wanted it to collapse in flames at the end, so I built a balsa wood framework and stretched wax paper over it and glued miniature bricks to the paper. The wax paper and balsa burned very quickly, causing the structure to collapse rather nicely.

SRB: *One more* Frankenstein/Jane Eyre *question: were you working from films as your main inspiration or springboard, or were you more grounded in the literature of Mary Shelley, Charlotte Brontë, and later Jules Verne and literary science-fiction?*

BP: Both, I'd say. I'd read *Frankenstein* and most of Verne's better-known works, but not *Jane Eyre* at the time. I'd seen the *[1943]* Orson Welles movieOr rather, the Robert Stevenson movie starring Orson Welles.

SRB: *Before we get into your adult evolution as a filmmaker and your known filmography, may I ask: the toughest thing for many of us was and/or is negotiating that distance between freelancing and/or making art as our calling, and somehow making a living at it. Were you juggling day-jobs while making your films, subsidizing the creative life as many do with unrelated jobs keeping roof overhead and materials and work funded? Was there eventually (or ever) a point where the filmmaking was keeping a roof overhead?*

BP: For most of my life (and at present) I've had to hold down "real" jobs to support myself while I made films. But shooting a movie frequently demands all your time, so I'd sometimes take a few weeks off or, in some cases, quit my day job and live off savings while the movie was being shot. There have been periods when filmmaking itself provided enough income so that I didn't have to do anything else. The five-year period when I worked at EI/Pop Cinema, I was a fulltime filmmaker. I even managed to *save* money! I live very frugally.

MYSTERIOUS PLANET (1982)

SRB: *Let's get into the films themselves, and if you're up for it, bridge the filmography with any projects that didn't reach fruition, and those where you did effects or tech work for others. So,* MYSTERIOUS PLANET— *Forgive me if I'm projecting a bit here. Seeing the Cy Enfield/ Ray Harryhausen* MYSTERIOUS ISLAND *(1961) during its primetime TV premiere on CBS in 1965 was a powerful life-changer for me; I remember being so blown away by it that I forced myself to read the Jules Verne novel (at age 10, that was a tough slog) and really grilling my grade-school teacher about Jules Verne. It was neither my first experience with a Jules Verne adaptation (that would have been the Disney 20,000 LEAGUES UNDER THE SEA, in a theater) or Ray Harryhausen's work (that would have been THE BEAST FROM 20,000 FATHOMS on TV, and FIRST MEN IN THE MOON in a theater one year earlier), but there was something about* MYSTERIOUS ISLAND *that really hit home: it impacted my play with friends outdoors that year, even. When I first saw* MYSTERIOUS PLANET *(on rental VHS, in the mid-1980s), I recognized a kindred spirit and reacted accordingly, and it's pretty clear the Harryhausen film inspired you. What was it about* MYSTERIOUS ISLAND *for you that prompted you to reinvent/remake it as* MYSTERIOUS PLANET?

BP: My introduction to **MYSTERIOUS ISLAND** was rather electrifying. I'd never even heard of the movie, but I was at a Saturday matinée in my home town when they showed the trailer. I was sitting right up front, and that giant crab looked big as life! I couldn't wait for the following weekend when they showed the movie (on a double bill with **ZOTZ!**, which I'd also been looking forward to). And when I saw it, I was absolutely floored. I still think it's perhaps Harryhausen's most fully-realized movie. It doesn't have the iconic monsters of **SINBAD** or a tour de force sequence like the skeleton fight in **JASON**, but in every other respect—story, dialogue, performances—it's a superior movie. I think that, next to **KONG**, **MYSTERIOUS ISLAND** is the film that's had the biggest impact on my life.

SRB: *Was* MYSTERIOUS PLANET *your first completed feature—it was the first any of us had access to out in the world, as a potential audience—and if so, what led to this particular screenplay and effort becoming the maiden voyage?*

BP: Yes, it was the first. I'd been trying to get some sort of feature off the ground for years. I'd written many scripts, most of them less ambitious, and done story art and built miniatures in an effort to raise money, but all for nothing. I finally contacted a local investment counselor with a frustrated creative streak and got him interested (which turned out to be a *big* mistake). He raised a little bit of money to do a movie. I don't remember if the idea of remaking *Mysterious Island* as a space opera came before or after. I was

a little bit inspired by **FORBIDDEN PLANET**. And it was probably inevitable. I'd been copying sequences from it ever since I was a kid.[6]

SRB: What was your writing and scripting process at that time? Did you develop MYSTERIOUS PLANET in a similar manner to how Harryhausen developed most of his films—in which the narrative was essentially contrived to bridge the special effects sequences he wished to create—or did it develop more organically, as a story first, around which you then concieved and worked-out the necessary creatures and special effects?

BP: I just sat down and started writing. It didn't take long. After all, I had the blueprint laid-out in front of me.

SRB: Fair enough! How much time did it take to move MYSTERIOUS PLANET from conception to live-action filming, and then through the extensive effects work to completion (and what years are we talking about, to establish a chronology here)?

BP: That's very hard to say. After all, it's been over thirty years! The movie was made around 1980. It probably took around a year to a year-and-a-half to do.

SRB: MYSTERIOUS PLANET opens with a battle in space, staged with the urgency and flavor of STAR WARS; did you conceive MYSTERIOUS PLANET consciously as a fusion of the new SF cinema of the late 1970s and the rather suddenly-antiquated "old-school" Harryhausen templates?

BP: Yes, very much so. Although Harryhausen wasn't quite so "old school" at the time. He still had **CLASH OF THE TITANS** ahead of him, and the CGI "revolution" wouldn't come along

6 In a personal email Brett sent me shortly after this conversation, he noted, "I was just reading a post from James Aupperle concerning **PLANET OF DINOSAURS** [1977] on the Classic Horror Film Board. Among other things, he had this to say:
'...my first draft for the [**PLANET OF DINOSAURS**] story was from Mysterious Island, which went in for a shipwreck theme. My treatment even had the title **MYSTERIOUS PLANET**, though I'm sure we didn't intend to use that on the release.'
His movie came out a few years before mine, so I guess I would have had to come up with a new title. One of the first distributors I approached about **MYSTERIOUS PLANET** was also handling **PLANET OF DINOSAURS**, and in fact talked about releasing them as companion features. Small world, eh?" (Brett Piper, email to Bissette, August 30, 2016, 8:42 a.m.). At the time of this writing, Aupperle's post (August 27, 2016, 4:04 PM) was archived at http://monsterkidclassichorrorforum.yuku.com/topic/23505/Planet-of-Dinosaurs?page=25#

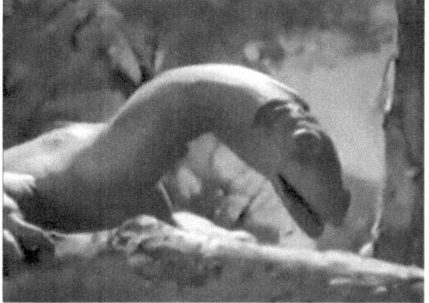

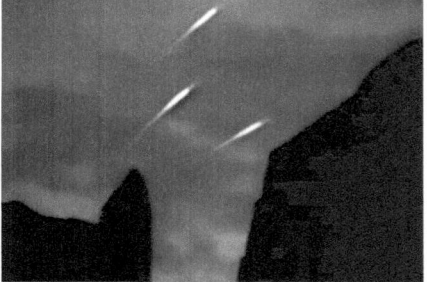

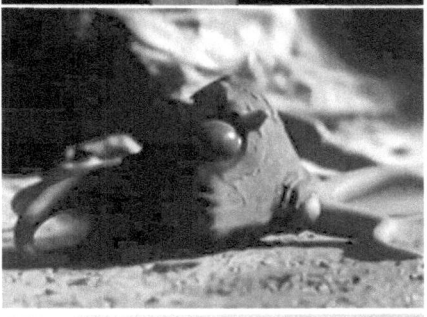

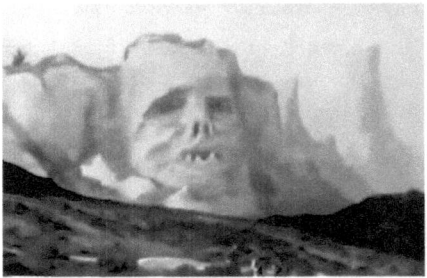

A quartet of special effects shots from Brett Piper's maiden voyage, **MYSTERIOUS PLANET** (1982). Included are two of the film's stop-motion creatures *[topmost and third image above]*, a night-sky sighting of the enemy spacecraft flashing overhead *[second image above]*, and this glass-painting shot of the planet's unexplained monstrous geological "face" formation, in which the stranded astronauts find a sheltering cave

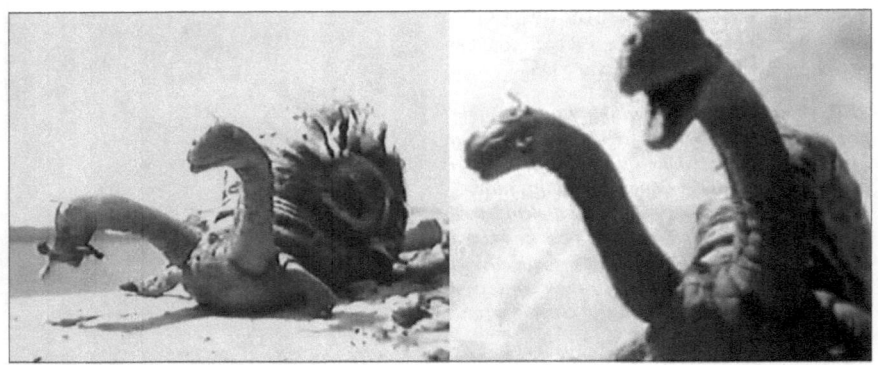

The first-ever eruption of monster mayhem in a Brett Piper feature film: shipwrecked engineer Tellus Markus (Michael Quigley—or rather, Quigley's "stand-in" animation model) in the jaws of the monstrous two-headed gastropod hybrid scavenging the beaches of the **MYSTERIOUS PLANET**

until **JURASSIC PARK** in 1993. Stop-motion was still being used in major features like **THE CONEHEADS** that same year.

SRB: Please, don't misunderstand me, Brett. I meant you moved beyond "old school" in story/narrative terms only—as you say, stop-motion animation, miniatures, etc. were still very much essential to the tool-kits of feature films in 1980-82. Narratively speaking, in terms of your script, MYSTERIOUS PLANET was pushing further than Harryhausen & Schneer's collaborations, including what followed with CLASH OF THE TITANS (where Bubo the Owl played like an unfortunate stab at incorporating an R2D2-type character). You were incorporating elements characteristic of the post-STAR WARS wave into your story, organically, in ways the "old school"

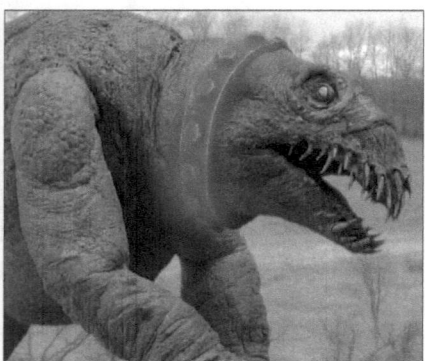

The toothy alien "hunting creature" (note that glowing control collar around its neck) in search of renegade humans on **OUTPOST EARTH** (2016); the most-recent stop-motion monster mayhem seen in a Piper feature

scripts characteristic of the Harryhausen/Schneer template did for stories. That's what I was referring to.

BP: Schneer (and Harryhausen I believe) always denied that Bubo was influenced at all by R2D2. I'd like to know just who the hell they thought they were kidding. He was an obnoxious little twerp anyway. I remember thinking it was unfortunate that they never got to make "SINBAD ON MARS", until I read the treatment for it and realized that it would have been just another lame Sinbad story nominally set on Mars. I hate to say they were old dogs unable to learn new tricks, because I'm older now than they were then, but hey—I'm working on a story right now that's all about taking the standard RH model and moving it onto contemporary times, so who knows.

SRB: So, about the opening of MYSTERIOUS PLANET—

BP: The opening of **MYSTERIOUS PLANET** was supposed to be entirely different. There was supposed to be a whole "prison break" sequence with the main characters before they took-off into space. But for various reasons (primarily economic) that was all replaced by a sequence using only miniatures. Miniatures have always been easier to deal with than people.

SRB: From the get-go, you were designing much more imaginative creatures than almost all other stop-motion animators or filmmakers— JACK THE GIANT KILLER, EQUINOX, FLESH GORDON and LASERBLAST come to mind as really pushing that envelope, however crudely—and that remains true right through to OUTPOST EARTH (the most recent of your films

I've seen [which has been completed, but as of this writing is still unreleased]). *MYSTERIOUS PLANET involves all manner of beings: the alien crew member, the small crustaceans on the beach, the outsized two-headed snail monster, the rotund bovine-like plant-eater, and so on. What's your conception process in creating your monsters and characters, Brett? (I'll ask about the actual construction process next—I'm just talking about your inventive designs and concepts here.)*

BP: Usually I have an idea in my head of what the creatures will look like as I'm writing the script. Occasionally I'll sketch them out first, drawing them real size so I can keep the proportions right while I'm building the models. It's pretty much the same process I use today.

SRB: Let's get into your modelmaking process a bit, if we may. Most of us never got beyond the 8mm "Plasticine-molded-around-bent-coat-hanger-wire" phase of "monster" animation models—well, I didn't. At what point in your life were you creating your own armatures, and what was that evolutionary process for your work?

BP: I can tell you one thing, I had no machinist father to make armatures for me![7] I started out, like everyone else, making models out of clay, moving on to wire and wood, then wooden armatures with beads for joints, finally full metal armatures with steel and brass joints. Entirely self taught, reinventing the wheel, so to speak. There never was any big evolutionary leap. It was a long, slow process of trial and error. The amazing thing is when I finally saw some of Harryhausen's armatures—the Cyclops especially—I thought "Mine look like that!" They look so primitive, compared to some of the other armatures I've seen, *[Jim]* Danforth's, for instance. But they all work the same.

I used every kind of armature in **MYSTERIOUS PLANET**. Clay, wire, ball-and-socket, depending on what an individual creature was required to do.

SRB: How did you go about putting "flesh" on those armatures—creating the "muscle" and meat and skins, the textures, and mold the creatures themselves? How did that evolve for you, from your high-school years on to MYSTERIOUS PLANET?

BP: It's all done mostly *[Marcel]* Delgado-style, built up in foam and latex over the armatures.

[7] Brett is referring here to Ray Harryhausen, whose machinist father constructed the armatures for Ray's early animation models.

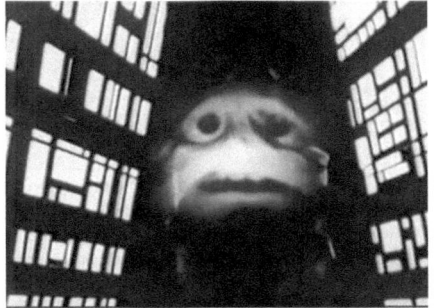

Miniatures, hand-animated puppets, and other live-action effects shots also figured in Piper's first feature **MYSTERIOUS PLANET**, including the still-living remnant of an alien super-civilization *[top two images]* and more organic predatory lifeforms *[bottom two images]*

The "stag beetle" creature from **DARK FORTRESS**, better known as **A NYMPHOID BARBARIAN IN DINOSAUR HELL** (1990); this was the only animation model Brett ever made a casting from. He conceived and filmed **DARK FORTRESS** as a *faux*-medieval fantasy adventure, but its distributor Troma Entertainment instead turned it into a post-apocalyptic SF narrative

Early on I experimented with casting the creatures from molds. Two of the creatures in **MYSTERIOUS PLANET**, the lake creature and the pachyderm, were done that way. Thinking back, the two-headed snail may have been as well. But it's a huge pain in the ass and the results don't justify the trouble, not for the sort of creatures I make, anyway.

SRB: Your creatures and characters have really maintained a strong sense of physical being—their design, their skin textures, all thanks to your extraordinary attention to detail and making them believably alive. What was the development of your animation modeling artistry, techniques and technology from MYSTERIOUS PLANET to the present? What major evolutionary steps or breakthroughs would you care to share with us on that aspect of your creative work?

BP: Again, it's been a long, gradual process. You learn from mistakes, try to improve your technique with each creature. I'm *still* learning.

SRB: How "deep" do you go with the creature designs conceptually, as in: Do you work them up physiologically as well as biologically, with speculative life cycles, diets, and so on in mind? Do you name your creatures when you create them (species names, or whatever)?

BP: Generally none of the above, unless it's specifically called for in the script.

SRB: Given the budgetary constraints you're working with, I take it the models are stripped back to armatures for recycling/reuse of those components. Is that the case, and if so, do you keep castings of the final models for yourself? What, if anything, survives, besides the films themselves?

BP: The only casting I ever made of one of my creatures was the "stag beetle" monster from **NYMPHOID BARBARIAN**, which I gave to my nephew (who played the little troll in the movie) for Christmas or his birthday or something. Otherwise I've never made copies. I do occasionally reuse parts from old monsters, although I rarely strip the puppets down for reuse. It's usually more a case of taking apart old armatures from creatures I never finished building. For example, I built a fairly elaborate camarasaurus armature for a dinosaur movie that never got made, and various joints and pieces from that have turned up in other monsters over the years. Still, I have few old puppets left. I've given a lot of them away, although I was frequently sorry I did. Not because I wished I still had them, but because they were often not treated too well.

SRB: Judging from images you've shared over the years, it seems you also create beings and creatures that don't end up in finished features from time to time. If so, do you keep those creations for possible future use?

BP: Those I tend to hang on to. I have a spider/brain creature sitting on my shelf right now next to an Ymir-like alien and some never-used dinosaurs. They were all built for movies that looked like they were going to get made, but never were. I keep them because I may still get a chance to do those projects some day.

SRB: I imagine it's different with each production, but I take it your creatures are "cast"—in both senses of the word!—before your live human actors are cast? And if so, do you show your actors the models so they know what they are "playing" against or with in effects sequences where they're playing to an "invisible" performer (the monster) that will be added later?

BP: It does vary, but as a rule I make the creatures after the principal photography is done. I have my hands full with other things before that. Sometimes I might show the actors a sketch of the creature, but more often I just describe it to them. A lot of times they've formed a mental image of the creature based on the script, and are surprised on seeing the finished movie that it looks nothing like they thought it would. And occasionally they really don't care. I'll try to describe the creature and their attitude is "Yeah, yeah, let's just shoot this thing..."

SRB: Nobody ever seems to comment on how well-cast your films are; regardless of the relative acting abilities, there's always a strong physical presence, your casts LOOK good, they look RIGHT, for their respective roles, and I chalk that up to you. I'm sure the casting process must have been a challenge on your initial features in particular; how did you go about casting MYSTERIOUS PLANET, as your first production?

BP: To this day, casting is the hardest part of making a movie. Even when I was working in New Jersey and casting out of NYC, it was a bitch. I'm convinced that the only place you can cast a low-budget movie without it being a major headache is in Los Angeles, where you can probably find all the actors you need waiting tables at any given restaurant, but if I ever try it I'm sure I'll find out I'm wrong again. Anyway, **MYSTERIOUS PLANET** was actually pretty easy, because it had a small cast and I wrote most of the parts for people I'd grown up with. The "Feral Girl" [Marilyn Mullen] came from a local modeling agency, and was great except that she was sixteen and her parents didn't like her doing the movie, so they'd interfere whenever they could. I'd get a call on the morning of a shoot saying she couldn't make it because her mom decided to go grocery shopping and she had to stay home to babysit her sisters. The female lead [Paula Taupier] had done some theater in the Boston area and was okay, except that when it came time to dub her dialogue her mother called to tell me, after the fact, that she'd left for Ireland with some friends

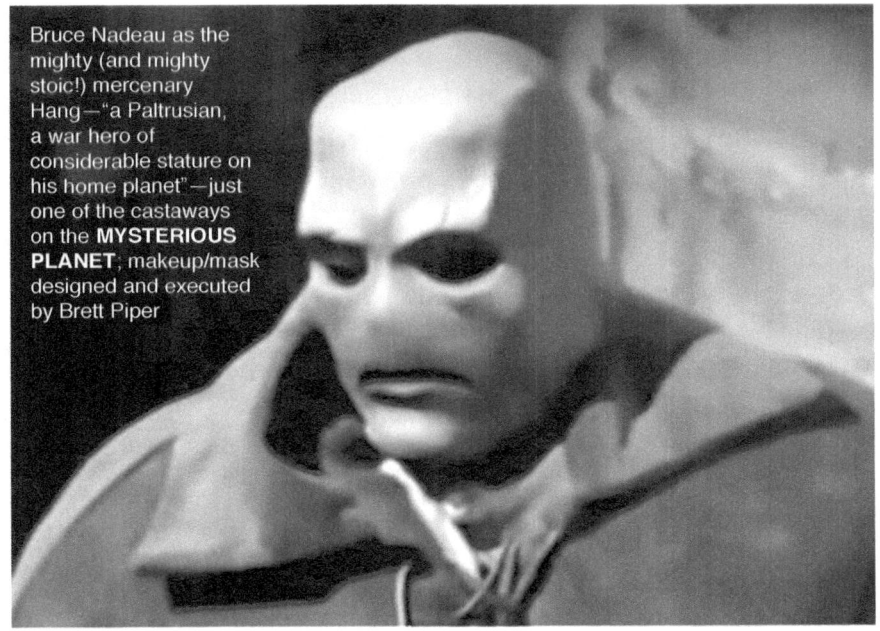

Bruce Nadeau as the mighty (and mighty stoic!) mercenary Hang—"a Paltrusian, a war hero of considerable stature on his home planet"—just one of the castaways on the **MYSTERIOUS PLANET**; makeup/mask designed and executed by Brett Piper

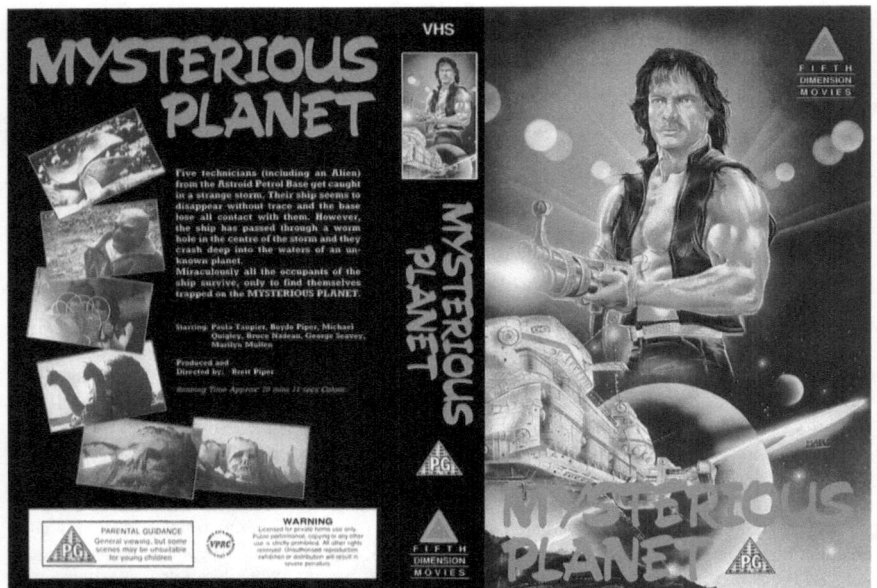

British VHS jacket art to **MYSTERIOUS PLANET**, which was released in the UK via Global Sales Ltd. in 1988 as part of the firm's "Fifth Dimension Movies" series; I reckon Boydd Piper's protagonist Arnus is meant to be the Ramboesque muscular male depicted here by the artist "Marc"—whose cover boy was clearly modeled after another, unrelated (?) Piper, the late wrestler-actor "Rowdy" Roddy—but Arnus sure never looks like *this* in the movie!

and wouldn't be back for several weeks. I got someone else to do her lines, and she was furious. She had a lawyer send us a letter threatening to sue if we didn't let her redo them herself. It gave us all a good laugh.

SRB: Who played the alien crew member in MYSTERIOUS PLANET—I presume you created the makeup/mask, yes?—and who were your other two male leads? And what relation was Boydd to you?

BP: The alien was played by Bruce Nadeau. He was a big guy and kind of a ham, so it worked out okay. Boydd is my younger brother. The other two male leads were George Seavey, whom I'd known since I was a kid (he played the telepath), and Michael Quigley, an aspiring performer I met when we worked together at an amusement park.

SRB: How do you work with your actors to ensure eyelines and the illusion of their looking at what isn't-yet-there (be it an environment, a creature, a ship, whatever) is working onscreen, as best you can?

BP: Not very well, I'm afraid. Usually it's just a matter of everyone agreeing on a certain spot:

"That tree over there." "The big one?" "No, the one next to it." "The one with the crow—oh wait, it just flew away..."

Until they all seem to be looking more or less in the same direction.

SRB: Just as vital as the creatures and characters in each film are your locations. MYSTERIOUS PLANET was filmed in New Hampshire and New England. Where, precisely; and how did you go about scouting and choosing locations for MYSTERIOUS PLANET, including those you altered/reinvented via miniatures, mattes, etc.?

BP: The beach scenes were shot at the Parker River Wildlife preserve in Massachusetts. No structures of any kind on the beach and limited access to people, so we could work largely undisturbed. The rest of the movie was shot locally, in southern New Hampshire, at various ponds and rocky fields and such, anywhere that looked more or less right, augmented by a few mattes and paintings here and there. All done in camera, needless to say, using century-old technology.

SRB: Did the "century-old technology" include glass paintings and the like, suspended between the camera and what you were filming?

BP: Yes, in some cases. I seem to recall that a few shots where the actors approach the "skull" cave were a glass painting, and some of the alien skies. There were foreground miniatures too, like the derelict space ship (which was copied from an old *Flash Gordon* panel).

SRB: As best you can remember, how long was the live-action shoot (the human characters' hairstyles stay consistent in the film, so it looks like it was done in a timely fashion), and how long was post-production for you on MP? Were there any major stumbling blocks in the home stretch?

BP: The shoot was broken-up into small segments, a few days here and there depending on everyone's schedule. It stretched-out over quite a while, but I couldn't say exactly how long. It might have been close to a year. And it was *all* stumbling blocks!

SRB: How did you bankroll the production and post-production, and who was Nicholas Hackaby—what did he do that earned him the producer credit on MYSTERIOUS PLANET?

BP: A local investment counselor got together a bunch of his buddies and they put up $5000 to shoot the movie. These guys were worth millions, and it took them maybe six months to cough-up $500 apiece, and it required a thirty-five-page contract! The actors worked for deferred payment, and they all got their money. There *is* no Nicholas Hackaby—I made him up to pad the credits.

SRB: Was MP shot on 16mm or 35mm? I'm curious what you ended up with within your means to exhibit and sell the film: a negative, interpositive, print(s)?

BP: The movie was shot on Ektachrome 7240 (VNF: Video News Film). This was a 16mm reversal film, commonly used back then for local news because the audio was recorded simultaneously on a magnetic strip on the film itself. The plan was for a guy I knew who worked at the local TV station to shoot it using an Auricon, a self-blimped camera that could record sound on the mag track. Unfortunately, this person ended up being, shall we say, a little less than reliable, and the whole movie was shot silent with my Bolex and post-dubbed. I had black and white dupes made from the original color stock and did all my editing on those, then match-cut the color original myself. This was what the final print was made from. A ¾" videotape master was made from the final print and VHS copies were dubbed from that.

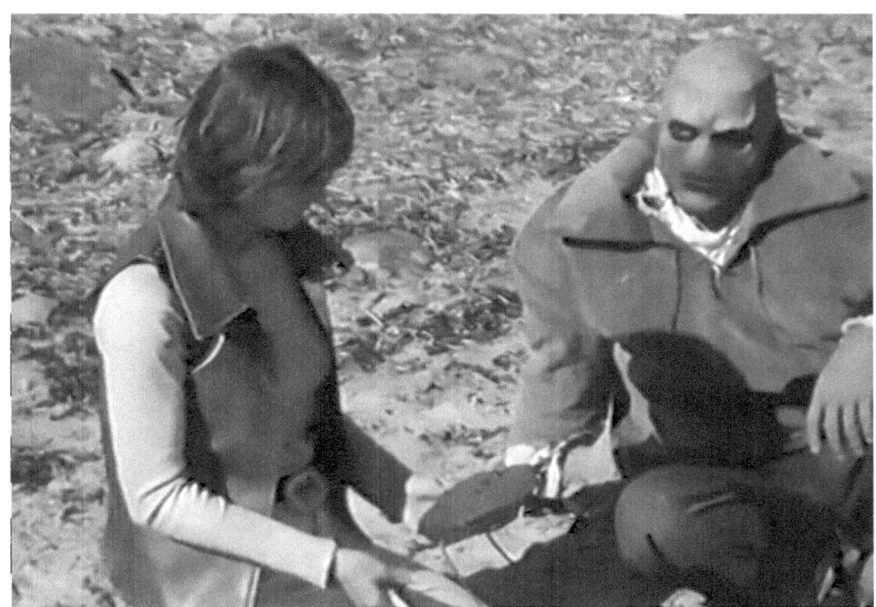

Mysterious Planeteers: Paula Taupier as Commander PC3 Rogan, holding a possibly-edible mollusk, which the Paltrusian mercenary Hang (Bruce Nadeau) certainly intends to eat. This sequence was shot on the beaches of the Parker River National Wildlife Refuge in Newburyport, Massachusetts

A native-dubbed version of **MYSTERIOUS PLANET** has become a staple of the German home video/DVD market, under the various titles **DER PLANET**, **STAR ODYSSEY: MYSTERIOUS PLANET**, and/or **DIE REISE ZUM PLANET DES GRAUENS**, currently available on DVD as part of this multiple-volume MIG/Eurovideo series simply entitled *Jules Verne*. Except for the soundtrack, the rather murky fullscreen transfers are identical to the original 1980s US and UK home video editions taken from the ¾" videotape master which Piper provided Dallas, TX broker Tom Moore of Reel Movies International in 1982. German collector/dealer/expert Markus Tump says, *"I sold truckloads of MP on film markets—it was evidently quite often to be found in sale bins of video-stores—but even though you never got much money for it (about 10 DMs) it seemed everyone wanted this movie in their collection. There were three* [editions] *on video, the others* [five to date] *on DVD,"* including an edition from Bild am Sonntag. *"Funny fact,"* Markus adds, *"Bild am Sonntag is the Sunday edition of Germany's foremost Yellow press 'news'paper, who in 1984-85 was warring against horror videos quite often, and vile."* (Personal message to author, quoted with permission)

SRB: When and where did MYSTERIOUS PLANET debut—was there a cast and crew showing? A local theatrical premiere? Festivals?

BP: No, none of the above. It just sort of sneaked out on videocassette.

SRB: Distribution is always a nightmare for filmmakers. But the early 1980s was a very, very different scene than it is now; can you describe what it was like then? How did you try and go about getting MYSTERIOUS PLANET out there, initially?

BP: Distribution was much easier in some ways. It was still possible to get cash up front for your movie, for one thing. At least then you knew you were getting *something*, even if the advance was all you were ever going to see. And there was still a market for low-budget product. TV stations all around the country were still using cheap movies to fill their 2:00 a.m. slots and such, the VHS boom was still on and small distributors were hungry for product, and you could sometimes even get regional movies shown at drive-ins. It was a different world. All that is gone now. The major studios have a complete stranglehold on the industry. It's the Walmart effect. The big guys crowd the little guys out of the industry, so there's less product and choice for the consumer. God Bless Capitalism!

SRB: Domestically, MYSTERIOUS PLANET was released on videocassette by the Oakland, CA-based Video City Productions in 1986.[8] What

8 Video City Productions wasn't around long—according to vhscollector.com, they were only in operation from 1984-1987—but they were prolific. Their other big-box home video releases included the infamous Italian Nazisploitation films **NAZI LOVE CAMP 27**, **SS SPECIAL SECTION WOMEN**, **THE LAST ORGY OF THE THIRD REICH**, and

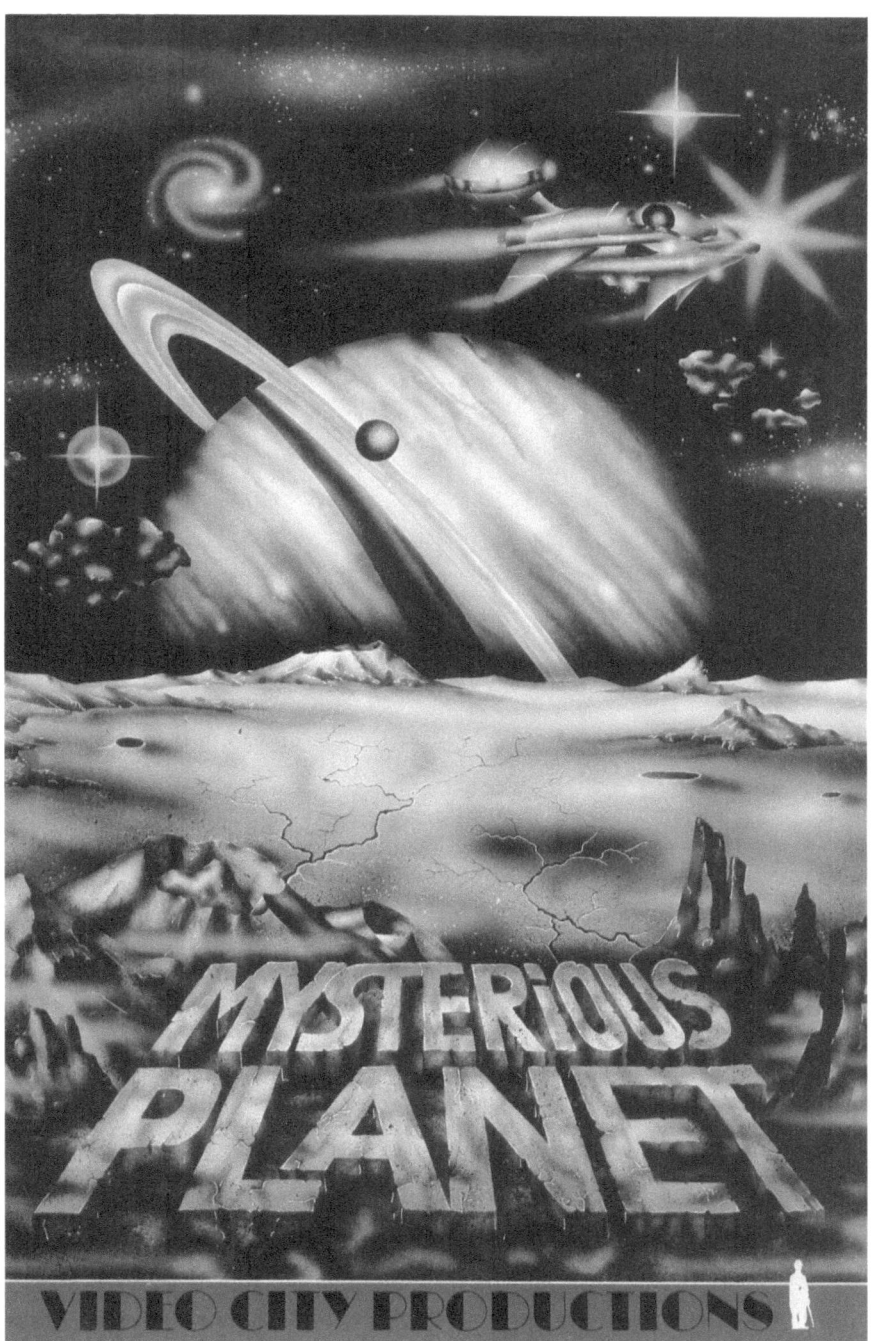

The colorful painted big-box front cover to the Oakland, CA-based Video City Productions 1986 VHS release of **MYSTERIOUS PLANET**, artist unknown. Though it's a rare collectible today, this release was in almost every New England video store over a couple of years in the mid-1980s. *[Scan c/o SpiderBaby Archives/author's personal collection]*

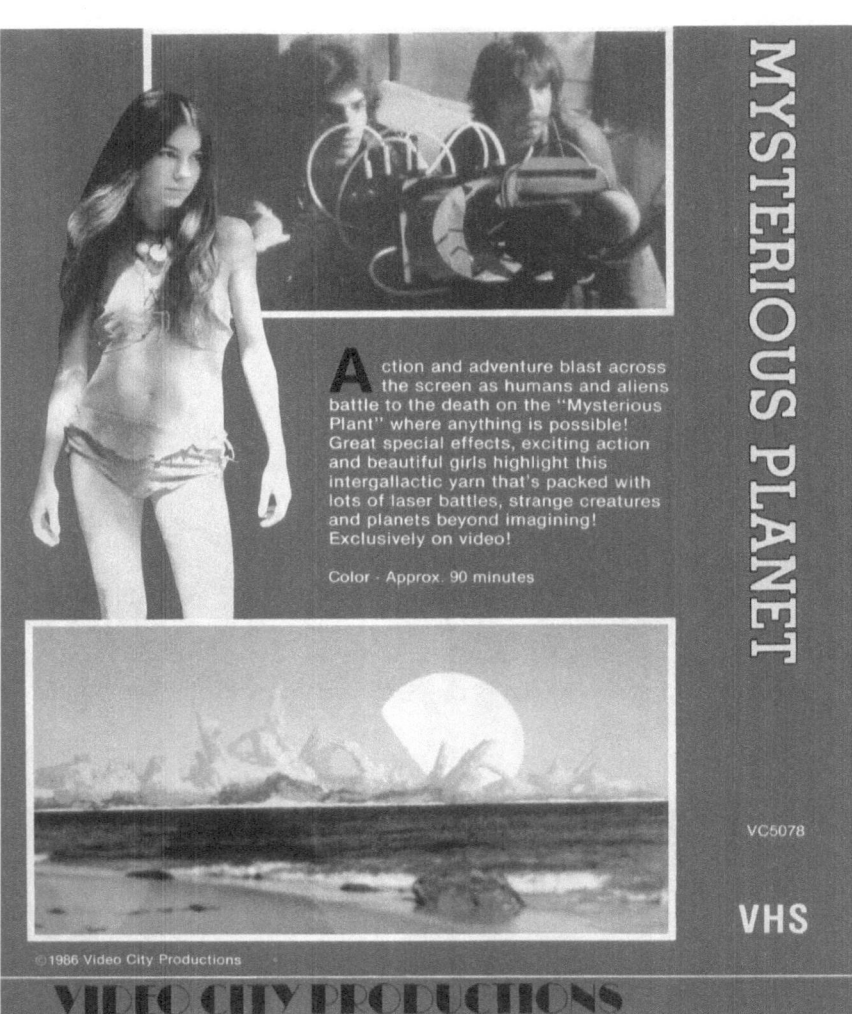

Back cover to Video City Productions' 1986 domestic VHS release of **MP** (scan c/o SpiderBaby Archives/author's personal collection), depicting *[top]* engineer Tellus Markus (Michael Quigley) and the mercenary Arnus (Boydd Piper), ready to open fire; *[top left]* teenager Marilyn Mullen as the mute "cavewoman"; plus one of Brett Piper's special effects glass-shot paintings which "customized" the horizon-line of the ocean visible from one of the Parker River National Wildlife Refuge beaches in Newburyport, Massachusetts.

can you tell us about that outfit, and that release?

SS HELL CAMP, cannibal films like Ruggero Deodato's **JUNGLE HOLOCAUST** and Jess Franco's and Franco Prosperi's **WHITE CANNIBAL QUEEN**, Jopi Burnama's **WAR VICTIMS**, Nick Millard's **CRAZY FAT ETHEL 2** and **DEATH NURSE**, the Paul Naschy vehicle **INQUISITION**, Cheung Yan-git's 1981 Hong Kong horror **THE DEVIL**, TV horror host John Stanley's **NIGHTMARE IN BLOOD**, Italian *Poliziotteschi* and other crime actioners, including **NEW MAFIA BOSS, MOB WAR, THE SICILIAN CONNECTION,** and **1931: ONCE UPON A TIME IN NEW YORK**, and oddities like **WAR KILL, SLAVERS, LADY STAY DEAD** and **FRANKENSTEIN'S GREAT AUNT TILLIE**.

BP: I don't know anything about it. I was dealing with Tom Moore at Reel Movies International in Dallas, Texas. He was a broker who handled independent movies. He did a pretty good job with the film, it made a nice profit for such a cheap little picture. Again, "nice profit" is no longer an incentive to distributors. If I proposed a film that I could *guarantee* would make $10,000,000, any distributor in the business would pass. They only want the big money, they have their eyes on that billion-dollar profit. It's like when the lottery gets

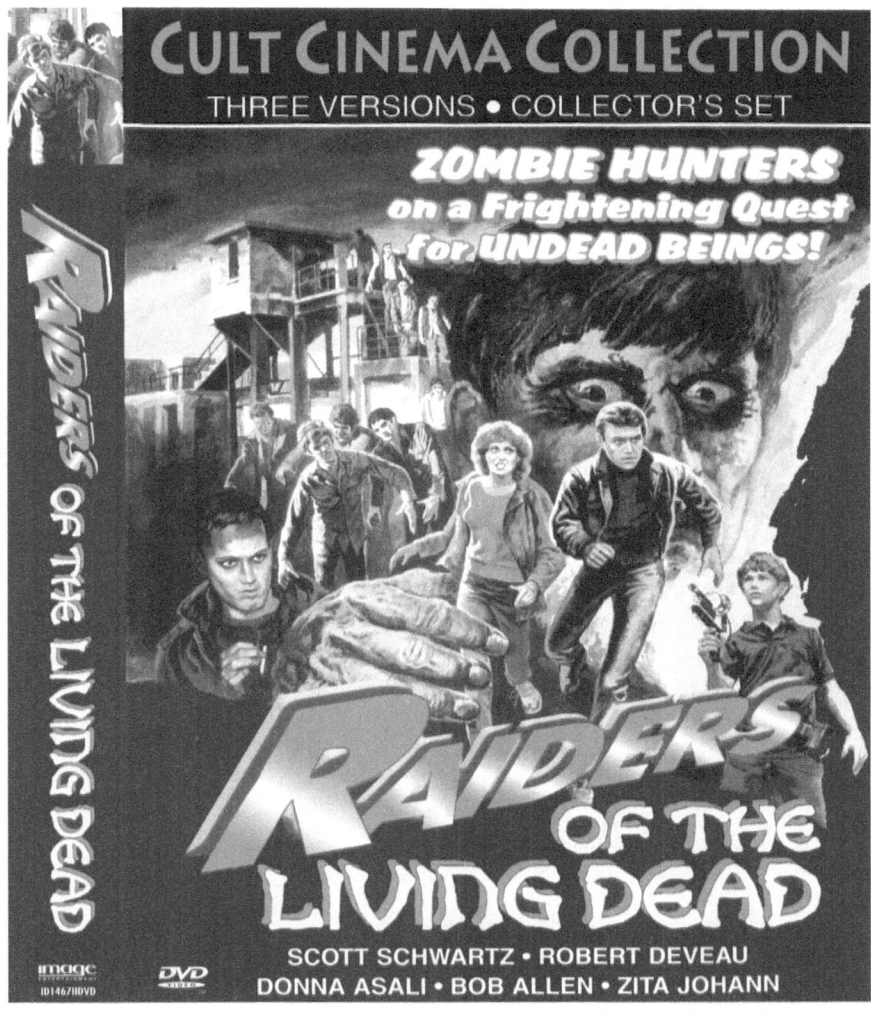

Front cover (and spine) art to the original and rather amazing 2-disc "Cult Cinema Collection", Image Entertainment's 2002 DVD release of Brett Piper's **DYING DAY**, the interim-stage work print **DARK NIGHT** (1983), and the final release version, Sam Sherman's **RAIDERS OF THE LIVING DEAD** (1986/89). It's *complicated*! (For more information, see p.28 and pp.32-34)

up in the hundreds of millions, a guy who plunks down his dollar and only wins $50,000 thinks he's been cheated.

SRB: MYSTERIOUS PLANET *enjoyed (if that's the word) quite an international video "life" in the 1980s; I've seen editions from all over the world. Were those legal releases, and were these revenue streams for you (I hope)?*

BP: I assume they were legal, although I guess some of them must have been crooked. I was dealing with a middle man, so I have no way of knowing. As I said, we turned a decent profit in relation to our cost. I probably made the same money as I would have working a decent day job for a year.

SRB: *How much time passed for you between the completion of* MYSTERIOUS PLANET *and your securing a deal with Tom Moore at Reel Movies International to get it out there—and what was it like, on your end, experiencing those early days of the videocassette revolution? When did you first see MP on a videoshop shelf?*

"An eerie film...If you are an avid collector of Zombie movies, you will like this flick."
—Jester-27, *Internet Movie Database*

A horror/action thriller dealing with the invasion of Zombies into a local community.

In a frightening abandoned prison off the East Coast, a doctor has revived executed convicts as "The Living Dead."

A teenager (Scott Schwartz, *The Toy*) has taken the laser out of a video disc player and made a weapon out of it. When the dead creatures are discovered, he pursues them, aided by his girlfriend and grandfather, played by veteran actor/Western star Bob Allen (Karloff's *The Black Room*).

A reporter (Robert Deveau) on the trail of the story is helped by the old librarian (acting legend Zita Johann in her final film role). Johann had been a big Broadway star and co-starred with Boris Karloff in *The Mummy*, starred in *Sin of Nora Moran* and co-starred with Edward G. Robinson in *Tiger Shark*.

On the prison island, the Zombies attack a security guard and tear him apart just as the reporter and the kid with the laser gun arrive to rescue a victim in the prison's caverns.

The film features incredible weird locations and great Zombie effects.

THREE VERSIONS

Director Sam Sherman's company, Independent-International Pictures Corp., purchased an unfinished short 80-minute film — DYING DAY from special effects filmmaker Brett Piper. When the buyers turned this film down because of poor quality, Sherman decided to re-shoot the film as DARK NIGHT. Buyers were happy with the improvement in the film and so Sherman went further and added more and more footage until the final project became RAIDERS OF THE LIVING DEAD — which was a big success, leaving very little of DYING DAY left in the final film. All three versions are on this disc — the final version of RAIDERS OF THE LIVING DEAD, Sherman's first work print cut of DARK NIGHT and Brett Piper's original DYING DAY. You can see the evolution of a movie and view many of the editorial and production devices employed to make the final version a marketing success. DARK NIGHT and DYING DAY are not rated.

INDEPENDENT-INTERNATIONAL PICTURES CORP. presents

starring SCOTT SCHWARTZ · ROBERT DEVEAU
DONNA ASALI · BOB ALLEN · ZITA JOHANN

produced by DAN Q. KENNIS

written and directed by SAM SHERMAN

an INDEPENDENT-INTERNATIONAL picture

SPECIAL FEATURES

- Special Audio Commentary Track by Sam Sherman
- Rarely seen "House of Terror" Live Horror Show Promo
- Theatrical Trailers for RAIDERS OF THE LIVING DEAD, *Brides of Blood, Mad Doctor of Blood Island, Beast of Blood, Brain of Blood, Blood of the Vampires, Horror of the Blood Monsters* and *The Blood Drinkers*
- Behind-the-Scenes Still Gallery

Two-Disc Set

RAIDERS OF THE LIVING DEAD ID1467IIDVD
Program Content: ©1986 INDEPENDENT-INTERNATIONAL PICTURES CORP. ALL RIGHTS RESERVED.
Artwork and Summary: ©2002 INDEPENDENT-INTERNATIONAL PICTURES CORP.
ALL RIGHTS RESERVED.
DVD Package Design: ©MMII IMAGE ENTERTAINMENT, INC. ALL RIGHTS RESERVED.
9333 OSO AVENUE, CHATSWORTH, CA 91311
www.image-entertainment.com • www.dvdinformation.com

DISTRIBUTED EXCLUSIVELY BY **image** ENTERTAINMENT

The views and opinions expressed on the audio commentary and in supplemental materials featured on this DVD are those of the participants and do not necessarily reflect the views or opinions of Image Entertainment.

Dolby and the double D symbol are trademarks of Dolby Laboratories Licensing Corporation.

Color/Total Feature Running Time: 3 Hrs. 58 Mins. PG-13 NTSC

Store under cool, dry conditions. DUAL LAYER FORMAT: Layer transition may trigger a slight pause.
WARNING: The program contained in this DVD is authorized for private home use only. All other rights are retained by the copyright proprietor. The FBI investigates allegations of copyright infringement, and federal law provides severe criminal and civil penalties for those found to be in violation. Made in U.S.A.

Back-cover copy to Image Ent.'s 2002 "Cult Cinema Collection" DVD release of **DYING DAY / DARK NIGHT / RAIDERS OF THE LIVING DEAD**, explaining some of the behind-the-scenes shenanigans, which Brett further elaborates upon in our interview. At the time Sam Sherman completed the extensive "reinvention" of Piper's **DYING DAY**, the fame which his young "star" Scott Schwartz had enjoyed from Richard Donner's **THE TOY** (1982, USA) and playing Flick, the gullible kid whose tongue got frozen to a flagpole in **A CHRISTMAS STORY** (1983, USA/Canada) had since passed. (BTW, no slight intended here whatsoever, Scott! ☺)

BP: I hate to keep saying this, but really, I have no idea. It's ancient history! I never saw **MYSTERIOUS PLANET** on any video shelf. I was contacted by the folks at *MST3K* about running it on their show, but it never happened. They were offering $10,000 for the rights—*twice* what the movie cost! As for what it was like "experiencing" the videocassette revolution, I'm afraid it took so long for me to pull a film together that the revolution was over before I had much chance to participate.

SRB: If I may ask, you note that MP was profitable; was Tom Moore a straight business partner in the distribution (to the best of your knowledge, and did you continue to see revenue as the film sold around the world to video? Did the partnership last beyond MYSTERIOUS PLANET?

BP: As far as I know, Moore was completely straightforward in our dealings. I do remember that he seemed pretty excited when he called to tell me about the deal he'd made for the US home video rights, and rather disappointed that I didn't respond with much enthusiasm. It wasn't that I didn't appreciate the deal he'd made, which was great for such a crappy little film. But I'm a New Englander—we don't *get* excited.

DYING DAY (1983) & RAIDERS OF THE LIVING DEAD (1989)

SRB: How quickly were you at work developing a new project? I'm confused as to what came next: DYING DAY, as you'd completed it, or GALAXY a.k.a. GALAXY DESTROYER a.k.a. BATTLE FOR THE LOST PLANET—which came next, and how did that come together for you?

BP: Again, no concrete memory of the timeframe. **DYING DAY** was the next project. It was part of a "package" I'd written, a sort of collection of generic monster movie tropes—a zombie movie, a vampire movie, a Frankenstein movie, a space movie, a werewolf movie, and a lake monster movie. There was at that time a short-lived fad of "generic" products, which came in plain white boxes with the product in black block letters: "CORN FLAKES", "CORN", "SPAGHETTI SAUCE", etc. There was even a line of paperbacks called "No Frills Books" with plain white covers with titles like "SCIENCE FICTION", "WESTERN", "ROMANCE". I thought it might be cool to do a series of "No Frills Videos" along the same line. Only the zombie movie ever got made.

SRB: That was a great concept for a trilogy. My students see REPO MAN and laugh at that generic packaging of the grocery store products in a couple scenes, not realizing that was only a slight exaggeration of a real packaging phenomenon. So, for you, when you conceived DYING DAY, the "Zombie Apocalypse" scenario was already the "generic" model, eclipsing the older "Haitian voodoo" model. Would DYING DAY be your first Apocalyptic SF opus?

BP: **REPO MAN** is a great movie! I assume by "Zombie Apocalypse" scenario you mean the Romero-style flesh-eating corpses (i.e., ghouls) that most people think of today when zombies are mentioned? Actually, that's not the case in **DYING DAY**. Them zombies don't eat nobody. They're real old-fashioned zombies; corpses reanimated to do their master's bidding. The little ritual you see in the movie involving salt and walking backwards around the grave and such is right out of Haitian folklore.

The minimal, uncredited makeup for the remote-controlled Atom Age zombies of Curt Siodmak's and Edward Cahn's **CREATURE WITH THE ATOM BRAIN** (1955) was easy-peasy to do: simply draw a wonky line across the actors' foreheads to show where the tops of the zombies' skulls had been popped-off, then just add dotted rows of little "rivets" (or possibly meant to be leftover scar tissue due to healed stitch-holes?) above and below the line to show it's been "reattached". But give the movie credit, okay: it *also* featured the first graphic use of explosive (if bloodless) bullet-hole squibs ever to be seen in genre films!

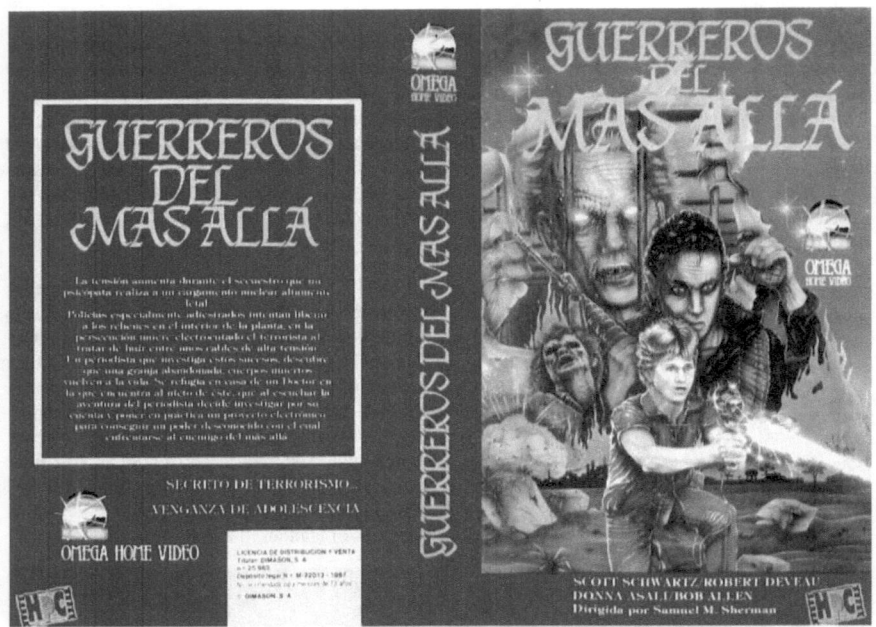

Omega Home Video's Spanish cover used the garish American advertising art painted for **RAIDERS OF THE LIVING DEAD** (released in Spain under the title seen here), Sam Sherman's reinvention of Brett Piper's **DYING DAY**

SRB: *No flesh-eating, true: I was thinking more of the "zombies in America" imagery, and the "shoot-'em-in-the-head" action, but now that you mention it, 1950s SF movies like* CREATURE WITH THE ATOM BRAIN (1955) *on through to the Vincent Price* THE LAST MAN ON EARTH (1964) *and even* The Outer Limits *on TV had set-up that kind of modern apocalyptic imagery: graphic gunshots in* CREATURE WITH THE ATOM BRAIN, *"zombies" wandering rural and urban areas in* LAST MAN. DYING DAY *wed the Haitian traditions with an "It can happen here" (in New Hampshire!) narrative. What zombie movies did you grow up with, and which ones in particular were you inspired by or riffing on?*

BP: **CREATURE WITH THE ATOM BRAIN** was an amazing movie for its time, very creative and visceral, but I never saw it until a few years ago. In fact, I think the only two zombie movies I'd seen before making **DYING DAY** were **PLAGUE OF THE ZOMBIES** and **THE GHOST BREAKERS**, both good movies but neither much of an influence.

SRB: *Did you research actual Haitian voodoo lore before scripting* DYING DAY?

BP: Yes, as much as I could in those pre-Internet days. I worked-in the resurrection ritual and a few other references.

SRB: *Sorry to ask again about timeframes and such, but as best you can recall, when did work begin on* DYING DAY *in terms of when you'd completed* MYSTERIOUS PLANET, *and when and where did you shoot* DD?

BP: I know **DYING DAY** was made before any profits were returned for **MYSTERIOUS PLANET**, so there couldn't have been much of a gap between the two. I remember going back to the money people and saying, "Look, the last movie didn't turn out so great, but I think with just a little more money I could do something a lot better", and to my surprise they went for it. I know they were using these investments for tax write-offs, so maybe it didn't matter to them. **DYING DAY** was all shot within fifteen miles of my home town. I think the furthest we traveled was to the "Big City" of Manchester, NH to shoot in and around a movie theater.

SRB: *DD had far more elaborate makeup demands, on a grander scale, than anything in* MYSTERIOUS PLANET. *How did you tackle that—solo, or did you have help on the special effects makeup?*

BP: Entirely solo. Some of the zombies were fairly elaborate makeups, others (mostly for the scenes with groups of zombies) were just masks I'd made, blended around the eyes. I also built a false zombie head which we took out into the country and blew apart with a shotgun. We shot it with two cameras, one running normal speed and one at 64 FPS *["frames per second"]*, and surprisingly the normal speed gave us the best shot.

SRB: *How did you go about casting DYING DAY—including your zombies?*

BP: The zombies were all just people I happened to know whom I could cajole into donning zombie outfits. On one occasion I had to make-up maybe half-a-dozen zombies, and by the time I got to the last one the rest had vanished. They'd all wandered down to the corner store to grab some beers, which they thought was a riot. I wonder if they'd had to show ID's? I think that was the same day we were shooting in a building in the middle of town and someone reported suspicious behavior to the cops. An officer showed up, took one look, and said "Yeah, I *knew* it was you". He had actually appeared in another part of the film. The three leads were theater actors from the Boston area, which meant they thought they were pretty hot stuff, slumming in the wilds of New Hampshire. I recall driving to a rural location, and one of then, seeing some cows in a field nearby, rolled down the window and mooed in a demonstration of urbane sophistication. Ya gotta love them thar city folks.

SRB: *Speaking of the police: unlike MYSTERIOUS PLANET, DYING DAY involved a fair number of urban and abandoned-urban settings, and a number of nighttime sequences—a far cry from the great outdoors and open beaches of PLANET. Since New Hampshire wasn't a hotbed of movie production, did you have to struggle for permissions or permits to shoot at your chosen locations for DYING DAY? Did that present a lot of obstacles?*

BP: No, I shot mostly on private property with the permission of the owners. There were no hassles at all.

SRB: *You made DYING DAY after the success of George Romero's confrontational DAWN OF THE DEAD had scored theatrically; were you tempted to up the gore quotient of DD, or were you creating a more "audience-friendly" blend of horror and action movie set-pieces?*

BP: I'm not a big fan of extreme gore. In fact, it always surprises me when people describe scenes from my movies as "scary". I don't think I've ever made a scary movie. I think I make what Terence Fisher described as "Fairy tales for adults".

SRB: *I really like how DYING DAY plays, story-wise. Its screenplay nicely tied together crime/*

Back from getting beer at the corner store... and *still* thirsty? (from **DYING DAY**, a.k.a. **RAIDERS OF THE LIVING DEAD**)

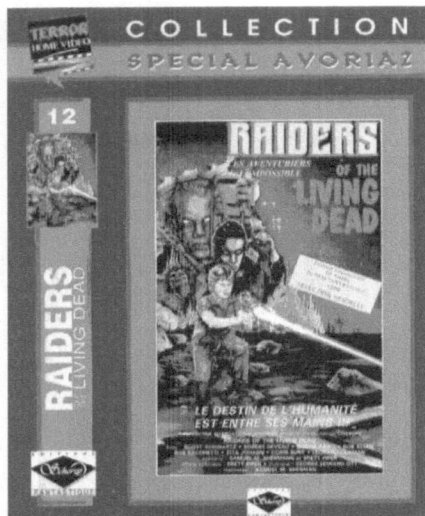

Box art for home video release in France, referencing the Avoriaz Fantastic Film Festival: the drive-in marketplace Sherman's Independent-International thrived within had dried-up by the late 1980s, but Sam got the movie out via the international home video

noir elements—your protagonist on the run, like The Fugitive, *a marked man trying to stay ahead of his pursuers—and the classical Gothic century-old "family curse" motif with 1970s-style action movie set-pieces. Were there any sequences you'd scripted, or wish you could have included, but time/money/means precluded it?*

BP: No, everything in the script ended up on the screen (and a little more—the "flashbacks" were added later to pad the running time). The *noir* elements were an attempt to give the zombie tale a new twist. I actually wrote a screenplay once which was a flat-out science fiction version of *The Maltese Falcon*. In my story, the "Fat Man" was an alien so obese he literally filled a house. I still think it would make a cool movie.

SRB: Did all of the "generic" screenplays you had planned at that time—Three? Six? You mentioned to John McCarty years ago you'd actually planned six of these films, including a werewolf script—mesh their chosen old-and-new genre tropes in a similar manner?

BP: I don't think anyone thought quite so much about "genre tropes" back then. All of them had some kind of twist to them, which might not seem so original now. In my werewolf story, the lycanthrope, instead of being a poor tortured Larry Talbot type, was a pathological sadist who *loved* being a werewolf. My Frankenstein story was in a sense a direct sequel to Mary Shelley's novel, beginning with the Monster's confrontation with Captain Walton on his ship in the Arctic, then picking up two-hundred years later when the creature's body washes up on the shore of Maine and he's "adopted" by a bunch of kids. It might have been interesting stuff.

SRB: Those are still *sounding pretty fresh to me, Brett; that's a great werewolf movie springboard, as is the Frankenstein one. Why was* DYING DAY *the only one of those concepts that ended up being made? Just no interest, no funding, or did something fundamental change for you?*

BP: I doubt it was funding, since none of those stories would have cost any more than the movies I actually did make (and they might well have cost less). I know my plan at the time was to do all six movies together to sell as a package, which I thought might increase my chances of success. When this wasn't possible, I simply put them aside and moved on to other things. "MONSTROSAURUS" (my lake monster story) continues to generate interest, for some reason. I've had several near-misses with people who wanted to produce that, and I was planning to do it myself only this summer, when one of the actresses I wanted for the lead became unavailable and I couldn't replace her in time. One of the problems with shooting in the northeast (as the rest of the industry discovered a hundred years ago) is being at the mercy of the seasons.

SRB: So, DYING DAY *was near-completion, you added the flashbacks to fill in the running time—how long was the original cut, and what was considered a "commercial" feature film length in 1983?*

BP: No, **DYING DAY** was completed *before* I added those flashbacks. It had already been sold to Independent-International when Dan Kennis called me up and squawked, "This movie is only 70 minutes long!" (Or whatever it was; maybe closer to an hour). They had never actually sat down and watched the thing. I would have been entirely justified in saying, "Tough cookies, boys, your check has cleared!" and ignoring them, but instead I shot and added a few more scenes to increase the running time. The irony is that they threw most of what I shot away and used my movie as stock footage to create their own, so it didn't really matter one way or another, and my extra time and effort was wasted.

SRB: Did the filming of those additional flashback sequences precede—or did that interrupt—work on your next film project?

BP: It was a while before I got another film going, so shooting those flashbacks had no effect whatsoever.

SRB: How did DYING DAY end up in Sam Sherman's hands, and what was the nature of the deal you cut with Sam? He's offered his account on his commentary track to RAIDERS OF THE LIVING DEAD, which is the considerably-transformed feature he carved out of and padded-into DD, but what was that like on your end, given the six years between the completion of DD and eventual Independent-International release of RAIDERS?

BP: I was shopping the movie around to likely distributors, and when you thought of low-budget schlocky horror in the 1970s, Independent-International was hard to ignore. So I sent them a VHS copy, they were interested, and we started to negotiate. They initially offered me some ridiculous number, a couple-hundred over what it cost to shoot, so I laughed politely, and said no thanks. They called me back a few more times, each time upping the ante. When they approached a reasonable figure, I passed it along to the "executive producer", the guy representing the investors, and he simply forgot all about it and never got back to IIP. They thought we were playing hard to get, so they upped the price a few more times until I finally took it upon myself to accept. So we actually made a little more money due to the "producer's" incompetence!

SRB: Let's follow through with DYING DAY becoming what it became, if you'll indulge me. I presume once its sale was finalized and you delivered those additional elements, they'd purchased all rights and it was out of your hands, yes? You didn't hear anything more until—until what? What did you finally deliver to Sam Sherman, and how much time passed before you were made aware of what had

As intended, some of the zombies for Piper's **DYING DAY** and for Sherman's reshoot footage for the **RAIDERS OF THE LIVING DEAD** revamp looked as if they'd shambled in right off the sets of **INVISIBLE INVADERS** (1959), **THE CAPE CANAVERAL MONSTERS** (1960), **CARNIVAL OF SOULS** (1962), **THE LAST MAN ON EARTH** (1964), or **NIGHT OF THE LIVING DEAD** (1968)

become of your feature film—and what did you think of what Sam had turned it into?

BP: I never dealt with Sam Sherman on **DYING DAY / RAIDERS**. It all went through his partner, Dan Kennis. But every now and then I'd get a call saying they were still working on the movie and it was turning out great, and I was going to be so pleased when I saw what they'd done with it. As you mention, I'd sold it to them outright, handed over all the elements, so they were free to do whatever they wanted with it. The first time I saw **RAIDERS** was on *USA Saturday Nightmares*, which was primetime nation-wide. I was a little—*perplexed*. It didn't make a hell of a lot of sense to me. My sister, who watched it also and had seen my original version, later said to me, "When you made that movie, didn't it have a *plot?*" But what the hell, it's all just part of the legend now.

SRB: *Did RAIDERS OF THE LIVING DEAD get any theatrical play in your neck of the woods? [I never saw it in any theater—by the end of the 1980s, the drive-in and "grindhouse"/nabe circuit that Independent-International had a niche in throughout the 1970s was gone, and it wasn't until I stumbled upon the videocassette for rent in a small Vermont grocery store that ROTLD was available in our part of New England...]*

BP: I don't know if it ever played theatrical anywhere. I know it was shown at the AFM, and *Variety* gave it a brief review. They basically said it was a mess except for a few atmospheric sequences—which were the parts of **DYING DAY** that IIP retained! I hope if Sam Sherman reads this he doesn't get too pissed-off. He's a good guy; I once spent a pleasant day with him scouting locations around New Jersey. But you've got to be thick-skinned in this business. And **DYING DAY** was no masterpiece anyway (although it *did* have a plot).

SRB: *I've met Sam Sherman at a couple of horror conventions and trade shows back in the 1990s; he always came across as a decent fellow. Were you pleased that your original edit of DD accompanied the original DVD release of ROTLD? That was an unusual step for that early in the "life" of the DVD format, and it did provide those of us who are fans of your work with a chance to finally see DYING DAY!*

BP: I guess it was good that viewers who were interested in that sort of thing could see the various incarnations of the movie and decide what was what for themselves.

BATTLE FOR THE LOST PLANET (1986)

SRB: *So, where did things go after the delivery of DYING DAY to Independent-International, and what led to work beginning in earnest on what became GALAXY / GALAXY DESTROYER / BATTLE FOR THE LOST PLANET? Were there any projects that you began work on, or wanted to be doing, between the delivery of DD and the launch of what proved to be your next feature?*

BP: First off, the actual title of the movie was **BATTLE FOR THE LOST PLANET**. And I must have begun it very soon after finishing **DYING DAY**, because I built and shot a stop-motion test of one of the creatures that was on the same negative as **DYING DAY**. I remember this because someone from IIP saw it and asked what the creature was for. I think I may have tried to interest them in getting involved in the new movie. If so, they passed.

SRB: *What market were you targeting with such an ambitious post-apocalyptic alien-invasion scenario?*

BP: I was merely trying to appeal to science fiction fans in general. And I wanted to get back to doing stop-motion monsters.

SRB: *You not only created stop-motion monsters for BATTLE—you had one of them wrap a tentacle around the leg of your heroine and drag her off your hero while they were indulging in some campfire coupling! It seems like you were out to reach more adult science-fiction fans than MYSTERIOUS PLANET appealed to. With the nudity in that night-time-creature-attack sequence and some stronger language than your first two films featured, were you consciously moving into* Heavy Metal *turf?*

BP: Not so much *Heavy Metal*. That's simply what audiences seemed to be looking for at the time.

SRB: *When you say "that's simply what audiences seemed to be looking for at the time", what specific films or movie trends were you inspired by or using as reference points to judge the market at that time?*

BP: Cheap genre films were expected to have some blood and gore and T&A. As I mentioned, I'm not that big on blood and gore, so that just left the boobs; the only problem with which, of course, is dealing with actresses. Some are fine, some are not, some pretend they're fine then cause problems at the last minute. What can you do?

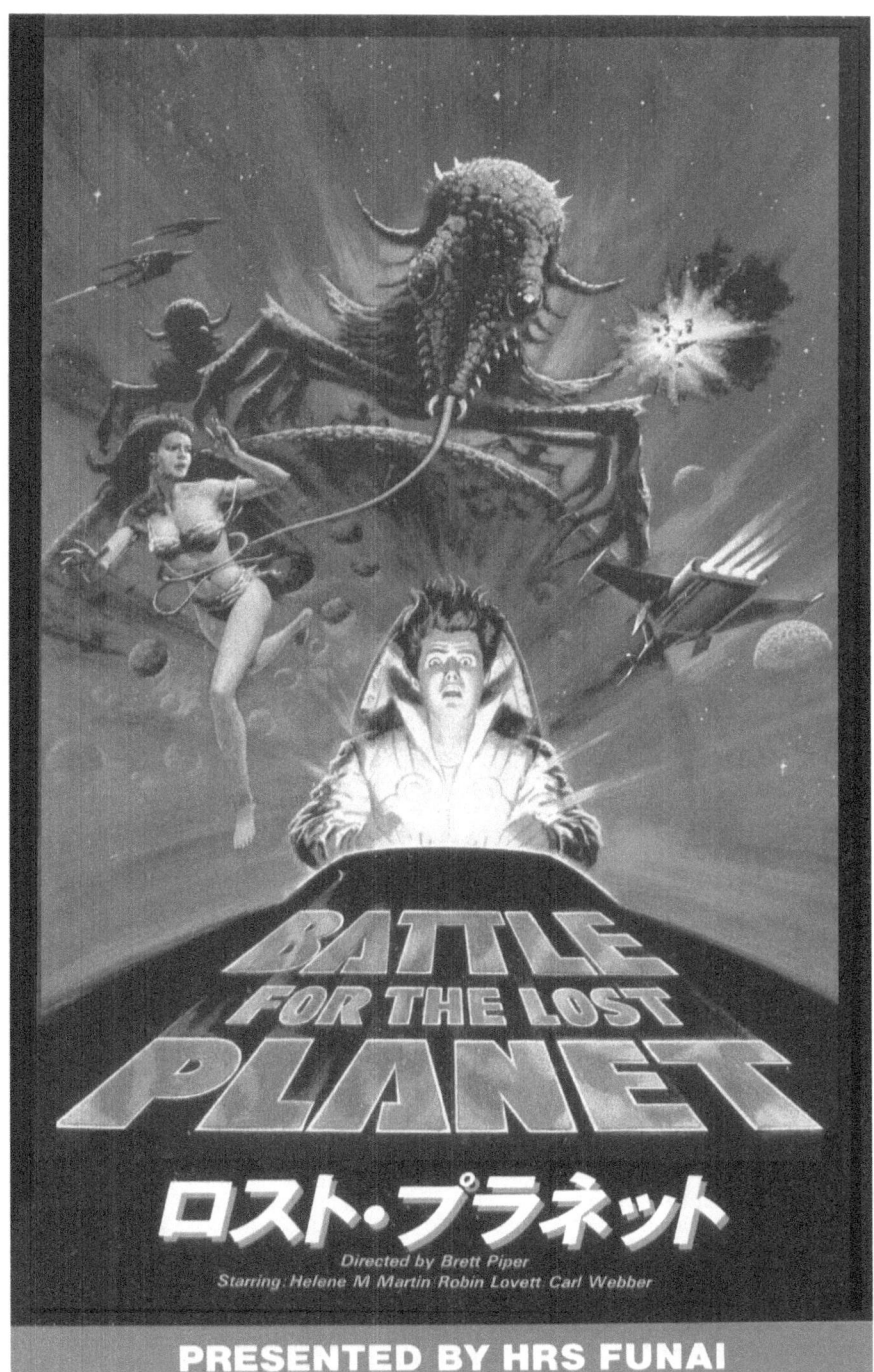

Pages 35-36: Front, spine and rear VHS/Beta cover art for HRS Funai Electric Co., Ltd.'s 1987 Japanese home video release of Brett Piper's **BATTLE FOR THE LOST PLANET**, which never enjoyed a legal domestic release that we know of [c/o SpiderBaby Archives/ author's personal collection] (artwork uncredited)

SRB: *Did you consider your scripting tighter and more efficient in* BATTLE*? I mean, you establish your hero, shift the story immediately into fifth gear with the theft of the space shuttle then blast-off into space,* and *have the alien invaders ravage mankind in just a little over five minutes of screentime—*

BP: I try to grab the audience at the beginning, then you can slow down and give yourself a little breathing room afterwards. Although I think (as best I remember—I haven't seen the movie in decades) that I could probably have shortened the rest of the movie and made it a little better.

SRB: *I take it you designed and applied all the alien makeups, but did you have assistance with applying the makeups this time around? There's a fair number of aliens onscreen in some of the action sequences.*

BP: I'm pretty sure I did all the aliens myself. They were one-piece appliances, pre-painted, that I slapped on and blended in. The only one I could afford to take a little time with was the "commander" of the invading alien fleet, because that was me. I played the alien and shot the sequence without anyone else around, which in pre-video days was kind of tricky. While I still had the makeup on, I dropped by my sister's place while she was having some kind of Avon/Mary Kay type party. They *didn't* try to sell me anything.

SRB: The elongated-nose aliens were pretty effective—and amusing. You played them as buffoons at times, and included a "nose-picking / booger-eating" gag at one point; but then again, BATTLE's hero was often the target of ridicule, and Mad Dog Kelly is played for laughs. Was BATTLE more fun for you—in the writing stage, if nothing else?

BP: Writing was the easiest part, the least hassle, but I don't know as I'd call it enjoyable. It was certainly easier for me back then, I never had anything akin to writer's block, but it wasn't fun either, it was just part of the process that had to be done. It was certainly preferable to the actual shoot, which was just miserable.

SRB: There's some nice outdoor locations in BATTLE—I'm picturing the rapids and waterfalls where the hero tussles with the mutants and loses his gun, which one of the mutants stupidly shoots himself with—along with the darker "abandoned basement" interiors and such. Where did you film BATTLE?

BP: Southern NH, northern Massachusetts. The dam was on public land, but we got chased away (nicely) by a guard anyway. A lot of it was shot in an abandoned factory. I actually rented a chicken coop to build sets in. Not a little chicken coop, but a big industrial-sized one that was divided into bays. The bay next to me was an auto body repair shop, so they were pretty big. I built my spaceship sets and a small section of "woods" in there.

SRB: When you set up an animation workspace in your own living space, as I imagine you've done a lot over the years, how much space is that, actually? A full room? How many miniature sets (for your animation models to "live" within, and the necessary lighting and camera equipment to function with that) have you ever had going at one time, in one space?

BP: My workspaces are usually pretty small. I don't think I've ever had more than eight-by-ten feet or so. And never more than one set-up at a time. In many cases I've had to build a miniature set, make damn sure I'd shot all the footage I needed of it, then tear it down to make room for the next one.

SRB: For BATTLE, you had the tentacled nocturnal creature to animate, and used it for more integrated interaction with your two actors than anything in MYSTERIOUS PLANET. Was it easier or more difficult to pull off a night sequence like that one, with the live-action and animation elements to integrate?

BP: It's much easier staging a scene like that at night. You can often hide the flaws in darkness. And since I couldn't do traveling mattes or green screen, sometimes I would do latent image mattes—I'd shoot my performers against black, then wind the film back and expose the miniatures and creatures into the corresponding dark areas. You can only do that with night shots.

SRB: You also had the miniature ships, which involved creating different illusions of scale—the slower illusion of movement in outer space of the giant alien armada ships, the fast, fleeting, darting motion of the hunting ships stalking the mutants and humans. STAR WARS *and* CLOSE ENCOUNTERS *really altered how miniatures had to look after the 1970s—you couldn't get away with the kind of miniatures outer space movies or alien invasion movies of the 1950s-1960s got away with. How did you go about constructing your miniature ships, and keeping up with the times?*

BP: I think some '50s movies actually did a pretty good job in portraying space travel; films like **FORBIDDEN PLANET** and **THIS ISLAND EARTH**. But you're right, the lower-budget stuff was usually pretty wonky. Static shots of a rigid spaceship against moving star backgrounds that frequently bled through the ship itself, or models badly flown on strings. I think my model effects were sort of halfway between the two—better than the cheapest of the cheap, nowhere near as good as something like **STAR WARS**. More like **STARCRASH**! Actually, my movies of that period look a lot like Luigi Cozzi's epics, except he had a hell of a lot more money to spend!

SRB: He did! He also could afford Caroline Munro and Marjoe—but your stop-motion creations were and are far, far superior to his! Did you adopt the technique of constructing your spaceship models out of borrowing "detail" elements from various plastic hobby model kits, or were you sculpting your ships—what were

1986's BATTLE FOR THE LOST PLANET: After an apocalyptic alien invasion, the remaining humans are hunted by roving alien invaders; survivors include the predatory biker gang led by Mad Dog Kelly (Joe Gentissi, with Helene Michele Martin), those seeking an alternative future like Dana (Denise Coward), and the film's ever-opportunistic hero Harry Trent (Matt Mitler)

your working materials for inert special effects objects (ships, etc.) and props (the miniatures of standing structures, like the alien's hideout/bunker in BATTLE FOR THE LOST PLANET*)?*

BP: Some of the ships were sculpted from urethane foam and covered with resin, a technique I learned about in an interview with Greg Jein. Others were made of wood and detailed, and many were cobbled-together from found objects. It all depends on what works best for an individual project.

SRB: Is it just me, or did you pattern the smaller hunting ships' movements after those darting ships in the 1964 ROBINSON CRUSOE ON MARS*?*

BP: Just coincidence (I think).

SRB: Were you happy with BATTLE*? Whatever difficulties the shoot itself presented, it was and remains a pretty solid step forward from the bedrock of* MYSTERIOUS PLANET *and* DYING DAY*.*

BP: Eh. As you say, it was a step-up from the previous two.

SRB: What was BATTLE*'s distribution history, Brett? It was the toughest film of all your features to find. I recall reading in John McCarty's* The Sleaze Merchants *chapter on your work that you landed a sweet deal for foreign rights on* BATTLE*—how did that come about, and was there ever an official domestic release of it (I only saw it thanks to a Japanese videocassette edition I tracked down and a friend who could convert that to VHS so I could finally see it)?*

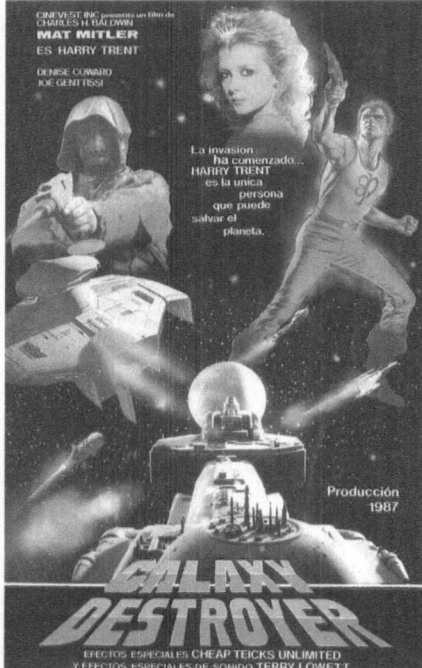

Cinevest Inc. landed **BATTLE FOR THE LOST PLANET** in multiple foreign home video markets, including this Spanish release (as **GALAXY DESTROYER**), which played-up Harry Trent (Matt Mitler) as a "Han Solo" or "Jack (**TRANCERS**) Deth" type of SF film franchise hero

BP: **BATTLE** was sold outright to a company in New York called 21st Century Distribution. What they did with it after it changed hands was really no concern of mine. Once the check clears,

that's it! Really a much preferable way of doing business than you have today, where no money ever changes hands up front and you're lucky to see a nickel on the back end.

SRB: Did you broker/handle the BATTLE FOR THE LOST PLANET distribution deal yourself with 21st Century—or were you working with a rep or an agent who took care of that?

BP: I handled it myself. I used to look through *Variety*, especially the big AFM issues and such, to find distributors who were handling cheap genre films, and saw a 21st Century ad for about a dozen of them, so I figured it was worth a shot. The usual phone calls and screeners followed, and he made an offer (again, a buy-out, all rights) which seemed acceptable.

[TO BE CONTINUED...]

©2016, 2017 Stephen R. Bissette, all rights reserved; special thanks to Brett Piper, all images from Brett Piper's films ©respective year of production, 2017 Brett Piper, unless otherwise indicated.

COMING ATTRACTIONS: MUTANT WAR, How **DARK FORTRESS** Became **A NYMPHOID BARBARIAN IN DINOSAUR HELL**, plus **DINOSAUR KID, THE RETURN OF CAPTAIN SINBAD**, and much, *much* more!

*[Note: For a full filmography of both Senkosha's Gekkō Kamen tele-serials and Toei's spinoff series of theatrical features, go to page 353.]

MOONLIGHT MASK
a.k.a. GEKKŌ KAMEN, The Ally of Justice!

by Dan Ross

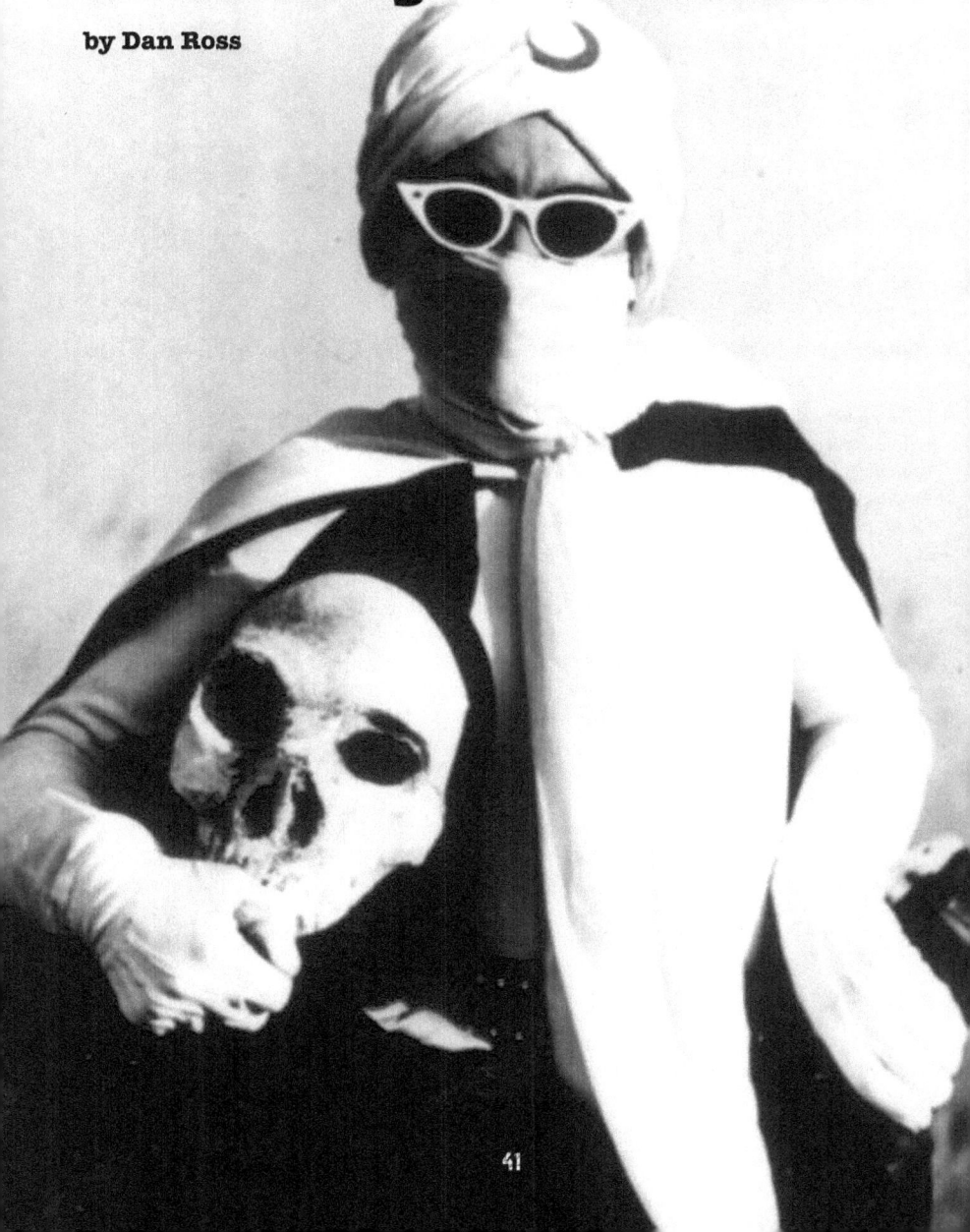

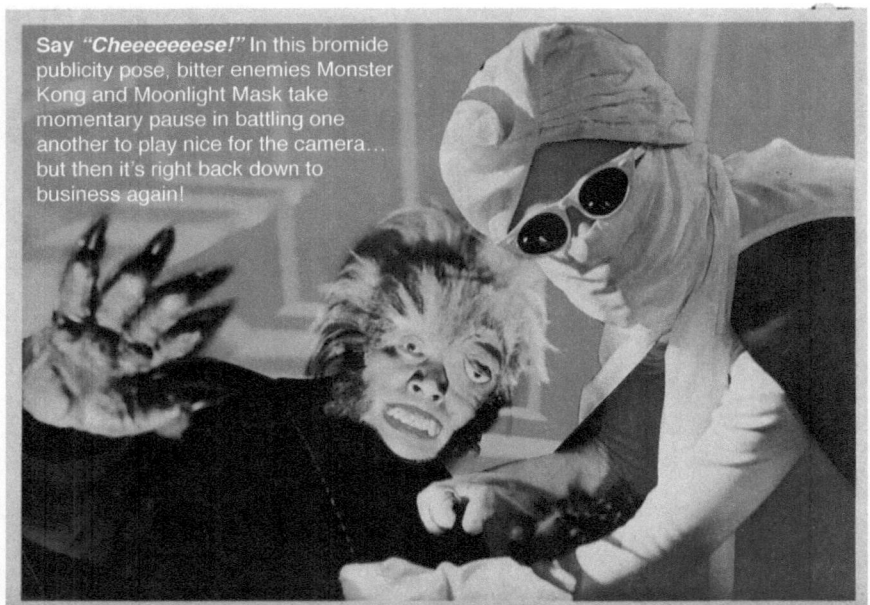

Say *"Cheeeeeeese!"* In this bromide publicity pose, bitter enemies Monster Kong and Moonlight Mask take momentary pause in battling one another to play nice for the camera... but then it's right back down to business again!

"We don't know where he comes from / But we all know his name / The gallant Moonlight Mask!"

That's how the opening song introduces Japan's first action-fantasy-hero television show, Moonlight Mask *(月光仮面 / Gekkō Kamen, 1958-59). Clad in an all-white leotard, white gloves and boots, studded black belt, white-and-red cape, scarf, a mask covering his face, white-rimmed sunglasses and a turban adorned with a silver crescent moon, he carries two 9mm automatic pistols (or .38 revolvers, etc.) and rides a white 250cc 1957 Honda Dream C70 motorcycle (or Rikuo 750) with a flash wing-tipped fairing to match his outfit. He can bomb along on his bike without holding onto the handlebars while shooting a gun in each hand, leap from the ground onto the roofs of multi-story buildings with virtually effortless ease, and kick major ass in hand-to-hand combat with ten or more goons at once! Throughout the series, he will repel, beat and otherwise variously thwart gangs of thieves, assassins, ghosts...and even a giant rampaging monster. But most importantly he would set a good example to youthful audiences of the 1950s:* "Do not hate, do not kill... let's forgive."

They may indeed not know where he comes from, but to this day most of Japan knows his name, what he looks like and recognize the plethora of merchandising products which display his likeness; ranging from video collections, books, clothing, toys, arcade games, candy and music, to restaurants named after him. However, unlike his film-based contemporary Starman *(スーパージャイアンツ / Supa Jiantsu, 1957-59), who was brought to Western shores by Walter Manley Enterprises in the mid-'60s, AND who is still reasonably popular with domestic and international fans even today, Moonlight Mask's live-action TV efforts would not wander beyond Japan's borders; indeed, in the US he is unknown even to many Japanese* tokusatsu */* kaijū */* daikaiju *genre fans.*

While still popular at home, the series didn't make it onto the Western international export market. Though episodes were dubbed by William Ross' Frontier Enterprises, I've not found evidence of it ever being distributed abroad. Despite this, Moonlight Mask was an influence on many facets of Japanese properties which are popular around the world to this day.

Along with being interesting for its historical influence, the series would feel familiar to Western fans of horror movies, film noir, cliffhanger serials, pulps and comic books. Why? Because it seamlessly weaves all of these elements together into an entertaining action drama featuring mysterious arch-villains, masked gangsters, sci-fi gadgets, land, sea and air chases, loads of henchmen cannon fodder for those 10-against-1 fights, and even the first giant monster ever featured in a Japanese television show. All wrapped in stark chiaroscuro, noir-like cinematography by Ryotaro Miyanishi (宮西良太郎), accentuated with a moody soundtrack by Ogawa Hiroki (小川寛興) and sprinkled here and there—for better or worse—with light comedy relief.

<p align="center">*******</p>

Who *is* this "Ally of Justice", and where does he come from?

Though himself being the inspiration for future creations, let's take a look back at those whom are possibly some of Moonlight Mask's archetypal antecedents. It seems every idea is built from another, so for brevity and sanity's sake, let's start during the 20th Century in the United States with pulp author Johnston McCulley, the creator of Zorro. McCulley wrote the first *Zorro* yarn "The Curse of Capistrano" in 1919 for *All-Story Weekly*. Don Diego de la Vega was to all appearances just a foppish dilettante nobleman living at his father's house. But when the need arose, he would don his black suit and mask and grab his sword and whip to become El Zorro (Spanish for "The Fox"), who fought the oppressive tyranny of Mexican rule in Old California. Zorro was and still is represented in pretty much all types of media: TV, movies, videos games, radio dramas, comics and story collections included.

Film critic and Japanese cinema historian, Tadao Sato (佐藤 忠男) speculated that heroes such as Kurama Tengu and Kaiketsu Kurozukin were inspired specifically by the silent film **THE MARK OF ZORRO** (1920, USA, D: Fred Niblo), starring Douglas Fairbanks. Shortly after its Japanese release in 1921, a slew of imitators sprang up, with Kurama Tengu (鞍馬天狗) leading the way.

In 1924, pulp author Osaragi Jiro (大佛 次郎) started writing a serialized *Jidaigeki* (時代劇 / "period drama") about the Zorro-like antiestablishment hero known as Kurama Tengu. While Tengu are generally benevolent—if nonetheless *creepy*—su-

Top: Poster for **KURAMA TENGU** (鞍馬天狗, 1928). **Above:** Cover art by Kuwata Jiro to one of his *GK/MM* manga

the serials until 1959. They were adapted into various films and TV series, starting with the eponymous theatrical feature **KURAMA TENGU** (鞍馬天狗, 1928). Osaragi's version of Zorro, who rode upon his trusty steed, dressed as a black-clad ninja and carried both a *katana* (刀 / "sword") and a pistol, inspired other highly-similar heroes, such as *The Amazing Black Hood* (解決黒頭巾 / *Kaiketsu Kurozukin*), who likewise fought a corrupt government back in mid-19th-Century Japan. Kurozukin was created by author Hitomi Takagaki in 1935, and later had a string of movies and four different TV series made about him, keeping him firmly in the public consciousness.

At the end of World War II, prolific stuntman, actor, producer and director Hayafusa Hideto (ハヤフサ ヒデト) self-produced, directed and starred in a vanity project called **THE AMAZING FALCON** (快傑 ハヤブサ / *Kaiketsu Hayabusa*, 1949). This action film featured a Zorro/Kurama Tengu-like masked avenger who fought machinegun-wielding bad guys and who now, in post-war Japan, rode astride a motorcycle and performed high-risk stunts on high-rise buildings. Because it was self-produced outside of the establishment studio system, no known intact prints now survive. A mere 49 out of the total 77 minutes of footage remains. Though in very rough shape indeed, what still exists is presently available on R2 DVD. Strangely enough, this movie used Offenbach's "Can-Can"—yeah, *the* Can-Can!—for its "action" music.

Starting with McCulley's pulp hero of the people, initially imported and emulated in *jidaigeki* then modernized by an early Japanese version of Jackie Chan, the next step in the chain would be... Moonlight Mask!

Due to poor ratings, in 1957, Japanese broadcaster Radio Toyko, KRT (株式会社ラジオ東京 / *Kabushikigaisha Rajio Tokyo*) canceled its series *The Tale of Ponpoko* (ぽんぽこ物語 / *Ponpoko Monogatari*, 1956-57). That show's timeslot was sponsored by the Takeda Pharmaceutical Co. (武田薬品工業 / *Takeda Yakuhinkogyo*), who were going to drop their advertising following the demise of *Ponpoko*. In order to keep this valuable sponsor, KRT producers and its radio and advertising agency, Senkosha (宣弘社), scrambled to create something new and exciting for the vacant timeslot. Although a major sponsor was at stake, KRT would only give the proposed replacement program a limited budget regardless. Senkosha's president, Toshio Kobayashi (小林利雄) had promised to deliver something truly extraordinary, and was alarmed by the low budget allotted him. Feeling it was unfeasible to pull-together a decent show for the severely lim-

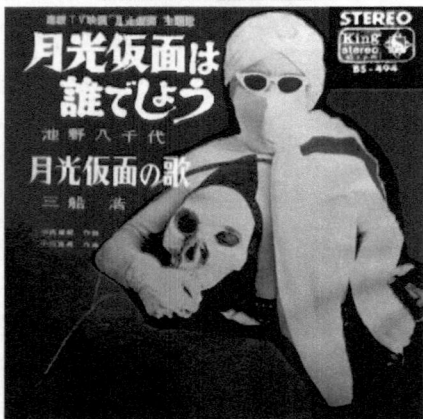

Above & Center: Picture sleeves to two of GK's numerous 7" 45-rpm vinyl records.
Top: One for the similarly-costumed title hero (Shin'ichi "Sonny" Chiba!) of *Messenger of Allah* (アラーの使者 / *Arā no Shisha*, 1960)

pernatural creatures, this character is an "ordinary" human who uses that moniker to freak-out the bad guys; all in order to fight the soldiers of a corrupt government in the 1860s. Osaragi wrote

ited funds which KRT were allowing, Kobayashi instead established Senkosha Productions as an in-house television production company, specifically to create this new program. After *Moonlight Mask*, Senkosha Productions would go on to produce several series, with notable standouts like *The Samurai* (隠密剣士 / *Onmitsu Kenshi*, 1962-65), *Prince of Space* (遊星王子 / *Yusei Oji*, 1959), *Silver Mask* (シルバー仮面 / *Shiruba Kamen*, 1971-72), *Iron King* (アイアンキング / *Iron Kingu*, 1972-73) and *Super Robot Red Baron* (スーパーロボットレッドバロン / *Supa Robo Redu Baron*, 1973-74).

Once the WWII prohibition on US programming had been lifted, George Reeves/Warner Bros. TV's *Adventures of Superman* (1952-58) became extremely popular on Japanese television. With this in mind, it was Senkosha president Kobayashi himself who came up with the idea of producing a locally-shot superhero show. Our previously-mentioned *jidaigeki* hero Kurama Tengu was pitched, but doing a period drama was considered too-expensive. Possibly taking a cue from **THE AMAZING FALCON**, in order to cut costs they simply took the root idea of Kurama Tengu and transposed it into modern times instead. Very few custom sets would need to be built, and almost no period costumes or makeup were needed. KRT scripter Yasunori Kawauchi (川内康範) was picked to write the new show. Kawauchi would go on to create several other superhero series in the same vein, such as *Warrior of Love Rainbowman* (愛の戦士レインボーマン / *Ai no Senshi Reinboman*, 1972-73), *Diamond Eye* (ダイヤモンド アイ / *Daiomondo Ai*, 1973-74) and *Symbol of Justice Condorman* (正義のシンボル コンドールマン / *Seigi no Shinboru Kondoruman*, 1975).

There were several potential titles suggested for the new series, such as "Dancing Mask" (おどる仮面 / *Odoru Kamen*), "Moonlight Champion" (月光王者 / *Gekkō Oja*), "Sunlight Mask" (日光仮面 / *Nikko Kamen*) and, finally—Moonlight Mask! Kawauchi, a practicing Buddhist, wanted to keep the idea of Moonlight Mask being an upright, helpful person at the forefront of crime-fighting. He was neither a shoot-first-ask-questions-later Dirty Harry type, nor a hardboiled pulp-style detective who left a trail of evildoers' dead bodies littering the landscape in his wake. Like his song says, he was an "ally of justice". Helping those in need was this hero's ultimate goal, rather than ventilating bad guys with lead. In fact, the "Moonlight" part of his name derived from Buddhism's Candraprabha (*Gakkō Bosatsu* [月光菩薩] in Japanese), the Moonlight Bodhisattva, who helps those in need. To make a fine point of it, Moonlight Mask's catchphrase was "Do not hate. Do not kill. Let's forgive." (Originally the phrase was "Do not hate. Do not kill. But let's investigate", which Kawauchi later fine-tuned.) Though he frequently pulled and used his two automatics, it was typically not to kill but merely to non-fatally incapacitate or disarm his opponents. Kawauchi felt it was important for this

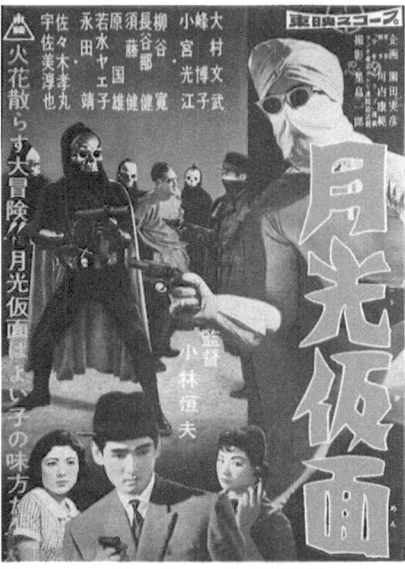

Above Left: Our hero in a local magazine ad for Plussy brand soda-pop (c.1970s?). **Above Right:** Local B1 poster for the first Toei spinoff movie, titled simply **GEKKŌ KAMEN**

Note: Interestingly enough, though it *looks* like a Harley (because when the company started out, Harley-Davidson allowed them to utilize their designs), it is actually a domestically-built bike called a Rikuo, which was used in the Toei *GK* movies; the Honda was seen in the TV versions. By that point, I do believe the Rikuo company were no longer associated with Harley, but their bikes were commonly called "Domestic HD's" ~ **DR**

Look Ma, No Hands! We can't help but wonder if John Woo got the whole "two-fisted handgunning" idea from this guy! But even Chow Yun Fat never tried it on a speeding 'sickle! Incidentally, according to the bikecentric Canuck blog Piston Brew (@ *pistonbrew.blogspot.ca*) in regards to Gekkō Kamen: "In fact, he was the first Japanese superhero and the first motorized superhero in the world *[A highly-contestable claim! – SF]*, combining for his missions a Harley-Davidson and a tuned Honda Dream Sports". (That said, in this shot from one of GK's movie spinoffs, he's seen riding a make called a Rikuo [see Dan's explanation directly overhead])

character to be someone whom children in post-war Japan could look up to. Pointedly noticing the epidemic of violence and suicide of the period, he wanted this role model to be a strong, sturdy hero, while also being compassionate and finding more peaceful alternatives to killing while plying his profession as a representative of law and order.

Along with writing the show, Kawauchi also wrote the lyrics for the highly popular, jaunty theme song. It proved so popular that Kawauchi went on to write lyrics for a whole string of mainstream pop hit songs throughout the '60s and into the '80s. Along with the show's opening ditty, he wrote a signature theme for Moonlight Mask himself; a somber, spooky tune which is heard just before he appears to his enemies each time. Though usually just the first few lines are sung before he appears, once in a while the whole three-and-a-half-minute number is played in full. It's most effective indeed at creating atmosphere and setting the proper mood.

With Senkosha getting started on the series and keeping in mind both the low budget and quick turnaround, a young KRT assistant director and editor, Sadao Funadoko (船床定男) was tapped to direct. This would be his first directing gig, and he would later take on other series such as above-cited *The Samurai* and *Space Giants* (マグマ大使 / *Magma Taishi*, 1966-67). Because of this businesslike "bottom-line" mentality, most of the production staff drafted for the series were inexperienced-but-eager personnel from around the KRT studio. Professional sound stages were too expensive for the production, so they shot in

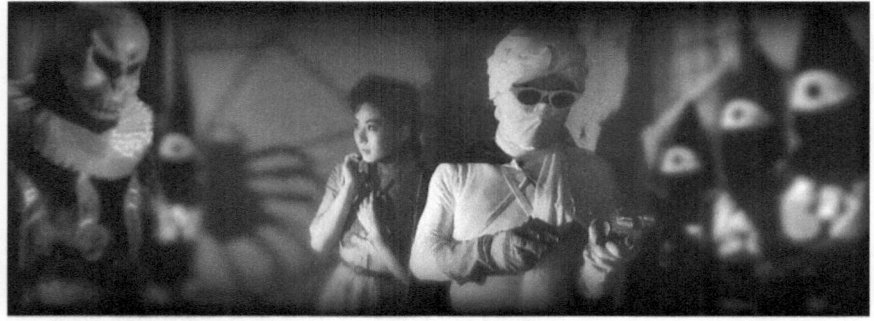

The present article's author Dan Ross kindly put together this stylin' "widescreen" photomontage of images taken from *The Ghost Party Strikes Back* story arc

and around President Kobayashi's own home; his reception room being used as Private Detective Juro Iwai's (祝十郎) office, while the garage was used for bad guy Skull Mask's (どくろ仮面 / *Dokuro Kamen*) hideout. Because of all the activity and fuss, during shooting Kobayashi's wife would stay at a hotel.

On-location shooting out in the streets gives one a stark impression of Japan at the time. Because the nation was still in the process of rebuilding following the ravages of WWII, Tokyo and Osaka are seen to have a lot of gravel and dirt roads. There's lots of mangy brush, weeds and unmanaged trees about. The outskirts of town are not bustling. Everything still feels pretty wild rather than jammed with glass skyscrapers, as today.

Other budget-saving measures were to use cheap, spring-wound, 16mm cameras. These only ran a 28-second wind per shot, which maybe contributed to the fast-paced editing of the show. The production couldn't afford rigs and tracks for shooting dolly shots, so they used the zoom on the camera in order to get up close into a scene. This became a popular method of tracking for so many productions from that time on through the '70s and '80s. One has to wonder if Moonlight Mask set a stylistic trend. Senkosha did it out of necessity, while other productions did it out of preference. Many of the prop pistols didn't shoot (i.e., made no smoke, flame or sound). The background sound effects were not only reused repeatedly (such as the same birdcall or dog-bark being heard in every instance), but some were supposedly "borrowed" without permission from Toho's sound library.

Producer Nishimura Sinichi (西村俊一) hired Toei Tokyo Studio (東京映画配給 / *Tokyo Eiga Haikyu*) contract actor Koichi Ose (大瀬康一) for the lead as Detective Juro Iwai, alias Moonlight Mask. Nishimura claimed the decision to cast Ose was made based on his clean-cut looks, which would be kid-friendly, and also because of his having a tense, engaging voice suitable for a masked hero. This was Ose's first leading role on TV. Later, in 1964, he would come to prominence as Shintaro Akikusa (秋草新太郎) in *The Samurai* (c/o William Ross' Frontier Enterprises). Interestingly, *The Samurai* became wildly popular in Australia, producing its own line of toys and clothing. It was popular enough Down Under that Ose would even visit to attend conventions. When he arrived (in costume) in Sydney, more than 7,000 fans greeted him at the airport. This was more than had greeted The Beatles when they previously visited Australia! Ose's most recent visit to an Australian fan gathering was in December 2016.

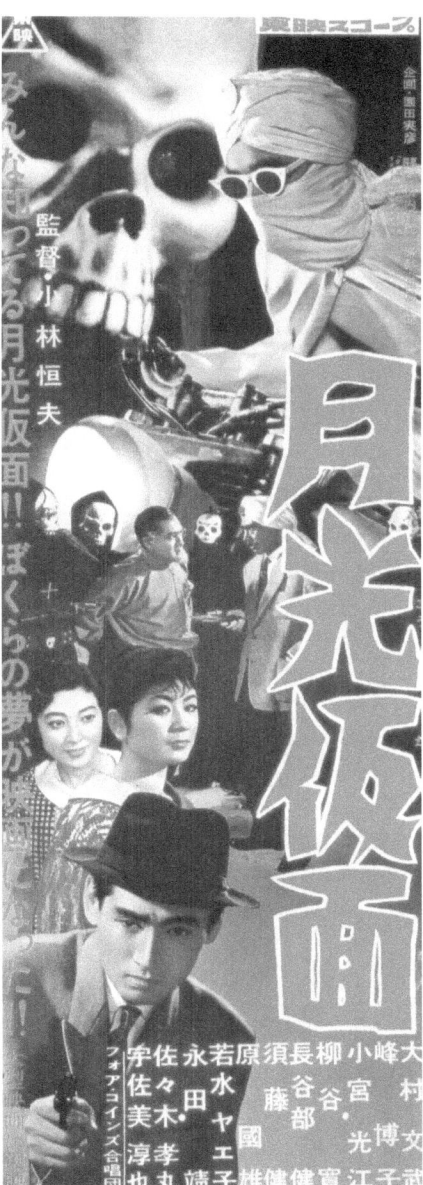

Japanese "speed" poster for the first *Gekkō Kamen* feature

Moonlight Mask ran on *The Takeda Hour* (タケダアワー) from February 1958 until July 1959 on KTR (what is now TBS: Tokyo Broadcasting System [株式会社TBSテレビ]). Sponsored by the Takeda Pharmaceutical Company, *The Takeda Hour* premiered with *Moonlight Mask*, and would continue sponsoring programs until 1974. It hosted a slew of legendary special effects adventures

Top: Splash-page for one of Gekkō Kamen artist Kuwata Jiro's "*Batman*ga". **Above:** Go Nagai's distaff nudie Gekko "variation" (!) Kekko Kamen lets it all hang out! (Cover to *KK* #4 [Vol. 4, January 1978])

The first 71 episodes of *Moonlight Mask* were 10 minutes apiece, and after that the runtime got expanded to 24 minutes, with a total of 130 episodes. The series was divided into five distinct story arcs, which are covered later in this article. While Senkosha was producing the show for television, due to its massive popularity (with an average of 40% audience share, which peaked at almost 68%—still the record for highest in the history of Japanese genre programs), Toei was inspired to produce a series of tie-in widescreen theatrical movies. Each movie was loosely based on the story arcs from TV. While the settings and characters were the same, the actors were different, with Ōmura Fumitake (大村文武) taking the role of Detective Juro/Moonlight Mask. The movies benefited from higher budgets, and it showed. There were more special effects, makeup, costuming, epic sets, bigger casts, and better locations.

Along with the movies, other media extensions included a spinoff manga which adapted the concurrently-running televised story arcs, an anime series produced in 1972, an ill-fated (i.e., flop) live-action color theatrical feature in 1981, and a kidcom anime series in 1999. The franchise also inspired plenty of parodies, including *mangaka* Go Nagai's (永井潔) sexy female variant *Kekko Kamen* (けっこう仮面). Originally meant simply as a punny "burlesque"-style gag he sent to an editor, Kekko Kamen went on to become her own breakout property. Starting as a manga in 1974, she was later adapted to anime, and then as a series of T&A-heavy live-action movies too.

The Moonlight Mask manga was drawn by Kuwata Jiro (桑田二郎), who also adapted other known properties, such as *Ultra Seven* (in 1978) and **RODAN** (ラドン / *Radon*, 1956, D: Ishirō Honda). Though Kuwata had been illustrating for a couple of years, *Phantom Detective* (まぼろしパンティ / *Maboroshi Tantei*, 1957) and *Moonlight Mask* were his first major manga breakthroughs. What he is primarily known for today is *8 Man* (8マン / *Eitoman*, 1963), which was adapted to anime and brought West as *Tobor the 8th Man* by ABC Films in 1965.

At the same time that Kuwata was drawing the ongoing manga adaptation, it was *also* being adapted for the rental manga market through publisher Suzuki Shuppan (鈴木出版). Drawn by Murayama Kazuo (村山一夫) and Inoue Minami (井上弘二), the rental manga market was aimed at a certain strata of customer who couldn't afford the slicker magazine-style comics. These tended to be cheaper productions bundled into thick book collections and rented, rather like you would a movie at a video rental store. While the Kuwata series is in print and still available at any book outlet, the rental version was never reprinted, and collections now go for huge sums.

(特撮 / *tokusatsu*), including the Tsuburaya classics *Ultra Q* (ウルトラQ / *Urutora Kyu*, 1965), *Ultraman* (ウルトラマン / *Urutora Man*, 1966) and *Ultra Seven* (ウルトラセブン / *Urutora Sebun*, 1967).

The Western phenomenon known as "Batmania" hit Japan in 1966, and with it came a manga from publisher Shonen Gahosha (株式会社少年画報社 / *Kabushiki-gaisha Shonen Gahosha*). Kuwata drew the entire *Batman* run based on the look and style of the Adam West/20th Century Fox/ABC-TV show *Batman* (1966-68), but with villains much more grounded in a Japanese aesthetic. This manga series was recently rediscovered by graphic designer Chip Kidd, who had a selection of story fragments reprinted in English in 2008. A few years after that, a cache of the entire run of the series was found. Immediately DC worked on getting the series cleaned up and translated for the U.S. comics audience. They are all available now under the title of *Batman: The Jiro Kuwata Batmanga* (2014-16). The *Moonlight Mask* manga, though as-yet not having been translated into English, is still in print 59 years later. A run-in with one popular Kuwata-created Batman villain, "Lord Death Man", was adapted for the Warner Bros. Animation series *Batman: The Brave and the Bold* (2008-11) and also incorporated into the DC Universe, where he now appears in their American comics.

Anime studio Knack Productions (ナック, 株式会社 KnacK), was formed from a mix of ex-employees from both Toei Animation (東映アニメーション株式会社 / *Tōei Animēshon Kabushiki-gaisha*), and Mushi Productions (虫プロダクション). Knack was the creator of the infamously bad *Chargeman Ken!* (チャージマン研! / *Chaji man Ken!*, 1974). They produced the anime version of *Moonlight Mask*, called *The One Who Loves Justice, Moonlight Mask* (正義を愛する者 月光仮面 / *Seigi Wo Aseuru Mono, Gekkō Kamen*, 1972). Like the Toei movies, it also aimed at adapting some of the original live-action TV serials. In this case, due to the luxury of being animated, the villains and monsters were much more exaggerated and fantastical in design. The series' kickoff episode, "Bat Man of Terror", features a villain who, remarkably, looks a lot like Go Nagai's *Devilman* (デビルマン / *Debiruman*). The anime series was exported to parts of Europe as *Moon Mask Rider*, and to Latin-American countries as *Capitán Centella*, where it proved to be enduringly popular to this day.

Premier International/Herald Enterprise Productions filmed the awkwardly-titled **MOONLIGHT MASK, THE MOON MASK RIDER** (月光仮面 / *Gekkō Kamen*, 1981, D: Sawada Yukihiro]), which was a full-color theatrical movie taking place 20 years after the setting of

Top to Bottom: A pair of shots from the '72 *GK* anime teleseries, plus another of the cutesy "downsized" title character from the turn-of-the-New Millennium kiddie show *You Know! Moonlight Mask-Kun* (a.k.a. *Little Moonlight Rider*)

the original series. This take on the character was no longer a detective named Juro, but instead a scientist fresh from the United States going by the name of George Owara (ジョージ小原), played by Daisuke Kuwabara (桑原大輔). This box-office disaster was unfortunately a strange combination of the garish, silly and cheap. It was supposed to be the big-budget—though not big enough, it seems—legit "coming-of-age" of the franchise, but was written-off quickly and sank into oblivion. This was unfortunate, since the international distribution would have been a great avenue for reinvigorating the franchise, had things panned-out as planned.

Gekkō Kamen's exciting story continues on page 54!

Wind-up clockwork *GK* tin toy, circa late '50s

月光仮面

A "one-eyed" hooded goon has a confrontation with the law in the TV story called *The Ghost Party Strikes Back*

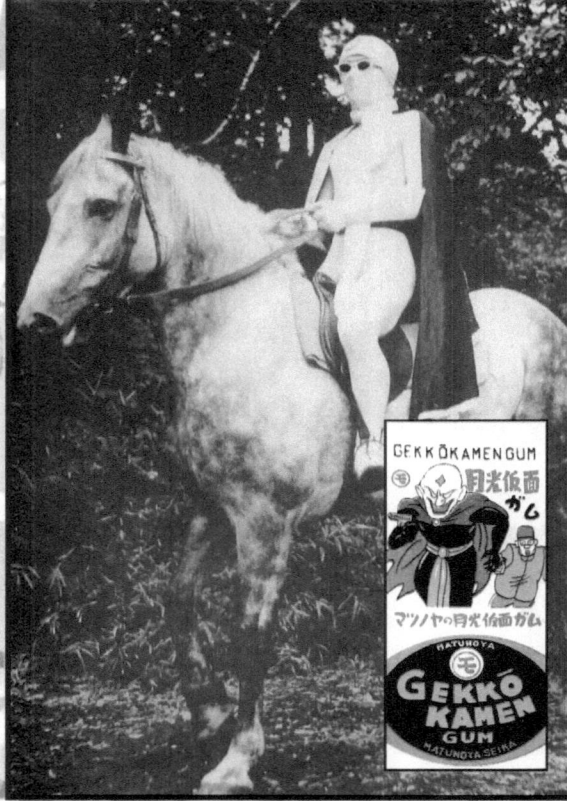

Above: *Unmasked Rikuo Rider!* Fumitake "Takeshi" Ōmura went whole-hog as GK in the Toei features.

Right: *Extra Horsepower!* Gekkō Kamen astride a decidedly different kind of mount in *The Secret of Baradai Kingdom* TV serial

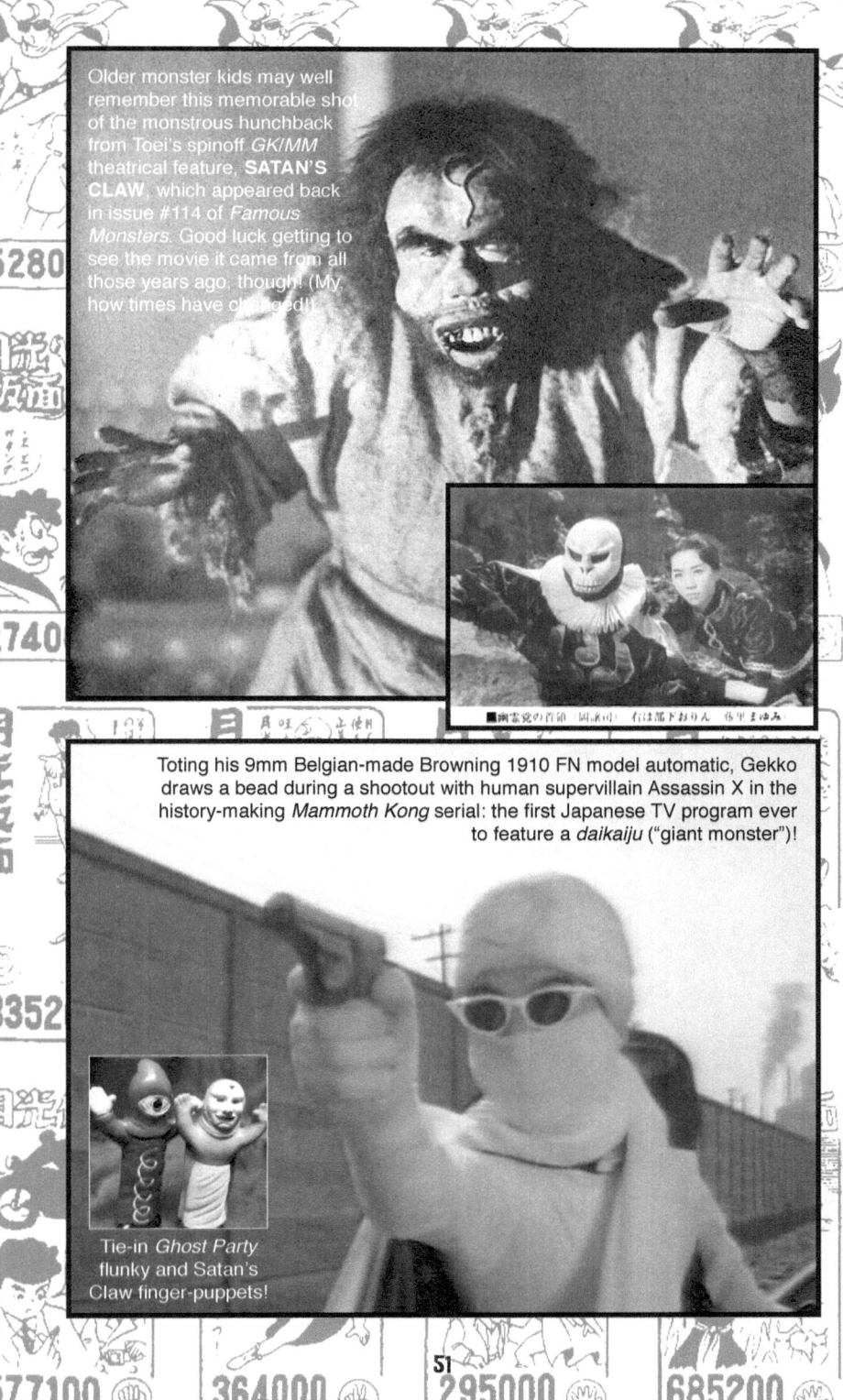

Older monster kids may well remember this memorable shot of the monstrous hunchback from Toei's spinoff *GK/MM* theatrical feature, **SATAN'S CLAW**, which appeared back in issue #114 of *Famous Monsters*. Good luck getting to see the movie it came from all those years ago, though! (My, how times have changed!)

Toting his 9mm Belgian-made Browning 1910 FN model automatic, Gekko draws a bead during a shootout with human supervillain Assassin X in the history-making *Mammoth Kong* serial: the first Japanese TV program ever to feature a *daikaiju* ("giant monster")!

Tie-in *Ghost Party* flunky and Satan's Claw finger-puppets!

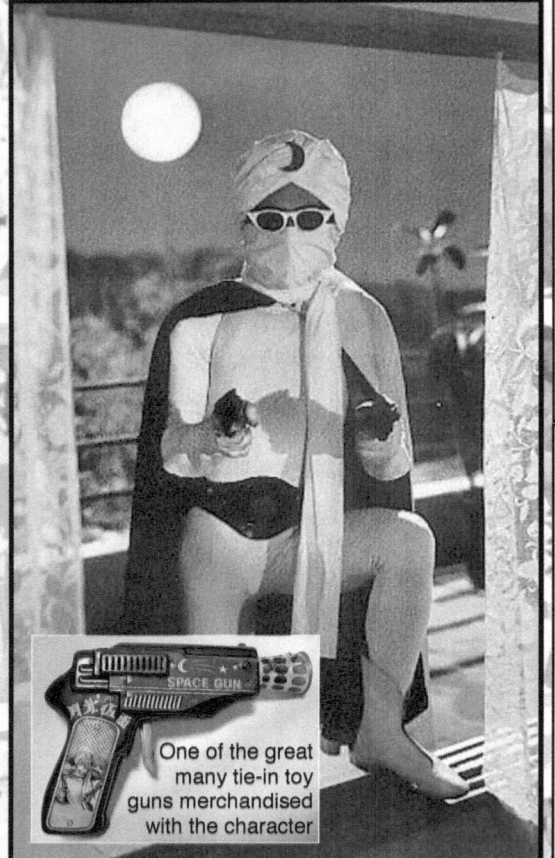

One of the great many tie-in toy guns merchandised with the character

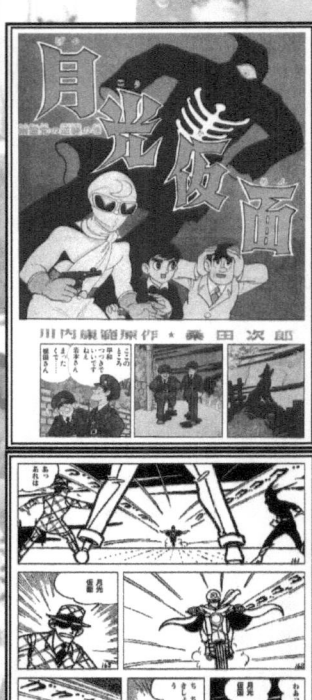

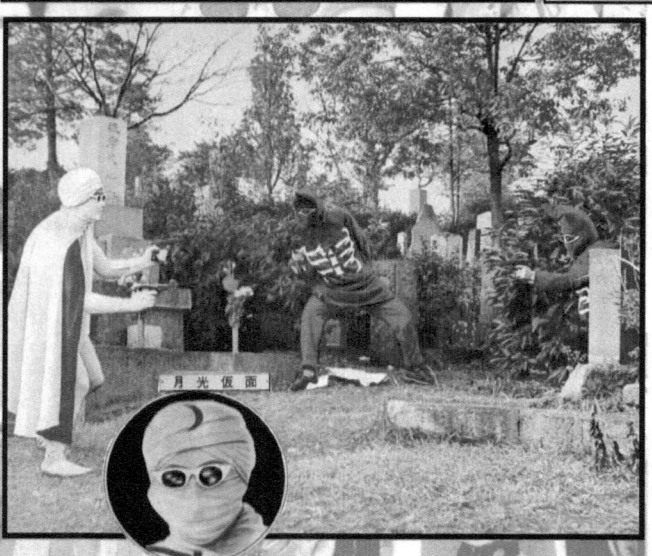

Clockwise, from Top Left: Juro Iwai a.k.a. Moonlight Mask, striking a heroic nocturnal stance in the silvery glow of his namesake; a splash-page and page of panels from one of Kuwata Jiro's *GK* manga; and our title hero tangles with some more cyclopean-hooded henchmen in another still from the teleserial *The Ghost Party Strikes Back*

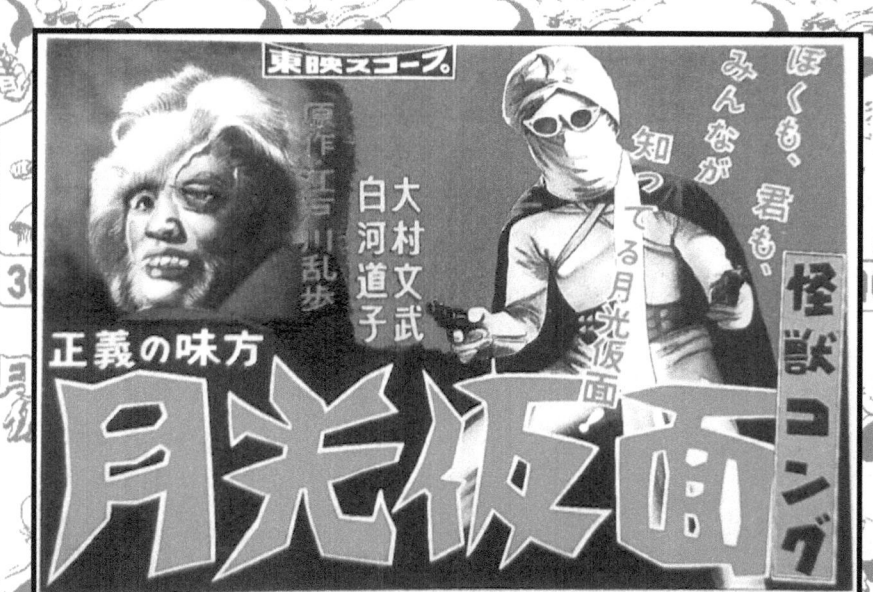

Another of *GK*'s numerous different-styled toy gun tie-ins

Top: Japanese poster for **MONSTER KONG**, Toei's more downscale—in more ways than one!—theatrical reinterpretation of the Daikaiju small-screen serial *Mammoth Kong*. **Above:** *Road Rage!* "Say hello to my little friend!" says Gekkō Kamen to Dokoru Kamen ("Skull Mask", natch!) from the roof of the latter's speeding getaway car during an action highlight in the inaugural TV serial. *[Note: The background fades seen on pages 50-53 are of a GK Menko card set released as a tie-in with the franchise!]*

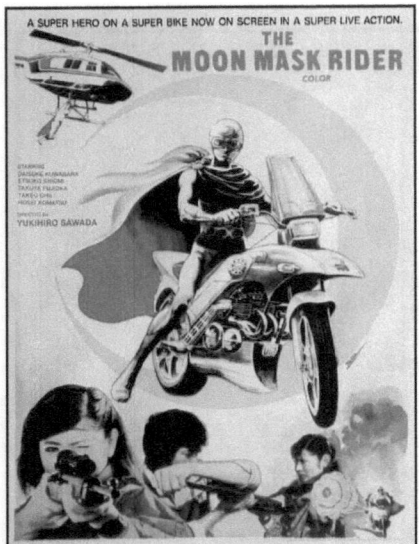

The GK story now continues on from page 49...

Most recently Moonlight Mask appeared in the comedy anime series *You Know! Moonlight Mask-Kun* (ごぞんじ!月光仮面くん / *Go Zonji! Gekkō Kamen-kun*, 1999-2000), a 25-episode Sunday morning kids' show filled with goofy humor. After Detective Juro Iwai has retired, he passes his crime-fighting identity and little scooter (which is actually a living alien!) on to young Yamamoto Naoto (山本ナオト), an elementary school student. TBS marketed this series internationally as *Little Moonlight Rider* with an English dub, but I've yet to learn of any English-language market which picked it up for airing.

The title hero himself, Moonlight Mask, has no origin story. The original 1958-59 series starts with Juro Iwai already in charge of his vigilante alter-ego, though all the primary players in the series meet him for the first time during the first story arc. We don't know why he has superhuman powers, such as the ability to leap atop tall buildings, disappearing and reappearing in a flash, being such a superb marksman, and having superior fighting skills. Maybe his parents were assassinated and it caused a lifelong grudge? Possibly he was trained by a secret sect of monks in the Himalayas, or something of that nature? Whatever the case may be, he simply *is* Moonlight Mask; no questions as to why or how. (Harkening back to the theme song: "We *don't know* where he comes from...")

Juro runs a detective agency which seems to assist the police and other governmental authorities more than spying on philandering husbands or tracking down robbers. He has two adult assistants, plus a handful of children who help him out. Kaboko (カボ子) is the smart female assistant who is the foil, always explaining things to Gorohachi (五郎八), the always-skittish comedy relief, who might remind one a bit of Jerry Lewis, Lou Costello or Shaggy from Hanna-Barbera's *Scooby Doo* (1969-) as he tends to stumble across the scariest situations which gives him a chance to mug his fright for the camera. There's also Inspector Matsuda (松田刑事部長), who is in continual need of Detective Juro/Moonlight Mask's aid; although he *is* handy for bringing in an army of cops when a big battle is on and reinforcements are required. The cases the agency runs into are pretty major: such as an international spy ring stealing an experimental bomb that could wipe-out millions of people at once, a mind-controlled giant monster rampaging through town, and tracking down a 600-year-old treasure from an ancient, lost kingdom.

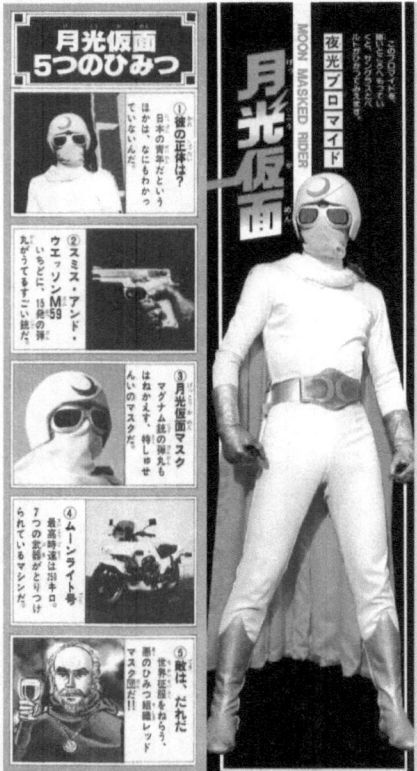

Top & Above: Pakistani poster and some Japanese promos for the bomb '81 cinematic reboot of the live-action *GK/MM* franchise

The show's rogues' gallery is where we can see the influences of US cliffhanger serials and movies on it, and in turn Moonlight Mask's profound influence on Japanese superheroes yet to come.

The first villain, "Skull Mask" (どくろ仮面 / *Dokoru Kamen*), is the leader of an international spy syndicate which kidnaps a benevolent (if misguided) scientist who created the "H.O. Joe" Bomb, a hydrogen-and-oxygen-based explosive device so destructive it is intended to deter all future forms of war. In the hands of the unscrupulous Skull Mask, you just *know* that bomb is going to be used as leverage for all sorts of extortion and strong-arming! And of course, Moonlight Mask is the only person with the means to put a stop to this sociopathic bunch.

In this story we see the hierarchical set-up for the rest of the series. Pulled from Westerns and serials, Skull Mask is a mysterious, masked ringleader who gives a band of henchmen orders to do various nefarious tasks. This occurs in so many serials that it makes more sense to use just one example; In Columbia Pictures' 15-chapter serial **THE SPIDER'S WEB** (1938, Ds: James W. Horne, Ray Taylor) "The Octopus", the mysteriously-hooded head honcho of a crime syndicate, uses his many minions to sabotage transportation routes and industrial complexes in order to gain power over corporate America. He always has several layers of cannon fodder arrayed between himself and his nemesis, the intrepid protagonist known as "The Spider". During each chapter, these criminal chumps wind up in a showdown with The Spider. Sometimes the hero with the arachnid namesake wins, at others he falls prey to some diabolical trap—these *were* cliffhangers after all!—yet ultimately endures to prevail over all comers.

Senkosha bigwig Toshio Kobayashi *[second from left]* on the *GK* set *circa* 1959, alongside the tiny 16mm camera it was shot with. The same company still holds the rights to the show to this day

A specially-posed action still for **SATAN'S CLAW**, Toei's lively theatrical remake of the TV serial known as *The Treasure of Baradai Kingdom*. If you think its masked supervillain looks creepy, just wait'll you get a load o' the horrible hunchback in it *[see p.51]*!

55

"Our hero Gekko Kamen races against time to save the Doctors daughter from a deadly trap"

Wooohhh!!!

All three screen-shots above were taken from a fan-subbed edition of Toei *GK* feature #2 (see p.354). In the style of old Hollywood cliffhangers, entries begin with dramatic voiceover narration *[top]* which recaps key events from the preceding episode. The serial ends with our hero *[bottom]*—in an image which is evidently intended to be taken more *figuratively* than literally—zooming off towards our planet's shining satellite on his high-flying "mock-Harley" Rikuo hog!

We see much of this same dynamic play out in each story arc of *Moonlight Mask*; either in a shootout or in hand-to-hand combat out in the middle of a field somewhere. In this first story arc, the identically-attired henchmen all wear trench-coats and fedoras, with black bandannas covering the lower halves of their faces. While the "one-versus-many" fight scenario is a pretty common trope going back far into history, this particular type of setup—with the hero squaring-off against multiple masked forces in a field, rock quarry or wherever—is highly reminiscent of what was later to be seen over and over again in so many of the *Masked Rider* (仮面ライダー / *Kamen Rider*) and *Power Rangers* (スーパー戦隊 / *Supa Sentai*) franchises, among many, *many* others.

It's possible the whole Masked Rider phenomenon *may* have been a direct consequence of Moonlight Mask. An article in the book *Kamen Rider 1 Character File* (Kodansha, 2004, reprint 2014) relates the following story: In 1970, Mainichi Broadcasting Corporation (毎日放送, MBS) was looking for a new hero show to produce. Ishinomori Shotaro (石ノ森 章太郎) was brought in by producer Toru Hirayama (平山亨) for several meetings to brainstorm a hero specifically in the vein of Moonlight Mask—namely, a fighter and motorcycle rider. Several concepts were iterated on, with Hirayama and Ishinomori finally settling on *Cross Fire* (クロスファイヤー) as their first major concept: a white-clad speed racer wearing a white helmet with a broad red cross on it. But Ishinomori felt the character too bland and went for a more Gothic design in the form of *Skull Man* (スカルマン), a black-clad, motorcycle-riding antihero with a human skull for a head. Ishinomori drew a one-shot *Skull Man* manga, but MBS producers felt it was too morbid for the audience they were aiming for. The final iteration would be the iconic "grasshopper"-themed *Masked Rider*, which started in 1971 and is still running strong in 2017. Ishinomori created several extremely popular franchises, such as *Cyborg 009* (サイボーグゼロゼロナイン / *Saibogu Zero Zero Nain*, 1964-81) and *Android Kikaider* (人造人間キカイダー / *Jinzo Ningen Kikaida*, 1972-73).

In *The Treasure of Baradai Kingdom* (バラダイ王国の秘宝 / *Baradai okoku no hiho*, 1958) the next villain is called "Satan's Claw" (サタンの爪). He is robed in a sarong, wearing an abnormally large white mask with a permanent crazed smile sculpted into the face and a glittering diamond shape set into the forehead. He is out to find a $20-million treasure in the ancient Southeast Asian kingdom of Baradai. Lost in a catastrophe 600 years ago, to locate this treasure he must first find three golden keys which, when combined, reveal the fabulous cache of riches. Descended from a line of thieves who were exiled by the Baradai kingdom's royalty, he is not looking to rule the world, but instead merely craves the treasure and exacting revenge in the name of his family's honor. The descendant Prince of lost Baradai, who lives in Tokyo, is the first to get knocked-off, and his map to the keys

stolen from him by Satan's Claw. The Claw's Tokyo-based gang, like our previous bunch, wear matching black trench-coats, fedoras and bandannas. But as our expedition heads to Southeast Asia, their costumes change to sarongs and a mixture of fezzes and turbans. Unfortunately, the setting for the "fabulous" Baradai Kingdom seems to be nothing more than local woodlands around Tokyo.

The Toei theatrical version of the serial was simply called **SATAN'S CLAW** (月光仮面 魔人の爪 / *Gekkō Kamen majin no tsume*, 1958), and it's really a treat. This is where it paid off in spades to have a bigger budget. Once the story leaves the confines of the city, we are witness to some wonderful sets, which are reminiscent of the old Hollywood in-studio jungle settings seen in the likes of MGM's **TARZAN THE APE MAN** (1932, D: W.S. Van Dyke), while some even feel like they could almost be from RKO's **KING KONG** (1933, Ds: Merian C. Cooper, Ernest B. Schoedsack). While there are no dinosaurs or giant apes to be had, there are pith-helmeted explorers aplenty, plus earthquakes, huge fissures that open up in the jungle which swallow people whole, ancient vine-covered ruins, a gigantic skeleton statue, creepy/shadowy caves, large bats and—last, but by no means least—a ferocious hunchback. If you have issue #114 of *Famous Monsters of Filmland*, the all-Japanese issue, you may well remember the hunchback from there.

While Baradai Kingdom unfortunately didn't boast a giant ape, the next *MM* serial would! Yes indeed, in *Mammoth Kong* (マンモスコング / *Manmosu Kongu*, 1958) Moonlight Mask really takes the plunge into the world of Japanese special effects shows as we've come to know and love them. First off, our vile villain "Assassin X" (殺し屋X / *Koroshi-ya X*) has a secret base that feels very much in the vein of a James Bond supervillain's; a large complex able to hold—well—a mammoth, tusked, gorilla-like *daikaiju*. Obviously, Senkosha was now able to afford some fairly fancy sets. Assassin X is wardrobed in sci-fi garb: a white robe with a large black "X" on the chest and a black, pointed domino mask. Like any "good" villain, he laughs maniacally when giving his nefarious orders. His henchmen are clad in all-black robes with white X's on their chests and hoods that form two peaks, almost like bunny ears!

Mammoth Kong, during some previous if untold adventure (probably battling Carl Denham on Skull Island!), is locked aboard a ship hauling him from his own ecosystem off to Japan. During a typhoon, the ship wrecks and Kong sinks to the bottom of the sea. Assumed dead, he winds up very much alive as a captive of Assassin X, who brainwashes the beast to do his dirty work, killing political leaders and generally trampling on Tokyo.

Senkosha president Kobayashi related a story of how they came up with the scale of the sets. The effects crew went to a toy store and bought the largest, most realistic toy cars they could find, then they built the miniature sets around the scale of those cars. Also, for scenes wherein Mammoth Kong and Moonlight Mask appear together, a miniature of the hero and his motorcycle were built and run on a track in order to ride around and outmaneuver the gorilla *kaijū*, even zooming between its legs at one point. Unfortunately, this track (a clear-cut groove in the middle of the miniature roadway) is highly visible in those scenes,

Above: A triptych more shots from the same fan-subbed edition of Toei's 2nd GK flick. In these, the titular death's-headed villain Dokuro Kamen stays true to his nasty nature by unleashing (pint-sized) Godzilla-like fiery breath-blasts and gleeful gales of evil cackling—*lots* more of the latter than the former!—on cue

A Moonlight Mask/Gekkō Kamen *Rogues' Gallery!* **Top Left:** Main baddie Dokoru Kamen in GK's debut tele-serial, *Skull Mask*. **Top Right:** Toei theatrical poster for **SATAN'S CLAW**. **Above:** Robot Kong and his mad, maniacally-laughing masked master, Assassin X. **Left:** Monster Kong, Mammoth Kong's much-more-modest, normal-human-sized counterpart in Toei's big-screen version

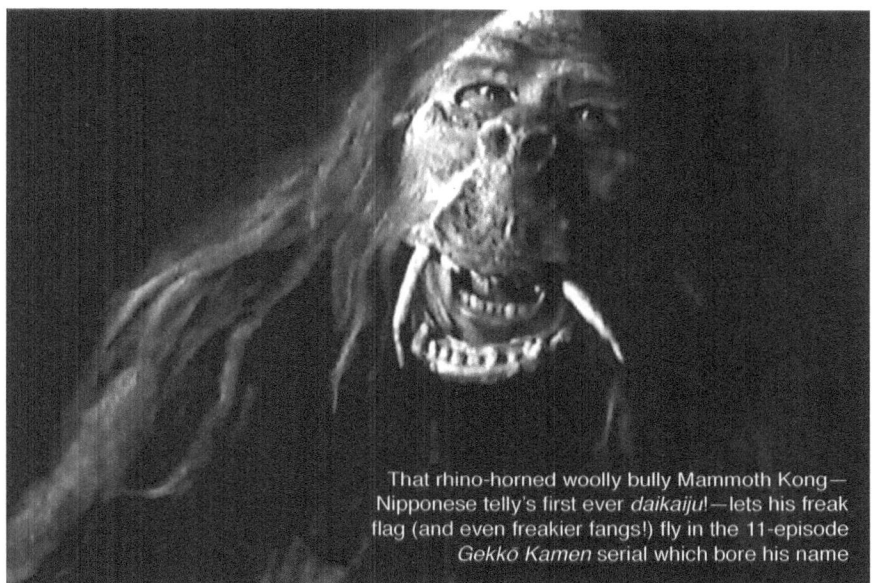

That rhino-horned woolly bully Mammoth Kong—Nipponese telly's first ever *daikaiju!*—lets his freak flag (and even freakier fangs!) fly in the 11-episode *Gekkō Kamen* serial which bore his name

but they're still a lot of fun to behold regardless. Despite its name, this Kong is only *slightly* ape-like. The long-haired costume fits close to the actor's body, giving him a very human form quite reminiscent of various takes on Bigfoot. His head is like a simian's, but with two huge fang-like tusks projecting downwards from the upper jaw like a saber-tooth tiger's, and a prominent horn in the middle of his forehead. Overall, it's not a bad effect at all.

Conversely, the Toei version of this serial, **MONSTER KONG** (月光仮面 怪獣コング / *Kaijū Kongu*, 1958), in a way feels much more cut-price, or at least a lot less grand. After **SATAN'S CLAW**, maybe they just didn't have the budget to take on a full-scale *daikaiju* and make it look good. Whatever the reason, the new Monster Kong is a completely different beast, though the story itself is only slightly different. While it's still firmly in the realm of science fiction—with atomic super weapons and other "hi-tech" gadgets—this Monster Kong is more of a Jekyll & Hyde story. This involves "The International Assassin Team" and their leader Killer Joe, who can turn himself into an immortal beast on cue. He's normal human-sized, wears spiffy clothes, drives cars and helicopters, and fires a machinegun. These guys are anarchists who want to kill off all government officials and intellectuals in order to let the world crash-and-burn out of control.

In *The Ghost Party Strikes Back* (幽霊党の逆襲篇 / *Yūrei tō no gyakushū*, 1959) we see the return of a gang sporting skull masks, although these guys have got one-up on the original Skull Mask crew, as they can turn themselves invisible! But their evil aims are fairly similar. The Ghost Party are also spies, but instead of kidnapping a scientist to get a bomb, they instead murder im-

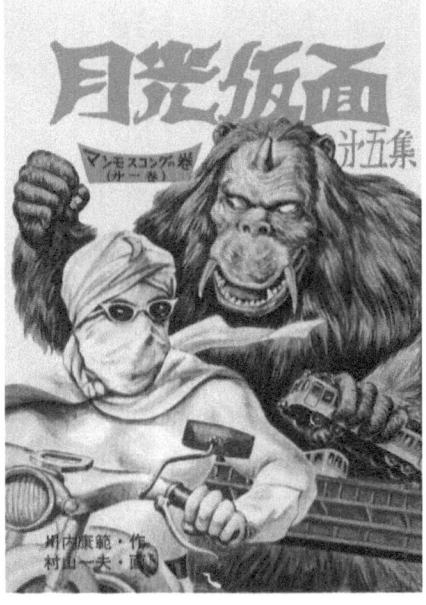

Local rental book cover for Vol.1 in the *Mammoth Kong* TV serial's 1958 tie-in manga adaptation (artist unknown)

Top & Above: Contents page and a page of panels from a *Mammoth Kong* rental manga volume (internal art by Kazuo Murayama).
Facing Page: Cover for Vol. 2 of one of *MK*'s rental volumes (artist unknown).

portant officials, then replace/masquerade as them in order to infiltrate various strategic government and scientific facilities; this is in order to gain access to radioactive materials to—*of course!*—cause still more mayhem and destruction. Our henchmen this time are dressed in black robes, topped with tall, pointy hoods boasting a single large eye decal sewn-on in front.

The final chapter in the Moonlight Mask live-action series is *Don't Toy With Revenge* (その復讐に手を出すな / *Sono fukushu ni tewodasuna*, 1959). Someone has taken up the identity of the deceased Skull Mask seen in the first story arc. By weaving a complex web of mystery and murder, his fiendish game is to take revenge on a group of shipwrecked survivors who abandoned him on an isolated island full of deadly spiders during WWII. A portion of this story arc takes place in flashbacks on a Pacific island, where the group of survivors fight for their lives against savage living conditions, with low rations to sustain them. This reminds me quite a bit of the old "mystery house" movies of the '30s and '40s; a whodunit with a small pool of suspects, but with the inclusion of masked opponents and plenty of shootouts.

Story-wise, the Toei movie versions of the last two serials do not differ that much from the TV show. Again, a higher budget for location and effects were a boost to the overall quality. A plus-one for these last two is that the serials were generally felt to drag a bit, so the movies judiciously condensed the stories down to a terse 65 minutes apiece. There were also some striking differences throughout the Toei movie series, such as musical interludes. At some point in each movie, a scene occurs where there is a barroom or similar establishment with a band that performs an entire song, which really slows down the momentum of the action. There is also the pronounced addition of goofball, almost cartoon-like comedy, with pratfalls and slide-whistle sound effects. It's subjective for the viewer to decide if musical numbers and slapstick comedy are a bonus or not.

By the final episodes of *Don't Toy With Revenge* (sometimes translated as "Don't Dabble in Revenge"), *Moonlight Mask* was starting to take some heat from newspapers and magazines about its action and perceived excess violence. Children were emulating their hero by engaging in acrobatics which were getting them injured and, even worse,

sometimes actually killed. In particular, one ultra-conservative paper, *Shukan Shincho* (週刊新潮) slammed the series and writer Kawauchi to the point where he sued the newspaper for defamation of character. But by then it was too late. Amidst rumors of censorship and the ongoing controversy regarding its violence, the first special effects superhero show ever to be made in Japan had been canceled. After its cancellation, a final unfilmed Kawauchi story was adapted to comics by Kuwata Jiro.

There have been further iterations on the franchise as discussed earlier in this article. Along with the reboots and merchandise, the public has not forgotten about their first TV hero and its

Main article text continues on page 66...

MAMMOTH KONG

Below: Mammoth Kong's full-sized performer, laid alongside miniature human marionettes; an "optical illusion" for the sake of showing scale. **Bottom:** The awesome "Gekkō-between-the-legs" scene from *Mammoth Kong*. (Note—like you could possibly miss it!—that groove cut into the roadway for the miniature bike to bomb along on)

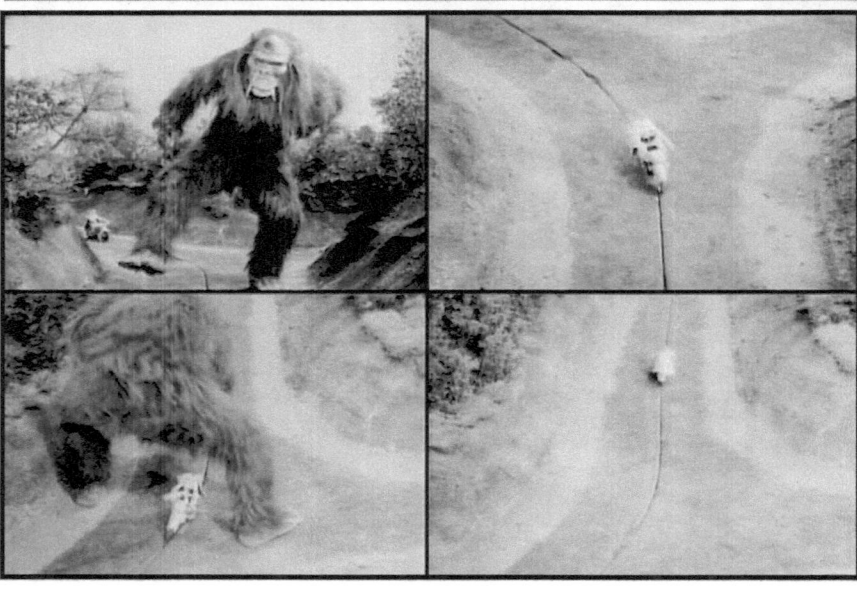

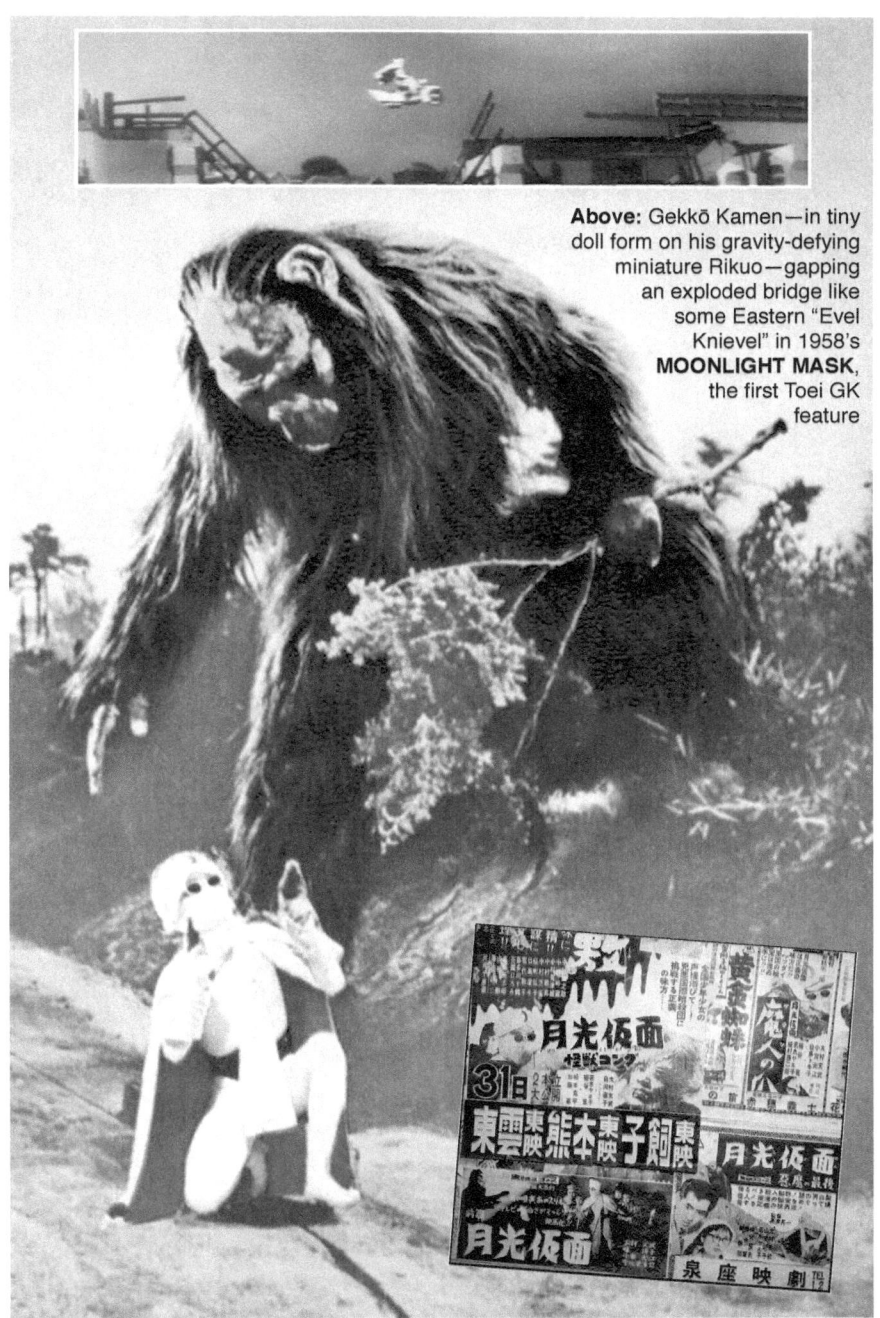

Above: Gekkō Kamen—in tiny doll form on his gravity-defying miniature Rikuo—gapping an exploded bridge like some Eastern "Evel Knievel" in 1958's **MOONLIGHT MASK**, the first Toei GK feature

Above, Background: A fab cut'n'paste composite image of Gekkō and Kong from one of the full-color bromide publicity cards that were issued as tie-ins with the show.
Inset: Assorted contemporaneous handout ads for Toei's *GK* theatrical features

Having been captured whilst running amok up in the frozen wastes of Alaska, the so-called "Beast of the Century" promptly gets shipped-off to Japan (Tokyo, natch!), where a news announcer ominously reports over the radio airwaves: *"The Mammoth Kong is fifteen meters tall. His strength is ten times that of an automobile, and his fangs can break through concrete. He is a terrifying monster! ...Professor Yamamura, a noted zoologist, says he is the biggest gorilla in the entire world!"* (quoted from the English-fan-subbed upload of *MK*'s first episode on YouTube; whose subtitled opening credits conspicuously misidentify the human star of the show, Gekko [a role filled over the entire course of the 131-episode TV series by Koichi Ōse], as being played by Fumitake Ōmura, who was actually the title character's performer in Toei's six-pack of spinoff big screen features)

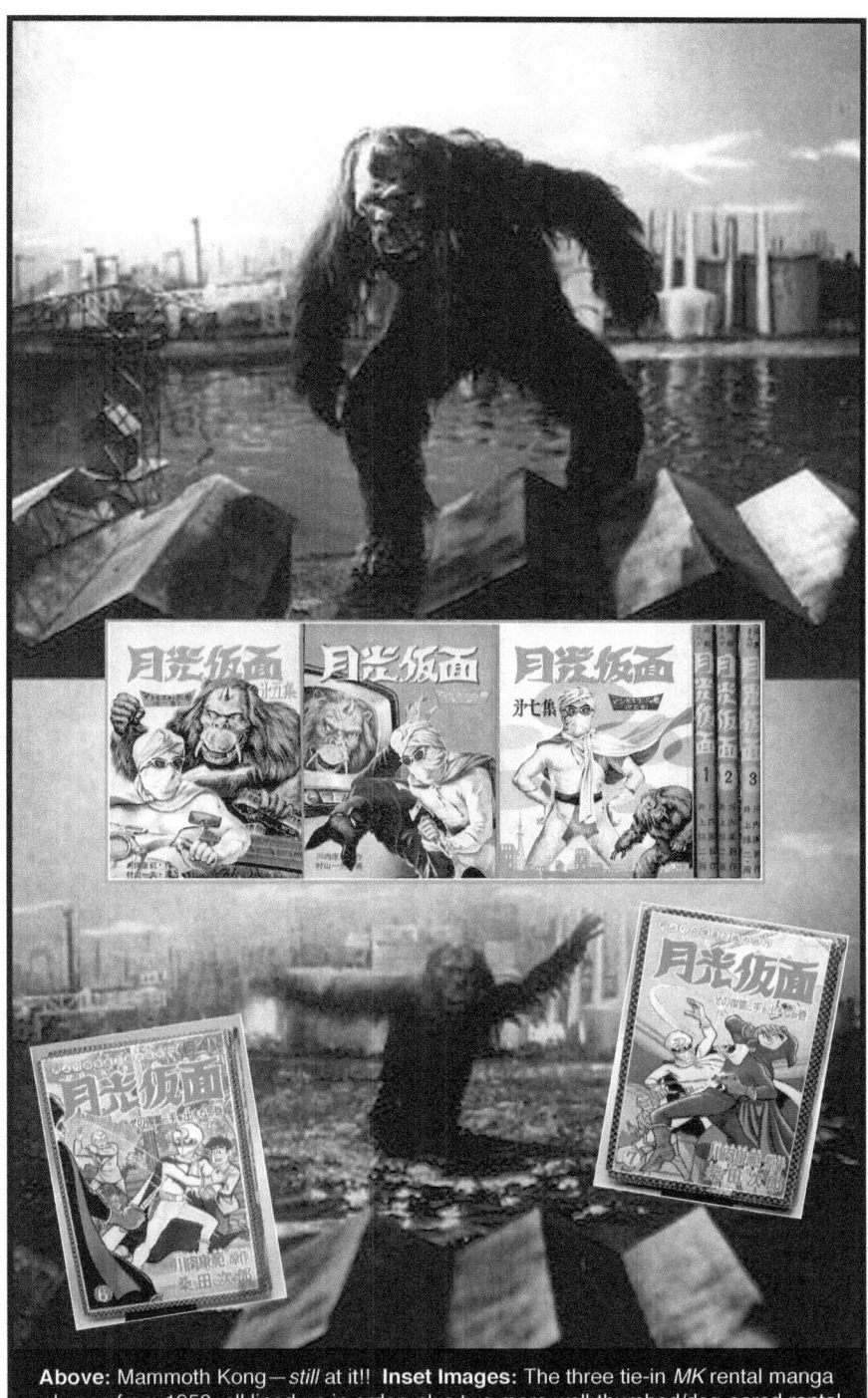

Above: Mammoth Kong—*still* at it!! **Inset Images:** The three tie-in *MK* rental manga volumes from 1958, all lined-up in order; plus two more well-thumbed/dog-eared rental book collections of different *Gekkō Kamen* manga adventures

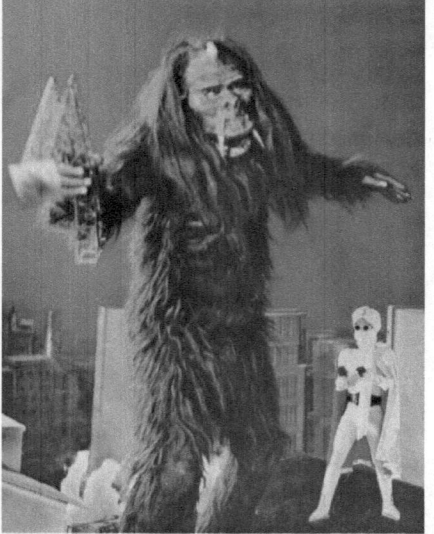

Continued from page 61

creator. In Hakodate (函館市), Hokkaido (北海道) there is a statue of the 1972 cartoon version of Moonlight Mask. Dedicated to Kawauchi, the plaque reads "Do not hate, Do not kill, Let's Forgive." In 2001 in Misawa, Aomori, a monument was also erected for Moonlight Mask and Kawauchi in commemoration of him living there for two decades, with much the same sentiment, wishing for peace and justice for the world.

And in these crazy, mixed-up times in which we live, what better way to end this article than on *THAT* optimistic note!

Top: Contemporary Senkosha ad for the *GK* teleserials' DVD releases...presented in "HD", yet! **Above:** Another paste-up bromide promo image of our crescent-moon-emblazoned/turbaned, white-masked, two-gun man from Japan squaring off against his monstrous horned, tusked and scary-hairy pseudo-simian foe, MK!

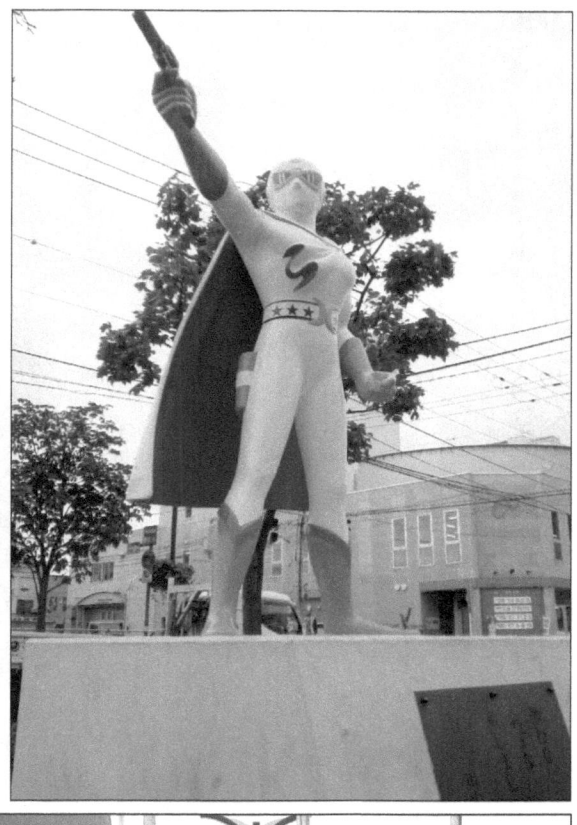

Above: Printed on easily-bendable thin card stock, this die-cut, glossy full-color paper mask of Gekkō Kamen was released as a promotional tie-in with the show. Just run a string through the two li'l holes one on each side, and you're all set to play at your favorite superhero! **Right:** This modern-day tributary statue of Gekkō Kamen stands in the port city of Hakodate (located on Japan's northernmost island, Hokkaido). **Below:** Another monument to same; this one was donated to Tokyo's Misawa Park in 2001. **Inset:** Molded mass-market plastic GK mask, circa 1980/90s (?).

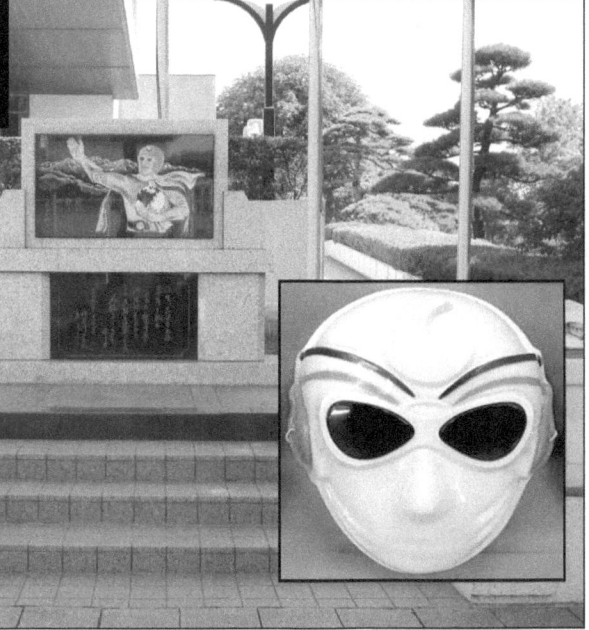

あなたのすべての祈りが答えられます！
(*Anata no subete no inori ga kotae raremasu!*)

ALL YOUR PRAYERS ARE ANSWERED!
Gods & Monsters Stalk the Earth as One in the *Daimajin* Trilogy

by Michael Hauss

I was first introduced to the fabulous Daimajin *(大魔神 / "Great Demon God" [alternately transliterated as "Dai Majin" or "Daimashin"]) series back in the late 1990s, when I purchased the whole trilogy on VHS, in Japanese, with English subtitles. I bought all three in one fell swoop from a company called A.D. Vision, and proceeded to view them in the logical chronological order of* **DAIMAJIN** *(大魔神),* **RETURN OF DAIMAJIN** *(大魔神 怒る / Daimajin ikaru) and* **WRATH OF DAIMAJIN** *(大魔神 逆襲 / Daimajin gyakushū)...or so I thought! The issue I had with that—a fact which did not dawn on me for a few years until the further growth of the internet—was that ADV had (evidently inadvertently) flip-flopped the titles of the second and third films, causing them to be in the wrong order. Thus, the so-called* **"WRATH OF DAIMAJIN"** *was in reality* **RETURN OF DAIMAJIN**, *and vice versa. Once that blunder was finally cleared-up and established in my mind, it made much more sense in terms of how each film was successively written and produced. Now, I'm not saying that these films have a continuing narrative from film to film (they don't), but the first two movies are more complexly-staged religious-themed/adult-oriented forays, whereas the third and final film is much more geared towards the younger (as in teen/preteen) crowd.*

Falling squarely into Japan's vibrantly verdant jidaigeki kaijū *("period monster") movie genre, the* Daimajin *trio consists of separate full-feature-length films, and all were filmed in quick succession in 1966, with each entry being released theatrically in Japan that same year, staggered every few months:* **DAIMAJIN** *(in April 17, 1966),* **RETURN OF DAIMAJIN** *(August 21, 1966) and* **WRATH OF DAIMAJIN** *(December 21, 1966). All three films were written by Tetsurō Yoshida ([吉田 鉄郎] not to be confused with a world-famous Japanese architect of the same name), with each production having a different director. Yoshida has many other well-known writing credits, including: Kenji Misumi's chanbara* **FIGHT, ZATOICHI, FIGHT** *(座頭市血笑旅 / Zatōichi kesshō-tabi, 1964), Kimiyoshi Yasuda's jidaigeki kaiju/kaidan* **YOKAI MONSTERS: 100 MONSTERS** *(妖怪百物語 / Yōkai hyaku monogatari, 1968) and its first sequel, Yoshiyuki Kuroda's* **YOKAI MONSTERS: SPOOK WARFARE** *(妖怪大戦争 / Yōkai daisensō, 1968), as well as the Yokai Monsters trilogy's vastly-underrated, lesser-seen and much-in-need-of-rediscovery final instalment,* **JOURNEY WITH GHOST ALONG YOKAIDO ROAD** *(東海道お化け道中 / Tōkaidō obake dōchū, a.k.a.* **YOKAI MONSTERS: ALONG WITH GHOSTS**, *1969, all Japan).*

INTRODUCTION

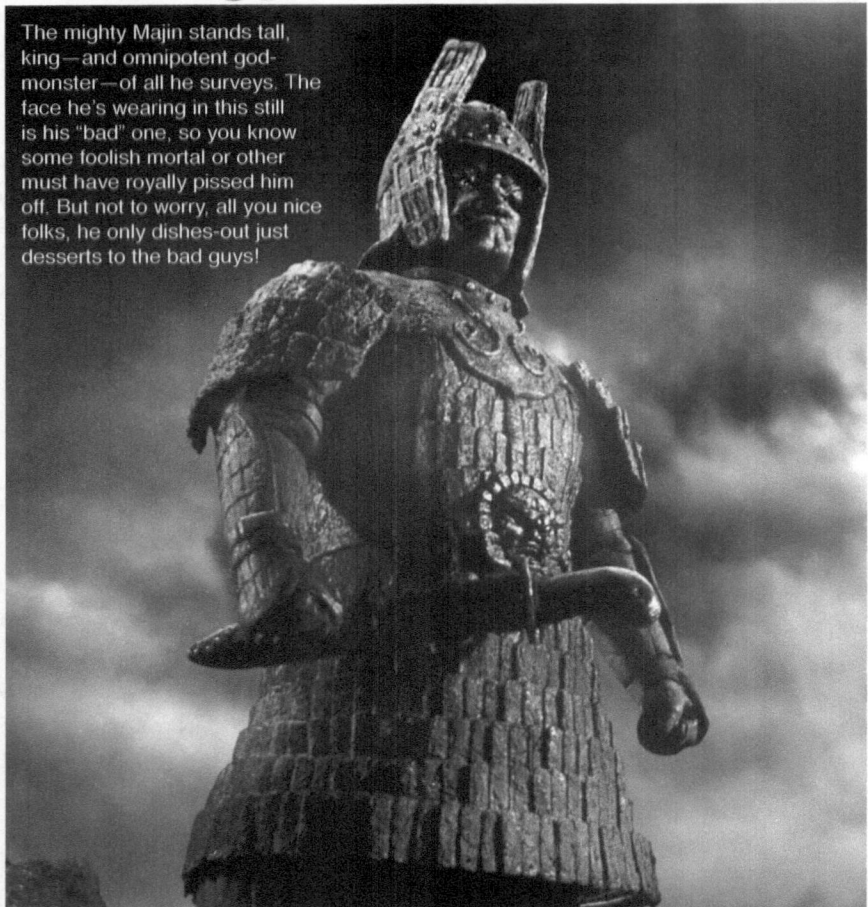

The mighty Majin stands tall, king—and omnipotent god-monster—of all he surveys. The face he's wearing in this still is his "bad" one, so you know some foolish mortal or other must have royally pissed him off. But not to worry, all you nice folks, he only dishes-out just desserts to the bad guys!

The three directors involved in the present series under discussion also made their mark on Japanese and world cinema. Part I, **DAIMAJIN**, the original entry (and the best of the three), was directed by Kimiyoshi Yasuda (安田公義 / *Yasuda Kimiyoshi* [1911-1983]), who directed several of the blind master-swordsman Zatoichi's (座頭市 / *Zatōichi*) adventures, as well as some episodes of the spinoff mid/late '70s TV series (which, like the movies, all starred the great Shintarō Katsu [1931-1997] in the title role), as well as the aforementioned **JOURNEY WITH GHOST ALONG YOKAIDO ROAD**, among numerous others. Part II, **RETURN OF DAIMAJIN** was directed by Kenji Misumi (三隅 研次 / *Misumi Kenji* [1921-1975]), who made his mark with films in both the *Zatōichi* and *Lone Wolf and Cub* (子連れ狼 / *Kozure ōkami*) series (starring "Zatōichi" star Katsu's real-life big brother Tomisaburō Wakayama [1929-1992] as *katana*-slashing killing machine/one-man army Itto Ogami; latter including being posthumously credited as co-director on the samurai splatter classic **SHOGUN ASSASSIN** (1980, Japan/USA, D: Robert Houston, Kenji Misumi), Roger Corman/New World Pictures' anglicized export "splice-job" (i.e., shortened reedit) of the first two films in the *Lone Wolf* sextet. The third Majin film, **WRATH OF DAIMAJIN** (whose original Japanese title given off the top above literally translates to "Angry Daimajin") had in its director's chair Kazuo Mori (森一生 / *Mori Kazuo* [1911-1989]), who is also noted for directing some of the films in the long-running and immensely popular *Zatoichi*

series. The *Daimajin*s' wonderful special effects were coordinated by Yoshiyuki Kuroda; a brilliant mix of live-action and miniatures, combined with the sadly-underused if superior effect of the rampaging "full-sized" giant Majin figure (actually a man in a rubber suit, needless to say!). Following this final series entry, Kuroda would go on to direct **YOKAI MONSTERS: SPOOK WARFARE** and co-direct **JOURNEY WITH GHOST ALONG YOKAIDO ROAD**, among others.

The prolific Daiei Film Co. Ltd (大映映画株式會社 / *Daiei eiga kabushiki geisha*, founded in 1942]) was the company that produced and distributed the three *Majin* films, leasing the rights for the first two movies to American International Television (AIP-TV) in the later part of the 'Sixties (aired as, respectively, **MAJIN, THE MONSTER OF TERROR** and **THE RETURN OF GIANT MAJIN**). For whatever reason, it appears that the third entry was never neither sold to nor distributed by AIP-TV. Entry #1, **DAIMAJIN** had only a very, very limited theatrical release in North America (by distributor Bernard Lewis in 1968). The Daiei studio had introduced the *daikaiju* Gamera (ガメラ), the flying superturtle, who started out as a bad guy and later became a heroic character, in their 1965 film **GAMERA: THE GIANT MONSTER** (大怪獣ガメラ / *Daikaiju Gamera*, 1965, Japan, D: Noriaski Yuasa), a move aimed at competing with Toho's successful *Gojira* (ゴジラ) / *Godzilla* franchise. While *Gamera* developed into a lastingly profitable franchise, the *Daimajin* series—whether initially planned that way or not—ceased after the third film (although belated reboots of the series were announced over the intervening decades from time to time, including back around the late '80s/early '90s in such Japan-fan magazines as August Ragone's slick glossy *Markalite*). Made back-to-back in 1968, Daiei would also produce the three *Yokai Monsters* films cited above, much in the manner/style of their *Daimajin* films (the *YM* triptych's third entry **JOURNEY WITH GHOST ALONG YOKAIDO ROAD** was released in March 1969). Daiei ceased production in 1971, and their assets were purchased outright in 2002 by the company Kadokawa Pictures (part of the mega-conglomerate Kadokawa Shoten [角川書店], founded in 1945 by Genyoshi Kadokawa); who, in 2010, produced *Daimajin Kanon* (大魔神カノン), a series for Japanese television that retells the story of Daimajin in a modern, up-to-date setting, complete with a more streamlined/modernized Majin design (whose ripped "new millennial" physique even includes a pronounced six-pack [talk about rock-hard abs!]) and—*of course!*—ample CGI FX ties things all together. It ran a full 26 episodes, ceasing production by 2011.

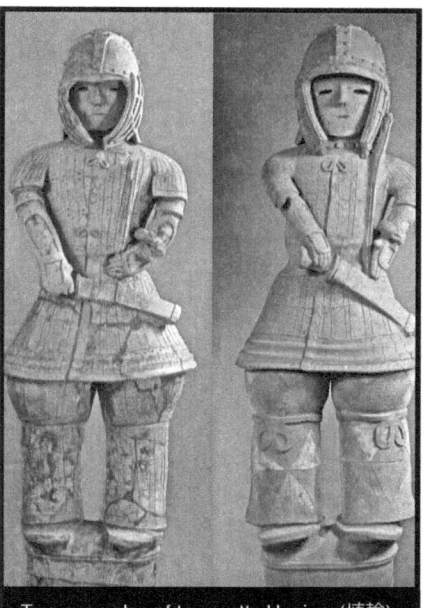

Two examples of terracotta Haniwa (埴輪) warrior figures, from Japan's Kofun Period (3rd to 6th centuries CE). Note the facial resemblance to Majin as he appears whilst in his benign Shino mode, and also the familiar "skirted/baggy-pants" *keikō*-style armor he wears in the films in both his "mood" modes

US ad for the first *Daimajin* entry, as aired on Michigan's station WXYZ-TV (from the February 26th-March 3rd, 1972 issue of *TV Guide* [Detroit Edition])

Shino, Majin's "good" face; as depicted in the foldout/wraparound sleeve of a *Daimajin* "sonorama": a 7" record/read-along storybook combo of a format that was a highly popular form of audio media with kids in Japan during the '60s, '70s and '80s (see also following two pages; artist unknown). The five pieces of art reproduced here are all from the sonorama that was released as a tie-in with the last of the trilogy, **WRATH OF DAIMAJIN**

Before you continue on to my individual reviews of the trilogy and weigh your considerations towards potentially purchasing and viewing the *Daimajin*s in the future *[Do it! They're all available in pristine condition on Blu-ray, and you won't regret it!* ☺ *– eds.]*, first a word of advice from an American viewer/reviewer, being that these films were made in Japan, where their way of filmmaking is vastly different from the rest of the world's cinema. These films are especially layered differently in that the Monster/God (actually two opposing gods in one body) is by turns both a passively benevolent and malevolently vindictive deity, who, while seemingly royally pissed at *everyone* once he puts his "angry" face on and lets the rage out, heroically helps the oppressed feudal peasantry to break their bonds of poverty, starvation and oppression from the exploitative, tax-hungry Shogunate. This as opposed to your more standard, common-and-garden-variety monster in Western sci-fi films of the '50s onwards (e.g., the killer cucumber alien in Roger Corman's **IT CONQUERED THE WORLD** [1956, USA] etc., etc., etc. *et al*), which typically were monstrous creatures who were also equally vindictive (often highly so, and non-stop!); but, as opposed to taking time out to avenge societal injustices done to us poor, put-open common folk, were instead planning on achieving some form of world domination—or even just having us for *lunch*! (case in point the classic *Twilight Zone* episode, "To Serve Man")—and for the most part showed no signs of concern or compassion whatsoever towards the comparatively puny species called Man (although exceptions do occur, of course). Contrarily, Majin is a god-monster whose entire focus is on the well-being/wrongdoing of humankind…and woe betide those of us who get on his bad side!

I should perhaps mention that the succession of characters in the *Daimajin* films are not properly introduced, so you must wait for the participants to be addressed by their given names before you can associate a face with a name. One last

thing of note is the beautifully spiritual belief in a higher power which these films present to the viewer. To be able to summon a god when the chains of oppression are at their heaviest would be a great salvation indeed to the oppressed. The use of prayer and the theme of righteous folk getting their revenge against their tormentors thus is a fantasy that evokes the spiritual beauty in our hearts, of the belief in a god (be it *any* god), who governs our wellbeing. The three films are heavy with religious symbolism, intermixing aspects of the Bible along with one of the longest-enduring of Japan's religions, the paganistic/animistic form known as Shinto (神道 / *Shintō*), which means "way of the gods" (it is also known as 神の道 / *kami-no-michi*, meaning "way of the Kami"; which means much the same thing). Shintoism is an ancient Japanese religion, and does not have any written point of reference, such as its own version of the Christian bible or other scriptures, but instead is more of a folkloric-based narrative, passed down through the ages from generation to generation by word of mouth. The Shinto gods are known as Kami, and these gods are spirits who are said to inhabit both animate and inanimate objects and control all the various aspects of everyday life, including such things as the elements/weather (including wind, rain and snow), mountains, and other features besides, ranging from the greatest right on down to the littlest things. One last thing: the **DAIMAJIN** character is called "Majin", the short form of its more formal name, in the subtitled VHS releases I used for this article (he was also referred to as such in the English-dubbed versions, done by some familiar voice actors from spaghetti westerns), so the angry—and, conversely, in his Shino mode, occasionally quite cheerful (if much more boring!)—god shall be addressed likewise as Majin in my reviews. And speaking of names, amusingly enough, in the German release titles of

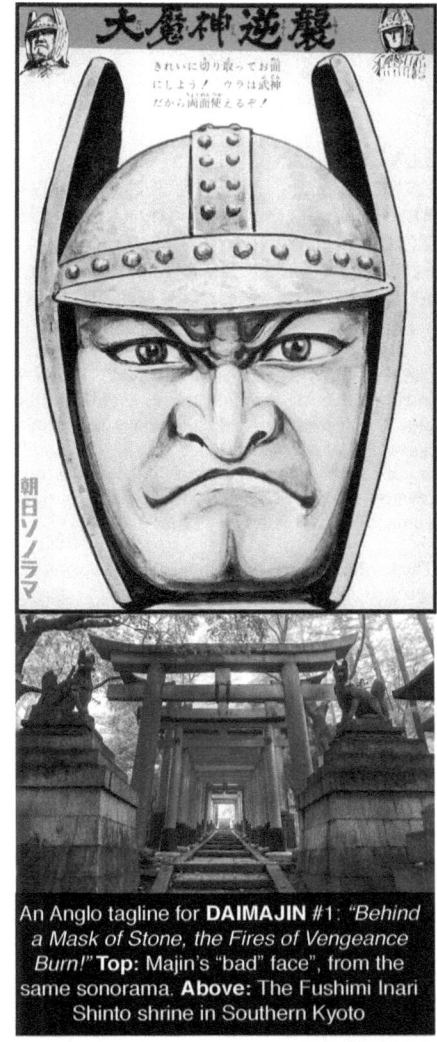

An Anglo tagline for **DAIMAJIN** #1: *"Behind a Mask of Stone, the Fires of Vengeance Burn!"* **Top:** Majin's "bad" face, from the same sonorama. **Above:** The Fushimi Inari Shinto shrine in Southern Kyoto

all three *Daimajin*s, the titular titan was renamed "Frankenstein's Monster", of all things! On that note, on to the review section…

#1:
DAIMAJIN
(大魔神, a.k.a. MAJIN; THE GIANT MAJIN; MAJIN, THE MONSTER OF TERROR; MAJIN, THE STONE SAMURAI; MAJIN THE HIDEOUS IDOL; FURY OF MOUNTAIN GOD)
Japan, 1966. D: Kimiyoshi Yasuda

(*ATTENTION: SPOILER ALERT!* The following three paragraphs reveal details of the plot which prospective first-time viewers might not wish to know about beforehand. Other spoilers are to be found elsewhere in the other two reviews too, so proceed with caution. Consider yourself forewarned!)

The earth shakes, as if from an earthquake, as the spirit of the angry god Majin—which is sealed away in rock amidst mountainous Okamidoni near Wolf's Canyon, kept in constant check by the good samurai god Shino (evidently derived from the word Shinto?)—is attempting to break free of its mountain… Thus begins the first *Daimajin* movie in fine style. Local villagers rush to their Shinto shrine to offer a sacrifice in hopes of appeasing the awakening angry god, led in the ceremony by Shinobu, the Shrine Maiden ([Otome Tsukimiya] see Endnote at the foot of this article]), high priestess of the Shino worshippers. During the ceremony, the good Lord Tadakiyo Hanabusa (Ryūzō Shimada), who rules over the small village, has his home and village attacked by a warring clan led by Lord Samanosuke (Ryūtarō Gomi), and his inside man, the brutishly sadistic, treacherous turncoat Gunjurō (Tatsuo Endō), a former drifter who was made Chamberlain by Lord Hanabusa before betraying him to Samanosuke. A fierce sword battle ensues, during which Kogenta (Jun Fujimaki), a youthful loyal vassal of Lord Hanabusa, spirits the Lord's young son Tadafumi (spunkily played by child actor Hideki Ninomiya) and even younger daughter Kozasa (child actress Masako Morishita) away from the nightmarish scene, led by Shinobu, the old, black-toothed Shrine Maiden, into the forbidden mountain area, where stands a huge stone idol erected to the kind and just mountain deity Shino, behind whose benign façade his evil counterpart Majin is kept imprisoned. Ten years pass, and the two children grow into young adults.

Since leaving it a decade earlier, now into early adulthood Tadafumi and Kozasa (adult players Yoshihiko Aoyama and Miwa Takada here take over their kiddie counterparts' respective roles) learn that their home village has become progressively worse under the rule of Samanosuke, who has forced the menfolk into toiling as around-the-clock slave labor, in his quest to have a mighty fortress erected, so he can continue to expand his area-wide domination ("You cannot defy our Lord!" exclaims one underling). Thus far, the ambitious Samanosuke has either overthrown or aligned himself with all the other powerful clans, but seeks to extend his power in the region using military force. When Kogenta, who has come down from the mountain to visit the village looking for any other surviving vassals of Lord Hanabusa who may have escaped the evil tyranny of Samanosuke, he is captured by Gunjurō and his men. Hence, the young Lord Tadafumi also de-

Another double-page spread from the same *Daimajin* sonorama record depicted on the preceding two pages (artist unknown)

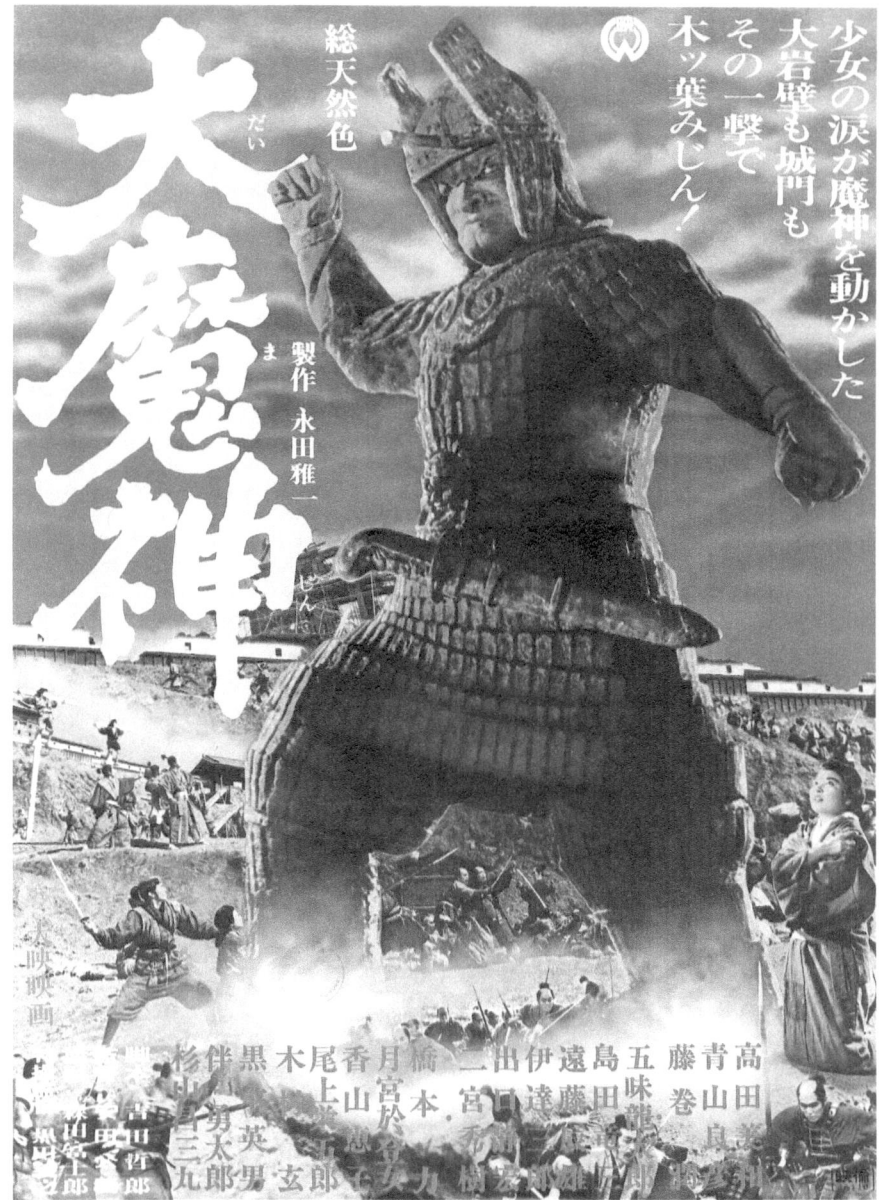

Japanese B1 poster for **DAIMAJIN** #1

cides to go into the village in an attempt to rescue Kogenta. To this end, he liberates a man (who has been suspended in the air upside-down, evidently as punishment) whom he believes to be Kogenta, only it proves not to actually be him; the whole thing merely being a trap set by the wily Gunjurō to lure the young Lord into their clutches. In a bold bid to secure Tadafumi's and Kogenta's freedom, Majin's earthly representative the shrine maiden Shinobu goes to confront Samanosuke about his evil ways, telling him, "You make people suffer to satisfy your own greed. Our God will not let you continue". Samanosuke, an arrogant disbeliever in such perceived nonsense, rebuffs Shinobu's words as simply her desperate attempt to save Lord Hanabusa's son. When Samanosuke

Top: DAIMAJIN #1's main meanie Lord Samanosuke (Ryūtarō Gomi) gets bossy with a subordinate. Not only is this nasty-arse samurai shogun a real dab hand at chopping down helpless old ladies with his snickersnee, but he throws a mean upside-down mini-Frisbee too! **Center & Above:** In the same film, Priestess Shinobu (Otome Tsukimiya)'s dying curse and Princess Kozasa (Miwa Takada)'s tears factor keyly into Majin's grand awakening

informs the priestess that curses do not exist, she counters with the cautionary proclamation "They *do* exist... I have the power to call our god!"

As local legend has it, a fierce warrior deity known as Majin is sealed within the graven image of Shino carved from the living rock of their shared sacred mountain. Samanosuke believes (more the fool him!) that, if he destroys the great stone idol, those remaining men still faithful to Lord Hanabusa will lose their morale as a result and cease being loyal to him. With that, Samanosuke jumps to his feet, pulls his sword and sacrilegiously slices Shinobu the old priestess, who cries, "God's punishment is on your head! ...Destroy the god who protects us, and the evil spirit Arakatsuma will come forth!" Ignoring her dire warnings, Samanosuke dispatches a group of his men into the sacred area up in the mountains to destroy the statue. The Princess—accompanied by a semi-orphaned young village ragamuffin named Take-bō (Shizuhiro Izoguchi), who has ascended the mountain in hopes of having a prayer answered asking the great god of the mountain to save his enslaved father—watch from concealment as the tyrant's men attempt to break apart the as-yet-still-idle idol, with nothing working until a huge, stake-like iron chisel is brought forth and, with a sledgehammer, driven deep into the statue's forehead. Alarmingly, blood pours from its wound, which causes the men to panic and flee. Even more alarming, a terrifyingly violent storm erupts and the land begins to tremble and shake. Fissures open up within it that swallow hordes of the lord's men (the deserving Gunjurō included), then slamming closed around them like giant jaws, sealing them within the earth. As the next day—that of Tadafumi's and Kogenta's execution—dawns, the frightening storm of the previous night has passed and the god now no longer stirs. Lord Hanabusa's daughter Kozasa kneels before the statue, uttering fervent prayers for it to awaken from its slumber and save her brother Tadafumi, and Kogenta too. This condemned pair are tied to crosses in the village, sentenced to be fatally pierced with spears in front of the whole village as examples intended to quell any further insurrections. All Kozasa's tears and prayers to awaken Majin amount to naught, however. That is, until she promises the god her own life as a sacrificial offering. Going to a nearby waterfall, she attempts to hurl herself into the raging torrent, only to be prevented by the brave boy Take-bō, whose selfless act of heroism finally moves and motivates the god—better late than never!—into action. A bright light streaks down from the heavens and occupies the inanimate idol. This causes it to become animated with unnatural life and movement. Its stony facial features transform into those of a glowering lumpy/green-faced, blazing-red-eyed demonic monster...the wrathful god Majin, with violent vengeance in mind! Just as the sides of the two martyrs are about to be speared, a bright light is seen in the sky, its appearance putting conclusive closure on the foolish Lord Samanosuke and all his evil machinations.

Shino's idol stands silent vigil over the land at his mountaintop shrine

Religious symbolism abounds in this film. Despite its traditional samurai attire and accoutrements, the general look of the Majin figure resembles that of the mythological man-made creature from Jewish legend called a "golem', which, while still an imposing figure in its own right, is generally depicted as far smaller in stature and is only made of mud and clay, as opposed to the solid stone of which the much-more-towering Majin is composed (he is a *daikaiju* take on the ordinarily more man-sized mud monster, after all).

The character of the Golem (/ˈɡoʊləm/ *goh-ləm*; Hebrew: גולם) comes from a Jewish/Yiddish parable that has been verbally passed down for centuries, with many different storylines involving the unnatural creature being told. The silent German Expressionist cinema classic **THE GOLEM: HOW HE CAME INTO THE WORLD** (*Der Golem, wie er in die Welt kam*, 1920), from which and whose legend the *Daimajin* series borrows heavily, was directed by Paul Wegener and Carl Boese, scripted by Wegener and Henrik Galeen from the novel *Der Golem* (1913-14), written by Austrian novelist/dramatist Gustav Meyer (née Meyrink [1869-1932]). **THE GOLEM** was the third film made by Wegener that prominently featured the legend; the two previous ones being **THE GOLEM** (*Der Golem*, a.k.a. **THE MONSTER OF FATE**, 1915, Germany, D: Henrik Galeen, Paul Wegener), which is now only extant in incomplete form, and the parodic/comedic short subject **THE GOLEM AND THE DANCING GIRL** (*Der Golem und die Tanzerin*, Germany, 1917, D: Rochus Gliese, Paul Wegener). Wegener himself played the man of clay in all three films wearing similar costumes/makeup, although in that lattermost one, he merely play-acted as a monster to fool his unrequited lady love.

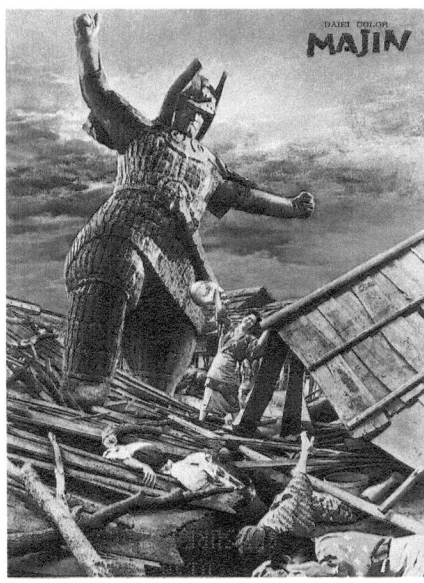

In **DAIMAJIN** #1, our antsy antihero of living stone really trashes the joint; Japanese lobby card

A quartet of screen captures from Paul Wegener's silent-era German expressionist classic, **THE GOLEM** (1920). The second image from the top shows Albert Steinrück as the clay creature's mortal maker, the cabbalist dabbler Rabbi Loew. The image directly above depicts Astaroth, the evil spirit which inhabits/possesses the man-made monster

The '20 version of **THE GOLEM**—the version which by far gained the most exposure outside its country of origin—had its world premiere in Germany the year it was made, and (as per the IMDb) had its Japanese premiere in 1923.

Interestingly enough, both the stories of **THE GOLEM** and **DAIMAJIN** possess highly similar basic themes and plot devices. The 1920 version of the golem legend revolves around one Rabbi Loew, a Kabbalist who, through astrology, foretells that, if not somehow averted, a disastrous destiny is due to befall the Jews. That foretold disaster looming large on the horizon comes care of the Holy Roman Emperor, who issues a decree for all Jewish people to leave the city of Prague, this no later than by the new moon. To prevent this catastrophic banishment of his people, after first praying to their God, to help protect his people Rabbi Loew creates an anthropomorphic monster out of dirt and clay and brings it to life using mystical magick. This golem is then brought by the Rabbi to a grand party which the Emperor is throwing, to which (shades of Nostradamus/Cagliostro) Loew is invited because he possesses the power to predict coming events and reads the Emperor's horoscope. A love triangle between three young people is the reason why the golem eventually turns to evil, when Astaroth, the Great Duke of Hell, influences the synthetic man-monster to wreak havoc within the Jewish ghetto it has been sworn to defend. Having gone rogue, the golem must eventually be destroyed and, when this is accomplished, he crumbles away into a mound of dried mud afterwards; whereas Majin's statue, its mission accomplished in spades, is similarly reduced to dusty debris at the finish of the first film. Like the golem, its statue is nothing more than an empty vessel, which only becomes filled with a sense of purpose when it awakens to come to the people's defense by taking the offensive against those who have cruelly mistreated them. When, in **DAIMAJIN**, the villains' attempted blasphemous destruction of the statue occurs at the lord's express behest, the evil spirit of the demon Arakatsuma manifests itself within it (much as does the demonic spirit Astaroth inside the golem), thus converting it over to "the dark side".

The film is a mystically beautiful mood-piece on the influence of the ancient gods upon mankind; gods who kept the history of men grounded under their mythic gaze. **DAIMAJIN**'s special effects, as with the second Majin entry directed by the legendary Yoshiyuki Kuroda, are magnificently rendered—smoothly integrating such components as miniature puppets and even a full-size

Majin mock-up capable of limited "animatronic" movement (such as raising its arm and swiveling its head)—and the optical intermeshing of the massive Majin with the normal-sized human cast is wonderfully advanced for the time; positively *flawless* even, for the most part, other than for the occasional matte-line being visible in some composite shots. Acting is across-the-board excellent, and the portrayals by all are spot-on, with the villainy of Samanosuke (whose player Ryūtarō Gomi at times evokes a combination of frequent *chanbara* genre adversaries Toshirō Mifune and Tatsuya Nakadai in terms of sullen intensity) kept restrained and not over-the-top, providing great contrast to the virginal beauty and moral purity of the young princess. All these ingredients endow the film with the vastness of scope within which to fully address its simple (if not necessarily simplistic) parable of Good versus Evil. I'm convinced that the filmmakers consciously incorporated various aspects of Shinto and Christian religion, as well as Jewish parables, into their scenario, and this cross-cultural blending of themes makes it all the more enjoyable, in addition to making things more understandable/relatable from a non-Japanese (i.e., more universal) viewpoint. While death by crucifixion has been part of many cultures/religions for thousands of years, the Crucifixion of Jesus Christ is the most well-known example of this slow form of execution, and at one point their villainous executioner Samanosuke remarks to the young Lord Tadafumi and his valiant vassal Kogenta, as they hang upon crosses and are about to be pierced through with spears, about why it is that no one has come to save them. Where is their god and Tadafumi's vassals as their time on Earth comes close to expiring? The parallels drawn between their plight and that of Christ are obvious here, and the scene is reflective of those Romans who walked by Jesus while he was nailed dying on the cross, asking him why "He saved others, but can't save himself!" (Mark 15:31). This mocking of His son was a way of also mocking God Himself; thus Samanosuke (who in the Anglo-dubbed export print proudly proclaims, "I am *not* a superstitious man" to the priestess Shinobu before coldly cutting her down with his sword), besides treating any and all gods in general with the utmost contempt throughout all his evil deeds, mocks the mere idea of such an omnipotent entity even existing right up until his dying breath (at least he's consistent in his disbelief, if nothing else…even when the clear proof he's oh-so-very-*wrong* is staring him right in the face!).

Also, the moment when Kozasa the plucky princess courageously reveals she is prepared to give up her own life for her people's sake directly reflects the passage in the Bible which reads, "Greater love hath no man than this, that a man lays down his life for

These above four shots neatly illustrate some interesting textual/textural commonalities shared by both *der golem* and *daimajin*. That former monster of clay was played thrice on film by German actor/filmmaker Paul Wegener, while the latter was played in all three Majin movies by actor/stuntman and all-round action cinema badass Chikara "Riki" Hashimoto. As sword-slinging samurai Mr. Suzuki, Hashimoto-*san* once squared-off against no less than Bruce Lee himself in **THE CHINESE CONNECTION** (精武門 / *Jing wu men*, a.k.a. **FIST OF FURY**, 1972)

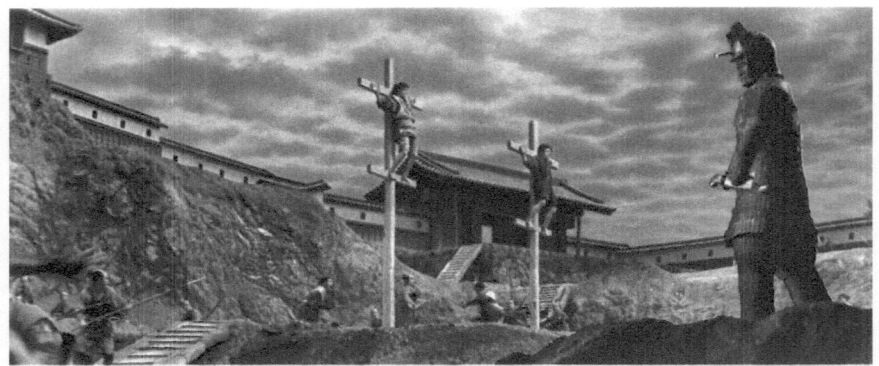

In this nifty panoramic optical composite shot from **DAIMAJIN**, youthful heroes Tadafumi (Yoshihiko Aoyama) and Kogenta (Jun Fujimaki) face crucifixion—albeit only *tied* to their crosses rather than actually nailed to them—as Majin (Riki Hashimoto) ominously strides into the frame from stage left...

his friends" (John 15:13. KJV). Another note on the film, this one more technical/historical in nature: during the initial siege and hostile take-over by Samanosuke and his goons at the start of **DAIMAJIN**, only blades are shown used as weapons. We then fast-forward just ten years, by which time guns have since been introduced into the volatile mix. This development would seem to place the film's timeframe at somewhere around a post-1543 date, as that was when gun-powder-charged firearms were first introduced into Japan, whereafter their manufacture and usage spread at a fevered clip, in the process totally reinventing the samurai's Bushido code of chivalry by gradually eclipsing it with the Way of the Gun. (Incidentally, set roughly 300 years later [circa 1860] during the Tokugawa Dynasty, in Akira Kurosawa's **YOJIMBO** [用心棒 / *Yōjinbō*, a.k.a. **THE BODYGUARD**, 1961]—which, famously, provided the basis for Sergio Leone's

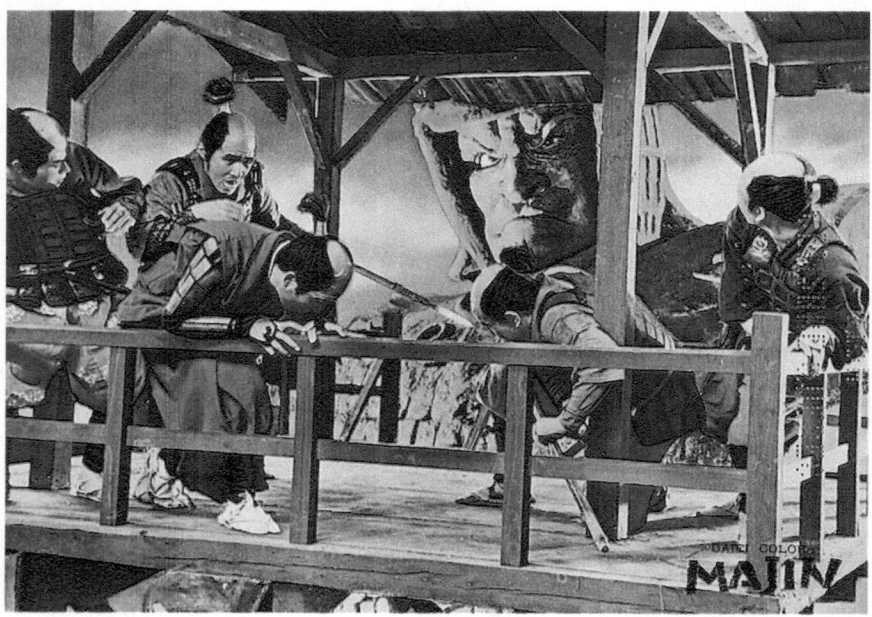

The marauding Majinator gives the slimy Samanosuke's watchtower sentries the double-evil eye, before trashing their perch right out from under them. (Incidentally, albeit not using the same actual footage, a virtually identical scene as seen here was replayed in the first sequel, **RETURN OF DAIMAJIN**)

A FISTFUL OF DOLLARS [*Per un pugno di dollari*, 1964, Italy/Spain]—the above-noted Tatsuya Nakadai, played Unosuke, an unorthodox, dirty-fighting young upstart samurai who disrespectfully/dishonorably brings a gun to swordfights in the form of an American-made five-shot cavalry revolver, much to his more "old school" nemesis Toshirō Mifune's disgust!)

At the end of the present film, amid the rubble of the collapsed fort, lies some broken chains with which Samanosuke's warriors had attempted to bind and restrain Majin. However, these were broken, left shattered into pieces…just as the cruel oppression the village was suffering under was smashed by the savage intervention/retribution of Majin, the striding, stomping stone avenger!

#2:
RETURN OF DAIMAJIN
(大魔神 怒る / *Daimajin ikaru*, a.k.a. **THE RETURN OF GIANT MAJIN; THE GREAT DEVIL GROWS ANGRY**)
Japan, 1966. D: Kenji Misumi

The second film in the *Daimajin* trilogy is a bit of a step down in quality from the first film, but it's still an exciting, thought-provoking—albeit obvious thinly-veiled reworking—of the originating series entry regardless. Part II once again revolves around the activities of a power-hungry, land-grabbing warlord, this time named Lord Danjō Mikoshiba (Takashi Kanda), who invades the lands of adjoining clans and oppresses their people, using violence, intimidation and much bloodshed to attain his avaricious goals. Mikoshiba is assisted by his equally villainous confidant General Genba Onikojima (Jutaro Kitashirō/"Hō-jō"). The graven image of Shino/Majin which serves as ever-vigilant sentinel over the region tries to forewarn the clansmen of Nagoshi about Mikoshiba's aims of overthrowing them by turning its stone face red (symbolizing blood and fire), which legend suggest indicates impending doom, and that the domain shall soon fall via some cataclysmic event. The Nagoshi Clan are too late to act, as their allies the Chigusas' village gets lit-up amid a lopsided battle against Lord Mikoshiba's invading forces. When Lord Juro (Kōjirō Hongō) of Chigusa escapes the slaughter, Mikoshiba believes he has escaped to Nagoshi, so attacks their village too, killing the Lord of Nagoshi and imprisoning his son Lord Katsushige (Kōichi Uenoyama), with a promise of death to him if the missing Lord Juro is not handed over. Lady Sayuri (Shiho Fujimura) of the Nagoshis, who is to marry Juro, goes to the island whereon stands Majin to pray to the statue of the samurai warrior for aid. While she is there, Lord Mikoshiba's men arrive and use explosives to blow-up the silently standing stone god; a destructive act which sends the shattered pieces hurtling through the air all about the area, its severed head falling and sinking into the lake.

Besides all this excitement, the plot offers up many narrow escapes and ominous threats about the forever-present vengeful god, which is actually *two* gods in one, both coexisting in the same body; each being, in essence, Jekyll/Hyde-like alter-egos of one another. Much bloodshed and misery initially go unacted-upon by Shino (the god's "Jekyll" side). Until, that is, the virtuous Lady Sayuri motivates the god(s) into action with her selfless plea that the lives of others should be spared and hers taken in their place. This act of self-sacrificial offering is the motivation

Just desserts seldom go down sweetly, and Samanosuke's give him a really acute case of—*uh*—heartburn

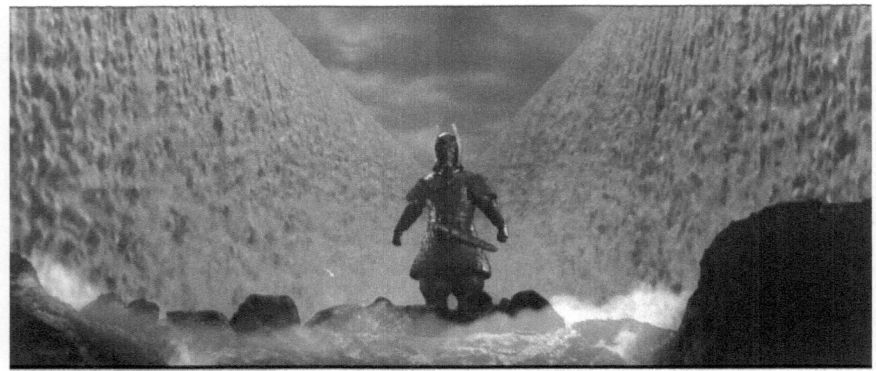
Majin makes like Moses in series entry #2, **RETURN OF DAIMAJIN**

that—once again, as in the first film—awakens the deadly Majin (the god's "Hyde" side). After emerging from the lake, now fully whole and at maximum power again, the wrathful avenger lumbers off on his unswerving path towards squelching Mikoshiba's evil tyranny.

As I said above, this first sequel is basically a reworking of the plot of the founding film and, while not nearly so flawlessly put together as the first one, is nonetheless still a superior effort that holds the attention and mixes in enough swordplay, violence and heavy-footed/fisted monster action to keep the viewer entertained. The actors are all outstanding, especially Shiho Fujimura as Lady Sayuri, who demurely blends such qualities as naivety, devout faith and understated complexity in a commandingly affecting performance. **RETURN OF DAIMAJIN**, like its predecessor from earlier that same year, stresses the power of prayer, again prominently displaying the cross (albeit in a mostly only symbolic/ambiguous Christian context), and offers up yet another attempted crucifixion; the crucified subject this time being the heroine Lady Sayuri, clad in her simple white kimono (shades of Joan of Arc at the stake?). Perhaps inevitably, the striking visual of Sayuri upon the cross conjured the mental image of the crucified Jesus in his white robe to my mind. **ROD** also incorporates still another aspect from the Bible, in the scene that has the Majin, in his implacable quest for vengeance and justice (one in the same thing?), parting the waters of the lake, much as Moses did the Red Sea (a sequence shown to great effect in legendary producer/director Cecil B. DeMille's splashy Hollywood biblical epic **THE TEN COMMANDMENTS** [1956]).

SEE THE HORROR OF A VILLAGE CRUSHED BY THE REVENGE OF HELL
Anglo export poster hype for **DAIMAJIN**

#3:
WRATH OF DAIMAJIN
(大魔神 逆襲 / *Daimajin gyakushū*, a.k.a. **MAJIN STRIKES AGAIN; GREAT MAJIN'S COUNTERATTACK**)
Japan, 1966. D: Kazuo Mori

With its formulaic repetition of the former films' well-established "Good versus Evil" melodramatic structure, it would be difficult to replicate the successful formula of the first pair for a third time running while managing to keep things fresh and original. Unfortunately, this the final film in the trilogy, released a mere seven months after the first, could not pull itself out from under the looming shadow of greatness cast over it by the first two entries. **WRATH OF DAIMAJIN** reuses much the same "oppressed peasantry" scenario as before, only this time out the harried menfolk of an exploited community are being forced into servitude to build a fort for the vicious Lord Arakawa at a volcanic hot spring where he uses the sulfur from it to make ammunition (as before, in the depictions of firearms and explosives seen in the first two *Daimajin* films, the inexorable advance of technology for the purposes of waging war seems almost as unstoppable as the mighty Majin himself). While the original used more of a rotating-character storyline, which gradually developed/fleshed-out its characters, **WOD** introduces four young heroes, who set out *en masse* on a valiant trek to cross the sacred lands—Majin's domain—for the purpose of conveying the news to the demoralized slave-laborers that their only avenue of escape lies through the stone god's haunted mountain.

This time around, unlike in **DAIMAJIN** and **RETURN OF DAIMAJIN**, Part III not only

exhibits substantially less flawless production qualities, but a less clearly-delineated setup besides, as the simmering/festering animosity for the evil overlord Arkawa (Toru Abe) is never properly built-up, and the youthful heroes, while all decent enough in their portrayals, never give the drama the emotional bond that made the first two entries such emotionally moving experiences. The power of prayer is still a prime motivator here, but the oppressed peasants are never given much screen-time, and therefore, as a consequence, in return we can't feel as sympathetically for them as we do for the victims of tyranny in the previous pair of superior entries, whose plights are better expressed. The main issue with this film for me was all the attention shown to the overlong/drawn-out journey of our quartet of youthful heroes, which detracts somewhat from the overall scope of the narrative. Also, the pacing in **WOD** is *slo-o-ow* and, while a real beaut to look at, the film just takes too long to get to the good parts, leaving the viewer completely detached from the action at times. The ending to this the series' swansong, like the others, is a rewarding quest for retribution and liberation. However, this one packs less of a punch, though, as it never gives the audience sufficient acts of treachery and evildoings from the Lord Arakawa for us to invest our empathy in his enslaved victims, who just don't appear quite oppressed *enough*. While **DAIMAJIN** and **RETURN OF DAIMAJIN** are definitely movies made for adults, what with all their religious implications, fierce swordplay and other violence, this series ender was ratcheted-down a few notches, and was obviously aimed more at the youth matinee crowd of its day.

While the fact that these films were made and released in such a mind-bogglingly fast fashion is simply amazing, it must be said that the basic plot device used in the first two was again repeated with slight variations to lesser effect in the third. So, while **WOD** still makes for a very worthwhile watch—which really amps-up the *FUN* quotient in its grand finale—the viewing of the whole trilogy in close succession leaves a bit to be desired, simply because of some of the repetition involved, which as a result becomes all the more apparent when the films are watched end-to-end one after the other.

All three *Daimajin*s toss-around such general themes as the oppression of people by a tyrannical aristocratic warmonger who is building a fort and/or conquering neighboring villages so he can expand his evil domain. In all three films, the plentiful use of prayer and the shedding of tears,

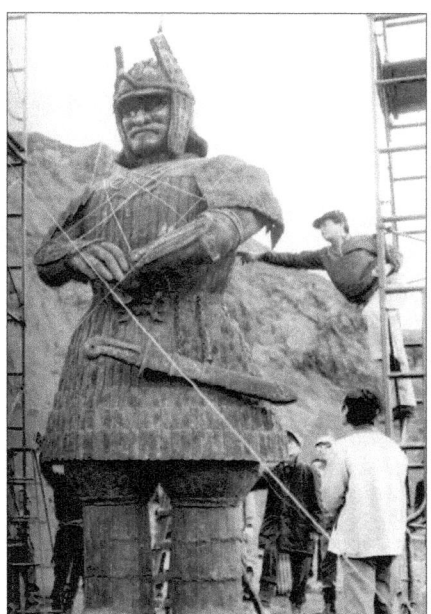

Behind-the-scenes on the **DAIMAJIN** set. **Top:** FX technicians attend to the full-sized poseable Majin figure, which had limited movement capabilities. **Above:** *Nose Goblin?* Leading lady Miwa Takada goofs around with part of her unhuman co-star

and unselfish, heartfelt displays of self-sacrifice all do their parts to help eventually motivate the dormant and initially seemingly indifferently aloof "rock god" (of a decidedly *different* kind!) into awaking from its dormancy and seeking vengeance (make that "poetic justice"!) for those in need of his salvation. The point is repeatedly stressed in the films of Majin being an angry god, who unleashes such unnaturally-generated natural phenomena as earthquakes, ava-

lanches, blizzards and violent thunderstorms during his all-too-infrequent moments of unchained wrath. Usages of religious imagery are heavily applied throughout the first two films, but not as prominent in the third entry. The use of devotional prayer towards a god is prevalent in all three films, while the renouncement of the god by the main power-hungry, warring lord is the main motivation behind all three *Daimajin*s' narratives. After much bloodshed and oppression, the protagonists' plaintive prayers are finally answered, and if anyone in their lives has ever had dreams of godly release and redemption from all their worldly tribulations, then this film series is a wish-fulfilment fantasy of deep-seated religious proportions come true!

To summarize, other qualities which all three Majin films have in common are excellent performances, well-paced direction and eloquent cinematography, plus solid-if-oft-overly-repetitious scripts. The acting really is *fantastic*—most especially that of the villainous warlords in each flick, whose parts are all ideally cast—who are never turned into over-the-top caricatures. The evocative scores for all three *Daimajin*s were composed by the legendary Akira Ifukube, of *Godzilla* series fame. Each score is a thrilling musical excursion that goes from a simple opening theme of restrained, classical orchestration to the crashing crescendos of thunderous drums and angry, blaring horns that accompany Majin in his violently cathartic climactic suppression of the people's oppressors. The third film's score really scales the summit in terms of aural quality, with the wild horns that blow at times making for masterful accompaniments to the more playful yet still somber mood of **WRATH OF DAIMAJIN**, the series' most kid-friendly instalment. Considering the more juvenile-slanted direction the trilogy ultimately took herein—evidently in hopes of broadening its consumer demographics?—perhaps it was for the best that the series didn't go for fourth or fifth (etc.) entries, as to see such an originally magnificent film series dragged down into the realm of total childish slapstick foolishness would have been much too painful to witness!

Majin! Gappa!! Gamera!!! Barugon!!!!
Contemporaneous Japanese mag hyping Daiei *daikaiju* flicks

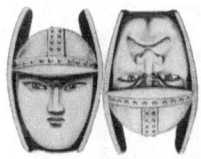

Endnote:
"The term shrine maiden (巫女 / *miko*), also called a shaman, refers specifically to altar girls of the Shinto religion. They live and work in a Shinto Shrine (a '*jinja*' in Japanese). Shrine maidens are generally virgins and take various rites of purity and chastity, and undergo various forms of physical and mental training. They also practice sealing and purification rituals, which are highly form-based and symbolic, and are used to bless, purify, or exorcise vengeful spirits" (quoted from *https://en.touhouwiki.net/wiki/Shrine_Maiden*).

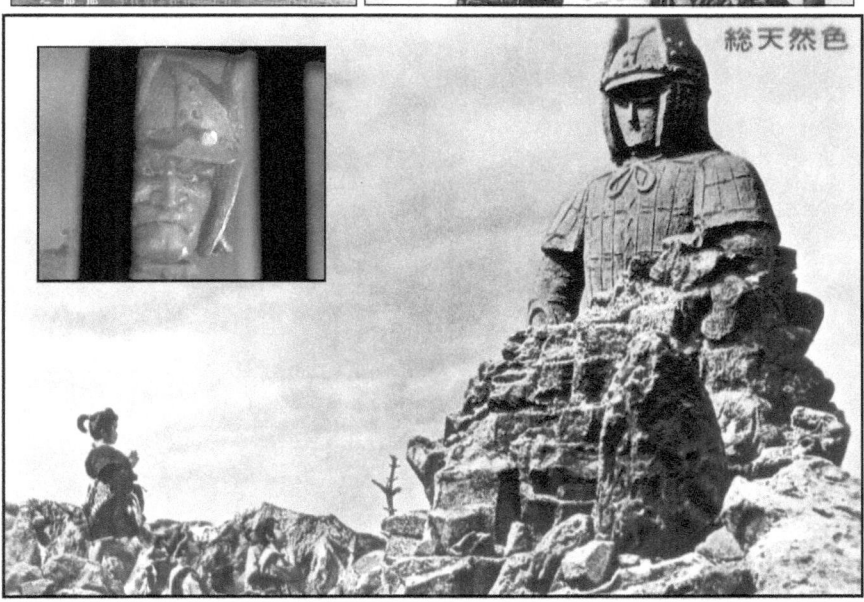

Top Left: *Abominable Snowman?* Beware the icy **WRATH OF DAIMAJIN**! **Top Right & Above:** Native tie-in magazine cover (artist unknown) and a lobby card for the same film. **Left, Center:** Japanese B2 poster for **RETURN OF DAIMAJIN**, the first sequel. **Inset:** *Here's Looking At You, Puny Mortal!* You don't EVER want Majin giving you *this* look (as he does to the bad guy in the first film)

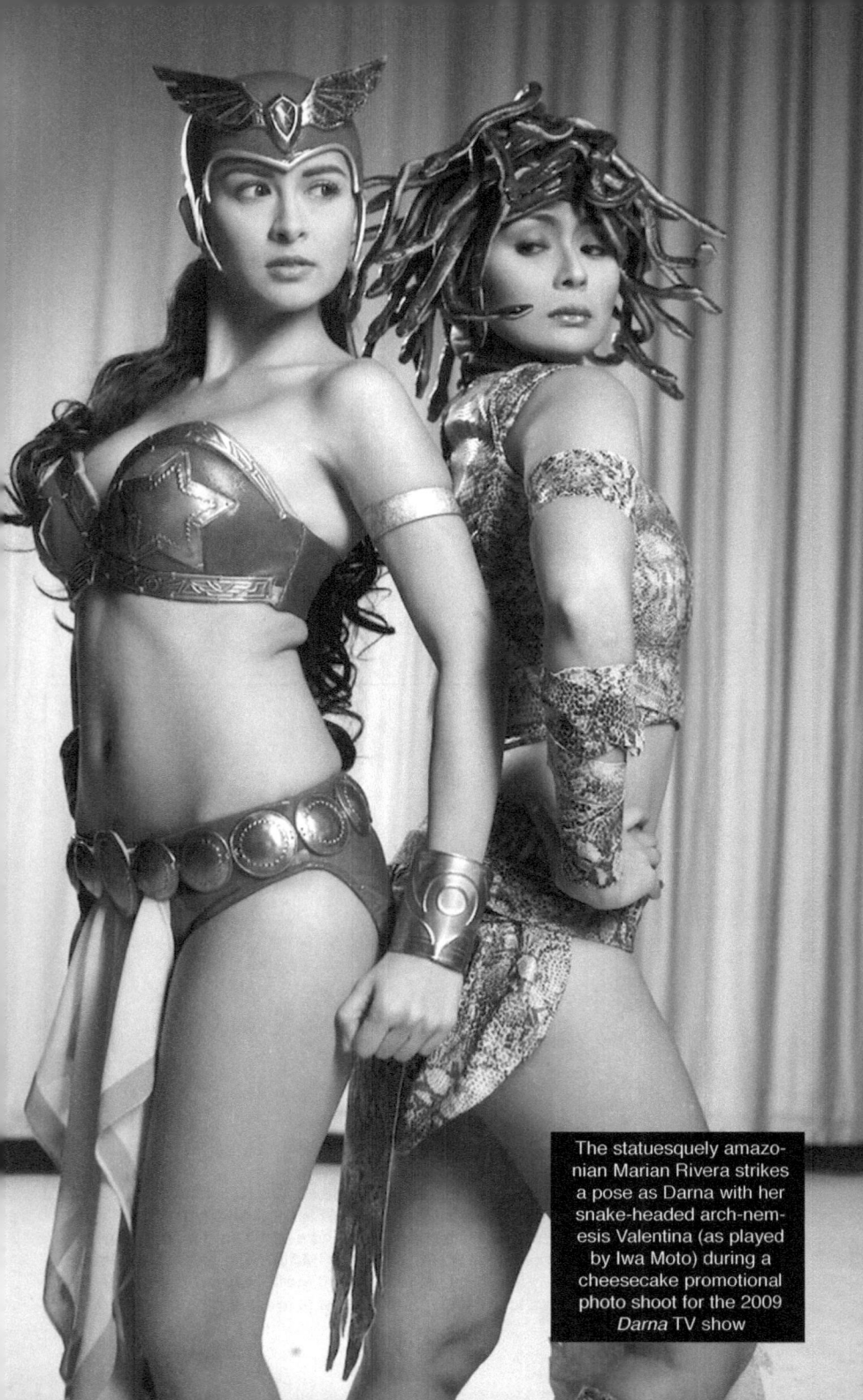

The statuesquely amazonian Marian Rivera strikes a pose as Darna with her snake-headed arch-nemesis Valentina (as played by Iwa Moto) during a cheesecake promotional photo shoot for the 2009 *Darna* TV show

[Note: A number of the rare vintage images used to illustrate this article—if by no means all of them—came courtesy of the Filipino film blogs Video 48 (@ video48.blogspot.ca) and Pelikula, ATBP (@ www. pelikulaatbp.blogspot.com). By all means give them a visit, as they both contain loads of interesting material!– eds.]

FLY, DARNA, FLY!
MARS RAVELO'S MIGHTY, SEXY SUPERHEROINE TAKES ON ALL COMERS— MONSTERS INCLUDED

by Louis Paul

Way back in Monster! *#3 (March 2014 [pp.54-56]), I wrote about a number of Hong Kong horror films. Having a new forum within which to express my ideas and criticisms, I was eager to share my interest in Asian horror and the related genres; and, while it's been a while since I last contributed to this mag* [Too long, Louis! Welcome back to the fold! ☺ – eds.]*, this time I'm writing about films which were produced roughly 1000 miles from Hong Kong—in the Philippines...*

The Philippine Islands have produced their share of monster/horror movies, most notably with the 1960s and '70s output from Eddie Romero and Gerardo de Leon (both of whom are responsible for entries in the *Blood Island* series—a crazy-quilt mixture of hardcore horror, grisly dismemberment, colorfully oozing, blood-dripping murders, and a heavy dollop of sexploitation, most often courtesy of some busty slumming American actress; you can read more about the entire *BI* series in my "Creature Feature" article back in *Monster!* #5 [pp.57-64]).

The Filipino movie industry seemed to also do well with a number of cheaply-produced exploitation and action movies in the 1970s. Besides the aforementioned Romero, who contributed SAV- AGE SISTERS (a.k.a. **EBONY IVORY AND JADE**, 1974), **SUDDEN DEATH** (1977), and many others, there was director Cirio Santiago, whose **TNT JACKSON** (1974), and **VAMPIRE HOOKERS** (a.k.a. **LADIES OF THE NIGHT**, a.k.a. **NIGHT OF THE BLOODSUCKERS**, a.k.a. **SENSUOUS VAMPIRES**, a.k.a. **TWICE BITTEN**, 1978) also employed a number of vacationing American and European actors. Hell, who could forget the Roger Corman/Jack Hill women-in-prison vehicle **THE BIG BIRD CAGE** (a.k.a. **WOMEN'S PENITENTIARY II**, 1972) and a number of Italian co-productions like Ruggero Deodato's **ULTIMO MONDO CANNIBALE** (a.k.a. **LAST CANNIBAL WORLD**, 1977) and **THE RAIDERS OF ATLANTIS** (*I predatori di Atlantide*, 1983, but it looked like it

Top: 1950 comic cover (art by Nestor Redondo). **Above:** 1999 splash-page (art by Angelo Dazo)

could have been produced a decade earlier)? When most of the international productions pulled out of the Philippines in the early '90s, a lot of locally-produced films tried to tackle the then-waning action movie landscape. Dozens of **ROAD WARRIOR** rip-offs seemed to pour out of the country, many of them landing on the shelves of local mom-and-pop video stores in the US, taking advantage of the exploding VHS market and the hunger for product, no matter the quality of the productions...case in point, some of Godfrey Ho's low-*low* budget "Ninja" series of films, which featured scenes from other movies, and managed to keep costs low by filming some quick action pick-up shots on the Philippine Islands.

What I'm writing about this issue are the *Darna* films. If you are unfamiliar with the films featuring the character of Darna and have an interest in horror, comic book action, monsters and sleaze, you are doing yourself a disservice by not exposing yourself to what is surely one of the strangest long-running series based on a comic book character (admittedly, Turkey had the sadistic *Kilink* series of movies [inspired by Italian comics], but these films have remained elusive, save for two or three that have surfaced in the last two decades).

Since Darna is quite obviously modeled on the American comic book character Wonder Woman, I thought a mention of her history is warranted. Wonder Woman was created by William Marston and first appeared in DC Comics *All Star Comics* #8 in 1941. Depicted as a heroine fighting for justice and peace—and, in later years, for sexual equality—Wonder Woman is widely considered (in retrospect) to be an early feminist icon. The characters origins present her as a warrior princess (Diana of Themyscira) who takes on the guise of homely Diana Prince. When not battling global threats in the 'Forties, then gangsters and criminals in later years, Diana's secret identity (not to mention costume) underwent many changes. The sexual equality business only reared its head in much later incarnations of the character, although the boys who grew into men (let's face it, the main reading and buying target of comic books) were more excited by the adventures that the very buxom character would get into. When the equally buxom actress Lynda Carter assumed the role of Wonder Woman in the eponymous American TV series of 1975-79, becoming an icon in the process, teenage boys and girls (but mostly teenage boys) tuned in to the weekly program. Unfortunately, the network (ABC) and the pro-

ducers were unsure of the direction of the show, which lasted three seasons. After having the series' first episodes take place in wartime 1940s, featuring all the timely cheese and slang of the era one would expect, season two inexplicably re-tooled the series to take place in then-current mid-'70s. Seemingly shot on the same three-block studio lot, the episodes became sillier as the show limped to its conclusion. Two episodes that were shot but not aired during the third season surfaced in '79, but by then no one seemed to care much.

But, back to Darna... Mars Ravelo (1916-1988) introduced the character of Darna in the 1940s comic books of the Philippines. According to Ravelo, who was inspired by Joe Shuster's *Superman* comics, the character of Darna would be a combination of Superman and his own mother. Calling Darna *Kamangha-manghang dilag* ("the amazing warrior maiden"), Ravelo drew the character as a buxom woman obviously inspired by the pin-up illustrator Alberto Vargas, who many will recognize from the appearances of his work in issues of *Playboy*. Ravelo also claimed that Darna was a tribute to his mom, who single-handedly raised him. Shopping the comic around, Darna first appeared in the pages of *Bulaklak* magazine in 1947...as Varga! (the character's physical similarity to the buxom fantasies painted by Vargas was obviously not lost on the publishers!).

Darna's costume certainly received much attention. Wearing a combination of red bikini and body suit, with gold stars on each brassiere cup, a red helmet with wings, gold bracelets, a belt topped with a flimsy loincloth and red boots with high heels, the character was drawn to adhere to male readers of the comics, the ideology of the super heroine, and Filipino culture. The gold stars were inspired by the Philippine flag, the loincloth a nod to native folklore costuming, and the rest... well, obviously inspired by Wonder Woman, and Vargas.

Darna would up and become the first female superhero in the Philippines. Essentially, Ravelo's stories centered on Narda (an inversion of the name Darna), her brother Ding, and their grandmother Lola Asay. When a falling star somehow turns into a magic amulet that young Narda wears, she magically becomes Varda. After a falling out with the publishers of the comic, Ravelo took his comic to *Pilipino Komiks* (in 1950) and returned the character back to her original name...Darna.

With more control over his creation, Ravelo hired future DC employee Nestor Redondo (1928-1995) to illustrate the comics and the character took on an even more sexually pronounced appearance. In

Top: Issue #2 of three put out by Mango Comics in 2003 (art by "Lan" Medina + Gilbert Monsanto). **Above:** Cover to the superheroine's March 3rd, 1968 issue (art by Nestor P. Redondo)

this revision of the series, a young girl named Narda swallows a magic stone (from the planet Mars or Marte, depending on which translation you may

Above: Local news ad and a fuzzy screen-shot from **DARNA AT ANG BABAING TUOD** (1965). The original Ravelo comics story of the same name was serialized in the Tagalog magazine *Liwayway Komiks*, also simultaneously appearing the same year in *Hiligaynon Magazine*, a leading weekly in Ilonggo (another of the many different native languages to be found in the Philippines). In addition to the ape-like monster shown above, the movie features co-star Gina Alonzo's villainous character Babaing (or Babaeng) Tuod, whose name can be translated as "Wood Witch"

read), transforming her into Darna. Staying inside her body, Narda can change into Darna, and then back, simply by shouting "*DARNA!*" Only Narda's brother Ding was aware of her secret, and, in later issues, her grandmother. Fighting evil and corruption, Darna's most formidable enemy was Valentina, a snake-headed demon goddess.

Darna first appeared on-screen in **DARNA** in 1951 (in black and white). Produced by Royal Films, reportedly a production house associated with the publisher of the comic book, the character was portrayed by Rosa Del Rosario (child actress Mila Nimfa played the young Narda). Del Rosario played Darna twice (also in 1952's **DARNA AT ANG BABAENG LAWIN** ["*Darna and the Hawk Woman*"]). I've not seen these two films, and I don't know anyone who has, but according to written accounts they were quite popular at the box office, even if the sexuality and the costume itself were toned-down for the primarily Catholic audiences.

It took ten years for Darna to appear on the screen again. Liza Moreno played her in two films in 1963 (also filmed in black and white). **SI DARNA AT ANG IMPAKTA** ("*Darna and the Evil Twins*") and **ISPUTNIK VS. DARNA**. Considered more atmospheric productions truer to the roots of the Ravelo character, the latter film also featured Isputnik, another Filipino superhero. Little else is known about these productions. In 1964, there was another film (this one directed by Cirio Santiago) in which Darna appeared: **DARNA AT ANG BABAING TUOD** ("*Darna and the Tree-Woman*"). Eva Montes played Darna, but, for some reason, more screen time was given to Gina Alonzo, who played the film's villainess, reportedly

Left, Top to Bottom: Gloria Romero as the sepent-tressed Babaing Impakta in **LIPAD, DARNA, LIPAD!** (1973), and a Filipino newspaper ad for same

because the studio was grooming her for stardom. Gina Pareno became Darna for 1969's **SI DARNA AT ANG PLANETMAN** (a.k.a. **DARNA AND THE PLANETMAN**), but this movie, produced by a studio that reportedly did not have the rights to the character, was more of a love story, with Darna falling in love with a mortal, who in reality was one of the Planetmen, who were the villains of the film.

Vilma Santos was one of the more well-known and fondly remembered actresses to portray Darna. The series of films in which she appeared in 1973 were box office hits in the Philippines, and also revealed many changes for the character. Darna and Narda were now both played by the same actress (Santos), Darna's costume was revised to a more sexy, revealing style (in contrast to the more modest one of the '60s films), and horrific elements appeared. **LIPAD, DARNA, LIPAD!** (*"Fly, Darna, Fly!"*, 1973) is one Darna movie I'd like to see, and hopefully soon I will be able to.

An anthology film featuring flying flesh-eaters, naked gorgons, hawk women and more...this one is sure to appear on my horizon one day.

In this issue, I will be reviewing the remainder of Vilma Santos' Darna films: **DARNA AND THE GIANTS, DARNA VS. THE PLANET WOMEN** (both 1973), and **DARNA AT DING** (*"Darna and Ding"*, 1980), plus giving equal space to two of my own guilty-pleasure Darna films, 1991's **DARNA** with Nanette Medved and **DARNA! ANG PAGBABALIK** (a.k.a. **DARNA, THE RETURN**,1994) with Anjanette Abayari. The full-bodied (Filipino-Russian) Medved and busty Abayari will set male testosterone levels all aflutter with a lot of their acrobatics and (slow-motion) bouncy running scenes. In fact, if you want to start your cinematic Darna experiences with these two films, and work your way back, I'd recommend it.

DARNA AND THE GIANTS
Philippines, 1973. D: Emmanuel H. Borlaza (also story) & Leody M. Diaz

Following her adventures in **LIPAD, DARNA, LIPAD!**, everyone's favorite scantily-clad cos-

> **Right, Top to Bottom:** Darna and Ding zoom high over Manila in **DARNA AT ANG BABAING LAWIN** (1952); Rosa Del Rosario and Cristina Aragon go at it in **DARNA** (1951); contemporaneous Pinoy newspaper ad for Cirio H. Santiago's 1965 film, starring Eva Montes as Darna

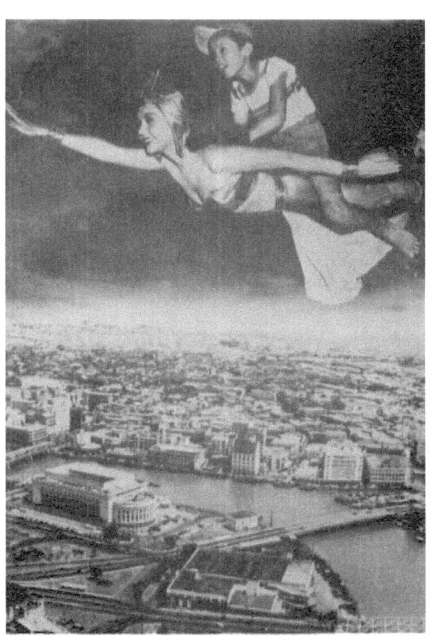

Clockwise, from Top Left: Tagalog news ad for the superheroine's 1963 outing; alternate news ad for her 1952 adventure; snake charmer Rosa Del Rosario as Darna deals with some pesky varmints; two shots of Gina Alonzo as the gnarly Impakta in **SI DARNA AT ANG IMPAKTA** (1963); and an alternate news ad for the 1965 movie (the first color *Darna* entry)

turned superheroine is back, as, this time, events take a decidedly more science-fiction-like turn. X3X, a humanoid space alien queen (and scientist, played by Helen Gamboa), wreaks havoc on planet Earth with her scheme of dominating the world by creating a race of giants. Darna springs into action to defeat X3X and save humanity. Oh, were it so simple as that…as Darna and her alter-ego Narda (along with young sibling Ding) spend much of the film's screen time running around in caves which house the laboratory of the sinister X3X as well as cells built into the walls of the cave that house both male and female villagers upon whom she plans to experiment.

While the "Giants" of the movie's title are not much of a fierce bunch, considering the low budget, the results of the forced perspective camera work come off much better than one would think. In lieu of budgetary concerns, scenes of Darna's flying prowess appear to be Santos herself suspended from wires attached to a crane over some badly matching background. If it were not for the cherubic charm of our star, who unabashedly wears the costume well, and displays a few impressive low-end martial arts moves and tumbles (no doubt taught by the film's stunt coordinator) that would make Diana Rigg's Emma Peel character laugh with glee, this entry in the series really has little going for it, save for the electric Gamboa as the villain. She really steals the film with little effort, partly by being villainous, and partly by displaying a hint of same-sex interest in our heroine, adding a slight hint of underpinned sexual drama to the movie. As for those "Giants", casting looked for the biggest and heaviest Filipino males they could find, and the tallest Amazonian women, and dressed the men in cavemen-like rags, the women in some sort of sexy bathing suits…and had them leer

and look menacing. I found some information which mentioned that Santos really didn't like showing so much skin as Darna, and wanted to wear a flesh-colored body stocking beneath the costume. The producers of the first Darna film talked her out of it, but production stills for **DARNA AND THE GIANTS** do show that body-stocking in some shots. Thankfully, it came off during the actual production. Unfortunately, still left in the film are some shots, usually after a fight sequence, where Santos is obviously struggling to keep her bikini briefs from falling down. Surprisingly, there's some scintillating hints of exploitation here with naked female backs, nurses undressing to their

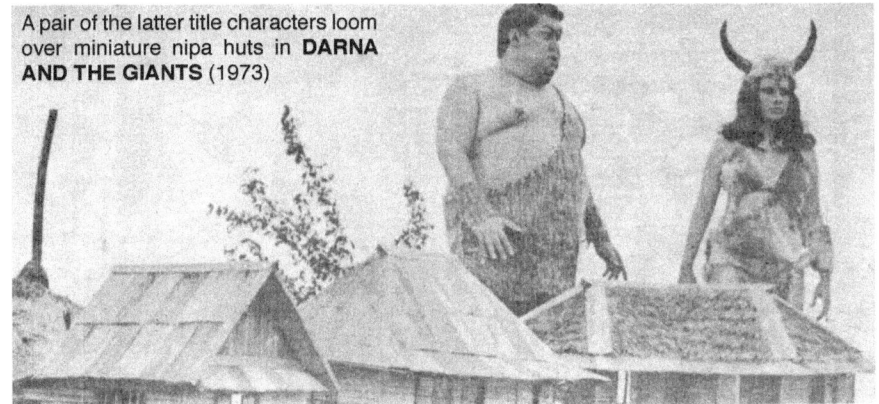

A pair of the latter title characters loom over miniature nipa huts in **DARNA AND THE GIANTS** (1973)

underwear, and, on several occasions, when stomped or clawed to death, victims of the giants gush streams of blood from their mouths and exhibit claw marks on their mangled faces. I'm not sure what kind of audience the production was aiming for, but by all accounts, the movie did well at the box office.

DARNA VS. THE PLANET WOMEN
Philippines, 1975. D/W: Armando Garces

Two years after **DARNA AND THE GIANTS**, and the series is rebooted with Vilma Santos again as the star. With an obvious lower budget (and even less imagination), this film finds Narda, now a crippled young woman (an obviously thinner Santos with an unflattering pixie hairstyle), living in a ghetto town populated by the poor and drunks. Accompanied by Ding, her young brother, Narda hobbles along with her handsome boyfriend Ramon at her side. When a group of locals taunt Narda and challenge Ramon to a fight, the beat-down seems to go on for far too long before grandmother Lola comes out to chase the villains away. Later, walking in the woods, Ramon is hit by a paralyzing ray emitted from a flying saucer. When Narda finds him frozen and still standing, his arms outstretched, she falls to the ground and weeps... but then a falling star lands at her feet, becomes a small stone, which she promptly pops into her mouth... and as she shouts "*DARNA!*"... yes, she becomes our beloved superheroine again. It appears that the flying saucer is the temporary home to a group of body-painted women from outer space led by red-haired Elektra (Rosanna Ortiz). They've come to Earth—the Philippines in particular—to experiment on the men, and to kidnap scientists. Oddly enough, once the threat is known, Darna reverts to the form of Narda and hobbles along the road, back home, and ends up looking out the window of her ramshackle home into the blackest night. Why she doesn't tackle alien woman ass is beyond me at this point, but that would make for a short movie indeed.

Meanwhile, Elektra unexpectedly turns up in a rainstorm in the middle of the night and beds Ramon (oh, he's been healed by this point... the result of the magic powers of supervagina, I have to assume). He's sort of less interested in Narda now... so, a pissed Darna has no choice but to battle the planetwomen in a series of poorly-choreographed fight scenes. My favorite of these is Darna's battle with the blue alien (Lita Vasquez), who appears to be stuffing her bikini bottom with the hairiest muff known to mankind. There's a sort of cheesy low budget space opera feel to some of the scenes set on the spaceship... at times reminding me of some of the American science fiction porno parodies of the late 'Seventies, and Santos seems oddly withdrawn from the proceedings... like she knew what a piece of garbage this movie really was.

DARNA AT DING

("*Darna and Ding*")
Philippines, 1980. D/W: J. Erastheo Navoa
& Cloyd Robinson

I've seen a number of patchwork films in my day. Movies assembled from bits and pieces from unfinished leftover outtakes and the like…but **DARNA AT DING** left me with my jaw dropped to the floor. Produced by a company that was owned by the family of popular child star Nino Muhlach (who plays the chubby, annoying Ding, brother of Narda/Darna) this is the third time Santos has appeared in a Darna origins story, except, this one has witches, demons, vampires, ghosts, a giant, a mad scientist and a zombie too!

The film begins with (a now much older) Narda accompanied by Ding, her brother. Narda finds the magic stone, utters the magic word "*DARNA!*"…and, in a cloud of smoke and a strike of light…she becomes the colorful heroine. Wearing perhaps the most modest of all the Darna outfits she wore in the series, Santos seems to enjoy the (again poorly-choreographed) fight scenes a little more than usual. For some reason, this movie feels to me like "Darna's Road Movie". Every few minutes something else happens…then we go on to another vignette.

Darna meets the Hawk Woman (Veronica Jones) and they speak briefly, tussle, then the Hawk Woman is dispelled with. Darna then comes across a giant (played by Max Alavarado, who also was a giant in **DARNA AND THE GIANTS**), defeats him, and then the film seems to settle down for a small-town burial. But then we switch to a night scene as a witch appears and

The high-flying heroine (therein played by Gina Pareño) previously encountered alien humanoids in this adventure from 1969

taunts someone, and as she comes close to frightening them to death…suddenly we meet a female scientist who is working on reviving the dead in what appears to be a castle (nice color gel lighting here reminiscent of Bava's **KILL BABY, KILL** [1966], intentionally or not). Then, out of nowhere, the man who was buried returns from the dead and bites a chunk out of someone's neck. Several vampires appear in another scene and menace someone. Then, it seems like we are in a different movie altogether as a mechanical robot (like in those old Republic serials…I think **THE MYSTE-**

A pair more of the towering humanoids from 1973's **DARNA AND THE GIANTS**, here with nothing but the sky to provide comparison to their scale

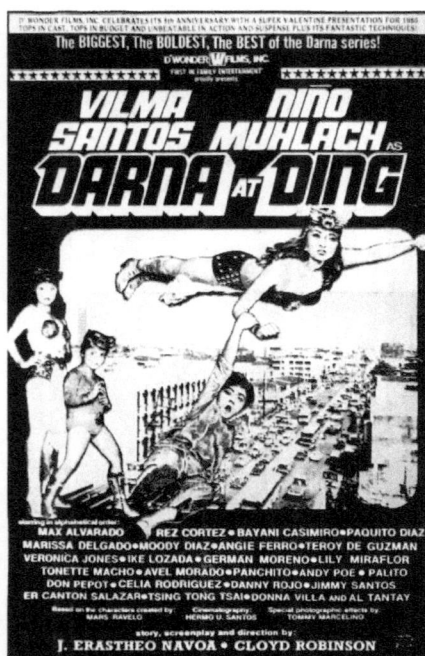

RIOUS DR. SATAN [1940] was the one that came to mind) menaces Darna, and she quickly vanquishes the metal monster. Soldiers are attacked by guerilla mercenaries, but Darna appears in time to save the day. And then we're back to the scientist, who admits to being a necromancer and that her plan to revive the dead is all a revenge scheme. And then, abruptly, as if no one had any good footage to wrap things up... the end.

In addition to being a singing sensation, Vilma Santos(-Recto), the so-called (by some) "Queenstar" of Philippine Movies, had an incredibly long career in the local cinema, amassing over 200 credits as a starring or featured performer from 1963 to 2013. Interestingly, in the midst of her "Darna" period, Santos also played Mars Ravelo's mermaid character Dyesebel (first played by Edna Luna in 1953) onscreen. Affectionately known to many as "Ate Vi", Santos, also a politician, was elected Mayor of Lipa City, Batangas, and, eventually, became the first female Governor of Batangas (her many political causes include "100% PhilHealth Coverage" and the "Free Public College Tuition Act of 2016"). One of her hubbies (from just 1980-82 ['84?]) was future '90s Pinoy cinema action man Edu Manzano (he of 1991's **DARNA** and its follow-up).

DARNA
Philippines, 1991. D: Joel Lamangan

This decidedly more modern and adult version of the Mars Ravelo stories and character begins with yet another Darna origins prelude. As young teenager, Narda (Francine Prieto) and her two brothers Ding and Dong lead a quiet life in their village. Narda (now played by Nanette Medved) grows into womanhood after finding the magic stone that will turn her into Darna. Medved's onscreen introduction has her appearing nymph-like from out of the water, naked save for a transparent nightgown, in slow-motion. The hope that this Darna will definitely be a more adult version of the story is quickly abated when comedy relief thugs happen upon the bathing Narda and her

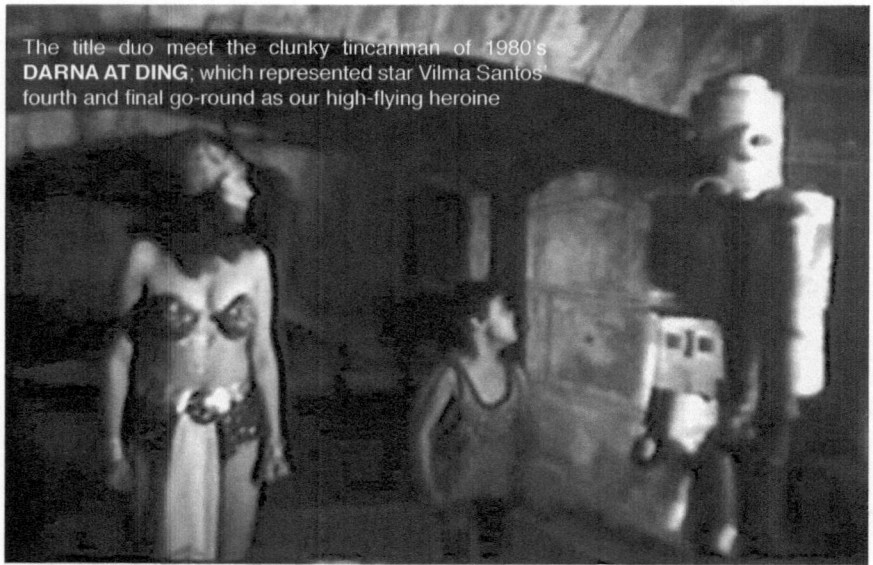

The title duo meet the clunky tincanman of 1980's **DARNA AT DING**; which represented star Vilma Santos' fourth and final go-round as our high-flying heroine

brother, and, after turning into Darna, she ties them together to a tree.

Narda journeys to Manila to find a position as a reporter with the local newspaper, and like a female version of Clark Kent/Superman, she can fight crime in the big city when Darna might be needed. Meanwhile, adventurer Dominico (Edu Manzano) finds something in a South American cave that he didn't plan on, and becomes possessed by a demon, possibly a minion of Satan. Told that he can achieve immortality and the strength of an overlord if he possesses the same stone that changes Narda into Darna, he then begins a scheme to kidnap Darna and acquire it for himself. Enter the snake-haired gorgon named Valentina (Pilapil), who, after a brief tryst with Dominico, joins forces with him to battle Darna. A couple of gun battles, a flying bat-winged woman with fangs and claws and a talking snake later, Darna finds herself, her friends and family framed and thrown into jail. Dominico manages to steal the stone, but now Narda doesn't seem to need it anymore to change into Darna, and she saves the day, reducing Valentina to ashes and pulling out Dominico's heart, killing him.

Nanette Medved was born to a Russian father and a Filipino-Chinese mother in Hawaii in 1971. She made a small number of films before retiring from acting at a young age. In recent years, she has been active in social and political endeavors in the Philippines. Despite being uneven, this **DARNA** is one of my two favorite films featuring the character. Even when Medved plays Narda she appears as a spectacled cosplay nerd with a shapely ass; I enjoyed watching her as much as when she appeared as Darna.

DARNA! ANG PAGBABALIK
(a.k.a. **DARNA: THE RETURN**)
Philippines, 1994. D: Peque Gallaga & Lore Reyes

Darna/Narda (Anjanette Abayari) tries to keep her family (Grandmother Lola, and brother Ding [Lester Llansang]) from becoming victims of the latest natural catastrophe to strike the Philippine Islands. Another typhoon has ravaged the area, and flooding has caused much havoc all around, leading some people to lose their faith. Enter Valentina (Pilita Corrales), Darna's nemesis and the series' resident Medusa...a sinister woman with a head of live snakes among her hair, with plans of world domination. Valentina is responsible for clobbering Narda and stealing the magic stone that enables her to become the mighty Darna. Unfortunately, the blow

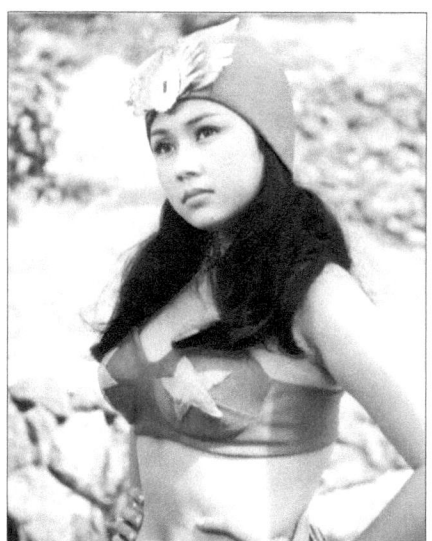

Even if it *did* look awful good on her, D's skimpy costume never did sit well with meteorically-risen Darnanian superstarlet Vilma Santos; indeed, she very nearly walked off the set of her later cheesecake vehicle **BURLESK QUEEN** (1977) because it demanded too much—*ahem*—jiggle of her

to the head leaves her nearly mute, an amnesiac, a little brain-addled, and without that magic stone, she's prey to any sleazy male who thinks that the shapely body hidden in the drab clothing of the unfortunate woman is theirs for the taking.

After nearly drowning, Narda and her family move to Manila to aid her recovery by recuperating in the home of a family friend. In time, we discover that Valentina needs Darna's magic stone to stem her own aging process (apparently she's been around for thousands of years), but things are not going well with her experiments with it, as gooey pus keeps appearing when she attempts to either rejuvenate herself or to turn into a super-Medusa. But wait! There's more! Valentina's equally crazed (and also snake-haired) daughter Valentine has her own ambitions of world domination, and under the guise of Dr. Aden she leads a millennium cult that preys on the fears and lost religious faith of those affected by the floods and the typhoon.

Valentine threatens, via televised evangelical sermons that contain subliminal messages and hypnosis, that the population of the Philippines will be destroyed unless they choose her as their savior. Narda's grandmother is one person who falls under the evil spell. Not enough trauma for poor brain-addled Narda, you think? Nah, that relative she and her family is stay-

Front and back covers of an HK DVD release of **DARNA! ANG PAGBABLIK** (complete with English subtitles!)

I'm heartily endorsing all readers to see this film, I won't go into too much more detail surrounding the climax of the film, but by all means, I would suggest you track down this collision of genres...scantily-clad superheroine, adult romance, horror (snake people, demons, transformations and monsters), and social commentary (the relentless typhoons, hurricanes, and floods that ravage the Philippines, and possibly the lessening of one's faith due to the barrage of hardships these people have to endure).

After what seemed to be a rather tepid response to Nanette Medved's **DARNA**, Producers Viva Films decided to once again try another go-round; this time they hit paydirt with the beautiful Anjanette Abayari as Darna.

This jaw-droppingly amazing jiggle epic feels like an (unintentional) homage to the films of Russ Meyer, as well as Jim Wynorski's (specifically, his **THE LOST EMPIRE** from '85). While the vital statistics of her petite 5' 3" frame are a mere (!) 35-24-34, somehow the filmmakers managed to squeeze Anjanette Abayari into an even *smaller* costume, then filmed much of her running scenes (there's a goodly number of those!) and quasi-acrobatic kicks, leaps and rolls in slow-motion, thus enhancing the "jiggle" effect, with Anjanette's verging-on-pendulous breasts bouncing and rolling for the camera...and also for we the viewers, of course!

Sometimes the film feels chaotic, and possibly, having two directors may be the reason, but it doesn't help matters much when the first quarter of the film really doesn't feature much of Darna at all. And, things do become mighty creepy with the Valentina/Valentine Medusa duo and their minions. But I just love that this film can so unabashedly jump around and features such an enjoyable performance by the lead (who, yes, jumps and runs around a lot...and you'll *like* it!).

Anjanette Abayari was born in 1970; she moved to the Philippines and appeared in a number of beauty pageants, and was named "Miss Philippines" in '91 (but was disqualified afterwards when it was learned that she was actually born in the US). Her roles in films since **DARNA**, possibly her most well-known "acting appearance", were usually minor, and her personal life took a decidedly quick nosedive into hell when an addiction to crystal meth (called *Shabu* in the Philippines) led to her making some bad career choices. While on a promotional tour in 1999, she was imprisoned in Guam and charged with possession of meth and suspicion of being a drug trafficker. As friends and loved ones begged the Philippine government for assistance to release Abayari from prison, she languished in jail for a time. Upon her release, she

ing with is displaying a natural or unnatural fondness for her, but nice guy local cop (Edu Manzano, who played one of the villains in the '91 **DARNA**, with Nanette Medved) also shows his liking for her.

When brother Ding manages to sneak his way into the cultist's lair and steal back the magic stone, it's finally time for Narda to change back to Darna, but will she be powerful enough to defeat the combined powers of Valentina and her minions of goblin-headed monsters, large talking snakes and the like, and Valentine's crazed evil faith followers? Well, since

moved to Los Angeles, and as recent as late December 2013, was informed that she may return to the Philippines to assist with the next "Miss Philippines" pageant scheduled for 2014. Rumors abound that she has still not entirely dealt with her meth addiction, and she may even have appeared in some Los Angeles-based XXX porn films here in the States while she spent time living here. What a way for the wholesomely virtuous Darna to end up!

Endnote: There were two short-lived television series featuring the Darna character, one in 2005, and the other in 2009. Angel Locsin, who played Darna in the earlier show, was reportedly trained in Wushu and kung fu before the start of production. In that program, which reboots the Darna mythology once again, the planet Marte is under attack from an evil alien race, and one person is entrusted with all the powers of the mightiest of Marte's warriors—yep, you guessed it!—the Earthling, Darna.

The 2009 series with Marian Rivera in the lead seemed to aim a little too high in the ambition department by attempting to infuse elements from the successful British *Dr. Who* series into a plot device that has this version of Darna be one of several who have lived through generations, and that every generation must fight the same (resurrected) villains as the earlier Darna.

Top: Commemorative First Day Cover from the Philippine Postal Corporation (PPC), issued in 2009 for the PI's yearly-held National Stamp Collecting month (i.e., November). The art (by Gilbert Monsanto) was previously seen on the cover to ish #3 of Mango Comics' 2003 *D* three-parter. **Above Left:** January 1952 edition of the comic, whose cover art shows Darna in a heated aerial cat/dogfight with Babaing Lawin ("Hawk Woman"), one of her long-time adversaries; art by the great Nestor P. Redondo. **Above Right:** Splash-page to the Ilonggo-language tie-in comic strip "version" of D's same-named 1965 big screen adventure (artist unknown) *[Scan c/o the collection of Steve Santos]*

Left: Angel Locsin as Darna '05, New Millennium-style! **Above:** Katrina Halili as the sinuously sensuous Serpentina in the 2009 teleseries. **Below:** Lorna Tolentino as the first TV Darna, from 1977. **Below, Center:** Victimized vixen Nadine Samonte and the exceedingly "clingy" (i.e., parasitical) Babaeng Impakta in the '09 series. **Below, Far Left:** Babaeng Tuod (Francine Prieto) and her familiar, the impish Impakta (trans: "devil" [etc.]), same series

Above: Darna & Ding zoom joyously through the skies in this wonderfully emotive '50s comic panel by future DC Comics hire Nestor Redondo

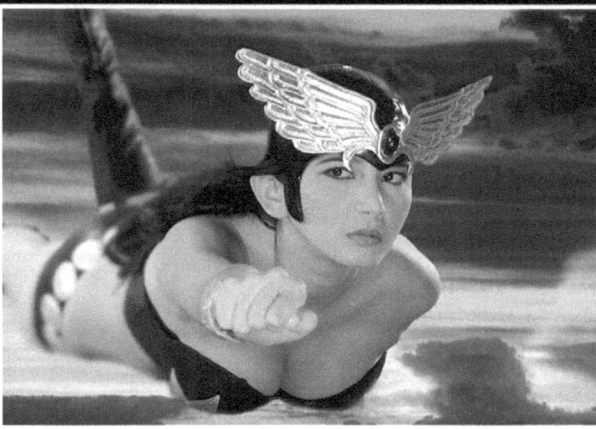

Right: Katrina Halili as Black Darna (those familiar with the comic *Shazam!* may recall Black Adam, the anti-Shazam. Same idea!)

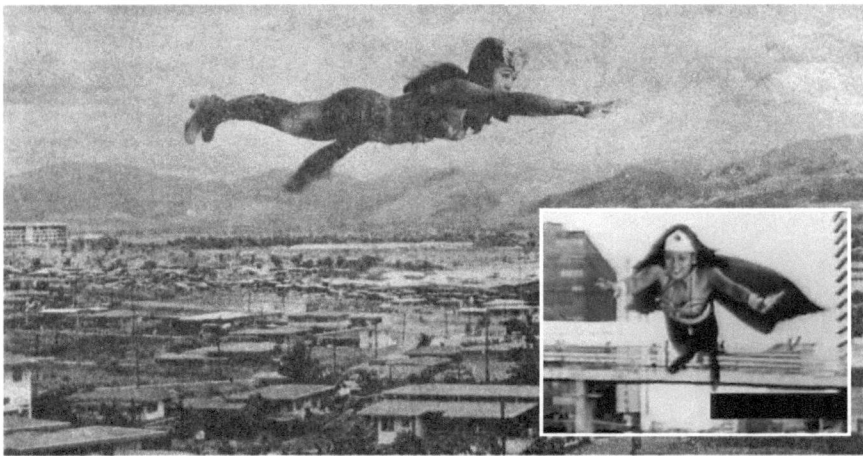

Above, Background: Vilma as Darna gets airborne in the aptly-titled **LIPAD, DARNA, LIPAD!** (which means "Fly, Darna, Fly!"). **Above, Inset:** Indonesian imitatrix Lidya Kandou jets high—er, make that *low*—over Jakarta in **DARNA AJAIB** (1980), a copycat clone from elsewhere in Southeast Asia

SELECT *DARNA* FILMOGRAPHY (compiled by SF)

*[*Note: While no doubt not entirely comprehensive, this list of all 14 "legit" titles also goes on to include several spoofs / spinoffs / rip-offs—usually authorized, if not always—all of which utilized the superheroine's character in some way, sometimes in merely a cameo role. Titles are listed in as accurate chronological order as is known. Unless otherwise noted, all titles were theatrical features]*

DARNA |– May 31st, 1951. D: Fernando Poe. Stars Rosa Del Rosario as Darna/Narda.

DARNA AT ANG BABAING LAWIN (a.k.a. **DARNA AT ANG BABAENG AHAS** [?] or **DARNA AND THE HAWK WOMAN**) |– August 15th, 1952. D: Carlos Vander Tolosa. Stars Rosa Del Rosario as D/N.

SI DARNA AT ANG IMPAKTA (a.k.a. **DARNA AND THE EVIL TWINS**) |– June 27th, 1963. D: Danilo Santiago. Stars Liza Moreno as D/N.

ISPUTNIK VS. DARNA (tr: *"Isputnik vs. Darna"*) |– August 12th, 1963. D: Natoy B. Catindig. Stars Liza Moreno as D/N.

DARNA AT ANG BABAING TUOD (a.k.a. **DARNA AND THE TREE MONSTER** [unconfirmed title]) – April 14th, 1965. D: Cirio H. Santiago. Stars Eva Montes as D/N.

SI DARNA AT ANG PLANETMAN (a.k.a. **DARNA AND THE PLANETMAN**) |– January 18th, 1969. D: Marcelino Navarro. Stars Gina Pareño as D/N.

LIPAD, DARNA, LIPAD! (a.k.a. **FLY, DARNA, FLY!**) |– March 23rd, 1973. Ds: Emmanuel H. Borlaza, Elwood Perez, Joey Gosiengfiao. Stars Vilma Santos as D/N.

Wholesome, fresh-faced Vilma Santos played D in no less than four Filipino feature films between 1973 and 1980

Gina Pareño as D in 1969's **SI DARNA AT ANG PLANETMAN**

DARNA VERSI BARU (tr: *"New Version of Darna"*) |– 1973. D: Unknown. This, the first known (?) Indonesian *D* series cash-in, stars Nia Zulkarnain (or Zulkarmain/Zulkarnaen). Other details unknown. (See also 1980's **DARNA AJAIB** below.)

DARNA AND THE GIANTS |– December 22nd, 1973. Ds: Emmanuel H. Borlaza, Leody M. Diaz. Stars Vilma Santos as D/N.

TERIBOL DOBOL |– 1975. D: Luciano B. Carlos. Not an actual *D* entry, this film co-stars then-still-ongoing movie Darna Vilma Santos in a different role, along with popular Pinoy comic Chiquito, who here appears as a shrill, madly-mincing Darna wannabe named "Darnita" during a dream—er, better make that *nightmare!*—sequence experienced by another character as a blatant in-joke to Vilma's main claim to fame (whose then-most-recent hit, 1973's **LIPAD, DARNA, LIPAD!** is even "subtly" name-dropped in the dialogue). For better or worse, drag Darnas have long been (and continue to be) a popular "thing" in the Philippines.

DARNA VS. THE PLANET WOMEN (a.k.a. **DARNA VS. ELEKTRA**) |– December 25th, 1975. D: Armando Garces. Stars Vilma Santos as D/N.

Darna! TV series |– 1977 (to 1981?). Stars Lorna Tolentino as D/N.

DARNA, KUNO...? |– March 30th, 1979. D: Luciano B. Carlos. A goofy spoof, starring (*male!*) comic superstar Dolphy as D/N; co-starring the "real" Darna, played by one-timer Brenda Del Rio; supporting actress Lotis Key also "becomes" the character at another point... looking a helluva lot more appealing in the costume than the dopey Dolphy does! Impending D/N portrayer Rio Locsin *[see next entry]* appears in a bit part herein.

BIRA! DARNA, BIRA! |– June 15th, 1979. D: Tito Sanchez. Stars Rio Locsin as D/N. Advertised as *"The Darna of Them All!"*

DARNA AT DING (a.k.a. **DARNA AND DING**) |– February 8th, 1980. D: J. Erastheo Navoa, Cloyd Robinson. Stars Vilma Santos as D/N.

DARNA AJAIB (tr: *"Darna, Wonder Girl"*) |– 1980. D: Lilik/Liliek Sudjio. This unlicensed Indonesian knockoff stars Lidya/Lydia Kandou as D/N.

CAPTAIN BARBELL |– December 25th, 1986. D: Leroy Salvador. Co-starring former D/N Vilma Santos' ex-hubby Edu Manzano as Capt. B and guest-starring Sharon Cuneta as Darna (who makes little more than a cameo).

Native poster for the first Indonesian Darna rip-off from 1973, starring Nia Zulkarnain

(no relation [?] to Rio Locsin, star of 1979's **BIRA! DARNA, BIRA!**) as D/N.

Darna TV series |– August 10th, 2009–February 19th, 2010 (140 episodes). Ds: Various. Stars Marian Rivera as D/N.

DARNA |– 2017 (?). First officially announced in or around September 2016, this proposed—if evidently as yet un-started/forestalled/hibernating—theatrical project for Erik Matti, director of *The Aswang Chronicles* movie duology, was (is?) set to co-star recent new millennial TV D/N performer Angel Locsin in the title role, along with ex-D/N player Gina Pareño (of 1969's **SI DARNA AT ANG PLANETMAN**) in a key supporting part.

Lotis Key as one of the 3 different Darnas— only two of whom are female—seen in **DARNA, KUNO...?** (1979)

DARNA: THE MOVIE |– December 25th, 1991. D: Joel Lamangan. Stars Nanette Medved as D/N.

DARNA! ANG PAGBABALIK (a.k.a. **DARNA: THE RETURN**) |– June 9th, 1994. Ds: Peque Gallaga, Lore Reyes. Stars Anjanette Abayari as D/N.

Darna TV series |– April 11th, 2005–November 25th, 2005 (170 episodes). Ds: Various. Stars Angel Locsin

As Babaeng Tuod, the wicked Wood Witch in the 2009 TV series, Francine Prieto goes back to her roots–*literally!*

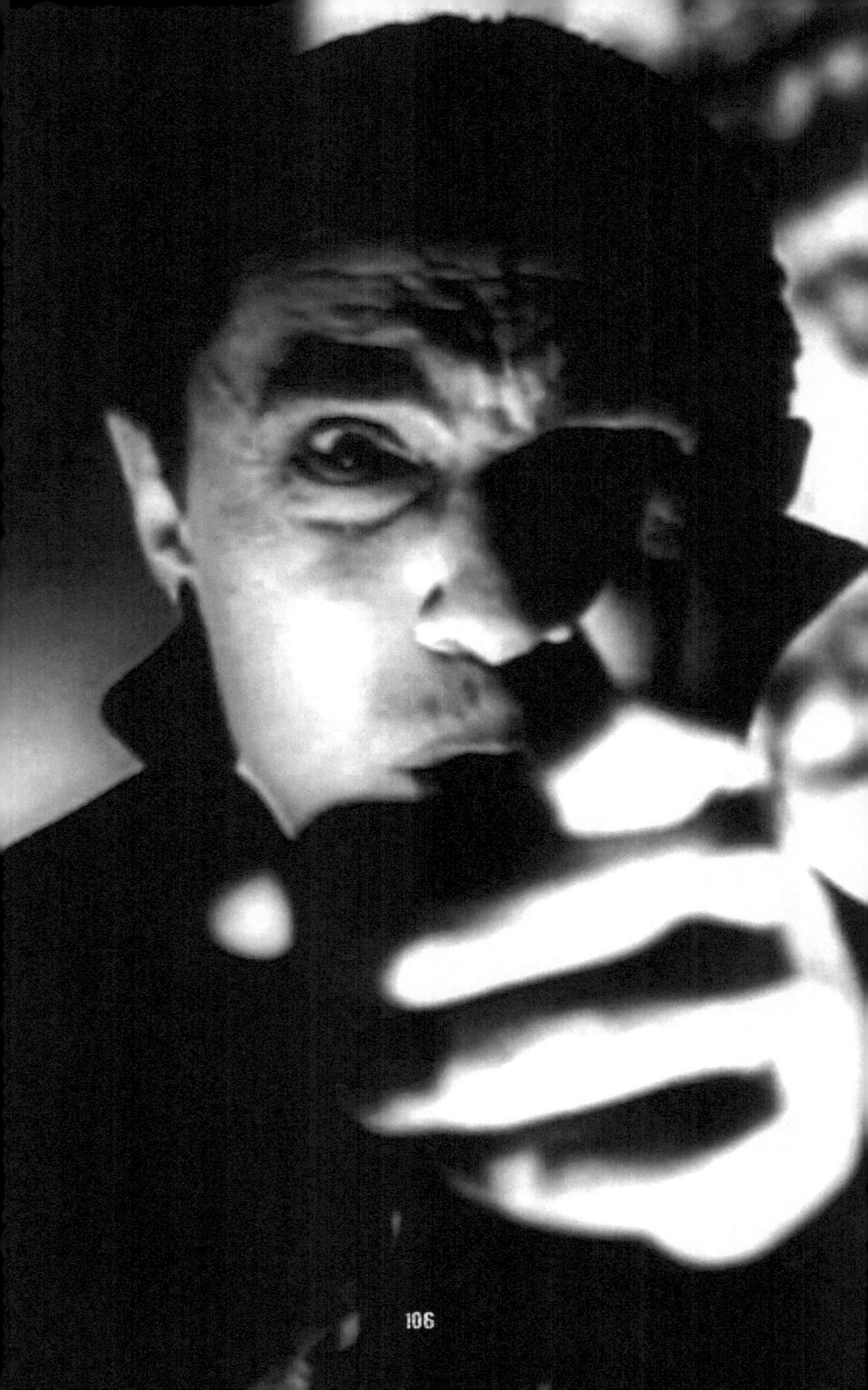

THE CHILDREN OF THE NIGHT:

Reassessing Tod Browning's DRACULA & MARK OF THE VAMPIRE

By Troy Howarth

[Author's Note: Special Thanks are due to writers Gary D. Rhodes and David J. Skal and Elias Savada, whose books Tod Browning's Dracula *(Rhodes) and* Dark Carnival: The Secret World of Tod Browning *(Skal/Savada), provided invaluable assistance in the writing of this article.]*

Irish author Bram Stoker (1847-1912), a Dubliner, hit the proverbial goldmine with the publication of Dracula in 1897. A literary agent and minion to the great theatrical impresario Sir Henry Irving, Stoker wrote a number of stories and novels, a number of them with macabre overtones, but nothing else in his oeuvre can compare to the lasting power of Dracula. It became his biggest-selling novel by far, and though he did not live to see anywhere near the full extent of its impact and influence, he nevertheless earned his place among the immortals because of it.

With the possible exception of a Soviet adaptation from 1920—about which nothing is known and no remnants of any kind have survived—it would seem that the first film adaptation arose, appropriately enough, from Hungary. **DRACULA'S DEATH** *(*Drákula halála, 1921) was directed by Károly Lajthay and featured Erik Vanko as an inmate at an insane asylum who claims to be Count Dracula. This was followed in close succession by the first major adaptation, the unauthorized **NOSFERATU** *(*Nosferatu, eine Symphone des Grauens, 1922, Germany), directed by the great F.W. Murnau. In an effort to avoid paying-out to the novel's presumed copyright-holder, the late Stoker's widow Florence, Murnau and screenwriter Albin Grau sneakily changed all the names of the characters in an attempt to hide its paternity.

Even so, it proved to be a remarkable movie, and it remains one of the finest films of its type. Artistic merit did little to quell the anger of Madame Stoker, however, who tried to have all copies of the film confiscated and destroyed. She very nearly succeeded in her goal, but a print survived—and when it was later revealed that Stoker had failed to secure a proper copyright for his most significant literary creation, charges of plagiarism were summarily dismissed.

Unbeknownst to many rabid horror fans, the man responsible for directing the first American version of **DRACULA** first had his eye on bringing the novel to the screen as more than a decade prior to his 1931 film version. In his exhaustively-researched book Tod Browning's Dracula, *author Gary D. Rhodes reveals documentation which proves that Browning had expressed interest in making a film out of* Dracula *as early as 1920. Had he succeeded in doing so, the development of the horror genre would have been expedited by a full decade! As it stands, the eventual film version he made in 1931 is regarded as the birth of the American horror genre—films made in America prior to it invariably were rooted in some form of realism or mundanity, but Browning's* **DRACULA** *eschewed reality in favor of pure fantasy. There is no last-minute plot twist explaining away the supernatural; Dracula is real, and he truly is a bloodsucking vampire! The film's success led Universal Pictures to produce* **FRANKENSTEIN** *(1931, D: James Whale), with Karloff becoming equally as iconic in the title role as Lugosi was as Dracula, and from that moment on, the floodgates were open full and wide. But before we get too far ahead of ourselves here, let's take a look at the one man who was arguably more responsible than any other American filmmaker for helping to usher in a genre of film which embraced the grotesque and the supernatural...*

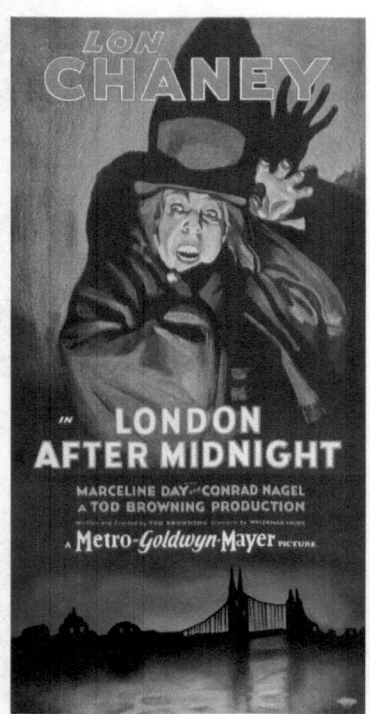 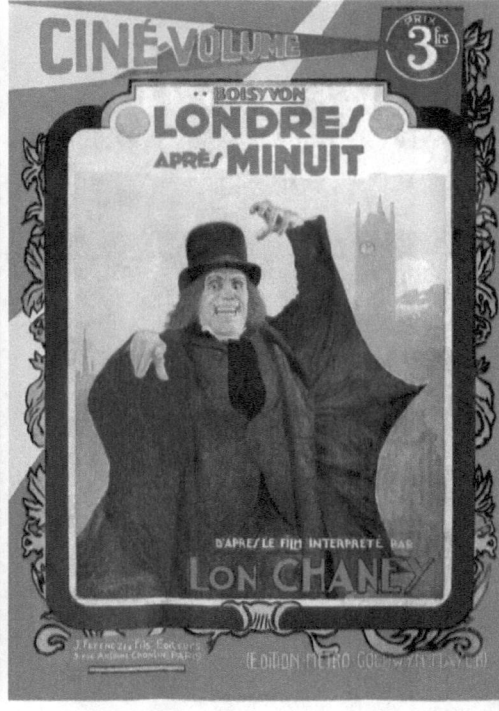

Above Left: This striking American three-sheet poster recently sold at auction for the astronomical sum of $71,700.00 (art unsigned). **Above Right:** French tie-in photoplay book (Paris: Boisyvon. J. Ferenczy & Fils Editeurs, 1929) for the film (art unsigned)

Tod Browning was born in Louisville, Kentucky in 1880, under the name Charles Albert Browning, Jr. He was drawn to the world of make-believe and the imagination from the time he was a very young child, and at the age of 16 he lived-out a fantasy held by so many children: he literally ran away from home and joined the circus. In this milieu, he did everything from slapstick routines as a clown to performing an act in which he was buried alive, and he eventually branched-out by directing plays in New York. He met up with pioneering American director D.W. Griffith, and the two men became good friends. Griffith cast Browning in a number of his early short subjects—most of them comic in nature, ironically enough—and he would also cast him in an uncredited role in his sprawling epic **INTOLERANCE: LOVE'S STRUGGLES THROUGHOUT THE AGES** (1916). Browning started directing short subjects of his own in 1915, when his career was derailed by a serious traffic accident: he crashed his car into a moving train, of all things, and it is believed that alcohol played a role in what happened. Browning sustained a broken leg and lost a number of his front teeth, but he made out better than one of his passengers, the actor Elmer Booth, who was killed. During the period of his convalescence, Browning occupied his mind by developing film scenarios. He got back in the saddle in 1917, and in 1919 he joined forces with actor Lon Chaney for a melodrama titled **THE WICKED DARLING**. Browning and Chaney worked well together: they shared a love for the grotesque and were willing to explore morbid subject matter which was far from the norm in American cinema of the period. They would continue to work together off-and-on until Chaney's death from throat cancer in 1930. Browning's macabre melodramas found favor with the public, and he was placed under contract by Metro-Goldwyn-Mayer. During his time at MGM, he was able to parlay his interest in adapting *Dracula* into a vehicle for Chaney, titled **LONDON AFTER MIDNIGHT** (1927). Based on a story by Browning called "The Hypnotist" and written for the screen by Waldemar Young (who later worked on the screenplay for the most terrifying film of the '30s, Erle C. Kenton's **ISLAND OF LOST SOULS** [1932], which featured Lugosi—in heavy makeup—in a key supporting part as "The Sayer of the Law"), it tells of a rash of vampire-like killings. Chaney portrays the inspector investigating the case, as well as the truly fearsome-looking vampire who is apparently responsible for the killings; however, a "startling" plot-twist at the end reveals that the vampire is a fake, and that the whole thing was an intricate plot designed to catch a murderer off-guard.

1927 Austrian newspaper ad for **LONDON AFTER MIDNIGHT**

LONDON AFTER MIDNIGHT allowed Browning to have his cake and eat it, too: with its high-Gothic atmospherics and images of Chaney and his minion (Edna Tichenor) skulking about sinisterly in the fog, it allowed him to visualize aspects of the *Dracula* scenario, but the final reveal is very much in keeping with audience tastes of the period, as American audiences were not yet comfortable with accepting the presence of the supernatural in their movies. Sadly, **LONDON AFTER MIDNIGHT** has

Messr. Tod Browning, esq. gives a stern mental middle finger to all his detractors

Above Left: US tradepaper ad (from *Film Daily* for April 14th, 1931).
Above Right: Grosset & Dunlap's 1931 American tie-in photoplay book

been classified as a "lost" film since a vault fire at MGM in the late 1960s. It was a huge hit with the public—out-grossing all of the other Browning/Chaney collaborations—but those who were fortunate enough to see it before it apparently went up in smoke are insistent that it was a routine film that would surely prove to be a major disappointment to fans after all the decades of hoopla since its disappearance if another print were ever located. In any event, the film was an important one in Browning's career, and it would exert a profound influence over his later forays into the vampire genre.

In 1931, Browning finally got his long-standing wish: Carl Laemmle, Jr. at Universal Pictures was agreeable to backing a big screen version of **DRACULA**. Despite protestations from his more conservative father, Laemmle, Jr. (known simply as "Junior" within the industry) saw commercial potential in the horrific subject matter, and was prepared to bring it to the screen as one of the studio's so-called "super productions". Universal was in essence a mini-major: not nearly so cash-rich as MGM or Paramount was, but higher up the food-chain than, say, Republic Pictures (whose mainstay/bread-and-butter was cliffhanger serials). Most of Uni's output comprised B-movie fare, but every year they would put a goodly chunk of dough into more "prestigious" projects. They scored big with one such production, Lew-

is Milestone's timeless WWI masterpiece **ALL QUIET ON THE WESTERN FRONT** (1930), which ended up winning an Oscar as Best Picture. Laemmle's father ("Sr.") made him President of the company in 1929 as a 21st birthday present, but the younger Carl's propensity for spending too much money on films which did not always return their investment landed the company in hot water, and by 1936, he and his relatives (for Universal operated rather brashly on the principle of nepotism!) were out, and a new group of executives took over. Junior's instincts may not always have been on-target, but horror fans owe him a debt of gratitude: without his vision and willingness to take chances, archetypal films like **DRACULA, FRANKENSTEIN** (both 1931), Karl Freund's **THE MUMMY** (1932) and James Whale's **THE BRIDE OF FRANKENSTEIN** (1935, all USA) would never have gotten made. Nevertheless, **DRACULA** was the essential first link in this history-making chain of events, and as such its importance in the history of the Horror Film cannot possibly be overestimated.

True to their goal of making **DRACULA** into one of their prestige pictures, Universal initially sought the services of Pulitzer Prize-winner Louis Bromfield to write the screenplay. In addition to having remained constantly in print (in umpteen different languages) since its publication in 1897, *Dracula* also enjoyed much success on

the stage thanks to an adaptation by Hamilton Deane from 1924, which was overhauled in 1927 by John L. Balderston, a major mover 'n' shaker in our story. The Deane version played in London and featured Deane himself as Professor Van Helsing, while Dracula was played in a derby by Edmund Blake; then in London by Raymond Huntley, who later appeared opposite arguably the most successful post-war Dracula of them all, Christopher Lee, in Hammer Films' "reimagined" version of Universal's '32 classic **THE MUMMY** (1959). When the play was brought to Broadway by producer Horace Liveright, he hired Balderston to make some radical changes, also hiring a Hungarian émigré by the name of Béla Lugosi—then virtually unknown outside his home country—to play Dracula. The play helped to make Lugosi's fortunes in America, though, as he would later confess, it would become as much of a curse to him as it was a blessing. When word got out that Universal was bringing the story to the screen, Lugosi campaigned long and hard to secure the title role. Interestingly, he was not the studio's first choice to play the part, however. It could be that they were looking to differentiate themselves from the Broadway play by casting somebody not already identified with the character, but prior to signing Lugosi they considered everybody from John Wray and Conrad Veidt to Ian Keith and Chester Morris (the latter recently seen in Roland West's batty old dark house mystery **THE BAT WHISPERS** [1930]). John Carradine, who later played the Count (a.k.a. "Baron Latos") for Universal in both Erle C. Kenton's **HOUSE OF FRANKENSTEIN** (1944) and **HOUSE OF DRACULA** (1945), also claimed to have been considered—but Carradine was prone to telling tall tales, and if he is to be believed, he also passed on playing the role of the titular monster in **FRANKENSTEIN** too, thus opening the door for little-known Boris Karloff to become a major star in his own right. A longstanding rumor has it that Browning was hoping to cast Lon Chaney as Dracula (and possibly as Van Helsing, as well) and that the superstar actor's death in August of 1930 sapped Browning of his enthusiasm for the project. In fact, given that Chaney was still under contract with MGM at the time of his death, the odds of his ever being seriously considered for the Universal film are slim-to-nil. It's quite likely that Browning *did* have him in mind when he tried to get a version going in 1920 and, of course, in **LONDON AFTER MIDNIGHT**, he did succeed in casting Chaney as both the inspector-*cum*-vampire authority and the phony vampire, but that's about as far as Chaney ever got with regards to playing Dracula (or any other vampire, for that matter) onscreen. It is also helpful to remember that Chaney did not die suddenly in 1930—he had been diagnosed with lung cancer in 1929 and underwent extensive treatment

Above Left: Native poster for the 1921 Hungarian film **DRACULA'S DEATH** (art unsigned).
Above Right: American magazine hype for **LONDON AFTER MIDNIGHT**

Above Left: A suitably freaky photo-portrait of the great Dwight Frye as Renfield, the fly-eating looney. **Above Right:** Lugosi strikes a fearsome pose as you-know-who

throughout the following year in a tragically unsuccessful attempt to stave-off the disease. Chaney was, frankly speaking, in no condition to play Dracula in 1930, and Browning knew it. There is also nothing to really support the idea that the two men were "best buddies" or anything of the kind: they worked well together, but they were not social with each other outside of work.

Contrary to popular belief, Browning approached **DRACULA** with enthusiasm. The screenplay process continued with Bromfield—whose original treatment hewed closer to Stoker than Deane/Balderston—being removed from the project. Other writers toiled on the project, including an uncredited Dudley Murphy, but the final script was credited exclusively to Garrett Fort. In fact, Fort worked pretty closely with Browning on the screenplay, but the director was not awarded a credit for his input. The net result of their efforts combines elements of Stoker with elements of Deane/Balderston. The entire opening section of the film—regularly referred to as a highlight of the picture—is taken from the book, as the play did not allow for any sequences set in Transylvania. The bulk of the action is confined to Dr. Seward's sanitarium and its adjoining house, which does stay true to the play, however. Despite Laemmle's best intentions, the production was hit with some financial woes, and some of the more ambitious sequences—such as a subplot involving the vampirized Lucy (Frances Dade) returning from the grave and terrorizing local children (as per Stoker's text)—were compromised and/or deleted as a result. Even so, the producer sank a good deal of cash into the production and advertising campaign, and the success it enjoyed when it was released around Valentine's Day (fittingly enough!) of 1931 conclusively validated his belief that audiences were more than ready to accept supernatural subject matter in their motion picture entertainment.

A great deal has been written both in-favor-of and against Browning and **DRACULA**. On the one side of the equation, writers like Tom Weaver

Brazilian pressbook ad for you-know-what

regularly decry it as stodgy and unintentionally humorous; on the other, in his book *Tod Browning's Dracula*, writer Gary D. Rhodes literally spends *hundreds* of pages debunking some of the myths surrounding its production and arguing in favor of the film's merits. As is so often the case, the extremes on both sides tend to take things a step too far. Weaver's somewhat condescending attitude towards the film is off-putting, while Rhodes occasionally strains a little too hard in an attempt to convince the reader of the film's greatness. One thing is for certain: the critical backlash against the film—which Rhodes traces to the 1950s, as it was reviewed quite favorably by many of the major publications in the 1930s—has resulted in Browning being viewed as something of a careless filmmaker. A look at his filmography does much to dispel this notion, however. Many of the films he directed prior to **DRACULA** are as noteworthy for their brisk pacing as they are for their audacity; so much for the argument that his approach is "stiff and stodgy"! Similarly, his work following **DRACULA** is often remarkably effective; just think of his 1932 *cause célèbre*, **FREAKS**, which nevertheless so horrified audiences that it effectively derailed his career. The distance of time coupled with the greater availability of the full scope of his filmography (though some titles, notably **LONDON AFTER MIDNIGHT**, remain frustratingly out of reach) reveals him to be a director of great skill and versatility. And most crucially, he was the first American director to openly embrace the macabre—so much so, in fact, that he became known by some critics as "the Edgar Allan Poe of cinema." British director James Whale made a terrific splash with **FRANKENSTEIN**, but he was never comfortable with being identified with any genre in particular; his subsequent horror films, from **THE OLD DARK HOUSE** (1932) to aforementioned **THE BRIDE OF FRANKENSTEIN**, are as satirical as they are horrific. Browning had no such qualms, and was happy to explore the darker recesses of the human soul in a series of startling and fetishistic melodramas, but **DRACULA** would become the defining film of his career—whether that is a good thing or not depends very much on which side of the critical fence you happen to be sitting on.

Beginning with the mysterious and beautiful strains of Tchaikovsky's *Swan Lake* on the soundtrack (this would be recycled for such subsequent Universal horrors as Robert Florey's **MURDERS IN THE RUE MORGUE**—another Lugosi starrer—and **THE MUMMY** [both 1932], as well as Kurt Neumann's **SECRET OF THE BLUE ROOM** [1933]),

Contemporaneous pressbook hype

DRACULA unfolds in a dreamy fashion as it focuses on the adventures of Englishman-abroad Renfield (Dwight Frye). Renfield is on his way to Castle Dracula to negotiate the sale of some property in England. Despite warnings from the locals that the Castle is to be avoided at all costs, he goes on his way and is met by the courtly-but-unsettling Count Dracula (Lugosi, natch!). Dracula plays the perfect host before finally biting Renfield and turning him into his minion. The two men then make their way by ship to England. These opening scenes are routinely cited as the highlight of the picture, and for very good reason: the atmosphere is so dense, one couldn't slice it with a razor-sharp knife! Despite filming exclusively on the Universal backlot, Browning, production designer Charles "Danny" Hall and cinematographer Karl Freund (subsequent director of **THE MUMMY** '32) create a real sense of the exotic. Castle Dracula is an architectural marvel, with its imposing staircase and assortment of odd creatures—some of whom, including some stray *armadillos*, of all things, have come under fire for being out of place in a Transylvanian setting... but this *is* a fantasy film, after all, and their presence makes for a most-welcome surrealistic touch, critics be damned. Lugosi's portrayal of Dracula is, of course, iconic. He would become the standard by which all comics (be they good or bad) would lampoon the character, and thus, for a contemporary audience, his interpretation has lost much of its potency due to simple repetition.

Contemporaneous trade paper hype

expressions help to make the character into something truly *unearthly*. It is a very different interpretation from the sensual and animalistic approach of Christopher Lee, for example, but it is every bit as valid. As for Dwight Frye as Renfield, he proved to be so successful in playing extreme insanity that he would largely be typecast in later films as bug-eyed loonies, much to his regret. Browning's direction is smooth and stylish, making good use of mobile camera work and well-thought-out compositions.

Once the action shifts to England, the atmosphere diminishes somewhat—but not, arguably, to the extent that critics like Weaver would lead one to believe. Consider, for example, the splendid nocturnal scene of Lugosi putting the bite on a hapless London flower girl ("Flower for your button'ole, sir?), or the audacious crane-shot which introduces Dr. Seward's asylum. Yes, there *is* more time devoted to people sitting around the drawing room talking than one would ideally like, but the "good bits" continue: Dracula's nocturnal visits to his intended victims are always memorably staged, and the confrontations between Dracula

If one can ignore the parodies, however, Lugosi is particularly memorable in these early scenes. His slow, deliberate line-readings and otherworldly

Like A Bat Outta Heck: We can't help but wonder if the same bat was used in both versions, but despite what those inset credits say, this Mexican lobby card for the Browning/Lugosi **DRACULA** actually accidentally (?) depicts a scene from the *Spanish* version, **DRÁCULA**! The actors depicted *[from left to right]* are Eduardo Arozamena ("Van Helsing"), José Soriano Viosca ("Dr. Seward") and Pablo Álvarez Rubio ("Renfield")

and his wily nemesis, Professor Van Helsing (Edward Van Sloan, another holdover from the Broadway production; albeit with a different name ["Doctor Muller"], he would play virtually the identical character opposite Karloff the Uncanny as **THE MUMMY**) are never less than gripping. If the ending seems a bit rushed and arbitrary—with Dracula being disposed of off-camera, with only the sound of the hammer driving in the stake and his final moans present as payoff—it nevertheless gets the job done, and is not quite so thoughtlessly-executed as some of the film's detractors have suggested. One must remember that the film was something new in the scheme of Hollywood filmmaking, and Browning was not at full liberty to go too far with the macabre thrills; there were also the technological shortcomings of the period to consider too, which simply would not have allowed for the kind of imagery that became almost *de rigueur* in later horror pictures. Simply put, Browning and company went as far as the standards and technology allowed them to go in 1930/31, and sooner than belittle the film for not being what one might like it to be, it is more helpful to appreciate it for what it is and for all the things it *does* accomplish.

Suitably stark B&W pen-and-ink line art (artist unknown) adorns this original German pressbook ad

DRACULA is *not* a masterpiece, but neither is it a failure, by any means. Its opening scenes and assorted other highlights are beautifully rendered. Lugosi's performance is prototypical and iconic, and he is ably supported by Frye and Van Sloan. At its best, the film attains the sort of otherworldly atmosphere which is rare in Stoker adaptations outside of Murnau's **NOSFERATU** and Werner Herzog's later color remake, **NOSFERATU THE VAMPYRE** (*Nosferatu: Phantom der Nacht*, 1979, West Germany), starring Klaus Kinski. Even if the whole does not equal the sum of its parts, **DRACULA** remains one of the most significant horror films ever made, and it—as well as its director—deserves better than some of the snarky and condescending critiques it has attracted in recent years.

Further complicating the film's legacy is the presence of an alternate Spanish-language version, made by a different cast and crew on the same sets of evenings once the American crew had finished their work for the day. This was not an uncommon practice in the early days of sound, before the then-not-technically-possible process of dubbing films became the standard. Produced by Paul Kohner and directed by George Melford, **DRÁCULA** is an interesting curio, but it is not all that it is cracked up to be. After its original run in 1931, the film disappeared for a period of time, but it was ultimately rescued from oblivion in the 1970s; it made its long-awaited debut on home video in the 1990s. It was enthusiastically received by fans as a welcome alternative to the by-then-over-familiar Browning version, but the distance of time coupled with a better opportunity to compare and contrast the two films has revealed the chinks in its armor. Certainly the film is to be commended for its brash sexuality, especially in the form of beautiful leading lady Lupita Tovar (the one instance of casting where the Spanish version trumps the American, as she proves to be *so* much more memorable than the comparatively much blander Helen Chandler), as well as for its occasional visual inventiveness. On the whole, however, it is undone by many of the same problems which mar the Browning film: for instance, a script which is longer on dialogue than on incident. For all the praise the Spanish version received for being so much more cinematic and dynamic, it is a slower and much longer film—clocking in at 104 minutes versus the American one's mere 75. If anything, Browning displays a far better grasp of visual storytelling, and manages to keep the action flowing much more smoothly, even if his version lacks some of the *frissons* evident in the Spanish version. *[As Jean Rollin well knows, what would a vampire movie be without* frissons*?! – SF.]* Coupled with the frankly truly inadequate central performance by Carlos Villarías as the Count, the over-extended running-time merely serves to make **DRÁCULA**

a pretty tough slog once the initial novelty value wears off.

Following **DRACULA**, Browning directed a sports drama for Universal, **IRON MAN** (1931). He was then invited back to MGM, where he was allowed to make the film that brought him lasting infamy: **FREAKS**. **FREAKS** is now regarded as something of a masterpiece, but it was seen as being in very poor taste in 1932, and it helped to put Browning out of favor with the studios. Luckily for him, he had signed a contract with MGM prior to the film's failure at the box office, so they continued to make use of his services. **FAST WORKERS** (1933) was credited as a Browning production, though he does not have an actual directing screen credit—possibly the backlash against **FREAKS** may have played a role in this? **FAST WORKERS** didn't set the box-office ablaze, either and, desperate for another hit, Browning cast his thoughts back to his biggest box-office triumphs: **LONDON AFTER MIDNIGHT** and **DRACULA**.

MARK OF THE VAMPIRE (1935) became Browning's next picture, and it neatly encapsulates both of those earlier triumphs. On the one hand, it is a remake of the Chaney film, which was not even a decade old at the time—but, being a silent film, **LONDON AFTER MIDNIGHT** was no longer in public circulation, and given that it was such a big hit in 1927, there was no reason to believe that the basic plot would not attract public favor once more. Crucially, Browning also elected to evoke **DRACULA** by again casting Béla Lugosi as the film's vampire figure. Universal was none-too-pleased, and vowed to sue if there was the slightest reference to **DRACULA** in the finished film, so the character instead became identified as "Count Mora"—and Lugosi's makeup and costuming would further differentiate the two characters. Browning was unable to resist the urge to work-in some daring new subject matter, however; hence, **MARK OF THE VAMPIRE** would become an early victim of the newly-enacted Hays Code. In fact, said censorial code had been in place since 1929, but, in June of 1934, it became much more rigid and strictly-enforced under the ever-watchful eye of boss censor Joseph Breen. Earlier in '35, Universal's **THE BRIDE OF FRANKENSTEIN** was hit hard by the new standards, which stipulated a number of "moral" guidelines pertaining to everything from sex and violence to infidelity and social justice. **MARK OF THE VAMPIRE**, as luck would have it, would follow suit when it was released just a few days later in April of 1935.

The original cut of the film explained the backstory of Count Mora as follows: he was involved in

Spanish (as in Spain) handbill herald for **MARK OF THE VAMPIRE**

an incestuous relationship with his daughter Luna (Carroll Borland), which culminated with his murdering her and then committing suicide. This explains the bloody (bullet-)wound on his forehead which is evident throughout the picture. Browning's daring inclusion of the incest angle was edgy as hell for the time, and it seems hard to believe that he honestly thought such a contentious plot detail would be allowed to skirt the censors. As it happens, suicide became another big "No-No" under the Breen administration, so the entire subplot was eventually hacked out of the film. It is rumored that the original cut of the film ran anywhere from 75 to 80 minutes in length, whereas the only version now available clocks in at around a mere 61 minutes (actually, only a half-minute-or-so over an hour; barely second-feature/programmer length!).

Australian newspaper ad

MARK's story, once again adapted from Browning's "The Hypnotist", with the screenplay credited to Guy Endore (best-known as the author of the novel *The Werewolf of Paris* [1933], which would later be filmed by Hammer Films/Terence Fisher as **THE CURSE OF THE WEREWOLF** [1961, UK]) and Bernard Schubert (who later contributed to the scripts of some of Universal's weakest horror films, including Reginald Le Borg's **JUNGLE WOMAN**, Leslie Goodwins' **THE MUMMY'S CURSE** [both 1944], and Harold Young's **THE FROZEN GHOST** [1945]), deals with the murder of a nobleman named Sir Karell Boroton (Holmes Herbert). The police, represented by Inspector Neumann (Lionel Atwill), are stymied, and the investigation does not produce a culprit. Professor Zelen (Lionel Barrymore), an expert on the occult, believes it to be the work of a vampire, and sets his sights on the mysterious Count Mora (Lugosi, natch!!).

MARK OF THE VAMPIRE is a stylish and diverting film, but unfortunately its closing plot-twist—revealing Mora to be an actor impersonating a vampire as part of a plot to unmask the real killer—an "anticlimactic" development which carried over from **LONDON AFTER MIDNIGHT**, has earned it a bad reputation among horror fans. It's to be regretted that the fans are so hung-up on this aspect of the story, since it actually works fairly well as a mystery plot, and it is so richly atmospheric as a piece of filmmaking. Rumor has it that Lugosi suggested an additional plot-twist where it would be revealed that the *real* actors hired to play the vampires should show up late at the end, apologizing for their tardiness, thus revealing that the supposedly fake vampires were, in fact, the genuine article—and it's entirely possible that such a final gag might have increased the film's favor with some of its detractors. But if taken on its own terms, there is *much* to love in this film!

Browning is often criticized as being a pedestrian filmmaker who could not make a successful transition to "talking" pictures. Much of this is directly attributable to the perceived shortcomings of **DRACULA**, but a viewing of **MARK OF THE VAMPIRE** really should be enough to invalidate these claims. Sadly—albeit predictably—the film's merits are often attributed solely to its gifted cinematographer, James Wong Howe. Indeed, many critics are fond of saying that the only merits evident in **DRACULA** are due to the work of its cinematographer, Karl Freund. Yes, film

Web Of Deceit: Goth icon Carroll Borland as **MARK**'s *faux* vampire woman casts her deadly spell over unwary "flies"

Bogus bloodsuckers Borland and Lugosi prowl the night in **MARK OF THE VAMPIRE**, with candle (a standard fixture of Gothic mood-pieces); although, if they actually *were* vampires (i.e., part-bat), you'd think they'd be able to see well enough in the dark without one!

is a collaborative medium, and the shortcoming of the so-called "*auteur*" theory" is due largely to its stubborn refusal to acknowledge this part of the process. However, an intelligent application of the theory allows for recognizing and praising the input of the various actors and technicians while proceeding on the understanding that, in the right circumstances, it can elucidate the guiding vision of a particular participant, whether it be the director, the writer, or even the producer. As such, it seems a shame to dismiss Browning as something of a "traffic cop" who only flourished when he had a gifted cinematographer at his side. Very little is ever made of the visual merits of such Browning-directed pictures as the two Chaney vehicles **THE UNHOLY THREE** (1925) and **THE UNKNOWN** (1927), or the above-cited **FREAKS**, for example, yet all three are crisply-lensed and very well-executed on the level of clear and concise visual storytelling. There is no denying the brilliance of Wong Howe as a cinematographer—he would go on to win Academy Awards for his work on **THE ROSE TATTOO** (1955, D: Daniel Mann) and **HUD** (1963, D: Martin Ritt)—and indeed his work on **MARK OF THE VAMPIRE** is of the highest caliber. But he was nevertheless working in conjunction with Browning, and the director's contribution to the visual assembly of the picture cannot be downplayed here while being viewed as all-important when discussing other films. **MARK**

OF THE VAMPIRE is every bit as atmospheric as the early portion of **DRACULA**, and it can be said that it does not suffer from that earlier film's overabundance of talky drawing-room sequences. There are some marvelous and eerie scenes of the characters investigating the fog-shrouded Boroton estate and the scenes of a silent Lugosi and Borland stalking about are among the most memorable to be found in any horror film of this vintage. The film also benefits from a high-value cast list, the type in which MGM specialized on a regular basis. Lionel Barrymore overplays his role as the vampire expert, but was a huge star, and claimed top billing over Lugosi. Lionel Atwill, then well on his way to becoming a major horror icon in his own right thanks to his star turns in **DOCTOR X** (1932) and **MYSTERY OF THE WAX MUSEUM** (1933, both D: Michael Curtiz), is much more effective as the arrogant police inspector, while Lugosi makes a powerful impression in his own role. Unfortunately, it seems that a good deal of his scenes were cut or otherwise impacted by the censorship woes, but his presence still looms large over the film nonetheless, and a memorable scene of him running at the camera would appear to have influenced both the much later **COUNT YORGA – VAMPIRE** (1970, D: Bob Kelljan) and **BLACULA** (1972, D: William Crain).

MARK OF THE VAMPIRE is too often dismissed as a triviality, but—like **DRACULA**—it deserves more respect than that. Comparing the two films, it can be said that **MARK** is the more aggressively cinematic and smoothly-paced of the two pictures, and this is largely down to the screenplay. Both films feature plenty of talky *longueurs*, but **MARK** breaks the action up a little more with some potently atmospheric sequences, whereas **DRACULA** seems a little stuffy and hemmed-in for much of its running time. Even so, both films display Browning's flair for the macabre, and both feature some indelible highlights well worth remembering. If fans can move past some of the prejudicial views voiced against both films, they should find much to savor and enjoy in them. Similarly, the tendency to marginalize Browning's direct involvement in both films while also decrying his execution of them—as noted by Rhodes, this contradiction is bizarre in itself—is a longstanding critical trope of sorts which needs to go the way of the dinosaur.

MARK OF THE VAMPIRE did mediocre box office, and Browning would follow it up with only two more pictures: the horror-fantasy **THE DEVIL DOLL** (1936), again starring Lionel Barrymore, and the mystery **MIRACLES FOR SALE** (1939), after which the director retired. He died in 1962, having already been killed-off once by *Variety* during the 1940s when they inaccurately (and presumably only unwittingly) reported his demise; no doubt the error tickled his penchant for morbid humor! Despite being repeatedly attacked by critics like Tom Weaver, Tod Browning deserves his place in the pantheon of major genre film directors—and, despite these repeated attacks on them, his two surviving explorations of the vampire myth continue to exert a fascination, as well.

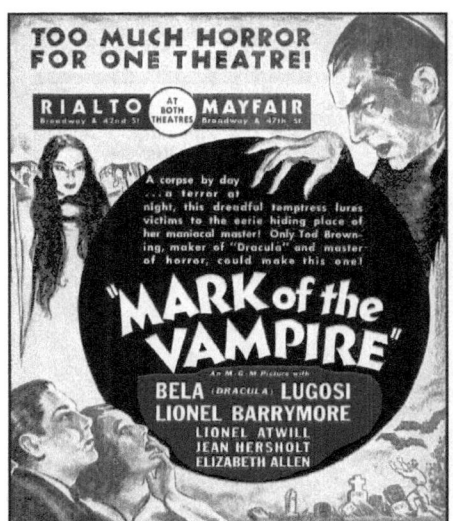 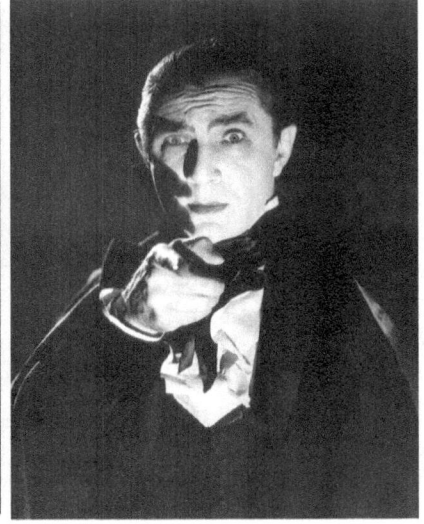

Above: Contemporaneous US trade ad (from *Film Daily* for May 1935), and another publicity pose of Béla, from the same film

One of the spiritually-possessed victims/victimizers to be—or rather *not* to be—seen in the yet-to-be-released Tamil ghost-hunter comedy **THILLUKU-THUTTU**, which will hopefully see the light of a projector at some point in the not-too-distant future

NEW TO REVIEW: HORROR CINEMA FROM INDIA PT. 1

As reported by **Tim Paxton**

I had just finished and handed-in my HUGE article on this same general subject for Monster!*'s "big sister" publication* Weng's Chop #10 *when I realized that I'd "somehow" overlooked covering a number of certain titles which should rightly have been included therein. Granted, said article—entitled "What Has Possessed You?! 50 Years of Indian Ghostly-Possession Cinema" (the loose Pt. 2 to an earlier piece I did for* WC*)—does cover more than 80 films in total. That's a LOT of movie-watching—especially at an average running time of over two hours!—and the project did take me over two years to gradually complete. So, you'd think I would be all through with that whole particular genre by now, right…?*

...WRONG!!

Waaayyy back in *Monster!* #7 (pp.46-64), I contributed a handful of pages on Indian fantasy films in conjunction with the first part of my article on Taiwanese Fantasy Cinema (which may well see a *second* part in these very pages someday! *[I'm all for the idea! – SF]*). Although I've covered the odd Hong Kong title in *M!* since then, I have yet to return to the subject of Chinese film; that will inevitably happen eventually, just not in this particular issue. Despite providing a fairly exhaustive backstory to my *WC* article (consisting of sociocultural as well as film-related information), I still have more to say on the subject of spiritual possession in Indian movies (we've long since established in these pages that ghosts and other forms of evil ethereal spirits are kinds of monster…at least to *us*, if not to everybody, it seems). In addition, as per this mag's format, I will also be concentrating on some fantasy as well as horror films—ones with actual *monsters* in them, of course!

To reprise/reiterate, while Western (Hollywood in particular) cinema, as with so many other places around the world, is largely lauded in India, our view of what their own industries have produced is all-too-often colored by cultural bigotry of sorts. This narrow-mindedness and "closed culturalism" on our part is key to the utter disdain—or perhaps just simple disinterested indifference?—which so many westerners seemingly feel towards

Promotional poster for (quote) "the first Tamil zombie film", 2016's **MIRUTHAN**

"Bollywood" product, what with all its musical interludes, ethnically-slanted comic relief, histrionics-filled melodrama and outrageous action; all of which aspects are most often products of their Southern Cinema branch of the industry. Some of the south's achievements include: S. Shankar's extreme example of their SF genre, **ENTHIRAN** (எந்திரன் [Tamil], 2010, a.k.a. **ROBOT** [in its Hindi-dubbed/US release form]), yet another by-product of the hi-tech "Terminator"-style action sci-fi subgenre; and S.S. Rajamouli's **BAAHUBALI: THE BEGINNING** ([Tamil/Telugu], 2015), a sprawling historical fantasy epic that broke box-office records all over the subcontinent. I guess you could call that latter one "the Indian **GLADIATOR**" (2000, UK/USA, D: Ridley Scott), just for the sake of another facile comparison—albeit chockfull of all the usual "southern weirdness", of course! (Incidentally, both those record-breaking B.O. blockbusters have already spawned sequels, naturally enough.)

Just in case you might be a first-time *Monster!* reader *[If so, welcome to the fold!* ☺ *- SF]*, I'll give you a bit of background on Indian Cinema: For starters, you may like to know that, unlike here in the West, where there is typically just a single major spoken-tongue per country, the subcontinent has no less than 17 official languages…

and each has its own separate, specialized film industry. Most outsiders do not realize this, and through simple ignorance merely assume that any film hailing from India is a "Bollywood" production. While much of what we see over here *is* from Bollywood—a.k.a. the Hindi-language film industry of Mumbai—most of my favorite Indian movies hail from the South Asian branch of the vast family tree: namely Kannada (dubbed "Sandalwood"), Telugu ("Tollywood"), Tamil ("Kollywood"), and Malayalam ("Mollywood") cinema. *[Speaking of Kannada—or rather, Canada, I should say!—I find it a shame that other movie industries worldwide always get stuck with "Hollywood"-based nicknames, as though Tinsel Town is the only sphere of reference on the planet. Hell, Toronto is commonly tagged "Hollywood North", FFS, even though we've been making our own movies up here (to varying degrees, for better or worse) for about as long as Hollywood has! Pardon this Canuck's interruption, eh! – SF.]*

As for **MIRUTHAN** (மிருதன் [Tamil], a.k.a. **CANNIBAL**, 2016, D: Shakti Sounder Rajan), it's a bone fide *zombie* film, so these days it wouldn't be at all out of place on the SyFy Channel, or Shudder, or any other online streaming service…or even on DVD (remember *those*?!), for that matter. The big deal about it is that, while it's been way-overtapped here in the West, Indian-made entries in this particular largely formulaic, tried-and-trusted (and some might say done-to-death [pun intended!]) horror subgenre are exceedingly rare indeed. Practically every filmmaking country in the world has had its share of zombie flicks, past and present, most especially in more recent years. But not so much in Subcontinental Cinema. In "Globalizing the Zombie", my editorial to *Monster!* #23 (our November 2015 "Zombified Edition!" [pp.2-4]), I did cover three such rare examples from India. Now, ghoulies and ghosties and *supernaturally*-animated corpses have always been at the heart of Indian horror; that much is a given. Still relatively unknown territory for Indian filmmakers, however, are scenarios involving *chemically*- or *biologically*-altered human beings (these typically all get lumped-in with the more traditionally-based kinds under the general heading of "Zombies"; which nowadays can even include those created via some sort of viral/bacterial contagion [etc.] which is passed on between still-fully-alive rather than "living dead" people; case in point those driven to uncontrollably commit insanely violent acts due to pesticide-tainted wine in Jean Rollin's grisliest film, **THE GRAPES OF DEATH** [1978; see p.181]).

So far as I know, the only other "legit" Indian zombie flicks besides **MIRUTHAN**, the present one under discussion produced thus far are **RISE OF THE ZOMBIE** ([Hindi] 2013, Ds: Luke Kenny, Devaki Singh)—which was loudly proclaimed as "India's first zombie movie" in the local press—**GO GOA GONE** ([Hindi] 2013, Ds: Krishna D.K., Raj Nidimoru), as well as the earlier Indian/British co-production **THE DEAD 2: INDIA** (2010, D: Howard J. Ford); all of which I devoted a few paragraphs each to back in *M!* #23. Given the not-so-grand total, I must say that is sure some *meager* pickings coming from a country that boasts fully SIX major film industries which produce *the* MOST movies *IN THE ENTIRE WORLD* per annum!

I am still unsure exactly why it is that India hasn't unleashed more such movies on us, considering that zombies are *über*-popular the world over in all media right now, and have been for at least the better part of the past decade straight. Ever since the original **NIGHT OF THE LIVING DEAD** (1968, USA, D: George Romero) and all the official/unofficial sequels/spinoffs and innumerable rip-offs made since there have been at the very least a dozen—and that's a conservative estimate—zombie flicks produced in the West and other parts of Asia even during the slowest of years. Rather than coming about as a direct result of supernature (as in many films from the past), reflecting mankind's universal anxieties about more modern-world possibilities (such as potential devastating global pandemics and the like), the majority nowadays tend to be based on some sort of contamination which either causes the dead to rise or the living to "turn" zombie.

Yes, there are of course the supernaturally-bent walking dead flesh-eaters of Italian filmmaker Lucio Fulci in films which, personally, I prefer over the kind that dwell on more real-world fears, such as pandemic-spread infections or some sort of environmental contamination producing killer corpses or zombie-like "regular" humans that then go on sociopathic rampages in hordes. By rights, what with India's higher instances of communicable diseases than many other countries and their various ecological issues, such as contaminated drinking water supplies and such, those lines of thinking should have seen at least a score or more Indian zombie flicks being produced since the 1970s! But then again, perhaps those very reasons might well be the core cause of why such films are so seldom produced in the homeland: for the simple reason that it strikes much too close to home for comfort in the eyes of most Indian moviegoers?

Whatever the case may be, instead we got—and *still* sometimes get!—numerous clones/knock-offs of **THE OMEN**, **THE EXORCIST** and **CHILD'S PLAY**, wherein spiritual/demonic possession or the reincarnation of some evil *aatma* ("soul") is key to the horror. There have been a few magically-reanimated monsters (with even fewer minor "walking dead" exceptions, such as the actual marauding *mummy*—an even greater rarity than the zombie in Indian cinema!—of 1987's **DAK BANGLA**, a Ramsay Family-made production which I covered all the way back in *Monster!* #2 [p.39]). I've lost track of how many zombie flicks have been made since Paul W.S. Anderson's video game-based movie franchise-starter **RESIDENT EVIL** and Danny Boyle's **28 DAYS LATER** (an unofficial British "remake" of Umberto Lenzi's classic **NIGHTMARE CITY** [*Incubo sulla città contaminata*, 1980, Italy/Spain]!) both did their bit in jump-starting the

MIRUTHAN (2016) runs the gamut of zombie clichés. In it, a horrid monster-making virus runs amuck due to a deadly toxic chemical spill at a secret government laboratory. The zombie subgenre is still a novel concept to Indian filmmakers, and all "our" old tropes are pretty much new to them; when it comes to undead antagonists, more ethereal ghostly entities rather than corporeally-solid walking corpses are more their bag

genre anew in 2002.[1] Indeed, biologically-created pandemic zombies running about madly—rather than slowly shuffling/shambling, as in the "old" days—have come to greatly outnumber the more paranormal variety in more recent years, and their kind keeps right on coming by the horde to this day, with no signs of ever slowing down. Some of my new millennial walking dead favorites have included **MUTANTS** (2009, France, D: David Morlet [see *M!* #4, p.56]), **THE HORDE** (*La Horde*, 2010, France, Ds: Yannick Dahan, Benjamin Rocher [see *M!* #4, p.56 and *M!* #23, p.39]), **COCKNEYS VS ZOMBIES** (2012, UK, D: Matthias Hoene), and **TRAIN TO BUSAN** (부산행 / *Busanhaeng*, 2016, South Korea, D: Yeon Sang-ho).

Our present film from India, **MIRUTHAN**, released last year, falls squarely into the "chemical accident-created" monster trope. Even before the credits roll we get the typical opening disclaimer for any modern (post-1977) Indian horror or fantasy film. I can understand all their movies' cautionary "Smoking Kills" notifications (which even pop-up *within* the actual action of the films themselves during scenes showing actors puffing away!), but this following warning boggles the western mind: *"THE VISUALS OF HORRIFYING FACES, BLOOD ON HUMAN BODY AND SPILLING OF BLOOD WHILE ATTACKING ARE ALL CREATED THROUGH SPECIAL EFFECTS AND COMPUTER GRAPHICS. SOUND IS DESIGNED TO SUPPORT THE VISUALS."* (Reading between the lines of this notice, it literally screams: "This shit is *fake*! Do not under any circumstances be foolish enough to believe in the existence of zombies!")

Now that's out of the way, the film opens with a rousing—albeit at the same time rinky-dink—dubstep theme playing over some simple title graphics. Cut straight to a group of men in yellow hazard suits loading barrels of toxic waste onto a company truck. They accidentally drop one canister, its lid pops open, and black smoking ooze spills out... Immediately, I think, *Hmmm, this looks like a probable* ***RETURN OF THE LIVING DEAD*** *clone...* The workmen hastily reseal the breached barrel, hustle it onto their truck, then speed away. Later, a passing mutt laps-up some of the spilled goo, which shortly transforms it into a zombie dog: with its flesh falling off and glowing red from some inside source. This zombified canine proceeds to attack a man on his way home from work; who in turn bites both his wife and their daughter, who then attacks a stranger outside their home, and so on and so on... *And so* starts the plague in formulaic fashion. Cut to a graduating class of police recruits, and we are introduced to the main players: Tough, no-nonsense police captain S. Karthik (Jayam Ravi) also serves as loving brother to his precocious little sister Maria (who is forever trying to set her single big brother up with a "new mama"). Karthik has a chubby sidekick by the name of Chinamalai (Kaali Venkat, who has starred in a number of Tamil-language Southern Indian horror films, including **PIZZA II: VILLA** [(பிஸ்ஜா 2, 2013 D: Deepan Chakravarthy] and **DARLING 2** [2016, D: Sathish Chandrasekaran]) investigate some mysterious attacks by local zombified citizens. Because of the investigation and an unintentional slight of a local big man, his daughter disappears. Karthik is then attacked by one of his apartment neighbors, a young girl who has turned into a hideous little monster with only one eye and a chewed-up face. He destroys the girl and a thuggish brute, noting how long it takes for their mutation to occur from "bite" to "fright" (*à la* **WORLD WAR Z** [2013, USA, D: Marc Forster]).

We later learn that the cause is some type of chemically-induced virus which is introduced into humans' bloodstreams through their being bitten by others. An order of "shoot to kill" is put into effect by the authorities and, placed under martial law, the city is in a state of panic, with rioting, looting, shops getting closed down, etc.—all set to a *horrible* Tamil "rock-and-roll" soundtrack! Karthik subsequently discovers that his sister was kidnapped by the owner of the very laboratory responsible for creating the deadly virus in the first place, and he eventually locates her at an isolated lab which is working on a cure for the plague.

The dance numbers are truly mind-numbing, and for those of you who may be wondering: yes, director Shakti Soundar Rajan does indeed plagiarize more than a few western-made movies! Including

1 There are a number of zombie films of note made prior to 2002, of course, but I am not going to get into that too deeply at the moment other than to cite a few examples here. Other films involving non-supernaturally-created zombies include Jorge Grau's "sonic pesticide"-activated **THE LIVING DEAD AT THE MANCHESTER MORGUE** (*Non si deve profanare il sonno dei morti*, 1974, Spain/Italy)—which, come to think of it, actually *does* have a secondary potentially more paranormal component besides its primary technological cause for the dead's rising—as well as Jean Rollin's hazardous waste-created **THE LIVING DEAD GIRL** (*La morte vivante*, France, 1982 [see p.190]), Dan O'Bannon's aforementioned **THE RETURN OF THE LIVING DEAD** (1985, USA)—with its chemically-traumatized reanimated corpses seeking that now-popular deadhead delicacy: (human) "*Braaaaaiiiiins!*"—plus Fred Dekker's alien parasite-driven **NIGHT OF THE CREEPS** (1985, USA [see *M!* #26, p.38]), Wilson Yip's comedy horror **BIO-ZOMBIE** (生化壽尸 / *Sun faa sau si*, 1998, Hong Kong), with its bio-weapon-created critters; and so on and so forth.

the concept of the unruly undead invading a shopping mall—which, as any horror fan will know, was originally central to the plot of Romero's **DAWN OF THE DEAD** (*Zombi*, 1979, Italy/USA); although my guess is that Rajan was probably "influenced" by the more hyperactive variety of deadhead seen in Zach Snyder's 2004 remake. Then there are various plotlines lifted from the above-cited **WORLD WAR Z**, too. Last, but not least, the entire "Karthik vs. the zombie horde" sequence during the climactic battle whilst surrounded by the undead with his guns blazing was—well—lifted from the aforementioned French flesh-eater favorite **THE HORDE**; I don't think it's just mere coincidence that Jayam Ravi's Capt. Karthik even *looks* a lot like Jean-Pierre Martins' thuggishly intense Ouessem character from that other film.

Another one from the zombie/scientifically-created monster bargain bin is the Telugu film simply known as **6** (2012; D: Srikanth Lingaad), which is about as close to a Frankenstein flick as you're going to get out of India these days. There were precious few to begin with, with films like H.N. Singh's **KHATRA** (1991 [see *M!* #25, p.40]) and maybe the entire **SHAITAN MUJRIM** (1979) / **KHOONI DARINDA** (1987) "series"[2] being the only ones that readily come to mind. The present movie reminds me of Eddie Romero's *Blood Island* films, made on even less of a budget with none of the gore, nor even a decent monster to be had. The story takes place in a village deep within the remote Nallamala

Scene Stealers: Blatant plagiarism is nothing new for Indian filmmakers. When scenes from another film (sometimes even *entire* films!) "inspire" a director to make movies based on "their own original ideas" (*not!*), that's how we wind up with the copycat likes of **MIRUTHAN**'s Captain Karthik *[above]* facing down an entire army of zombies alone—much along the lines of how the gangsta thug Ouessem *[below]* does in the French Z-horror, **LA HORDE** (2010)

2 A mad scientist creates a vampire from a living corpse in both films, which are somehow related. This mystery is discussed in *M!* #19 (p.12) and *M!* #23 (p.119).

The wild-eyed mummy monster from the movie known only as **6** (2012); which is, yet again, another zombie-like offspring of weird viral experimentation

forest, where the inhabitants are terrified to go out after nightfall, lest they fall prey to a hungry ghost prowling the vicinity. People are dropping like flies after getting caught out after dark, with their corpses found the next morning drained of blood.

This mysterious entity that is attacking and killing folks proves to be the reanimated corpse of Vijay (Jagapati Babu), a popular research doctor whose wish was to aid the poor, who was also the boyfriend of a local woman by the name of Tripura. Seems that, while they were out on one of their many romantic strolls through the jungle together, a sudden storm rolled in, during which Vijay got struck by lightning and killed. He is immediately buried instead of being burned (he is a Christian apparently, as are many of the monsters that are brought back from the dead in Indian cinema), and Tripura grieves nightly beside his grave. As Tripura weeps over his headstone she is approached by the local mad scientist, who offers to bring her lover back from the dead.

Her benefactor—who is decked-out in the standard Indian "mad scientist" get-up: glasses and beard, with a wild "Einsteinian" fright-wig—suspects that Vijay was only clinically dead (whatever *that* means!), and that, by way of his specially-concocted viral serum used in conjunction with a unique chemical-soaked full-body-wrap, he was able to bring the man back from the beyond. The big drawback to this medical triumph is that Vijay has now become a bloodthirsty "mummy", who hunts his victims nightly from 6:00 p.m. to 6:00 a.m. sharp. A determined scientist, along with Tripura and the local police inspector, lead a crack squad of monster-hunters into the thicket surrounding the village in search of Vijay (*à la* **PREDATOR**, which a few scenes here emulate), taking with them a couple doses of an antidote to the alien virus that is controlling the monster.

There are a few oddly striking scenes sprinkled throughout **6**. One of the best comes when the monster Vijay walks *down* a tree. Now, *that* was pretty eerie—at first—although it was thereafter reused so often that it ruined the initial startling effect due to simple repetition. I was generally surprised at the quite considerable amount of wirework was used in the action sequences. I would have thought that CG would have been utilized far more than it was. We do get some unconvincing, sub-video game quality graphics (I'm thinking *The Sims* here!), which were utilized to show a vulture flying overhead, an aerial view of the village, plus a few other images which could easily have been shot with a drone or something other than shit CG. Wrapping the monster up in tatty cloth windings as a mummy is also a good way to save a buck or two: as in no expensive, elaborate full-body costume or crappy CG required! Indian filmmakers have almost always had an aversion to using full-body or prosthetics-endowed monsters for their movies. Some filmmakers during the '80s and '90s—such as the Ramsay Family, Vinod Talwar and Mohan Bhakri—tried their hand at full-body monster suits,

Promotional web-ad for **6**

with interesting results. But when computer graphics first made a splash in Mahesh Bhatt's 1992 were-tiger film **JUNOON** (to be covered jointly by myself and Steve F. next issue) and, in a much more spectacular manner, Kodi Ramakrishna's **AMMORU** (1996 [see *WC* #4]), well, that pretty much put the kibosh on practical effects in Indian monster movies from then onward. In this post-Ramsay world, I was surprised to see the monster in **6** looking like a mummy, with some odd-looking post-production "eyes" added-on for effect. I'm guessing that, at age 50, actor Jagapati Babu, Vijay's performer, didn't want to get all wound up in the costume himself, so a stunt stand-in was used in his place, with Babu's rather penetrating eyes being digitally added later for close-ups.

The mummy-like superman wipes out the police force without much problem, eventually catching up with his creator too. In classic monster movie fashion, their meet-up results in the maker meeting—well—his maker, this when Vijay quite literally stomps him to death before he can administer the anti-vaccine. Vijay then turns on his ex-girlfriend and starts to choke the life out of her, but not before she delivers a needle full of the concoction into his neck. The creature's body reacts to the potion, and Vijay tumbles over dead for a second time… this time for keeps (?). Tripura then returns to the village and honors her late boyfriend's message of hope.

6 ends up not so mind-numbingly bad as I had imagined it might. It's just plain old "meh", with the obligatory music video track, this time a Telugu rap-pop song called "Andhamaina Teenage (F)", along with some outtakes and gag reel stuff. What the film *does* have going for it is its

Oh, But The Subcontinental Cinemagoer Does So *LOVE* Their Cheap CG! Two excellent examples originate from virtually opposite ends of the spectrum… **Above:** The almost-comical demons from such fantasy films as **DAMARUKAM** (2012). **Below:** And then there is also the fantastical snake demon from the Disney-produced **ANAGANAGA O DHEERUDU** (a.k.a. **ONCE UPON A WARRIOR**, 2011) too

monster. Granted, this *is* just a reanimated corpse wrapped in linen. Nothing too gratuitous. But it made me think, just *where are* all the monsters in Indian films? Sure, ghosts and possessed folk abound; seems like you can't spit without hitting some greasepaint-faced possessed soul. But *monsters…* not really. Vikram Bhatt tried it recently with **CREATURE 3D** (Hindi, 2012 [see *M!* #10, p.11]), but that was a total bomb. Occasionally demonic beasties do pop up in fantasy films, like the Disney-produced **ANAGANAGA O DHEERUDU** (Telugu, 2011, D: Prakash Kovelamudi), and **DAMARUKAM** (Telugu, 2012, D: Srinivasa Reddy) In **DAMARUKAM**, a huge horned ogre

2016's **KAASHMORA** features a snarling ancient warrior wizard who returns from the dead to cause havoc

causes havoc for the hero as he battles an evil *tantrik*. Being Southern, CGI played a major part in the film's effects, and the ogre is typical of that industry's standard. Kodi Ramakrishna's angry goddess film **AMMORU** (Telugu, 1995) paved the way for CGI in the Telugu, Tamil, and Malayalam industries. It doesn't seem to hurt that most of the effects—and especially the creatures, unfortunately—are not all that well-rendered, which probably boils down to how quickly and *cheaply* these films are made.

KAASHMORA (*"Deadly Spirit"*, 2016) is a rather well-done Tamil fantasy/horror comedy that deals with white vs. black magic and fakery vs. actual supernatural powers. Its use of CG is handled better than most of it contemporaries.

As for the glut of religious fakery that is endemic to Indian culture... Other films like to take the piss out of the wide variety of fake *babas*, *yogis*, masters, *tantriks*, and other so-called "holy" men who are only out to scam cash from their worshippers. Not unlike the fundamentalist faith healers that prey on the gullibility and ignorance of their flocks in America. Imagine the type of money-grubbing Fundamentalists we have here in the States, but magnified a *thousand-fold*! **KAASHMORA** opens with an "actual" supernatural event when a vulture steals holy *tantara* palm sheets from a temple and delivers them to a monster. We then cut to Kaashmora (Tamil actor Karthi), a popular TV holy man from a family of *fakirs*, who tricks his followers into believing that he can not only perform actual magic on stage but also defeat the forces of black magic. To help finance his "magical" empire, Kaashmora also runs other con-jobs along with his shady family and a network of *fakirs*. Unfortunately, after trying to pull one con too many, he ends up ripping-off the city's #1 gangster. To make matters even worse, after he comes into contact with a young college woman named Rathna (Nayantara),

things begin to get *weird*, and Kaashmora's phony-baloney acts of paranormal showmanship start giving way to *actual* supernatural forces messing with his reality...

Okay, we're one hour into this 160-minute flick, and things *just* start to roll. After all the fakery and farcical stuff, the *real* magic takes center-stage. Kaash is lured to an old mansion, where he encounters an assortment of *actual* spiritual forces, soon coming to the realization that he is somehow connected, through reincarnation (that old standby in Indian fantasy films), to the ghost of an ancient badass warlord named Rajnayak (also played by Karthi). It's the well-worn "Good vs. Evil" plot-path from then on in, but there are enough original moments that you don't get left feeling cheated by the time the end credits roll.

KAASHMORA benefits greatly from the deft direction of him known mononymously as Gokul, who is definitely someone to watch if he decides to stay within the fantasy/horror genre, as this is only his third feature film, and it is so much better than much of what came out of the Tamil film industry last year. The humor is subtle, and no one is mugging throughout their scenes. Actress Nayantara was also in the ghost-possession film **MAYA** (Tamil, 2015, D: Ashwin Saravanan), the James-Bondish **IRU MUHAN** (Tamil, 2016, D: Anand Shankar), and as the goddess Sita in the late director Bapu's blockbuster devotional, **SIR RAMA RAJYAM** (Telugu, 2011). In **KAASHMORA**, Nayantara balances her character out nicely between sexy and serious, and I look forward to seeing her in another fantasy-based flick.

One thing that Southern Cinema is good at, and known for, is the insane cross-pollination that goes on between the Telugu-, Tamil-, Malayalam-, and Kannada-language film industries. One prime example is **NAGAVALLI** (Kannada, 2012, D: Ku-

mar), which is also known as **KALPANA HOUSE** in its 2014 Tamil dub, which should not be confused with the 1989 Malayalam movie **KALPANA HOUSE**, directed by P. *Chandra*kumar (see *M! #24, p.94*), which can be found retitled as **BANGLOW No. 666** under its Hindi-dubbed release on home video or via streaming services. To make matters even more confusing, another of Chandrakumar's films has been given the alternate title of ***KHANDALA*** **HOUSE**, which is one of two reedited versions of the director's **CHUDAIL: THE WITCH** (1998 [see *M! #27, p.36*]).[3] Both of these former Kumar films are vastly superior to **NAGAVALLI**, the present entry in the spiritual possession genre under discussion, which has also been released in a Telugu version as **KALPANA GUEST HOUSE**, with the bogusly erroneous release date of "2015" stuck on it (YouTube is notorious for these kinds of intentionally misleading mislabelings, making my job of sorting out the facts a tough one!). Nevertheless, the parts that *do* work in the film are pretty bizarre... and steeped in oodles of cheap greasepaint!

It's a warm summer night, the full moon is high, and a gang of partying twenty-somethings are drinking, smoking, and making-out in a park nearby to a local walled guest house known as the Kalpana Estate (or guest house), and on the grounds of this house is a lonely tomb... Bored with her boyfriend, a girl leaves the party to go for a stroll alone. She stops under a banyan tree, thinks twice about her boyfriend, then hammers a note for him into its bark. Suddenly she is attacked by a ghostly skull! Her lifeless body is discovered by her friends the next morning. Cue the title sequence...

That pre-credit sequence sums up **NAGAVALLI** quit neatly. Here, in the hi-tech 21st Century year of 2015 (or 2012; the actual production/release date is unknown), we still have a movie that uses a fright wig-topped plastic skull with googly goggle-eyes as its "horrifying menace"! These highly-practical (!) effects come complete with a visible string, via which the so-called ghost goes bobbling along on. And that skull? Why, it's merely an inexpensive

3 *Kalpana* is a Hindi girls' name, meaning "Imagine" or "Fantasy"; while the term *Khandala* means a quiet/silent, deserted place where people don't go, as nobody lives there. **KALPANA HOUSE**, then, can translate as "Ghost-Girl House", while **KHANDALA HOUSE** means "The Deserted House", which makes little sense if you know the film **CHUDAIL: THE WITCH** (1998). I'm sure it makes more sense in context to the culture, but I also suspect that all these retitlings have more to do with simple deception rather than being actual, legit titles. Just for the record — you know, to help keep things clear, and confusion to a minimum — **KALPANA GUEST HOUSE** can also be found under the name **KALPANA HOUSE** in its Tamil dub.

Halloween prop, is all. If Kanti Shah and his crew were still releasing their films on a regular basis, then you could say **KALPANA GUEST HOUSE** has "*that*" look and feel to it.[4] This is 100% pure, no-frills, dimestore horror! I had no idea quite *what* to expect after this wacky introduction.

What does follow is so typical of the possession genre when we are introduced to Rajeshwari (Madhushalini) who is the pampered wife of Auditya (Venu), a local police detective who decides to take his family to visit his ancestral home out in the country. Yes, it *is* indeed the very same mansion wherein that young woman was killed by that ghost! No sooner have they arrived than the couple's car mysteriously stalls as is pulls into the driveway and passes by the family crypt. And if you have seen as many of these films as I have, you know that, once a car stalls-out *anywhere near* to a spooky spot in an Indian horror flick, well, some ghostly entity is sure to latch onto someone shortly! And indeed, the ghost here does seem to take a fancy to Rajeshwari, so it follows them to their summer home. It then begins to go around systematically terrorizing the family (which also includes the detective's nephew, his girlfriend, and the mute groundskeeper). At first it's only *little things*, like the rattling of pots and

4 In fact, Shah and Sapna *are* still in the film business, it's just that I can't seem to be able to track down any of their latest efforts. But it's not for want of trying, I can assure you! I've been searching for Kanti Shah and/or Sapna's latest films for the past few years now. They have made the odd supernatural title that has a trailer, but the actual movies themselves are nowhere to be found. I'm keen on seeing their **MMS KAAND** (2014), **HAUNTED JUNGLE** (2016) and **OLD GHOST HOUSE** (2016), though.

Promotional poster for **NAGAVALLI**

Greasepaint ghost #1 from **NAGAVALLI**

odd echoing whispers in people's ears. Then it jumps to possession, murder and, finally, wild uncontrollable revenge when an exorcism attempt by a *tantrik* fails to oust the evil spirit. The ghost proves to be that of Nagavalli (Daksha Mahendu), a young woman and former lover of Auditya who had burned to death in an accidental, drunken immolation. Having now returned to Earth in ethereal form to torment the living, she is hellbent on destroying everything near and dear to Auditya—who, being such an asshole, probably deserves some punishment!—up to and including all of his family members.

There are three major factors which make this rare Kannada horror film worthwhile: Firstly, there is little in the way of comedy, and all we really get is a brief encounter with two goofy police detectives, complete with "zinger" sound effects, doinky synth stabs and some serious mugging. Then, as well as a refreshing dearth of dumbass comic antics, we have the film's next saving grace(s)—aside from the lack of any forgettable musical numbers (there are none at all, which is both odd and welcome)—which are the *verrry* practical effects and crude makeup for those before-mentioned spooks. The thick coat of white greasepaint and blackened eyes of an actor playing a "possessed" young man may look like a cheap, cheesy effect; and it *is*, to some extent, of course. However, it also plays into the traditional fear of the Southern albino ghost called a *mohini devva*. The clownish look of the ghost plays into my own personal belief that, the more bizarre a creature appears in a film, the more likely that might be how an *actual* supernatural entity would appear, if it existed. Who's to say that malevolent ghosts *don't* look ridiculous, and that invading aliens *can't* resemble Hello Kitty?!

The big payoff, of course, comes when the sexy Rajeshwari gets possessed by the ghost. Instead of that gorgeous lead actress, we are now presented with a hideously-disfigured horror that resembles a woman who had been severely burned—or rather, a half-assed makeup job which tries and give the audience a sudden cheap jolt! Odd as this is, it's only her face which is transformed into a hideous visage, while the rest of her appears just fine. Which brings me to **NAGAVALLI**'s third and final plus: its leading lady. Cute, sexy, and a decent actress to boot, Hyderabad-born Madhushalini (a.k.a. Madhu Shalini). A minor starlet of Telugu and Tamil (and in this case Kannada) cinema who got her big break appearing in two films by Ram Gopal Varma, Madhushalini scored a bit-part in the director's 2012 Hindi crime drama **DEPARTMENT**, and went on to appear in her first supernatural film with his **BHOOT RETURNS** (also in 2012). Since starring in **NAGAVALLI**, her future roles have included a bit-part in **ANUKSHANAM** (Telugu, 2014, D: Ram Gopal Varma), another low-budget greasepaint spook show called **POGA** (Telugu, 2014, D: Marthand K. Shankar), and the yet-to-be-released (though completed in 2014) goddess film, **SEETHAVALOKANAM** (Telugu, D: Madala Venu).

As you may very well know by now, Indian cinema has built a reputation as being the biggest plagiarist of ideas around. I've covered all sort of unofficial remakes and outright rip-offs of Western (and some Asian) film properties. One of the biggest sources for Indian horror films other than the unholy trinity of **THE EXORCIST, FRIGHT NIGHT** and **CHILD'S PLAY** is Sam Raimi's *Evil Dead* series. **BACH KE ZARAA** (Hindi, 2008, D: Salim Raza) has got to be one of *THE* most glaringly obvious rip-offs in the history of Indian cinema, stealing as

Greasepaint ghost #2 from **NAGAVALLI**

it does so shamelessly from the first two *ED* entries, **THE EVIL DEAD** (1981) and **EVIL DEAD 2** (1987, both USA); I'm assuming that the costliest third entry in the series, the medieval period piece **ARMY OF DARKNESS** (1992, USA), was just way too outside their budgetary scope for them to bother even trying to copy it. That said, **BACH KE ZARAA** is fun in a knuckleheaded way... much like the movies it does its darnedest to mimic. **BACH KE ZARAA** follows the misadventures of a gang of twentysomethings as they are possessed and/or killed-off one by one by an evil ghost in an abandoned cabins deep in the woods. There is no actual gore in the film, and much of the bloodshed is offered off-screen, although we do get to see some actual monsters for once, which makes a nice change. Doesn't hurt that the director Salim Raza's name *kinda* sounds like... yep... "Sam Raimi", either!

As I mentioned above, India has a *lot* of official languages, and each has its own individual film industry. I have recently been intrigued by the output of "Ollywood" (!): the Odia-language film industry. Odia is a small state on the East coast of India. Its film industry goes all the way back to the 1930s, with their first ever production being a mythological film based on the *Ramayana*, entitled **SEETA BIBAHA** (1936). As far as the horror genre goes though, two of the earliest entries (that I could uncover) are reported to be **DEKH KHABAR RAKH NAZAR** and **RAJANIGANDHA**, both from the 1980s; although those titles are yet to be confirmed. There *were* Indian films of those titles made in the '80s, but one is an action film and the other a family drama. So, the hunt continues on that score. I did find and review **PUTULER PRATISODH** (for *Weng's Chop* #4.5 [p.118]), a 1998 Bengali/Odia remake of the Kannada killer baby doll film **AATMA BANDHANA** (1990, D: Shreekaanth Methatha), which yet again borrows heavily from... **CHILD'S PLAY** (*go figure!*). Also, there *seems* to be a remake of the Kannada film **NAA NINNA BIDALAARE** (1979, D: Vijay), which had already gotten a Hindi remake by the same directot as **MANGALSUTRA** (1981, D: Vijay), starring superstar Rekha. Then there's **KANDHEI AKHIRE LUHA** from 1997, directed by Rabi Kinnagi, with its "...unique horror concept with family drama"[5]—whatever *that* means! Yes, it's yet *another* film I can't locate to review, even though there are bits and pieces of it up on YouTube.

Newcomer Sanjay Nayak seems to be the hottest ticket nowadays for Ollywood horror, and the guy

5 *http://incredibleorissa.com/oriyafilms/oriya-horror-movies-ollywood-films/*

VCD sleeve art for **BACH KE ZARAA**

has been pretty busy, producing over 20 films in under ten years. Not all of them are horror, though; as with most Indian directors, he ropes-in his audience using a "shotgun" strategy to grab their attention, then chops and changes from genre to genre hoping to strike B.O. gold. But like many Western filmmakers, he got his start in horror, his first film being **RAKHI BANDHILI MO RAKHIBA MANA** in 2002. Finding his films are a tricky proposition, but do they ever look good! From the teasers I've seen for three of them, we get a guy dying after being cut up with a sword, but his severed hand crawls off to seek vengeance; then there is the archetypically vengeful female spirit, and even one that looks like some kind of mystical child with its guardian spirit mother. However, since none of these films are available on either home media or on YT (only their musical numbers!), I am left to merely salivate over them sight unseen.

Except for **MITA BASICHI MU BHUTA SATHIRE 3D**, which is available for viewing in YouTube, although the quality is *horrendous* (it was ripped from some satellite feed then upped to YT in separate segments). Also, from all accounts, it seems that Nayak has remade **MY DEAR KUTTICHATHAN** (Malayalam, 1984, D: Jijo Punnoose), which was India's first ever 3D horror movie, even beating the Ramsay Brothers' **SAAMRI 3D** (Hindi, 1985 [see *M!* #14, p.85]) into cinemas by a few months. In this film, as with the just-cited **MY DEAR KUTTICHATHAN**, the ghost of a little boy is the key to finding a hoard of magical treasure, and he is hunted down by greedy *tantriks* who are eager to get their greedy mitts on the booty. At least, that is what the *original* version was about. It's hard to tell what the hell is going on in **MITA BASICHI MU BHUTA SATHIRE 3D**, but that doesn't bother me, as the film is full of wacky monsters and funky CG effects. Nayak's low-budget, if special effects-laden approach reminds me of a cross between the late Tamil director Ramanarayanan/Rama Narayanan's work (known for his wild Nagin, Goddess/Devotional, and SF films) and that of—yet again—Kanti Shah and his gang. **MITA BASICHI MU BHUTA SATHIRE 3D** is not to be confused with the 2016 Hindi film **BHAYANAK AATMA OF MARIA** (D: Sanjay Verma). Having only seen the teaser for that one, I can say with some confidence that it appears to be your usual vengeful female ghost story, with *tantrik* exorcisms and so forth; looks *horrible*, but I will still watch it!

What *I* want are more gritty black magic movies from India. I recall the time back in the '70s, '80s and '90s when Taiwan, Hong Kong, Indonesia, and other South Asian countries made some of the absolute *best* of that particular horror subgenre to be had anywhere: boasting wild wizard battles, killer ghosts, gruesome curses and skulking undead. Nowadays I try and recapture some of those same (or at least somewhat similar) thrills with Indian films. Not quite the same, though. Totally different aesthetics and religious aspect...and strict censorship over gore and nudity, along with archaic blasphemy laws make for some pretty chaste films indeed. And since we are on a roll with Odia-language films here, up next is **KAUNRI KANYA 3D** (2013, D: Soumya Ranjan Sahoo). Still, every once in a

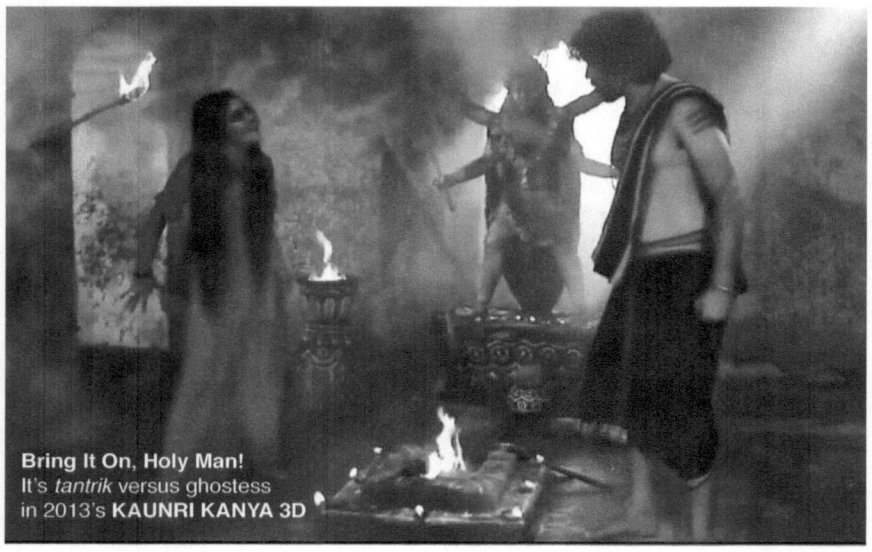

Bring It On, Holy Man!
It's *tantrik* versus ghostess
in 2013's **KAUNRI KANYA 3D**

Web promotional art for the Odia-langauge **KAUNRI KANYA 3D**

while, bits and pieces of films like **KK3D** do manage to surprise/entertain me. It isn't an overall great film, but it at least tries to scare-up some decent black magic thrills, so points for that. In this shot-in-HD effort, a young doctor by the name of Akash (director Sahoo) and his wife Riya (Kavya Kiran) relocate to a small village, where they bear witness to some brutality and superstitious beliefs in action among the locals. Before long, the couple are being haunted by the vengeful spirit of Anusuya (Prakruti Mishra), a woman who was beaten and burned alive by a group of villagers after she was suspected of witchcraft (something which *still* happens in India to this day). Seeking—what else!—revenge, the ghost takes possession of the wife and begins picking-off her killers one by one. There is an underwater ghoul attack which is pretty funky, and even a battle of the *babas* at the film's conclusion when we discover that an evil *tantrik* is controlling the ghost. **KAUNRI KANYA 3D** is an atypical greasepaint and CGI horror film in that it is fairly well directed and shot despite being produced on the most meager of budgets. Its two biggest faults being the auto-tuned musical numbers and any credible atmosphere due was lacking due to some inspired but unaccomplished cinematography probably due to the fact that this was a 3D film. For once the CG effects actually enhanced the film's supernatural moments rather than diminish them.

2014 FEAR OF THE YEAR (Odia, 2014, Ds: Tapas Jena, Pradeep Das) is pretty much the same deal. A group of college-age kids stop at a remote travel lodge and encounter evil forces. One at a time they become possessed and either turn into monsters or else are killed by their peers. Any film in the Odia language is a rarity (relatively speaking), and a horror film doubly so. Pity that **2014 FOTY** is another rip-off instead of an original idea, but some of the makeup effects—there is very little gore in the film—are passable enough. **BHAYANAK ATMA**

(2013, D: Sanju Baba) is still another Odia-language horror, and while it does "borrow" some elements from **THE EVIL DEAD**, at least the monster in this film is (somewhat) unique. Yet again, yet another group of young adults decide to party down at a creepy summer cottage, only to have an evil force crash their bash. The monster—a ghost-like entity which appears either as a floating CG skull or a shimmering, silver-skinned fanged creature—can both possess people ethereally and/or outright physically kill them with its corporeal claws. There are a few brief P.O.V. tracking sequences which remind one of the Raimi *ED* films, but overall **BHAYANAK ATMA** *is* kinda original; although I have a sneaking suspicion that the filmmaker is a fan of those low-budget Barons of Sleaze, The Shah Brothers, Kanti & Kishan. The film ends when the goddess Kaali intercedes, whereupon the last remaining survivor of the party is presented with the deity's holy *trishul* (trident) to slay the ghost. Once it is vanquished, those who were killed by the ghost are all miraculously revived. *Jai Kaali Maa!*

Just like in Sam Raimi's **THE EVIL DEAD**, the ghost-like zombies of **2014 FEAR OF THE YEAR** besiege a remote cabin-full of college kids

BOO! A lookalike scene from **2014 FEAR OF THE YEAR** which looks likely to be have been "influenced" (*you don't say!*) by **THE EVIL DEAD**

To put the capper on this article, I have two shout-outs:

BEWARE those insidious YouTube trailers which are assembled to sell you *"the most frightening film ever, and a new high in Indian horror cinema"*—even when what is up for grabs looks nothing like the advertisement. The 2015 Tamil film **DARLING** is the perfect (*not!*) example of this sort of sleazy hard-sell tactic. All the poster art and previews made this comedy out to be a spooky ghost film. Well, it *is* a ghost film, that much is not in dispute. Sadly, it is also a truly *horrid* comedy! A good-looking one from director Sam Anton, but the original Telugu ghost/possession film **PREMA KATHA CHITRAM** (2013, D: J Pradhakar Reddy) was marginally better. It is not to be confused with **DARLING**, the superior 2007 Hindi horror-comedy from Ram Gopal Varma, which, despite some serious overacting from its star Fardeen Khan, is worth watching nonetheless. There was a 2016 sequel to Anton's film called—small wonder!—**DARLING 2** (D: Sathish Chandrasekaran), which looks nothing like the first film judging by its poster and the teasers that I have seen. But looks can be deceiving…as was the problem with Anton's film!

TRIPURA (Telugu, 2015, D: Rajkiran/Raj Kiran) is another film which looks decent enough, but it's an overly-talky murder mystery that only really delivers in its final few minutes. A young woman is murdered by her boyfriend in a fit of rage. So, with a dead body in dire need of hiding, he walls it up in his house, which happens to be still-under-construction. Then, when

The fanged, oddly-shimmering demon from **BHAYANAK ATMA** (2013). Incidentally, for better or worse, in this the Digital Age, inevitably, computer-generated obfuscation/obscuration of critters in horror movies is all par for the course. But when used judiciously and creatively—as in the 2004 Thai humdinger **UNHUMAN** (see p.286) and the 2004 Nipponese nightmare **MAREBITO** (see p.150)—it can work quite effectively indeed in a film's favor

it appears as though another man's wife is channeling the final few minutes of his victim's life, the murderer must off the unsuspecting couple to keep his secret. Just when it looks like he'll get away with the dirty deed, the ghost of his murdered GF bursts out of the wall and puts an end to his evildoings. Not the best film of its type, by any means, and yet another one that advertised a spook which would only then show up right at the film's conclusion. The she-ghost—all-blue, with funky white eyes—makes for a decent enough monster, but had more of her terrorizing been depicted throughout the film, it would have been better.

Top: A classic blue-skinned spook with albino eyes, from **TRIPURA** (2015). **Above:** The Tamil film **MOOCH**, also from 2015, wherein we get a brief glimpse of the ghastly ghost with the glowering, glowing eyes

Last and very least for this issue's I-horror column, we have **MOOCH**, a 2015 Tamil film from director Vinubharath Y. **MOOCH** starts out with a very cool folk-horror feel, as a pregnant mother and her young son are fleeing the assassination of her husband by the mob. While on the run, they make it to an unfinished home out in the jungle, where the woman dies while giving birth to her daughter, whereafter the orphans are raised in her absence by a spectral being of unknown origin. Years later, the kids—having since gone feral, scampering around on all fours, covered in dirt with thick manes of dreadlocks—are discovered by some workmen. They are adopted by a kind family, who clean them up and give them a home. Little do their kindly foster parents know upon adopting the two jungle kids that their protective ghost is also part of the package deal; which proves to be a good thing, as the gangster who killed their father is out to finish the job by eliminating his offspring. Kudos to Vinubharath Y. for at least trying something different within the genre, although the overall effectiveness of the film falls flat.

On that note, I am outta here... More to follow in the next issue of *Monster!*

NEXT ISSUE: Still more Indian monster movies we have yet to cover.

And, coming soon: *The Zee Horror Show* episode guide. We are also working on the most-comprehensive (we *hope*!) article covering the Ramsay Brothers' TV productions from the 1990s!

H.P. LOVECRAFT & THE LOVECRAFTIAN IN JAPANESE CINEMA

by Cédric Monget

[translated for Monster! *from the French by Eric McNaughton, with additional input by the editors]*

Introduction: "Weird" Japan

The West has recently discovered in Japan a land of eclectic horror. In manga (still the most popular medium) in films (animated or not) which are being more widely broadcast, in books, more and more of which are now translated, Japan reveals an original vision of fear. But if the Western reception to all this is relatively recent; to the Japanese this fear is an ancient one.

There is, of course, in Japanese culture as in any culture, an important role for these tales and legends which attempt to give meaning to the everyday hazards of suffering and death common to humankind. There is, of course, that which is unexplained but which one believes explicable—then there is the rest… Spinoza says, somewhere, that chance is the asylum of ignorance. The truth is that, before speaking of chance, one speaks of gods and spirits; then, from there, ghosts, demons and monsters. Every misfortune, every pain has a meaning: that of a punishment, a malevolence. Whose? Of a dead man who refuses to disappear altogether because he has been harmed by a diabolical being whose wickedness or indifference to the lot of men is self-evident. In short, like any traditional culture, Japan is a world populated by the supernatural, and this is what is at the origin of their horror.

However, by its insular nature, in particular, the supernatural has taken on specific features to the Japanese. There is, of course, a whole tradition of ghost stories, often inspired by Buddhism and continuing with Chinese culture, well-known in the West through the work of Lafcadio Hearn (1850-1904), of whom Lovecraft thought most highly. But, in the case of Japan, it is a country also populated by strange creatures called Yōkai *(*妖怪*,* "monster", "strange apparition" or "ghost" [etc]*).* There are animals that can be transformed into humans (similar to the different types of European [et al] "were-creatures"), demonic ogres/trolls (鬼 / oni), warrior monsters (e.g., 天狗 / tengu, a.k.a. "heavenly dog"), and even ordinarily inanimate objects that become supernaturally animated *(*付喪神 *or* つくも神 / tsukumogami)—which seem particularly peculiar to us Westerners—plus many other baffling beings besides. In fact, it is enough to watch **YOKAI MONSTERS: SPOOK WARFARE** *(*妖怪大戦争 / Yōkai daisensō, 1968, D: Yoshiyuki Kuroda)[1] or its remake **THE GREAT YOKAI WAR** *(*妖怪大戦争 / Yōkai daisensō, 2005, D: Miike Takashi) to get some idea of the incredible teratological variety of Japan. As for those who wish to delve deeper into the subject, I urge them to visit author Zack Davisson's excellent website Hyakumonogatari Kaidankai, where they can find translations of these frightful stories from ancient Japanese literature.[2]

1 See Eric Messina's review back in *Monster!* #24 (p.61)

2 Said site's full title and subtitle is "百物語怪談会 Hyakumonogatari Kaidankai – Translated Japanese Ghost Stories and Tales of the Weird and the Strange" (@ *hyakumonogatari.com*); Mr. Davisson is also the author of the book *Yūrei: The Japanese Ghost* (Chin Music Press Inc., 2015), which is currently available for sale on Amazon.

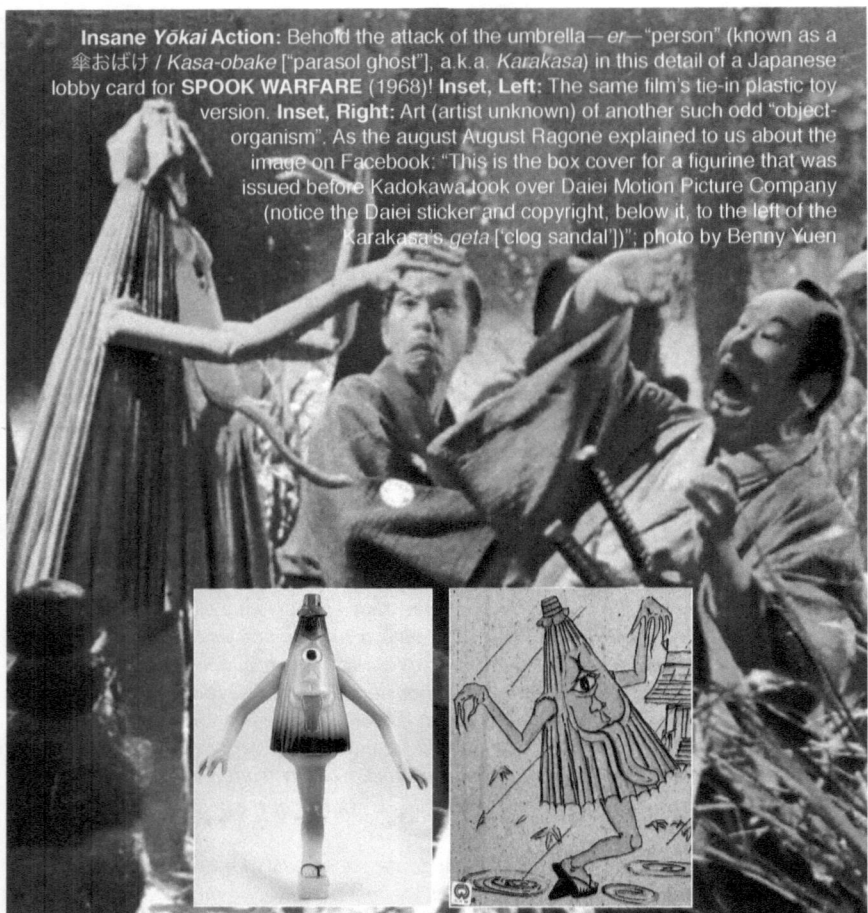

Insane Yōkai Action: Behold the attack of the umbrella—*er*—"person" (known as 傘おばけ / *Kasa-obake* ["parasol ghost"], a.k.a. *Karakasa*) in this detail of a Japanese lobby card for **SPOOK WARFARE** (1968)! **Inset, Left:** The same film's tie-in plastic toy version. **Inset, Right:** Art (artist unknown) of another such odd "object-organism". As the august August Ragone explained to us about the image on Facebook: "This is the box cover for a figurine that was issued before Kadokawa took over Daiei Motion Picture Company (notice the Daiei sticker and copyright, below it, to the left of the Karakasa's *geta* ['clog sandal'])"; photo by Benny Yuen

However, the modern Japanese horror which dominates today—so-called "J-Horror"—does not draw its substance solely from Japan's past. Its roots also draw on the lasting influence of European Gothic literature and its sequels. This arrived in two waves: The first with the work of Poe, following the forced opening of Japan to the West in the middle of the 19th Century; the second with the arrival of the works of Lovecraft following the defeat of Emperor Hirohito's imperial Japanese armed forces by the Allies in 1945. But in the end, the two waves merged to give birth to a true tsunami of terror, monsters and horror!

Perry & Poe; MacArthur & Lovecraft

In the kitbags of the occupying U.S. forces, paperbacks of the Armed Services Editions abounded.[3] One of them, No. 730, was a collection of 12 "selected ghost stories" from Lovecraft. *Ghost* stories? No, of course not, but no matter the editors' error, *The Dunwich Horror and Other Weird Tales* was read by GIs, reread, loaned, resold, lost, and in many cases, copies of this particular book eventually fell into Japanese hands. And not just *any* hands, in fact...

3 According to Wikipedia (@ *https://en.wikipedia.org/wiki/Armed_Services_Editions*): "Armed Services Editions (ASEs) were small, compact, paperback books printed by the Council on Books in Wartime for distribution within the American military during World War II. This program was in effect from 1943 to 1946. The ASEs were designed to provide entertainment to soldiers serving overseas... The small books were convenient for soldiers because they fit easily into a cargo pocket... Over the life of the program, over 123 million copies of 1,322 books were printed".

A disciple of Poe (of whom Lovecraft himself was likewise a disciple), Tarō Hirai (1894-1965), better-known as Edogawa Rampo—a pen-name derived directly from the name "Edgar Allan Poe"—read this collection and was left stunned by it. Possibly he may have received much the same shock as when he had first read Poe? Perhaps, if he had been younger, would he have consequently taken a different pen-name ("Ruwekarafute" [=Lovecraft])? In any case, he published in *Hoseki*, the horror magazine that he had just founded, an article in which Lovecraft was cited as an author to be read.

Meanwhile, Tadashi Nishio adapted HPL's 1919 short story "The Statement of Randolph Carter"[4]—not because the Japanese translation failed to capture the essence of Lovecraft, but because they made it their own; thus allowing the birth of a specific national "Lovecraftism" (for better or worse, see the *kawai*-zification of the Myth of Cthulhu). Thus, the following years saw the appearance, rather slowly and gradually, of other translations, but also of several adaptations in comics, too. One of the first was that of his 1928 tale "The Dunwich Horror" (first published in *Weird Tales* in 1929); this, early in his career, by Shigeru Mizuki (1922-2015), a *mangaka* ("comics creator") who was greatly inspired by American comics, but whose work was also firmly rooted in traditional Japanese horror. He was the creator, in 1960, of GeGeGe no Kitarō (ゲゲゲの鬼太郎 [originally known as 墓場の鬼太郎 / *Hakaba no Kitarō* / "Kitarō of the Graveyard"]), a ghostly child living amongst *yōkai*, but who also encountered monsters from other cultures in Asia, as well as European ones too. Such encounters are to be found in Mizuki's version of the Lovecraft story.

So as to better appeal to the target readership, everything in it is instead transposed to Japan, and adapted so as to be more immediately comprehensible to the Japanese reader. Hence, the town of Dunwich, Massachusetts becomes "Hatsume", a Japanese mountain village, while Miskatonic University becomes "Torikata University". The names of the characters change, too (i.e., nothing "Yankee"!). Protagonist Wilbur Whateley hides, more conveniently than in New England, the malformations inherited from his father under a kimo-

no. In the same way, the purely Lovecraftian material, the names of books and of gods which betray their origins, are absorbed and incorporated into Japanese culture, and it is Buddhist sutras that Professor Armitage, therein renamed "Aoyama", reads in the famous final scene of the unveiling of the terrible Yog-Sothoth (renamed, to ensure an unpronounceable name became more pronounceable to Japanese tongues, as... *Yōkai Yogurt*, no less!). In any case, it illustrates the local tendency to make Lovecraft a "sort of" Japanese author.

Cosmic Horror and the Atom Bomb

Now, part of the originality of Japan is not only in its supernatural tradition and its relation to horror. It is also because it has known the devastation of nuclear fire and then seen its maritime space become the playground of the crazy scientists of the atomic age, during tests which were sometimes lethal for the indigenous peoples, as well as for Japanese sailors besides. Thus, **GODZILLA** (ゴジラ / *Gojira*, 1954, D: Ishirō Honda) begins with a mysterious explosion and the successive disappearances of several ships—it's hard not to be reminded of the 23 crew members of the Jap-

Lafcadio Hearn (known in Japan as 小泉 八雲 / Koizumi Yakumo) and his Japanese (second) wife Koizumi Setsu, to whom he remained married from 1891 until his death at age 54 in 1904; they had four children together

4 First published in *The Vagrant* (May 1920). The story has been adapted to the screen on a number of occasions (at least a half-dozen times) as short films since the start of the 2000s alone. Its best-known adaptation to date is arguably **THE UNNAMABLE II: THE STATEMENT OF RANDOLPH CARTER** (1992, USA, D: Jean-Paul Ouellette [see Tim Paxton's review in *M!* #26, p.27]).

1945 US military photograph of the Hiroshima atomic mushroom cloud

the dramatic monster, the *kaijū* (怪獣), the famous Godzilla, whose name, for the Western ear, intermixes a fantastic etymology of both deity and animal (i.e., "gorilla") in a synthesis which evokes the materialist horror of Lovecraft. That said, it is almost certain that the film owes nothing whatsoever to the influence of the author from Providence. However, there are many thematic similarities between them (e.g., lying dormant between sleep/death down in the ocean's depths, the gigantic nature of the threat, its illogical existence which eludes the ken of men, et cetera). That is why there is an almost quasi-messianic expectation of many fans for a film about Godzilla vs. Cthulhu! In short, Godzilla was *not* a Lovecraftian film, but in the minds of a growing number of people, it has, in a sense, *become* one.

anese tuna-fishing boat Daigo Fukuryū Maru (第五福龍丸 / "Lucky Dragon No.5") who were involuntarily irradiated by nuclear fallout in March of the same year by the then-largest nuclear bomb ever to be tested by the United States.

Then, in this inspired and influential film, comes

If Ishirō Honda's lengthy career began with Gojira/Godzilla, it certainly didn't end there. In 1963, he directed **MATANGO** (マタンゴ), possibly the first example of Japanese cinema to clearly possess a discernibly Lovecraftian dimension, even if it is only indirect at best. Honda, who considered the film to be one of his best, was actually inspired by "The Voice in the Night" (1907), a short story by William Hope Hodgson (1877-1918), an acclaimed English author who was a direct influence on Lovecraft. In order to adapt the story to better suit Japanese

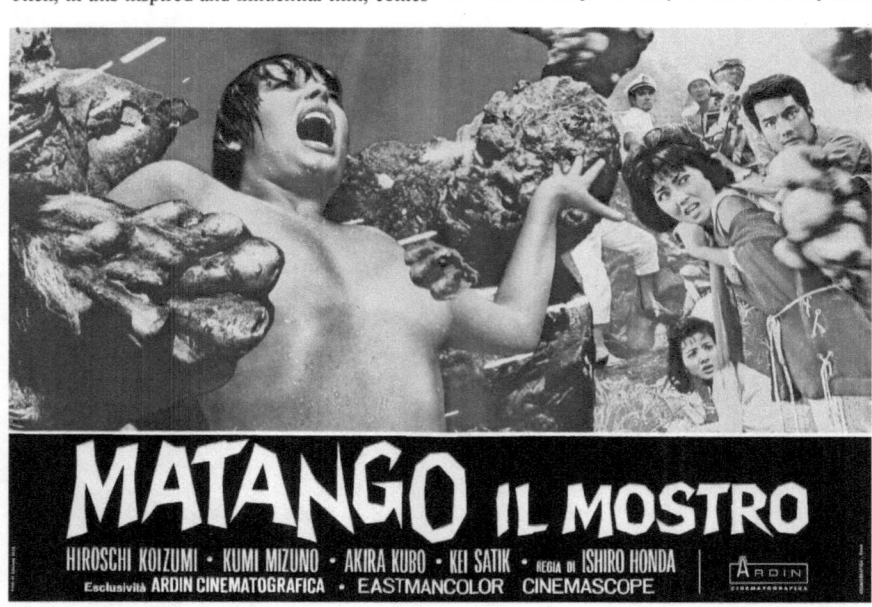

Them Saucy Italians! ☺ A bizarrely "sexed-up" cut'n'paste 1970s Italian *fotobusta* for **MATANGO**. (*Note:* The tactfully-covered nude girl is none other than German actress Andrea Rau in a shot "borrowed" from Harry Kumel's erotic vampire sleeper **DAUGHTERS OF DARKNESS** [*Les lèvres rouges*, 1971, France/Belgium/West Germany])

Funguys & Fungals: MATANGO's monstrous mushroom people provoke eeks from all

tastes, for the occasion Toho Productions recruited two native sci-fi authors, Masami Fukushima (1929-1976) and Shinichi Hoshi (1926-1997), both of whom were highly knowledgeable in regards to how things were done here in the West. It's interesting to note that the spirit of horror in **MATANGO** is of quite natural—as opposed to supernatural—origins, and scientifically-based. The authors were not writers of outright fantasy or horror as such, but rather of science fiction and, moreover, both possessed a special sensitivity to scientific accuracy. Indeed, Fukushima leans more towards hard science fiction (he rejected the "Space Opera" style of pulp sci-fi, and had translated some of intellectual British SF figurehead Arthur C. Clarke's writings into his native tongue), while Hoshi devoted part of his work to the career of his grandfather Yoshikiyo Koganei (1859-1944), a doctor trained in Germany who was a pioneer of anatomical dissection, anthropology and histology in Japan.

The result of the work of these two authors is shaped by scriptwriter Takeshi Kimura (1912-1988), who often worked in collaboration with Ishirō Honda. **MATANGO**'s structure is almost completely Lovecraftian in that it corresponds to some of the narrative tricks frequently used by the author (such as an unreliable first-person narrator, a retrospective narrative, etc). A man visits a professor detained in a psychiatric asylum. The professor claims he is not crazy, then proceeds to relate his fantastical story to his skeptical visitor. It is this narrative which constitutes the main part of the film, that in effect is nothing but an extended flashback sequence.

A group of intellectuals and artists take a pleasure trip on a yacht. Following a storm at sea, their ship, rendered helpless and floundering, runs aground on the shores of an island covered with mushrooms (the European viewer cannot help thinking for a moment of a dark version of Belgian cartoonist Hergé's tenth Tintin adventure, "The Shooting Star" [*L'Étoile mystérieuse*, 1941-42]). In search of food, the castaways discover the wreckage of an abandoned boat completely covered with fungus and mold and, after having cleaned this stuff up so as to make it more habitable, they settle there, without ever questioning either where it came from nor the fate of its crew (yet another Lucky Dragon No.5 reference!). Finally, as food supplies become exhausted, they begin to tear the boat apart, then—ravenous for sustenance and having no other option—certain members decide to sustain themselves via eating from the ready supply of mushrooms thereabouts, although the vitality they derive from these abnormal fungal growths is (unsurprisingly enough) not natural.

The island and the wreck of the boat, the places where the action takes place, are terribly disturbing, yet also things of rare beauty. The acting of Shigeru Komatsuzaki, Juichi Ikuno and Akira Watanabe under the direction of the great Eiji Tsuburaya is exceptional. Rather than actual jungle locations being used (although some authentic rain forest is seen early in the film), an indoor set was artificially created in-studio; the wrecked vessel, on the other hand, was installed on a beach upon the island of Oshima (as well as being largely shot on specially-constructed interior sets). In any case, these wild,

overgrown settings are endowed with a perversely unnatural abundance that seems lifted straight out of Lovecraft's story "The Colour Out of Space".[5] In both cases, the stories' scenarios abound with paradoxically morbid lifeforms; this aspect is crucial to understanding the originality of the kind of horror depicted in **MATANGO**.

As is often the case with Ishirō Honda's works, the characters play crucial roles in the story's development. Their dire situation may have been imposed on them by Fate, but it is their actions in response to this situation that are at the heart of the narrative. The seven passengers and crewmen of the yacht each have relatively well-developed (if uneven) personalities. In any case, they gradually crack under the pressures of their situation. The question of finding food—that of survival—is the central theme. At first, it arises out of the question of sharing, which brings out their individual egoisms; then it is symbolically reformulated like that of the Forbidden Fruit; the island is indeed a *strange* Garden of Eden. Mushrooms are an abundant and tempting potential food source all around them, but one which the protagonists' human intelligence and animal instincts perceive as potentially dangerous to them.

In fact, these mushrooms have been radioactively contaminated—dare I say "atomicized"?!—and they now have the ability to transform those who consume them into, essentially, fungoid folk (hence AIP-TV's notoriously lurid American title, **ATTACK OF THE MUSHROOM PEOPLE**). Rarely in the cinema have we seen creatures more bizarre than these! The costumes designed by Shigeru Komatsuzaki are wonderfully outrageous, and these 'shroom-monsters seem well within their element in this jungle that wavers unsteadily between a dream and a nightmare. Moreover, this strange, hallucinatory climate, and also the exceedingly and fittingly psychedelic nightclub scene shown in a flashback-within-a-flashback (which makes one think of a similar scene in **GODZILLA VS. HEDORAH**)[6] obliges us to remember that the film is separated by only a few years from the ethnomycological work of Valentina and Gordon Wasson, and their discovery of psychoactive mushrooms. Indeed, it recalls to mind the title of the famous interview with Valentina published in a 1957 issue of *This Week*: "I Ate the Sacred Mushroom"!

All the ingredients of Lovecraftian biological/body horror are here. As often happens, the danger is not merely death, but the struggle for survival in a body that becomes increasingly alien to the

An ever-increasingly mucked-up **MATANGO** mushroom man (Hideyo Amamoto, our front cover boy)

The Dunwich Horror and Other Weird Tales (Editions for the Armed Services, 1945)

5 First published in *Amazing Stories* (September 1927). See Tony Strauss' review of the recent movie adaptation **THE COLOR OUT OF SPACE** (*Die Farbe*, 2010, Germany, D: Huan Vu) in *M!* #28/29 (p.8).

6 ゴジラ対ヘドラ / *Gojira tai Hedora*, a.k.a. **GODZILLA VS. THE SMOG MONSTER**, 1971, D: Yoshimitsu Banno.

"owner" (there are many examples of this to be found in HPL's work, including those who gradually transform into fish-folk in "The Shadow over Innsmouth" [1936], the corpse in "The Thing on the Doorstep" [1933], etc.), or coping with a mind that becomes ever-more-alienated due to advancing madness (examples of this in HPL are far too numerous to list!). However, the national background remains prevalent. This fungal contamination—this fearsome fungus among us—corrupts the body slowly but surely, evidently echoing the frightful deaths of hundreds-of-thousands of Japanese who were irradiated by the atomic mushroom clouds of Hiroshima and Nagasaki in the final days of World War II.

In a sense, the 1945 nuclear bombings of Hiroshima and Nagasaki by Boeing B-29 "Silverplate" Superfortress bombers with the 509th Composite Group of the United States Army Air Forces (US-AAF) plays a similar role to the horror of Lovecraftian inspiration as that played by the 1925 Kanto Plain earthquake to the horror of poetic inspiration. In both cases, the typical indigenous current of *"ero-guro-nansensu"* was to be renewed and strengthened.

Kaijthūlu? Tentacthulu?

Between the gigantism of Godzilla and the physiological eccentricity of the mushroom men, everything was in place to bring back the incredible variety of *yōkai* and the multi-variegated forms of *kaijū* in all the various television series which proliferated from the late '60s onward and—especially—throughout the 1970s. Eiji Tsuburaya's company Tsuburaya Productions, whose work includes the above-just-discussed **MATANGO**, played a decisive role in this *kaijū* explosion. *Ultra Q* (ウルトラQ / *Urutora Kyū*), the first major *tokusatsu* (特撮 / "special effects") teleseries devoted to *kaijū*, was produced by the same company. This series, broadcast from 1966, is about the investigations of three youngsters interested in mysterious affairs, whose episodes almost always conclude with the appearance of some sort of strange monster or other. Each episode is a clever mix of monster movie with disaster movie, unified by a somewhat surreal narrative which was guaranteed to charm both children and adults alike.

The imagery is neat, the music excellent, and the quality of the special effects benefits greatly from the experience of Eiji Tsuburaya and his colleagues. As for the scenery, costumes and even some of the very cries of the monsters themselves, these were, in part, "borrowed" from Toho films!

Top: Akiko (Miki Yashiro) makes nummy noises after sampling **MATANGO**'s "magic" (*not!*) mushrooms. **Center:** Akira Kubo exhibits the end-result of eating those yummy fungi! **Above:** Italian *soggettone* for the film (inset art by Renato Casaro)

In addition, *Ultra Q* not only benefited from a considerable budget for a television program at the time, but also a skillful marketing campaign. Indeed, a week before the broadcast of the first episode, a pseudo-documentary had been televised to lead people to believe in the existence of giant monsters which it was necessary to investigate!

In any case, the show was a considerable success that opened the way for the franchise *Ultraman* (ウルトラマン / *Urutoraman*), which began later that same year, '66. What is striking, in *Ultra Q* as in *Ultraman*, is the quirkiness of the monsters. It should not be forgotten that the term *kaijū* means "strange beast", though this in no way implies gigantism. However, the ultra-*kaijū* are often *dai-kaiju*: that is to say, GIANT *kaijū*. Strange beasts, therefore, and sometimes giant ones besides: one must analyze these terms one-by-one to see how there is a relationship with Lovecraft.

Firstly, in most cases they are beasts (but not always, see, for example, the character of Princess Otohime seen in the sixth episode[7]); that is to say beings of a biological nature or, in any case, similar to those of biological beings. These monsters generally do not belong to the supernatural, but are of a biology/nature unknown in the present state of science (e.g., Ragon, the title she-creature of the twentieth episode,[8] which is of a race of fishmen, much like The Deep Ones of Lovecraft), or of a nature modified by science (such as, in the ninth episode,[9] Mongular, a mole that accidentally absorbs a growth-accelerator and becomes monstrously mutated).

From there arises their strangeness. If, for example, the biology of the Ragons seems very understandable (they are anthropomorphic beings that reproduce sexually, and they love their offspring: this is the plot of episode 20) there are other beings that completely escape the Classical scientific conceptual framework. The most exemplary case is that of the extraterrestrial entity in the eleventh

7 "Grow Up! Little Turtle" (育てよ! カメ / *Sodateyo! Kame*), episode #6

8 "The Undersea Humanoid Ragon" (海底原人ラゴン / *Kaitei genjin Ragon*), episode #20

9 "Terror of the Sweet Honey" (甘い蜜の恐怖 / *Amai Mitsu no Kyōfu*) , episode #9

Left, Top to Bottom: *Ultra Q*'s Japanese main title card, plus three shots of the supercool "gillwoman" (note breasts!) from episode #20 of the show, entitled "The Undersea Humanoid Ragon"

Science Fiction
Action Adventure

ULTRA Q

The vast forces of Nature, apparently, exist in harmony and balance. Then, one day, this order of things suddenly becomes turmoil! Strange, gigantic creatures rise thru the Earth's crust in an earth-quaking uproar...sea monsters attack the shores on the crest of steaming tidal waves...weird beings from outer space savage the Earth in a rage of inspired vandalism. All this comes before the camera in the most colorful, amazing array of special effects and optical illusions ever seen on TV. Here's fantasy made startlingly credible by realistic treatment of the unreal. Every program is a triumph of TV production and artistic ingenuity.

Modern Science vs. Champions of the Age of Dinosaurs

In ULTRA Q, a new, strange world bursts upon us. Cities topple, powerplants disintegrate in a blaze of pyrotechnic fury. Whole populations flee as the "weird creatures" stamp and thrash across the land. Science comes to the rescue! A renowned scientist and his young friends—a girl newsreporter and an airman—challenge the destroyers. In feats of daring and inventiveness, they turn every defense and weapon known to science against the menaces, in the suspenseful battle for human survival that climaxes every adventure.

L O C A L E	F O R M A T
Science labs, conference rooms, city and country and underground caverns...anywhere on and under the land and sea.	— half-hours, each with 3 one-minute commercials and identifications at beginning and end.

A page from United Artists Television's press kit for *UQ*, which, despite English-dubbed episodes evidently (?) having been prepared, never (?) actually got aired stateside

episode.[10] Originally a tiny thing brought back from Saturn by an exploration rocket, Balloonga balloons into a huge cloud that feeds on energy before departing the Earth, bound for a distant sun (by the way, this departure towards a far-off star evokes, HPL's "Beyond the Wall of Sleep"[11]).

This logic is pursued, in particular, in the series of the *Ultraman* franchise, but, beyond that, all the traditional Japanese imagination is reinterpreted

10 "Balloonga" (バルンガ / *Barunga*) , episode #11

11 First published in the amateur periodical *Pine Cones* (October 1919).

by the yardstick of a fictional science. It is the repetition of the Lovecraftian teratology revolution started in the 'Thirties that we witness in Japan during the 'Seventies. As in the time of *Weird Tales* magazine (founded in 1923; its heydays was in the 1930s), the monsters, including those from folklore, evolved from the realms of fantasy to science fiction. Thus, the domain of Nature extends itself. Darwinism now replaces demonologists (in the Go Nagai *mangaka*, hell and prehistory are often confused...). Moreover, since the beginning of the 1960s, the anatomical plates or fictitious layers of *yōkai* and *kaijū* have multiplied. And the horror is no longer so supernatural as it is more "hyper-natural" in the sense of being *too* natural—*dangerously* natural, if you will.

Chiaki J. Konaka:
A Lovecraftian Makes His Cinema

Without doubt, one of the important moments in the development of the Japanese Lovecraftian tradition and its international recognition is the publication—first in Japanese, and then in English—of *Lairs of the Hidden God*, a four-volume collection of Lovecraftian stories. Produced under the supervision of Ken Asamatsu (Asamatsu Ken= "Arthur Machen"!), one of the great Lovecraftians of the Land of the Rising Sun (if not, quite simply, *the* GREATEST). The work is a compilation accompanied by articles, biographical appendices, et cetera. Among the authors, one concerning the cinema must especially be remembered: namely Chiaki J. Konaka.

Konaka has been an important figure in anime and *tokusatsu* since the early 1990s. He has written over 200 scripts and participated in some of the great successes of anime, such as *Serial Experiments Lain* (シリアルエクスペリメンツレイン / *Shiriaru Ekusuperimentsu Rein*, 1998), for example, and *Digimon* (デジモン / *Dejimon*)—where he abundantly let himself go with the Lovecraftian name-dropping... However, neither of these works is actually Lovecraftian. On the other hand, the last episodes of *Ultraman Tiga* (ウルトラマンティガ / *Urutoraman Tiga*, 1996-97), with a pre-human city emerging from the Pacific, are much more marked by the American author's influence.

It must be said that Konaka considers himself both an admirer of Lovecraft and a theorist of

4 images from *Ultra Q*. **Top & Above:** Namegon (ナメゴン), the googly-eyed alien slug-snail from episode #3, "The Gift from Space". **Top Right:** A tie-in *UQ* "sonosheet" a.k.a. "sonorama" (kids' vinyl record and read-along story booklet/picture sleeve). **Right:** Mongular (モングラー) the giant mole-monster of episode #8, "Terror of the Sweet Honey"

horror. He discovered the gentleman in the '70s. The first HPL text he read was "The Dunwich Horror" (1928, first published in *Weird Tales* in April 1929). Besides, he has a particular attachment to him. Later, he discovered "The Shadow over Innsmouth", which had a lasting impact on him, since he wrote the screenplay for the first film he directed in 1992, **THE SHADOW OVER INNSMOUTH**. Twelve years later, he returned to an explicitly Lovecraftian work, **MAREBITO** (discussed later), but this time left the direction to a professional, Takashi Shimizu (**THE GRUDGE** [呪怨じゅおん / *Juon*, 2002], etc). For this latter film, he worked on the script. However, if the source material is Lovecraftian, it does not come directly from Lovecraft, but rather from a novel that Konaka regards highly, Ken Asamatsu's *Queen of K'n-Yan*, itself inspired by *The Mound*, by Zealia Bishop, but of which Lovecraft is the true author...[12]

A Japanese television adaptation of Lovecraft's famous tale, **THE SHADOW OVER INNSMOUTH** (インスマスを覆う影 / *Insmus wo oou kage*, 1992), illustrates the points above. It was the creation of Chiaki J. Konaka, who wrote the script and directed the filming. The work he did in adapting this story to the Japanese consciousness is quite similar to that of Shigeru Mizuki's for "The Dunwich Horror". Everything is reinterpreted within the yardstick of Japanese culture; but a Japanese culture, as we have seen, which has mutated from prolonged contact with more Western traditions of horror. So here we are with "Akamu" instead of Arkham, "Dan'uichi" for Dunwich, "Insmus" for Innsmouth and, for Kingsport, a literal translation: "Oko" (*"the port of the king"*); although, that said, at one point a bilingual Japanese/Anglo signboard is seen which gives HPL's original names for all three places. Broadcast for the first time on Japanese television on August 25, 1992, it has not been translated since, so we are largely dependent on the work of Dr. Senbei of the Tokyo Scum Brigade.[13]

Above: The opening credits and incidental signage of the otherwise fully-Japanicized TV HPL adaptation **THE SHADOW OVER INNSMOUTH** (1992) makes no attempt whatsoever to disguise its inspiration source

12 According to Wikipedia (@ *https://en.wikipedia.org/wiki/The_Mound_(short_story)*): "'The Mound' is a horror and sci-fi novella H.P. Lovecraft wrote as a ghostwriter from December 1929 to January 1930 after he was hired by Zealia Bishop to create a story about an Indian mound which is haunted by a headless ghost". (See also the following url: *http://apgnation.com/articles/2015/06/23/17832/interview-with-screenwriter-chiaki-j-konaka*)

13 See Tokyo Scum Brigade (@ *http://tokyoscum.blogspot.fr/2010/06/shadow-over-innsmouth.html*). If you go to that url just given, the page provides you with links to all 7 separate segments of インスマスを覆う影 (**THE SHADOW OVER INNSMOUTH**, 1992) that are uploaded on YouTube (@ 0729mooncave's channel); bonus is that Dr. Senbei has considerately provided detailed,

The plot of the TV movie does not differ much from that of the story which everyone knows. A series of incidents draws the attention of Shirato Takuyoshi (Shiro Sano), a journalist, about mysterious events that seem to have been occurring for a considerable length of time in a small, out-of-the-way port village. With the consent of his boss, he goes there to investigate. On the way, he meets a tomboyish young female delivery driver, Hatano Tamami (Michiko Kawai), with whom he teams-up. Innsmouth appears to him a disturbing city (he is very poorly-received when served at the tavern...), yet intriguing nonetheless. On several occasions, he meets a beautiful woman (Kimie Shingyōji), clad in a kimono and carrying a parasol, whose resemblance to a character who haunts his dreams both disturbs and fascinates him. His wanderings provide the core of the narrative, but it is the explanations given to him by the curator (Ishibashi Renji) of the little local folk museum which illuminate the shadows, give full meaning to mysterious events and announce the final revelations...

If the natural settings are perfectly-adapted and the music is very well-chosen (as are sound effects, which are of the highest quality), on the downside it is obvious that the means and budget available to the director were severely limited. Special effects such as makeup are for the most part only minimal, though never clumsily-handled. Thus, the most accurate picture of The Deep One that is shown on the screen is not direct, but revealed through a series of photographs; this remoteness of rendering makes things more credible, more effective and ultimately more terrifying. However, the distinct lack of budget is sometimes most apparent on the screen. Shots are often static. Also, during one scene on the beach, while the young female driver attempts to seduce the hero, you can even spot part of the microphone at the corner of the screen!

Having said that, the work of the actors is above reproach. Thus, in the beach scene that has just

These 2 Pages: 8 more shots from Konaka's **THE SHADOW OVER INNSMOUTH**. **Above, Top:** A long-shot of the inlet at Innsmouth. **Above, Bottom:** The icily lovely "mystery woman", as played by the ever-so-photogenic Kimie Shingyōji. (We'll leave you to find out for yourselves what those two central images are all about!)

highly-literate English synopsis breakdowns at his site to complement the untranslated segments of the movie. Or, if you don't need the Anglo synopses as a guide, you can simply go directly to YT to access the segments individually (Pt. 1 is at the URL addy *https://www.youtube.com/watch?v=gUiOPtGgnGk* – simply key that in, and consecutive links to the remaining 6 parts should pop up on the right of your screen). Having watched it myself, I can assure you it's well worth a look! *NB*. Unfortunately, we can't provide any English link titles to help expedite your search, because all the YT links include only Japanese characters. According to an English commenter in the thread below Pt.7 of the upload: "wow this has got to be one of the best Lovecraft adaptions I have ever seen". ~ SF

been mentioned, the young driver reveals her feelings for him to the protagonist and is distraught by the cold reaction of the man she tries to seduce. This makes the scene most touching indeed. Her failure is not there to justify her change of attitude towards the hero, a change of attitude so useful for the narrative, but also to give her character psychological depth and to ensure that the viewer develops an attachment to her. In this same scene, the protagonist remains relatively cold and distant, simply because he has other preoccupations than flirting on his mind! It must be said that Shiro Sano, who plays his role beautifully, is a fervent lover of Lovecraft (he is also author of one of the short stories in the books edited by Ken Asamatsu). He is also a talented actor, who seems to be intensely involved in the narrative, although his sometimes non-emotive acting often makes him appear as merely a passive spectator of events. In this respect, he is fully a Lovecraftian character. The only thing that animates him is his desire to know more about the mysteries surrounding him. Even his interest in love for Kayo, the young widow whom he meets in his investigation, is ultimately explained only by a form of imperious curiosity. This has less to do with the beauty of her visage—God knows that Kimie Shingyōji is a rare beauty!—but more to do with the inexplicable feeling of familiarity and kinship he feels towards her.

At this level, we touch the key of the narrative and the heart of its originality in relation to the stories of Lovecraft. If, in Lovecraft, sexuality—or, more generally, relations—between men and women, are set back, conversely, in this telefilm by Konaka, they occupy front and center-stage. Indeed, we see the main character escape the naïve and healthily natural love of the young driver for the poisonous beauty of the mysterious kimono'd lady whom he first met on the quay (who has some exceedingly dark secrets), about whom the curator of the folk museum at one point makes a curious and disturbing remark, referring to her as "a widow... in a *way*". The truth is that this woman who will bring him into her home, with whom he is about to have sexual relations—until an external interruption spoils the mood—is not actually a widow, since her husband is still living...

Here, we could ask: from there, does Chiaki J. Konaka more follow the stories of Lovecraft, or those of the Greek tragedians? As it happens, almost by pure chance, Sano's protagonist winds up killing the so-called widow's husband during a random encounter in the street at night, without recognizing this monstrously foul, fanged

Above, Top: Protagonist Shiro Sano's "Lovecraftian" boss, who facially rather resembles a kind of caricature of HPL himself. **Above, Bottom:** Sano's understandable reaction to that pop-eyed piscine *thing* in the third picture

These 2 Pages: 8 shots from Shimizu's **MAREBITO** (2004).

Above, Top to Bottom: The subterranean realm discovered below Tokyo; one of its unhuman denizens; Shin'ya "**TETSUO**" Tsukamoto as Masuoka, the psychotic protagonist; and another, clearer view of that unhumanoid deep-dweller

human—*more* than human, to be honest!—for who he actually is. (*ATTENTION: SPOILER ALERT!*) Symbolically speaking, hero Sano fills Oedipus' part. He kills this man—who is in reality his own *father*, whom he fails to recognize—then becomes the replacement "husband" of his own mother (now an *actual* widow since her son's act of patricide) without realizing it. However, unlike Oedipus the King of Sophocles, both his father and mother are fully cognizant that the protagonist is indeed their son! Only, the hero ignores the truth by believing his real father is dead and that his mother is interred in a psychiatric hospital! Konaka seems to be saying that the notion of generation has no *raison d'être* beyond the passage of time; that the sin of incest is irrelevant to immortal, amoral beings who are no longer human, as with these Cthulhu worshipers.

In this telefilm, the question of origin and returning to one's origins is present only in the pathological and monstrous form of incestuous relations. In the online article cited above, Dr. Senbei notes that the main character, the delivery girl and the museum's curator each represent three common trends among those Japanese people who have left the rural world for the urban world. Some move away forever from their village of origin. Such is the case of Sano's main character, who had forgotten the whole of his past; others move away, but eventually return once again to the same region at some point. This is the case with the young driver who, by her "hip" clothing, her way of life (etc.) shows that she is no longer really living in a small fishing village, only she doesn't make a clean break and move away from it completely, but instead merely shuttles back and forth between one "world" and the other whilst making her daily deliveries. Now, anyone familiar with the life and works of Lovecraft knows just how much this issue of living in a big city, being torn away in the middle of childhood, then being returned, is often present. In letters, Lovecraft speaks of himself and his atrocious stay in New York, and then of his almost ecstatic return to Providence, and in certain passages of his writings he puts down these same thoughts in the spirit of the tale's protagonist. Thus, this quite excellent telefilm shows a great depth and richness which is really not surprising, it seems to me, if one recalls the sizeable talent of its director, Chiaki J. Konaka.

MAREBITO (稀人 / *"Unique One"*, 2004) is the story of a nightmare or madness, unless it is actual reality itself which is crazy or nightmarish. The film's narrative has no real end, and it leaves open the question of the reality (or not) of what is shown. Better, it plays with the viewer to make us

constantly doubt, but never enough to reassure, so much so that we feel a diffuse discomfort throughout the film. What do we see at the heart of the film? And besides, who sees what and how during these 90 minutes? These questions will have to be asked, but before that, let us briefly describe the film...

Masuoka (played by Shin'ya Tsukamoto, director of the cyberpunk cult fave **TETSUO, THE IRON MAN** [鉄男 / *Tetsuo*, 1989], no less), an obsessive-compulsive freelance videographer, records footage of a man (Kazuhiro Nakahara) who kills himself down in the subway by sticking a knife into his brain through his eye. Upon investigating, purely out of morbid curiosity, he discovers, beneath Tokyo, a whole unknown world of tangled tunnels, along which he wanders until he reaches a gigantic, rocky crag-filled cavity somewhere deep within the Earth which he identifies as "The Mountains of Madness" of Lovecraft—although one rather thinks of Ken Asamatsu's world of K'n-yan instead. While exploring the ancient ruins of a city of nonhuman construction, he finds, chained by the ankle within a concavity of the rock wall, a naked young girl (Tomomi Miyashita), of a cadaverously pallid complexion. He proceeds to set her free her, then takes her back to his studio apartment up in the "real" world. From there, the rhythm of the narration becomes slower, almost hesitant. The girl, to whom the hero gives the name of "F", wastes away, spends most of her time sleeping, and refuses all foodstuffs. Until, that is, he discovers quite by accident that the only exception to this is blood... preferably *human* blood. He will first give her his, and then begin to kill others in order to furnish her with greater quantities of it.

The scenario may seem tenuous. In truth, it is saturated with references and allusions, explicit or not, to occultist literature and horror. The film's subterranean world makes one think of the one described by Bulwer-Lytton in *The Coming Race* (1871), which is confirmed by the mention of the name herein of the founder of theosophy, Mrs. Blavatsky, but there are also references to the Agartha or the Shambhala, too. The presence of this myth of the hollow earth is further accentuated by the discussion of the hero with the ghost (?) of Kuroki Arei, the subway suicide, about Deros (short for "detrimental robots"), characters from Richard Sharpe Shaver's (1907-1975) *I Remember Lemuria!* (1945) and *The Return of Sathanas* ([1948] ambiguous text, if anything; see *The Shaver Mystery*). However, the hollow ground is not thought, in this film, as an outright supernatural place. It is more of a dream dimension, really. Yet it is at the same time deeply rooted in reality: this journey to

Above, Top to Bottom: Playing the fish-out-of-water character known only as "F" almost entirely in mime, Tomomi Miyashita does a splendid job of capturing both the character's vulnerability and the feral ferocity of her "other" side...as is more than just hinted at in the two bottommost images

Ad-art for Chiaki J. Konaka's **THE SHADOW OVER INNSMOUTH** (1992), made for Japanese TV

the center of the Earth begins in mundanity, and the trespassing journeyer must first avoid being spotted by the employees of an underground urban industrial complex, as well as homeless people dwelling deeper down in the labyrinthine tunnel system.

Kaijthūlu Lives? German lobby card for **GODZILLA VS. HEDORAH**, featuring that shambling heap, "The Smog Monster"!

From the point of view of modernity, **MAREBITO** fits perfectly into the landscape of contemporary Japanese horror cinema; a "cinema" which is based primarily on the video medium for both shooting and broadcasting. However, the choice of video here is not only practical from a technical standpoint, it's also a vital part of the narrative and, beyond that, of the very meaning of the work itself. Which brings us right back to Lovecraft again. It all begins for the hero when, while replaying the scene of the suicide he shot for the umpteenth time, it dawns on him that, just before piercing his right eye with a blade, the distraught Kuroki Arei seemed to fix his terrified eyes on an unknown *something* seen only by him. It is by scrutinizing Arei's gaze how Masuoka comes to the realization that he has seen a sight whose horror surpasses everything, something inexpressibly terrifying. There is a Lovecraft story wherein much the same happens, entitled "The Unnamable" (1923).[14] In this very brief text, in which the two protagonists discuss—as per the title—the essentially inexpressible, its existence and its accessibility, it is the matter of a windowpane which, by being looked out through by some abject being within the room beyond it, would have "memorized" the looker's image ("Windows retained latent images of those who had sat at them"). It is all a question of how we look—not only of the window, but also of the camera, the room and the object within.

MAREBITO's main character never looks directly at the world. He only sees what passes through the lens of a camera and remains recorded. Even when he walks down the street, he has his eyes forever fixed on the viewfinder/monitor of his camera or on the screen of his mobile phone, which is connected to a closed-circuit camera in his apartment that he uses to keep an eye on the unattended F in his absence. This is not a found-footage film, but a *made*-footage one! Besides, one can almost suspect that the origin of this is not only the result of clear intention, but also out of necessity (due to the psychotic Masuoka's morbid obsession/fixation). Shooting 90 minutes of film in eight days is a feat that has its constraints and visible consequences.

In the world of Lovecraft, most narrators are unreliable. In **MAREBITO**, the hero is also the cameraman, we see what he sees, but we are no more sure than he is of what we see! "Madness is contagious", he says in the film. This is the case,

14 First published in *Weird Tales* in 1925. An oft-maligned "adaptation" of this mere sketch of a story was **THE UNNAMABLE** (1988, USA, D: Jean-Paul Ouellette [see Eric Messina's review in *M!* #26, p.24]).

and the madness affects us, too. What should we understand? Is he merely a madman who, having ceased taking his Prozac so as to "heighten" his mental faculties to certain things, imprisons his daughter and treats her like a domestic animal? Is he a psychopath who murders women—both his own female family members and others—not out of hatred, but because some inner voice tells him that he needs human blood? If the film actually was allegedly found-footage, we would not have to ask ourselves this question. The narrator would be sure. However, he is *not*—far from it—and Tsukamoto's whispering voice in combination with the music of Toshiyuki Takine creates a sonorous atmosphere that evokes nothing but anguish, dread and, ultimately, utter chaos.

In one of Lovecraft's most famous passages, at the beginning of his most famous short story, "The Call of Cthulhu" (written in 1926, first published in *Weird Tales* in February 1928), he begins: "The most merciful thing in the world, I think, is the inability of the human mind to correlate all its contents". At a key moment in **MAREBITO**, Arei Furoki seems to be saying the same thing to Masuoka, but he doesn't know what to do with him. Put another way: "The feeling that we know as 'terror' is actually ancient wisdom, sealed in our subconscious mind". **MAREBITO** is the history of the suffering inherent in knowledge. Knowledge is the monster lurking in the darkness of ignorance, but ever-ready to spring forth into full light before the unblinking lens (be it of a camera, or the naked eye).

Lastly, Lovecraft and Konaka only repeat in their own language—that of horror literature and cinema—what Ecclesiastes said before them (1:18): "*Eo quod in multa sapientia multa sit indignatio; et qui addit scientiam, addit et laborem* / For in much wisdom is much grief; and he that increaseth knowledge increaseth sorrow".

Top, Left to Right: *Call of Cthulhu*, one of the numerous recent manga adaptations of HPL works; Ken Asamatsu's novel *Queen of K'n-Yan* (Kurodahan Press, 2008); Japanese edition of a volume in the *Lairs of the Hidden Gods* series; **Above:** A subtitled screen-capture from **MATANGO**. Unable to resist temptation any longer and encouraged by Mami (Kumi Mizuno), Kasai (Yoshio Tsuchiya) at last partakes of the magic mushrooms

DÉLIRE ET DÉSIR
The Dreamworld of Jean Rollin

by John-Paul Checkett

Introduction

Horror fans are typically notoriously unfriendly to the outsider. While this may at first appear paradoxical, given the genre's preoccupation with freaks, misfits, and monsters, in reality most horror cinema is predicated on the notion that difference is evil, that tradition trumps innovation, and that the status quo must and will be preserved. Thus, it should come as no surprise that devotees of this most conservative of genres often respond with hostility bordering on rage to those who fail (either by choice or accident) to adhere to its dogmatic conventions.

One of the most unfairly-maligned genre outsiders is Jean Rollin (1938-2010), the eccentric fantasist who first garnered public attention as the writer and director of **THE RAPE OF THE VAMPIRE** (*Le viol du vampire*, 1969), which was billed as "the first French vampire film". Over the course of three decades and 17 genre films, Rollin was greeted with almost universal disdain by both critics and horror fans in his native France, even when he was the *only* regular producer of horror cinema in that country. The legacy of this contempt remains potent. Mention Rollin to a genre fan only vaguely familiar with the man's work, and (s)he will likely describe him solely in the language of his detractors: as the director of amateurish, cheaply-made, and ponderously slow vampire sex movies. In France, these became known as "*Rollinades*"—a term that, although sometimes intended as derisive, at least acknowledges that his films do merit consideration as a genre all their own.

Rollin's outsider status originated with the almost unbelievable circumstances surrounding the release of his first film. A friend of his had purchased the rights to Producers Releasing Corporation's (PRC) Poverty Row George Zucco/Dwight Frye feature **DEAD MEN WALK** (1943, USA, D: Sam Newfield [see *Monster!* #8, p.24]), and hoped to exhibit it in the two Parisian theaters then specializing in fantastic cinema. Unfortunately, the film was far too brief to be shown as a single feature, and Rollin was invited to shoot additional material to create a program suitable for distribution. Rollin assembled a group of friends, including famed comics artist Philippe Druillet—later of *Metal Hurlant/Heavy Metal* et al, who rendered the poster art for several of Rollin's films, the present one included—and shot a surreal, largely-improvised 45-minute black-and-white short about a psychoanalyst's attempts to cure four sisters suffering from delusions of vampirism. Producer Sam Selsky was pleased enough with the result to encourage Rollin to extend the film into a full-length feature. Rollin responded with a "second part" featuring the resurrection of all the deceased characters, the arrival of a majestic black Vampire Queen, and the efforts of a medical researcher to determine the scientific foundations of vampirism. The final result was submitted to censors as two individual shorts and was therefore subjected to less-stringent restrictions than a feature film, leading the provocative sexual content to be approved with only minor cuts. **THE RAPE OF THE VAMPIRE** premiered in May of 1968 during the student riots in Paris, and since nothing else was playing at the time, the critics attended *en masse*. Although the audience responded with overt hostility—booing and throwing objects at the screen—and the critical response was scathing, the scandal associated with the premiere generated interest in the film; which also, unfortunately, cemented Rollin's reputation as a low-budget sex-film director.

Rollin and one of the Castel Twins (you decide which!) during the director's creative heyday, the 1970s

With the advent of home video, Rollin's reputation has enjoyed a gradual process of rehabilitation—though his cult still claims far fewer members than the likes of Lucio Fulci, H.G. Lewis, or even Jess Franco do. One barrier to widespread genre acceptance is the fact that *Rollinades*, despite the presence of vampires, zombies, graveyards, and ghosts, are decidedly *not* horror films. With the exception of his two commercial gore outings **THE GRAPES OF DEATH** (*Les raisins de la morte*, 1978) and **THE LIVING DEAD GIRL** (*La morte vivante*, 1982), and the more experimental **THE NIGHT OF THE HUNTED** (*La nuit des traquées*, 1980), his films are largely devoid of either horror or suspense, and rarely attempt to disturb or disgust the viewer. Rollin's films are also very slowly-paced, leading many viewers to describe them as intolerably dull, and are characterized by a melodramatic theatricality that modern audiences may find off-putting. Furthermore, unlike most genre fare, Rollin's films are not plot-driven in any conventional sense. This is in part the result of Rollin's habit of improvising on set (as he often began filming without a shooting script), but also reflects the influence of the American serials he loved as a child, where the story is often simply an excuse to shepherd audiences from one cliffhanger to the next. For Rollin, the plot exists not to tell a linear story, but rather as a means of creating an atmosphere of expectant wonder so that audience members might be receptive to the images and set-pieces that comprise his true artistic agenda. In other words, there is *just enough* of a plot to lead audiences to wonder "what's next?" and to provide a context within which his images might evoke their full emotional resonance.

Those who praise Rollin often do so primarily for his visual artistry, and his films are remarkable for the images that have left indelible impressions on those who have witnessed them. The most famous of these include the Vampire Queen from **THE RAPE OF THE VAMPIRE**—a black woman dressed in an elaborate fetish costume (that includes a lizard-shaped tiara and a bat emblazoned on her crotch) licking blood from

Louise Horn in **THE RAPE OF THE VAMPIRE** (1968)

a curved dagger; a mysterious woman playing a grand piano in a deserted cemetery; a vampiress emerging from a grandfather clock at the stroke of midnight; and a statuesque blonde dressed only in a black cape stalking her prey with an immense scythe. His characters are usually clad in costumes that are alluring, sinister, and almost always provocatively surreal. Rollin is also particularly adept at finding and utilizing a startling array of surrealistically fascinating locations, including decaying castles, cliff-bound beaches and overgrown cemeteries, while employing props such as multicolored dolls, skulls, religious icons, and fetish objects to amplify their unworldly atmospheres. But to describe him as exclusively or even primarily interested in the generation of provocative images does not explain why he would choose to work within a narrative framework, or to obsessively employ recurring images such as vampires, a pair of naïve young girls, clowns, and the beach at Pourville-sur-Mer in Dieppe, Normandy.

The temptation to view Rollin as a symbolist is also problematic, as both viewers and critics have expressed frustration when trying to interpret the meaning of the images he employs—to determine what Rollin is "trying to say". Rollin's recurrent characters, places, and images, however, are not meant to represent ideas, but rather to evoke emotions such as wonder, melancholy, enchantment, and intrigue. His films are not meant to be analyzed, but to be experienced. Rollin himself has said that he repeats "images

Top: *The Blood Is The Life!* The dominatrix-like Queen of the Vampires (Jacqueline Sieger) has a quick lick during **THE RAPE OF THE VAMPIRE** (1968). **Below:** Behind-the-scenes on the set of **THE NUDE VAMPIRE** (1970)

Dominique and playmate in **THE SHIVER OF THE VAMPIRES** (1971)

which represent an emotion" throughout his various films, connecting "dreams and stories like a construction system" so that "the audience can make their own thing out of them". The reference to dreams is critical to an understanding and appreciation of Rollin, and "dreamlike" is the word that is most often used to describe the languid surrealism of the typical *Rollinade*. Such a description is likely to create a false impression, however, as cinematic dream sequences have traditionally been employed as simply a justification for surrealistic set design, to generate shocks independent from the narrative proper, or as a means of indulging in Freudian exposition. Rollin, on the other hand, depicts dreams as they are actually experienced by the dreamer, and this is his unique contribution to cinema.

Psychology and neurology have long been preoccupied with the nature, purpose, and the meaning of dreams. While most readers might be somewhat familiar with the psychoanalytic assertion that dreams are the symbolic manifestations of repressed desire, this conception has been replaced by a greater understanding of the relationship between dreams and memory. One of the primary tasks of the sleeping brain is to consolidate memories—to catalogue them in the brain so that they may be retrieved later. Dreams occur during REM sleep, the state during which the brain links the memories of an event with the emotions evoked by that event. Memories may then be retrieved by the waking mind, accompanied by a stored emotional response to the events or situations depicted. It is important to note that every time a memory is recalled it is degraded, meaning that our most cherished memories are, in fact, the least reliable. Dreams that include fantastic content occur when

Jean Rollin—Vampire!

degraded memories are stimulated during REM sleep, with the brain "filling-in" the gaps with incongruous images and events. Thus love, loss, and the fantastic are inextricably entwined.

Within this context, Rollin's filmography might well be described as the most consistently authentic depiction of the dream state in Western cinema. The recurring images, characters, locations and motifs represent Rollin's most cherished and emotionally redolent memories and experiences (the beloved serials, the kiss of a young girl, the beach he visited as a child) recalled through the mist of dream, with the fantastic elements serving as a reminder that these memories are fading with each recollection. It is no wonder, then that loss plays such a significant role in Rollin's films—the loss of love, of life, of individuality, of place, and of childhood. Dreams are also associative in nature, meaning that a vision in a dream is likely to spark a memory that then influences the subsequent content of the dream. Much in the same way, when a scene in a Rollin film calls to mind a character or location from a previous film, that character or setting is likely to suddenly appear with little narrative justification.

It is important to note how frequently Rollin used the word "naïve" to describe both his films and the actors he preferred to work with. Almost all of Rollin's films feature naïve innocents—usually, though not always, represented by two young girls—wandering through a series of fantastic set-pieces with their eyes wide open to the wonders that unfold before them. It may well be argued that, through these characters, Rollin provides the viewer with guides to help them navigate his cinematic dreamscape. One cannot enter dreams with preconceived notions, nor can the dreamer engage with the dream through rational cognition. *Naïveté*, it might be said, is thus the essential and perpetual condition of the dreamer.

The eroticism of Rollin's films is also influenced by this dream aesthetic. First-time viewers familiar with his reputation as a sexploitation director are likely to be surprised at how little screen-time is actually devoted to erotic content—very little of which in his earlier work depicts actual sexual intercourse. In numerous interviews, Rollin has insisted that eroticism was imposed upon his films by producers for commercial reasons, and he has repeatedly expressed profound discomfort with directing softcore sex scenes and with the possibility of revealing his own erotic fantasies on film. However, Rollin clearly has an affinity for filming attractive women who appear entirely comfortable in various states of undress, and the erotic content of his films rarely fails to arrest viewer attention. Often this impact is due to the illogical and intrusive nature of the content—with characters disrobing and/or coupling with little narrative justification. While this jarring incongruity at times appears to be a function of Rollin visually acknowledging the imposition of such material on his films, it also is usually entirely consistent with the dream-logic of his narrative style.

Redemption/Kino Lorber's releases of thirteen of Rollin's films on Blu-ray presents viewers with an ideal opportunity to discover or revisit the dreamworld of the *Rollinade*. The films are mastered in high definition from original negatives, contain brief interviews with Rollin and long-time collaborators such as Natalie Perry and Jean-Pierre Bouyxou, and often may be viewed with either dubbed English or (preferably) the original French dialog. Each disc (with the exception of **THE ESCAPEES** [*Les échappées*, 1981]) also contains a booklet that offers both analyses of the films included, as well as an overview of Rollin's career written by critic, novelist and *Video Watchdog* editor Tim Lucas. Lucas has long been one of Rollin's most intelligent and eloquent apologists, and his insights prove an invaluable addition to an already remarkable package. Each of the movies on the thirteen discs is reviewed in detail below.

Blood Sisters: The Castel Twins were cover ghouls on *Video Watchdog* #31 (1996)

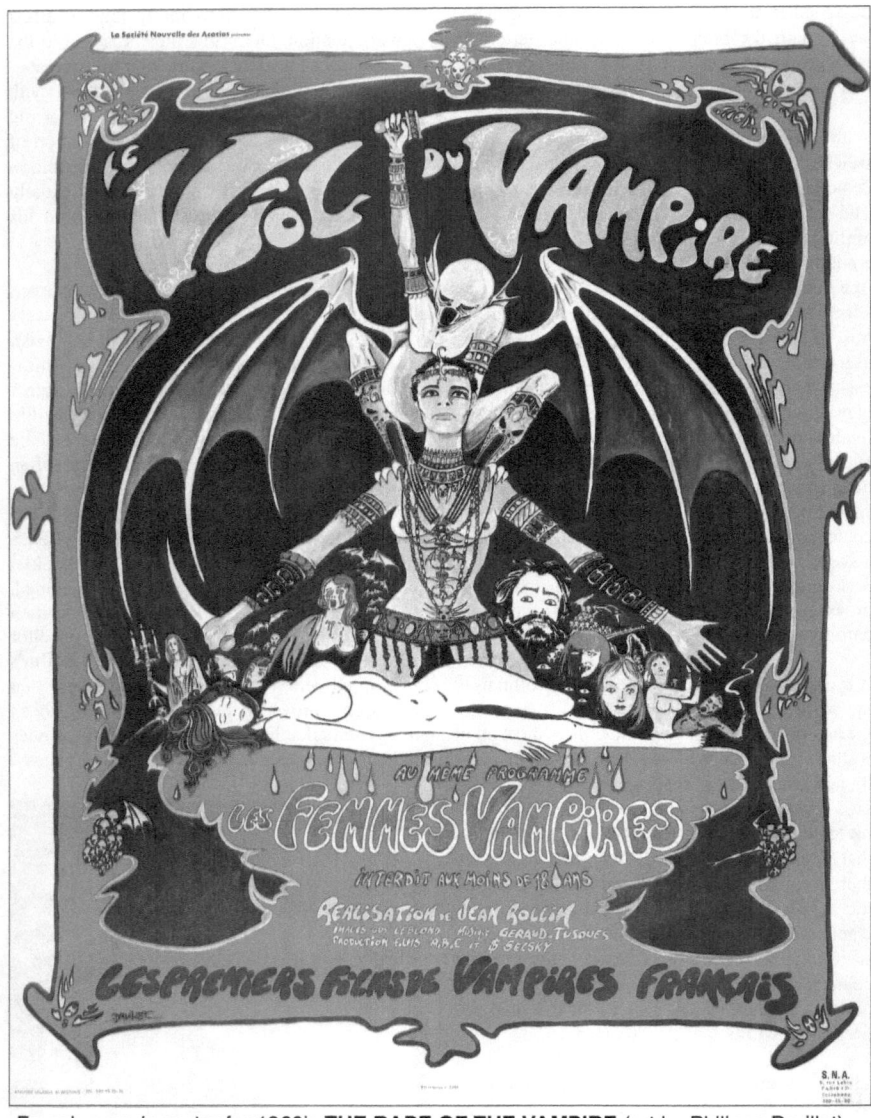

French *grande* poster for 1968's **THE RAPE OF THE VAMPIRE** (art by Philippe Druillet)

THE RAPE OF THE VAMPIRE

(*Le viol du vampire*)
France, 1968
Redemption/Kino Lorber
94m 50s, $24.95, BD-0

Introduced in the opening titles as "a melodrama in two parts", Rollin's debut is, as previously explained, really two short films knitted-together to meet the required length of a theatrical feature. The first section, entitled "The Rape of the Vampire", concerns the plight of Thomas, a young psychiatrist, and his two colleagues Brigitte and Marco, who journey to a rural village in the hope of curing four young women of their delusions of vampirism. The four sisters live in a dilapidated mansion surrounded by hostile villagers, and remain under the thrall of a strange effigy that periodically speaks to them. Thomas quickly ascertains that the siblings are remarkably inconsistent in their vampiric symptomatology

(two, for example, have no fear of light), and thus determines that they have in fact been cruelly manipulated into believing themselves to be the monstrous sisters of local legend who were raped, mutilated and murdered by villagers five decades before. As the brief segment moves toward a conclusion in which the angry villagers storm the château and dispatch most of the cast, Thomas discoverers that his diagnosis is only partially correct. While the sisters are indeed the victims of both mental illness and an elaborate hoax, they also happen to be *genuine* vampires.

The second segment, "The Queen of the Vampires", begins with the arrival of the eponymous villain—a striking black woman in elaborate fetish gear— and her entourage, who reveal that the sisters had been an integral part of the Queen's plan to unleash a new era of vampiric rule. Thomas and one of the sisters are revived, and soon discover that the Queen and her minions, both human and vampire, have taken control of a local clinic where experiments are being conducted to find a serum that can provide nourishment for the undead. After a baffling series of conspiracies and betrayals, the film culminates in a shootout within the Grand-Guignol theatre.

In his recollections of filming **THE RAPE OF THE VAMPIRE**, Rollin explained that his doubts about ever being given the opportunity to make another film led him to "pack it with as many images and ideas as possible", resulting in a "Dadaist mess". Producer Sam Selsky, however, believed that the film's bizarre nature and abundance of female nudity would prove profitable, and set out to find an avenue for distribution. In order to sell Rollin's "incomprehensible serial" to the Moulin brothers for exhibition in their theaters, Selsky reportedly distracted them during their screening of the film, and then audaciously explained away their confusion by assuring the pair that they had missed the critical plot twists which would have clarified everything!

Selsky proved only indirectly prescient, as the film's financial success owed more to the scandal associated with its premiere than to its inherent qualities. Rollin was shocked by the hostility his film generated, but it is not difficult to understand why viewers responded with outrage. Were **THE RAPE OF THE VAMPIRE** simply a succession of unrelated images and scenarios, it might have found a more receptive audience as something of an early "head picture". Instead, the film contains *just enough* plot to make its overall incoherency annoying, and it exists in an uncomfortable netherworld between surrealistic

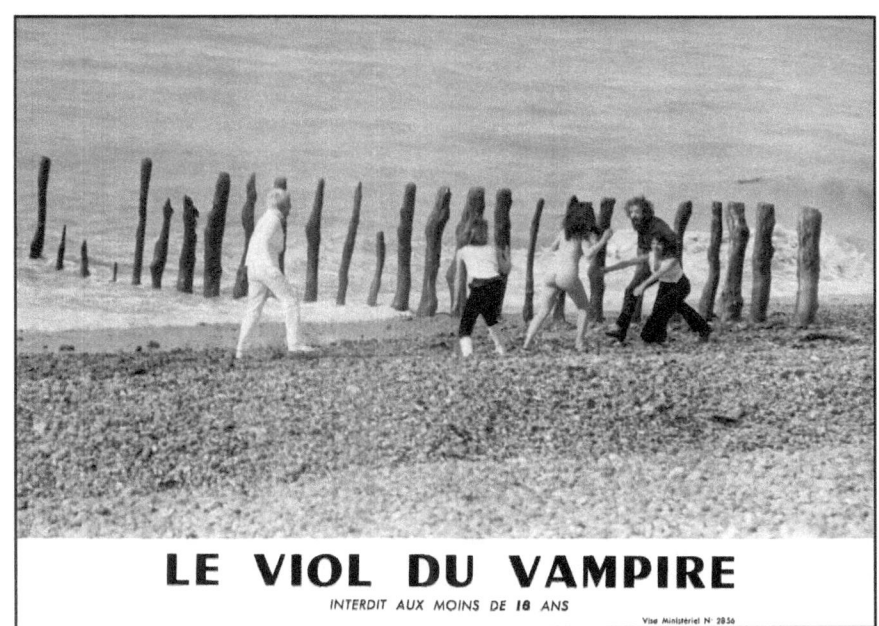

Nude Beach: Here showcased in a French lobby card for **THE RAPE OF THE VAMPIRE**, these rotted wooden pier-pilings on the Dieppe shoreline at Pourville-sur-Mer are a recurrent Rollin motif

The Queen of the Vampires *[inset]* takes the pause that refreshes before a bizarre, multi-breasted plush bat idol in **THE RAPE OF THE VAMPIRE** (1968)

collage and linear narrative—as if a group of children were improvisationally reenacting a serial they only vaguely remembered.

The inverted crucifix *[top]* seen in the vampiric satanists' funeral procession during **THE RAPE OF THE VAMPIRE** (1968), whose trailer *[above]* trumpeted it as *"The First French Vampire Movie!"*

That being said, contemporary viewers who can now view the film within the more sympathetic context of Rollin's complete filmography will find much to enjoy. The sets, costumes, and props are consistently startling in their originality, with the giant stuffed bat festooned with female breasts being especially memorable. From the opening scene in which the blind sister's breasts are caressed by an offscreen figure, Rollin demonstrates an obvious talent for infusing his films with erotic energy. The film also contains one of the most chillingly perverse scenes in Rollin's *oeuvre*: when Marco encounters a Catholic funeral procession, complete with a horse-drawn carriage, in a Parisian cemetery. As the procession advances toward the camera, the priest suddenly breaks into a maniacal grin, revealing a set of fanged incisors. The camera then pans up from the altar-server's hands to reveal an inverted crucifix, making it clear that we are actually witnessing the vampires engaging in a blasphemous masquerade. Also notable is a scene of a blind character playing skittles—a scene that would be very closely replicated by Werner Herzog two years later in **EVEN DWARFS STARTED SMALL** (*Auch Zwerge haben klein angefangen*, 1970, West Germany).

There are, of course, a number of themes and images that will become mainstays in future *Rollinades*, including the beach at Dieppe, physicians and hospitals imbued with sinister connotations, and overt sadomasochism. The vampires' human minions are depicted as more

vile and sadistic than their undead overlords—an idea that would be further developed by Rollin in **REQUIEM FOR A VAMPIRE** (1971). The character of Marco may also be seen as an early draft of "The Boy" in Rollin's **THE IRON ROSE** (1973). Unfortunately, Rollin's typical weaknesses are also on display, including his penchant for comically prolonged spasmodic death throes, his inexpert handling of gunplay, and the amount of screen time dedicated to characters simply processing from one place to another. Nonetheless, **THE RAPE OF THE VAMPIRE**, clearly a labor of love by everyone involved, remains one of the most audaciously original calling cards in genre film history.

THE NUDE VAMPIRE

(*La vampire nue*)
France, 1970
Redemption/Kino Lorber
84m 41s, $24.95, BD-0

While staking-out his wealthy father Georges' (Maurice Lemaître) townhouse to ascertain mysterious goings-on there, Pierre Radamante (Olivier Rollin, the director's half-brother) encounters a beautiful woman (Caroline Cartier) with whom he feels an immediate and overpowering affinity. During their flight from her pursuers—black-clad figures in bizarre animal masks—the woman is shot dead and her body reclaimed by the denizens of the townhouse. This bizarre event solidifies Pierre's resolve to unravel the mystery of his father's secret life, and,

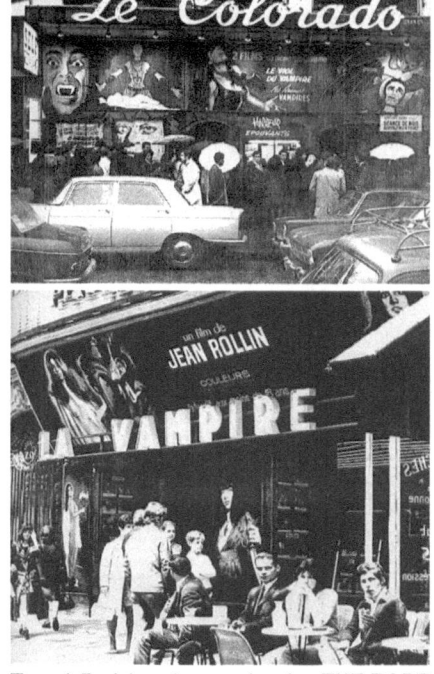

Top: A Parisian cinema showing **THE RAPE OF THE VAMPIRE** on its initial disastrous run, *circa* 1968. **Above:** Another French marquee, this time advertising **THE NUDE VAMPIRE** (1970). **Below:** The Castel Twins, Catherine and Marie-Pierre (billed thereon as Cathy and Pony Tricot) in the same film, with male lead Olivier Rollin (Jean's half-brother)

masquerading as an invited guest, he infiltrates the estate and soon discovers that it harbors a suicide cult dedicated to providing willing blood-sacrifices to the mysterious woman, who has somehow survived her recent ordeal.

With the assistance of his artist friend Robert (Pascal Fardoulis) and a cadre of mysterious strangers who appear precisely when most needed, Pierre is soon able to coerce an explanation from his father. Georges reveals that his beautiful captive is impervious to death or injury, and that he and his associates have been conducting experiments on her to unlock the secrets of immortality. Assuming she is a vampire, they have been feeding her the blood of the suicide cult's victims, all the while living in mortal fear of the day when others of her kind will seek her out and exact revenge against her captors. Disgusted with his father's actions, Pierre begins to suspect that he may have far more in common with the vampire and her allies than he initially suspected; a suspicion that is confirmed when the helpful strangers lay siege to his father's villa.

Rollin stated that for this, his second feature and the first one in color, he wished to make a conventional mystery, and thus relied upon a pre-written script rather than improvising during the course of filming. However, the production was plagued by his own mismanagement of financial resources, his inexperience, and delays in post-production after he was hit by a car. Rollin himself was less than fully satisfied with the end result, noting that a number of the film's strongest ideas are left underdeveloped, including the final revelation that the "vampires" are really mutants who represent the next stage of human evolution. The action sequences are also clumsily-executed, and as much as one would like to charitably argue that they contribute to the *naïveté* that Rollin cherishes, they prove distracting even to the most sympathetic viewers.

Fortunately, Rollin's emerging strengths are also evident, and if **THE NUDE VAMPIRE** fails as a mystery, it succeeds splendidly as a *dream* of a mystery. The influence of serials is even more pronounced than in **THE RAPE OF THE VAMPIRE** (1968), as evidenced by the film's mad doctors, gun-toting *femme fatale*, hairbreadth escapes, and the animal masks and hoods reminiscent of Georges Franju's **JUDEX** (1963) and Louis Feuillade's silent serial **LES VAMPIRES** (1915, both France). But its languid pace, surrealistic images and set-pieces, and distorted timeframe are more representative of a Republic serial filtered through the haze of half-sleep. **THE NUDE VAMPIRE** includes a number of striking visuals and an arresting use of color, including the opening scene featuring hooded figures in a laboratory replete with vials of brightly-colored chemicals, the multicolored animal masks worn by Georges' henchmen, and the final scene in which Cartier emerges from a bright red portal that suddenly appears in the middle of a seascape. Interestingly enough, the most dreamlike sequence is also the least overtly fantastic: when Pierre and Robert sneak into the father's office building during the dead of night,

Top: Maurice Lemaître and the Castel Twins in **THE NUDE VAMPIRE** (1970), with feline friend. **Above:** Michel Delahaye as the "Grandmaster" of the film's vampire-like evolutionary mutants

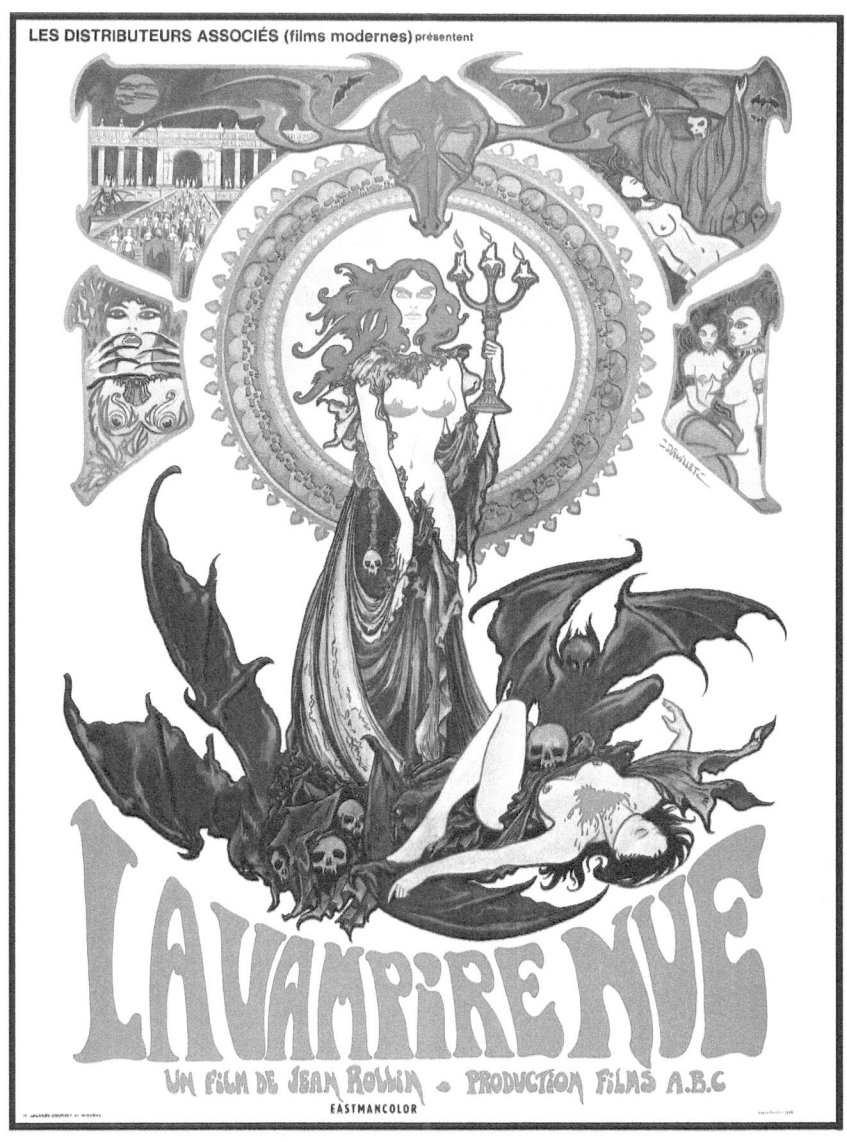

French *grande* poster for 1970's **THE NUDE VAMPIRE** (art by Philippe Druillet)

therein passing a series of open doors revealing administrators and secretaries enacting little vignettes related to typical business life.

As is typical in his work, here Rollin continually subverts genre conventions, beginning with the title. Traditionally, any film entitled **THE NUDE VAMPIRE** would deliver plenty of "vampire" and very little "nude", but here Rollin offers just the opposite. Furthermore, there are no coffins, bats, or crypts on display, and the humans are far more preoccupied with obtaining blood than the "vampires" (who not only are portrayed as sympathetic victims, but, in another bit of irony, also comprise the angry torch-mob at the finale).

THE NUDE VAMPIRE is also remarkable for introducing viewers to the twins Catherine ("Cathy") and Marie-Pierre ("Pony") Castel, who would appear separately and together in a number

of Rollin's later films. Here, they attack their roles as the Radamante family's servants/pets/concubines with an earnestness bordering on religious devotion that proved to be far more than an affectation when one sister knocked herself unconscious during the performance of a stunt. Given the provocative title, the eroticism here is relatively restrained, with prolonged nudity limited to the opening laboratory scene and an extended view of Robert's nude model. The Castel Twins, although they sport a number of fascinating fetish outfits, are almost criminally underutilized in this regard, but this would later be rectified in Rollin's X-rated **THE SEDUCTION OF AMY** (*Phantasmes*, 1975).

Though certainly not the director's strongest work, nor even the best entry point for a Rollin neophyte, **THE NUDE VAMPIRE** is both diverting in its own right and important as a preview of what was to come.

THE SHIVER OF THE VAMPIRES

(*Le frisson des vampires*, a.k.a. **STRANGE THINGS HAPPEN AT NIGHT**)
France, 1971
Redemption/Kino Lorber
94m 54s, $24.95, BD-0

En route to their honeymoon in Italy, newlyweds Antoine (Jean-Marie Durand) and Isle ([roughly pronounced "Izzlh"] Sandra Julien) decide to pay a visit to Isle's only remaining relatives, two eccentric cousins who live in a foreboding castle. Upon their arrival in the neighboring town, they are informed that the cousins had died the previous day, but that the household's servants are waiting to receive them. When they reach their destination, they are informed by the beautiful female maids (Marie-Pierre Castel and Kuelan Herce) that their masters are in fact still alive, and will eventually appear. It turns out that the cousins, after their investigation into a corrupt Isis-worshiping cult had led them to embark on a career as vampire hunters, have fallen prey to the hypnotic charms of the vampiress Isolde (Dominique), who soon sets her sights on Isa.

From the opening scene, a black-and-white depiction of a funeral in a dilapidated graveyard, **SHIVER** proves to be a far more traditional vampire film than Rollin's initial two outings. Gone are the pseudoscientific trappings of **RAPE** and **NUDE**, as Rollin anchors the story within a strictly supernatural framework, complimented by a more traditionally gothic atmosphere. However, by bathing scenes in primary-colored lighting, employing unusual costumes and props, and scoring the film with progressive/acid rock instrumentals, he makes sure that no one would ever mistake this for a Hammer production. The film is also more inventively shot than the preceding year's **THE NUDE VAMPIRE**, with frequent use of 360-degree pans.

One of the most surprising elements of the film is how successful the comedy sequences are, proving that Rollin may have underestimated himself when he stated that because he is not a "universal director" he could never direct a comedy. The two vampire cousins (Michel Delahaye and Jacques Robiolles), dressed in outrageous glam-rock attire, deliver wonderfully idiosyncratic comedic performances with their exaggerated theatricality a perfect counterpoint to their largely inane dialogue. Robiolles, looking like a combination of Ralph Bates (**LUST FOR A VAMPIRE** [1971, UK]) and Roman Polanski (**DANCE OF THE VAMPIRES** [1967, USA/UK]), delivers an especially strong performance, practically stealing the film whether he is delivering a soliloquy or simply seated in the background. It is important to note that the success of the comedy sequences is not simply due to the actors, as Rollin makes a number of interesting and successful comedic choices. For example, when the cousins are delivering a lecture at the dinner table, the camera is placed between them, with each in turn leaning into the frame to deliver his lines. By the end of the scene,

Nobody does giant metallic fake fingernails like Jean Rollin! The frisky artist's life-study model from 1970's **THE NUDE VAMPIRE** (actress unknown)

the lecture has degenerated into a shoving match, as each vies for the camera's attention.

There are also a number of subtle and obvious barbs directed at male vanity. Robiolles' vampire is constantly putting on and removing his eyeglasses, requiring them to see properly but obviously disliking the way they look on him. Antoine, leaping from his bed in response to a perceived threat, still takes time to don his ascot before venturing out. Initially presented as fearless vampire killers, it gradually becomes clear that the cousins' war with the undead was primarily motivated by a quest for glory rather than any moral impulse, and that once they are "turned" they easily alter their agenda to pursue the establishment of a vampiric dynasty by subjugating Isolde through rape and planning to breed with their young cousin.

The erotic content this time—it *was* released into some markets as **SEX AND THE VAMPIRE**, after all—is far more pronounced than in **THE NUDE VAMPIRE**, though still relatively tame compared to where Rollin would soon venture with his next film, **REQUIEM FOR A VAMPIRE** (1971). Once again he displays a talent for shooting attractive women who appear totally comfortable nude, but the film also maintains a more perverse undercurrent with its depictions of incest and rape. That being said, it's remarkable how *charming* the film is, most frequently provoking smiles of delighted surprise rather than fear or unease. This is most evident in the numerous inventive ways in which Isolde

Gallic Gothic I: Vampiress Caroline Cartier prowls the night in **THE NUDE VAMPIRE** (1970); see-thru negligée *not* optional, but obligatory!

makes her entrances—none of which will be spoiled here. But almost equally enchanting are the little affected bows the vampire cousins give after each of their speeches, the scenes of the maids solemnly covering the graveyard crosses with blankets in preparation for the vampires' arrival (not to mention the joyful little dance

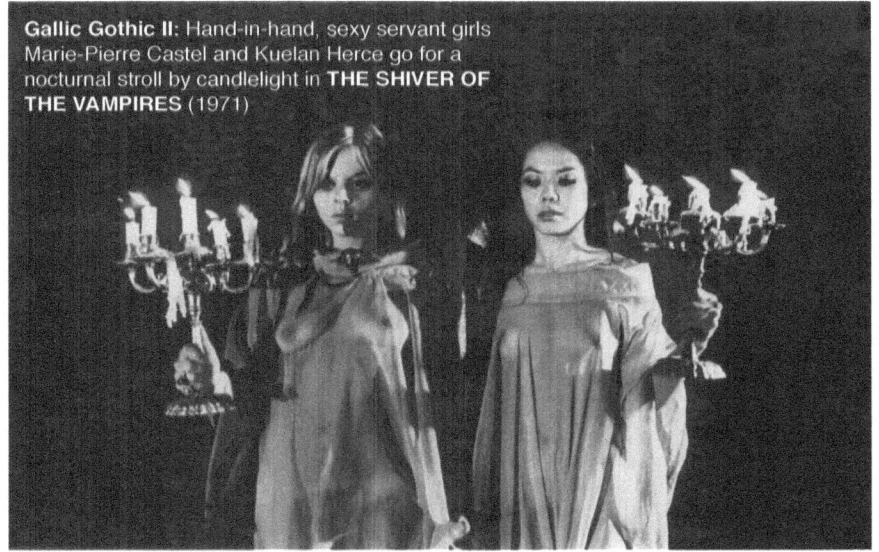

Gallic Gothic II: Hand-in-hand, sexy servant girls Marie-Pierre Castel and Kuelan Herce go for a nocturnal stroll by candlelight in **THE SHIVER OF THE VAMPIRES** (1971)

they perform when freed from bondage), and the randomly-inserted shots of the nude Castel serenely draped over various parts of the castle's architecture.

Though far from a perfect film—there are still too many prolonged shots of people simply walking, and the exaggerated death-gasps of the actors continue to provide unintentional comedy—**THE SHIVER OF THE VAMPIRES** remains one of Rollin's most accessible and enjoyable films.

REQUIEM FOR A VAMPIRE

(*Requiem pour un Vampire*, a.k.a. **CAGED VIRGINS**)
France, 1971
Redemption/Kino Lorber
86m 49s, $24.95, BD-0

Rollin's fourth feature film is not only the director's favorite and the best introduction to his work, it is also the quintessential *Rollinade*, incorporating everything—both good and bad—that the director is best-known for. The project began when producer Sam Selsky, pleased with the returns from **THE RAPE OF THE VAMPIRE** (1968), offered to finance another film, provided that Rollin was willing and able to work quickly. Rollin stated that he envisioned two clowns playing a piano in a cemetery, and decided to write a film that would incorporate that image. With no other ideas in mind, he approached the screenplay like a campfire story, making it up as he typed and finishing it within two days. The result is a film that cannot be analyzed, but rather must just be *experienced* as the purest example of Rollin's dream aesthetic.

The plot of **REQUIEM** is elegant in its simplicity. Two young women dressed as clowns are introduced in the middle of a combination car-chase and shootout. Although their male companion is killed, they are able to elude their pursuers and continue their flight, first by motorcycle, then on foot. After a series of surrealistic misadventures, they wind up in a deserted château, where they find themselves in the clutches of the Last of the Vampires and his sadistic human servants, who plan to use the girls to continue his bloodline.

This brief summary, however, fails to convey how the film perfectly mirrors the pseudo-narrative of the typical dream. For example, the film is almost devoid of dialog, with only a single line occurring

Top: Still and logo graphic from the French pressbook for **THE SHIVER OF THE VAMPIRES** (1971), showing Dominique as Isolde the vampiress. **Above:** Sandra Julien (with Dominique), in the same film. Incidentally, just for the record, Julien's character therein is named Isle (roughly pronounced "Izzlh"), not "Isa," as stated at the IMDb!

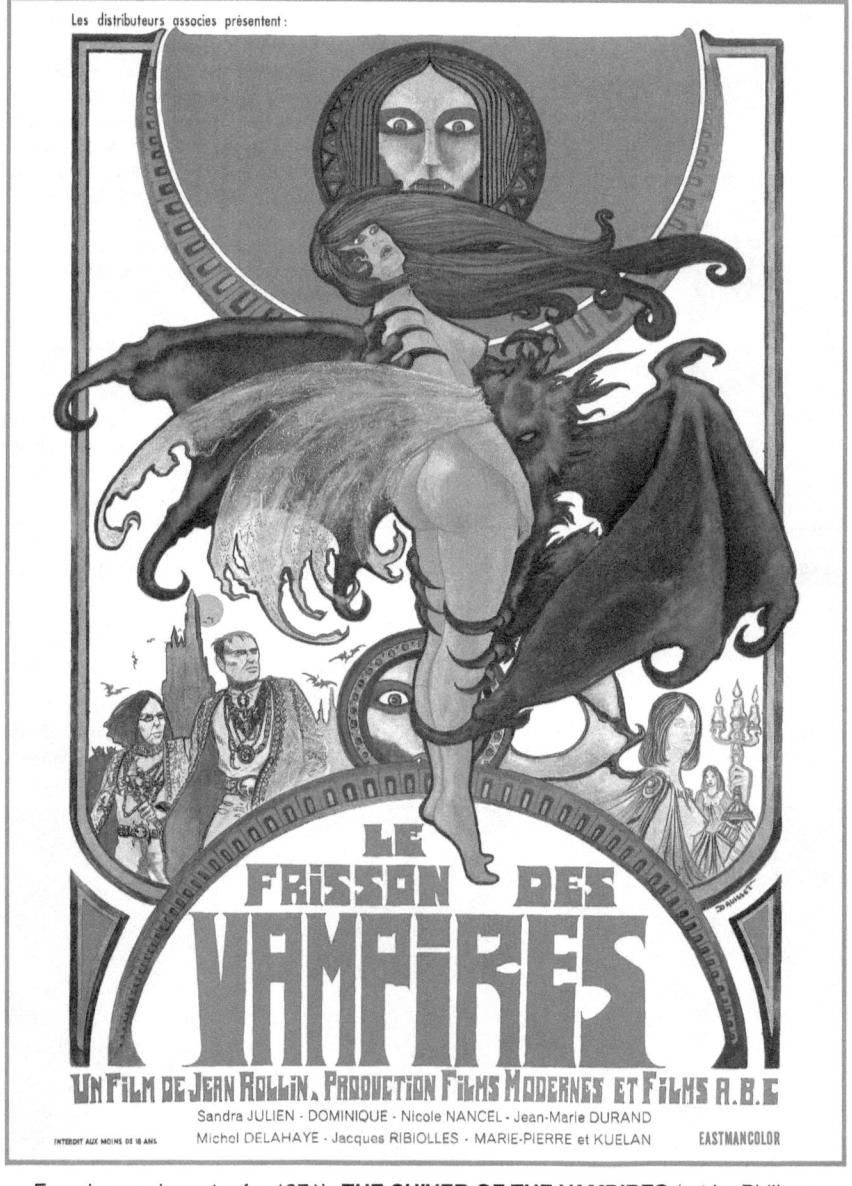

French *grande* poster for 1971's **THE SHIVER OF THE VAMPIRES** (art by Philippe Druillet); the third and final poster design the artist did for Rollin

within the first 43 minutes. The opening—which begins, like dreams do, in *medias res*—is one of the most surprisingly incongruous in fantastic cinema history. Furthermore, dream logic unfolds throughout the film in a remarkably accurate manner. Guns appear when needed, and disappear when not, and wounds heal once they no longer serve a narrative purpose. The characters repeatedly costume themselves in bizarrely impractical clothing, and display sudden and inexplicable periods of paralysis, panic, and calm. The narrative constantly shifts from the serene to the frightening to the erotic and back again, and the film ends abruptly—as dreams do— with the

Extra-sexploitative US grindhouse one-sheet poster

two protagonists escaping the central scenario. There is also a marvelous sequence in which a stagnant pool is suddenly speckled with red and white liquid, and when the source of this infusion is revealed, the viewer is reminded how dreams imbue even the most mundane activities with a sort of magic and wonder.

The erotic content of **REQUIEM** is far more pronounced than in Rollin's three previous films, and includes depictions of lesbian foreplay between the two young protagonists, a scene in which Castel loses her virginity while making love on a gravel path, and prolonged scenes of sadomasochistic whipping. However, the most notorious scene is a five-minute segment, lit in bright red and scored with blaring rock music, in which the vampire's male henchmen ravish three chained captives within the underground crypt. This scene was included at Selsky's insistence, and was responsible for the film being released in the United States as a sexploitation vehicle (under its lurid **CAGED VIRGINS** drive-in/grindhouse title in 1973). Rollin has disavowed it, and it remains questionable whether he was involved in its filming. However, all of the sex-scenes are consistent with both the *naïveté* and the dreamlike ambience of the film, as the groping and writhing resembles nothing so much as the erotic fever-dream of a child who has no idea of the actual mechanics of sexual intercourse. Consistent with the title, a wistful atmosphere of loss is also prevalent—not only in the young girls' journey from innocence to experience, but also in the depiction of the vampire as a sad creature on the verge of extinction who despises his minions yet uses them as a source of sensation to cope with his fear of diminishment and death.

The filming of **REQUIEM** was apparently one of the most pleasurable professional experiences in Rollin's career, and for once luck was on his

In this B&D+S/M-laden scene during **REQUIEM FOR A VAMPIRE** (1971), amidst loads of self-loathing, guilt and tears, Michelle (Mireille Dargent, kneeling) attempts to beat an answer out of her friend and lover Marie (Marie-Pierre Castel), who ain't tellin'

side. Although he intended to recast the Castel Twins as the young protagonists, Cathy was unavailable, leading him to substitute Mireille Dargent as Michelle instead. This not only permitted some exploitable erotic interaction between the two female leads, but Rollin was so pleased by her performance that Dargent was included, again wearing clown makeup, in his next two films as well. Dominique, the aggressive vampiress from 1971's **THE SHIVER OF THE VAMPIRES** (and also the ex-wife of the director of photography) returned, bringing along her current boyfriend, an English cameraman. Apparently, although her ex-husband and boyfriend were friendly toward one another on the set, each sought to outdo the other in making Dominique appear beautiful on camera. All of these factors contributed to a final product that proved Rollin capable of producing an accessible, commercially viable film while remaining true to his personal artistic vision.

It should be noted that the Blu-ray disc's English subtitles differ from those featured in Redemption's original DVD release, and contain an unfortunate mistranslation apparently derived from the English dubbing track. In the original French dialogue, when relating their backstory to the vampire's minions, the two girls explain how they escaped from a New Year's party by "knocking-out a guard". Unfortunately, the new subtitles have them saying that they "killed a man" (with the English dub adding that he "was annoying")—an error that makes these two characters appear far more malevolent than naïve.

Rollin has described **REQUIEM** as "an attempt to simplify the structure of a film to the extreme". He would carry this idea even further in his next fantastic film... almost destroying his career in the process.

THE IRON ROSE

(*La rose de fer*)
France, 1973
Redemption/Kino Lorber
80m 2s, $24.95, BD-0

The boy (Hugues Quester, billed as "Pierre Dupont") and the girl (Françoise Pascal) notice each other at a wedding reception, and arrange to go bicycling the next day. After cycling through a deserted train yard, they decide to rest within the confines of an immense cemetery. There, they

Top: French pressbook cover for **REQUIEM FOR A VAMPIRE**, featuring Michel Delesalle as "The Old Vampire", looking suitably long-in-the-tooth. **Above:** "Pony" (Marie-Pierre) Castel has her color scheme checked for the camera on the **REQUIEM** set

picnic, wander the grounds, and discuss their differing perspectives on life and death before retreating to an underground crypt to make love. Their passion exhausted, they emerge to discover that night has fallen on All Souls' Eve, when the barrier between Life and Death is most permeable. Worse still, they are now inexplicably unable to find the exit, so are forced to wander the grounds in an attempt to keep warm. The boy responds to the predicament with anger and violence, while the girl gradually succumbs to the influence of the dead.

WE KEEP RIGHT ON A-ROLLIN ON PAGE 175

JEAN ROLLIN SIDEBAR #1

7. Sex-Vampires

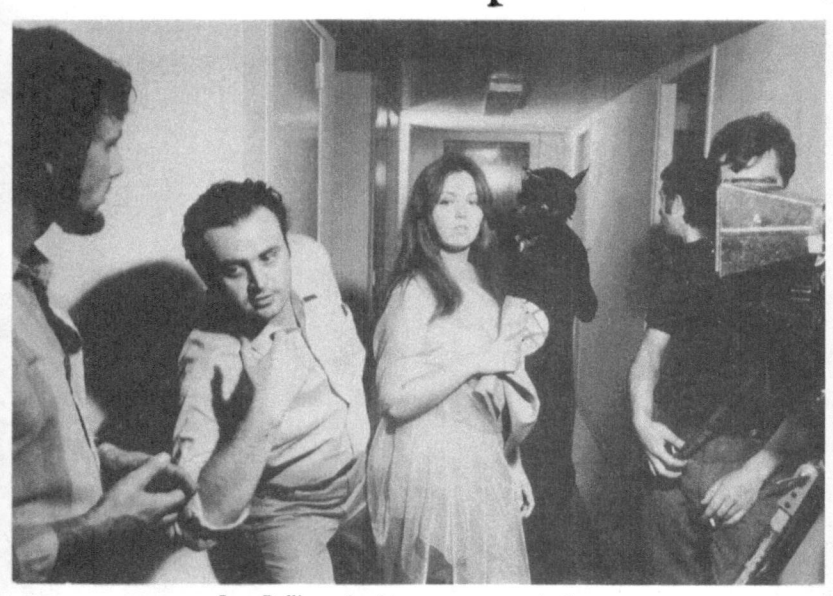

Jean Rollin urging his cast on to new devilment.

With Caroline Cartier on the set of **THE NUDE VAMPIRE** in 1970

Dating from when the director was still very much a going concern and operating at the peak of his creative powers, some of the earliest serious coverage written in the English language about Jean Rollin's work was to be found in Barrie Pattison's small, slender if pioneering volume entitled The Seal of Dracula *(London: Lorrimer Publishing, 1975), an overview of international vampire cinema as it then stood, whose seventh chapter, "Sex-Vampires", reprinted below in its entirety, was—logically enough—largely devoted to Rollin, if also giving his contemporary and rough Spanish equivalent Jesús Franco an honorable more-than-just-passing mention along the way. In the spirit of education and publicity, the following longish excerpt from Pattison's text—which possibly oversteps the boundaries of what might be considered "fair usage"—is here reprinted without permission, if respectfully and with proper credit given. (NOTE: Where needed,* Monster!*'s editorial remarks are interspersed in italics and square brackets throughout.)*

SEX-VAMPIRES

Not all vampire films slot comfortably into their national cinemas. France has no fantasy vampire cinema with any continuity, outside the work of Jean Rollin. "Grand Guignol is dead," he comments, and continues it.

Rollin made the traditional new-wave beginning in the early sixties with short films made with his friends. This period ended when a distributor needed a half-hour film and commissioned what became **LE VIOL DU VAMPIRE** *[see* **THE RAPE OF THE VAMPIRE** *(1968), p.160].* Rollin then encountered the producer Sam Selsky, who suggested that all they had to do was shoot another hour to have a complete feature. This was **LA REINE DES VAMPIRES** *["Queen of the Vampires"],* the second part of the composite film, deliberately given all the characteristics of a serial.

The partnership with Selsky has continued with Rollin insisting on the surreal elements of their output (which Rollin does not rate as pornographic, since there are no bed scenes). The partnership has been one of the most successful of the recent French cinema, running to another five films, with budgets increasing from **LE VIOL**'s $40,000 to the still modest $120,000 for **LES DÉMONIAQUES** *[see THE DEMONIACS (1974), p.176]*.

LE VIOL and **LA REINE** follow an incredibly complex story during which a psychiatrist and his friends try to free two demented sisters, whose main occupation is being pack-raped by the locals. The girls believe themselves victims of a vampire curse laid on them by their sword-fighting ancestors. The local chatelaine encourages this belief with a Zardoz performance behind a sinister effigy. The final confrontation on the beach proves the curse a reality. Along comes the queen of the vampires—an African lady given to reclining topless on the tigerskin seats of her automobile. She operates out of the clinic where vampire girls suck blood through plastic tubes from kingsize jars. The doctor and the analyst contrive to massacre the vampires during a theatre black mass performance.

LA VAMPIRE NUE (1969) *[see THE NUDE VAMPIRE, p.163]* is Rollin's first film in colour. Here the scientist using a girl in his vampirism experiments is foiled by his son, who becomes the girl's lover in alliance with the chief of the vampire sect. In **VIERGES ET VAMPIRES** (1971), also known as **REQUIEM FOR A VAMPIRE** *[see p.168]*, two girls escape from a reformatory and shelter first in a graveyard then in a castle filled with vampires, who attempt to enslave them. Similarly, in **LE FRISSON DES VAMPIRES** *[see THE SHIVER OF THE VAMPIRES (1971), p.166]*, the two brother vampire hunters are halted in their work by Isolde, the master of the world's vampire agent who wishes to prevent the vampire race's extinction. The brothers themselves become vampires and menace a young married couple, before finally realising the horror of the situation and destroying themselves and their girl victims. The plot content of Rollin's films is their least significant element, becoming little more than an excuse for the images. In each film, he returns to the beach at Dieppe, where the naked lover is whipped with seaweed in **LA REINE DES VAMPIRES** and the shipwreck is washed up in **LES DÉMONIAQUES**. Rollin's sequences often resemble panels of a comic paper more than film scenes. He restaged a Magritte painting, placing his vampire shielded by her coffin in the sunlight for **LE FRISSON DES VAMPIRES**. His work is full of these bizarre images, with the vampire arriving from the grandfather clock or down the chimney in **LE FRISSON**, while the two girls in the clown costumes in **REQUIEM FOR A VAMPIRE** prefigure the clown visiting the grave in **ROSE DU FER** *[{sic} see THE IRON ROSE (1973), p.171]*. Also haunting are the impaled dove and bat of **LE VIOL** and the beast-headed men of **LA VAMPIRE NUE** *[see THE NUDE VAMPIRE (1970), p.163]*.

Rollin stands right outside the body of French film-making. His technicians are little known outside his films, and while Sandra Julien did manage to spin-off a career in films of the **JE SUIS UNE NYMPHOMANE** *[a.k.a. I AM A NYMPHOMANIAC, 1971, France, D: Max Pécas]* cycle after her lead in **LE FRISSON**, Rollin prefers to work with non-actors. In his casts are film-maker Maurice Lemaitre, sculptor Nicholas Deville and Lone Sloane artist Philippe Druillet who designs his striking posters.

Even the specialised magazines are far from sympathetic to Rollin's output, heaping abuse on each new offering. The director is, however, more affected by the theatres in which his work plays. In Paris only one cinema, *Le Styx*, is a suitable first-run house for a fantasy film, and most of Rollin's output gets lumped in with the skin-flick trade, although one production did turn up on the Champs Elysées. He remains one of the most curious phenomena of the contemporary cinema.

Despite the criticism, Rollin's style has become an influence, notably in **LE SADIQUE AUX DENTS ROUGES** *[a.k.a. THE SADIST WITH RED TEETH]*, Jean-Louis van Belle's Belgian *[actually French]* production of 1970 *[see pics, pp.182+184]*. In this, a young man under treatment for a vampire obsession finally runs amok at a fancy dress ball. Although the film is generally dismissed, the comic paper invention and the attempt to find a contemporary vampire film idiom, do deserve attention.

One film-maker, whose career has points in common with Rollin's, is the Spaniard Jesus/Jess Frank/Franco, though no one would confuse their work. Franco also has little to do with the industry of his native country. His efforts are handled largely by the exploitation circuits and also receive a rough passage from reviewers. He is one of the most active film-makers in the world today, with an output of more than sixty features, including twelve in 1973 alone.

His contribution to vampire cinema in recent years has been considerable. As well as his **EL CONDE DRÁCULA** *[COUNT DRACULA, 1970, Spain/West Germany/Italy/Liechtenstein]* there is **VAMPYROS LESBOS** / *Die Erbin des Dracula* (1970) in which a young American girl is confronted by a Countess, whose face has appeared in her hallucinations and who is discovered to be a descendant of Dracula. In 1971 Franco made **DRÁCULA CONTRA EL DOCTOR FRANKENSTEIN** *[a.k.a. DRACULA, PRISONER OF FRANKENSTEIN, Spain/France (see* Monster! *#28/29, p.49)]*. In this one, Dennis Price plays a Doctor Frankenstein, who revives his monster in the person of the seven-foot Fernando Bilbao, and who confronts Howard Vernon as Count Dracula accompanied by Britt Nichols as his resurrected bride. This was followed by **LA HIJA DE DRACULA** (1972) *[a.k.a. DRACULA'S DAUGHTER, France/Portugal (see* M! *#28/29, p.52)]* in which Miss Nichols and Mr. Vernon followed the exploits of Dracula's daughter. Here, Maria Karnstein is given by her dying mother the key to the crypt where the undead Count lies. Soon all the underclad girls of the district are menaced, the Karnstein maid, the night-club dancer and Amy, Maria's lover. When the police force breaks its way into the crypt, it finds two coffins.

These films draw on Franco's regulars, the late Dennis Price and Soledad Miranda (an attractive girl who also appeared in his straight erotic films under the name of Susan Korda). Bilbao, Albert Dalbes, Paul Muller and particularly Howard Vernon, the established French character actor. Vernon's comment to Vampirella on finding himself among Franco's nudes and gore is the revealing: "I'm not a modest or moral individual… I act without distaste or conviction."
~ Barrie Pattison

Above Right: Barrie Pattison's seminal book on vampire cinema (London: Lorrimer, 1975). **Above Left:** The startling/shocking "crotch-bat" scene from **REQUIEM FOR A VAMPIRE** (1971)! Even if the creature is obviously merely a flat photographic cardboard cutout "animated" (ever-so-slightly) by an invisible pull-string, simply due to the—um—juxtaposition, the effect is still more than a little unsettling to this day. These two images were scanned as-is, not from Pattison's above-quoted *Seal of Dracula* book, as you might expect, but rather from another, earlier book put out by the same publisher as part of the same loose series. Entitled *Movie Fantastic: Beyond the Dream Machine* (London: Lorrimer, 1974), by David Annan, the book in question—a small, slim (132-pp.) overview of science fiction, fantasy and horror in cinema and popular culture as it then stood, with an emphasis on illustrations rather than text—was published in the US by Crown Publishers/Bounty Books of NYC. There was no mention of Rollin in the book other than in the caption to a handful of nudie vampire stills, of which these were by far the raciest. As a young lad in the UK during the mid-'70s, I spent my hard-earned pocket money (I worked a daily paper route on foot) on a softcover copy of *Movie Fantastic*, and it was this particular pair of images which I found most fascinating in the entire book. I can't think quite why! (*Wink.*) **~ SF**

CONTINUED FROM PAGE 171

At once Rollin's most unusual and personal film, **ROSE** premiered at the second Convention of Cinéma Fantastique, where the director himself introduced and attempted to explain the film. After being forced for commercial reasons to incorporate more and more softcore sex onto his films, Rollin was determined to make a "very serious, profound film" and hoped those gathered would at least appreciate his intent to "do something different". By all accounts, the screening proved an unqualified disaster, and **THE IRON ROSE** was met with unbridled hostility from both critics and audiences alike (much as had happened in 1968 with **THE RAPE OF THE VAMPIRE**). This was devastating to Rollin not only on a professional level, as it impaired his ability to find financial backing for projects for the next few years, but also emotionally, as it represented wholesale rejection of his most sincere artistic endeavor to date.

Despite its surrealistic premise and execution—which resembles not only such theatrical works as Samuel Beckett's *Waiting for Godot* (1948-49; first performed in 1953) and Harold Pinter's *The Dumb Waiter* (1957; first performed in 1960), but also much later films like Gus Van Sant's **GERRY** (2002, USA/Argentina/Jordan)—this is one of Rollin's most intellectually coherent films, though it is still open to multiple interpretations. At its most basic level, the film explores the inexorable power of death and the varying ways in which human beings simultaneously embrace and deny awareness of our ultimate end. The film begins with the young couple, newly in love, trying to impose life on the domain of the dead by picnicking on a grave and making love in a crypt. However, when night falls and the girl becomes more attuned to the world of the dead, she realizes that the barrier between life and death is nothing more than a "crystal wall"—a boundary as transparent as it is fragile. The boy stubbornly expects both the girl and the cemetery to adhere to the rules of the material world, while the girl slowly comes to realize that the dead are not only free from pain and hardship, but also exist in a state of perpetual harmony where conflict is no longer necessary. Thus, she begins to view death as the infinite prolonging of love and passion, rather than its termination.

The film can also be seen to depict the entire life of the relationship—from initial passion through conflict and betrayal to sacrifice and reconciliation, until the lovers are first separated by, and then finally united in, death. It is also interesting to consider a third possible interpretation of the film suggested by Rollin's description of the two title characters: the boy who "remains the same close-minded little provincial guy for the entire film", and the girl who is "full of passion, and

Françoise Pascal as "The Girl" in **THE IRON ROSE** (1973), with headbone

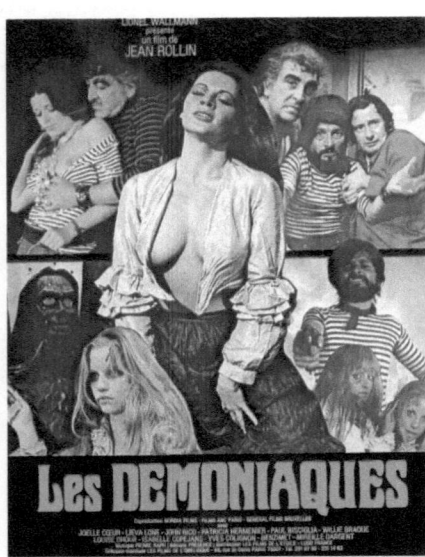

French *grande* poster for **THE DEMONIACS** (1974)

Given that there are only two characters, this is clearly a film that will rise or fall based on the performances of the two leads, and in this case, Rollin was exceptionally fortunate. For once, outside interference worked in his favor, as the producer insisted that he cast Pascal as the female lead. In the interview that accompanies the film on the disc, Pascal notes that she was acutely aware of Rollin's disappointment with her, and set out to prove him wrong by immersing herself heart and soul in the project. This apparently led to an enthusiastic collaboration between actor and director resulting in the single best performance in Rollin's entire *oeuvre*. However, even male lead Quester's hostility to the entire project (leading him to insist that his name be removed from the credits) works in Rollin's favor, rendering the boy's shrill petulance more thoroughly convincing still.

Although **THE IRON ROSE**'s reputation has improved with age, it is clear that the memory of its rejection stayed with Rollin all his life, leading him to summarize the film as a story of a "passionate desire for a love that cannot be found"—a theme that would be explored more explicitly in his later film **LIPS OF BLOOD** (1975).

since her passion isn't shared at all by her companion, she projects it onto... the cemetery, huge and enigmatic, which she loves". In this light, the film can be viewed as Rollin's (possibly unconscious) reply to critics who dogmatically insist that he limit himself to the conventions of horror cinema rather that follow his own idiosyncratic passions. At the end of the film, the boy, ruled by convention, winds up forever imprisoned within a stone cell, while the girl, ruled by passion, is granted the sprawling vista of a seashore.

ROSE is also unusual in that Rollin here repeatedly employs visual symbols for thematic rather than simply emotional purposes. This is evident from the beginning of the film, in which the Last Vampire from **REQUIEM FOR A VAMPIRE** (1971), the clown from both that film and **THE DEMONIACS** (1974), as well as the elderly gatekeeper from **THE NUDE VAMPIRE** (1970), all enter the cemetery to pay their respects, as if Rollin is asserting that even dreams must eventually acknowledge death as their master. A scene of the couple squabbling cuts to a shot of a headless cherub. The boy, unrelenting in his determination to impose a rational order on the night's proceedings, believes he has finally escaped the cemetery, only to find himself trapped within the linear precision of a military graveyard. Both the Christian cemetery and the titular iron rose itself—a talisman wielded by the girl throughout the film—symbolically unify the ephemeral with the eternal.

THE DEMONIACS

(*Les démoniaques*, a.k.a. **CURSE OF THE LIVING DEAD**)
France/Belgium, 1974
Redemption/Kino Lorber
100m, $24.95, BD-0

Made during a period of personal crisis when his popularity was at an all-time low, **THE DEMONIACS** represents a significant departure for Rollin, being a somewhat awkward hybrid of swashbuckler, sexploitation vehicle, and *Rollinade*. Not only is it the first of his films to feature no vampires whatsoever (as even **THE IRON ROSE** [1973] had featured a brief cameo from one), it is also unusually action-oriented and anchored to a far more linear and traditional narrative than his previous works. The film was a Belgian coproduction, and Rollin was forced to employ Belgian actors and technicians, resulting in a film that vacillates between material reflecting the director's recurrent preoccupations and that which is obviously the product of external demands.

THE DEMONIACS, which is set sometime "during the end of the last century" in a cursed

seaside village, begins with a group of wreckers luring a ship to smash against the rocky shoreline in order to plunder its cargo. The three pirates and their sadistic female companion Tina (Joëlle Coeur) discover that two young girls (Lieva Lone and Patricia Hermenier) have survived the wreck, and promptly proceed to rape, bludgeon, and leave them for dead. Returning to a brothel tavern, their leader, The Captain (John Rico), is haunted by the spectral apparitions of the two young victims, who in reality have survived their ordeal and made their way to the ruined abbey outside of the village, which is said to imprison a "dark angel". There, they encounter two gaolers, a monk and a clown (Mireille Dargent from **REQUIEM FOR A VAMPIRE** [1971] again), who inform them that the captive Devil (as played by assistant director Miletic Zivomir) will likely grant them the power to exact their revenge, should they decide to free him.

Rollin stated that **THE DEMONIACS** was meant as an *homage* not only to the pirate films he enjoyed as a child, but also to German Expressionism. This proves to be a wise stylistic choice, as the prolonged scenes of rape and physical abuse would likely be unbearable were they depicted in a more realistic fashion. Mirroring the chapter-play structure of **THE NUDE VAMPIRE** (1970), **THE DEMONIACS** is far more action-packed than the usual *Rollinade*, featuring as it does various chases, gunplay, fistfights and conflagrations. Actions scenes are by no means Rollin's strong suit, but here he is able to overcome his usual clumsiness thanks to clever editing. The film is also notable for its emphasis on psychological rather than emotional themes. This emphasis is not only evident in the steady decomposition of The Captain as he becomes more and more unhinged by guilt, but also in the intriguing depiction of his sadomasochistic relationship with Tina. The Captain, a criminal who chooses to sleep with a hangman's noose above his bed, is portrayed as the ultimate masochist—a man trapped within an endless cycle of compulsive malfeasance followed by unbearable guilt. Tina, on the other hand, possesses a sexual sadism that transcends the animalistic to become something of a force of nature, and she clearly derives orgasmic pleasure not only from the torture and murder of her victims, but also from the ensuing agony inflicted on her lover's conscience. As the embodiment of Sadean excess, Coeur's performance is so remarkable that when Rollin chooses to underscore her beachside masturbation scene with a series of cannon blasts, it actually appears fitting rather than absurd.

A Jean Rollin Drive-In Double Feature! Corpus Christi, Texas newspaper ad (dated November 11th, 1977)

Despite the film's adherence to a linear plotline, the associative dream logic of the typical *Rollinade* is also prevalent. When the two girls enter the ruined abbey, the viewer is immediately reminded of the runaways in **REQUIEM FOR A VAMPIRE**, and, as if on cue, the clown from that film suddenly reappears herein. When Louise Dhour, the graveyard pianist from **REQUIEM**, makes her appearance as a clairvoyant madam who serves as a sort of one-woman Greek chorus, she once again plays that same instrument. A dreamlike aura clearly emanates from the set designs—especially the tavern decorated with

Italian *due-fogli manifesto* for 1974's **THE DEMONIACS** (art by "Mos"/Mario de Berardinis)

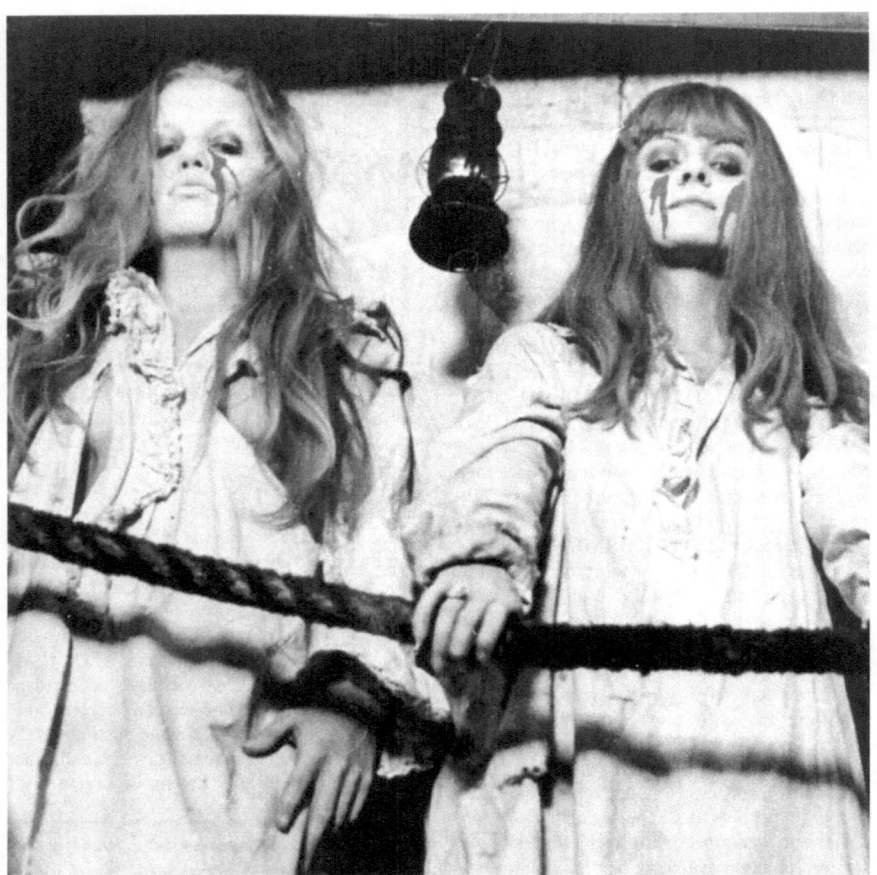
Gory ghoulgirls Lieva Lone and Patricia Hermenier in **THE DEMONIACS** (1974)

macabre dolls, totems, and wall-hangings—and from the locations employed, such as the ruined abbey, a graveyard of wrecked ships, and the seaweed-encrusted shores on one of the cluster of islands in the Chausey group (situated in the English Channel some 17 kilometers offshore from Normandy). The actors also display the exaggerated theatricality of the typical *Rollinade*, but it appears that critics and audiences were more receptive to this style here, as it was so well-suited to the material. It's also interesting to note that, as in **REQUIEM**, the primary supernatural threat is once again revealed to be a relatively benevolent one.

The film's most glaring weakness is its lack of narrative resolution. The first hour of the film features Rollin's most coherent narrative to date, as the steadily intensifying atmosphere of guilt and revenge builds to what appears will be a grimly satisfying climax. Instead however, the last 40 minutes prove a confused mess, leading to a finale that, although beautifully shot, is profoundly unrewarding. As has been stated before, traditional narratives have never been especially important to Rollin (or to his devotees), and his endings have always been a particular weakness. What makes these flaws so devastating here is that **THE DEMONIACS** begins with an atrocity rather than a mystery, and thus provokes a level of emotional engagement that demands the clear resolution that Rollin so often fails to deliver. The erotic scenes (all heterosexual) also seem overly long and intrusive—with the exception of those involving Coeur—and for the first time come across as the obvious product of external pressure.

The shooting of **THE DEMONIACS** was plagued by the sorts of catastrophes that had unfortunately now become so typical of a Rollin production. The Castel Twins, for whom the roles

of the young survivors were specially written, proved unavailable. Although Rollin was soon able to find a suitable replacement for one of the girls, she suddenly resigned in response to a rumor that the director was running a clandestine prostitution ring and would force her to walk the streets to secure money for the film (!). Rollin was greatly dissatisfied with the actresses he eventually cast—especially Patricia Hermenier, whom he described as an "unbearably skinny modeling student" who spent the shoot shivering uncontrollably in the cold. Apparently, assistant director Miletic Zivomir proved completely incompetent, but could not be fired because he had already been cast in the pivotal role of *Le Diable*. To make matters worse, producer Lionel Wallman took the rushes to Paris to view, only to return and inform Rollin and the crew that the material shot was completely unusable—a demoralizing experience that soured the atmosphere on set. Fortunately, Wallman was mistaken, as he did not understand the difference between rushes and finished film, and thus was confused by the absence of sound and music. There were bizarrely fortuitous moments as well: as when Rollin exhausted his funds with one week still left to shoot, Wallman purchased a lottery ticket at a local tavern, and won enough money to complete production.

Although an enjoyable experiment, **THE DEMONIACS** might best be said to exist in a sort of netherworld between Rollin's most personal films and those (like his gore opus **THE GRAPES OF DEATH** [1978]) that were more clearly attempts at commercial success. At the very least, it serves as a testament to Rollin's perseverance, and is the first indication that he could adhere to a more traditional narrative—an ability that he would employ with even greater success in his next film.

LIPS OF BLOOD
(*Lèvres de sang*)
France, 1975
Redemption/Kino Lorber
86m 55s, $24.95, BD-0

While attending a party with his mother (Rollin regular Natalie Perrey), Frédéric (Jean-Loup Philippe) is stunned to discover that a photograph of a dilapidated château prominently featured in a perfume advertisement revives a long-repressed childhood memory in him. He suddenly recalls how, at the age of twelve, he became lost in the wilderness surrounding his home, and was sheltered in those same ruins by a beautiful young woman dressed entirely in white. Before departing in the morning, he pledged his love to her, offering her a toy as a token of his devotion, and then never saw her again. The adult Frédéric shares his newfound discovery with his mother, hoping that both the ruins and the young woman will provide a clue to his inexplicable lack of childhood memories. His mother responds with a mixture of confusion and hostility, urging him to forget his quest to locate the château. Undeterred, he tracks down the photographer, who initially refuses to provide him with any information, stating that she was paid to remain silent. However, her attraction to him leads her to promise to reveal all should he agree to meet her that night at the city aquarium.

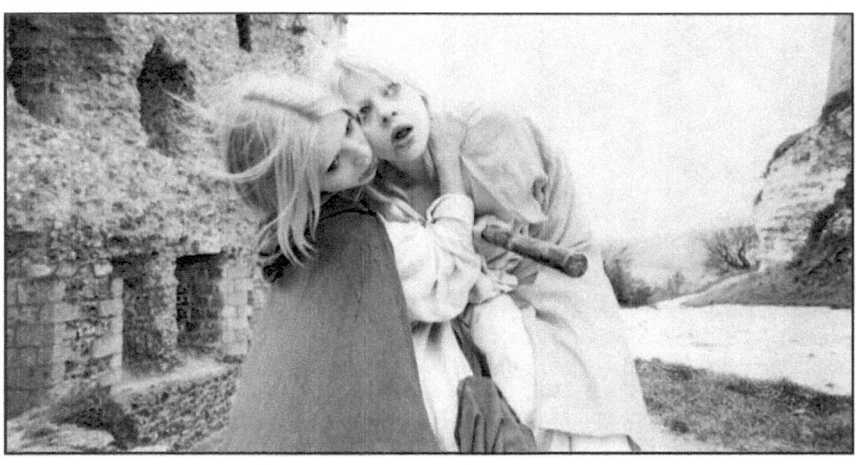

The Castel Twins in **LIPS OF BLOOD** (1975)

Top: One of the fabulously stark rural ruin locations seen in **LIPS OF BLOOD** (1975). **Above:** The film's French pressbook, with gruesomely erotic cover art by the local underground comics illustrator known as Caza

Killing time before his appointment in a theater that happens to be showing Rollin's 1971 film **THE SHIVER OF THE VAMPIRES** (albeit advertised as **THE NUDE VAMPIRE** [1970]), Frédéric is accosted by the silent apparition of his lost love, who leads him on a trek through the rain-soaked city, during which he unknowingly frees four female vampires (including both Castel Twins) from captivity, survives several assassination attempts, and barely escapes from the clutches of a malicious psychiatrist determined to "cure" him through electroconvulsive therapy. The finale leads to the discovery of both the château and the true identity of the mysterious young woman, as well as a family secret that tests Frédéric's devotion to his lost love.

In a number of interviews, Rollin has referred to **LIPS** as his best and most fully-developed script; and rightfully so. For once, there is a comprehensible story arc, clear motivation for his characters, and, most atypical of all for the director, a fully satisfying conclusion. Furthermore, the film elegantly employs its dreamlike sequences in the service of its narrative, rather than simply as arresting artistic or emotional detours. In the essay accompanying the disc, Tim Lucas refers to **LIPS** as Rollin's **SOMEWHERE IN TIME** (1980, USA, D: Jeannot Szwarc), but in many ways the film more closely resembles Martin Scorsese's **AFTER HOURS** (1985, USA), as both feature a naïve innocent forced to negotiate a surreal and threatening urban dreamscape in pursuit of his feminine ideal. Though successful as an exercise in the fantastic, the film may also be viewed as a sympathetic portrayal of how a consensual incestuous love relationship might appear to those involved in it. Given the prevalence of this theme, it is also surprising to note how, with the elimination of a few moments of largely incidental nudity and the slight alteration of one plot revelation, **LIPS** could easily be remade as a rather touching *children's* film.

LIPS is admittedly imperfect (for example, the rationale for the assassination attempts are unclear), but its faults are likely due to a number of factors beyond Rollin's control. In the first place, shortly before shooting commenced, one of the producers declared bankruptcy, forcing Rollin to reduce his shooting schedule by a week. This led to a number of scenes critical to plot development either being truncated or eliminated entirely. Furthermore, according to actress and production assistant Natalie Perrey, the crew was, throughout the shoot, overtly hostile to Rollin, leading to an oppressively negative environment that caught both she and the director completely

by surprise. Their spirits were buoyed, however, by the presence of Rollin's 8-year-old son Serge, who played Frédéric as a child, and who was so excited to appear in the film that he often repeated his lines in his sleep. Viewed exclusively within the context of these setbacks, **LIPS OF BLOOD** would be considered a remarkable success, but the film should be considered a significant achievement on its own terms, as it represents the single best melding of Rollin's unique style and themes with a compelling and cohesive story arc. Unfortunately, the film's release coincided with the introduction of hardcore pornographic feature films in France *[in fact, an X-rated edit of LIPS was even released in the US under the vulgar title SUCK ME, VAMPIRE – ed.]*, and Rollin's lyrical meditation on childhood loss proved a financial disaster.

THE GRAPES OF DEATH
(*Les raisins de la morte*)
France, 1978
Redemption/Kino Lorber
90m 35s, $24.95 BD-0

Along the course of a train journey to visit her fiancé, the owner of a remote winery in the cold, barren and mountainous Cévennes region of France, Élisabeth (Marie-Georges Pascal) is accosted by a violent stranger whose face seeps blood and pus. After escaping from the deserted train, she wanders the countryside seeking assistance, encountering a strange father and daughter in a deserted farm, a beautiful blind girl named Lucie (Mirella Rancelot), who is fleeing her brother's home in response to some vague threat, as well as a mysterious blonde (Brigitte Lahaie) who glides through the chaotic hellscape like some spectral dominatrix. All the while, she is pursued by the disfigured denizens of the region, whose consumption of contaminated wine has triggered compulsive homicidal behavior in them.

After the financial losses associated with **THE IRON ROSE** (1973) and **LIPS OF BLOOD** (1975) and his subsequent exile into hardcore pornography, Rollin embarked on what would become a trilogy of more conventional horror films that he hoped would prove commercially viable. **GRAPES**, widely considered the first French gore film, proved a commercial success, and also featured the first mainstream film performance by hardcore actress Brigitte Lahaie, whom Rollin had previously directed in the pornographic film **VIBRATIONS SEXUELLES**

Top: French *grande* poster for 1978's **THE GRAPES OF DEATH** (art unsigned). **Center:** Mirella Rancelot as blind girl Lucie, the ill-fated village "bad luck charm". We find out just how ill-fated she is not so very long after we first meet her. **Above:** One of **GRAPES**' putrefying, pustulent "pesticide zombie" villagers, on the prowl

THE THRILLS & CHILLS CONTINUE ON PAGE 185

THE ROLLIN INFLUENCE
JEAN ROLLIN SIDEBAR #2

Outré production design and crazy costumes abound in the outrageously over-the-top vampire-themed production number in Jean Yanne's musical comedy **CHOBIZNESSE** (1975, France)

In spite of how largely ostracized/lambasted the director was by most within the notoriously snobbish/elitist French film industry, as well as by establishment critics too (if not always with the paying punters), the Rollin influence—especially among more avant-garde / experimental and underground filmmakers from the very fringes of the mainstream cinema—began to show itself relatively early in France, including in these 1970s productions whose imagery is depicted on these pages.

More *el cheapo* plastic fangs are on show in the oddball comedic sexy shocker **THE SADIST WITH RED TEETH** (1971, France)

A scene from Pierre Unia's French sexcom **LES MAÎTRESSES DE VACANCES** (1974)

Above Left: A 1973 French book of erotic horror tales by Alan Newman (art by Tony Bastos). **Above Right:** From the ultra-obscure French film **LE SALUT EST DANS LAFUITE**, *circa* the 1970s

Top Left: A "living dead girl" from Claude d'Anna's pretentiously arty French-Belgian-Tunisian co-production **DEATH DISTURBS** (*La mort trouble*, 1970). **Top Right:** From a '70s French (?) erotic film (?) called **LE SEXE ET SATAN**; other details unknown (in fact, the image may not even be from an actual film at all, but we found it in an old skin-mag *au français*). **Above Left:** Another funky fangs'n'femme shot from the brilliantly bombastic vampire stage revue in Jean Yanne's otherwise non-horror musical comedy **CHOBIZNESSE** (1975, France). **Above Right:** Native poster for the French film **THE SADIST WITH RED TEETH** (1971)

**THRILLS AND CHILLS
CONTINUED FROM PAGE 181**

(1977, France). Although blessed with an ample budget and professional cast, the present project still proved something of an ordeal due to the frigid temperatures which the cast—especially the lightly-clothed Lahaie—were forced to endure. The grace with which she conducted herself led Rollin to prominently feature her in his next two films.

The film has understandably been compared to Romero's **NIGHT OF THE LIVING DEAD** (1968, USA), but Rollin adamantly denies both the influence and similarities, noting that **NIGHT** is a claustrophobic siege film, while **GRAPES** is intended as a disaster movie in the tradition of **THE POSEIDON ADVENTURE** (1972, USA, Ds: Ronald Neame, Irwin Allen), with bickering survivors forced to negotiate a broad and hostile landscape. In this way, the film resembles the environmental apocalypses of British author John Christopher, especially his novel *The Death of Grass* (1956), which was filmed by Cornel Wilde as **NO BLADE OF GRASS** (1970, UK/USA). Furthermore, unlike Romero's somnambulant ghouls, Rollin depicts the afflicted as maintaining some degree of sentience and existing in a state of constant physical, psychological and emotional torment as they compulsively enact behavior that they find abhorrent.

While clearly a commercial venture that largely eschews the director's hallmark obsessions, **GRAPES** does incorporate numerous elements found in the typical *Rollinade*. Mirella Rancelot's blind Lucie, wandering the countryside in a flowing white nightgown, could easily pass for the blind sister from **THE RAPE OF THE VAMPIRE** (1968), although here she is depicted as the virginal counterpoint to Lahaie's blonde vampiress. Lucie's ultimate fate also evokes the horror of suppressed incestuous desire, a theme evident in a number of the director's previous works. Most importantly, however, the film clearly reflects Rollin's dream aesthetic, as **GRAPES** is largely devoid of dialog, involves no clear narrative arc, and devotes much of its running time to depictions of the protagonist simply wandering from one scenario to another—often through picturesque ruins or beautifully desolate landscapes. However, unlike the previous films, the set-pieces linked together through the protagonist's journey here generate disgust and horror rather than melancholy wonder. That being said, the violence is far less gruesome than one might expect, as the gore scenes

Bastards!

Your Pretty Face Is Going To Hell: Things get messy for both Brigitte Lahaie and Michel Herval in **THE GRAPES OF DEATH** (1978). Blame it on the wine!

are clearly more the product of obligation than any enthusiasm on Rollin's part. Surprisingly, the film is entirely devoid of erotic content, and Pascal holds the distinction of being the only female protagonist in Rollin's *oeuvre* to remain fully clothed throughout a film.

Promoted as an "ever-expanding nightmare" on the disc's cover, **GRAPES** might be better characterized as a rather accurate cinematic depiction of a "frustration dream" in which the dreamer sets out to accomplish some goal—here a quest for a working telephone—only to be repeatedly thwarted in an increasingly surreal manner at every turn. Given that dreams are the byproduct of the brain's linking of events and emotions in the catalogue of memory, one would fully expect Rollin to experience frustration dreams at this particular juncture in his career, and it is difficult not to see a narrative in which something quintessentially French (i.e., *vin*) is revealed to be poisonous as a rather pointed attack against the culture that rejected him. A fairly successful compromise between Rollin's artistic inclinations and commercial demands, **THE GRAPES OF**

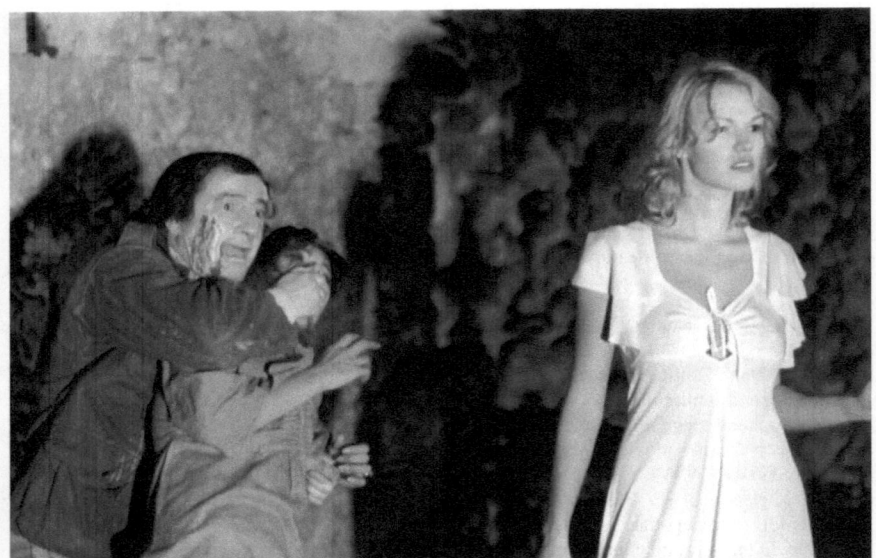

Things get nasty in **THE GRAPES OF DEATH** (1978); Serge Marquand, Marie-Georges Pascal and Brigitte Lahaie.

DEATH might best be considered the Rollin film for people who hate Rollin films.

FASCINATION
France, 1979
Redemption/Kino Lorber
81m 28s, $24.95 BD-0

Upon escaping from a band of thieves whom he has double-crossed, the foppish scoundrel Marc (Jean-Marie Lemaire) seeks refuge in a seemingly abandoned château, only to discover it to be inhabited by two beautiful young women, Elisabeth (Franca Maï) and Eva (Brigitte Lahaie). Although they claim to be servants awaiting their master's return for the season, as the evening progresses it becomes clear that both are lying, and that they seem strangely determined to keep Marc within the estate. When they finally reveal that they are really preparing for a mysterious midnight gathering of women, Marc anticipates an erotic adventure, so decides to see the evening through—a decision he will come to regret.

The second film in Rollin's commercial horror trilogy, **FASCINATION** was originally intended to be a low-budget erotic film, but Rollin, to the consternation of his co-producer, ratcheted-up the horrific elements and returned to his former improvisational style. Like his earlier, more experimental works, **FASCINATION** began filming with no shooting script, and all scenes were developed on-set. Nevertheless, the film is remarkably cohesive, and many critics hail it as Rollin's best film. Fans of the director (including this reviewer) are likely to disagree, as much of what makes Rollin unique is subordinated to the demands of a more conventional narrative. The film's intriguing scenario (based on a short story by Jean Lorrain), focusing on a female blood cult spawned by the therapeutic use of ox-blood to treat anemia, permits Rollin to approach his fascination with vampirism from a new angle and to generate tension from the cat-and-mouse game played within the château. Rollin, however, is not particularly adept at generating suspense, and the film's languid pace consistently fails to evoke the *frisson* its scenario promises. Furthermore, although it contains numerous artistic flourishes—such as a scene depicting two women in white gowns waltzing on a narrow bridge, and, most striking of all, the sight of Lahaie clad only in a black cloak stalking her prey with a scythe—Rollin's creative surrealism is far-too-restrained.

On a positive note, the performances are all solid, and the erotic content, which is far more pronounced than in his previous horror films, seems less intrusive—stemming naturally from both the narrative and, of course, Lahaie's presence. Rollin's use of existing locations continues to prove a strength, as evidenced by a climax set within the interior of an enormous Escheresque pigeon coop.

The turn-of-the-century setting permits a lyrical tone more consistent with the typical *Rollinade* than the far more violent **THE GRAPES OF DEATH** (1978), though the wonder and melancholy of his earlier works are largely absent here.

Rollin and his co-producer were able to successfully sell **FASCINATION** to a major French distributor, who planned to open the film simultaneously on 12 screens in Paris. Unfortunately, eight days before it was set to open, a professional dispute within the company led to the cancellation of these bookings. The film then found its way into a mere handful of theaters, disappearing quickly despite an unusually warm critical reception that proved Rollin was fully capable of making a successful traditional horror film when he set out to do so. However, the film also revealed an ironic truth: that, while his detractors may rightfully claim that the typical *Rollinade* fails as a horror film, devotees of the director may in turn justifiably claim that it is difficult for a conventional horror film to succeed as a *Rollinade* either.

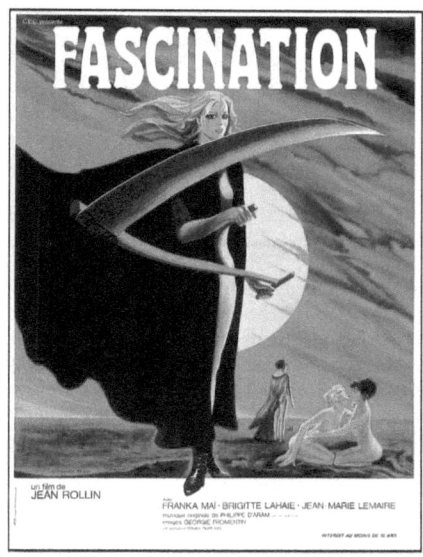

French tradepaper ad for 1979's **FASCINATION** (art by Charles Rau)

THE NIGHT OF THE HUNTED

(*La nuit des traquées*)
France, 1980
Redemption/Kino Lorber
91m 20s, $24.95 BD-0

While driving alone down a deserted road, Robert (Alain Duclos) is waved-down by Elysabeth (Brigitte Lahaie), a beautiful nightgown-clad blonde who begs to be rescued from unnamed pursuers. His attempts to understand her plight are frustrated by what initially appears to be her amnesia, but is later revealed to be the steady deterioration of both her short- and long-term memory. Robert offers her asylum at his apartment, but during his absence she is quickly recaptured by her pursuers, who return her to a glass-enclosed high-rise in the heart of Paris. There, she and others who share her debilitating condition are held prisoner by a physician named Dr. Francis (Bernard Papineau) and his assistants, one of whom exploits the opportunity to sexually assault the female patients. Elysabeth and her beloved friend Véronique (Dominique Journet) plot escape, while Robert sets out to find his missing love and to solve the mystery of both her illness and her imprisonment.

NIGHT, which Tim Lucas appropriately describes as "Cronenbergian" in the disc's promotional materials, is considered an anomaly within Rollin's oeuvre, as it falls outside the boundaries of both the typical *Rollinade* and of his commercial horror and pornographic work. In the interview that supplements the disc, Rollin explained how he was offered a small budget to produce a hardcore pornographic film, but convinced the producer to let him try to make a

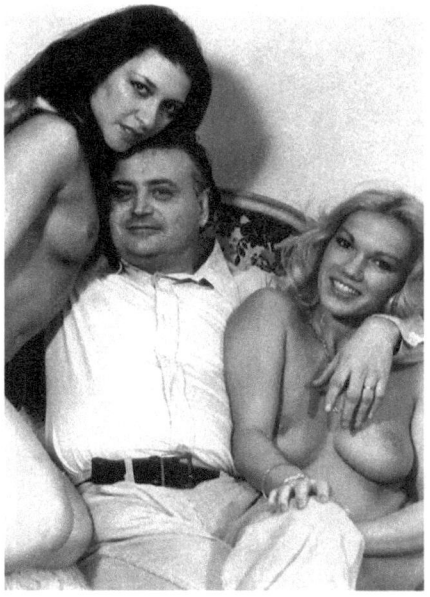

Man, that poor Jean Rollin sure had it rough

"real film" within the same limited budget and schedule instead. Rollin claims to have written the script in one day, with filming lasting just a brief ten days. The producers were profoundly unhappy with the finished product, subsequently added two hardcore sex scenes, then released the film under a different title. Rollin himself was not enamored with even his original cut, describing it as "the seed of a great film that was never realized" due to time and budgetary constraints.

NIGHT is nowhere near as bad as Rollin believed, nor is it the radical departure from form that it has so often been labeled. The narrative, though somewhat underdeveloped, is surprisingly focused and cohesive, as the limitations imposed prevented Rollin from pursuing the inspired tangents he typically indulges in during the filming process. The cast, which includes a number of actors recruited from hardcore pornography, is quite strong, and Lahaie delivers a touching and convincing performance—remarkably beautiful in her tragic vulnerability. Sinister clinics tucked away in sterile office towers had been a staple of Rollin's films since his debut, but here the idea is moved to the forefront of a narrative that reworks the basic premise of **THE NUDE VAMPIRE** (1970) by replacing that film's fantastic content with the focus on environmental catastrophe that drives both **THE GRAPES OF DEATH** (1978) and, later, **THE LIVING DEAD GIRL** (1982). Though much of the film is shot within the stark confines of the clinic, the interior of Robert's apartment showcases Rollin's talent for evocative set design. Lying at the top of a steep stairway, its rust-colored walls, pillow-strewn interior, and numerous houseplants make it look exactly like the secure nest it is meant to represent. The sex scenes, though overly-prolonged, here have a clear narrative purpose, as the afflicted patients, devoid of memories, crave physical contact to anchor them in a perpetual present and thus preserve their last vestiges of consciousness. In this way, Elysabeth and her cohorts resemble the Last Vampire from **REQUIEM FOR A VAMPIRE** (1971), who seeks sensation as a means of staving-off diminishment and nonexistence.

Most importantly, **NIGHT** stands out as the most nightmarish of Rollin's dreamscapes, and is far more frightening, especially in its final third, than the Grand-Guignol histrionics of **GRAPES**. The horror stems not only from its obvious and intentional evocation of both the Holocaust and the steady process of dehumanization that made it possible, but—more importantly—from its exploration of memory as the source of human identity. Given that, throughout Rollin's work, the fading of memory is portrayed as a source of melancholy, it is not surprising that the complete obliteration of memory would be presented as the ultimate nightmare and equated with the loss of the soul itself. Although the film falters in its rather mundane explanation for the events depicted, **NIGHT** also contains one of Rollin's most successful and emotionally evocative endings.

After this fascinating if not entirely successful experiment, Rollin would eventually return to his supernatural roots with **THE LIVING DEAD GIRL**; if unfortunately within an entirely different cinematic climate.

THE ESCAPEES

(*Les échappées*, a.k.a. **THE RUNAWAYS**)
France, 1981
Redemption/Kino Lorber
106m 50s, $29.95, BD-0

Confined to a psychiatric hospital and labeled incurably non-communicative, Marie (Christiane Coppé) is awaked from her catatonic stupor by a chance encounter with fellow patient Michelle (Laurence Dubas), a habitual runaway hospitalized for her incorrigibly rebellious behavior. Forging an immediate and profound attachment to her new friend, Marie accompanies Michelle when she escapes into the night to seek

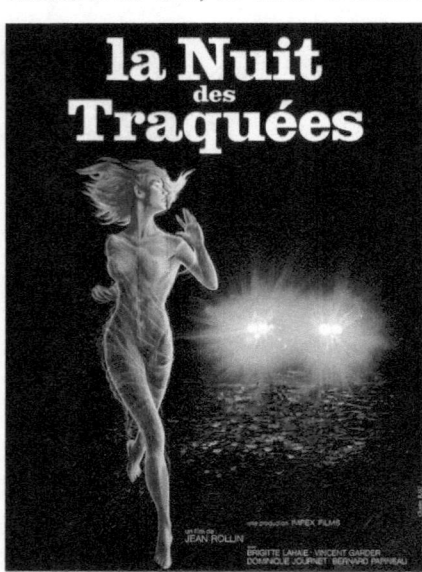

French *grande* poster for **THE NIGHT OF THE HUNTED** (art by Charles Rau)

love, happiness, and adventure. While wandering through a forested wilderness, they encounter a traveling tent show, whose proprietor Maurice (Claude Lévèque) hires them to serve drinks while his exotic dancers perform in a junkyard to an audience of drunken sailors. When the police raid the show and take the troupe into custody, the girls befriend wily pickpocket Sophie (Marianne Valiot) and matronly nightclub diva Madame Louise (Louise Dhour), who offers them safe haven while Sophie persuades her lover Pierrot (Patrick Perrot) to let them stow away on his embarking ship. On the night of their departure, however, the two innocents attract the attention of a band of libertines (which includes Rollin regular Brigitte Lahaie), with characteristically tragic results.

Never released theatrically and basically disowned by Rollin as "a disaster", **THE ESCAPEES** (originally known as *Les paumées du petit matin*) is the first Rollin film to be completely devoid of overtly fantastic content *[it is included here purely in the interests of completism for being part of Redemption/Kino's series of Rollin Blu-rays – ed]*. According to the director, **NIGHT**'s producers demanded that he make a "real movie with a real story", and stipulated that he turn his scenario over to a professional screenwriter, Jacques Ralf, to rework the material into a more conventional thriller. Of course, expecting Rollin to deliver a "conventional thriller" is akin to hiring an impressionist to produce mechanical blueprints, and matters were further complicated when, according to Rollin, Ralf's script arrived only two days before shooting was due to commence, and it proved to be a ponderous, dialogue-heavy mess. In desperation, Rollin attempted to fuse his original treatment with Ralf's screenplay, resulting in "a strange film that was badly-mastered". Viewers hoping that the film's high-definition debut might reveal it to be an underappreciated gem ripe for reevaluation will be disappointed to discover that its poor reputation is richly deserved, with **THE ESCAPEES** best described as an inferior first draft of Rollin's **THE NIGHT OF THE HUNTED** (1980) reworked as a bad parody of European art films. After establishing its fairly interesting premise, the screenplay then meanders through a series of stagnant vignettes which are largely devoid of tension, humor or wonder, and its desperate attempts to evoke the sad "poetry of the streets" fails spectacularly thanks to dialogue that consists almost entirely of melodramatic pseudointellectual clichés. While Rollin's films have never been particularly known for cohesive plotlines or thrilling action, the patience of

French DVD cover for **THE ESCAPEES**

even the most sympathetic viewer is repeatedly tested by both the film's absence of any sort of narrative tension, nor any diverting detours into the fantastic and surreal either.

That being said, the film is not entirely devoid of interest. The female actresses all deliver committed performances, with the two leads being touchingly effective in creating an aura of bruised vulnerability. There is also a surprisingly poignant moment in which Maurice rationalizes his fall from "legitimate" theatre by claiming that his tent show represents "street" theatre, which is the *only* "real" kind of theatre anyway; only to have his illusions punctured by an abrupt reminder that he is now merely a pimp. Unlike the typical *Rollinade*, Ralf's screenplay overtly references other contemporary films, with Marie's sudden awakening from her vegetative state calling to mind the celebrated "Juicy Fruit" scene from Milos Forman's **ONE FLEW OVER THE CUCKOO'S NEST** (1975, USA), and the genuine tension briefly evoked by the encounter with the libertines dependent on the viewer's memories of similarly ill-fated encounters in Wes Craven's **LAST HOUSE ON THE LEFT** (1972, USA), Fernando Di Leo's **TO BE TWENTY** (*Avere vent'anni*, 1978, Italy) and Aldo Lado's **NIGHT TRAIN MURDERS** (*L'ultimo treno della notte*, 1975, Italy). Interestingly enough, the present film's otherwise ludicrous climax also anticipates the central premise of Rollin's

next film, **THE LIVING DEAD GIRL**, which could—with only a minor tweak—have been written as a sequel.

Although, as said, devoid of any fantastic content, the film does, in many ways, reflect the dream-logic of the typical *Rollinade*. Characters often make their first appearance in a surrealistic manner, such as when the girls encounter a black gypsy beating a drum in a deserted field, or when Louise Dhour's nightclub matriarch is introduced as she surveys her domain whilst perched immobile on her club's stage like a monument to herself. Like many of Rollin's previous films, **THE ESCAPEES** unfolds in an urban dreamscape within which all doors are left unlocked to the dreamer, permitting easy entry into whatever building strikes one's fancy. This latter conceit leads to the film's most beautiful moment, which comes when Marie stumbles into a deserted ice rink and spontaneously performs a majestic figure-skating routine, with a touch of the fantastic added by the presence of an inexplicable illuminating spotlight. Associative dream logic is also evoked by casting a number of actors previously associated with the director; as when, for example, the dockside nightclub immediately evokes memories of the tavern in **THE DEMONIACS**, cuing Dhour's appearance. If **THE GRAPES OF DEATH** (1978) is the archetypical frustration dream, then **THE ESCAPEES** can best be understood as the type of dream that so disappointingly fails to live up to its initial premise—such as when a dream begins as a fantastic voyage with a lost love, and abruptly concludes in the midst of an interminable wait at the airport.

Although difficult to recommend on its own terms, **THE ESCAPEES** serves as a valuable reminder of the sort of magic which Rollin brings to a project, as the absence of his trademark "tics and mannerisms" makes for a dull and colorless affair. His next project, although one of his more commercially successful, would involve an entirely different sort of compromise, however...

THE LIVING DEAD GIRL

(*La morte vivante*)
France, 1982
Redemption/Kino Lorber
89m 45s, $24.95, BD-0

Rollin's best-known and most commercially successful film is, in reality, one of his least typical. When a toxic chemical spill reanimates the corpse of beautiful Catherine Valmont (Françoise Blanchard), she returns to her childhood home, a château rendered vacant since her mother's death. Her revival proves an ordeal, as Catherine finds herself physically uncoordinated, possessing only limited consciousness, and prone to bouts of intense pain that can only be alleviated by the consumption of human flesh and blood. Through a fortunate accident, she is able to attract the attention of her childhood friend Hélène (Marina Pierro), with whom she shared a pledge to affirm their eternal love by one day dying together. Hélène, perhaps motivated by guilt over her failure to abide by their pact, or simply by a desire to prolong their renewed bond, soon dedicates herself to finding the victims necessary to satiate Catherine's hunger. But as Catherine's consciousness begins to return, she evidences nothing but horror and revulsion at the monster she has become, and begs Hélène to restore her to death, leading to a climax that Tim Lucas rightly describes as an emotional holocaust.

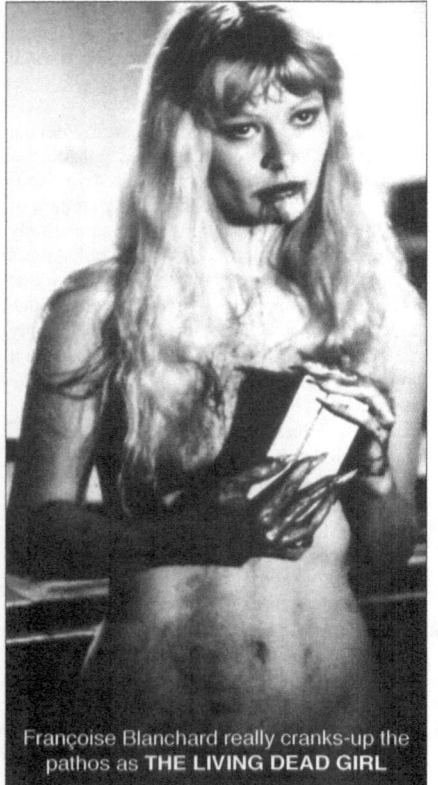
Françoise Blanchard really cranks-up the pathos as **THE LIVING DEAD GIRL**

Although hampered by a limited budget and severely compromised by commercial demands (such as its emphasis on graphic gore), **THE**

LIVING DEAD GIRL demonstrates what Rollin was capable of when provided with professional actors and the time necessary to see his vision through. Both Blanchard and Pierro deliver convincingly emotional performances, with Blanchard especially skillful at conveying the physical and psychological changes her character endures as she becomes more and more bound to the land of the living.

THE LIVING DEAD GIRL is unusual not only for the emphasis on character development that is largely absent from Rollin's films, but also in the subtle way this unfolds. Catherine begins the film as a feral creature driven only by need, but as her consciousness expands so does her capacity for altruism and her awareness of herself as an abomination. It is also interesting to note how Hélène's profoundly selfish nature is gradually revealed. It is she who, in the childhood flashbacks, demands that she and Catherine become blood sisters, and who insists that they should follow one another unto death, only to later renege on that promise. When she discovers Catherine living in the château, one of her first responses is to ask with surprised indignation why she had not been called. It is Hélène who lures innocent victims to their deaths so that she might fulfill her need for Catherine's ongoing presence. Even Hélène's final self-sacrifice—commonly regarded as an act of atonement—may be viewed instead as the culmination of her cowardice and selfishness, as she not only refuses Catherine's plea to destroy her, but also actually prolongs her beloved's torturous existence. It is also remarkable to note how subtle the lesbian content is in the film, as Hélène and Catherine never engage in any type of overtly sexual behavior, yet their relationship does indeed appear deeply romantic in nature.

Despite this subtlety of character, the tone of the film constantly vacillates between melancholy elegance and nauseous vulgarity, evidence of the compromises that Rollin was forced to endure. This is clear right from the beginning, when Catherine's revival is attributed to a toxic waste spill, even though the narrative later suggests a more poetic and emotionally resonant explanation: the unfulfilled pact. Even worse are the distracting English-language scenes (which serve absolutely no narrative purpose whatsoever) featuring Mike Marshall and Carina Barone as a bickering couple whose loutish antics and unintentionally comedic deaths make for excruciating viewing. Rollin had little affection for gore, and the scenes of explicit carnage—with the exception of the finale—are handled in a perfunctory and largely unimaginative manner, although he does make explicit his equation of gore with hardcore pornography in the scene where gouts of blood spatter over the face and breasts of a naked woman in a manner identical to the "money shot" that concludes the typical porn scene.

Rollin behind-the-scenes during **TLDG**'s shoot in '82, with the late Françoise Blanchard (1954-2013)

It is not difficult to understand why Rollin was willing to participate in such a compromised project. Following the commercial failure of **LIPS OF BLOOD** (1975), Rollin found himself exiled to the ghetto of hardcore pornography, and his subsequent and infrequent forays into the fantastic, even when relatively successful, proved significant departures from the intensely personal films that characterized his early career. **THE LIVING DEAD GIRL** provided him with an opportunity to return to fantastic cinema, albeit at a time when the genre was dominated by the gore-

French *affiche* for **THE LIVING DEAD GIRL** (1982)

drenched fare that became ubiquitous in the wake of Romero's **DAWN OF THE DEAD** (*Zombi*, 1978, Italy/USA) and Fulci's **ZOMBIE** (*Zombi 2*, 1979, Italy). Despite his distaste for explicit gore, Rollin was able to fairly successfully pen a scenario that combined graphic depictions of viscera with the emotional lyricism that had become his trademark. Unfortunately, the producers did not have confidence in Rollin's ability to produce a film with international appeal, and an especially appalling aspect of the shoot involved the simultaneous filming of an "American version" by director Gregory Heller. Apparently, after Rollin would shoot a scene, Heller would then step behind the camera and shoot an identical scene featuring the same actors speaking English. To make matters worse, Heller would openly ridicule Rollin on the set, an indignity that Rollin apparently stoically ignored.

Though by no means a representative film, the parts that are successful represent some of Rollin's best work. Furthermore, the film's central dilemma can itself be seen as a metaphor for Rollin's artistic predicament at the time: a demeaning immersion into violence that served only to revive his career as a fantasist in a painfully compromised form, relegating his cinematic vision to a sort of excruciating half-life. It is thus no wonder then that the film is dominated by an almost unbearable atmosphere of grief and disgust in the response to the loss and degradation of something once-much-beloved.

The book that gave Jean Rollin's career a new lease on life

TWO ORPHAN VAMPIRES

(*Les deux orphelines vampires*)
France, 1997
Redemption/Kino Lorber
107m 7s, $24.95 BD-0

Self-promoted as Rollin's "last film", **TWO ORPHAN VAMPIRES** was made at a time of simultaneous triumph and crisis for the director. The grey-market video boom of the late '80s and early '90s fueled renewed interest in his work, thanks to genre aficionados looking to expand their horizons. Furthermore, Cathal Tohill's and Pete Tombs' book *Immoral Tales* (London: Titan Books, 1994), an overview of European sex and horror films, offered a long and spirited defense of Rollin's *oeuvre* that sparked an official renaissance. Authorized releases of his films soon followed, as did cover stories in numerous genre publications. In the wake of this renewed popularity, Rollin was provided the opportunity to make another vampire film, this one with a budget sufficient to permit him the artistic freedom he was so often previously denied. Sadly, at the same time, Rollin was also diagnosed with kidney failure, requiring dialysis and making him acutely aware that he was nearing the end of his life.

ORPHANS features two beautiful young blind girls, Henriette (Isabelle Teboul) and Louise (Alexandra Pic), who reside in an orphanage outside Paris and are cared for by the devoted nuns (including Natalie Perrey), who refer to them as "blind angels". In reality, the two are vampires who are blind only during the day, and who wander the surrounding cemeteries at night seeking prey. Both girls possess only vague memories of their past, but believe that they are vampiric archetypes who have reenacted a cycle of destruction and rebirth since the dawn of time. The film follows the two as they are adopted by a kindly physician whom they come to resent, named Dr. Dennary (Bernard Charnacé), wander landscapes both urban and pastoral meeting other fantastic creatures (including a werewolf, a winged vampiress known as the Midnight Lady, and a ghoul), and struggle to define both themselves and the rules governing their strange existence.

Based on a novel he had written several years earlier, **ORPHANS** is by far Rollin's most intellectually engaging work, with more layers of potential meaning than even **THE IRON ROSE** (1973) possesses. It is entirely possible, for example, that the orphans' blindness is the

Alexandra Pic and Isabelle Teboul open wiiiide in **TWO ORPHAN VAMPIRES**

product of hysteria, and that their beliefs about themselves are the delusions characteristic of profound mental illness. Subtextually, the film also works as a fairly realistic depiction of adolescent psychology. Adolescence is the most acutely self-reflexive stage of development, and the two orphans, faced with their crises of identity, do exactly as adolescents are wont to do—that is, weave a personal mythology that posits them as immensely powerful and important beings only temporarily relegated to obscurity. They, like most adolescents, see themselves as gods in disguise.

But the orphans' assertion that "all gods are real, because they are imaginary" opens a far richer avenue for analysis: viewing the film as the work of a dying artist engaging in a dialogue with his creations about their respective futures. If **THE LIVING DEAD GIRL** (1982) were self-reflexive—that is, offering a commentary on itself—on a subtextual level, **ORPHANS** goes even further by incorporating this reflexivity into the narrative proper. Henriette and Louise know that they are archetypes (in fact, the combination of Rollin's two major archetypes, "The Virgin" and "The Vampire")—characters or "dreams" compelled to reenact similar narratives in a cycle of perpetual destruction and rebirth. But this knowledge provokes awareness of an even greater mystery: the questions of *why* they exist, and of who or what dictates the rules of "the game" they are compelled to play. The orphans defiantly conclude that "no one" is in charge, that they "just are", and the rules are "just the way it is". Once these assertions are articulated, the orphans set out to define themselves, and the film then explicitly explores the relationship between character and author, with Dr. Dennary standing-in for Rollin as the girls' "father" figure. Just as Dennary confines the girls to the château, Rollin binds them to

Rollin's original novel (Paris: Fleuve Noir, 1993). Note the cover girls' resemblance to The Castel Twins

the demands of his narratives. Like Dennary, who almost fatally wounds Louise, Rollin also proves a potentially fatal threat, as he has "killed" them in previous films and may well do so again. Thus, the orphans' murder of Dennary may be seen not only as an attempt to assert their freedom *within* the narrative, but also to pursue freedom *from* the author-imposed narrative.

It is important to note that Dennary's death is permanent, while the orphans—even after their destruction at the end of the film—will eventually be reborn. In the same way, though an author may be mortal, his characters will be revived every time a viewer or reader engages with the narrative. This observation suggests that Rollin might have in some way been influenced by Spanish author Miguel de Unamuno's celebrated 1907 novel *Niebla* (a.k.a. *Mist* or *Fog*), in which the protagonist, Augusto Perez, engages in a prolonged argument with the author, during which he first becomes aware of himself as a character in a novel, and then fights for his life when he realizes that the narrative is about to demand his death. Augusto finally comes to the conclusion that he himself is more "real" than Unamuno, as perhaps the author's sole purpose is to serve as a medium through which Augusto's story might be conveyed to the world. It is important to note that, at the beginning of *Niebla*, Augusto frees himself from uncertainty and paralysis— thus initiating the narrative proper—by deciding to follow the first dog he sees, just as the two orphans begin the process of self-reflexivity when they follow a stray dog into a graveyard.

The orphans assert their freedom from the author in still another way besides: by describing how, once others recognize them as "dreams", the two vampires will be "loved and protected" by them, because in that way they too "could dream about *[the orphans]*". In other words, once the dream or narrative is conveyed to a reader or viewer, the characters are freed from authorial authority, as the reader or viewer is able to engage in interpretations that the author never considered, or to imagine the characters in scenarios that the author never wrote. It is fascinating to note how often the film asserts textual (rather than authorial) authority, as the girls regularly consult alternate texts—including a treatise on Aztec mythology and a bound collection of old circus and magicians' posters—to define themselves in opposition to the authorial demands of the current, author-imposed narrative. By assuming the roles of readers of their own narrative/destiny, they seek to wrestle control from the author by redefining themselves, and aim to be loved "for what *[they]* are".

Closely related to this theme is the film's recognition that all human beings are essentially fantasists, creating stories to make sense of our experiences while surrounded by others doing just the same—weaving stories that might well include *us*. Thus, we are simultaneously both the authors and subjects of fantasies. The two orphans are viewed as "angels" by the nuns who care for them, but see themselves as the bat-god and winged serpent of Mesoamerican mythology. When the two stalk a woman (Brigitte Lahaie) outside of a deserted circus tent, their victim is first alarmed, as she suspects she is about to be mugged, but then ironically becomes both relieved and indignant when the two orphans reveal their fangs, assuming that they are simply "carnival brats" trying to scare her. The sight of the widowed physician leaving church with his two sexy wards on his arms appears remarkably lecherous, but the elderly women who observe the spectacle describe it solely in terms of beatific benevolence and innocence. Dannery, who is constantly referred to as "kindly" by the members of his parish, is not above shooting blindly at what he guesses may be a prowler, and almost fatally wounds Louise in the process. Most interesting of all, when the two orphans leave the crypt of the

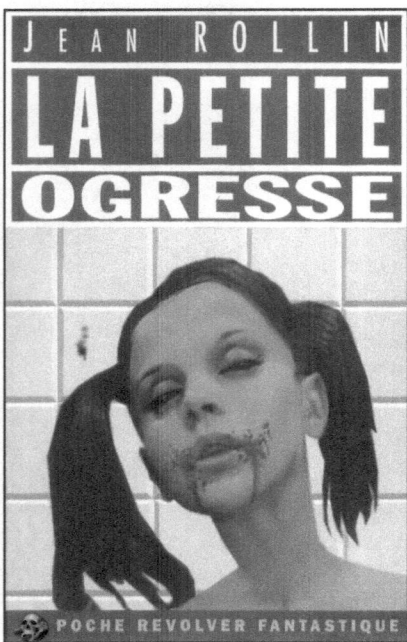

This 1996 novel by Jean Rollin covers some familiar themes (see also text on p.215)

Midnight Lady, Rollin cuts to an "in-joke" close-up of Tohill & Tombs' *Immoral Tales*, reminding knowledgeable viewers that the author of the current story is himself the subject of another textual narrative. Consistent with Rollin's preoccupation with the link between memory and loss, the orphans note how cherished memories also are essentially fantastic creations, as when Henriette reassures Louise that they will one day remember the time in which they were goddesses, and her friend replies, "Even if they *are* all false memories, we will remember them".

Rollin described the filming of **ORPHANS** as a happy experience, since he was able to approach the project with a fully-developed script and scenario, and to employ actors who would have no difficulty delivering the material in a convincing fashion. Rollin's direction is assured and at times ingenious, such as when he takes advantage of the narrative assertion that vampires "see blue at night" to employ a blue filter that enables him to shoot the lengthy nighttime scenes during daylight. The orphans' awareness of themselves as archetypes permits Rollin to revisit locations and characters from his previous films, although the beach at Pourville-sur-Mer in Dieppe regrettably fails to make a reappearance herein. As in **THE LIVING DEAD GIRL**, there appears to be a strong romantic connection between the two female leads, but the absence of any erotic contact between them seems to reflect a love that has transcended the sexual. **ORPHANS** is, importantly, Rollin's most dialogue-intensive film, and the talent he evidences here will surprise viewers who consider him primarily a visual artist.

A triumphant and thoroughly engaging comeback, **ORPHANS** is also fairly saturated with melancholy, and serves as Rollin's final word on the inextricable link between innocence and experience, between knowledge and *naïveté*. We, like the dying director, are forced to acknowledge how, as one ages, one's accumulation of experience and knowledge steadily grows, until we finally arrive at the threshold of Death. There, we must divest ourselves of worldly knowledge and assume the *naïveté* of both the infant and the dreamer.

Though **ORPHANS** was presented by Rollin as his final film, he actually completed three more genre films—**DRACULA'S FIANCEE** (*La fiancée de Dracula*, 2002), **LA NUIT DES HORLOGES** (2007), and **LE MASQUE DE LA MÉDUSE** (2010, all France)—before his death on December 15, 2010, some three months after

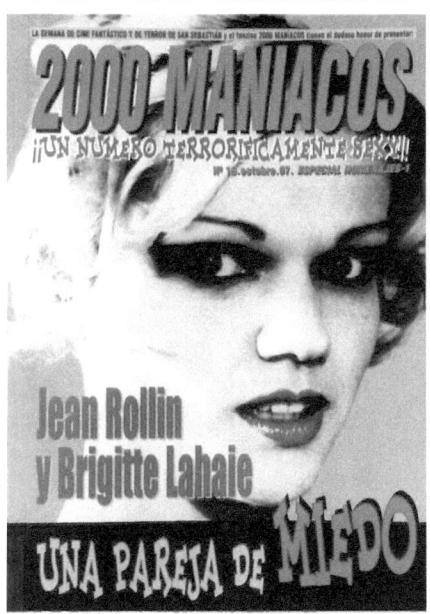

Top: Then still in its former B&W "fanzine" format, this 1973 ish (N°5) of the future long-running full-color glossy French prozine of the same name dealt with a bunch of Rollin material; the cover girl is Caroline Cartier in 1970's **THE NUDE VAMPIRE** (as seen on p.163 herein). **Above:** The director and his frequent leading lady got ample coverage in issue N°19 (October 1997) of this popular Spanish zine

wrapping that last film just listed. Fortunately, he lived long enough to appreciate the increasing esteem with which his body of work was held, and to receive a lifetime achievement award at Fantafestival—an annual fantastic film festival held in Italy.

Rollin, however, still remains an outsider, with his filmography representing a sort of detour from the mainstream of horror cinema—although a detour that is a worthy destination unto itself. The curious are invited to wander through the fields and cemeteries, past the deserted châteaux and abandoned city streets, until you come upon the open expanse of a rock-strewn beach.

Hanging on the horizon is a crimson door, slightly ajar, with a burly man peering out.

He beckons you, smiling…

Mireille Dargent as the clown in **THE DEMONIACS** (1974)

Main Reference Sources:
Rollin, Jean – *Virgins & Vampires* (Berlin: Crippled Publishing, 1997)
Tohill, Cathal & Tombs, Pete – *Immoral Tales* (London: Titan Books, 1994; New York: St. Martin's Griffin, 1995)

Above Left: Yes, yet again, doomed romance is also a key theme of **DRACULA'S FIANCEE** (*La fiancée de Dracula*, 2002); Sandrine Thoquet and Thomas Smith (still by Jean Rollin). **Above Right:** Marlène Delcambre as Steno in **THE MASK OF MEDUSA** (*Le masque de la Méduse*, 2010). She is holding a life-casting of the head of Simone Rollin (1934-2016), the director's wife, who played the ghastly gorgon in the film

Top Left: Sporting dagger-like fingernails—a minor recurrent Rollin motif! (see also p.160)—the director's frequent casting choice Brigitte Lahaie later reappeared in his third-to-last film, the nunsploitation/vampire romance **DRACULA'S FIANCEE** (2002). **Top Right:** That film co-starred Thomas Desfossé as The Count. **Bottom Left:** Dominique emerges from a grandfather clock at the stroke of midnight in **THE SHIVER OF THE VAMPIRES** (1971). **Bottom Right:** Such antique "time machines" were another pet Rollin symbol, and a supernatural grandfather clock also factors into **DRACULA'S FIANCEE**

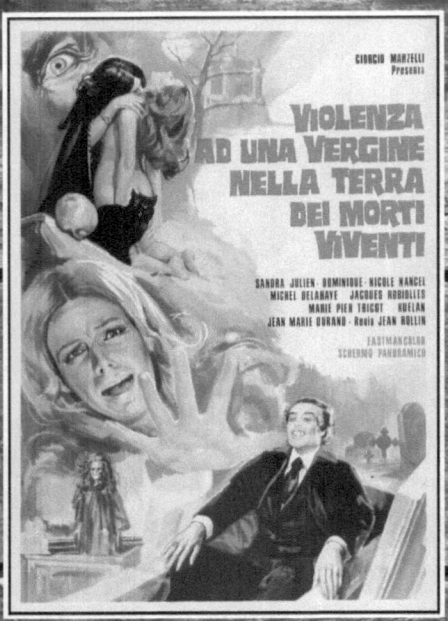

Above: Italian *due-fogli manifesto* for 1971's **THE SHIVER OF THE VAMPIRES** (art unsigned), complete with the inevitable "Chris Lee"-like bloodsucker! **Right:** Vampire's familiar Marie-Pierre Castel isn't bothered one bit by crucifixes in the film. **Below:** Castel and Kuelan Herce at **SHIVER**'s sacrificial altar, with virginal (?) victim. That's scene-stealing "Polanskian" vampiric fop Jacques Robiolles with his head in his hands in the background

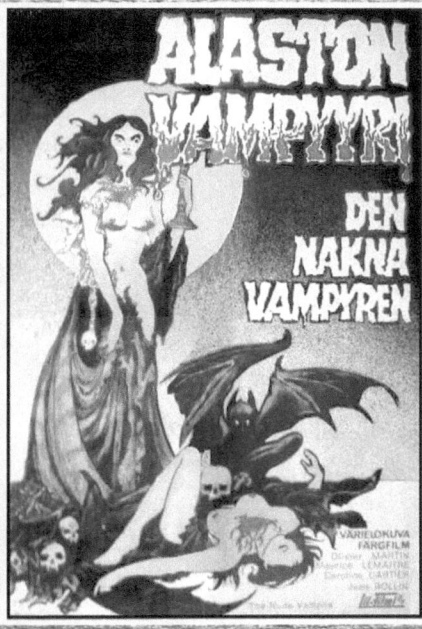

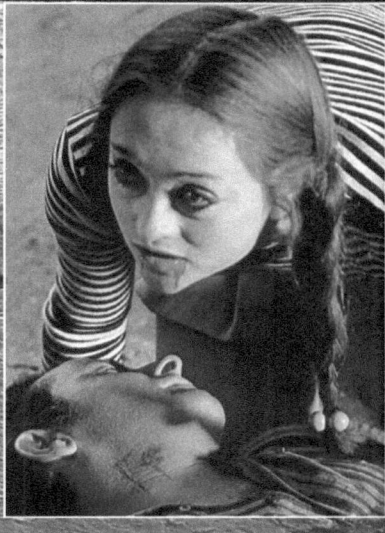

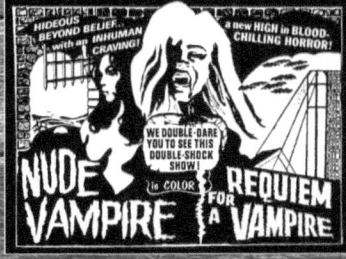

Top: *"Their Kisses Are Bites!"* French lobby card for **THE SHIVER OF THE VAMPIRES** (1971). **Above:** Finnish poster for 1970's **THE NUDE VAMPIRE** (art unsigned, but it mimics Philippe Druillet's original French poster artwork). **Above Right:** Neophyte vampiress Mireille Dargent quenches her first thirst for the red stuff in **REQUIEM FOR A VAMPIRE** (1971). **Right:** '70s Yank/Canuck grindhouse/drive-in pressbook ad

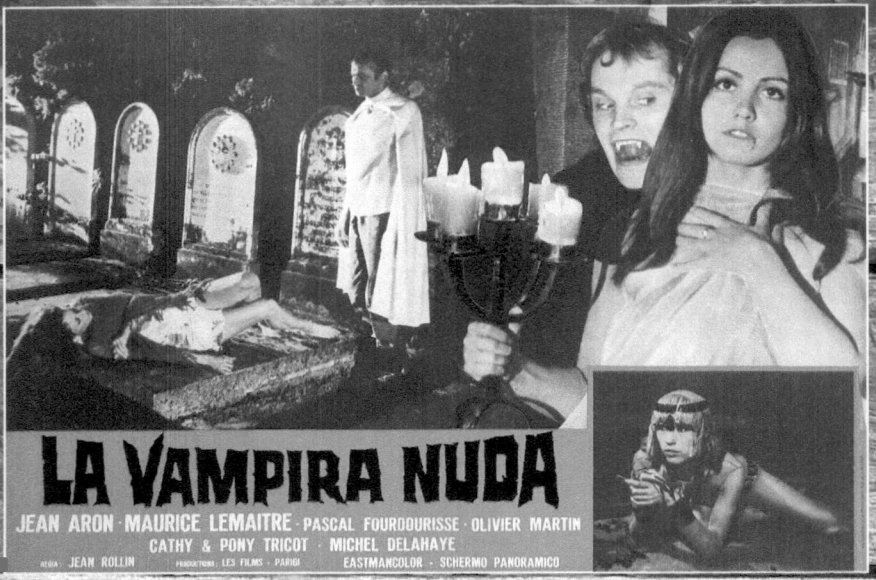

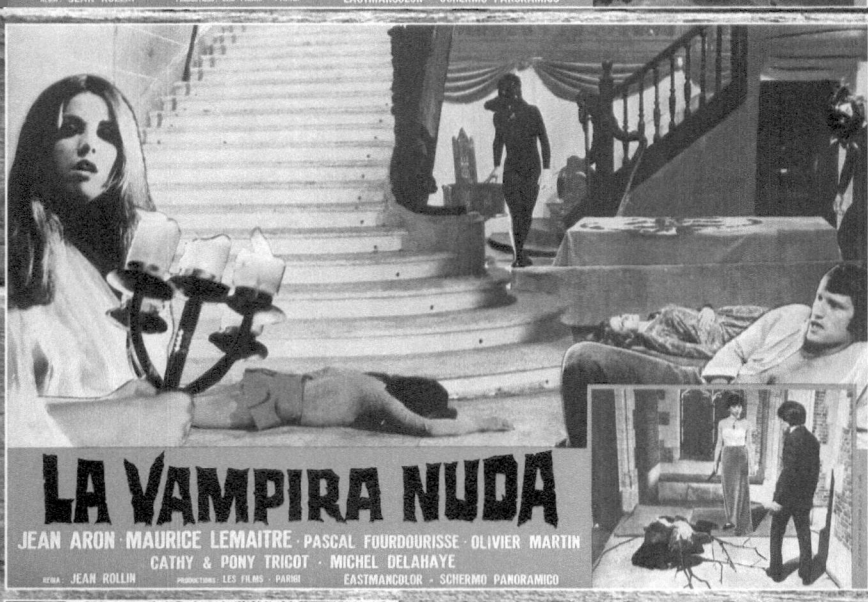

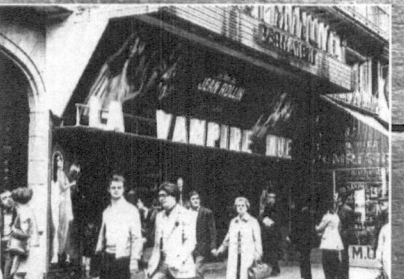

Top: A pair of lively, everything-but-the-kitchen-sink Italian *fotobuste* for **THE NUDE VAMPIRE** (1970). **Left:** A Parisian cinema marquee advertising the film on its first run

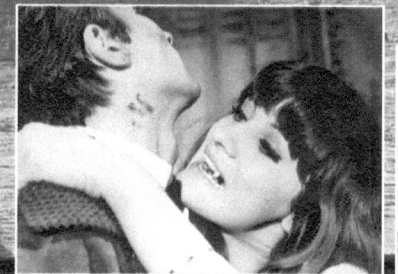

Top & Above: While decidedly unorthodox, **THE RAPE OF THE VAMPIRE** (1968) does contain its share of hoary tropes, as when Solange Pradel puts the bite on her true love, Bernard Letrou. **Right:** In the same film, the bestial, imbecilic henchman (Don Burhans) likewise sups his fill, albeit a whole lot more brutally. **Below:** Mireille "Dily" Dargent and Marie-Pierre "Pony" Castel get affrighted by immobile robed skeletons in **REQUIEM FOR A VAMPIRE** (1971)

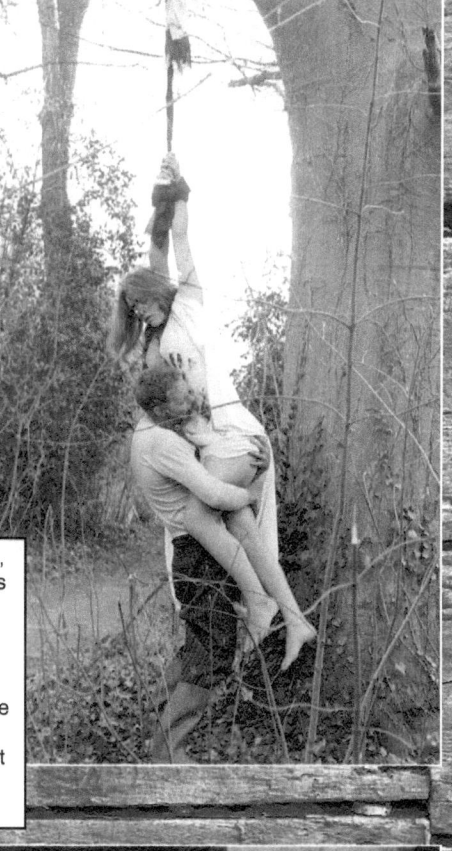

4 more stills from **THE RAPE OF THE VAMPIRE** (1968). **Clockwise, from Top Left:** Sleeping beauty Ursule Pauly (?), in her coffin; the diabolist fang-gang have themselves a bit of a frolic through the sunny countryside; some hippy dude we can't identify (possibly a crew member?) on the set with Solange Pradel; and ingénue Yolande Leclerc rises from the operating table at the vampires' "blood donor" clinic, neither fully dead, nor entirely alive

THE NAKED AND THE DEAD MONSTER MEETS JEAN ROLLIN

Interview by Marcel Burel

*[Dating from circa 1993, this interview originally appeared in the slick-and-glossy *Monster! International* #4 (1994), which was a special split issue with Kronos Productions' long-gone-but-not-forgotten cheesecake'n'kitsch publication *Highball*. Having been revised/updated herein, we now proudly re-present this close-to-a-quarter-century-old item as a crucial companion piece to this issue's major Rollin article by John-Paul Checkett. *Monster!*'s editorial comments have been inserted wherever pertinent in square brackets. Numerical endnotes are also included.]

Introduction

These are difficult times for monster movies—they just aren't as popular as they once were. [That was then, this is now! ☺ – ed.] *Of the new films that are being made and distributed worldwide, the majority never seem to reach theaters; it's straight-to-video for this less-than-desired and often critically-dismissed genre. It's especially hard in France, where, since 1967, Jean Rollin has built a certain reputation as that country's only credible horror film director...but, in these the 'Nineties, he's fallen on lean times.*

Like them or not, the movies of Jean Rollin will, in some way, affect you. Critics who hate his films remark on such things as their "amateurism", "cheapness", "slowness", and/or "compromising eroticism".
However, those of us who know better understand Rollin's approach to horror films: the peculiar atmosphere they

She-known-only-as-Dominique *[top]*, with Sandra Julien in **THE SHIVER OF THE VAMPIRES** (1971)

During the lean years prior to his "resurrection", Rollin scored acting stints in several no-budget "N.G. Mount"/ Norbert Moutier productions, including the "cerebral" splatter flick **TREPANATOR** (1992 [see p.217])

Interviewer Marcel Burel's original 1993 MONSTER! INTERNATIONAL Mini-CV, re-presented hereunder as-was:

Involved with French film publications for over twenty years, Marcel has written for *MAD MOVIES, IMPACT, TRAVELLING, CINE ZINE ZONE, MONSTER BIS;* and was the French film correspondent for the German magazine *VAMPIRI.* He also published his own fanzines: *THE BAT* and *FANTAZINE.* He is currently collaborating on a book about fantasy/horror films.

possess, the originality of their execution, and that certain poetry about them which clearly separates his work from that of other directors worldwide. It is because of Jean Rollin's relentlessness in building a career entirely devoted to the unusual that he deserves our sympathy and admiration. Whilst undergoing perpetual commercial constraints, he managed to keep these films—no matter what genre they fell into—uniquely his. In his horror films, Rollin's vampires are unlike any others; his fantasy and imagination mock traditional approaches to the vampiric myth, and he likes nothing better than giving that myth a surrealistic twist. Familiar with the rigid frameworks laid-out by Universal and Hammer studios, Rollin worked hard to reinvent their tired formulae by adding his own bizarre touches, and the resulting films mentioned in this interview are sheer poetic genius!

M!I *talked to Jean Rollin in his Paris apartment at a moment in his life where his career is taking a literature-based turn. The movies he loves to make are hardly possible in a world ruled by television* [The Internet was only really just getting started at that time], *money, and an overall lack of imagination. Surrounded by numerous books, he shared with* M!I *some reflections on his career, style, ideas, and—last, but by no means least—*eroticism...

MARCEL BUREL: *You have a book out called* Les deux orphelines vampires *["The Two Orphan Vampire Girls"], which incorporates two of your biggest passions: the popular novel and vampires. Was it initially a project for a film? The book has atmosphere which we find in your movies as well...*

JEAN ROLLIN: Obviously, my writing is very visual—"*cinéma*-writing"—but the book was written a little more than one year ago, and could become a film later if I can find the financing. At one time I was going to make an adaptation of it for the theatre as a play for Le Théâtre du Grand-Guignol in Paris. There would have been a show of three plays, like in the good old days. We would have revived two plays of terror from André de Lorde *[1869-1942]* from the beginning of the *[20th]* century, plus a modern play as a curtain-raiser. I had just begun to write the adaptation, but we couldn't find a theatre, and the project vanished. In other respects, this novel will have a series of sequels: *Le retour des deux orphelines vampires ["The Return of the Two Orphan Vampire Girls"]* is already written. There are two other books in the works that will be published soon. They will be part of a new series at Le Fleuve Noir *[A long-running Parisian publisher of* romans populaires, *founded in 1949]*, and which is called, for the moment, *Frayeurs ["Frights"]*.

MB: What about film?

JR: I made a movie last year which is called **UNE FEMME DANGEREUSE** *["A Dangerous Woman", a.k.a.* **KILLING CAR**, *1993, France]*. But that's all. It's a thriller with fantastic ambience. There is nothing irrational in the film, it's just the way I treat it, which is close to the fantastic. I made it for a theatrical release, but eventually it will be distributed primarily on video. *[As of 2013, said film's worldwide DVD rights were held by L.C.J. Editions & Productions.]*

MB: How have your films been distributed in the United States?

My very first movies have been shown in theaters in the USA. It was then that the movie business broke-down there, like ours did here. After initial theatrical runs, there was only a small profit from distribution, then television, and then...*nothing* at all! Recently there are some not-very-honest people who are making illegal video dubs, and we had to lodge a complaint against them. *[We're not mentioning any names here, but the guilty know who they are! Hint: anyone remember the "company" whose justifiably much-reviled acronym*

Top: This 1998 Rollin written work targeted a youth readership. **Above:** Nuit d'Avril's 2005 edition of Rollin's 1995 "animal girl" novel (see text of p.212 and endnote #1 on p.213)

was VSOM?] The problem with America is that anything which is not American rarely exists on videotape, so they steal from the authors without paying for the rights. It's not just my movies; they steal from a lot of people. They just duplicate tapes they find in video shops, which explains why what they sell looks so bad. The results are almost *unwatchable*, and they're putting ads in many film publications. It isn't right, and we are prosecuting them. It would have been a lot easier for them—people who are film enthusiasts and collectors—to contact us, and then we would have made a deal for the rights rather than have them steal the films. But it's not only a question of money. I find it unpleasant that tapes of my films they distribute in America are of hideous quality. It would have been *very easy* for them to obtain a suitable print from us. *[As Redemption Video eventually did in 1994.]*

MB: What do you think of the actual revival of old films which are now called "Trash" or "Psychotronic"?

JR: It's a good idea to distribute some old things, among which there are probably some very interesting films. However, you have to keep a minimum of critical spirit, and not find *every* product of the '50s and '60s "inspired"! That's simply not true. There've been some really awful ones. In the same way, it's also very stupid to denigrate some genres of films where there is always something interesting. For the Americans it's different, as they discovered an aspect of moviemaking they weren't familiar with before—I mean the very small independent productions which try to infiltrate the system. They have cheap productions, even "Grade Z" movies which are made by tradesmen with no ambition at all. On the contrary, they also have underground movies made by talented artists. For instance, there are the first films of John Cassavetes *[1929-1989]*. But there is a state of mind, typically European, which consists in making movies cheap—slapdash, but with artistic ambition. The Americans didn't have that, and they are now discovering it. But you must be able to sincerely say that in some films there is a talented director who is trying to say something with as little money as possible; then there is another one made by a sausage merchant! It's a fairly recent phenomenon. A few years ago, a non-English-speaking film wouldn't have sold one copy in America. Now the French versions of my films are bootlegged and distributed with no subtitles, and they are selling *many* of them. *[Ironically enough, without this under-the-counter if bold-faced bootleg industry to help in getting their works seen, many oft-pirated "cult" filmmakers such as Rollin might have acquired far smaller fanbases than they managed to build outside their countries of origin due to the easy availability of illicit dupes. C'est la vie!]*

MB: Your first film was LE VIOL DE VAMPIRE *[see* THE RAPE OF THE VAMPIRE, *p.160]*, in black-and-

Top: Édite Roman's 2010 collection of reprinted Rollin stories. **Above:** Belles Lettres' 1998 edition of another of Rollin's unfilmed "animal girl" stories (see endnote #2, p.213)

An "in-joke" scene—note background poster!—from Rollin's hedonistic mostly-softcore sexpo **BACCHANALES SEXUELLES** (1974); the actresses are Marie-France Morel *[top]* and Joëlle Coeur

white; it created a scandal when it opened. What was shocking at the time—the eroticism...?

JR: No, it wasn't eroticism, but rather the Dadaist elements of this movie. People didn't understand the story. It was an amateur film in the sense that, for the technical team and actors, it was their first movie. Previously, I had just done some shorts. The movie was in large improvisational, and that madness helped it become a minor classic to people nowadays. We shot **LE VIOL DE VAMPIRE** in 1967, and it opened in May 1968 in the middle of political upheavals and nationwide strikes which shook France. We had raving reviews like in *Le Figaro [France's longest-running and most widely-circulated national daily newspaper]*, where someone wrote, "It looks like a film made by a team of drunkards after a good dinner"! The critics fell on us because the film came out during a general strike, and the distributors didn't want to open any new films that particular week. So all the critics had nothing to watch except my film, and they *all* saw it. We were covered with insults by absolutely *everybody*. The only good review that was published was in a Belgian fanzine which talked about "genius"! The people were shouting and whistling in the screening rooms. It was incredible.

MB: The shooting conditions of** LE VIOL DE VAMPIRE **were quite astonishing, I do believe...?

JR: Yes. I met a distributor who owned the rights to an American vampire movie, but the film was too short (70 minutes) and he asked me to shoot a short to flesh-it-out. At that time, my company, ABC, could only produce shorts. I met an American producer living in France, Sam Selsky, who found the financing. Completed, the film lasted

45 minutes, and Selsky told me, "If we shot 45 minutes for 100,000 francs, we could shoot another 45 minutes and we will have a finished product costing 200,000 francs". The problem was that, at the end of the first episode, all the characters were dead; that explains the apparition of the Queen of the Vampires bringing back to life the two lovers.

MB: After the largely negative reception of your first movie, how did you manage to make a second one?

JR: It had quite a good run in spite of everything, and many people saw it. The exhibitors were happy, despite the scandals that the film produced in screening rooms. Once they even were obligated to call the police for an intervention in a theater, The Scarlett, because the spectators created an uproar to such a degree...

MB: Do you think that your movies have aged well?

JR: It depends which ones; if I watch **LA VAMPIRE NUE** *[see THE NUDE VAMPIRE, p.163]* again, for instance, I believe it has aged a lot, and I wouldn't make it the same way nowadays. The price of materials has changed so much that if I was to make it again, the budget would be tremendous. There are many sets and lots of characters... But there exists in these films a certain *naïveté* which is the flavor of the '60s, and a pleasant something—like the perfume of that era.

MB: You've always attached great importance to the sets...

JR: Yes, the place where we shot **LA VAMPIRE NUE** is a gigantic castle situated at Rochefort-en-Yvelines, near Paris. It has never been inhabited other than by a few units of the German army during the Occupation *[in World War II]*. It was built by an Austrian diamond merchant at the beginning of the *[20th]* century, and it's supposed to be a copy of one of the castles of Louis II of Bavaria. This merchant was in fact a spy, and the castle was to be the palace of the Kaiser, if the Germans had won the 1914-18 War. *Incredible*, isn't it?! As they *didn't* win the war, the castle stayed uninhabited. There are 365 rooms—one for each day of the year—and there were good elevators which served as lifts; it was outrageous, an incredible amount of machinery in this place, and it's completely abandoned. It has become difficult to shoot there now, as the place is collapsing.

MB: The first films you made, although full of nudity, aren't very erotic...

JR: Yes, it can be said that there is a lot of nudity in **LA VAMPIRE NUE**, but there has been more in the next ones. The reasons are twofold: commercial criteria that we had to respect, and personal aestheti-

Top: Fleuve Noir's 1999 sequel to Rollin's 1993 work, *Les deux orphelines vampires* (see pp.192 and 205). **Above:** Éditions Films ABC's 2006 edition of one of Rollin's wolfen-themed horror novels

cism. At that time, there were no X-rated movies, so when a film had a little nudity or eroticism, it was shown in a circuit of specialized cinemas, like the Midi-Minuit and the Scarlett. Now all these screening rooms which were devoted to B-movies only show X-movies. But back then, they were playing westerns, thrillers, horror films, and what was called "sexy movies". Of those films, the German or Italian movies were considered to be the most-sexy! So we had two solutions: we could add a few relatively inoffensive sequences with a couple in a bed, or we found *another* way. As I've never been fond of "bed scenes", I found it more interesting to try to transform that into something which could match better with the fantastic and horror. That explains the unclothed girls in surrealistic situations that can be found in some of my movies; that was different compared to the sexy movies of the time.

MB: It has been said that the surrealistic side of the films was yours, and that the sexy part came from Sam Selsky.

JR: Well, in fact, Sam Selsky, who is a good American—very traditional—saw our surrealistic meanderings and was naturally a little worried. "Where are we going to show that?" he asked. From an intellectual point of view, he found what we were doing interesting. We were still inexperienced filmmakers at the time, so he had the idea to add a little eroticism. In that way we could be sure that the film would find a distributor.[1] Though I've nothing against eroticism, it can't be said that I am crazy about naked girls under veils, but the commercial imperatives require it. I believe that transparent veils in the night is not a really poetic eroticism, because it's a little conventional. But visually it's more interesting than if they were fully-naked. Let's say that it's a manner to remove a constraint to my profit; some of my movies have been considered erotic wrongly, if you consider **REQUIEM POUR UN VAMPIRE** *[see REQUIEM FOR A VAMPIRE, p.168]*, which contains only *eight* minutes of eroticism in its 90 minutes.

MB: Which are the erotic sequences that you like most in your films?

JR: I like the confused and perverse relationship suggested between the twin girls in **LA VAMPIRE NUE**. Also in **LES RAISINS DE LA MORT** *[see THE GRAPES OF DEATH, p.181]* when Lucas *[Paul Bisciglia]* becomes mad and, unable to control himself, cuts off the head of his

Above: Another shot of Marie Pierre-Castel's and Mireille Dargent's big sadomasochistic "love/hate" scene in **REQUIEM FOR A VAMPIRE** (1971)

girlfriend, nailing it on a door, and yelling that he loves her. This is tragic and impassioned eroticism. There is also the final sequence in **FASCINATION** *[see p.186]* when Fanny Magier *[as Hélène]* says, "You're beautiful like that, with his blood on your mouth". It's one of the most erotic

1 Amusingly enough, its dollar-conscious American producer's name is given as "$am $elsky" (sic!) in the opening credits to several of JR's films.

Leading ladies Franca Maï and Brigitte Lahaie in Rollin's 1979 thriller; French lobby card

moments that I have ever filmed, because it contains *emotion*.

MB: Do fantasy and pornography go well together on film?

JR: No, I don't think so. We believed it would one time, when the "X" came to France. Many directors like me believed that it was something new, and that we could make some experiments, but it's impossible. Because if you're doing a fantasy movie and you put X material in it, the audience for X movies won't get enough of what they want, and the people who like fantasy will leave. Even when you can add eroticism in any kind of movie, it won't work with an X film. It's too direct, too precise; it excludes many things. It's like making a thriller where you shoot people for real. It wouldn't work. I tried in 1974 to mix fantasy and "X" with **PHANTASMES** *["Phantoms", a.k.a.* **THE SEDUCTION OF AMY** *or* **ONCE UPON A VIRGIN**], and it was a failure, because it cost more than an X-rated movie, and it didn't work better. After that, to make a living, I was compelled to make porno movies during a certain period in my life. I was waiting for new projects to become available.

MB: You have used many X-movie actresses in your films…

JR: Yes. I have nothing against people who have made X movies—I've done some myself. It's not a problem to use them in normal movies. I've been in contact with X actors who were sincerely interested in the profession…at least when I keep close to this side of the genre. These actors are trying hard to improve themselves and find a way into the profession.

MB: Is Brigitte Lahaie a good example of that?

JR: Not precisely. It didn't happen like that for her. Brigitte had no ambition to become an actress when she began making X-rated movies. And it's by doing them that she began liking the work. Then she became a real comedian, but it wasn't her purpose initially. I hope that we will have the opportunity to work together again. *[They did indeed, some three-to-four years after this interview, on 1997's* **TWO ORPHAN VAMPIRES** *(see p.192); then once again five years later still on 2002's* **DRACULA'S FIANCEE** *(La fiancée de Dracula; see pp.195-197)]*

MB: Have you had any problems with the censors?

JR: Two times. The first time with **LE VIOL DU VAMPIRE** where the board of censors required me to cut one shot; it was a sequence of black mass

at Le Théâtre du Grand-Guignol: the elevation of the Host. But in fact, all this happened in the middle of a general strike, so we couldn't do the cutting and the film opened complete, and nobody noticed. The second time it was for **LES RAISINS DE LA MORT**, where we nearly got the "X" certificate for violence (it passed by one vote)... and that at the time would have forbidden the opening of the film, because it would have been rated X. Although it wasn't pornography, no theater would have accepted it. You have to remember that when the "X" law came, it was done hypocritically, because it all began with people adding hardcore sequences in some movies. *[Intended to "spice-up" tamer fare in hopes of making it more profitable, this became a common practice on the Continent during the mid-/late '70s and beyond.]* I had been asked to do the same, especially with **LES DÉMONIAQUES** *[see THE DEMONIACS, p.176]*, but I always refused.

Finally, in 1974, when the board of censors realized that in fact there were movies circulating with added *[i.e., "hardcore"]* sequences, they decided to stem the flow of these films by making certain decrees. For us B-movie directors, it was a dreadful disaster, as all the theaters that previously specialized in B-movies changed their venues to porno movies. It was the case with **LÈVRES DE SANG** *[see LIPS OF BLOOD, p.179]*, which wasn't badly-distributed initially. However, the week that the film opened, pornography was allowed in the French theaters, and all the screening rooms which were supposed to show my film changed their bookings to X-rated movies. Sadly, **LÈVRES DE SANG** opened completely unnoticed.

MB: Where did your initial interests in vampires come from?

JR: The answer is probably a result of the first horror film I saw, when I was ten... it was a *mistake*! My mother sent me one afternoon to the theater, and we thought we were going to see a western. However, there was a misinterpretation of the posters in the front of the theater, and the western was going to be shown the *week after*. So, instead, we saw a horror movie, which absolutely *terrified* me; it was a vampire story. It took me 20 years to find the title, and it turned out to be **HOUSE OF DRACULA** *[1945, USA, D: Erle C. Kenton]*, in which there was Lon Chaney, Jr. as the werewolf, the Frankenstein creature *[Glenn Strange]* and the Vampire *[John Carradine as Count Dracula, alias "Baron Latos"]*.

Later on, as a filmmaker, I was interested by the fantastic and its surrealistic side—the use of collage, the freedom to arrange things in a way which is not logical or rational.

With my taste for the unusual, I find most-interesting those monsters that are most *human*. Take the vampire: apart from some fetish elements, he is an attractive person like a normal human being, especially if the vampire is a woman. In comparison, the werewolf, creatures of some mad doctor, et cetera, are distorted characters. The vampire is a poetic myth because he is the myth of *fascination*, and the werewolf, for instance, is repulsive.

MB: You've never been tempted by other myths? I remember you had a couple of projects concerning the werewolf...

The stunning Brigitte Lahaie: a scythe-wielding, blood-drinking wildwoman from Rollin's FASCINATION (1979)

An unexpected viewing of **HOUSE OF DRACULA** deeply affected Rollin as a young boy

JR: There was "LA LOUVE SANGLANTE" *["The Bloody She-Wolf"]* and "BESTIALITÉ" *["Bestiality"]*, which will become a novel. *[Neither script ever made it to the screen, although that latter one did indeed see print. (See endnote #1)]* But in these stories, the transformation was from a superb human creature—a woman—straight into an animal. There wasn't any werewolf, with its hybrid human side...

MB: You're not interested in Frankenstein?

JR: I don't know why, but the myth of the Creature doesn't intrigue me. The same goes for the living dead *[i.e., as in zombies]*; they don't arouse my curiosity, because of the inhuman element. Their robot side removes the poetry. The only exception is **NIGHT OF THE LIVING DEAD** *[1968, USA, D: George A. Romero]*, which is a total success; formidably effective. When I did **LES RAISINS DE LA MORT**, I came to the decision to make the *opposite* of what George Romero did. **NIGHT OF THE LIVING DEAD** is based on claustrophobia. We did the contrary: our characters are roaming in open space. Whereas the zombies of Romero are creatures with no conscience, our monsters are perfectly conscious, and they suffer from their condition.

MB: With all the projects concerning Dracula and vampires last year [circa 1992], *haven't you tried to shoot a new vampire movie?*

JR: I tried. I've done what I could to be able to make "LE RETOUR DE DRACULA" *["The Return of Dracula"]*, which is a completed and rather humorous script which I am very fond of. I contacted all the TV channels in France, and found absolutely nobody wanting to produce it. I contacted the TV networks, because it's actually impossible to shoot a film if you don't have a big budget, some big-named stars, and already have the rights sold to television. When we told them that we wanted to do this film, and to open it after the Coppola movie so it would be a success, they didn't want to do it. They didn't think that Coppola's **DRACULA** *[1992, USA]* would work at all, though by the end, of course, it was a success.

MB: In past years, you've had a lot of projects that didn't work out...the one with the late Joe Spinell [1936-1989], *for instance?*

JR: Yes. I met Joe Spinell at the Sitges Film Festival *[in Spain]*, and we met again another time, and he was enthusiastic to make a film with Brigitte Lahaie, and thought it could be fun to come to Paris. We had the idea to make a vampire movie whose title parodied **AN AMERICAN IN PARIS** *[1951, USA, D: Vincente Minnelli]*, and it was called "AN AMERICAN VAMPIRE IN PARIS"; a good title. Alain Petit wrote the script, which wasn't bad at all, but Joe Spinell—who was a very *peculiar* character—went back to the States, where he lived with his mother. We tried to contact him again one or two times, but it was very difficult, and everything stopped there. He died sometime after.

With Brigitte Lahaie, we had a project called "BESTIALITÉ" *[see above and endnote #1]*, in which she transforms into a beast. There was the other werewolf project, "LA LOUVE SANGLANTE", in which I had initially cast a part for Joëlle Coeur *[leading lady of 1974's aforementioned* **THE DEMONIACS***]*, and then Tina Aumont *[future guest star of 1997's* **TWO ORPHAN VAMPIRES** *(see p.192)]* agreed to do it. Brigitte was also cast to do another movie, with little Yoko *[who, in 1984, starred in* **LES TROTTOIRS DE BANGKOK** */ "Sidewalks of Bangkok" for Rollin, as well as in a few XXX-raters too]*. There was a script I liked a lot called "ENFER PRIVÉ" *["Private Hell"]*, which I eventually turned into a book. *[See endnote #2]*

Among other plans, there was "BLOC MENTAL" *["Mental Block"]*, which was a little in the style of a Cronenberg film, or Brian De Palma's **THE FURY** *[1978, USA]*. Along with three friends, Jean-Pierre Bouyxou, Alain Petit and

Pierre Pattin, I wrote a gory script titled "HEC-ATOMBE" *["Slaughter"]*. I also worked on a "Bluebeard" project—a Countess Báthory production which was supposed to be shot in the Soviet Union, a "Gilles de Rais" project. *[15th-Century nobleman Gilles de Montmorency-Laval, Baron de Rais, one of Joan of Arc's comrades-at-arms, later became an infamous serial killer, unpopularly known as "The French Bluebeard".]* I was supposed to make a film called "LE CULTE DU VAMPIRE" *["The Vampire's Cult"]*, whose title changed to "LES AVENTURES D'ANNIE" *["The Adventures of Annie"]*. Do you want some more?! …"JUNGLE GODDESS", "LES CHERCHEURS DE MYSTÈRES" ["Mystery Researchers"], "LES DEMOISELLES DE L'ÉTRANGE" ["Strange Little Girls"]…

MB: Are you fond of private jokes in your films?

JR: Yes, I like that. I have a habit of repeating images that I have already used in my other movies. I change them and use them differently. For instance, the clown: I put one in **REQUIEM POUR UN VAMPIRE**, but I wasn't completely satisfied, so I used another one in **LA ROSE DE FER** *[see **THE IRON ROSE**, p.171]*, and in **LES DÉMONIAQUES**. The same for *[grandfather]* clocks: I had a woman emerging from a clock at the stroke of midnight in **LE FRISSON DES VAMPIRES** *[see **THE SHIVER OF THE VAMPIRES**, p.166]*, and then in a particular scene in my newest *[as of 1993]* film, **UNE FEMME DANGEREUSE**, I had the killer woman hidden in a clock when everyone is looking for her in the room. I've also put this clock sequence in some of my books… *[(See endnotes [& p.226] for more about the writer-director's written works.) Rollin would reuse this pet "people-inside-grandfather-clocks" motif additionally just past the turn of the New Millennium in his final vampire outing, 2002's above-cited **DRACULA'S FIANCEE** (see pp.195-197).]*

MB: In closing, are you interested in genres other than le fantastique*?*

JR: I find it interesting to be able to make images from my imagination. For that, the fantastic genre is the best. Imagine a woman coming from a clock in a context which is not fantastic—it's difficult to believe. But if I was asked to make another style of film where I could drop some personal inclinations, I would do it. The most difficult film to make is a comedy. I don't feel that I am capable of making a comedy…although, at the beginning of my career, my movies made a lot of people *laugh*!

Endnotes (by SF):

1 – First published by Éditions Fleuve in August 1995, *Bestialité* was reprinted in December 2005 by Editions Nuit d'Avril; each (?) in French-language-only editions. The automated online English translation c/o Google Translate of the book's hyperbole posted at the French booksellers' website Babelio (@ *http://www.babelio.com/livres/Rollin-Bestialite/235014*) and on Amazon France (@ *https://www.amazon.fr/Bestialité-Jean-Rollin/dp/2350720152*) details its contents thusly:

"In the attic of his castle in Sologne, the Count de la Fresnaye hides a terrible secret, a secret he has just brought back from his long stay in India… His daughter, Elisabeth, is deeply intrigued by the strange noises and grunts that sometimes emanate from the locked attics. In the middle of the forest that surrounds the manor, on the nights of full moon, a strange black-haired teenager bathes naked in the pond. Who is she? Why does her presence seem so evil? Only Miarka, the gypsy who can decipher the past and the future in the lines of the hand, has the answer… Because she knows the mystery of bestiality. Will she decide, in spite of everything, to protect Elizabeth against this terrible curse? Jean Rollin here presents a superb novel, renewing with originality one of the key themes of fantastic literature…"

2 – We've thus far been unable to determine exactly when Rollin's novel *Enfer privé* was first published, but (in 1998) around five years on

Asian actress Yoko was at one point hoped to star in an unmade Rollin project

from when this interview dates, the Belles Lettres publishing house released it as a volume in their "Les Anges du Bizarre" series. Again thanks to Google Translate for providing us with the following *somewhat* legible translation—albeit with some "tweaking" by co-ed Fenton—of excerpts from an unsigned French customer review at the website Culture SF (@ *http://www.culture-sf.com/Enfer-Prive-Jean-Rollin-cf-377*):

"Lola is a prostitute of luxury. Very expert at her art, she even has specialties, among others, while hunting around a path along the shore she catches an inesperated game, a wild child, a wolf girl. This girl is delivered to the phantasms and profits of Lola and her maquerelle. *Lola finally falls in love with the little girl, which will lead to her loss... The book is a succession of constructions of scenes and atmospheres cutoff from dialogues. One feels that the author is describing a film. The atmosphere is poetic and dreamlike, quite that of the* erotico-fantastic *films of the '70s... My opinion: Despite a pronounced erotic character, it is certainly the most accessible of the books of this collection, and it quite finds its place there... Jean Rollin, filmmaker and novelist of the fantastic, gives us a rare, truly Sadean novel. The cruelty and hatred of the characters, however, leads to a kind of innocent tenderness; terrible and unhealthy images that give a glimpse of a small corner of blue sky quickly covered with red blood..."* (Regardless of the awkward translations—and more likely *because* of them—the online author's words capture a surreal feel highly fitting to Rollin's oeuvre.)

3 – Below follows information pertaining to some of Jean Rollin's other printed works, all derived from French-language sources on the internet:
La Cabriole a disparu / "The Cabriole Disappeared" (Paris: Liv'éditions, 1998), was part of the "Létavia Jeunesse" collection and geared towards younger readers.

As part of their "Frayeur" ("Fright") series, *Les pillardes* ("The Pillars") was published by Le Fleuve Noir in 1999; that same imprint had also put out Rollin's 1993 novel *Les deux orphelines vampires* (adapted to the screen as **TWO ORPHAN VAMPIRES** [1997]), to which the '99 book is a sequel. An English translation of an online description for it reads:

"A whole family is assembled for the squire's birthday, when someone knocks at the door... These are two pretty blind girls who ask for hospitality on this stormy night. The vampire or- *phans are back! What is the secret of 'Fleur de Rail' that his brother locks at night? What mysterious mystery hides inside the cliffs of Dieppe? Mutant creatures, clandestine cemeteries, traveling clocks, the whole panoply of fantasy is deployed for this strange journey."*

Still another phantasmagorical fantasium bearing Rollin's byline is *Alice et Aladin / "Alice and Aladin"* (Paris: Éditions Films ABC, 2005), which is hyped by its publisher with the following ad-copy, here once again translated from the French: *"Who is this mysterious person, wearing a top hat and holding an umbrella, coming out from the depths of the Seine by a staircase overlooking the Quai Saint-Michel? In the deserted rooms of the Delmas-Orfila-Rouvière Museum, at the very top of the faculty of medicine, wanders a menacing crocodile that slips between the casts of the heads of the guillotines, the anatomical waxes of wonderful women with wild eyes and open bellies... Just in front of them, the mummified head of the assassin Narcisse Porthoult stares at the visitor with an expression of infernal horror... In the cemetery of boats of Chausey island, a ghost dressed in white walks at night, and in the little church a priest who has grown crazy howls with anger after the specters who mock him... In the archives of the Museum of the Navy, one can find the secret of the sinking of the ship Amphora. But who is hidden in the bottom of the Emperor's barque? Alice and Aladin, brother and sister mediums, investigate in the remains of the castle of Terremor. Mysterious trances seize Alice and force her to face the beach of bones and what lies in Watt Street... Only Aunt Augustine knows the secret of the childhood of Alice and Aladin. Did they kill their parents? All this will be revealed in front of the tomb of Raymond Roussel, at Père-Lachaise* [Cemetery], *after they have drunk the magic water of the last Wallace fountains."*

Still another self-published Rollin novel is *Deraison* (Paris: Éditions Films ABC, 2006): in which *"...a strange young woman, alone at a table in the back of a provincial bar, writes mysterious love letters. The narrator will follow her, approach her, and receive in her turn, like others before him, passionate letters. A relationship will emerge between them. But this relationship will turn out to be madness, blood and murder. The wolf leader trains the reader on the black Causse, where one, then two women come out of their graves and take the lead of a group of wolves. Leaving behind them a bloody trail, they will rejoin what remains of a once-prosperous manor. There will be accomplished the most terrible of familial revenge."*

Boasting rather shocking cover art which is sure to offend/disturb those with more sensitive sensibilities, *La petite ogresse* ("The Little Ogress" [1996?]) was reprinted by Éditions Films ABC / Éditions La Nef Des Fous in 2007 (it was previously reprinted by Éditinter in 2004, too). Said shockingly surreal, symbolic artwork depicts a delicate B&W charcoal-and-chalk rendering—seemingly emulating a combination of an artist's life model study and some anatomical illustration from a medical textbook—of a naked-below-the-waist prepubescent girl in the process of peeling open the flesh of her upper torso so as to expose her internal organs while peering inquisitively into them. Hype for this novel reads:

"It only takes one meeting... The one of a man on the verge of suicide and a little girl come from nowhere, who weeps on the steps of a Parisian staircase, so that the whole universe tilts. Who is this character to whom his disinterest for life opens the gates of an elsewhere populated by radiant ogres, necrophagous attachments and ferocious dwarves? It is the magic of Jean Rollin: to know how to arouse the ineffable. Like the strange red-haired girl, he takes us by the hand and draws us in his wake towards these intimate territories. Countries where tenderness and cruelty, irony and fear, and of which one never leaves intact. No one better than Jean Rollin—a quiet passerby with his hands in his pockets and the streets of the 20th borough—has been able to give substance to the dazzling vertigo, the endless routes where innocence feeds on human flesh and makes one foot-to-nose with conformism." (<< Translated from the French with surprisingly lyrical eloquence by Google Translate. I barely made any alterations at all to this one! ~ SF.)

Bats swarm on the cover of Rollin's 2005 phantasmagoria, from his self-owned Éditions Films ABC imprint

"His unusual choices, the insurmountable and often comical problems he encounters and the harshness with which criticism tackles him make up the itinerary of someone who is resolutely on the margins of traditional cinema." So goes the description—here translated to English from the original French—at the website *gibertjoseph.com* in regards to Rollin's autobiographical, nearly 500-page book entitled *Moteur coupez! Mémoires d'un cinéaste singulier* / "Cut the Motor! [sic?] Memoirs of a Singular Filmmaker" (Paris: Édite Roman, 2008).

Bille de Clown ("Clown's Ball") was published by Édite Roman in 2009: *"In* Clown's Ball, *Jean Rollin revisits erotic writing, 'with just the thought of introducing crudity into dialogues breaking a fantastic scene and providing a shock.' Not to shock, but to play, to surprise... and not without humor."*

In 2010, the same publisher put out the anthology Écrits complets t.1, which compiles the following Rollin short stories and novellas into a single 600+-page volume: *"Une petite fille magique"* ("A Magical Little Girl", 1988), *"Dialogues sans fin"* ("Endless Dialogues", 1997), *"Tuatha"* (2001) *"Rien n'est vrai"* ("Nothing is True", 2004), plus *"Déraison"* and *"Les trois petites filles sorcières"* ("The Three Little Witches", both 2005).

NB. Copies of all the books cited in the final endnote can be obtained online (@ *www.gibertjoseph.com*). Do bear in mind that all the titles mentioned hereabouts are, so far as we know as of this writing, only available in Rollin's native *français*, though.

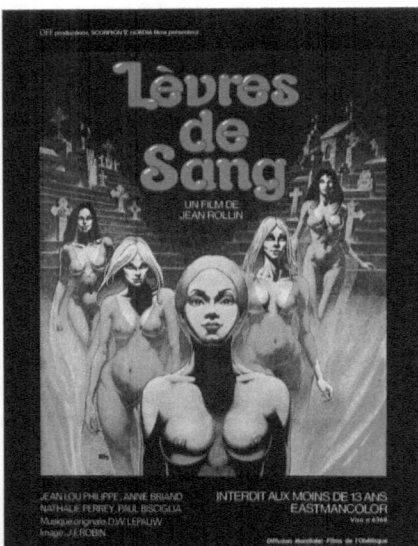

LEVRES DE SANG

THE STORY

In the cold, lonely Montmartre Cemetery, an eerie procession carries white forms down into the depths of an obscure vault. After the portals close, moans are heard, muffled by the thickness of the walls.

During a cocktail party, an energetic young publicity agent named Frédéric sees a poster showing a ruined castle and it somehow recalls his strangely forgotten boyhood.

Through the image of the castle, the white figure of a girl returns to his memory. He is deeply disturbed by her. One evening, she appears to him like a ghost in the darkness of a movie theater.

Is she real? Or is she an hallucination?

Frédéric follows her, pursues her, searches for her, constantly led on by her apparitions in the most unexpected places.

She guides him to the Montmartre Cemetery where he thinks he has strayed unawares but he has come to the place she wanted him to come to. He is surrounded by caskets. A peculiar obsession urges him to open one of them... He has unwittingly let out evil spirits, women with lips of blood who roam about Paris spreading terror and death. Frédéric runs away, wandering aimlessly about, convinced now that the girl really exists somewhere, the prisoner of some weird evil spell. He goes looking for her at the ruined castle where he is certain he will find the answer to the riddle. In his search, the figure of the girl keeps returning, guiding him sometimes in the right direction, sometimes astray, but he manages to get to the castle and down into the vault where the girl's casket lies.

He is not alone. His mother and other people are there and they explain the family curse to him, telling him that the only way to remove it once and for all is to destroy the girl.

But love wins. Frédéric deceives everyone and the vampires are destroyed... except one, and the accursed race, saved from total destruction, lives on in the love of Frédéric and Jennifer.

Top Left: Sexy French *affiche* for 1975's **LIPS OF BLOOD** (art by Caza). **Top Right:** This Anglo synopsis from that film's multi-lingual French export pressbook captures a suitably "Rollinesque" mood (prose possibly even written by JR himself...?). **Above:** Extra-lurid German A1 poster for 1978's **THE GRAPES OF DEATH** (art by K. Dill). **Right:** The back cover to the *Monster! International #4 / Highball #2* special "flip-over" split ish from '94 (art at both ends by—Alex Wald!)

CÉRÉBRÉS AU GRATIN

(loose translation: "BRAINS WITH CHEESE")

A *Monster!* Moron's Lovingly Long-Winded Ode to the Zany D.I.Y./S.O.V. French Zombie Flick TREPANATOR, Co-Starring Jean Rollin

by Mongo McGillicutty

Loose translation of the film's French introductory card, whose quote is accredited to H.P. Lovecraft: *"Life is a hideous thing, and the hidden face of our knowledge oozes with fragments of truth that make it a thousand times more hideous... Science will possibly be the ultimate exterminator of our human race."*

Anglo disclaimer in the end-credits, just in case you might be wondering: *"No Thrue* [sic] *Animal Was Mistreated During The Filming Of This Motion Picture."*

The preceding was clearly added-on as a joke in regards to some serious abuse "suffered" (note quotes) by a poor black lab cat-cum-experimental guinea pig over the course of this nutty movie's relatively brief runtime (78 minutes); the joke being that said animal is actually merely a super-phony dummy stand-in/ hand-puppet that is less-realistic than the average kiddie's kitty plush toy, and a slow-witted kindergartener shot-up with too much Ritalin couldn't be fooled into thinking it was authentic. Indeed, only someone with half a brain and a triple-lobotomy on top of it could ever be fool enough to mistake it for the real deal. So not to worry, feline fanciers! (Okay, now we've got that out of the way, on with the show, monster fans...)

What, with this here issue being in large part devoted to the late, great Jean Rollin and all, my mighty **Monster!**-masters Messrs. Paxton & Fenton thought I ought to contribute my very first review ever to "our" (i.e., their) mag. They said it's high time I either pull my weight around here, or else sling my hook. Also, they invited me to use as many words as I wanted to, because chances are I won't be getting to see my byline in these pages too often, so I'd best make the most if it. So, with absolutely no remuneration for myself (unlike the rest of you lucky high-paid, dollar-a-word contributors), here goes nothin'...

Left: Assorted key frames from the S.O.V. production's crudely video-generated if endearingly earnest opening title sequence

TREPANATOR (1992, France, D: "N.G. Mount"=Norbert Moutier) really gets off to a flying start, which whets your appetite for the blood feast to follow. At the outwardly picturesque psychiatric clinic (=loony-bin/ slaughterhouse) run by a certain wannabe Frankenstein named Dr. Victor Roll—played by Rollin; who else but?!—all sorts of splattery shenanigans have been going on. For instance, as a lengthy introductory sequence, shot entirely *sans* dialogue, shows us, titular "trepanator" Roll(in), who sports what appears to be a painted-on oversized moustache *à la* Groucho Marx (!), is shown methodically and diligently committing "surgical" indignities on various bits and pieces of human corpses that are strewn all over the joint's rancid basement/dungeon, which is more akin to a charnel house than a medical institution. Shades of the *Hellraiser*s, chunks of flesh hung on hooks from chains bedeck the place from wall-to-wall like obscene Xmas decorations. The mad doctor keeps mute (if still-living) severed heads arrayed on his workbench, and at one point uses a samurai-style *katana* as a makeshift oversized "scalpel" to lop the top off a bald-pated bodiless noggin as casually as if removing the end of a boiled egg with a butter knife. He then proceeds to yank this "egghead"'s brain from its skull then places it in what appears to be a Pyrex baking dish, carrying it towards the dead body of a young man lying supine atop his operating table...

From out of nowhere, a pair of armed men pull up outside this house of horrors in their car, then enter with their sidearms drawn in readiness while surveilling the clinic's cellar. Upon confronting Roll, when he resists arrest while swinging his post-trepanning skull-slicing sword at them, they gun him down in self-defense. Even as the madman who gave him unnatural life dies, the freshly-operated-on "patient" on the tabletop has his violently traumatic "rebirth", via having the gloppy grey matter which was extracted from that aforesaid severed head transplanted into his own recently-debrained nut, thus causing him to become resurrected—or perhaps "re-animated" might be a better choice of word, considering **TREPANATOR**'s blatant inspiration source (which explains ol' HPL's name being dropped right in the opening

titles, too). This corpse reanimation happens right under the very nose and terrified gaze of a little *garçon* whom we rightly assume must be Roll's juvenile son, who has been watching his potty *père* from concealment as he committed his medical atrocities. Jr.'s pubescent psyche is rattled and left permanently damaged by the trauma of these horrifying events, which not unsurprisingly stay with the lad into manhood.

For some reason, upon hearing the over-amped *buzzzzz* of carrion flies on the soundtrack during the epic (12½-minute) opener, I was suddenly reminded of the classic Frank Zappa horror dirge from 1976 entitled "The Torture Never Stops" (off his amazing *Zoot Allures* album), which opens with the memorable lyric lines "Flies all green and buzzin'/ In this dungeon of despair"; in fact, in my opinion, **TREPANATOR**'s entire opening sequence might ideally be rescored with that just-named track to even greater effect. Personally, I think it would fit it mighty darn swell. But WTF do I know? I am only *Monster!*'s coffee/whipping boy and occasional cuddle-puppy, after all. But I digress... *[Yeah, Mongo, STFU and do your job, boyo! And make me a cuppa while you're at it, eh. – SF]*

Immediately following the above-described drawn-out introduction to the plot proper, the scene abruptly shifts from sometime in the not-so-distant past to (as a video-generated title informs us, otherwise we'd never guess) "New York To Day *[sic]*"; although, while I can't say for sure, not being a native Noo Yawker, I don't think the generic shots of high-rises shown were actually shot anywhere even *close* to NYC (nor even NY State either, for that matter). Even a single stock insert shot of such instantly recognizable landmarks as the Empire State Building or World Trade Center was beyond the reach of the budget, I can only assume.

Anyway, after first drilling a series of precise trepan holes into the laid-out corpse's shaved cranium in a geometric pattern using a Black & Decker power drill, Doc Roll then neatly saws off the uppermost section of skull with a handheld electric circular saw (possibly

Right, Top to Bottom: There are gory body parts of all kinds on show in **TREPANATOR**, but what would a Frankensteinian horror movie be without brains...especially ones in jars! By the way, that's no less than the great Jean Rollin having his exposed cerebrum probed in the second picture!

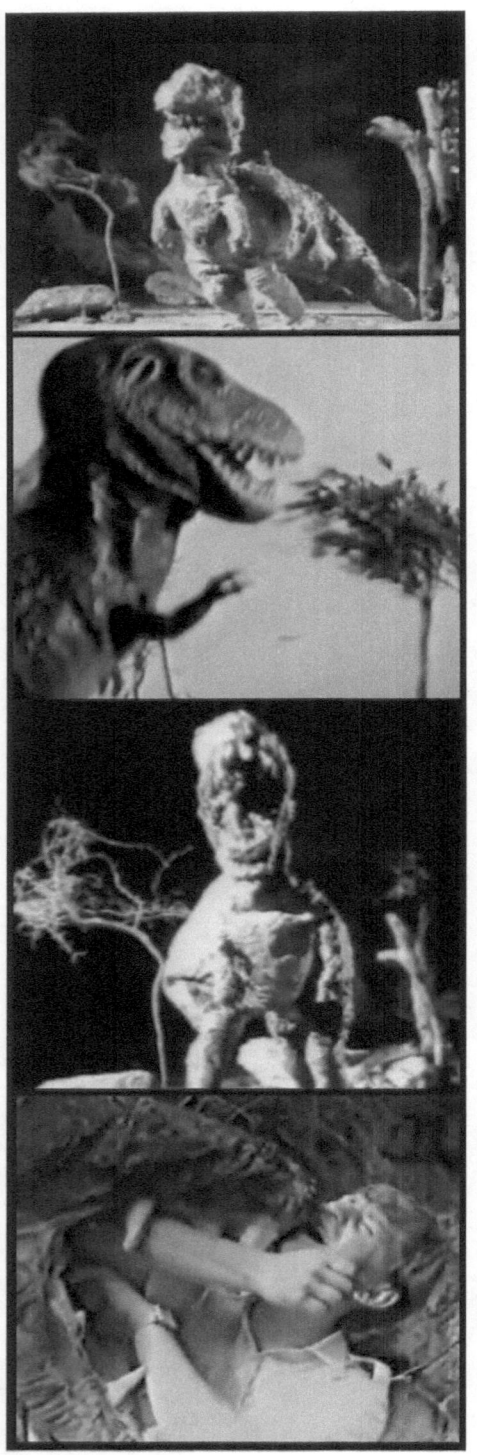

of the same make, though chances are that B&D *weren't* an actual official sponsor...but stranger things have happened).

A not-untalented actor of some naturalism with a quite commanding if offbeat screen presence, Rollin here gets to play not just one but two parts in the forms of both Roll, Sr. and his son (the latter *sans* a goofy Groucho 'stache)...the initial of whose otherwise unmentioned first name is self-consciously revealed to be "J" (possibly standing for "John", perhaps?), as an emphatic zoom-in onto the new sign out in front of the Rolls' clinic—which has since, like Doc. Jr., relocated across the Big Soup—reveals. Yes, you guessed it: this new second Rollin character is none other than the late-middle-aged adult version of that traumatized boy we saw spying on his long-deceased father's abominations of medical science during the intro. Enter Dr. Roll, Jr.'s portly associate Herbert East (get the punny name? [played by the top-billed Michel Finas]), who, as a pupil of Roll's has some even more "innovative" ideas of his own regarding the fine art of corpse-reanimation. The milieu and stage thus set, so begins the plot of **TREPANATOR** proper...

But first, some background details. Director "Mount"/Moutier is best-known for making the ghastly Gallic gorefest **MAD MUTILATOR** (a.k.a. **OGROFF**, 1983 [see *Monster!* #19, p.76]), but his astonishingly astounding canon also includes the ultra-lowly likes of **LE SYNDROME D'EDGAR POE** (*"The Edgar Poe Syndrome"*, 1995), **ALIEN PLATOON** (1992) and **DINOSAUR FROM THE DEEP** (1993, all France), those lattermost two also guest-starring Rollin.

In that just-mentioned '92 "*épique*" [sic!], while military boffin Dr. Nolan (Rollin) attempts to control a chained-up extraterrestrial super-soldier by means of an implanted electronic device, keying frantic "abort" commands into his rinky-dink, portable TV-sized computer console (circa 1975 model!), the captive, exceedingly aggressive creature—some big dude in a rubber monster mask and army surplus store combat fatigues—proceeds to clobber him on the skull with the butt of its humongous machinegun (a clunky, wobbly "special FX" prop which appears to be tenuously slapped-together from black-painted balsa

The ten-*centime* terminator of **ALIEN PLATOON**

wood and plastic tubing, and maybe even some Styrofoam too) then snaps its ankle-chain to go on a murderous rampage through the "military scientific complex" (!). This entails mowing down a dozen or so observers—none of whom make not only no attempt whatsoever to dive for cover, but don't even utter a single sound of alarm either—in one of the most hilariously unconvincing "massacre" (!) scenes ever shot. During this, the muzzle of the rickety prop gun is never shown while it "shoots"—surely the single biggest blunder any so-called action movie can make!—with an unconvincing dubbed-on *budda-budda-budda* sound effect hoping to convey the illusion that it is actually discharging bullets while the monster man jerks it back and forth, as though from the "kick" of the heavy recoil.

As if that isn't remarkable enough, better yet, for Mr. Mount's tawdrily-mounted '93 aquatic dino *aventure*, the above-cited **DFTD**, Rollin reappeared as the senior member of a party of intrepid explorers who encounter the title creature (a wannabe "Tyrannosaurus" [?!] about ten times cuddlier and less-scary than Barney the purple dinosaur) in its (un)natural habitat. Ambitiously if primitively depicted via ultra-jerky stop-motion animation, an almost-static miniature rod-puppet and even a full-size prop head with hinged, tooth-filled jaws (none of which three elements even remotely match-up properly with any of the others!), this prehistoric reptile unnaturally alive in the modern world isn't presented with anywhere near as much style, smoothness and professional slickness as is to be found in Brett Piper's work, but—thanks in large part to the sheer audacity of it—is irresistibly endearing nonetheless. Making things that much more precious still for us D.I.Y. monster movie maniacs, Rollin—clearly reacting to something outside the frame which he couldn't actually see—hams it up royally (complete with all the "appropriate" [!?] histrionic hand gesticulations a Frenchman could possibly muster) while witnessing the much-too-cutely cuddlesome T. Rex chow-down on a couple of his colleagues before it gets blasted by a powerful pistol and topples over with all the grace of a skittle after being hit by a bowling ball. Witnessing the primitivism of these two Moutier projects, one can't help wondering how such a seasoned filmmaker like Rollin might have reacted to the finished products (i.e., with the utmost diplomatic tact or brutal honesty, or a combination of both?). Considering he appeared in three of Moutier's films, he was probably grateful

Facing Page: 4 shots from **TREPANATOR** mastermind Norbert Moutier's **DINOSAUR FROM THE DEEP** (1993). **Top to Bottom:** The title character's tubby, much-too-happy-looking "Barney"-like stop-motion doll; its mismatching, barely mobile rod puppet "body double", used for closer shots; "Barney" again, this time looking a *tad bit* angrier; and the "same" dino's "stunt stand-in": a life-sized, hinge-jawed "T. Rex" head used for C/U attack scenes

to be getting at least some sort of paycheck for his time, so perhaps he chose not to express too many negative opinions in hopes of keeping the gigs coming. But that's all just simple supposition on my part. *[Quit with the presumptions already, will ya, Mongo! Stay on-point, mister! – ed.]*

And speaking of special guest stars, for the present film—*er*, video—under review, *monsewer* Moutier gives us a bonus cameo from prolific trash/horror movie producer (and occasional director of same) William "**MANIAC**" Lustig. Cast herein as an American man plagued by bad dreams ("Oh, terrible nightmares", he says *en anglais*), Lustig makes the (presumably fatal) mistake of visiting the clinic for a psychiatric consultation from Dr. Roll. While drowsing under heavy sedation in the operating theater, he has a nightmare containing a blatant imitation of the title zombie vigilante law-enforcer (originally played by the late Robert Z'Dar) from Lustig's own *Maniac Cop* trilogy, all of which he directed from scripts by Larry "**IT'S ALIVE**" Cohen. I frankly confess I was unable to determine quite what became of Lustig's only fleetingly-seen character here, but I have to assume he came to some sort of sticky end (albeit entirely off-screen, if at all). His presence herein does amount to a pretty inspired piece of casting on Moutier's part though, no doubt about it, which doubtless doubles its worth in horror fans' eyes.

While crude to be sure, gore effects (which come courtesy of a five-person team that consisted of three gals and two guys) are nothing if not spiritedly handled, and there is a plentiful supply of them to be had, as well as a constant barrage of grisly *grand guignol*-style imagery which ladles on buckets of blood 'n' guts (and brains 'n' bones, etc). Indeed, the competent videography—even if it does spend a tad too much time gawking at random heaps of splattered bodily organs with all the fixings—maintains a high level of viewer interest and, although the production has its fair share of static shots taken with a bolted-down

Left, Top to Bottom: The presence of Jean Rollin helps makes **TREPANATOR** that much more special…*priceless*, even! In the topmost shot, he can be seen wiping-off his samurai sword "scalpel" after performing some precision impromptu brain salad surgery with it. The second and last shots depict a couple of his more animated facial expressions (seen in insert reaction shots); the third one catches him in a more naturalistic moment whilst fielding a phone-call

camcorder and actors who barely move around the frame, imagery is often shot from interesting angles, with plenty of cutaways, inserts and C/U's to sustain our attention.

Although it's occasionally of a vividly purplish hue not unlike the juice of pickled beets, the fake blood mixture used appears atypically realistic at times, adding extra queasiness to some scenes. Leave it up to him known as Karl (Michael Raynaud), the mad medicos' resident imbecilic limping henchman with bad hair, to sop-up all the slops; at one point, amusingly enough, wringing-out a double-fistful of floppily fleshy human tissue into a pail like a wet dishrag. Then again, maybe it actually *was* just a rag, for all I know. Whaddaya want from me, anyway?! I'm only this mag's mascot, on a par with the village idjit. Speaking of which, shades of this issue's **THE BRAINIAC** (see p.229), Karl the idiotic henchman—possibly in hopes of increasing his limited IQ a few points?—develops an addictive appetite for brains, but rather than eating 'em raw he at least takes a moment to sautée them in a frypan over a brazier first before delicately tucking in with his knife and fork. After being caught at it in mid-mouthful, the brainless brain eater gets an XL hypodermic injected into his own via his left nostril by East, which not only unclogs the victim's sinuses just handy-dandy but leaves him a slobbering dead-alive zombie as a result. Even more audacious still, in a subsequent scene which seems to be endeavoring to outdo the notoriously outrageous and meaty "head-exploded-by-basketball" scene in Wes Craven's **DEADLY FRIEND** (1986, USA) for sheer wackiness, an old codger on crutches—one of the bad doctors' "successful" experimental subjects—gets his inadequately stitched-on block knocked clear off at a family picnic when a little girl accidentally power-boots a brightly-colored kids' ball in his direction. The other picnickers' collective wide-eyed, open-mouthed "horrified" reactions to this unexpected development are hilarious to witness! In another highly entertaining moment among the many to be had here, the above-noted feline experimental subject—well, *half* of it, anyway (i.e., the top/front end)—plays a catalytic role during **TREPANATOR**'s right-out-to-lunch climax. It's often been said that every dog has its day. Here, it's that semi-moggy which, after being so horribly maltreated beforehand, finally has his (hers?); this by crawling away from its surgically-detached lower body on its forepaws along the lab table, then launching its legless torso into the air at East in an effort to claw his eyes out. (Yes, it's every bit as wacky as it sounds!)

This preserved lab specimen in **TREPANATOR** unfortunately never actually comes to life

Linda!

Attempts to whip-up some faux American ambience are seldom more transparently fake than in a sequence purportedly taking place at an NFL (?) game, for which mismatching grainy footage of decades-old football action is loosely intercut with French cast members allegedly spectating from the bleachers (a tiny, cramped set which looks about as convincing as the famous airplane cockpit shower-curtain backdrop in Ed Wood's **PLAN 9**). Now, if this was some super-slick Continental mockbuster attempting to pass itself off as being set and shot in America, the unconvincing results might be not only pathetic but irritating as fuck. But since **TREPANATOR** is such a zilch-budget if enthusiastically zesty affair and we're willing to cut it all sorts of slack out of simple empathy, its feeble attempt to fool us almost seems... well, *admirably audacious*, somehow. For the sake of some Yank-themed satirical comedy, we get a staged TV news broadcast of a heated debate between a pair of French-speaking "American" (!!) presidential candidates, Tedakis (Olivier Richard) and Schulter (John Lano), whose televised mutually verbally abusive confrontation swiftly degenerates into physical violence that causes Rollin as Roll's jaw to drop in shock so violently that he loses his lip-grip on his trusty pipe while tuned-in from his study at home. Although this ambitiously-if-ineptly-staged sequence is largely extraneous and comes and goes without much rhyme nor reason, the quick edits showing Rollin's slack-jawed reactions to the pugnacious politicos' onscreen antics are admittedly pretty amusing to witness (as are others elsewhere within the narrative; though nowhere near as hilarious as the facial contortions he pulls in the aforementioned **DINOSAUR FROM THE DEEP**!).

Hold on, wait a sec: turns out that set-to between the two political rivals *does* factor into the plot after all... Having kicked-off from cardiac arrest due to the trauma caused by his fisticuffs with Tedakis, his hated competitor for the presidency, the recently-deceased Schulter is paid a visit in the morgue by a brain-napping nocturnal prowler, who makes off with the contents of his skull. In a subsequent garish scene (one of plenty), evidently just for the fun of it—well, *and* for profit too—Roll, Jr.'s overeager trepanning apprentice East (whose performer Finas commendably really gets into the part, and then some) chainsaws a man to bits just to get his brain out. Yep, you guessed it, brainiacs: the ultimate goal

Left: *Ungrateful Dead!* The understandably vengeful zombies of **TREPANATOR** get their own back in a decidedly messy manner during the film's EC Comics-styled climax, which really pours on the blood'n'guts...and slapstick comedy, Grand-Guignol style!

is to insert the dead presidential hopeful's mushy mental matter into a new body as part of some nefarious scheme, probably ultimately involving world conquest or something of the sort. As far as I could discern, that potential aspect of the storyline got jettisoned somewhere along the way from A to Z, though. Maybe it's just me, but it definitely appears as if more than one "key" subplot got left behind with some strings trailing somewhere, leaving holes big enough for the Eiffel Tower to fit through sideways. Or maybe I'm just missing something vital to the comprehension of it all here. Could well be. Though, strange as it may seem, miscomprehension actually seems to *enhance* this flaky flick's appeal. At least for me.

On that note (*ATTENTION: SPOILER ALERT!*), cue the EC Comics-style revenge-from-beyond-the-grave resolution, as the terrible trepanator's various zombified victims collectively rise from under the covers on their lab-slabs to treat him to a taste of his own icky medicine, *sans* any spoonful of sugar to help it go down nice. In a desperate last-ditch effort to preserve his superior cerebrum for posterity, the megalomaniacal/narcissistic Herbert East performs some drastic circular saw surgery on himself before catching the last train headed southbound-and-down for keeps; all that remains where his head had just been afterwards is a messy mass of red glop. But if you think for an instant that means there won't be at least two (or even three) surprise twist endings more besides this one, have you ever got a wrong number, *mon ami.*

Despite his oft-avowed aversion to gore during his own filmmaking career (although the likes of his **THE GRAPES OF DEATH** [1978; see p.181] and **THE LIVING DEAD GIRL** [1982; see p.190] certainly don't shy away from their grislier concerns), director-author-actor Rollin appears to be having a right old time for himself in **TREPANATOR**, and he even gets trepanned himself at one point (although what happens to him after that is decidedly vague, as he doesn't really factor in the plot beyond that). But yes, have no fear, Rollin fans, even when presented in this tawdry a context, the man's dignity and mystique emerge completely unscathed! In the interests of an in-joke/sight gag (which may well have been a stipulation of his contract), Moutier even gives him an onscreen visual plug for one of his novels *[see notes at the end of this review – ed].*

Much of Patrick Giordano's simplistic/minimalistic electronic score represents the umpteenth attempt by exploitation filmmakers—be they European or otherwise—to slavishly emulate both John

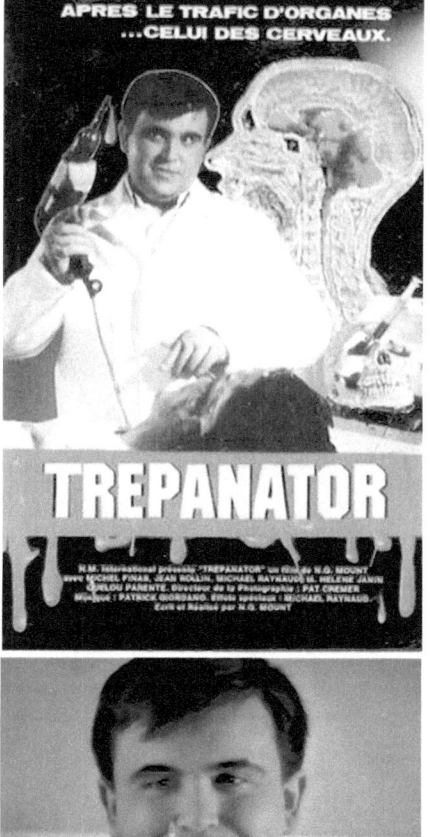

Top: *"After the organ-trafficking comes...the brains."* French VHS cover. **Center:** Michel Finas as **TREPANATOR**'s junior mad doctor, in his element. **Above:** The uncredited player in its *Maniac Cop* homage

Carpenter's oft-copied **HALLOWEEN** theme and Mike Oldfield's "Tubular Bells" (from **THE EXORCIST**) simultaneously. The closing theme, performed in English by Giordano's group Mad Murdock, is a pretty damn smokin'/catchy hard rock number called "Right or Wrong", which pounds out/rounds out this great fun slice of "alternative" entertainment in fine style. Thanks in large part to the derivative, repetitive incidental musical score heard elsewhere and plenty of visual interest besides, for all its goofiness—and quite likely *because* of it—**TREPANATOR** succeeds in being strangely compelling; I might even go so far as to call it mesmerizingly fascinating, in fact. And no, I don't think of it as a "guilty pleasure", by any means. There's absolutely no guilt involved. Call me easy to please, if you must. Just *don't* call me Shirley. The name's Mongo. Got that?

NOTES: The JR novel plugged at one point herein is *Les demoiselles de l'étrange* / "The Damsels of the Strange" (Filipacchi, 1990), a 269-page edition; Filipacchi subsequently published an extended (458-pp) edition in 1997. Later still, in 2003, Rollin's own imprint Les Films ABC, in conjunction with another of his sometime publishers (É-dite), reprinted the book in a 320-page edition under the more elongate title of *Estelle et Edwige, les demoiselles de l'étrange*. As of this writing, copies of that latter edition were available for sale online at the website Book Node (@ *https://booknode. com/les_demoiselles_de_l__trange_0830662*). The following is a translation of its French ad-blurb thereat: *"This complete and partly unpublished edition of* Les Demoiselles de l'Étrange *leads the reader in a fantastic soap opera. On the trail of the demon Andras, the ancient Medusa, and the cursed chessboard of the Elven towers, passing by the sinister chatelaine of Ker-Goal, murderer of the little Tùatha, the Demoiselles'* caracolent *mysteries of enigmas, Bloody Nun in specters haunting the little Parisian cemeteries... Estelle and Edwige, the return of the great serials: the shadows of Rocambole, Harry Dickson, Fu Manchu are not far off. Let yourself be led by the hand, and follow the charming Demoiselles in their disheveled adventures"*. Copies of the Florent Massot publishing house's shorter '93 mass-market paperback edition are on offer at Amazon UK (@ *www.amazon.co.uk*), albeit in French only, as with all the other editions mentioned here. On a related note of trivia pertinent to the present movie being reviewed, a Brazilian thrash metal band called Trepanator (formed in 2007)—whose recordings include an EP entitled *Massacre Craniano* (2015)—may well have derived their name from it. In fact, the odds are good that they did; but if not, they *should* have...

Left, Top 3 Pics: Crude handmade signage is but one of **TREPANATOR**'s many inventively economical charms. **Left:** The same edition of the Rollin novel that gets a close-up in the movie

LOOK!
BACK ISSUES OF
MONSTER!

Is your collection of MONSTER! complete? Order your Back Issues NOW from amazon.com. Buy now, trade later with fellow fans for issues you're missing.

#30 - Stop-Frame Animated Critters!

 #1 - Premeir issue!
 #2 - Creature issue!
 #3 - Spooky issue!
 #4 - Bollywood Beasts!

 #5 - Hamburger Movies!
 #6 - Giants & Yetis!
 #9 - More Snow Monsters!
 #10 - Halloween Monsters!

 #11 - Special KAIJU issue - Tony Luke cover!
 #14 - EQUINOX!
 #16 - Mexi-Monsters!

 #17 - Lady Frankenstein!
 #20 - GARGOYLES!
#22 - A Monster in Tokyo!
 #23 - Bollywood & Zombies!

 #24 - Dangerous Dinosaurs - cover by Denis St. John!
 #26 - Cover by John Rozum!
#28/29 - Double Issue!

These are but a few of the startling covers for the equally astounding issues of MONSTER! Cover prices range from $5 to $12.95 depending on what amazing stuff is in what issue! Don't pass up an opportunity to OWN THEM ALL!

amazon.com
Or buy directly from the publishers at wengschopstore.com

COLLECT THEM ALL!

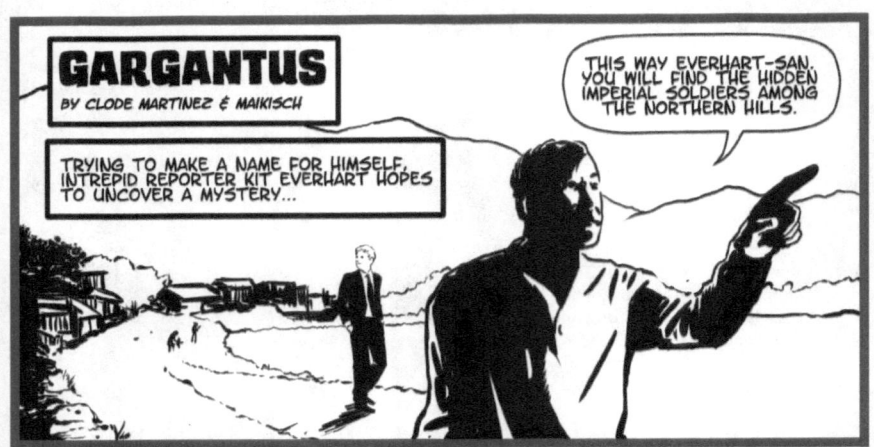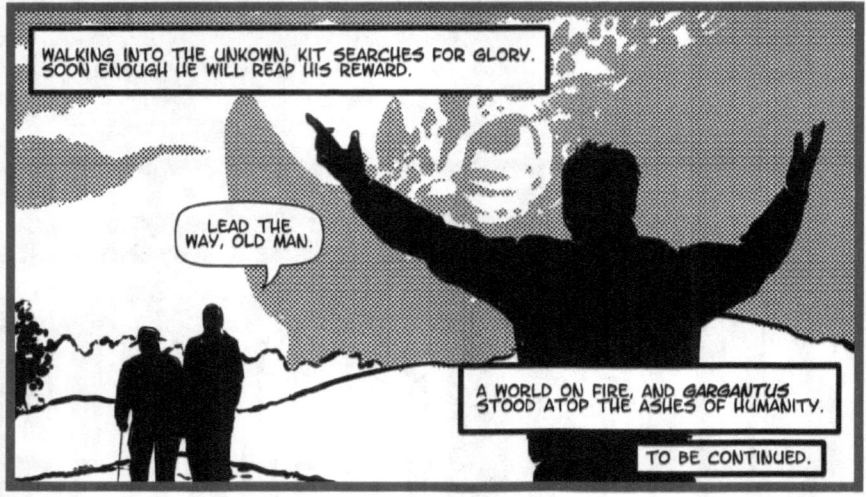

REVIEWS

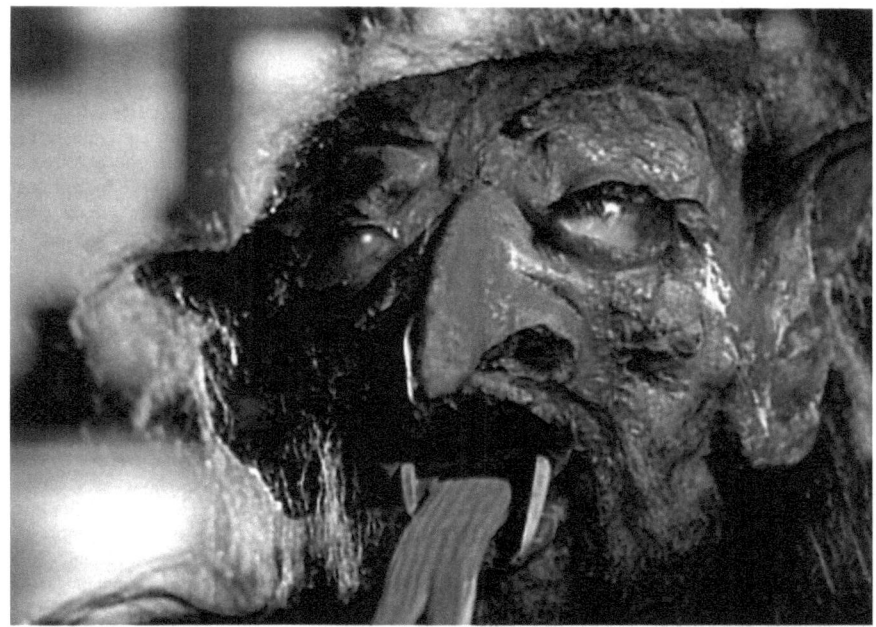

El Brainiac blows a big, wet raspberry at pedantic, pretentious, boring, elitist (etc.) Film Snobs everywhere! (Not that we ever get *those* sorts poking about in our pages, though)

THE BRAINIAC
(*El barón del terror*)

Reviewed by Christopher J. Maurer

Mexico, 1962. D: Chano Urueta

I call this *"A Stargazing, Witch-Burning, Brain-Sucking Good Time!"*

Most of us are at least somewhat familiar with the Salem Witch Trials that occurred in colonial Massachusetts between 1692 and 1693. The witchcraft hysteria and the resultant trials and executions that happened in Salem have repeatedly been explored on both the big and small screens, including in adaptations of Arthur Miller's oft-staged/filmed 1953 play *The Crucible* (e.g., Raymond Rouleau's French 1957 [*Les sorcières de Salem*] and Nicholas Hytner's American 1996 versions), all the way up to WGN America's recent teleseries *Salem* (2014-16). On a superficial level, they add a much-needed occult/supernatural flavor to American culture. More importantly, however, the Salem Witch Trials are an unpleasant historical reminder to us that the fires (and nooses) of fear and ignorance, when fed by certain power-abusers in positions of authority, can result in such extremes as mass-hysteria and state-sponsored murder. In whatever light you look at them, these trials have become part of our collective consciousness, and similar such matters recur in horror cinema with some regularity, as here.

What I was *not* aware of prior to watching **THE BRAINIAC** was that similar atrocities had been occurring in Mexico (formerly known, thanks to those invading *conquistadores*, as Nueva España / "New Spain") both long before and long after the Salem Witch Trials took place. In 1571, Torquemada's Spanish Inquisition spread to Mexico, and from then until its abolition over 230 years later, the Mexican Inquisition executed more than 50 people for crimes ranging from heresy, to practicing Judaism, to sexual misconduct. It is the Mexican Inquisition which provides the initial backdrop and catalyst for the events that unfold in **THE BRAINIAC**.

Mexican poster (art unsigned)

*[The nutty nunsploitationer/demonic possession flick **SATANICO PANDEMONIUM** (1973, Mexico, D: Gilberto Martínez Solares), formerly available on DVD from Mondo Macabro, also features the Mexican Inquisition up to its usual tricks, including putting heretical nuns to torture – SF.]*

The present film's story begins in 1661, with torches blazing and black-hooded inquisitors passing judgment on a strange Spanish aristocrat, one Baron Vitelius d'Estera (played by Mexican horror figurehead Abel Salazar). While reading-off his *lo-o-o-ong* list of transgressions, the inquisitors variously charge the sinful Baron with witchcraft, necromancy and lecherous behavior with married women and maidens alike. The Baron seems unimpressed by the proceedings, cracking an amused smile as the charges are read aloud to him. It becomes clear during the trial that the Baron does indeed possess strange, supernatural abilities. Perhaps he *is* a warlock. Perhaps a nice public burning is in order...

Despite the mitigating testimony regarding the Baron's good works given at his trial by his friend Reynaldo Miranda (played by Rubén Rojo), the Baron is sentenced to be burned at the stake for his crimes. As the flames rise up, the Baron spies a comet in the sky overhead. A grim gleam comes to his eye and, for his last words, he lays down a curse on the hooded inquisitors, calling them each out by name. He warns them that, several centuries hence, he will return from the dead to exact vengeance on his executioners' descendants. Fast-forward to 1961, when the Baron returns to make good on his promise.

Reissue Mexican lobby card for **THE BRAINIAC**

Several of the actors in the film played dual roles—both the 1661 participants in the Baron's trial and execution and their 1961 descendants. What struck me as weirdly coincidental was that this long-range revenge/dual-role plot device was subsequently used in an almost identical fashion for **THE HAUNTED PALACE** (1963, USA, D: Roger Corman), American International Pictures' hybrid Lovecraft/Poe adaptation, which I reviewed back in *Monster!* #27 (p.14). The villains in both films are burned alive as warlocks at the beginnings of their respective pictures, and even their verbal curses also seem to echo one another. **THE BRAINIAC**'s Baron Vitelius d'Estera identifies each inquisitor by name while vowing,

"Baltasar de Meneses, Alvaro Contreras, Sebastián de Pantoja, Herlindo de Vivar... I will return to your world in 300 years, when this comet passes through our latitude again. Then I will carry out my revenge. I will eliminate all of your descendants and exterminate your damned lineage!"

THE HAUNTED PALACE's Joseph Curwen (played by Vincent Price) likewise names his killers in his own malediction:

"As surely as the Village of Arkham has risen up against me, so shall I rise from the dead against the Village of Arkham. Each one of you—Ezra Weeden, Micah Smith, Benjamin West, Priam Willet, Gideon Leach—all of you and your children and your children's children shall have just cause to regret the actions of this night. For from this night onwards, you shall bear my curse!"

According to the IMDb, **THE BRAINIAC** (under its original Spanish title, natch) was first released in Mexico in November of 1962, while **THE HAUNTED PALACE** was first released in the United States in August of 1963 (**THE BRAINIAC** likewise received its AIP-TV release in the States that same year, precise month unknown). It would be interesting to know if either director Roger Corman or his screenwriter Charles Beaumont had seen **THE BRAINIAC** while working on their film for AIP and (consciously or subconsciously) incorporated its plotline into their script.

Baseless rumors of idea-theft aside, and returning to the movie at hand, let us now fast-forward from 1661 to 1961, when the Baron does indeed return to Earth on the comet, as promised. In his '60s incarnation, the Baron is a brutal and relentless killer with a taste for (as per the US title) human brains. He transforms into a hairy horror that sucks gray matter out of the back of his victims' necks, leaving their empty-headed corpses to be puzzled-over by a dogged police detective, played straight by David

Above: Title cards from the opening credits to AIP-TV's Anglo dub. While subtitled editions of Mexploitation movies (most of which were never dubbed into English) are just fine and dandy, we wouldn't wanna do without KGM's comparatively precious few redubs, because the Americanized voice-dubbing adds a whole new level of surrealism to the proceedings—especially in the case of the present looney movie under double-review!

Silva, and his less-than-dogged colleague, played for light comedy by actor-director Federico Curiel (who also co-wrote the screenplay). *[Light comedic roles were nothing unusual for Curiel, as he played a good many of them earlier in his movie career while billed under his stage name "Pichirilo"; although, by the time he appeared in this film, he'd put on quite a bit of weight and gotten a good deal jowlier since his heydays– SF.]*

The protagonists are a pair of starry-eyed fledgling astronomers: Reynaldo Miranda, who "just happens" to be a direct descendant of the Baron's long-dead friend and ineffectual character witness Marcos (and is likewise played by Rubén Rojo); while his fiancée, Victoria Contreras (played by Rosa María Gallardo), "just happens" to be the descendant of one of the Inquisitors who put the Baron to death... much to her future peril. Via powerful telescope at the local observatory, this bonded pair of stargazers are scanning the heavens in search of the strange comet that disappeared from the sky upon the night of Baron d'Estera's arrival. Shortly after his reappearance/resurrection, he befriends the lovely couple. As the movie progresses and the brainless bodies pile up like a stack of *churros*, the star-struck lovers remain completely clueless to the fact that their cultured, well-spoken new acquaintance and neighbor is in reality the killer (and not only that, but isn't even human, either).

The creature design is effectively gruesome: a frightful long-tongued, bearded fiend with a pulsing (yes, it actually *pulses*!) devil-head, with paws (or are they claws?), each ending in two elongate tube-shaped, sucker-tipped "fingers". I've never seen anything like this nightmare before or since! Yes, the costume's rubbery. Yes, it is little more than a semi-inflatable Halloween mask and a pair of funny mittens. But if you go into the viewing experience without the ironic skepticism of a hardcore *Mystery Science Theater 3000* viewer *[Now there's BRAINLESS for ya!* ☺ *– SF.]*, you can really vicariously share in the horror of the Baron's victims throughout the film. The side-by-side dual suckholes that Baron Brainiac leaves on the backs of his victims' necks are reminiscent of a vampire's bite-marks; but they're larger, grosser, scabbier affairs that I found much more satisfactory from a monster-movie standpoint than the pristine twin pinpricks one usually associates with Dracula movies.

In keeping with the title, brain-eating amounts to a *LARGE* part of this movie. The Baron doesn't only

Left, Top to Bottom: *Presto-Changeo!* A simple double exposure/overlap and optical dissolve is all it takes to turn man into monster when Abel Salazar becomes...**THE BRAINIAC!**

suck them out of his victims while in monster form. The movie also actually shows him, in normal human form, daintily spooning brain matter from a large goblet he keeps locked in a cabinet! Not since Dr. Lecter's culinary endeavors in **HANNIBAL** (2001, USA, D: Ridley Scott) have I seen this much cerebral consumption going on! It was actually quite surprising for me to witness this type of realistic gruesome goriness in a black-and-white 1960s monster movie. In fact, this flick has *so much BRAIN* on the brain that traditional *tacos de sesos* (beef-brain tacos), even make a cameo appearance over the course of the narrative!

The director, Chano Urueta, directed almost 120 movies in a career that spanned over four decades, from 1928 to 1974. His other horror/monster efforts include a retelling of Mary Shelley's *Frankenstein* (1818), entitled **THE REVIVED MONSTER** (*El monsturo resucitado*, 1953), as well as **THE WITCH'S MIRROR** (*El espejo de la bruja*, 1961), both of which are on my "find and see" list. His directing style in **THE BRAINIAC** is—to put it bluntly—brutally straightforward. Corpses burnt to a crisp, a man strung-up upside-down and drowned in a bathtub and, as mentioned above, the Baron feasting on what appears to be *real* brains *[or at least realistic blancmange simulacrums thereof ☺ – SF]*...NOTHING is left to the imagination!

Grisly moments abound in **THE BRAINIAC**

The Baron himself is played with a coolly bland nonchalance by Abel Salazar, who also produced the movie, among numerous others besides. With a couple exceptions, the rest of the actors don't put much "oomph" into their performances. The first exception is the various women who shriek their lungs out in terror whenever the Baron transforms and attacks them with his obscenely waggling two-foot tongue and pervy sausage fingers; all these actresses are top-quality scream queens, who really get the job done. The second exception is Mexi-monster movie icon Germán *"El Vampiro"* Robles (who plays another of the Brainiac's many victims), when he is mesmerized into total paralysis on the spot while his daughter is at the monstrous Baron's mercy. As he stands nearby gaping helplessly but unable to move a muscle to help her, Robles' expressive eyeballs bug-out in a way that somehow manages to be comical, heartbreaking *and* frightening, all at the same time.

Will those detectives manage to put all the clues together and solve the three-centuries-old mystery in time? Will the evil brain-addicted Baron ever complete his mission of vengeance? Will they actually bother explaining to us how it was that a totally cremated 17th Century warlock somehow ended up hitching a ride on an incoming meteorite? Does he perhaps eat brains for extra padding, to prevent his pulsating rubber head from leaking air, like a hairy beach ball...? So *many* questions!

But no, I won't spoil it for you! Suffice it to say, if you're looking for a quick (77-minute), weird Mexican monster classic, **THE BRAINIAC** is right up your alley. (Oh yes, and it's got *flamethrowers* in too...so now you know you just *HAVE* to see it!)

Brain Freeze! René Cardona, Sr. has a *"WTF!"* moment in **THE BRAINIAC**

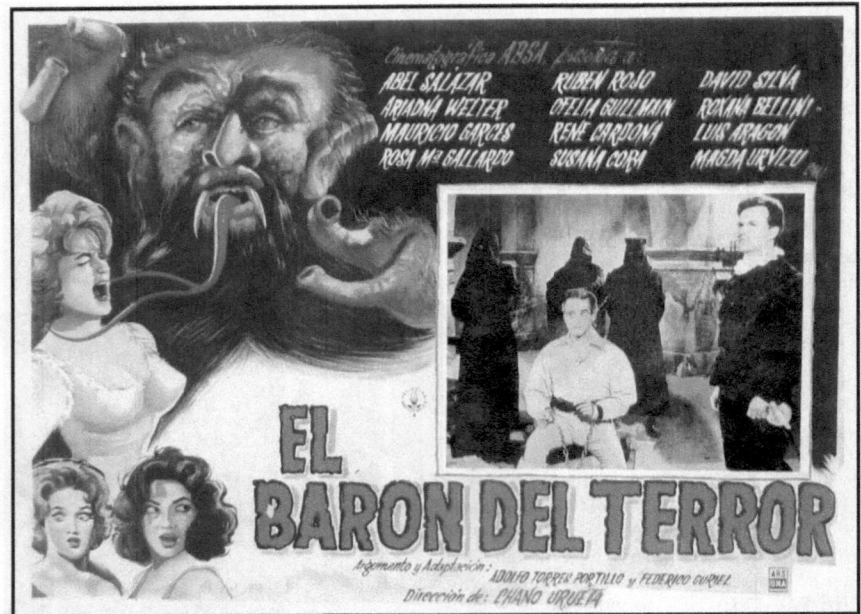

First-run Mexican lobby card for **THE BRAINIAC**; Abel Salazar *[left]* and Rubén Rojo can be seen in the inset still

THE BRAINIAC
(*El barón del terror*)

Reviewed by Mongo McGillicutty

Mexico, 1961. D: Chano Urueta

The seen-it-all-before forensic surgeon ain't never seen nothin' like this: *"In the years that I've been working in this morgue, I've never run across a case like this. The skulls of these two victims show two perforations. Possibly the murderer used an electric drill. I say this because the person who did it was quite skilled. Just look at these two orifices! A most astounding thing has occurred in these cases: you see, the cephalic matter was sucked-out through these small openings...* [Moves over from the male victim to the other victim instead, this one female.] *Please look at this: the same little holes in exactly the same place that they were bored in that other fellow's skull...!"*

In addition to the unique brand of wrestling films, as any internationally-inclined creature feature maven worth their salt well knows, Mexploitation also encompasses a substantial number of "straight" monster films laid in both contemporary and period settings. One of the true wonders of non-wrestling Mexi-monster cinema, Chano Urueta's *mucho grande fantabuloso* [sic!] **EL BARÓN DEL TERROR** (*"The Baron of Terror"*) will likely sound far more familiar to many a cult movie fan under its now-famous K. Gordon Murray release title, **THE BRAINIAC**.

Murray's several-dozen strong so-called "Spookies" movie package that was sold direct to US television in English-dubbed state during the '60s boasted many of the finest Meximonster titles. However, it is **THE BRAINIAC**—which stands alone in a class all by itself!—that remains one of the strangest and most wonderful acquisitions ever to be Mexported. Among the frequently incestuous Mexi-monster lineage, it stands alone as a totally unique concept; its pedigreed roots completely untainted by the mongrel genes of the main family tree. And in this case, that's a good thing, a very good thing indeed.

Basic plotline about an accused and convicted warlock being burned at the stake and returning centuries later to exact revenge on the ancestors of his condemning inquisitors may well have been assimilated from Mario Bava's **BLACK SUNDAY** (*La maschera del demonio*, Italy, 1960). But there similarities end. Woven into **THE BRAINIAC**'s otherwise stock storyline is a pointy-snouted, throbbing-headed monstrosity—*señor* Brainiac himself—with a penchant for

slurping out assigned vendetta victims' brain matter using his elongated tongue, which is forked like a snake's; its sharp twin tips being the means by which the creepy critter pierces the backs of its victims' necks at the bases of their skulls, in order to suck their pre-softened you-know-whats out through them like drinking straws into its tum.

Okay, okay already, so this one's been covered to death over the years. But I just couldn't resist covering it, seeing as how it's one of the goofiest and/or greatest Mexi-horror flicks of all time and an absolute fave of mine, and seeing as how I haven't put my two cents' worth in about it yet... *[We'd already given Chris Maurer the spot, and he did a much better job of reviewing it than you, but since it is such a humdinger of a movie, we don't mind getting a lesser second opinion about it (even from you!). You should consider yourself lucky, after your in-shockingly-poor-taste **TREPANATOR** review this ish, that we're even allowing you a second chance to redeem yourself, Mongo! Three strikes and you're out! – eds.]*

Repackaged by him under the directorship of voice actor Paul Nagel/"Nagle", this loopy Mexican import was one of a whole bunch that woefully-unsung (M)exploitationeer extraordinaire K. Gordon Murray picked up for English-dubbed US release in the early-'60s. It's a jolly good thing it *was* dubbed too, believe you me! The plot is not what might generally be deemed very "conservative", and doesn't obviously pilfer either too many American or European sources for the bulk of its inspiration. As far as I know, **THE BRAINIAC** is a wholly original creation; though, come to think of it, maybe it might have borrowed a bit of its brain-sucking angle—which is done rather like blowing an egg in reverse—from that ultra-classic gringo cerebrum-slurping super-schlocker **FIEND WITHOUT A FACE** (1958, UK, D: Arthur Crabtree). Come to think of it, remakes of both movies might well be in order, even if the odds of anyone ever topping either seem remote... but there's no harm in trying, right?

In the far-flung past year of 1661 (precisely three centuries before the year of the film's production), warlock Baron Vitelius of Estera (the ever-quirky Abel Salazar [1917-1995]) is condemned to a fiery death via *auto-da-fé* by the all-powerful Mexican Inquisition for practicing heresy and witchcraft (etc., etc., etc. [yep, he sure is one *evil* bastard!]). We get a distinct inkling that Vitelius ("of unknown origin") has by no means been wrongly-accused by the tribunal, and he most certainly is possessed of supernatural powers. We realize this when, just prior to his public roasting, the accused warlock magically sheds his ball-and-chain shackles, transferring them to the ankles of his two guards instead; then, moments later, we find ourselves wondering why he doesn't just make the stake and pyre (etc.) simply disappear too... but presumably he had his reasons. As flames consume his utterly unrepentant earthly corporeal form, a comet passes overhead, and the vile Vitelius vows to return to Earth 30 decades into the "future" (now so very much in the past!) on that

Above: These shots give us—and his comely co-star Ariadna Welter!—a good gander at *señor* Brainiac's obscenely protruberant extendo-tongue, pointy ears and tusk-like eyeteeth...and let's not forget those sucker-tipped (to quote reviewer Chris Maurer) "pervy sausage fingers" of his, too!

Brain Food: Salazar as Baron Vitelius just can't resist snacking between meals! Not that it ever spoils his appetite, mind you, cuz when it comes to brain-eating, he's a bottomless pit whose eyes are never too big for his belly

very same returning comet to exact merciless retribution on his executing inquisitors' direct descendants...

Action plummets ahead to 1961, as the comet makes its reappearance as predicted. A whopping great block of rock plonks down to Earth from the heavens like a lump of what Devo once termed "Space Junk", and from within it emerges a hideous crabby-clawed, lamprey-fingered, fork-tongued beastie with an elongated, pointy schnozz. Yipper, here's where the fun *really* begins! Transforming from this barely humanoid monstrosity into his dapperly handsome old human guise—albeit donning more modern garb so as to better fit in with fashionable early '60s society—Baron Vitelius then sets up castle near to the very same site where all his proposed victims have likewise so conveniently chosen to take up residence, all within a mere hop, skip and jump of each other. (This should be easy!) To kick things off nicely, the baron gleefully slurps the grey matter from a couple of locals (just for practice) with his sharp, eel-like oral organ, which, I reiterate for the forgetful, is forked like that of a snake. Of course, thanks to autopsies performed by the diligent medical examiner (Mauricio Garcés) quoted off the top of this review, this blatant sociopathic behavior shortly alerts even the slow-witted local police force, who soon clue-in to the cause of death (coroner: "The victims' *BRAINS* have been *SUCKED* out!" [Gee, Doc, enough with the technical mumbo-jumbo already! Dumb it down a little for us laymen, will ya!]).

In order to speed up his long-simmering vendetta somewhat, Vitelius throws a big shindig at his place, inviting everybody on his 300-year-old shit-list over for cocktails and polite conversation, tactfully neglecting to mention on the invitations that the main course on the evening's menu is human headcheese: *THEIRS!* In the meantime, he can barely contain his enthusiasm for dining on brain matter, so has to periodically satiate his jones for jellied mind-mush with regular secret spoonfuls from his posh silver storage urn. (Unlike Karl the addle-brained/brain-addicted lab assistant in N.G. Mount's outrageously awesome **TREPANATOR** [1992; see p.217], who at least browns them a tad in a pan over a burner with a pinch of seasoning before chowing down, Salazar prefers his mental matter—never mind rare—but totally *raw*, as-is. Oh, and forget in the refrigerator. He just stores 'em at room temperature, to ensure maximum overripeness!)

Victims fall fast and furious. After being transfixed by the baron's luminous stare (i.e., a spotlight shone on his face from out-of-frame), they are horrified by the throbbing-domed, tongue-lolling horror he reverts to for the crucial brain-suck. He succeeds in ingesting those of most of the cast, until there soon remains only one last pesky descendant left to slurp.

The cops are frantic with worry: what could possibly have happened to poor Ronald (called "Reynaldo" in the original Mex version; played by Rubén Rojo, the older brother of fellow actor Gustavo "**THE VALLEY OF GWANGI**" Rojo) and his fellow astronomically-inclined betrothed Victoria (Rosa María Gallardo)? It soon develops that Vitelius has them over at his place. However, he doesn't want to kill Ronnie, who just happens to be descended from the one and only guy who offered the baron any defense against the Inquisition way back in the 17th Century (a character likewise played by Rojo, in period costume [a ruffle-collared tunic and puffy-kneed pantaloons]). And on top of that, Vitelius is none too sure he wants to kill the virginal (?) Victoria—the final victim on his itinerary—either, for that matter, realizing he's developed a bad case of the hots for her and wants to do more than merely *suck* her brains out (don't you just *love* blatant lowbrow double *entendres*?!). Torn between two conflicting impulses, Vitelius ultimately decides to go the honorable route ("My hate is much stronger than my love, like a master no one can control!"). To this end—old habits are hard to break, after all—he becomes his monstrous self again for one more last-minute brain-drain just to settle up accounts and finally put some conclusive closure on things. (*ATTENTION: SPOILER ALERT!* Skip the last part of this para to avoid learning how the movie ends.) Trust those spoilsports the dopey cops to bust in just as the brainiacal baron's about to chow down on his final course, and they proceed to rub him out with a couple of handy flamethrowers. Poor sucker.

Even boasting more than a few Expressionistic flourishes, **THE BRAINIAC** is one of those irresistibly daft little treats that you can slurp up and savor over and over again *ad infinitum*, and still always derive pleasure from (no guilt about it!). The scenes wherein Salazar's insatiable shape-shifting, skull-sucking nobleman whilst in human form partakes of tasty human brain "snacks" from an ornate bowl using a dainty little long-handled parfait spoon—while wearing elegant formal evening attire, yet!—are alone well worth the price of admission. There was plenty of wry wit at work behind the screenplay, co-written by journeyman fantasy filmmaker Federico Curiel (whose first name hereon was anglicized to "Frederick"), who also played a bit-acting part in the film (his detective character is informally addressed as "Benny" by his superior officer, played by the stocky, shave-pated David Silva [1917-1976], who regularly appeared as masked wrestler Huracán Ramírez's bare-faced/ out-of-the-ring "stand-in" in a series of lower-end Mexi-flexis during the '50s and '60s). In addition, we get Curiel's director-actor colleague, René Cardona, Sr. (here cast as Luis Meneses, descended from Vitelius' hated enemy Baltasar de Meneses).

Complete with suitably bookish spectacles and a dapper beardlet, the late, great Germán "Count Lavud/Duval" Robles (1929-2015) co-stars as renowned historian Prof. Indalecio Pantoja, another victim numbered on the bad Baron's shit-list. Sultry, full-lipped brunette starlet Roxana Bellini appears

Above: Frozen into total immobility by the throbbing/puffy-headed monster's hypnotic stare, Germán Robles can only stand and gape in helpless horror—with some apparent unintentional humor mixed in!—while his luscious onscreen daughter (Roxana Bellini) gets her brains sucked out right before his very eyes…if entirely outside the frame

as Robles' onscreen daughter María, with whom the Brainiac "necks" right before Daddy's horrified eyes while he is unable to lift a finger to save her (this thanks to having been hypnotized into immobility by the monster beforehand). El Brainiac's long roster of victims also includes cuddlesome cutie-pie Ariadna Welter ([1930-1998] previously seen as the heroine of both Robles/Fernando Méndez's *El Vampiro* duo [1957-58], as well as later co-starring in **LAS MUJERES PANTERAS** [1967; to be covered next issue]), who here appears as a coquettish barroom floozy who gets more than she bargained for when she gives the wrong guy the come-on after last call. Oh yes, and let's not forget the appearance by Ofelia Guilmain (as Cardona's onscreen wife, *señora* Meneses), who might quite likely be most familiar to *Monster!* readers with an especial fondness for Mexploitation fare as the supersexy wicked witch-queen in **LITTLE RED RIDING HOOD AND THE MONSTERS** (*Caperucita y Pulgarcito contra los monstrous*, 1960, D: Roberto Rodríguez), for which her character therein was a blatant live-action imitation of the one in Disney's **SNOW WHITE AND THE SEVEN DWARFS** (1937, USA). Herein, although she doesn't get many lines or much to do, during another of numerous memorable scenes to be had, she does get the ol' brain-suck treatment c/o you-know-who (er, *what*) right before her mesmerized-to-the-spot hubby Cardona's disbelieving eyes. But if you think she has it bad, he gets it even worse... (hint: can you say "incinerated by blast furnace", kiddies?).

"Could it be that the whole's thing's a hallucination?" asks Rojo as our hero Ronnie at one point. Which raises the possibility that the whole fanciful concoction might have been dreamed-up by co-scriptwriters Federico Curiel and Adolfo López Portillo while off on a bender after swallowing down a few too many mescaline-saturated tequila worms and peyote buttons, perhaps? Indubitably, **THE BRAINIAC** is truly wacky, wild and wonderful stuff indeed! While the film has no true equivalent in the multi-nuanced Mexploitation spectrum, it somehow ideally personifies the Mexi-monster mythos regardless, and for this writer remains a quintessential example of the form, to be cherished and savored for posterity. It is *the* prototypical example by which all others may be measured, as well as the absolute optimum place to start if you've a mind to cultivate an appetite for either Mexican monster movies...or human brains.

NOTES: The Frank Zappa/Captain Beefheart tune "Debra Kadabra" (off their joint classic *Bongo Fury* elpee, from 1975) alludes to this film in its typically wacked-out Beefheartian freeform/random word association lyrics (e.g., "...turn it to channel 13 and make me watch the rubber tongue when it comes out! ...Make me grow Brainiac fingers, but with more hair!"). In fact, at one Plasticdada II's YouTube channel (@ the link *https://www.youtube.com/watch?v=-3kEjC_Wlp8*), there's even an upload of the song set to manipulated video clips from the movie! In addition to that further bit of immortalization of a pop cultural landmark which had already by then well-immortalized itself, amongst other things, the operative pun-word in this quintessential psychotronic flick's title became still further ensconced in pop culture for posterity by becoming incorporated into the name of both England's The Brainiac 5 (formed in Cornwall in 1976; reformed in 2013) and '90s alt-rock/avant-garde/nuevo wavo act Brainiac, hailing from Dayton, Ohio. Although, in the case of The B5, they were probably only thinking of the DC Comics character called it when they chose their name, we like to think that Brainiac got theirs from here (or at least a bit of both). Incidentally, speaking of classic punny monster names which were reused by recording artists, there was also an obscure late '70s NYC no-wave band calling themselves Manster (one of whose few claims to fame was appearing on the *Live at CBGB's* double elpee in 1976), but that's a different story... ~**SF**

Alex Wald's way-cool cardboard mini-Brainiac standee from Southern Culture On The Skids' *Santo Swings* EP (Estrus Records, 1996)

A SPECIAL BONUS *MONSTER!* COMIC REPRINT

cosmos aventuras
PRESENTA A
My Dinner With EL BARÓN

$3.00

PASION!
VENGANZA!
HORROR!

ADAPTACION:
Alejandro Waldinski

MDWEB Cover: In a severely limited edition of just *35* (!) copies—all photocopied on tan-colored, "legal" size (8½" x 11") paper, then lovingly collated, folded and hand-saddle-stitched by the creator—an advance proof edition of this B&W (or rather "black-and-tan"!) 16-page/single-panel-per-page (15 images in total), digest-sized comic was run off back in August of 1992. At that time, the artist sent out a number of tantalizing "teaser" preview copies of said (and to date, *sole*) edition to help generate interest on the fanzine scene; including sending a review copy—no less than the very same one which was scanned for this belated official *M!* reprint, as it happens—to Yours Truly's long-gone Toronto-based Mexploitation zine, *¡Pánicos!* (which gave it a plug in their [i.e., my] #4 ish). Back then, Alex was hoping to eventually put together a "deluxe" edition—numbering a full 500 total print-run—of *MDWEB* someday, planned to be printed in purple ink on higher-quality paper stock. (We're *still* waiting on it! ☺) The "fine print" on the comic's credits page read: "*My Dinner With El Baron* is adapted from the motion picture, **EL BARÓN DEL TERROR**, Clasa-Mohme Studios, 1961, and believed to be in the public domain. Original screenplay by Adolpho *[sic — ed.]* Lopez Portillo and Frederic *[sic — ed.]* Curiel. Produced by Abel Salazar. Directed by Chano Urueta. Adaptation and illustration by Alejandro Waldinski. [...] No part of this publication may be reproduced without written permission from the publisher. All rights reserved. ©1992 by Edicions Estraña." (© renewed in 2017 by Alex Wald & Astromonster Fine Arts) ~**SF**

***MDWEB* Panel #1:** In the actual film itself, (adding to its at times quite tangibly "Expressionist" feel) any and all exterior shots of the observatory—as with a number of other buildings seen elsewhere throughout the action—are shown only in the form of flat, static photographic backdrops *[as at left]*, with actors briefly seen standing and/or moving in the foreground before them. Glimpsed a number of times throughout the action, the catalytic arcing, slowly-overflying comet *[at left, inset]* is depicted as a blurrily shimmery/twinkly animated optical effect set against a starfield; subsequently reappearing at one point as a "lighted sparkler on a string" (for wont of a better term!) high in the night sky.

DID YOU SEE THIS CARD, RONNY? IT SAYS "BARON VITELLIUS OF ASTAIRA CONSIDERS IT AN HONOR TO INVITE YOU TO THE RECEPTION HE IS GIVING AT HIS NEW RESIDENCE ON FALCON HILL ON MONDAY, THE 21st," AND HE EXPECTS US TO GET THERE AROUND NINE O'CLOCK.

WE'LL BE ABLE TO FORGET THAT COMET FOR TONIGHT AT LEAST.

***MDWEB* Panel #2:** Our hero Reynaldo (Rubén Rojo) and heroine Victoria (Rosa Maria Gallardo), budding stargazers both, inside the observatory presided over by their learned senior astronomer mentor, the aptly-named Prof. Saturnino Millán ([Luis Aragón] who even, as per his namesake [i.e., "Little Saturn"], has a picture of the great ringed planet on his wall!); an interior set which receives quite expansive coverage in the early portion and subsequent portions of the film... although it isn't actually until quite a bit later into the narrative that they are heard uttering the lines (or variations thereof) quoted in Alex's art above (a little thing called "artistic license", don't you know!).

"MISS CONTRERAS, RENALDO, IT'S CERTAINLY A PLEASURE TO SEE YOU AGAIN. AS YOUNG ASTRONOMERS YOU ARE BOTH ABLE AND INTELLIGENT."

MDWEB **Panel #3:** Acting neighborly in his new home, Baron Vitelius d'Estera greets his guests (our protagonists Reynaldo a.k.a. "Ronnie" and Victoria a.k.a. "Vicki") at his flash *castillo* bachelor pad. In the photographic image at left, taken from earlier in the film, having only just recently touched-down inside an aerolite which thuds to Earth with all the grace of a lead balloon filled with cement, Vitelius (Abel Salazar) claims his inaugural victim when he first offs then ingests the mental matter of an incidental male passerby who happens to spot him emerging from within the newly-alighted meteorite, but foolishly doesn't beat a hasty retreat and instead sticks around to spy on the hideous, hirsute and seemingly extraterrestrial monstrosity. Upon "dining" on this man's brains, El Barón then magically assumes the corpse's clothing, thereafter transforming himself into the dapperly sinister gent seen here; in this shot—taken against a surreal 2-D photo-backdrop—seen out for a stroll after dark.

"THANK YOU, BARON, PLEASE--JOIN US."

"REALLY, BARON! THAT'S A SHAME!"

"DON'T THINK I'M RUDE. IT SO HAPPENS LIQUOR DOES ME DAMAGE. I ONCE HAD A VERY STRANGE DISEASE."

"IS THERE ANYTHING THE MATTER, BARON?"

"JUST A PAIN I FEEL OCCASIONALLY. EXCUSE ME, PLEASE..."

MDWEB **Panel #4:** The subtitled proclamation at left—which, as with the other dialogue excerpts quoted hereabouts (both in Alex's adapted comic text and the film's Anglo subtitles) vary according to whether it's the Spanish-language or English-dubbed versions of the film you happen to be watching—is basically the loose equivalent of Béla Lugosi's ominous personal in-joke line from Tod Browning's **DRACULA** (1931, USA [see p.108]), that famously goes: "I never drink...*wine*". While Béla's Drac is a vampiric vintner who would much rather imbibe a whole other kind of *vino* (i.e., of only the literally bloodiest red there is), Salazar's terror-baron instead prefers to slurp-up... uhhh, but at this point, do we *really* need to repeat what his potent potable of choice is?! If so, it must mean that the brain-thirstily brainiacal *el señor* Brainiac has already drained what was left of your mind!

***MDWEB* Panel #5:** *Brain Food?* Feeling uncontrollably peckish and—due to his candidly-mentioned, if tactfully unspecified "strange disease"—unable to suppress his gnawing hunger pangs for the squooshy skull-guts he craves even while right in the midst of a swank, formally-attired soirée he is throwing at his palatial digs in La Loma del Halcón ("Falcon Castle"), Baron Vitelius secretly proceeds to a locked antique cabinet containing his emergency stash of the gooey grey stuff (which he euphemistically describes as "my medication" [!?] in the subs to Casa Negra's Mex DVD version); where—with a combination of roughly equal parts eager appetence and guilt-riddled self-disgust/loathing—he furtively takes the pause that refreshes only a cerebrum-slurping monster such as himself... (Personally, we'd much prefer Smartfood® brand white-cheddar-cheesy popcorn ourselves, or better yet, considering the current Mex context, their zesty Spicy Jalapeño Ranch flavor; but then there's no accounting for taste, we suppose.)

244

> I ADMIRE ALL THE FACETS OF PRE-HISPANIC CULTURE AND THAT'S THE REAL REASON I WANTED TO VISIT YOUR COUNTRY. IT HAS SO MUCH BEAUTY.

My admiration for the prehispanic culture

MDWEB Panel #6: The dinner-do continues at Vitelius' castle, which, much like the Count does with Carfax Abbey in Bram Stoker's *Dracula* and so many movie adaptations thereof, star Salazar as the baronial brain-feeding fiend *[center]* has only just recently purchased for the purposes of pushing his sinister hidden agenda. Those of his guests depicted in this screen-shot *[at Salazar's left]* are *señora* Meneses (Ofelia Guilmain), her hubby Luis (René Cardona, Sr.) and Prof. *don* Indalecio Pantoja (Germán Robles), along with *[at his right]* Prof. Saturnino Millán (Luis Aragón) and the latter's perky astronomy student Victoria (Rosa María Gallardo).

> THIS HISTORY TELLS US ABOUT THE TRIAL, TORMENT, AND RESULTING SENTENCE CARRIED OUT BY THE AUTHORITIES OF THE HOLY INQUISITION AND HELD IN THE CITY OF MEXICO. THIS ALL HAPPENED IN THE YEAR 1661 AGAINST VITELLIUS OF ASTAIRA, WHOSE ORIGIN WAS UNKNOWN AND WAS NEVER DISCOVERED.

> "FOR HERESY AND FOR FURTHERING HERESY, FOR DOGMATIZING AND FOR HAVING USED SORCERY, SUPERSTITION, AND CONJURING FOR EVIL ENDS THAT ALL MEN ARE ATTRACTED TO. FOR MAKING RECOURSE TO MAGIC AND NECROMANCY -- FOR TRYING TO SEE INTO THE FUTURE BY EMPLOYING DEAD BODIES. AND FOR SEDUCING YOUNG MAIDENS THAT COULDN'T -- RESIST."

MDWEB **Panel #7:** In **EL BARÓN DEL TERROR** proper (as opposed to Alex Wald's reimagining / condensation of its essential ingredients here), the vengeful Baron Brainiac *[center, right]* ominously reads aloud his lo-o-ong criminal record from a book of the 17th-Century Mexican Inquisition's transcribed minutes whilst in the presence of his top shit-listers Prof. Pantoja (Robles) and Pantoja's smolderingly super-sultry daughter Maria (Roxana Bellini). In the interests of streamlining the plot of his condensed comic version above, Alex instead replaces this pair with just the heroine Victoria (Gallardo)—Vitelius' lust interest—alone. (*Note:* Not that we've compared it word-for-word or anything, but much [if not all] of Alex's script was quoted verbatim [albeit sometimes in shuffled/rearranged order] from the dubbed dialogue of K. Gordon Murray & Co.'s 1963 American TV import version.)

Was Vitelius Destera an ancester of yours?

THE AUTHORITIES OF THE INQUISITION SENTENCED THE ACCUSED TO DISGRACE. TORMENT WAS CONSIDERED JUSTIFIED. THE NEXT DAY HE WAS DRESSED IN THE CROWN AND THE SHIRT OF FIRE. HE WAS EXPOSED TO PUBLIC RIDICULE AND THEY CONFISCATED HIS WEALTH.

HE REFUSED TO REPENT AND HE WAS BURNED.

I SHALL RETURN TO YOUR WORLD WHEN THAT COMET COMPLETES ITS CYCLE! WHEN THAT HAPPENS I WILL TAKE MY REVENGE UPON YOU! I WILL KILL EACH AND EVERY ONE OF YOUR DESCENDENTS AND I SHALL EXPUNGE YOUR FOUL LINEAGE FROM THIS EARTH!

I will return to your world in 300 years, when this comet passes through our latitude again. Then I will carry out my revenge. I will eliminate all of your descendants, exterminate your damned lineage!

MDWEB **Panel #8:** While the above "curse from the stake" scene happens early into the actual film, Alex Wald instead places it as a flashback which occurs quite a bit further into his own whirlwind-paced narrative. At right, we see The Brainiac 300 years hence, having only just very much returned to Earth, as promised!

> I WAS CONDEMNED AND WAS BURNED ALIVE! I AM VITELLIUS OF ASTAIRA!

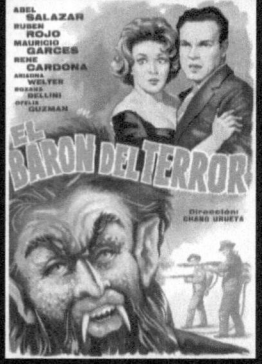

MDWEB Panel #9: In the movie, about the closest the monster comes to striking the above "attack" pose—with its pervy sausage-fingers fully-erect and well to the fore!—occurs during the incidental random killing of a streetwalker (an "outdoor-indoors" scene *[see at left]* which was actually shot against a static photographic backdrop depicting a well-lit street by night); this particular scene doesn't appear in the comic. At right is a Spanish—as in Madre España—poster for the film (art unsigned).

SEÑOR BARON! YOU KNOW THAT'S IMPOSSIBLE!

YOU DON'T TRUST ME? BE COMPLETELY CONFIDENT OF VITELLIUS OF ASTAIRA. THESE JEWELS ARE LOVELY AREN'T THEY? ah, BUT YOU-- NONE CAN COMPARE TO YOUR TENDER GAZE. IT'S TOO BAD YOU CAN'T BE MINE ALONE. I LONG TO LOVE YOU AND ADORE YOU ABOVE ALL -- I SWEAR IT!

MDWEB **Panel #10:** During its final stages, **THE BRAINIAC**'s scenario gets messy in a whole different way than previously; this when the lustfully long-lonesome bachelor Baron makes his move on wholesome heroine Victoria. Ironically enough, after promising to present her with a special gift in advance of her upcoming wedding to her hunksome hero Reynaldo, the shape-shifting aristocrat abruptly goes all "brainiacal" on her ass while offering her both the Estera clan's literal family jewels as well as his own much more figurative ones…or is it the other way round?! His scandalous attempt to pledge some troth of his own with Vicki behind her dearly beloved/betrothed's back—right in the very next room, in fact, the creep!—precipitates the lightning-fast closing concatenation in classically brutish "Me monster! You woman!" fashion.

BUT THERE'S NO WAY NOW. MY HATE IS MUCH STRONGER THAN MY LOVE-- LIKE A MASTER NO ONE CAN CONTROL! WHY DID DESTINY ELECT YOU-- WHY, I WANT TO KNOW! VICTORIA CONTRERAS, THE DESCENDANT OF THAT ACCURSED INQUISITOR! THREE HUNDRED YEARS AGO THAT MAN ORDERED ME BURNED. BUT AT LAST I'VE RETURNED TO MY LOVE TO HAVE MY REVENGE ON EARTH! ¡GGRRRAAA!

¡AAAYYY! RENALDO!

MDWEB Panel #11: Unable to contain his understandably entirely-unreciprocated love/lust for her —I mean, can you blame her? Just *look* at him, FFS!—Baron Vitelius makes a desperate grab for Victoria, his 'orrible oral organ all excited for a taste of not just her mental one. While this particular "still" has no real direct equivalent in the movie, the funky artist's impression above nonetheless well captures the flavor of multiple similar previously-seen attack scenes therein *[examples at both left and right]*.

> GET AWAY FROM HER! I MUST CARRY OUT MY **REVENGE**! RONNY, YOUR ANCESTOR DEFENDED ME 300 YEARS AGO -- DON'T MAKE ME FORGET IT!

> **NOTHING CAN STOP ME!**

***MDWEB* Panel #12:** No sooner has Baron Brainiac, in a moment of unbridled passion, sought to "consummate" his nonexistent relationship with the vivacious Vicki without even so much as a single marriage vow being exchanged beforehand than the whole shaky shebang and kit'n'caboodle go pear-shaped in the time it takes for a shrieking chick to skedaddle from one room to the next straight into the arms of her one true love (at left we see the C/U reaction shot of her when she first sees El B for what he actually is). Now that the cat's well-and-truly out of the bag and there's no stuffing it back in, Vitelius has nothing more to hide as he readies himself for one last gloriously gluttonous gory orgy of brain-gorging to round out his vendetta but good. Cue fiery climactic confrontation here...

Loved — By a CreaTure of EviL!

***MDWEB* Panel #13:** (*ATTENTION: SPOILER ALERT!*) In the last act, when the intrepid coppers played by David Silva [*right*] and "Pichirilo" Curiel [*left*] arrive with their handy-dandy brainiac-blasting flamethrowers all fired-up and ready to go, the *guano* really hits the fan big-time for—¡*EL FINITO GRANDE*! (...*Adiós, el barón.*)

BARON VITELLIUS

BRAIN-EATER! FROM THE AEROLITE!

300 YEARS AGO I WAS BURNED AT THE STAKE BY THE HOLY INQUISITION!

NOW I'VE RETURNED TO HAVE MY REVENGE ON EARTH!

¡300 AÑOS ATRAS FUI QUEMADO POR LA SANTA INQUISION!

¡AHORA YO AGRESADO PARA MI REVANCHA EN ESTE MUNDO!

GLUE PAGE TO CARDBOARD AND CUT OUT PIECES.

FASTEN ARMS AND LEGS WITH METAL BRACKETS.

CUT SLIT IN MOUTH AND SLIDE TONGUE THROUGH. JOIN TAB TO BACK WITH GLUE. LEAVE A SMALL LOOP TO MAKE TONGUE MOVABLE.

PEGE ESTA PAGINA EN EL CARTON Y CORTA LOS PEDASOS.

AJUSTE LOS BRAZOS Y LAS PIERNAS CON LOS BRACKETS DE METAL.

CORTA LA PIEZA DE LA BOCA Y PONGA LA LENGUA ADENTRO. PEGE EL CARTON DE LA LENGUA Y DEJE UN ESPACIO PEQUENO PARA QUE SE PUEDA MOVER LA LENGUA.

Loved — By a Creature of Evil!

MDWEB Back Cover: Rounding out this super-neatola comic treat in fine style, Alejandro Waldinski (hmmm, wonder who *he* might be...? *[wink]*) generously provides us with a cut-outable paper dolly of the big bad baron, complete with XL extendable mental probe-*cum*-mind matter-lapper! At left—real itty-bitty like—is *Monster!*'s very own pre-assembled version, which we put together in Photoshop then converted to negative image just to make it look all the freakier still, as well as simultaneously make the shoddy job we did of it that much harder to see. Yes indeed, better you print out your own copy of the original and make one up for yourselves! ☺ **Right:** ...And speaking of Hispanic brainiacs, say *"¡Hola!"* to him/it known as *Bicefalo Verde* / "Green Dual-Brain *[sic?]*" (stamp #16 in the *Monstruos Diabolicos* series, put out by the Cromos company of Spain)

16 BICEFALO VERDE

Top Left: *M!*'s very own pre-assembled paper Brainiac doll, which we put together in Photoshop for the occasion! **Above & Left:** Exclusive to this ish are these preliminary conceptual sketches by Alex Wald for his *MDWEB* comic (dating from *circa* 1991-92). The one above shows his impression of Abel Salazar as Baron Vitellius (renamed "Vitellius" in the comic), while the one at left depicts the monster getting far fresher with a female victim—note positioning of those pervy sucker-fingers and tongue of his!—than he ever does in either the original movie or the finished digest comics adaptation of same

Above: A pointy profile sketch (etc.) on lined notepaper of you-know-who/what (dated November 13th, 1991); the artist's notation at the bottom left of the drawing reads: "Drawn in Sung's van with his lousy pen" (note ink bleed-through from back of page, showing some sort of brain-creature!). **Right:** More quickie thumbnail renderings of the Brainiac's monstrous mug (dated October 29th, 1991). **Top Right:** Simply because there's no such thing as too many gratuitous Brainiac shots, here's another one of the "real" deal, just for the sake of comparison!

Another master cartoonist—the great Daniel "*Eightball*"/"*Ghost World*" Clowes—gave *señor* El Brainiac a brief on-TV cameo in Fantagraphics' 1986 premiere issue of his still-much-beloved cult fave *Lloyd Llewellyn* comic. This classic B&W title was deeply-steeped in various psychotronic cinema and other pop cultural references / homages / in-jokes. It also included oodles of other brain-melting bizarrity (our word!) besides over the course of its run, including other monsters, mutants, aliens, robots, etc. (see more @ *danielclowes.com*)

...And so, after a Mex brain-sucking monster *nonpareil*, we now proceed to some Brit ones that much prefer to "suck on bones"; meaning quite literally rather than *(ahem)* just figuratively *(wink)*... **Comin' At Ya!** Waving its freaky feeler ahead of it into the foreground to find its way, one of **ISLAND OF TERROR**'s slimy Silicates slithers towards the camera, creating an almost "3-D" effect

ISLAND OF TERROR

(a.k.a. **NIGHT OF THE SILICATES**)

Reviewed by Andy Ross

UK, 1966. D: Terence Fisher

Trailer narration: *"A remote island destined for total destruction... Out of an experiment on life came a devastating death! ...Science creates. Can science destroy? ...Fiction or fact? This could really happen! ...Can this horror be destroyed? ...Can these terrified people be saved from certain death? ...Fire, bullets, bombs could not penetrate its impregnable shell! But something did—what?! See **ISLAND OF TERROR** at this theatre soon!"*

By the mid-'60s, the name of Terence Fisher had become synonymous with the horror genre. He had, after all, been the driving force behind both **THE CURSE OF FRANKENSTEIN** (1957) and **DRACULA** (a.k.a. **HORROR OF DRACULA**, 1958, both UK) and, as such, was to make household names of Peter Cushing and Christopher Lee. Beginning his film career as an editor on such British films as **JACK OF ALL TRADES** (1936, D: Robert Stevenson) and **THE WICKED LADY** (1945, D: Leslie Arliss), Fisher's attachment to Hammer was to see him helm no less than *sixteen* of the studio's most-celebrated horror productions.

Equally at home directing costume dramas as he was contemporary thrillers, with **ISLAND OF TERROR**, Fisher (who had overseen two science fiction efforts [**FOUR SIDED TRIANGLE** and **SPACEWAYS**] for Hammer in 1953), was to pay a return visit to the realms of SF.

The Teutonic Roots Of *Hentai* **Tentacle-Porn?!** 1970s German A1 poster for **ISLAND OF TERROR** (art by K. Dill)

On the remote Petrie's Island, a group of scientists led by the reclusive Dr. Phillips (Peter Forbes-Robertson) are working on a cure for cancer. In the midst of their experiments, the team unwittingly manufacture a silicon-based organism that feeds exclusively on calcium; a potentially catastrophic occurrence which, due to the fact that the human skeleton largely consists of that aforementioned element which the lab-created creatures sustain themselves on, does *not* bode at all well for the island's unsuspecting inhabitants…

Following the death of esteemed local Ian Bellows (Liam Gaffney)—who is discovered inexplicably reduced to a mushy boneless husk by good-natured local bobby Constable John Harris (Sam Kydd, from **THE PROJECTED MAN** [1966, UK, Ds: Ian Curteis, John Croydon; see *Monster!* #28/29 [p.12])—the not-unduly-concerned Dr. Landers (Eddie Byrne, from **DEVILS OF DARKNESS** [1965, UK, D: Lance Comfort]) dutifully heads for the mainland in the island's sole seaworthy launch to seek the expert assistance of top-ranked pathologist Brian Stanley (Peter Cushing). At a loss for an explanation himself, Stanley suggests they pay a visit to a leading bone specialist, Dr. David West (Edward Judd, from **INVASION** [1966, UK, D: Alan Bridges]).

His cozy "night in" with moneyed debutante Toni Merrill (Carole Gray, from **CURSE OF THE FLY** [1966, UK, D: Don Sharp]) thus disrupted, the initially disbelieving and dismissive West resigns himself to assist the other academics in their ongoing investigations into the mounting mystery. Proposing to expedite their return on the firm condition that she is allowed to accompany them, the glamorous, want-for-nothing Toni secures the short-term use of her father's personal seagoing helicopter to shuttle them to the island. Due to prior scheduling obligations unable to procure the transport beyond a one-way trip (and with the one-and-only local launch being no longer at their disposal), the entire island and all its inhabitants are left cut-off from the mainland. After performing an autopsy on the deflated corpse of Bellows and none the wiser as to the cause of his death, the brain trust of Drs. Landers, Stanley and West head for the secluded mansion of a certain Dr. Phillips. Forcing entry into the place, the trio soon discovers the "absent" scientist's own emaciated deboned corpse and, upon further investigation down in the basement laboratory, also the ravaged remains of his ill-fated work force. Upon liberating Phillips' records in an attempt to uncover the truth, the three men set up a temporary HQ in the local B&B ("bed and breakfast").

Translated tagline: *"Nothing Can Stop These Bone-Devouring Monsters!"* Mexican lobby card for **ISLAND OF TERROR** (art unsigned); in the inset still are co-leads Carole Gray and Edward Judd

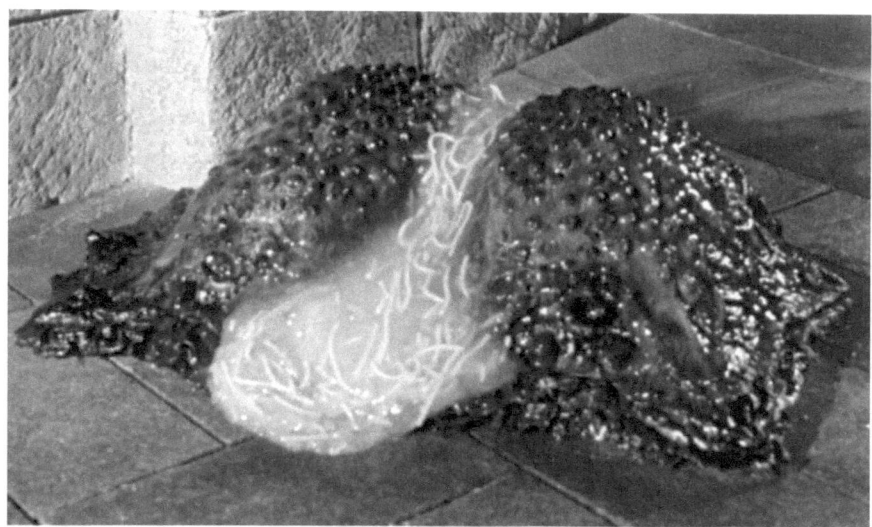

Eeee-Oooo! Via binary fission, a self-reproducing Silicate does the splits in **ISLAND OF TERROR**, releasing a seminal fluid-like secretion of what resembles a mixture of semolina/congee paste and spaghetti. (*YUM!*)

When a subsequent visit to the mansion reveals the means by which the so-called "Silicates" not only feed but also how they reproduce, Stanley and West rally the villagers to mount a concerted counter-attack. Proving impervious to the effects of bullets, petrol bombs and even dynamite, and possessing the ability to double their numbers every six hours via the asexual reproductive process of binary fission (i.e., dividing their bodies into halves, *à la* amoeboid organisms), the silicates pose an immediate and increasingly deadly threat. Holed-up in the island's town hall with rations enough to last for a week, as the islanders prepare themselves for the inevitable onslaught, while time steadily runs out, Stanley and West strive tirelessly to protect them by coming up with a solution...

Having established himself as a reliable leading man for Fisher, in **ISLAND OF TERROR**, Peter Cushing was to take something of a backseat to the pivotal hero, as played by Edward Judd. To all intents the older and wiser of the film's protagonists, thanks to Edward Mann's and Al Ramsen's snappy script, the Hammer stalwart gets to deliver some of the film's better one-liners. Steadfast and self-sacrificing, the role of Dr. Brian Stanley proves to be one of Cushing's more warmly human, credible performances. Here we get to see Cushing not only as the "have-a-go" heroic type, but also as the caring senior spokesperson and, as such, he's an absolute joy to behold. That the celebrated actor was to play second-fiddle to Judd's square-jawed macho alpha male speaks volumes as to the latter's integrity. Whilst Judd, whose résumé already included such notable entries as **THE DAY THE EARTH CAUGHT FIRE** (1961, UK, D: Val Guest) and **FIRST MEN IN THE MOON** (1964, UK, D: Nathan Hertz Juran), was no stranger to the science fiction genre, in **ISLAND OF TERROR** he brings a genuine depth to his reluctant if stoically stalwart hero. Alas, in Carole Gray's character, we're still floundering in the realms of the vulnerable scream queen/damsel-in-distress here. Something of a disappointment, considering she first enters the fray as a charming and self-assured individual, in the (then-standard) capacity of defenseless female, the actress is criminally underused.

In **ISLAND OF TERROR**, something much worse than this is about to happen to Peter Cushing

Terror Tentacle: Carole Gray gets sniffed by a Silicate's probing appendage

Embracing fundamental elements from both the science-fiction and horror genres, **ISLAND OF TERROR** takes the best of both worlds and merges them into a particularly effective end result. Though the silicate antagonists—appearing not unlike a Patrick Troughton-era *Doctor Who* "nasty"-of-the-week—might lack the fearsome appearance of, say, Ridley Scott's xenomorphs from the *Alien* franchise, there can be no mistaking or underestimating the extent of their predatory prowess…not unless you want to wind up with one of their lamprey-like sucker tentacles sucking your entire skeleton out! Encased in an impenetrable outer shell, and with an ever-curious probing proboscis eager to seek out its next unsuspecting victim, the Silicate is indeed a force of nature-gone-awry to be reckoned with. Despite the fact that they are so painfully slow-moving, the fact that these relentless crawlers are gravitating (in their own good time!) towards their chosen (human [and/or bovine]) food source is an aspect of this film that remains inherently creepy.

It would be somewhat amiss to call your production "**ISLAND OF TERROR**" and then not have something concrete to back it up with, and, on account of its well-paced shocks and overall sense of ever-impending menace, the film acquits itself quite admirably. There's always the uncomfortable feeling (because of their low profile) that you never quite know when the silicates are going to pop up next. After shrewdly abandoning the unearthly sound that preempts their appearances in the early stage of the production, by the third act, Fisher has opted for a far more cunning and stealthy approach from his predators. With the silicates multiplying at an alarming rate and the villagers hastily evacuating to the town hall and barricading themselves inside, **ISLAND OF TERROR** very swiftly moves into siege mode. With its flimsy wooden doors, glass skylights, and faltering generator, the hall proves a decidedly poor "safe" haven, to say the least. Huddled together in the candlelit coldness, their eyes peer-

This is how you'd look if all your bones had been sucked out of your body, just so you know

ing into the gloom for the first sign of movement, it should come as little surprise that panic soon ensues among the understandably easily-spooked locals. Retreating towards the hall's infirmary, their backs literally to the wall, as the silicates smash their way through hurriedly-erected barricades, the final assault on the town's residents still remains edge-of-your-seat stuff even after five decades.

No bones about it (pun wholly intended!), **ISLAND OF TERROR** is a marvelous science-fiction shocker. Incredibly well-scripted and abundant with witty, observant dialogue, that the film hasn't achieved wider note is something of a mystery. One of two features that Fisher would helm for Planet Productions (the other being the in-many-ways-alike sci-fi potboiler **NIGHT OF THE BIG HEAT** [a.k.a. **ISLAND OF THE BURNING DAMNED**, 1967, UK, D: Terence Fisher; see *M!* #8, p.32]), whilst the origins of the two films' antagonists (the first man-made; the second, extraterrestrial) were quite literally worlds apart, the setting—an isolated outcrop under siege from an unknown entity—was markedly similar.

Bearing a further structural resemblance to the enduringly popular **THE DAY OF THE TRIFFIDS** (1962, UK, Ds: Steve Sekely, Freddie Francis), **ISLAND OF TERROR** is very much a Cold War shocker, through and through. Belonging to a subgenre wherein science furnishes both the cause and the cure, besides tipping its hat to such genre classics as **THE QUATERMASS XPERIMENT** (a.k.a. **THE CREEPING UNKNOWN**, 1955, UK, D: Val Guest) and **X THE UNKNOWN** (1956, UK, Ds: Leslie Norman, Joseph Losey), **ISLAND OF TERROR** proffers an early example of what we refer to nowadays as "survival horror". Cut-off from the mainland and besieged by an ever-growing army of mutant predators, the comparatively "backward" islanders' only hope lies in the expertise of a handful of newly-arrived, "highbrowed" strangers. But what happens when these (clearly) better-educated outsiders find themselves at a loss to find a solution? Do you remain in the relative safety of numbers, or does your desire for preservation compel you to flee…?

Drivin' To The Drive-In! What better way to see this classic Brit-horror double feature than from the back seat of a vintage hardtop 'Stang, while "cuddling" (*wink!*) with your honey!

LAKE OF DRACULA

(呪いの館 血を吸う眼 / *Noroi no yakata – Chi o sū me*, a.k.a. **THE BLOODTHIRSTY EYES**)

Reviewed by Eric Messina

Japan, 1971. D: Michio Yamamoto

This is actually the second feature in the so-called "Bloodthirsty Trilogy" that commenced with **THE VAMPIRE DOLL** (幽霊屋敷の恐怖 血を吸う人形 / *Yūreiyashiki no kyōfu Chi o suu ningyō*, a.k.a. **BLOODSUCKING DOLL**, 1970, Japan) and concluded with **EVIL OF DRACULA** (血を吸う薔薇 / *Chi o suu bara*, a.k.a. **THE BLOODTHIRSTY ROSES**, 1975, Japan).

I've been waiting to see this Asian bloodsucker flick for a while; I just never got around to it until recently. Ever since I saw it featured in Pete Tombs' excellent, pioneering book *Mondo Macabro* (Titan Books/St. Martin's Griffin, 1998), I've wanted to check it out. As I'm sure most *Monster!* readers know, that book title is also the name of *the* most important DVD company when it comes to hard-to-find Indonesian (plus some Indian) and Eurotrash weirdness that we all obsessively crave.

The present toothy Toho terror tale starts off with a little girl on a beach who wanders off looking for her mischievous dog Leo after he scuttles away. Little does she know that the pesky critter is luring her into a trap as sure as a fly stuck in a treacherous spider web. In the "cryptic" mansion,

Slurp!

Italian *due-fogli manifesto* for **LAKE OF DRACULA** (art unsigned)

the *Dark Shadows* TV series (1966-71, USA), and who is followed by some pale, gaunt, sexy chick. Shin Kishida plays the Barnabus Collins-style figure here. He's been in a few of the most-graphic and -beloved samurai series, including *Lone Wolf and Cub* (子連れ狼 / *Kozure Ōkami*, 1972-74, Japan), *Zatoichi* (座頭市 / *Zatōichi*, 1964-73, Japan), as well as **LADY SNOWBLOOD 2: LOVE SONG OF VENGEANCE** (修羅雪姫 怨み恋歌 / *Shurayuki-hime: Urami koiuta*, 1974), the sequel to **LADY SNOWBLOOD** (修羅雪姫 / *Shurayukihime*, 1973, both Japan, D: Toshiya Fujita).

This Toho-produced film bangs you over the head with its vibrant over-stylized shots, and the forced perspective makes for a nice touch. The cinematography by Rokuro Nishigaki is top-notch, but the actual contents are pretty tepid for a Japanese film, and it relies rather too heavily on European folklore. It takes a while to get going, but does at least have a rewarding ending. We follow the trajectory of Leo the dog and what became of his traumatized owner Akiko (now played as a young adult by Midori Fujita). She's channeled that traumatic childhood encounter during the opener into her weird, surrealist/Daliesque "giant eyeball"-type paintings. In textbook vampire movie fashion, a coffin is delivered to the wrong place, and its owner (who has eerily translucent skin and bright yellow eyes), there's these three undead creeps, including a warbly-eyed bearded one (whom we later find out is a sympathetic character who attempts to protect said child). Next comes the main spook, who has the look and demeanor of the famous patriarch of

A classic Gothic trope—that of the swooning nightgowned lovely cradled in the lonely monster's arms—is reenacted, Eastern-style! Shin Kishida as the vampire and Midori Fujita as the damsel-in-distress of **LAKE OF DRACULA**.

shows up to kill whomever accidentally received the delivery—Jeez, talk about wrong place, wrong time! All of Akiko's irritating friends try to psychoanalyze her, but—shit—that must get real *old* real quick!

The Dracula figure's appearance seems partially based on Christopher Lee as well as Jonathan Frid, and they give him an eerie slash of light over his face. To further belabor the point that he's a bestial gore-gobbler (as if we didn't know!), he kind of mugs at the camera while drooling a mouthful of blood. Talk about a sloppy eater! Where's the Japanese garlic when you need it?! Soon, a rash of victims with—you guessed it!—neck-hole punctures begin appearing along the shores of Lake Fujimi (which you can rightly assume is where the movie's title comes from). Sadly, however, there's no scene in which Dracula hits the water to do the "Monster Swim" (title of yet another novelty pop gasser by Bobby "Boris" Pickett, of "Monster Mash" fame).

Moving right along, the main female character's poor mutt Leo winds up getting torn to shreds by some infected dude he attacked while guarding her house shortly after the film started. Fake or not, that bit of animal cruelty was uncalled-for; I mean, the head vampire could just as easily have simply bitten the dog instead and turned him into an immortal unholy canine servant like **ZOLTAN – HOUND OF DRACULA** (a.k.a. **DRACULA'S DOG**, 1977, USA, D: Albert Band). They pad the storyline with a lot of "relationship" scenes that chew up the run-time along with the scenery, and it's mildly annoying that they don't focus on how or where (etc.) these bloodthirsty monsters seen in the beginning came to exist, or why they've decided to follow this poor girl into her adulthood—I guess she's just really *unlucky*!

Now, if this were an '80s vampire movie from Hong Kong's Golden Harvest company, we'd be wading waist-deep in maggots and crimson rivers of erupting jugulars. But it's from Japan, and the early '70s, so some degree of restraint is unavoidable. Even though it's rather-too-reserved—especially for a Japanese horror film—it's well-made, classy and interesting enough. My main complaint would be that it's so *slooowly*-paced for such a relatively short film, and the ending is directly lifted from Hammer's **DRACULA** (a.k.a. **HORROR OF DRACULA**, 1958, UK, D: Terence Fisher). Incidentally, I remember as a kid walking in on that film's wild finale during a TV airing and seeing Christopher Lee crumble first into withered flesh then to dust, and my mom

1970s (?) reissue Japanese B2 poster for a J-horror triple-bill that included **LAKE OF DRACULA**, along with Nobuo Nakagawa's *kaidan* **THE GHOST OF YOTSUYA** (東海道四谷怪談 / *Tōkaidō Yotsuya kaidan*, 1959) as one of its co-features. We haven't been able to determine what the third film's title is, but according to the highly knowledgeable site Pulp International (@ *www.pulpinternational.com*), it has something to do with a swamp…and possibly also hell, too

yelling *"Turn around! Don't look!"* (Of *course* I watched the whole scene!)

Returning to **LAKE OF DRACULA**… Akiko ponders and pontificates on Western religion, and fears the devil might be coming for her. Later on she's cornered by the undead, and they compliment her freaky eyeball painting; maybe they're actually nice, and just eccentric art critics—it's entirely possible! Her sister Natsuko is played by Sanae Emi (1951-1988). According to Japanese Wiki, Sanae was murdered at the age of just 36 by her ex-husband Akihiko Yashiro. Emi was also a pop music songwriter, whose pen-name was Tsuzuru Nakazato. Yashiro was a recording director for the Philips Records label. He'd been stalking her after they broke up. Yashiro stabbed and killed her with a kitchen knife (my thanks to Hiroshi Hasegawa for that information). Herein, her character becomes infected by the usual Drac-hickey, and she requests that they burn her body (in this case, it's

a good idea to plan-out your cremation on such short notice!). Akiko's boyfriend turns into a crash-course "Van Helsing" wannabe and rattles-off tidbits about cannibals and vampires possibly being one in the same; the only difference is that Dracula's victims become his slaves for all eternity.

As previously stated, the pacing of this movie is surprisingly tedious. That's its biggest flaw. I would never equate it with the dream-like pace of a Jean Rollin film, even though people have been known to conk-out for a nap while sitting through his ponderous gothic gals'n'gore fests (I don't want to hang out with such people anytime soon, but what do I know: I do so love me some slinky French vamps!).

I must say that I was somewhat disappointed that **LOD** is largely so uneventful, but for ravenous vampire fans it surely beats bullshit like the much-too-obvious *Twilight* film franchise and *True Blood* teleseries (both 2008, USA).

In closing, on a note of trivia relevant to the present film under review, there's a noise-punk band from Chicago called Lake of Dracula, who are pretty cool.

BLOOD OF THE VIRGINS
(*Sangre de vírgenes*)

Reviewed by Martín Núñez

Argentina, 1967. D: Emilio Vieyra

The same country of such great filmmakers as Carlos Hugo Christensen, Leopoldo Torre Nilsson and Armando Bo is also the homeland of another director who, happily, has likewise achieved some much-deserved worldwide ("cult") recognition: Emilio Vieyra (1920-2010).

Argentina, the same country of Carlos Gardel, Diego Maradona, Ernesto Guevara, Federico Moura, Isabel Sarli, Astor Piazzolla and many other relevant figures in world culture, deserved its own Vampire, and experienced exploitation filmmaker Vieyra was more than willing to provide one...

Being a detective movie aficionado, Vieyra started out as a stage actor in his youth with (*film noir*) cinema always on his mind; as a consequence, before getting behind the camera, he even happened to perform bit parts in two Argentinean movies: **AYER FUE PRIMAVERA** (*"It Was Spring-Time"*, 1954, D: Fernando Ayala) and **EL ÁNGEL DE ESPAÑA** (*"The Angel from Spain"*, 1957, D: Enrique Carreras). After these movies, he moved to the United States to study TV direction at Columbia University, during which time he also opened/operated a store on the side. This small business was his vehicle to raise money in order to start his own production company once he got back home to Argentina.

His first directing job came by pure luck. He was producing an anti-communist movie, but he had to jump into the director's chair himself, because no one else wanted to take the risk of signing-on for such a controversial movie, since almost every artist has Left Wing tendencies. *[Not that being Left-leaning or even an all-out Leftist necessarily means being a supporter of such an—as has been historically-proven again and again—intolerant, inhumane, murderous and generally oppressively authoritarian/totalitarian ideology as Communism, by any means. Pardon the intrusión!* ☺ – *SF.]* An obscure *policier*, Vieyra's directorial debut was musicalized by none other than the aforementioned Astor Piazzolla, the father and master of modern tango music. Starring locally-born blonde bombshell Libertad Leblanc (Isabel Sarli's chief professional rival), the film was entitled **TESTIGO PARA UN CRIMEN** (*"Witness To a Crime"*, 1961), which received a US release in '63 under the much more sensationalistic/sexploitative title **VIOLATED LOVE** (tagline: *"A story of vengeance in the flesh!"*); this led Vieyra to learn how important a thing it was for his films to get distribution in the States. In this way, after directing a couple of "straight" flicks, the director made his very own first exploitation movie, which was shot in English and set in a small town in the United States (although the movie was actually

Idiot Box: A weird TV signal mesmerizes viewers in Vieyra's **STAY TUNED FOR TERROR**

shot in Barrio Palomar, Buenos Aires). Titled **EXTRAÑA INVASIÓN** (*"Strange Invasion"*, 1965) in Argentina and elsewhere in Latin America, it was released in the States as **STAY TUNED FOR TERROR**. The movie was also backed by a North American TV producer to release it nationwide, contrary to Vieyra's previous efforts which had mostly attracted Hispanic audiences alone. How well (or not) the movie went over in the USA is a mystery even to Vieyra himself, who claimed that after finishing it he never learned anything about its fate outside Argentina, the country for which he held the rights...however, the movie wasn't actually released in its country of origin until the mid-'Seventies, a decade after it was made!

The plot was quite fresh for its time. In said small US town, people are becoming addicted to a strange TV signal that beams in nothing but weird hypnotic images on the tube, and—like they are all part of some cult—everyone exposed to this signal stares blankly at the screen for hours, just like zombies (remember Emilio Estevez's relatives in **REPO MAN**?!). Made on a really tight budget, his "sort of" forerunner / prototype / anticipator of **"VIDEODROME"** *[one can't help but wonder if Cronenberg might ever have been exposed to it c/o its Anglo export version? – SF.]* was starred-in by none other than Italo-American *noir* (etc.) icon Richard Conte, evidently in hopes of generating a more "international" flavor and probably to better improve its chances of securing distribution outside the Argentine market. Possessing a number of interesting elements, this "US-wannabe" sci-fi movie works just as fine as its northern counterparts.

Vieyra's next movie was the amazing **PLACER SANGRIENTO** (*"Bloody Pleasure"*, 1967), known in the States as **FEAST OF FLESH** (a.k.a. **THE DEADLY ORGAN**), a sort of police thriller about a monster-masked killer on the loose in a coastal town, who attracts carefree young ladies to him with a particular piece of music in order to transform them into his (sex-) slaves! Its crazy plot works really well, and I think this movie might well appeal to your *Monster!* tastes, dear reader.

And so, following the preceding frenetic work, we come to the movie that has me writing these humble lines: **SANGRE DE VÍRGENES**—the first South American vampire movie ever made! For sure, Mexi-monster movies like **THE VAMPIRE** (*El vampiro*, 1957) or **THE VAMPIRE'S COFFIN** (*El ataúd del vampiro*, 1958) *[both directed by another Hispanic noir enthusiast/ exponent, Fernando Méndez – SF.]* were "Sharp-

Argentine poster for Vieyra's sci-fi drama **STAY TUNED FOR TERROR** (art unsigned)

Fangs" Latin cinema efforts which predated it, but the Mexican industry was way ahead of South America's. Considering how Argentina was one of the region's biggest producers, their industry was not all that large, yet had somehow managed

Emilio Vieyra checks the viewfinder on the set of one of his 1960s movies

to produce genre fare almost since the inception of Cinema itself.

Horror movies like **EL EXTRAÑO CASO DEL HOMBRE Y LA BESTIA** (*"The Strange Case of the Man and the Beast"*, 1951, Mario Soffici), yet another adaptation of R.L. Stevenson's oft-filmed "Jekyll & Hyde" tale, or **OBRAS MAESTRAS DEL TERROR** (*"Masterpieces of Terror"*, 1960, Enrique Carreras), an anthology of three Poe stories co-written by and starring Narciso Ibáñez Menta, paved the way that attracted moviegoers to theaters, avid for local fright flicks. In this context, producer Orestes Trucco approached Vieyra with the proposal of producing a vampire flick, a wild and crazy idea for the day. But, being a daredevil, Vieyra took the risk.

The script is nothing new, for sure. After a wild psychedelic party (with a fair amount of dancing naked ladies) a bunch of "beatniks", their car out of gas, get stuck in the middle of nowhere; this while driving to their hotel through a popular touristy zone in Bariloche, a sort of Argentinean "Alpine" region in the southern part of the country. Seeking shelter for the night, the stranded motorists proceed on foot to a big old abandoned house—previously seen during the brief (and gory!) intro—in which a troubled girl named Ofelia (the voluptuous Susana Beltrán) is torn between the love of two guys: a nice guy loved by her family and a sinister character who represents the dark occult forces. After she makes her choice, all hell breaks loose... But first we have to watch the ultra-cool animated main titles. After this animation, we get into some classic "something-weird-is-happening" atmosphere. In the house, Beltrán as the now-vampirized Ofelia seduces Raúl (leading man Rolo Puente) and, following an erotically-charged sequence (quite daring for its time) of them making love, we begin to realize that the party girls have gone missing. It's at this point that the police storyline begins; an element present in virtually every Vieyra movie, due to his love for these sorts of stories. *Comisario* Martínez (played by Vieyra himself) starts a kind of shitty investigation when one of the girls finally shows up in the house, but she's acting weird and seems to be in shock. In a state of terror, she is only able to spell-out the word "blood" (i.e., *sangre*) right before fainting. She's been left weakened and deathly afraid, and despite having twin telltale fang-marks on her neck, no one but Puente's Raúl character actually believes she might have been attacked by a vampire. Which is why he calls in his brother-in-law to start a parallel investigation, and everything flows along as a

Cover and contents page to the 2013 premiere issue of one of Martín Núñez's *amigo* Dario Lavia's pair of *en español* Argentine zines; the other one is called *Cineficción*. For ordering info about *Cinefania Macabra*, visit their retail page online (@ *www.cinefania.com/macabra/*)

This still provided for *M!* by Dario Lavia formerly graced the cover of his zine *Cinefania Macabra*

good vampire movie should (albeit one with a strong "camp" element and some very illogical plot devices, for sure). By the middle of the movie, we almost have every exploitation movie angle covered, and this is great!

For instance, Gore (*Check!*): Right in the first five minutes, we get a blood-soaked sequence, and if we stick it out till the movie's ending, we get to see even more gallons of cool-colored fake blood in a sequence that has to be seen to be fully appreciated. All of the three main gore sequences have geysers of spurting blood, Japanese-style. For a South American movie, these splatter sequences are quite edgy, and possibly help in explaining what an easy sell this movie was abroad (and why it wasn't released in Argentina until many years later due to domestic censorial restrictions); well, that part and the next key element too…

Naked Ladies (*Check!!*): As well as the blood, we have to wait less than ten minutes to start seeing plenty of boobs, first in the abovementioned party in which the protagonists' personalities are established: the "joker"/smartass (played by

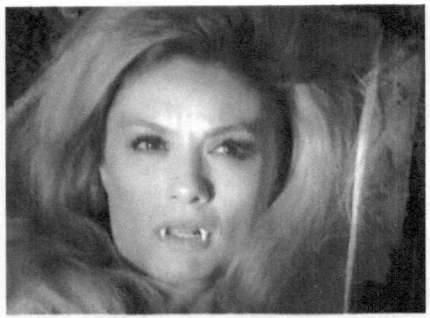

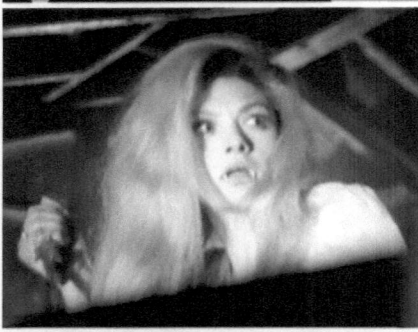

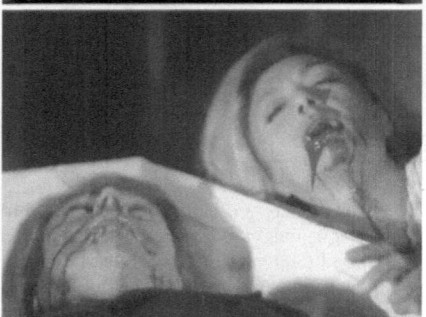

There sure don't seem to be too many (*ahem*) "unsullied maidens" in it, but the fangs'n'femmes are out in full force for Emilio Vieyra's **BLOOD OF THE VIRGINS**, Argentina's first-ever vampire flick. **Above:** Susana Beltrán as Ofelia and Walter Kliche as Gustavo in the film

producer Orestes Trucco, who does his best to look about 20 years younger), the footloose-and-fancy-free young ladies, the suave Rolo Puente, et cetera. But as the movie moves forward, we get to see plenty more naked girls—Vieyra knew *exactly* what audiences wanted!

Oh yeah, and let's not forget... Big Fangs (*Check!!!*): Following the first attack by the original vampire, the one who started this whole curse years ago, we see some more pretty cool vampires. The "leader" is played by none other than Walter Kliche, an actor born in Uruguay who started his career in Argentina then moved to Chile, where he became a TV idol thanks to his roles in multiple soap operas from the late '70s on into the early '90s. Beloved by females of all ages in Chile, this heartthrob refused to talk with me when I called him to chat about his role herein. He regrets making this movie, and getting him to understand how historically important it is was impossible; the only thing he told me was how *shitty* he thinks it is! But Kliche even rejected/derided **SANGRE** in an Argentinean national newspaper.

However, this movie is not just plain exploitation, because Vieyra added-in two elements that are highly personal and unique touches, the first and most-striking being the use of red-filtered shots of flying seagulls, accompanied by very bizarre music that prevents these shots from appearing silly (because they *are*!), but with the music overlaid atop this imagery, we get something that comes somewhere near to auteur-cinema, a sort of exploitation surreal/avant-garde touch that helps the movie to have its own unique personality. Incredibly, its no-budget resourcefulness enwraps the entire movie in a gloomily melancholic atmosphere. It was a bold bet, but Vieyra succeeded admirably. The other standout element is the music. Composer Víctor Buchino gives us a jazzy, easy-tempo score that really augments the movie's action. Besides the eerie "seagull" music, the rest of the film's score provides a key ingredient that helps viewers to endure/forgive the often dumb dialogue.

But trust me, if you're into vampires, then this movie is more than just an archeological rediscovery. No, **BLOOD OF THE VIRGINS** is a well-structured "small" movie that, despite some silly moments, has some real value by virtue of its creative merits. For such a slimly-budgeted effort, Vieyra builds a movie that entertains, shocks and surprises, helped along by his smart use of fangs, blood and—last, but by no means least—*boobs*!

This Page, Top Left: If, despite its rather blatantly misleading title and poster artwork (by the artist "Raf"), this film actually *was* a "real" vampire movie, it would have set an important precedent in the Argentine Cinema years before **BLOOD OF THE VIRGINS**—the "official" first one—came along (in '67). However, **EL VAMPIRO NEGRO** (1953, D: Román Viñoly Barreto), while a fine film in its own right, is instead a moody *noir*ish "remake" of Fritz Lang/Peter Lorre's brilliant "true crime" serial killer shocker **M** (1931, Germany), which was released in many Hispanic markets under that same Spanish title as the '53 film. **Top Right:** Argentinean poster for **BOTV** (art unsigned)

Facing Page, Bottom Left: 1970s Italian *locandina* for **BOTV** (art unsigned). **Facing Page, Bottom Right:** "Sexed-up" one-sheet poster for the 1963 US release of Vieyra's '61 crime drama, **TESTIGO PARA UN CRIMEN**. **Above:** BOTV's funky Mexican poster (art by P. Carreño). **Left:** Artwork from the film's groovy psychedelic animated opening title sequence (artist/animator unknown)

Following this film, Vieyra kept on working in the amazing world of exploitation, helming highly successful titles such as: **LA VENGANZA DEL SEXO** (*"The Vengeance of Sex"*, 1968; released in the US as **THE CURIOUS DR. HUMPP**, with additional insert scenes directed by Jerald Intrator), **LA BESTIA DESNUDA** (*"The Naked Beast"*, 1971), **ASÍ ES BUENOS AIRES** (*"So It's Buenos Aires"*, 1971), the Argentinean blockbuster western comedy **LOS IRROMPIBLES** (1975), and the sociological drama **EL PODER DE LA CENSURA** (*"The Power of Censorship"*, 1983). Vieyra's last movie before his death in 2010 was **CARGO DE CONCIENCIA** (*"Guilty Conscience"*, 2005). Argentinean cinema would not be the same without this man, who dedicated his life to cinema as spectacle.

NOTE: Some of the images used to illustrate this review were provided to me by Dario Lavia, Argentinean cinema connoisseur, researcher, all-round cool guy and editor of the (outstanding!) magazines *Cinefania Macabra* and *Cineficción*. ~ **MN**

THE SNAKE WOMAN

Reviewed by Les Moore

UK, 1961. D: Sidney J. Furie

Dramatic trailer narration for United Artists' stateside release: *"In this lonely house, a fanatic scientist defies the laws of nature and unleashes a creature that holds a whole village in cold terror! ...In the twilight world between witchcraft and science, a young detective meets a beautiful girl. But can he see behind her lovely eyes the snake-cold stare of murder?!"*

UA's stateside poster tagline: *"Teen-age beauty turns into deadly reptile at will...spreading horror with fang and forked tongue!"*

Also released under the even more luridly exploitative title **TERROR OF THE SNAKE WOMAN** and made by Furie shortly after he directed another minor if substantially better-known—

As Atheris the slinky she-serpent, Susan Travers (who later bit-parted in Robert Fuest's **THE ABOMINABLE DR. PHIBES** [1971]) doesn't get to do much here but look drop-dead gorgeous; which, in a considerably better film, might have been more than enough. However, besides her beauty, what this film sorely needs is some basic monster madness!

Arnold Marlé and Stevenson Lang in a German lobby card for **THE SNAKE WOMAN**

and better—Brit-horror classic, **DOCTOR BLOOD'S COFFIN** (also 1961; see *Monster!* #23 [p.7]), this long-elusive film—one of only comparatively few monster movies made in the West to utilize she-serpent themes along similar folkloric lines as India's *naga* ("cobra woman") myths—provides a neat bridge between **CULT OF THE COBRA** (1955, USA, D: Francis D. Lyon; see *M!* #28/29, p.32) and **THE REPTILE** (1966, UK, D: Terence Fisher; see *M!* #10, p.27). While it quite possibly may have been influenced in at least some part by said '55 film (starring the mysteriously sultry Faith Domergue as a vengeful Lamian snake-chick with sexual repression issues), it seems almost a lead-pipe dead-cert that **THE SNAKE WOMAN** served as an even bigger influence on said '66 one, whose plot bears far more similarities to the present film's than can plausibly be attributed to mere coincidence, even if the end results achieved by the later film far outstrip this one in terms of quality.

Unlike his previous shocker **DR. BLOOD**, which was filmed on pricier Eastmancolor stock, the present film was instead shot more economically in glorious black-and-white. Both films were however lensed in spacious widescreen (at a full 1.85:1 aspect ratio) to better make the most of their authentic English rural locations, although **THE SNAKE WOMAN**'s mostly bleak and dreary inland northeast England moorlands terrain is a good deal less picturesque than **DR. BLOOD**'s postcard-pretty Cornish coastal scenery (way down in England's southwest), which looks all the more scenic in full-color, while the present film's foreboding moors—largely seen by night—appear that much drearier and bleaker still in stark monochrome.

In the aforementioned **CULT OF THE COBRA**, serpentine seductress Ms. Domergue serves as the executor of a snake-worshipping sect's supernatural vengeance against wrongdoers, putting the fright-bite—if only in the most subdued and inoffensive fashion—on a succession of US servicemen who have been marked for death for daring to intrude on said sect's secret rites. **THE REPTILE** tells what is essentially a rudimentarily analogous tale, albeit told in an entirely dissimilar manner. In it, Dr. Franklyn (Noel Willman, equally well-known as suave bloodsucker Count Ravna from Hammer's own **THE KISS OF THE VAMPIRE** [a.k.a. in altered form in the US as **KISS OF EVIL**, 1963, UK]) pokes his overly curious academic nose into things that don't concern him whilst in Victorian British Colonial Malaya, much to his later regret. As a punitive measure, his beloved/devoted daughter Anna (Jacqueline Pearce) suffers an accursement discourtesy of "The *ulang santu*—the snake people" which causes her to degenerate into a humanoid of reptilian characteristics... or is it perhaps the other way round?

There are more than merely superficial thematic similarities between it and **THE REPTILE**, although in terms of overall entertainment value, **THE SNAKE WOMAN** lags *far* behind it, it has to be said.

The story is set in superstition-steeped rural turn-of-the-20th-Century Northumberland, England in the town of Bellingham. Much of the first half of the narrative occurs in 1890. Proceeding—if recklessly and irresponsibly—whilst secure in the knowledge that injections of snake venom into patients has had beneficial effects for sufferers of such debilitating ailments as hemophilia, epilepsy and rheumatism, using her as his human guinea pig, research scientist Dr. Horace Adderson (John Cazabon)—whose field of specialization, as befitting his punny name (i.e., "Adder's son" [get it?]), is herpetology, the study of reptiles—has been administering such treatments to his wife Martha (Dorothy Frere) over a period of some years to help alleviate her mental illness. Now pregnant and close to giving birth to their first child, the expectant mother is fearful of the potential harmful long-term side effects of all the injections ("But what about the *baby*?!" she cries plaintively). Following one more hypodermic of venom, she goes into both neurotoxic shock and

labor simultaneously, whereupon her husband calls on the urgent ministrations of elderly local physician Dr. Murton (Arnold Marlé, previously seen as un-aging title character Anton Diffring's aged, much-more-ethical colleague Dr. Ludwig Weiss in the genuine Hammer offering **THE MAN WHO COULD CHEAT DEATH** [1959, UK, D: Terence Fisher]). The female baby—impossibly cold-blooded, yet alive nonetheless—survives the delivery; if not her mother, who shortly succumbs. The now-motherless baby's eyes remain wide and unblinking ("Like a *reptile!*") at all times; yet, after all the irresponsible meddling with his wife's and their child's health he's guilty of, Doc Adderson doesn't clue-in to the potential cause of the baby's mutation! After its mournful mother promptly ups and croaks at the mere sight of her "monstrous" newborn (which is actually only a completely normal-looking infant shot in dim light in hopes of giving it a more "sinister" appearance), word soon gets around that something is amiss (but a miss is as good as a mile, as they say; and this movie really misses the mark, for the most part).

"It is the Devil's offspring!" exclaims the old druidic/wiccan/psychic midwife Aggie (Elsie Wagstaff) superstitiously. "A thing of *evil!*" It is she who runs to the local pub to alert villagers as to the abomination that has been born in their midst, and seems destined to doom them all simply by association. Before you can say "Angry mob bearing flaming torches", mentally-addled hag Aggie the agitator ("It was the serpent brought Man's downfall!") summons the village bobby (Jack Cunningham) and other menfolk to the Addersons' home, bent on ridding their community of the so-called "serpent child". However, because the compassionate Dr. Murton has since spirited the baby away to safety, the rabble satiate their fury by instead slaughtering Dr. Adderson's reptilian lab specimens ("*...slimy monsters!*") and putting his laboratory to the torch, during which concatenation Dr. Adderson also perishes. Having supposedly only temporarily been left in the care of a kindly hermit/shepherd (Stevenson Lang, whose flute-tootling character, albeit possessing the gift of sight, faintly evokes O.P. Heggie's blind violinist in **THE BRIDE OF FRANKENSTEIN** [1935, USA, D: James Whale]), he winds up getting saddled with the orphaned snake-baby/baby-snake to raise into early adulthood. Now 20 years of age, the runaway girl, known as Atheris (the lovely, far-from-reptilian Susan Travers), roams the moors in ragged clothing in a semi-feral state, shunning folk as much as they shun her in return. She shares a strange affinity with snakes, and, in keeping with her parents' snaky surname given above, her Christian name is derived from that of a genus of poisonous snakes called bush vipers, which are indigenous solely to tropical sub-Saharan Africa.

Before you can hiss "*Sssssss!*" yokels begin turning up dead from the bite of what appears to be—improbably enough, in the English coun-

Top & Above: German program and A1 poster (art unsigned) for **THE SNAKE WOMAN**

tryside—a King Cobra, at least according to old Army man Col. Clyde Wynborn (Geoffrey Denton) who, while serving in Colonial India has seen such things—similar telltale, vampire-like fang marks in human flesh—before. At close to the halfway mark, at the colonel's summoning, rising young hotshot detective Charles Prentice (John McCarthy) is dispatched by Scotland Yard to investigate tall tales of the snake-girl's curse out in the boonies ("There has to be an explanation", he surmises sensibly. "A perfectly logical scientific explanation" [*Hah!*]). One clue (e.g., "Her skin was as cold as *ice*") leads to another—if nowhere fast—and a snake-charmer's flute also plays (pun intended) a "key" role. But it isn't until Prentice discovers Atheris' freshly-shed skin out on the moor late at night that the true enormity of what she is (and *isn't*) begins to fully dawn on him.

The film was produced by George Fowler (1912-1993), whose filmography, whilst not overly expansive, includes a number of titles which should be of interest to *Monster!* readers with a bent/jones for more "old school" creature features. For instance, he first served in a producer's capacity on the notorious pulp sci-fi gobbler **FIRE MAIDENS OF OUTER SPACE** (1956, UK, D: Cy Roth [see *M!* #18, p.27]), subsequently serving as producer of the above-noted **DOCTOR BLOOD'S COFFIN**. Most frequently employed as a production manager during his 30+-year career, his more notable credits in that capacity include **THE DAY OF THE TRIFFIDS** (1962, UK, Ds: Steve Sekely, Freddie Francis), **THE BRAIN** (*Ein Toter sucht seinen Mörder*, 1962, UK/West Germany, D: Freddie Francis) and **THE PLAGUE OF THE ZOMBIES** (1965, UK, D: John Gilling; see *M!* #10, p.25). Perhaps most interestingly of all within the context of the current review, he later functioned as PM on **THE REPTILE**; one can only wonder whether he might have offered any unofficial input into that film's script, or if at the very least he felt any sense of déjà vu during the shoot. The present snake-chick flick's American-born scriptwriter Orville H. Hampton (1917-1997), who wrote scads of TV episodes for various series, has equally-as-impressive genre cred, having lent his prolific pen to such Hollywood SF/horror classics as **ROCKETSHIP X-M** (1950, D: Kurt Neumann), **LOST CONTINENT** (1951, D: Sam Newfield), **THE ALLIGATOR PEOPLE** (1959, D: Roy Del Ruth), **THE FOUR SKULLS OF JONATHAN DRAKE** (1959, D: Edward L. Cahn), **THE ATOMIC SUBMARINE** (1959, D: Spencer G. Bennet), **JACK THE GIANT KILLER** (1962, D: Nathan Juran) and **BEAUTY AND THE BEAST** (1962, D: Edward L. Cahn), following which he mostly returned to writing for the small screen for the remainder of his career.

Skinless! John McCarthy and Elsie Wagstaff find **THE SNAKE WOMAN**'s cast-off epidermis

Philip Martell's (1907-1993) and Buxton Orr's (1924-1997) score frequently attains a suitably pseudo-Hammeresque tone. Martell of course was musical director on a whole pile of Hammer/Amicus/Tyburn (etc.) horrors during the '60s and '70s; pretty much every damn one you can name, in fact! As for Orr, his far shorter filmo at least boasts a couple of certified monster movie doozies in the forms of **FIEND WITHOUT A FACE** (1958, UK, D: Arthur Crabtree) and **FIRST MAN INTO SPACE** (1959, UK, D: Robert Day), plus he was yet another alumnus of the oft-above-cited **DR. BLOOD**, too. While not really known for much work within the fantasy field, DP Stephen Dade did also lens **DR. BLOOD**, plus the moody Brit sci-fi thriller **THE NIGHT CALLER** (a.k.a. **BLOOD BEAST FROM OUTER SPACE**, 1965, D: John Gilling), starring John Saxon, as well as that lovably bird-brained schlocker **THE VULTURE** (1966, UK/Canada/USA, D: Lawrence Huntington), starring Akim Tamiroff.

Running a concise—some might say too short, if it was a better film—68 minutes in total, it has all the earmarks of being improperly finished, or at least one whose makers gave up on prematurely rather than even bothering to try making it into something even halfway less unmemorable than it unfortunately is. Certainly lacking in the polish of the usual Hammer outing, it's not difficult to understand why this forgotten British horror has remained thus for so long, although its simple obscurity endows it with a certain amount of curiosity value, of course. That is, until you actually take the time to sit through it. While not utterly without merits, they come few and far between indeed, and there is a criminal shortage of supernatural spookiness to be had. Due to the dire dearth of monstrous elements, we have little to hold our attention other than for a few engaging performances. The cast is all over the place in terms of acting aptitude (or lack thereof), although there are some standouts. For instance, one who stood out in my mind from the rest of the cattle call was Frances Bennett (1930-2014), a theatrically-trained actress (born in India of Brit descent) who plays Polly, barmaid down at the local pub. While she only gets a few scenes, she does get a substantial number of lines in one of them opposite the hero (some nonsense to do with his—*ahem*—flute), and her down-to-earth naturalism is not only most engaging but highly attractive to boot. Bennett never made too many appearances in feature films but, in addition to appearing on the Stratford stage, she appeared on literally slews of TV shows.

US one-sheet poster (art unsigned)

While it isn't completely devoid of all mood, **THE SNAKE WOMAN** doesn't exactly generate an atmosphere of dread to complement its somber milieu. I'm sorry to have to report that, for a supposed horror movie, it falls far short of being horrifying, nor is it even particularly suspenseful. In fact, the supposedly "scary" stuff is handled the least effectively, and is dispensed with in a clipped, perfunctory manner which seems to indicate that Furie wasn't too engaged in his direction (although slovenly editing can take some of the blame too). Scenes/moments which should have been better-emphasized are passed over with seeming indifference as to whether they could have been done in a more effective manner.

"Amazing", says the hero's superior officer at the Yard after the case is closed. "Absolutely, utterly incredible!" *Overstatement alert!*

Not *quite* as boring as watching paint dry, this film of woefully unrealized potentials is just about as dull as dishwater. Come to think of it, watching dishwater might actually have a tad more entertainment value, for the most part. This is definitely a one-time-only watch, so far as I'm concerned, and I'm about as forgiving as they come when it comes to enduring cheapo monster movies which most people would find unwatchable, so that's sure saying something.

Veronica Hurst and Katherine Emery, on one of **THE MAZE**'s fabulously moody Menzies sets

On second thought, scratch what I said about only watching it once! Maybe I'll at least give it a second chance. Now that I know what to expect from it (not much at all), my expectations won't be set so high, so maybe I might get more out of it than I did the first time round. It *could* happen. Strange how that works, eh?

NOTE: Perhaps understandably considering the mediocre end results, sales outside the UK seem to have been sparse and spotty at best, although it did make it stateside, as well as onto the German market too. Geo. Fowler much later produced the bizarre, long-lesser-seen "sexy shocker" **VENOM** (a.k.a. **THE LEGEND OF SPIDER FOREST**, 1973, UK, D: Peter Sykes), starring starlet Neda Arneric as the "Spider-Girl". From what I remember of it (not much), that film—which I saw on late-night TV a couple times back in the '90s, and haven't seen since—at least had a quite substantial amount of eerie atmosphere and eroticism going for it. As for **THE SNAKE WOMAN**, one of its "key" props, that snake-charmer's flute, was apparently intended to be interpreted as some sort of sexy phallic symbol; only, any "eroticism" to be had here is kept as subdued as everything else, so it barely even registers.

THE MAZE

Reviewed by Andy Ross

USA, 1953. D: William Cameron Menzies

Pressbook hyperbole: *"Bare-Legged Beauty, Strange Monster Leap Into Audience From 3-D Screen!"*

Excerpt from the trailer, hosted by the film's star: *"Hello, ladies and gentlemen. I'm Richard Carlson. If I look somewhat older and more drawn than I have in my recent pictures, it's because of the harrowing experiences I've been having here in* **THE MAZE**... *the first picture in 3-Dimension that delves into the weird and terrifying world of the supernatural. If you're familiar with the exciting effects that can be achieved with 3-D, you can imagine what happens when something from the Great Beyond reaches right out of the screen to clutch at you. Oh, and one more thing: after you've seen* **THE MAZE**, *please don't reveal to your friends the secret of its story or its startling climax... Because, you see, we think* **THE MAZE** *will amaze you!"*

This monochromatic mood-piece has all the trappings needed for some spooky gothic go-

ings-on: a decaying castle in the Scottish Highlands, a deep-rooted (decidedly *dark*) family secret, and a spurned fiancée determined to discover the truth about her troubled beau…

What I find fascinating about being a horror fan is that no matter how many movies you *think* you've seen, and no matter how extensive you consider your knowledge of the medium to be, there are always hidden gems that have yet to be discovered. One of a slew of '50s fright flicks that sought to explore the experimental realms of 3-D ("three-dimensional") filmmaking, William Cameron Menzies' **THE MAZE**—adapted to the screen by Daniel B. Ullman (of **MYSTERIOUS ISLAND** [1961, UK/USA, D: Cy Endfield] fame) from the once-popular, now-largely-forgotten 1945 short novel of the same name (a.k.a. *Le labyrinthe*) by Swiss author Maurice Sandoz (1892-1958)—was to prove a marked departure from the director/art director's previous big-screen offerings. Born in New Haven, Connecticut in July 1896, Menzies (who died in March 1957) first appeared on the Hollywood rollcall back in the pre-sound era. An art director on such high-profile productions as Allan Dwan's swashbuckling adventure **THE IRON MASK** (1929) and Edward Sloman's musical **PUTTIN' ON THE RITZ** (1930, both USA), in his "secondary" capacity of director, Menzies is perhaps best-known as the man behind such timeless science fiction classics as **THINGS TO COME** (1936, UK) and **INVADERS FROM MARS** (1953, USA).

Though devoid of the former's meaningful message, and lacking the visual spectacle of the latter, **THE MAZE** was to prove something of an unusual addition to Menzies' filmmaking résumé. A work that doesn't fully adhere to any one specific genre (i.e., a horror/mystery with a sprinkling of pure science fiction added), **THE MAZE** is an atmospheric—albeit slow-burning and restrained—thriller. Its tale is told in retrospect by Edith Murray (Katherine Emery [1906-1980]), the rather stuffy aunt of the heroine, Kitty. The story Aunt Edith proffers is a peculiar one indeed…

Scottish-American Gerald MacTeam (Richard Carlson [1912-1977], a long-time genre player soon to be seen in another—much better-remembered—3-D monster movie, **CREATURE FROM THE BLACK LAGOON** [1954, USA, D: Jack Arnold]) is heir-in-waiting to the title of Baronet of Craven Castle. When we first meet Gerald—an easy-going, happy-go-lucky, fun-loving sort—he is off on a carefree vaca-

Contemporaneous US newspaper ad. Some ads subtly incorporated a passable simulacrum of the Dali "monster" face artwork—seen at the bottom of p.279—into their design

Letter For You, Ma'am! One of the few moments when the 3-D gimmick gets right in yo' face

tion in the South of France. This while enjoying the company of his soon-to-be bride, the pretty Kitty Murray (played by prim'n'proper English rose Veronica Hurst (1931-), here making her Hollywood debut some years before appearing in **PEEPING TOM** [1960, UK, D: Michael Powell]), along with their extended middle-class entourage. The sunny skies and vibrant nightlife are a far cry from the mist-enveloped Highlands of his ancestral seat in Bonnie Scotland. Serving to dampen the party mood, when news arrives informing him of his Uncle Samuel, the incumbent Baronet's, illness, Gerald feels duty-bound to return post-haste to the land of his birth. Followed soon after by a letter informing the women of his uncle's demise, Kitty is, unsurprisingly, devastat-

Seasoned genre performer Michael Pate as the sinister castle butler in **THE MAZE**

ed when Gerald suddenly and abruptly deems it necessary to conclusively call off their engagement. Distraught and suspicious as to his sudden change of heart, the jilted beauty persuades her bit-of-a-busy-body auntie to accompany her to Craven Castle, entirely uninvited by Gerald. Clearly unwelcome in the home of her former affianced, the first thing that strikes Kitty is the dramatic change in, not only Gerald's temperament, but even his appearance, too. Once dashing, vivacious and full of energy, the new Laird of the manor has become but a gaunt shadow of his former self. A man who, to all intents, bears the entire weight of the world on his shoulders, that Gerald has settled for his solitary existence is perhaps of little surprise. Having been obliged under sufferance through circumstance to accommodate the ladies overnight, Gerald rather roundly lays down the rules of the house: besides the securing of all internal doors by 11:00 p.m. sharp, the immaculately-pruned hedged maze that nestles to the rear of the castle has been declared strictly off-limits.

During the night, after being awoken from a fitful sleep, alerted to something shuffling (and *squelching*) heavily along the hallway outside her room, Kitty uncovers a secret doorway leading to a heavily-cobwebbed stairwell. Cautiously ascending the cold, stone steps, she soon finds herself at a window that affords an unobstructed view of the maze below. (Incidentally, this sequence prompts one of the few—and unusually subdued—instances in **THE MAZE** where exploitation of the 3-D gimmick rises to the fore, if only in a small way; this when an incidental squeaking rubber bat on a string strafes/dive-bombs both Hurst as Kitty and we the audience...if only in a half-hearted way, before then flapping floppily off whence it came amidst the generously-festooned garlands of cobwebs.) Contrary to the labyrinth being out-of-bounds (at least to them), as the women have been told, however, Kitty learns that this "strict" house rule does not apply to *everyone*. Her curiosity piqued by the nocturnal comings-and-goings she witnessed (if only in part and indirectly), the next morning Kitty insists that her aunt should play-up her in actuality none-too-severe head cold in order to buy them some more time at the castle. On her way to inform Gerald of their sudden change in plans, the appearance of peculiar sycamore leaf-shaped, webbed foot-prints, coupled with the haste of the house-help to erase them from sight, leads Kitty to embark on a spot of private detection which, while done in his best interests, goes completely against her former fiancé's wishes. Deeply concerned as to Gerald's

health (and especially his state of mind), Kitty takes it upon herself to orchestrate a "surprise" visit from their well-meaning group of friends, who are likewise concerned about him. As night falls once more and the locks are secured on the doors of the guest bedrooms to ensure the unwelcome guests stay put, a filched key leads Kitty to uncover the terrible secret of Craven castle…

Mood/milieu-wise in a similar vein to **THE OLD DARK HOUSE** (1932, USA, D: James Whale), **THE CAT AND THE CANARY** (1939, USA, D: Elliott Nugent) and **THE SHUTTERED ROOM** (1967, UK, D: David Greene [see *M!* #27, p.70]) *et al*, **THE MAZE** fits neatly into the timeless "haunted house" stable of suspense-horror. With its impressively foreboding visuals, deftly-rendered atmosphere and suitably dramatic performances, the overall feel of the production bridges the gap between Agatha Christie-style murder mystery and the darker concerns of Lovecraftian inheritance horror. Not fully pursuing either angle to their natural conclusions, by the film's third act, the proceedings are made unnecessarily complicated via the introduction of what is intrinsically a science-fictional element. A shocking secret— far worse than any mere skeleton in a closet— that has brought shame upon the MacTeam clan for generations, whilst the creature that frequents the maze by night is by no means an all-out monster per se (except in its appearance), it can hardly be considered human, either. As such, **THE MAZE** straddles yet another well-used HPL theme, that of body-horror.

Top & Above: Doubleday & Company of New York's 1946 first edition hardcover (art by Salvador Dalí)

No Spoilers Here! Feelin' froggy, Carlson as the bad-tempered baronet reads-up on his family's weird curse. But just what—if anything—does that goofy frog-shaped paperweight on his desk *[above]* have to do with it...? *[WINK]*

Key players in the scenario are Craven Castle and its environs themselves. Due to the masterfully ominous mood attained and sustained (thanks in no small part to both DP Harry Neumann's cinematography and Marlin Skiles' musical score), said building and grounds take on a virtual independent life of their own, almost like some giant, sentient entity. This aspect is accomplished chiefly by director Menzies' set design, which endows the crumbling old manse with a foreboding character suitable to the sinisterly somber proceedings. According to a news item in the industry tradepaper *The Hollywood Reporter* (for February 5th, 1953), Menzies had not been the first choice to serve as designer of **THE MAZE**'s distinctive sets. No less than Spanish surrealist artist Salvador Dalí (1904-1989)—who had contributed the dust-jacket artwork and a number of illustrative plates to Doubleday's US/UK (etc.) editions of Sandoz's original '45 novel—was hoped to handle the film's set design. Sadly, that didn't come to be as, for whatever reason, his concepts weren't used in the film. But, while it's fascinating to conjecture how Dalí's unused designs might have looked, there's no denying that Menzies' self-designed settings come as far more than merely a consolation prize, as without them the film would surely suffer for it.

Collectively, the human cast—which also includes Australian-born actor Michael Pate ([1920-2008] best-known to genre fans as vampire gunslinger Drake Robey in **CURSE OF THE UNDEAD** [1959, USA, D: Edward Dein]) as Craven's stone-faced butler, William—deliver their performances with both style and grace. Familiar to science fiction fans from his lead performances as smart, sensible protagonists in **IT CAME FROM OUTER SPACE** (1953, USA, D: Jack Arnold) and the aforementioned **CREATURE FROM THE BLACK LAGOON**—the pair of which were also shot in 3-D during the short-lived "first wave" craze for the medium that spanned the years 1953-54—**THE MAZE** finds Richard Carlson in a slightly more subdued mode as the cursed Baronet Gerald MacTeam. Offsetting Carlson's formerly charming, now (following his sudden unexpected and seemingly permanent "mood-swing") sullenly brusque lead and adding some much-needed spirit to the proceedings, in the form of Veronica Hurst's devoted Kitty Murray character we are presented with our reluctantly intrepid heroine; a woman who, in spite of the grim-faced Gerald's increasing coldness towards her and alienation from her, is determined to win back her man...no matter how much she has to meddle in his private affairs to do so!

Visually, the film owes a great deal to the fright features of the 1930s. With the castle's dominantly central staircase set highly reminiscent of that which the great Béla Lugosi descended in **DRACULA** (1931, USA, D: Tod Browning [see p.107]), while the contrasting use of light and shadow bear a striking resemblance to that

which highlighted Charles D. Hall's art direction on James Whale's **FRANKENSTEIN** (1931, USA), the present film—if not necessarily intentionally so—mirrors/mimics the style of Universal's legendary horrors. Even when viewed in its two-dimensional format, it's more than evident that the film was made with the third dimension in mind, although the gimmickry is kept to a more discreet degree than in, say, the much more blatantly "in-your-face" **HOUSE OF WAX** (1953, USA, D: André de Toth). Complete with numerous direct-to-camera moments (e.g., Kitty reaching out a hand to hasten her exit from the swimming pool; a letter intended for Aunt Edith presented directly to the audience in the extreme foreground, so close we can read the address),

THE SEVENTH CURSE's Old Ancestor gets his freaky on!

whilst the swooping bats in the tower scene fail to convince in the second dimension, one can safely imagine that when viewed in 3-D they would have played their parts particularly well. In whatever format it's viewed, **THE MAZE** remains a quirky horror-mystery. Tapping the Gothic vein of brooding atmospherics and bestowing a contemporary approach to its characters, it's an unusual concoction that plays out rather well.

Drawing clear parallels with the works of H.P. Lovecraft, from its deliberately cryptic introduction through to the eventual shock reveal, **THE MAZE** maintains an overwhelming sense of encroaching, inexorably approaching menace. *Why* are all the windows overlooking the maze bricked-up? And *why* are the castle doors locked an hour before midnight? *Why* do the bad-tempered Baronet and his domestic staff act so suspiciously? And, most of all, *why* is that mysterious maze so stringently out-of-bounds?

Worth a watch for its splendid atmosphere alone, whilst **THE MAZE** may appear somewhat quaint, stilted and dated by today's standards, what it does proffer is a unique insight into the early use of 3-D cinematography. It illustrates that, when integrated into the action with judiciousness and subtlety rather than overdoing things through simply being too emphatically obvious about it, the medium could actually enhance rather than overwhelm a movie, complementing it as opposed to becoming the primary focus.

THE SEVENTH CURSE

(原振俠與衛斯理 / *Yuan zhen-xia yu Wei Si-li*)

Reviewed by Jeff Goodhartz

Hong Kong, 1986. D: Nam Nai Choi

Hong Kong action/exploitation auteur Nam Nai Choi (a.k.a. Lam Nai-choi, a.k.a. Lan Nai Tsai) has only recently begun to receive the well-deserved attention and notoriety that had previously eluded him here in the West. Though his films were popular among fans at the time, it proved curiously difficult to put a name to the works. Thanks to the efforts of hardcore Hong Kong film fans the world over and the eventual omnipresence of the internet, we have long since figured out who was responsible for all those weird, wacky and mostly wonderful films that stretched from the early 'Eighties on through 1992 before sadly, suddenly and mysteriously coming to an end.

Among Nam's strongest genre efforts are the intense and exciting Shaw Brothers-produced police actioner **MEN FROM THE GUTTER** (暗渠 / *An gu*, 1983); the **GHOSTBUSTERS** (*what else?!*)-inspired spooky spoof **THE GHOST SNATCHERS** (俾鬼捉 / *Bi gui zhuo*, 1986); **KILLER'S NOCTURNE** (不夜天 / *Bu ye tian*,

1987), which for much of its first half lulls the audience into thinking it's just another dull crime potboiler, only to then feature an *insane* mid-film boxing match with a kangaroo (!) and ending in one of the most intensely over-the-top bloodbaths in the annals of Hong Kong action cinema (let *that* sink in for a moment!); the raunchy Category III period-piece **EROTIC GHOST STORY** (聊齋艷譚 / *Liu jai yim taam*, 1987); the visually wild, manga/anime-inspired **PEACOCK KING** (孔雀王子 / *Kujaku ō*, a.k.a. **LEGEND OF THE PHOENIX**, 1988) and its less-inspired sequel, **SAGA OF THE PHOENIX** (阿修罗 / *A xiu luo*, 1990); as well as **THE CAT** (卫斯理之老猫 / *Wai si li zhi lao mao*, a.k.a. **THOUSAND YEARS CAT**, 1992 [see *M!* #3, p.18]), a sci-fi tale derived from a popular series of pulpy novels featuring an Indiana-Jonesian adventurer named Wisely, which is highlighted by a wonderfully-edited battle between a cat from outer space and a possessed dog (!).

Unquestionably however, Nam's most notorious work was/is his penultimate feature, **STORY OF RICKY** (力王 / *Lik Wong*, 1991). Based on the Japanese manga *Riki O*, it was/is a film of such spectacularly gross, over-the-top violence (if in a purely cartoony way) that it earned its Category III rating on that alone, as opposed to for the usual nudity and rape that tend to pervade these movie nasties. It became famous here in the States first for its comic lead-in on *The Daily Show*'s "Five Questions" segments, before making a surprise appearance on no less than… *TCM Underground*! All that aside, my favorite of Lam's movies (yes, **RICKY** notwithstanding) is our present title under review: the ultra-gory Indiana Jones-style action-adventure/horror pic— **THE SEVENTH CURSE**!

As the pre-credit sequence commences at a well-to-do cocktail party, we are introduced to our two protagonists: Chin Siu Ho as Dr. Yuen Chen Hsieh and a just-on-the-verge-of-superstardom Chow Yun Fat as Wisely (yes, the character from the aforementioned novels that Waise Lee played in aforementioned **THE CAT** and whom Sam Hui portrayed in Teddy Robin Kwan's **THE LEGEND OF WISELY** [衛斯理傳奇 / *Wai Si-lei chuen kei*, 1987], to name but two of the character's scattered film appearances *[his name can also transliterate as "Wesley", as in the English subs of my DVD version of 7TH CURSE – SF]*. The host mentions their many adventures together, and before you can say "Here's one of them now", the title credits roll over an exciting opening SWAT team vs. kidnappers sequence featuring longtime Shaw heavy Wang Lung Wei as head baddie and even-longer-time Japanese actor Yasuaki Kurata casually cast as the Chinese police chief. Because one of the captives is in need of medical attention, Chen Hsieh disguises himself as a doctor to distract the kidnappers so that the SWAT team can close in. Another Shaw

Heavens To Betsy! 4 shots of stacked starlet Sau-lai Tsui as an Asian jungle girl named "Betsy" (*yeah, right!*). **Top to Bottom:** The magically alluring Betsy speaks, appears repeatedly *au naturel*, provides further proof that knives and nipples simply *don't* go together—EVER!— and, in her semi-disfigured state, gets mistook for a spook by easily-spooked lead

Above Left: If the eyes are indeed the windows to the soul, then Old Ancestor really needs to close his damn drapes! **Above Right:** Elvis Tsui as that lousy, no good sumbitch of a witchdoctor, Aquala—creator via mass-infanticide (it was *worth* it!) of the monstrous "Little Ghosts" demon

legend, Kara Hui Ying Hung shows up playing a policewoman who was supposed to go along disguised as a nurse, but unfortunately she gets conked on the head and knocked out by overzealous reporter, Rainbow (none other than the usually wonderful Maggie Chung in an uncharacteristically annoying turn, whose character here is known as Tsai-hung in the Cantonese version). Rainbow nearly ruins everything, but—following a brief-but-exciting shootout/martial arts battle—the mission proves successful. Now that our prospective couple Chen Hsieh and Rainbow have "met cute", our actual story kicks-in…

After ditching his newfound stalker—I mean "love interest"—at yet another nighttime pool party, Chen Hsieh returns home to be attacked by a mysterious stranger known as Black Dragon (popular HK bad guy Dick Wei, in a rare heroic turn). After a scuffle—and by "scuffle", I mean an always-welcome, several-minute-long kung fu throwdown!—our intruder informs our hero that he is due to have a relapse of his "blood spell", and must return to Thailand within three days… or else face the consequences. Initially dismissing this news, Chen Hsieh (who is apparently *quite* the playboy!) attempts to bed a local lady

friend, only to have blood erupt from his leg right in mid-coitus. Visiting his old friend and master Wai and his assistant So (Sibelle Hu), Chen spills the beans to them. A year ago, while assisting an elderly professor on an expedition in Thailand hoping to find a treatment for AIDS, Chen and the party run afoul of the feared Worm Tribe and its intimidating (yet oddly effeminate-sounding) witchdoctor leader, named Aquala (Elvis Tsui). Attempting to rescue Betsy, Black Dragon's would-be bride (whom he first encountered while she was taking a dip in a lake, allowing for some delightful eye candy for the discerning viewer!), Chen succeeds, but also places the entire expedition in deadly peril. They are killed or—even worse still—captured. After watching the professor die in a splatterrific eruption of worms, Chen is then force-fed something *[so far as I could tell, apparently a handful of human teeth? – SF.]* which causes his blood spell to come into effect. Freed and left to die in the jungle, he is discovered by Betsy who, after slowly disrobing (*thank you, movie!*), feeds him a temporary antidote which she carves out from inside one of her breasts (!?).

Back in present time, Wai comes to the realization that a return to Thailand is necessary in order to cure our hero once and for all. Said permanent cure consists of certain sacred grains stored in the eyes of a gigantic subterranean Buddha statue; one which is guarded by a bunch of *very determined* kung fu-fighting monks. Along for the ride is ever-pesky spoiled brat Rainbow who, as it turns out, is Wai's own cousin, no less. Our group organizes and prepares to do battle with the Worm Tribe. No easy task, as Aquala has a number of cheesy-looking—if exceedingly potent—monsters at his disposal. Among these are little flying spirit fetus creatures that can burrow clear through people like nobody's business (each of these li'l nasties is created from mashing-up the bodies of a hundred captured local children... *no, really!*). The main threat, however, is "Old Ancestor", a living skeleton that can transform into a horrific winged monster vaguely resembling the **ALIEN**. Incidentally, this monster enjoys ripping open the backs of its victims' necks and sucking out their spines.

While it's hardly the first or last time that action and horror have been meshed together in Hong Kong cinema, it has never been done so with such crazed panache as here. Director Nam's inspiration and creativity (to say nothing of sheer *gonads!*) is at an all-time high, and he appears willing to go for the proverbial jugular as often as possible. The very idea of showing, albeit only briefly, children being crushed to death in order to create a flying fetus-beastie is so perverse that, in almost any other movie, it would prove to be a showstopper for fans and a deal-breaker for practically anyone else. Yet here amongst the nearly non-stop parade of over-the-top madness, it's treated very matter-of-factly, and can almost (but not quite) be dismissed as just another plot device. As for Old Ancestor, as effectively scary

Top to Bottom: Old Ancestor goes through some scary changes in **7TH C**

When he isn't smokin' his HUGE grampa pipe, HK cool cat Chow Yun Fat smokes monsters with his pocket rocket-launcher

as it is in its final Gigeresque form, it is just as silly in its initial appearance as a cadaverously skeletal marionette. Just in case anyone was taking all the straight-faced insanity with any degree of seriousness, this leads to a laugh-out-loud moment when, after first showing-off its power and ferocity, the spindly skeleton faces-off against Chen Hsieh by striking a kung fu pose which echoes his opponent's own! The penultimate bout between Old Ancestor and the now-captured-and-on-our-side spirit fetus provides a most welcome climactic gory monster battle (albeit a supremely *fucked-up* one!) for us Kaijū fans. Action enthusiasts, meanwhile, have plenty to gravitate toward too, as the shootouts and martial arts battles are top-of-the-line '80s-style confrontations: which means they are among the *best* ever committed to film. The highlight may well be the extended battle between Chen Hsieh and Black Dragon against the statue-guarding monks. This is a wild, swinging (from suspended vines), hard-hitting confrontation that ends with Black Dragon striking a hasty bargain with the suddenly-agreeable monks; never mind that several of their number had fallen to their apparent deaths during the battle, while another got shot—it's all okay now!

THE SEVENTH CURSE is unmatchable entertainment from the Golden Age of Hong Kong Cinema. It is an action/exploitation fan's *wettest* of wet dreams! That it's not more well-known or highly-regarded than it is amounts to a crime against humanity greater than any that Aquala committed in the film itself (yes, even greater than crushing a hundred children to pulp!). As for Chow Yun Fat fans, who will likely be disappointed that their hero receives relatively little screen-time (his role is merely a glorified cameo, really); I put it to them that *where else* will you get to see the great actor puff on a pipe AND produce and discharge a bazooka (perhaps the sole notable piece of artillery absent from John Woo's **A BETTER TOMORROW 2** [英雄本色續集 / *Ying hung boon sik II*, 1987])?! Enough said!

Needless to say, a Blu-ray release of this would be most appreciated. *Anybody...?*

UNHUMAN
(อมนุษย์ / *Amanut*, a.k.a. **EVIL ALIENS**)

Reviewed by Steve Fenton

Thailand, 2004. D: Toranong Srichua

Some of the choicest subtitles: *"I'll chop you up into pieces! Creatures from hell! We must quickly kill all of them. Before they start to breed and conquer the world."* – *"The thing I'm most sure about is they have strong sexual hormones. More deranged sexual desires than any ordinary human."* – *"My guess is you're cloning a new breed of humans by taking animal DNA and injecting it to clash* [sic?] *both breeds..."* – *"But this is immoral. You're breaking the laws of nature. It's injustice towards medical science. Most important, you're challenging God."*

Having only ever seen it once prior to this time, I'd been planning on doing a review of this super-funky Thai creature feature for quite a while now. Finally, being as this our #32 issue is shaping-up to be another ginormous grab-bag/raging slab of esoteric/exotic monster madness from around the world, I figured it'd be in good company, so here it is...

As some readers may have noticed, I can quite easily ramble on for pages (and pages...) about the most "minor" (*not to me!*) movies. Shee-it, a 3000-word write-up on even the most sub-mediocre movie ain't nothing for me! But sometimes a movie comes along that I just wanna—*need* to —say more about without feeling in the least bit restricted by any sort of constraining word-count allowance (how lame is that?!). As in the case of the present title under review, which I actually *did* exercise quite a bit of restraint while writing about anyway, believe it or not. Trust me, I could likely have expended *double* the amount of words on it with very little provocation. That's how much it inspires me to want to sing—indeed, trumpet!— its praises loud'n'proud to the world. There. After *that* preamble, if I haven't grabbed your attention yet, I ain't never gonna; so by all means leave this review right here and now, if you wish. Cuz it's set to be quite the long'un. I shall try my best to keep it as near to 5000 words (max) as possible, but there's really no telling beforehand what the final tally will be. That's just the way I roll. So consider yourself forewarned! ☺

In its quintessentials, **UNHUMAN** is basically yet another of the virtually countless uncredited derivatives of shameless eugenicist H.G. Wells' enduringly popular novel, *The Island of Dr. Moreau* (1896), albeit modernized to better appeal to more contemporary audiences (especially those of Thai origin). It is also greatly padded-out and elaborated upon, but the main gist and moral of the story are ultimately much the same: DON'T mess with Mama Nature—unless you want her to get her own back in the worst possible way.

In typical sci-fi movie fashion, **UNHUMAN**'s spacy opening titles are laid over a twinkling starfield. Courtesy of entry-level CGI FX, a swarm of colossal meteorites/asteroids are seemingly on a direct collision course with Earth, evidently guided there by some extraterrestrial force. In the Panomdongrak province of Thailand, Yai Thong, an old Cambodian witch-woman to whom superstitious local folk pay heed, ominously predicts that something bad is about to befall us Earthlings big-time ("I received warning from the dark spirit world", she reveals via the relatively coherently-translated English subtitles. "From this night evil spirits are coming down. There'll be deaths!" she shrieks shrilly). Having camped-out in the vicinity near the ruin of a centuries-old Siamese palace/castle—one of the many such ruins in the area along the Thai/Cambodian border—a group of "teenage" (i.e., twentysomething) astronomy majors led by San (pretty-boy teen heartthrob Surachai Saeng-agas/Sorachai Sang-aakaat) record the spectacular meteor shower on their camcorder as it flashes across the night sky (surprisingly enough, no one has a cell-phone to shoot it with!). Before you can excitedly shout "*Hey! Shooting star!*" like one of them does, they witness one of the meteors—it is in actuality an alien spaceship

Top: UNHUMAN begins much like many a '50s sci-fi picture from the West. **Center:** One of the title critters gets stroppy. **Above:** The unhumans perch atop ancient Siamese ruins like gargoyles on a cathedral

(...or *IS* it...? [*wink*])—crashing to the earth not far from them, while the others in the swarm pass by harmlessly high overhead well outside Earth's atmosphere, evidently continuing on their flight safely past our planet. However, no sooner has the one (dubbed "Leonic") they spotted alighted in a fiery flash than the students hear a nightmarish cacophony of bestial cries emanating from the surrounding jungle...

We learn that no less than three people fell victim to vicious murders during the previous night, shortly after the meteor touched down; all of them bearing the same types of wounds—their flesh shredded, as if by the teeth and claws of a tiger or bear ("What can tear human flesh up like this?"). However, no evidence of any sort of animal DNA was found in the wounds...only traces of *human* tissue were left by the killer(s). One of the victims, a crazy old man named Mr. Paew, had been assisting a sinister scientist named Dr. Mun (Khowit Wattanakul), who has been conducting experiments—in secret collaboration with the old witch—using human organs at the same top-secret research facility nearby to where all three of the murder victims had been employed, "coincidentally" enough (note quotes). And not only that, but a number of workers there (such as aforementioned old codger Mr. Paew) have increasingly been coming down with an accelerated form of madness—reminiscent of demonic possession—caused by strange hallucinations... *The plot thickens!*

"The villagers here believe an ancient tale that dark spirits are buried under the castle waiting to be awakened by a fireball", explains a cop on the case of the falling meteorite sighting to his superior officer Detective Inspector Bhichit (the top-billed Sira Pathrat [ศิระ แพทรัตน์ in Thai], yet another hunky heartthrob; whose real name can also be transliterated as Sire Phattrat and whose character's surname was alternately transliterated as Pichit in the subs of my DVD edition. Such is the variability of the Thai language in transliteration to the Roman alphabet!). Suspecting that supernatural forces are afoot (indeed they *are!*), local villagers begin to desert the area in droves, fearful that the ancient prophecy from their folklore foretold by the witch Yai Thong is coming true. Those few who remain hang charms all about the village (including what appears to be the [fake] corpse of a stillborn male baby, dangling from a tree-limb with its neck in a noose!), in hopes of keeping the millennia-old demonic spirits at bay. The filmmakers make a game attempt to overlap the potentially extraterrestrial / supernatural angles, and, rather than making for strange bedfellows, this mix works quite well, adding extra onion layers of subtext to the narrative.

Sam snake sez to one of **UNHUMAN**'s deceased failed experiments, "*Damn!* You're uglier than I am!"

Intrigued by the mounting mystery, rather than make themselves scarce in the aftermath of the seemingly paranormal recent events, the "kids" (who *still* haven't whipped out a cell-phone yet!) elect to stick around and try to get to the bottom of things. Indeed they do. Right through to the bitter(sweet) end, in fact. (Such stubborn staying power/stickwithitness in "today's" generation comes as quite the surprising revelation, I must say. But I digress...)

A sizeable force of army personnel has been mobilized to the area, setting up base-camp near to the spot where the meteor came down. "You're thinking our world is being invaded by *aliens*?" asks skeptical Lieutenant General Naris (Nivait Kanthairath), who is in charge of military operations, with wry sarcasm of one of his subordinates. Also reminiscent of the bug-hunting grunts in **ALIENS** (1986, USA/UK, D: James Cameron), scenes showing jittery, trigger-happy soldiers in heavy camo combat gear prowling the jungle in search of monsters inevitably recall **PREDATOR** (1987, USA, D: John McTiernan).

An expert in genetics, Dr. Narisara (lovely leading lady Chonrada Mekratree/Cholrada Mekratri [Thai name ชลดา เมฆราตรี], whose first name also transliterates from her native tongue as Chonlada and Chollada, as I've seen it variously given) is none other than Gen. Naris' own daughter, whose chums' pet-name for her, logically enough, being as she is one, is "Doc". Having been permitted by her high-ranking daddy to participate in the investigation, she questions another employee of the shady scientists named Mr. Mek, who, hallucinating wildly, becomes increasingly paranoid and hysterical then all-out violent, suspecting that the "evil spirits" are out to get him. During the resultant struggle with a soldier who is standing by, Mek steals his sidearm and promptly blows his own brains out.

Early on, to reveal the monsters' presence without actually showing them, their P.O.V. shots are done with a blood-red filter. When a trio of would-be rapists molest a young woman named Mayom (Narawan Nirattisai) in the woods after dark, a roaring, Bigfoot-like beastie—a guy in a glorified ape-suit—and a gargoyle-like reptilian humanoid (glimpsed in quick flashes via a green-tinted "night vision" optical effect) explode out of the bush to lay waste to the scumbags. As for their near-victim Mayom, she is taken to the monsters' cave hideout, where she has a too-close encounter of the third kind with a pair of bulb-headed humanoids, both naked (albeit with their naughty bits discreetly obscured). Mayom subsequent-

Above: 4 more shots from **UNHUMAN**. The 2 topmost pics show the alien-like "New Breed" clones

only seldom do we get a good (or at least a *better*) gander at any of them. Now, if this was one of those monster movies—without mentioning any names, we know there are *many* of this type!—where the filmmakers played coy with their critter and showed it as little as possible, all these teasy flash-glimpses of it would quickly grow annoying because we'd see it for what it was: a cop-out. But since this film's director Toranong Srichua really piles on his monsters thick'n'fast, there are so many of the suckers coming at us over the course of the runtime that not being able to make them out too well most of time isn't such a bothersome issue. Yes, in this instance it's a simple matter of *more* is more, as opposed to less! And, rather than being slow-moving—which makes some of those "peekaboo"/"now-you-see-me-now-you-don't"-type monster movies that much worse—**UNHUMAN** for the most part barrels right along at a decent enough clip that it never has time to get boring; for which it deserves major props/points! Hell, even the wrinkly-kneed (make that wrinkly *everything*!) critter costumes are lovable in their own clunky way, much in the manner that we love the work of such special makeup pioneers as Paul Blaisdell and their ilk (although those seen here are considerably more streamlined and less-complex than the archetypal Blaisdell designs [bless 'em!]).

A Google search in **UNHUMAN** turns up these images on someone's laptop

ly escapes from the monsters' cavern and flees through the trees, to be rescued by a squad of soldiers. Unfortunately, having been driven right over the brink by the shock of her ordeal, she is unable to provide the authorities with any information about what happened to her.

A fleetingly-seen six-titted (!) monstress—one of a number of the same species seen herein, if evidently played by male performers—resembles a hybrid of the Creature from the Black Lagoon and the Monster of Piedras Blancas (along with bits of just about any ten-thousand other critters you could name at random! [Including Bill Malone's Syngenors, for example]). In some scenes, the monsters resemble sleeker and more compact, faster-moving versions of It! The Terror from Beyond Space, which is far from a bad thing. How they appear onscreen largely depends on the lighting/editing (etc.) from scene-to-scene, as

My guess would be that Srichua is more than familiar with, if not necessarily those actual specific movies just cited in the preceding paragraph, then other similar ones, as well as critter pictures from other eras of Western cinema besides. I really like how he takes what he wants from more Hollywood sources and incorporates them into a Thai cultural context, intermixing elements of local folklore to give it a more personal stamp, rather than simply trying to slavishly imitate American product purely in the name of commercialism, as so many other filmmakers so often do, perhaps most especially when it comes to "formulaic" fantasy/horror fare such as this. Sure, some scenes are a bit too self-consciously "Hollywoodized" for my liking, but not enough to even come close to spoiling the viewing experience for me an iota. The main thing here is the energy and enthusiasm involved, which radiates from the screen in such a way that, if you're a dyed-in-the-wool monster maniac, you couldn't dislike it even if you wanted to (but why would you *want* to?!).

While economically-produced, **UNHUMAN** (cool title, BTW!) benefits immensely from being shot out in the untamed wilds of Thailand amidst authentic ancient ruins and rain forest. Although a rough-around-the-edges threadbareness caused

by the exceedingly lean budget does sometimes reveal itself, for the most part (not bad for a 108-minute movie) the film musters-up some pretty decent production values, and it definitely has enough cinematic qualities to make it qualify as a "real" movie. Periodic creative flourishes such as rapid-fire editing and "speed-up-then-slow-down" footage (for wont of a better term!) adds extra energy to the visuals. About the only time its budgetary restraints become obvious is whenever CG imagery is used; which, thankfully, isn't the case with the monsters, for the most part, although much of their scenes are heavily digitally processed so as to make them more difficult to discern too clearly. The fact that the wrinkliness of their baggy latex costumes is so obviously apparent even in these quick glimpses was more than likely why director Srichua opted not to overshow them; and in this case, the tactic works rather well instead of being irritating, as it is in so many monster movies. But while the quick edits and cutaways do their tactful best to avoid showing the monster suits too much, that isn't to say we don't get to see plenty of them, if only in sum total rather than on an individual basis. The high-speed shots of the inhumanoids taken from various distances and angles further add to the frenetic energy generated, and by the final fade we've collectively gotten sufficient looks at the brutes (there are only a few distinct species) to have a pretty good idea of their appearance. So it's all good.

"Yai Thong has them all under her black spell," a local Buddhist monk, the Venerable Bhikku (played by the suitably dignified Soranun R. Ekkawat), tells Insp. Bhichit. By this the holy man means not just the superstitious yokels, but also the escaped monsters too. As played by senior actress Phimpan Bhuranaphimp—albeit minus any cone-hat, hooked nose, broomstick or black cat (although she does have a cauldron of sorts)—the grey-haired/faced, greenish-lipped, black-toothed Yai Thong is pretty much everyone's standard conception of a witch. Getting

Big Love: Whilst the visually-inventive **UNHUMAN**, made with loads of TLC, thankfully uses all-practical SFX (*bless 'em!*) for the most part, there is plentiful non-intrusive digital manipulation of the imagery to be had; this largely done in hopes of obscuring/enhancing certain aspects of the loveably rubbery monster suits. **Top 2 Pics:** The mere flash-glimpse we get of this six-boobed, pouched "marsupial" momma-monstress in C/U effectively begins with a stark negative-image shot. **Bottom 2 Pics:** A quivering "vibrato" digitized optical effect not only blurs-out (some of) the monster suits' rough edges, but also injects extra energy into the energetically hyperactive unhumanoids we see going on the rampage for goodly portions of the movie. As far as monstrous action goes, highly talented director Toranong Srichua really manages to "get it up" (in-joke alert! [*nudge-wink*]) and keep it up for the duration!

Fang-Face: There seem to be bits of both "It! The Terror" and Don Dohler's "Nightbeast" in this dimly-viewed uglymug

progressively more crazed as the movie goes along, Bhuranaphimp really gets into her role, unleashing ear-piercing cackles and banshee-like shrieks of glee/rage whenever the (evil) spirit takes her. Her character (and what she represents [i.e., the "old ways"]) is the main link which connects this otherwise atypical new millennial Thai monster movie with those more traditional ones from Thailand's past. This wicked witch of the East (as with the teeming legion of similar witches to be found in Asian fantasy cinema) represents ancient black magic, whilst the mad scientists represent a much more modern evil power: that of "Science Gone Too Far!" (BTW, anyone remember the amazing Dictators song by that name? Well, the same applies here! Just to belabor the point further, here's some lyrical excerpts from it: *"Science gone too far! / How did you ever break the jar? / Science gone too far! / Maybe it hasn't grown too far / Don't let it die! / Its molecular structure is one-of-a-kind / It's a world gone haywire / Radiation only added the fuel to the fire! / Now there's a creature on the loose [...] / Innocent people have to die / As it grows, as it grows, as it grows and grows and grows and GROWS!"* Do pardon my self-indulgent digression! ☺) To continue, in **UNHUMAN**, these two seemingly diametrically opposite forces—the millennia-old dark arts and super-sophisticated modern technology—collaborate for the common bad, each exploiting the other for its own nefarious ends. Another equally traditional character in the drama is Ven. Bhikku, the wise Buddhist monk, whose unswerving goodness provides vital counterpoint to all the villains' badness; although he is not above feeling pity and empathy for the pathetic (quote) "new breed" of people (i.e., the big-domed, alien-like human clones). These benign, shy and retiring creatures—a male and his female mate—represent a higher stage of Man's evolution, and the venerable exponent of Buddha's teachings presumably identifies with this pair-bonded couple on account of their gentleness and beneficence. These pixie-eared, chrome-domed clones—or one of them, anyway—play a key part in the film's resolution which I shan't be revealing.

Mid-2000s Toronto Chinatown bootleg DVD jacket for **UNHUMAN**. (I know I shouldn't have, but at a mere 2 bucks Canuck, I couldn't resist buying a copy! ☺ ~SF)
[Scan c/o The Fentonian Institution]

Sadistic midnight skinny-dipper Dr. Willasinee rips the heart out of a monstrous peeping tom

But, as usual in a movie such as this, it's the scurvy evildoers whose antics we're mostly here for!

Speaking of which, not only was Yai Thong the cackling, rotten-toothed hag the rabble-rouser who instilled a terror of the evil beings in the townspeople in the first place, but she later treacherously actually leads the Unhumans in a massed attack on the community. At this point, the narrative detours into a classic "siege horror" situation. During this wickedly entertaining, dynamically-edited sequence, monsters crash'n'smash clear through the corrugated roofs and wooden walls of hut dwellings with the greatest of ease, yanking the guts out of people and generally making a major nuisance of themselves. Once again, the energy level runs high here thanks to constant motion and high-speed cutting (which somehow makes even the guy in the shabby Halloween rental gorilla costume come across as not just frightening but positively *terrifying*! All on account of the sheer dynamism and kinetics of the action). Amounting to one of the exuberant and exhilarating action highpoints of the movie—and there are quite a few of those to be had, believe you me—this memorable sequence shows one of the skinny pseudo-"It!" critters slaughtering an entire family (yep, young'uns an' all!) in about ten seconds flat—including slashing Mom's jugular open with its razor-sharp talons and crushing the kiddies' skulls in its jaws—before chowing-down on various bits and pieces of 'em, munching'n'crunching away like nobody's business while making the monster equivalent of nummy sounds (i.e., various satisfied growls, grumbles and gurgles). There are some other nasty surprises in store for you during this demented passage which I'll not breathe a word of, however much I might want to describe every last gruesome detail! (Hint: it involves quite a lot of meaty chunks.)

Elsewhere, during the sexiest sequence, complete with some tasteful T&A (accent on the "A" part!), Suthita Ketanont, the nubile/willowy Thai starlet playing Dr. Mun's partner-in-crime Dr. Willasinee (whose surname is spelled Virasini in the cast-list and that other way in the English subs), goes for a late-night skinnydip in a woodland pool, basically functioning as tantalizing live bait for the prowling nightbeasts. As she sensuously bathes herself under the moon's silvery glow, apparently having been attracted to the scent of female in the air, a pair of the easily-aroused male monsters shows up, only to get blasted-down with concentrated automatic weapons fire by Mun's mercenaries. At another point we learn that the unhuman beings were part-created using equal quantities of both the male and female doctors' genetic material, hence certain character traits of both of them— their sexual perversions included—were passed on to their monstrous artificially-birthed progeny,

Monster Mash!

thus explaining their abnormal sex-drives (which [*ahem*] come into play later on).

At around the movie's midway point, the man-made monsters break out of their cages *en masse* and run riot through the complex which has been their prison, leaving devastation and chaos in their wake, then make off to free-range it out in the surrounding countryside. Escaped lab specimens, such as pangolins, crocodiles, iguanas and snakes (the sources of "raw materials" used in the gene-splicing experimenters' creations) crawl about amidst the wreckage and remains—both human and unhuman—left scattered all over the shop during the monsters' savage rampage in the lab building.

Cinematography, fittingly enough considering the largely "all-natural" locations, is highly organic. There's some damned inventive camerawork going on here at times (despite such obligatory clichés as the ol' slowly strobing backlit ventilation fan motif first popularized by Ridley Scott in **ALIEN** [1979, UK/USA] and seemingly seen in every SF movie since). The ever-varying diversity of the visuals definitely does its bit to help hold our attention. For instance, in a scene where our main hero and heroine Bhichit and Narisara take deep breaths then submerge themselves in a nearby river to elude a pair of pursuing monsters (of the so-called "ruthless breed" the Venerable Bhikku told them about; the New Breed's dark downside), the camera peeks furtively up and out at their monstrous pursuers standing on the bank no more than 10 yards from them (if that), with water sloshing directly up against the camera's lens for real in the bottommost third of the screen. This adds immeasurably to the immediacy of the moment, instilling an exciting "you are there right in the thick of the action" dynamic. A lazier filmmaker would simply not have bothered with such a potentially tricky camera setup, so the effect is that much more special for it. A very nifty scene indeed! Not only does it cleverly allow the protagonists to escape from jeopardy—for the time being!—but it also further establishes their attraction for and ever-strengthening bond with one another; this because, while keeping their heads ducked under the water, his love interest Narisara runs out of air, so, romantically enough (!), our/her hero selflessly blows some of his own into her mouth…any excuse for a smooch! (You'd think all the bubbles they make about it might alert the monsters to their proximity, but the nasty buggers have already loped off further down the riverbank well out of earshot by then.)

Seeming like a whole lot more than that simply due to how things were shot and edited, the mere half-dozen-or-so performers playing the unhumans (whose all-practical special makeup was by Som-

phong Suwantha, from models created by Visit Sujitt & Team) do a fine job of convincingly coming over as ravening beast-creatures, variously loping, lurching, scurrying and bounding all over the scenery on cue. Interestingly enough, while we never do get a decent look at it—merely glimpses here and there—one of the multi-breasted she-monsters (evidently sprung from marsupial genes) carries a floppy-armed rubber baby unhuman around with her, its upper half showing outside the kangaroo-like pouch in her belly (this interesting aspect might have been one worth developing, but nothing is ever done with it). Another scarlet-colored specimen, this one apparently not possessing any epidermis, with its sinews/viscera exposed, kept reminding me of the infamous "living skinless corpse" in **HELLRAISER** (1987, UK, D: Clive Barker); although its flayed appearance certainly doesn't seem to bother it any.

As the subplot-stuffed story progresses, managing to stay fairly linear in its objective even while branching-off on different tangents from time to time, we gradually realize that things are by no means how they appear—although the monsters are all-too-genuine, thankfully enough. But here comes the rub…

"There aren't really any aliens," rightly deduces Insp. Bhichit, who's nobody's bitch, speaking to the monster-makers at the scientific research center which is at the core of the problem. "You're hunting for unhuman *[sic]* that escaped out of here." The so-called alien ship that came in along with the meteor swarm turns out to be nothing but a fallen hunk of space junk (i.e., the wreckage of an old NASA satellite called Firefox) that got knocked out of Earth's orbit. Yes indeed, this is one *twisty* plot, for sure! And surprisingly enough, unlike we've seen in a gazillion movies made here in the West, the government *isn't* behind the nefarious scheme to transform animals into humans. Instead, it's a strictly privatized endeavor of diabolical Drs. Mun and Willasinee/Virasini, who have their dirty fingers in every pie they can get them into, so it seems. In addition to the whole gene-splicing thing they've got going, they're also into both cloning humans *and* organ-harvesting for fun and profit too ("They clone people and then kill them! Take out their organs and sell it *[sic]* to rich people!" – "They kill one life to extend another life. That's damn despicable!" spits one of the hip young heroic faction in disgust). Hence, the potential for malpractice suits from interested parties seems unlimited! The ethicality (or *not*) of first creating then destroying clones after they have served their usefulness by providing much-needed replacement organs to suffering patients on long waiting-lists arises between blossoming lovebirds Insp. Bhichit and Doc Narisara. But when her pops Lt. Gen. Naris suffers near-fatal cardiac arrest due to the rigors of his job and it is determined that he needs a heart transplant ASAP, his daughter is morally conflicted as to whether they should resort to using a cloned/harvested one to save his life or not. Subplot is piled atop subplot ten-ply, yet, strangely enough, the narrative never really seems too busy or muddled; but without the better-than-usual subtitles to guide me, I likely wouldn't have had the slightest idea what to make of much of the "subtler" goings-on!

Critters galore!

Yai Thong makes for a pretty standard witch character, but her performer Phimpan Bhuranaphimp really throws herself into the characterization, further adding to **UNHUMAN**'s sizeable entertainment value

At around the 75-minute point, shortly following the monsters' savage slaughter of the villagers, **UNHUMAN** abruptly switches gears to become a balls-out/straight-ahead combat actioner instead! This when Drs. Mun and Virasini/Willasinee make a run for the Cambodian border and attempt to link up with a gang of bandits from on the other side of it. A posse of Thai soldiers in Humvees go in hot pursuit, sparking some excitingly-staged, explosion-filled battle action (while the lion's share of the explosions were genuine pyrotechnical effects, a non-intrusive few of them were computer-generated). Within minutes though, things get back to monster action again, with the creatures running wild on the battlefield, savaging anyone who comes within claw's reach and feeding on the corpses. Meanwhile, nearby, Mun and Willasinee get captured by their own unhuman "children", who take them back to Yai Thong's hideout. There they brutalize Mun and (non-explicitly) sexually abuse Willasinee, basically raping her half to death (*gasp!*). "I didn't create you for *this*!" screams Dr. Mun in outrage. "She's your *mother*!" In the aftermath of this, Yai Thong the unhumans' "adoptive grandmother" (so to speak!) demands that the geneticists create more of their kind, explaining, "I'll use my black magic to control them". Screeching and cackling up a storm, when confronted by the Ven. Bhikku, the benevolent Buddhist monk mentioned earlier, who calls her out on all her evildoings (and he also has mystic powers, natch), she threatens to turn the captive hero/heroine into obedient zombies, as she has done to the unhumans and her human followers before them using a herbal elixir for that purpose.

Things get good and crazy again during **UNHUMAN**'s destruction-and-chaos-filled climax, which I shall not spoil any of by revealing what happens here. Let's just say that, Dr. Mun, as with his Wellsian counterpart Dr. Moreau, gets forcibly invited to a blood'n'guts party in a (figurative) "House of Pain" of his own making; a literal world of hurt which all his pleas for mercy to the monstrosities he helped create cannot save him from...

I remember enjoying this a lot the first time I watched it back in the mid/late '00s. This is only the second time I've ever seen it, and I like it all the more now. *LARGE*, in fact. As more recent

Asian creature features go, it amounts to quite the hidden gem, even if it is such a diamond-in-the-rough. In fact, that makes it even more precious to me. That said, I shall say no more about it other than: see it at your earliest possible convenience!

NOTE: In closing, the following amusing short item of trashy tabloid news (i.e., gossip) was posted on May 3rd, 2013 at the Thai website Coconuts Bangkok (@ *http://bangkok. coconuts.co/2013/05/03/viral-video-thailand-%E2%80%99s-weirdest-erectile-dysfunction-ad-ever*). It concerns a minor controversy surrounding something which involved director Toranong Srichua ([or Sricheua] whose first name I've also seen transliterated as Thokranong [as on the DVD cover for the Triad bootleg of **UNHUMAN** that I picked-up in Toronto's Chinatown some years ago for a mere two bucks]). The piece is so amusing that, rather than bother rewriting its content myself, I decided to simply reprint it verbatim, copied-and-pasted over direct from said site (so sue me!). The only changes I made besides pointing out any spelling errors were adding in ellipses instead of periods at the paragraph breaks and removing the tabs/line-spaces between same. (Get ready to have a titter!):

"A TV commercial for erectile dysfunction medication re-surfaced online today and quickly became an object of ridicule in the Thai internet community... The ad's rediscovery owes to the actions of Maxim *model Amonwan Sirikittirat, 26, who recently made headlines by fileing* [sic] *a police complaint that let* [sic] *to the deportation of her boyfriend Howard Wang. Wang, a Taiwanese actor and singer who used to work in Thailand, was convicted of entering the kingdom illegally... Netizens conducted background checks on Amonwan and discovered that, in addition to two R-rated films, she had starred in an advertisement for Big Love with veteran erotic filmmaker Toranong Srichua. But what actually secured the advertisement's popularity was dark humor and low production quality. Poor acting skills and weird, irrelevant copy found their way into the mix as well... 'If I have time, I'll travel with a close female friend,' said 60-year-old Toranong. 'If I'm on a motorbike, I'll take her to the mountain. If on a speedboat, I'll take her to the middle of the ocean. If on a Cessna aircraft, I'll take her to either the far North or deep South'... Toranong's female companion in the ad is Amonwan, who tries to spicily kiss Toranong, yet appears self-conscious while performing the act."*

And now for one final note of slimly-related musical trivia: As far as death metal bands go, there's at least one (and possibly a score more) known as Unhuman, as well as another called Inhuman. Oh yeah, and let's not forget that fun black metal act of avowed Satan-worshippers called Unhuman Disease, whose recorded works include the *Black Creations of Satan* album (2009). On that note, I'm outta here! PS. And as of now (actually *eleven* words from now), the grand total word-count is 5,076!

Long Rider: Toranong Srichua, **UNHUMAN**'s director, in his infamous Thai TV commercial for so-called "Big Love" (!) erectile dysfunction medication. In this screen-shot, the spry sexagenarian has just finished tastefully "rolling over in the clover" with his roughly 55.5% younger co-star in the spot, local supermodel/*Maxim* babe Amonwan "Amie" Sirikittirat (who is said to have the biggest breast implants in all of Thailand!). The motorcycle is supposed to be "subtly" symbolic, in case you couldn't guess!

Sony's late '80s Japanese VHS jacket for **THE CROSS OF SEVEN JEWELS**

THE CROSS OF SEVEN JEWELS
(*La croce dalle sette pietre*, a.k.a. **CROSS OF THE SEVEN JEWELS**)

Reviewed by Dennis Capicik

Italy, 1987. D: Marco Antonio Andolfi

Outlandish yet sloppily slapdash in its crude approach to basic storytelling, first(-and-only)-time director Marco Antonio Andolfi's grubby urban "werewolf" tale is part-horror, part-*poliziesco* and ALL stupidity! As well as being virtually uniformly unappealing to look at, despite its overall aesthetic ugliness and many of its extremely glaring flaws, it remains strangely mesmerizing regardless; even if we do find ourselves watching it largely slack-jawed in amazement and incredulity at how off its rocker it is. Outside of directing the present film, Andolfi appeared in bit parts in tawdry low-level dreck the likes of Luigi Russo's **BLUE PARADISE** (*Adamo ed Eva: la prima storia d'amore*, 1978, Italy), so it seems quite odd for him to attempt helming an entire feature from a standing start. But much like the late, great Edward D. Wood Jr., he is also a bit of a "Renaissance man", who not only directs, but also acts, writes, edits and even undertakes the not-so-special makeup effects himself too! Was it a simple case of ambition overstepping ability? Or of ego overestimating talent? A wannabe filmmaker's act of sheer desperation and devotion to visualize his pet project, competence and critics be damned? *You be the judge!*

Commencing in a gloomy, red-lit dungeon, pastaland regular Gordon Mitchell (good ol' Chuck Pendleton himself, one of the true luminaries of zilch-budget Eurotrash cinema!) is overseeing a lowly—and decidedly non-erotic!—satanic mass in the hopes of resurrecting his sect's demonic deity, known as Aborin. As his black-leather-S/M-gear-clad followers flog and grope each other ("Rip me to shreds!"), Mr. Mitchell grows increasingly excited ("*Aborin!* We are your slaves!" he cries. "Come and take me!"), but then one of the women—or so it seems, anyway— shortly becomes transformed into some sort of shaggy-haired, gorilla-type monster (that at one point makes Wookie-type sounds!) which, we rightly assume, can only be Aborin…*reborn!!*

Abruptly and rather confusingly, the action jumps to sunny Naples-by-the-sea, where our self-ap-

pointed/styled star/hero Marco Sartori (director [etc.] Andolfi, hiding behind his "Eddy Endolf" [!] pseudonym) is having a prearranged meeting with his long-unseen cousin Carmela; a touching scene which, for some strange reason, is cross-cut with a beachside heroin deal—transacted by some decidedly miscast "actors"—that is observed by Mitchell as he grins for the camera (which, other than for a few lines of dumb dialogue, is about all he really does throughout; variously glowering, grimacing and mugging directly into the lens, often in extreme foreshortened close-ups that emphasize his chiseled chin). While the newly-reunited cousins are strolling through the streets in a bad part of town casually chatting about the sorry state of crime-infested Napoli ("Naples is a *mess*!"), Marco—who always wears it around his neck, for "sentimental" reasons (*not!*)—has the title gaudy jeweled silver cross (a special prop "vital" to the plot) snatched by one of a group of purse-snatchin', motorcycle-ridin' *scippatori* ("thieves"). Standing idly by, some members of the local populace who witness the crime react accordingly ("So what *else* is new!" one says apathetically. "It's like a national pastime!"). When the police arrive, in spite of the fact that Marco evidently can't tell a dirt-bike or a moped from a motor scooter while explaining what happened, they nonetheless help track down the thieves. However, his pilfered cross still remains MIA.

And then, in a surprising revelation, the woman whom he *thought* was his cousin actually turns out to be her ex-roommate Elena, an imposter who has since headed off to Milan (unbelievably, his genuine cousin Carmela nonchalantly explains away her former roomie's actions as merely her idea of a joke, without any further explanation than that!). Upon tracing Elena's whereabouts to a seedy Milanese nightclub thanks to a tip-off, Marco meets chain-smoking, pot-dealing bar floozy Maria (the still-cute Annie Belle), giving a pleasingly earnest and fairly believable performance), but is soon harassed and eventually extorted by the club's solitaire-playing owner (Andrea Aureli) to provide the mob with a banking list of his employer's "fattest poultry" (i.e., richest clients). Apparently, Marco is a banker, or at least some sort of bank employee with access to privy information; not that this particular angle of the plot ever goes anywhere beyond this one scene, that is. After having the crap beaten out of him in one of the most poorly-blocked-out "fight" scenes ever seen onscreen—ending with the star, who also served as his own stunt stand-in on the shoot, taking an inglorious (and hilarious) face-flop onto a breakaway wooden table, that collapses under him instantaneously, like a house

Naked weirdwolf alert!

of cards!—Maria comes to his aid and helps him try to locate his precious jeweled cross (because "It's a matter of life and death!"). All in a panic, Marco accosts a lowlife, ornery fence ([Piero Vivaldi] "*Calm down!* You're makin' my ulcer do *somersaults*!"), demanding that his valuables be returned to him. But yet again, his pinched pendant is nowhere to be found. Right as the clock strikes midnight, the old crook gets to witness firsthand what happens to Marco if he isn't wearing his cross: he changes into something not entirely human, which may—or may *not*—be a werewolf: consisting of an overstuffed furry pelt on his head and some hairy mitts. Not only does this "wolfen" mask end at his upper lip, leaving his entire lower jaw bare, but nobody even thought of at least sticking a set of cheap plastic fangs in his gob to give him a slightly more monstrous appearance, an oversight which is especially conspicuous for the simple reason that he grins and grinds his teeth in close-up so much. Other than for his fuzzy mask and mittens whilst in his "transformed" (!) state, he goes around completely naked (his candidly-bared [*ahem*] "male unit" thankfully digitally blurred-out on Japanese video). In a completely *bizarro* bit of nonsense, he telekinetically (?) melts the fence's face into a pile of goop, making for a pretty well-done and quite disgusting effect which definitely grabs your attention, even if it is obviously just a wax mold of actor Vivaldi's head being melted with an out-of-frame blowtorch.

Then, in another astonishing bit of mindless madness, the film features an almost five-minute sepia-tone montage of clips from past and even future (?) scenes, all jumbled together in no particular order whatsoever, which may include some possible clues as to Marco's curse, for those who can be bothered trying to figure out such cryptic symbolism as Andolfi (who also served as his own editor, don't forget) evidently hoped

this surreal sequence should contain. Maybe it was all only a dream (read: nightmare!) but, like the rest of the film, none of it is ever made very clear at all…assuming Andolfi or anyone else on this slipshod poverty row production even knew themselves! Anyway, with the help of his devoted new squeeze Maria, who fell for the blandly handsome Marco like a ton of bricks at first sight, he travels back to Naples—accompanied by typical travelogue footage of local landmarks, including the famous Castello d'Ovo ("Castle of the Egg")—and begins to weave his way through further encounters with low-level criminals. His quest leads to Don Raffaele Esposito, a powerful but paranoid Camorra boss, who believes Marco may be an undercover cop out to book him for any number of his many crimes. After much "brutal" interrogation, Marco just about wipes-out the don's entire syndicate when he once again—this time courtesy of an agonizingly *slo-o-owww* "time-lapse" sequence in which he sprouts no more than a few months' worth of facial hair, tops—transforms into the naked werewolf-man to go on another "terrifying" tear. In yet another curious bit of plotting, we learn that Esposito had actually gifted the stolen cross to his mistress in Rome, a medium/fortune teller better-known as "Madame Amesia, the Sorceress" (played by brunette sexpot Zaira Zoccheddu, who the year previous had appeared in the sleazy shockumentary **MUTANT SEXUAL BEHAVIOUR** [*Noi e l'amore – comportamento sessuale variante*, 1986, Italy: Antonio D'Agostino]. Her modest career evidently stopped short after the present

All hail Aborin—the wooly wookie/gorilla demon from hell!

film…as did its mastermind Andolfi's too, come to think of it).

In case you couldn't tell already from the above description, this is undoubtedly one of the *stranger* "werewolf"—*if* you can call it that!— movies ever conceived (if that's the right word for it), and although he's never referred to as a werewolf per se, the randomly interspersed stock shots of moonlit dogs and other such random genre tropes certainly point in that direction. Plus, Andolfi's attempts in his role as SFX wiz (especially the hairy, clawed paw shown in close-up more than once throughout) definitely do seem to have been "inspired" by Jack P. Pierce's/John P. Fulton's work on Lon Chaney, Jr.'s *Wolf Man* movies. That said, the single transformation scene shown in **TCOSJ** passes like molasses, without ever really changing Andolfi the actor's appearance very drastically or dramatically. But, even if he did lack the technical skills necessary to make a proper job of it, at least his heart seems to have been in the right place.

For "all" (note quotes) his seeming werewolfishness, however, this curse (a result of black magic) is never passed on to anyone through his bite, and the mere wearing of titular cross is the (quote) "antidote of evil" which prevents him from transforming; hence the reason why he becomes so frantic to get it back after it is stolen from him. It's also suggested that Marco is the actual offspring of Aborin, the furry gorilla/wookie-monster, who, in yet another of the film's barely-coherent flashbacks, first causes Marco's mother's face to distort via minimalistic bladder effects, then makes her stomach telepathically swell and explode as he growls (the only time that he ever actually speaks), "*Slut!* You think you can command me to go! You must *die*! You're coming with me to *hell*!" Already utterly baffling enough, the film becomes even *more* confusing towards the end when Gordon Mitchell, as some sort of Satanic High Priest, randomly appears in the middle of the road as a ghostly apparition to "torment" (i.e., mug and leer at) Maria while she races by car to help Marco, who, once again, succumbs to his dreaded curse. In yet another completely delusory moment, Marco attempts to get his cross back from Amesia, who seems more like a common

Right, Top to Bottom: At the stroke of midnight, if poor Marco isn't wearing **THE CROSS OF SEVEN JEWELS** to prevent it, *this* happens…

prostitute than a medium as she parades around her bedsit apartment all dolled-up in cheap lingerie (she purrs invitingly, "Since we *do* have some time on our hands…"). Upon being coerced into sex, right in mid-coitus—which is heavily-pixelated for censorship purposes—Marco transforms into the naked werewolf and, while humping away at her in a highly unconvincing manner which even the thick digital censorship can't obscure, he (*GULP!*) violently rapes her to death while drooling foamy white goo onto her face, leaving her crotch area a bloody mess afterwards. And there's aging starlet Zoccheddu lying under him acting like she's in a porno movie or something! (The scene is pretty pornographic at that, made more-so by the heavy pixilation, which makes things appear all the sleazier, although the original footage was obviously only softcore in explicitness.) Whereas if this sequence had been done with any degree of realism it might be more than a little disturbing, it's all so ridiculous and ineptly-staged that it's impossible to take seriously. Instead of being shocked, we're left shaking our heads in bemusement at the utter lunacy involved.

Barely released anywhere—*big shock!*—including even in its native country Italy, **THE CROSS OF SEVEN JEWELS** is the demented brainchild of Andolfi, whose heart was certainly in the right place, but unfortunately his enthusiasm far outweighed his skills as a filmmaker. Similar in basic concept to Paul Naschy's tormented werewolf character Waldemar Daninsky, both Andolfi's performance and film are a *far* cry from Naschy's often melancholically poetic werewolf sagas. Like Naschy, he appears in just about every scene, and likewise has no trouble bedding the ladies, but he is certainly *not* leading man material, unlike Naschy, who had his own special brand of charisma which appealed (and still continues to appeal) to a broad fanbase, perhaps now more than ever before, even in his heydays. As dubbed by prolific voice actor Ted Rusoff, the comparatively uninteresting and non-charismatic Andolfi appears suitably awkward throughout; like a lost child in the city as, with boyish idealistic innocence, he desperately searches for his lost cross throughout Naples, Milan and Rome, sticking out like a sore thumb while associating along the way with various seedy underworld types. In this regard, the narrative almost plays-out like some peculiar late-entry *poliziesco*. Inexplicably, a token *commissario* even figures into the proceedings as he half-heartedly investigates the bloodless "massacre" at the Camorra compound; but like everything else here, it rapidly goes nowhere, and fast.

Face Off! Witness the telekinetic meltdown of the underworld fence (Piero Vivaldi)

Here continuing her string of Italian films, which also included Joe D'Amato's **ABSURD** (*Rosso sangue*, 1981, Italy), pretty French actress Annie Belle (a.k.a. Annie Brilland), is probably best-remembered for her role in Jean Rollin's **LIPS OF BLOOD** (*Lèvres de sang*, 1975, France [see p.179]). Much like her character herein, the not-untalented, naturalistic actress seems thoroughly mystified by everything in the film, but she admirably manages to keep a straight face in scenes opposite her onscreen wolfish true love Marco (good thing too, as we don't imagine that many retakes were permitted on this virtually *lire*-less shoot!). Some of her "name" co-stars—including Gord Mitchell, Andrea Aureli and even ex-leading man Giorgio "George" Ardisson as a badass *capo dei capi* in the Sicilian Mafia (a part which he performs with great assurance and competence, it should be said)—aren't given much to do. Although, by this point in their careers, a state of affairs in large part attributable to the severe nosedive the Italian commercial movie industry took *circa* the mid-'80s, they were all more than accustomed to appearing in low-level junk like this. And that's actually as surefire an advance indicator as any of this flick's cut-rate origins…so, if you glanced over the cast list prior to watching, you can't say you weren't given ample warning.

Domestic DVD cover art

At one point, the passed-out Andolfi, upon coming to face down on the cobblestones after going off on one of his hairy tears the night before, exclaims groggily to Annie Belle, "Something *horrible* happened!" Did it ever! **THE CROSS OF SEVEN JEWELS** is, fittingly enough, a mind-boggling foray into the absolute lowest echelons of Italian cinema and is, quite possibly—and this is sure saying something!—one of the absolute WORST Italian horror films you're ever likely to encounter…so that's just *got* to be some sort of recommendation, right?

ZARKORR! THE INVADER

Reviewed by Brian Harris

USA, 1996. Ds: Aaron Osborne, Michael Deak

Monster Island Entertainment's trailer narration: *"Tommy Ward was an ordinary postman. Until an incredible creature appeared, changing his dull life forever. Now, it's up to Tommy, a beautiful cryptozoologist, a mad scientist—and a little luck—to find a way to destroy it. Citizens of Earth, BEWARE! …And get ready to meet **ZARKORR! THE INVADER**! …Stomping, smashing and crashing to Earth!"*

Mt. Aurora, California: *AVALANCHE!* Or… *not…* When the side of the mountain comes down, a massive, 180-foot-tall reptilian creature emerges from flames, then proceeds to stomp, smash and crash its way through the small mountainside town of Aurora Valley.

Elsewhere, Tommy the postal worker (Rhys Pugh, billed hereon as "Rees Christian Pugh") is visited by the holographic image of a tiny, extraterrestrial teenage girl, Proctor (Torie Lynch), who notifies him that he's been specially selected to be Earth's champion and defeat the monstrous Zarkorr. But before he can prepare for battle, he must know these three things:

1. Zarkorr *cannot* be defeated. Not by any earthly weapons available. In-development or otherwise.
2. Zarkorr is targeting Tommy. He *cannot* hide from it.
3. Use whatever resources you can find to defeat the undefeatable monster.

Having finished offering our soon-to-be hero these three tips, she grants him a cryptic nugget of advice, "Zarkorr contains the key to his own destruction".

Title card for **ZARKORR!**'s Japanese video release as 巨大怪獣ザルコー ("*Huge Monster Zaruko*")

Feeling a bit crazy, and not knowing what to do, Tommy makes his way to the local TV station, where he attempts to convince a cryptozoologist (Elizabeth Anderson) to help him; understandably enough, she assumes he's crazy. Out of desperation he takes her hostage in order to force her assistance. Along the way he picks up the assistance of a police officer, a wheelchair-bound hacker and a few simple town folk.

Can an odd metallic object found smashed into a building in Arizona be the key to stopping Zarkorr and his reign of destruction? *Maybe…*

It's funny, when I sat down to re-watch this film, I kept wondering why I couldn't seem to remember anything about it. When Zarkorr bashes his way through the side of the mountain, I was like, "*Right on!* This looks like fun. I don't know how I could have forgotten this". Then the film started in earnest (if that's the proper word for it), and I remembered why I'd so thoroughly forgotten this production…it was nothing but "blah-blah-blah", with very little monster action (a grand total of about five minutes).

Don't get me wrong, there's nothing really at fault with the crazy characters and performances, only there was *so much* talking going on here, I kept asking myself just *who* it was that Charles Band & Co. we're targeting with this film. Certainly not kids, as it's highly unlikely many of them would have sat through this amount of tedious inaction. *Adults?* Perhaps, but the dialogue is so inane—at times feeling improvised—I have a hard time believing most grown-ups would have found this silliness entertaining. So just who is **ZARKORR! THE INVADER** for…?

Now, I'm sure the budget was low on this, so it's totally understandable that they would try to keep the rubber suit and model city scenes to a minimum. I mean, once you smash most of that mini-city, if you don't have a bigger budget to build a few more backup city sets, you're pretty

Special **Z!** video lobby card #5 out of a set of eight

much *kaput*. Cool. But why not shoot a buttload of footage for cut scenes of Zarkorr swinging his arms, shooting his eye-lasers and mugging for the camera? How about Zarkorr being pegged with bottle-rockets getting shot out of model tanks? Or bottle-rockets being launched from water, maybe? Why would you just fill the film with near non-stop *chatter*?!

As far as the acting goes, it all worked well enough. Some of it goes waaayyy over-the-top, but it's nothing you haven't seen in an episode of *The Mighty Morphin Power Rangers*. De'Prise Grossman was fun to look at, and Rhys Pugh does a good job of playing the terrified, reluctant hero, but the film started stretching my patience with the Bible-spewing police officer and jabbering/cackling madman hacker. All of it was seemingly played straight-faced; which is appropriate, considering the fact that none of it was actually *funny*.

The true star of **ZARKORR! THE INVADER** is—as it should be—Zarkorr himself; unfortunately, we just don't get *enough* of him to satisfy our *kaijū* craving. For a man-in-a-rubber-suit monster movie produced by Full Moon/Charles Band for his Monster Island imprint, you'd think they would have placed their star creature up-front-and-center for a good portion of the film. Unfortunately however, that simply isn't the case here, and this really brings it all the way down from being "just tolerable" to "incredibly tedious".

Now, don't let my negative review scare you away from checking it out, as sometimes you just have to get your hands dirty and experience bad cinema for yourself. If you're interested enough in this film to purchase it, through their website Full Moon is currently offering a 3-disc box set entitled *Mega Monsters* (@ $19.95), containing **ZARKORR! THE INVADER**, along with **KRAA! THE SEA MONSTER** (see my review below) and a self-promotional Full Moon clip-comp entitled **MONSTERS GONE WILD**. This compilation consists of *three straight hours of* clips from 18 different Full Moon features, featuring all of their best monsters. Not a bad set if you're a fan of all three of these productions, or FM fare in general. If you can't justify paying $20 for them, a quick search on Google reveals a few places you can pick it up from for as low as about ten bucks. If that's *still* too much, you can always catch **Z!** streaming on Full Moon's Roku Channel instead.

NOTE: Not only did he supervise the SFX on **Z!** and served as its co-director, veteran FX man and frequent monster suit performer Michael "CEL-

Best Shot: Yankee *daikaiju* wannabe **ZARKORR!** tries his darnedest to make like a real one

LAR DWELLER" Deak may (?) even have donned the Zarkorr costume herein too.

KRAA! THE SEA MONSTER

Reviewed by Brian Harris

USA, 1998. Ds: Aaron Osborne, Dave Parker

Two years after Full Moon's Monster Island imprint releases the woefully disappointing **ZARKORR! THE INVADER** (1996 [see above]), along comes more low-budget *kaijū* action c/o FM/MI. This time around, we get less talking, more monster destruction, a goofy "Italian" alien and a *Mighty Morphin Power Rangers*-style group of heroes—albeit *sans* their *sentai* "morph" outfits—that go by the name of Planet Patrol. **KRAA! THE SEA MONSTER** is definitely more geared toward the tweens and, in my opinion, is considerably more entertaining than **ZARKORR! THE INVADER**, though it's not without problems of its own.

Deep within a dying universe lies the planet Proyas, a dead world which is used as a hideout by the galaxy's deadliest villain, Lord Doom (Michael Guerin, later to be seen in the *Power Rangers Time Force* series [2001, USA], aptly enough). Not content to sit around while his planetary prison gets colder, he commands his diminutive henchman Chamberlain (Jon Simanton, from **TURBO: A POWER RANGERS MOVIE** [1997, USA]) to send one of the biggest, baddest planet-wrecking monsters down to Earth to rid our planet of its teeming inhabitants; this in or-

Heads up, Mr. Puppet Dude, **KRAA! THE SEA MONSTER**'s right behind you... (Uh-oh, too late)

der to make it more livable for the intergalactic supervillain and his crew. With Kraa (whose suit was largely worn on the film's shoot by John Paul Fedele) on his way, Lord Doom seemingly has it in the bag. Or *does* he...?

The unauthorized transporting of the monster Kraa through space towards our solar system doesn't go unnoticed, however. The aforementioned intergalactic police force known as Planet Patrol (Stephen Martines, Alison Lohman, Anthony Furlong, Candida Tolentino) has picked it up on their sensors, and plans to launch an interception mission. Unfortunately for them, Lord Doom had foreseen their meddling, so he launches a devastating attack on the PP's station. Now fully incapacitated and facing imminent destruction, the Planet Patrol sends out an emergency transmission to Agent Mogyar (J.W. Perra, from Full Moon's **HEAD OF THE FAMILY** [1996, USA, D: "Robert Talbot"/Charles Band]) to intercept and destroy with extreme prejudice.

When Mogyar crash-lands his ship right in the middle of a small-town diner, he attracts more than just the attention of diner owner Alma James (Teal Marchand) and burly biker patron Bobby Machen (R.L. McMurry), he also attracts unwanted attention from a special military group that has tasked with hunting aliens; all three are quickly detained by this group.

With Mogyar's presence on Earth revealed to Lord Doom, Kraa is given new orders: find and exterminate Mogyar before he can put together the necessary resources to destroy *him*. Now, Bobby and Alma must join forces with Mogyar to defeat Kraa...or else mankind will be totally annihilated! (Oh, and Planet Patrol are in peril as well, but, yeah...)

KRAA! THE SEA MONSTER is watchable, and at times entertaining. It's no worse than your average giant monster episode of *Power Rangers*, so if you have a high tolerance for cheap *tokusatsu*, *kaijū* and *kaijin*, you may find it a reasonable enough watch. For me, some of the worst things about this production are its most endearing, I think. For starters, the acting was pretty damn bad, especially from Stephen Martines, as Capt. Ruric of Planet Patrol. Ouch. The rest borders on bad-TV-for-kids-type acting; the kind you might have seen in *Big Bad Beetleborgs*, *VR Troopers* and the oft-aforementioned *Power Rangers*. It's all tolerable enough, and doesn't get quite as "doinky-doinky-doink" as the above three kidvid examples just-cited, but this aspect is noticeable and memorable enough (for all the wrong reasons) to

make you think twice about ever sitting through **K!** again.

Another issue I had was Mogyar, the alien agent. The reasoning behind his Italian accent was explained, cool—but, man!—the whole, "Hey, they-a put-a me under arrest-a, badda bing badda boom" thing just isn't at all endearing. I'm sure today, someone somewhere would take major offense at this. Me, I was just *annoyed* by it. It's the *little* things, right? (It's *always* the little things!)

In a *kaijū* movie, it's (meant to be) all about the *BIG* things, though. We want a cool-looking badass that wreaks havoc on wonderfully-constructed miniature sets. We want explosions, fire, crashing vehicles, and loads of screaming...all of which we *got*! Now, I will say, they could have sorely used some cut scenes of people shrinking/shrieking in terror, covering their eyes, fleeing and even preparing to get crushed (etc.). However, the conspicuous absence of human victims left me feeling a bit empty and dissatisfied, but it was made all better when Kraa unleashed his force-ray on a passing train. *Nice!* Considering the budget, which was undoubtedly low, Kraa looked cool. Only don't expect much in the way of facial articulation, as his jaw remains slack throughout the film. He looks a bit like a cross between the mutated salmon of **HUMANOIDS FROM THE DEEP** (1980) and the imitation "Creature [from the Black Lagoon]" in **THE MONSTER SQUAD** (1987, both USA). Only...*sillier*.

KRAA! does its best to wrap things up neatly, but some of the loose ends feel rather—*well*—grim, to say the least. With Alma knocked unconscious and in custody and Bobby seemingly electrocuted to death, one wonders whether you should be cheering or mourning. Sure, Planet Patrol and Mogyar do their thing, but what of the mere mortals that helped them? No damn idea, they just leave those particular loose ends hanging. *YARGH!* Perhaps the ultra-cheapo cut'n'paste sequel **PLANET PATROL** (1999, D: Russ Mazzolla)—featuring snatched sequences from the Band/FM properties **CRASH AND BURN** (1990, D: Charles Band), **SUBSPECIES** (1991, D: Ted Nicolaou), **DOCTOR MORDID** (1992, Ds: Albert Band, Charles Band) and **ROBOT WARS** (1993, D: Albert Band)—fills us in? Hmm...yeah, I highly doubt it too, even if Teal Marchande *is* credited in it.

Can Americans make Kaijū? The answer is a resounding "YES!" Can they make it/them *well*? Eh...how about you decide for yourself. **KRAA! THE SEA MONSTER** is currently available on DVD, so why not give it a shot.

Top & Center: Kraa does what any self-respecting giant monster would do: busts shit up! But with that constant smile on his face, you just know he must love his job. **Above:** The well-worn original Kraa suit is on sale at Monsters In Motion (*www. monstersinmotion.com*) for a mere $1,400.00—not bad for a chunk (okay, a li'l bitty smidgen) of American mock-*daikaiju* movie history!

Spooky web-based promotional art for
CHUDAIL STORY

CHUDAIL STORY

Reviewed by Kinshuk Gaur

India, 2016. D: Surya Lakkoju

Director Lakkoju makes it easy for his audience to identify the evil in his film: **CHUDAIL STORY** translates as "Witch's Story" (as *chudail* means "witch"), and the *chudail* is one of the most popular female ghosts/monsters in all of Indian cinema. There are countless folklores in our traditional culture which deal with this evil creature, much like the West has its vampires. Similarly, using *chudail* in the title of a film is much akin to using Dracula's name in a Western film: as an Indian, you are instantly aware that the film will be in the horror genre. Until now, the best movie ever made about a *chudail* has been **VEERANA** (1985, Ds: Shyam & Tulsi Ramsay *[see* Monster! *#31 {p.7} for Kinshuk's and Tim P's detailed joint review of this classic Bollywood monster movie – ed]*).

Sadly, Lakkoju has *not* kept up that tradition...

As the film opens, we see the gorgeous actress Preeti Soni as the titular monster. She walks the earth under the guise of a human female by the name of Sashi Rekha, and she kills young men to remain young forever. Just in the credit sequence alone she kills three young men, luring them to their demise by using her sexuality to ensnare them. As happens so very often in many Indian horror movies, five friends find themselves stuck out in the middle of the jungle when their car breaks down.[1] The group abandon their vehicle and decided to take shelter in a house nearby, where they will ask if they can use the phone to call a mechanic. Just prior to knocking on the door to see if anyone is home, an old man approaches them. He warns the "kids" that a witch lives in the house, and that she kills young men to stay forever young.

As per this type of film, the friends laugh at the old man, ignoring his warning, then approach the house. Here we see sexy Sashi, a.k.a. the *chudail*, greeting the visitors.

Over the course of the time that Sasha tries to seduce the two main male protagonists, Robbie (Amal Sehrawat) and Goldie (Sorab Rajpurohit), strange things begin to happen to the group. Goldie is shortly found to be missing, and Chandu (Akash Rathor) sees Robbie murdering Goldie. But does he *really*..? When the rest of the gang investigate the murder scene, they find nothing. The sinister air of mystery increases as the plot thickens, and people begin to die one by one...

By the film's conclusion, Robbie turns on the rest of his friends,[2] and, under the *chudail*'s influence, he kills them off... with the exception of Devika (Nidhi Nautiyal), with whom he is in love. Because Robbie is unable to kill her, she is able to escape the compound, leaving him and the rest of her (dead) friends behind with the monster. The movie ends with a rather clever scene showing all the people who have been killed by the *chudail* hanging on the wall of the main room, pinned there by magic, with the witch regarding/admiring their corpses.

Good writing has never been a strength of Indian horror films. The screenwriters love being hackneyed with their work. In my opinion, Lakkoju broke one of the primary rules of most horror movies worldwide: you should scare your audience by *avoiding* exposing the face of the ghost; for there is always a greater fear of the unknown. But that as a concept hasn't penetrated well into the psyches of Indian filmmakers. **CHUDAIL STORY** does not

1 Protagonists experiencing automotive problems is a classic trope of Indian cinema: your car breaks down just outside of some spooky mansion, and a monster decides to stalk your party; come to think of it, that seems to be a classic situation in just about *any* country's horror cinema!

2 I could give a "Spoiler Alert!" at this point in the review, but, honestly, how many people besides Tim Paxton will actually watch this film...and I am sure *he* saw it coming, anyway! *[I'm planning on giving it a watch, Kinshuk! Even if it doesn't sound too impressive, there's a lovely English-subbed, widescreen, HD copy of it on YouTube, so who can resist?! ☺ – SF.]*

have its protagonist possessing a ghostly face (either by makeup or a mask); instead, Lakkoju tries to intensify the drama amongst the people stuck in a horrible situation with a mysterious *chudail* lady...but he fails miserably!

Atmosphere is the most important thing for any horror movie, and this movie does *not* give you any chills or goose-bumps. There is nothing in the way of artistic cinematography, nor does the director bother to create any sense of the foreboding whatsoever either. There is no difference between daytime or night; everything about the film is just flat and dull.

The less said about the acting the better, but I should say *something* about it, I suppose: Preeti Soni (who portrays the main character with such levity) looks beautiful enough, but—really, honestly—she can't act worth a *damn*! This is her second movie after having starred in Aron Govil's 2011 Hindi remake of **PRETTY WOMAN** (1990, USA, D: Garry Marshall), entitled **U R MY JAAN**. The rest of the cast here are unknown faces, and their acting is forgettable. The only other recognizable face in the movie is Pankaj Berry as the mechanic who shows up to fix the gang's broken-down car. He manages to ham it up throughout his total three minutes of screen-time, before he too is killed by the witch. Berry is well-known to Indian TV audiences, and also acted in two episodes of the Ramsays' late '90s series, *The Zee Horror Show*.

Preeti Soni as **CHUDAIL**'s witchy ghostess, hungry for men and their vital—*uh*—essence

a lively WWII pre-credits sequence—settling us into 1973 by the time the director's credit pops up—joining the narrative proper just as the evacuation of Vietnam is underway. "We didn't lose it, we *abandoned* it," Lt. Col. Preston Packard (Samuel L. Jackson) says early on, setting-up his character neatly in just one line: now, here's a man in *need* of a war! True to its own establishing setup (and to the **APOCALYPSE NOW**-like poster design (see below) gracing one of its nifty

KONG: SKULL ISLAND

Reviewed by Stephen R. Bissette ©2017

USA, 2017. D: Jordan Vogt-Roberts

No, it's *not* **KING KONG**—the era of explorer-filmmakers is well behind us now—and while Jordan Vogt-Roberts/Dan Gilroy/Max Borenstein/Derek Connolly/John Gatins' **K:SI** finally offers a cinematic Skull Island worthy of the 1933 original, exploration isn't the *modus operandi* of this movie. This Skull Island is cool as hell, and we *do* see a lot of its flora and fauna, but we don't get to explore it; not even Frank "Bring 'Em Back Alive" Buck-style exploration, the imperative that fueled real-life-explorers / adventurers / filmmakers Merian C. Cooper and Ernest Schoedsack to make **KING KONG** (1933, USA).

No, **K:SI** is actually a *war* movie, but it plays that card right from get-go. The film opens with

One of a whole series of posters designed to promote the release of **KONG: SKULL ISLAND** (2017)

Much as **TARZAN THE APE MAN** (1932) had its elephant's graveyard, so does **SKULL ISLAND** have a skeletal graveyard of its own, and Lt. Col. Preston Packard (Samuel L. Jackson) makes of it a battlefield when he ignores the advice of WWII survivor Lt. Hank Marlow (John C. Reilly): "I've only been here *28 years*—what do I know?!"

promotional images), **KONG: SKULL ISLAND** is, first and foremost, a war-adventure/monster movie. Simply put, it is *the* greatest DC Comics "The War That Time Forgot" movie made to date!

The US military has been dealing with dispatching prehistoric monsters since at least 1899 (i.e., in Wardon Allan Curtis' "The Monster of Lake Metrie" [*Pearson's Magazine*, September 1899], which also boasted a brain-transplant—from human-to-plesiosaur, no less!—and Hollow Earth theory among its virtues), so **SKULL ISLAND** is tapping into a grand tradition, though most *Monster!* readers will perhaps associate it with Edgar Rice Burroughs' first Caspak/Caprona lost-world opus *The Land That Time Forgot* (1924) and the Amicus film adaptation of same (1974, UK/USA, D: Kevin Connor). What was glorious to Silver Age comicbook readers in Robert Kanigher, Ross Andru and Mike Esposito's *Star-Spangled War Stories* "War That Time Forgot" G.I.'s-versus-dinosaur adventures (including a **SON OF KONG** riff: a giant white gorilla figured in some instalments) usually boils down in cinematic terms more to the likes of **UNTAMED WOMEN** (1952, USA, D: W. Merle Connell) and **DINOSAUR ISLAND** (1994, USA, Ds: Fred Olen Ray, Jim Wynorski) type fare... but no, I'm *not* damning **KONG: SKULL ISLAND** with faint praise here!

Now, I saw **K:SI** with a best friend who *loves* the original '33 **KING KONG**. He wasn't happy with the present film, overall. Given the disappointment my screening *compadre* had with the film, I must offer a few caveats:

Firstly, nobody believes me when I say it, but I truly try to see every movie with *no* advance expectations. *[I actually try to do much the same myself, but it's such a hard thing to manage, especially these days, what with all the ever-more-oversaturated media hype! – SF.]* I wasn't joking when I said to manager Chad Free at the Springfield Cinema where we saw this that my *only* expectation was "There *better* be a gorilla in it!" Truthfully, that was *it*. I genuinely had zero expectations going into this; I'd avoided every single trailer, every single teaser, article, blurb; I'd seen and read *nothing whatsoever* about it. I try to watch movies on their terms, savor what they *are*, instead of fuming in my seat over what they *aren't*. This allowed me to enjoy **K:SI** absolutely for what it is. (Read on!)

So, again I say—**KONG: SKULL ISLAND** *isn't* **KING KONG**. **KK** was born from early 20th Century adventurers exploring remote corners of the planet. This imperative gave the original **KONG** its driving passion, its pace (I can *still* hear Max Steiner's urgent "trek-through-the-jungle" music underscoring even **KK**'s quiet passages), its need to see what's lurking behind the next tree and over the next ridge—which contemporary SF/adventure movies simply *don't have* anymore. (Animation sometimes does: for instance, Studio

Ghibli's **THE RED TURTLE** [*La tortue rouge*, 2016, France/Belgium/Japan, D: Michael Dudok de Wit] was *all about* the exploration, even if only of a confined island space.)

In **K:SI**, there's no exploratory factor, really; the ruse of exploration is proffered by monster-hunter Bill Randa (John Goodman) early on, but it turns out that Randa has an agenda aligned with the military's after all. The militaristic war frame is aggressively established right from the first frames, and as soon as Randa insists on a military escort, any imaginative David Attenborough/ *Planet Earth*-type potential is succinctly and definitely quashed. Yes, we *will* see some of the wonders of Skull Island, but we won't be stopping to drink any of it in.

See, **KONG: SKULL ISLAND** is *a war movie*. Just as we seem incapable in America of not seeing everything—and I do mean *everything* (even going to the restroom!)—as some sort of inherent conflict or warzone, **K:SI** is a war movie. It's a war *monster* movie... oh yes, and there's *TONS* of magnificent monster flesh bashing-it-out on the big screen throughout; but almost every mainstream studio monster movie since James Cameron's **ALIENS** (1986, USA/UK) has been a war movie, really. Cameron codified the template for a generation (remember, **AVATAR** [2009, USA/UK] was a war movie; or, to set some handy reference points for how **ALIENS** was the game-changer, Ridley Scott's **ALIEN** [1979, UK/USA) was an SF/*horror*/monster movie, but Scott's **PROMETHEUS** [2014] was an SF/*war*/ monster movie). For that matter, in the context of Toho Studios and the links provided in **SKULL ISLAND**'s coda to that monster universe, the last *daikaijū-eiga* to embrace exploration (more specifically, exploration-versus-exploitation) as its narrative engine was **SON OF GODZILLA** (怪獣島の決戦 ゴジラの息子 / *Kaijū-tō no Kessen Gojira no Musuko*, 1967, Japan, D: Jun Fukuda; in which attempts to establish a scientific weather-control outpost set things in motion), and before that, way back in 1961, was **MOTHRA** (モスラ / *Mosura*, Japan, D: Ishirō Honda). After **KING KONG VS. GODZILLA** (キングコング対ゴジラ / *Kingu Kongu tai Gojira*, 1962, Japan, D: Ishirō Honda], they *all* essentially became war movies (interplanetary war, monster wars, etc).

Every passage through Skull Island terrain in this new **KONG** is about the mission: getting to the checkpoint. Getting to the fallen soldier who still might be alive out there. Then, the mission creep: Packard has his own agenda (no surprise, the script is constructed around it as the imperative, and ultimately the central conflict, of the film). Thus, despite some good and even great characters, despite glimpses and fleeting tastes of what might-have-been—the introduction of the tribal culture and peek at their village life, John C. Reilly's show-stealing WWII vet, the spectacular night-sky "light" display, the line about "...those aren't birds, those are *ants*"—this is every bit a war movie. As such, it's all about the spectacle of conflict: between men and beasts, between beasts and beasts. **KONG: SKULL ISLAND** does not mislead the attentive viewer on this point: it begins as a war movie, and it *ends* as a war movie. Like I said, this is "The War That Time

A couple of **K:SI**'s CG monsters reminded us of Brett Piper designs, primary among those being the unusual "log" creature *[above]* that surprises Major Jack Chapman (Toby Kebbell, of **WRATH OF THE TITANS, DAWN OF THE PLANET OF THE APES, WARCRAFT, A MONSTER CALLS**, etc). The creature was part-based on both a sort of Phasmatodea (i.e., stick insects a.k.a. walking sticks), and caddisfly larvae (Trichoptera); the latter build protective aquatic cocoons around themselves formed of sediment, twigs and rocks, stuck together using mortar-like silk secreted from their salivary glands

Due to trademark/legal issues, title ape of **K:SI** might not be the "King" himself, but he *is* one of the liveliest onscreen Kongs of all time, in many key ways quite different from both "Obie" O'Brien's '33 sto-mo KK and Peter Jackson/Andy Serkis' '05 reboot. The behind-the-scenes motion-capture performances here were by Terry Notary and Toby Kebbell, with a single monster character the end-result

Forgot"—and in a just world, Robert Kanigher would have lived to see it.

Then again, Cameron's **ALIENS** was ripe with suspense. There's *zero* suspense to be had in **K:SI**. Oh, it's *fun*; no exaggeration, I had a whole *barrel* of it with **K:SI**. The monster action onscreen is inventive, expressive and impressive. But, however much spectacular monster set-pieces galvanize and entertain li'l ol' me—and oh, they do, *they do!*—there's nothing suspenseful here, really. As soon as Packard, Randa, and their cohorts arrived at Skull Island and started carpet-bombing their "seismic" devices (visually hammering home the obvious metaphor: that they're bringing the Vietnam air war to Skull Island), they deserve whatever they get—and it arrives in a hurry, so don't fret. I cared what was happening onscreen, mind you, but I was never in actual suspense, and there is a difference. The moments burned into my brain from initial viewing are the jaw-dropping, at times breathtaking spectacles of monster muscle, power, conflict, strife: but there's absolutely *no* suspense. Nothing even close to it. Everyone's bottom-of-the-food-chain, and almost everyone except photojournalist Mason Weaver (Brie Larson, as our "anti-war photographer" heroine) is either carrying *buku* firepower and/or ends up rapid-firing rounds or wielding a samurai sword at some point. This is a body-count war movie not unlike the WWII and Korean War movies my Dad took me to as a wee lad. "I sure hope those letters to Billy get home" may pluck the heartstrings or create some measure of emotional investment, but it *isn't* suspense, folks. You learn fast growing up on war movies not to get too attached to any one character, when they're all cannon fodder—or, in this case, monster chow!

That said, this is a streamlined spectacle. There's precious few action sequences stretched beyond the interminable Robert Zemeckis/Peter Jackson/Steven Spielberg/George Lucas milking-the-action-beyond-Tex-Avery-level hilarity breakpoint here, and that's to the better. The movie moves like a juggernaut, with only a few leisurely moments; but that movement is, as I say, mission-oriented. Go here. Get there. Oh, we have to pause here to acquire what we need to get there. That's OK, and it is what it is, and that was fine for me, but...

Well, like all monster movies, there are nagging questions, which is why I don't worry about 'em till the movie is over. Like, why is this isle even called "Skull" Island here? (One visual tease *almost* gives us the classical skull-like bluff and caves, but immediately eliminates the obvious with a CGI camera move inward) *Who* called it "Skull Island," when, why? Where did all these helicopters come from (they sure aren't all going to fit on *that* deck; is there more than one carrier)? How can Reg Slivko (Thomas Mann) backpack all his shit along with a record player and LPs (that magically don't warp!) in such heat? Could those li'l pterosaur-like thingies really carry *that* much weight into the air (at least Ray Harryhausen made his **ONE MILLION YEARS B.C.** pteranodon big enough to believably lift Raquel, and was pragmatic enough to make his **VALLEY OF GWANGI** pteranodon struggle some to get clearance carrying that kid)? And so on. There's some great, even *GRAND* monsters

here (I'm carefully avoiding spoilers), but the "Skullcrawlers" essential to the narrative are inelegant and less than credible to me design-wise; much like the swarming carnivorous *Tao Tei* of **THE GREAT WALL** (长城 / *Chang cheng*, 2016, China/USA, D: Zhang Yimou), their anatomy doesn't really make much sense: two limbs, a mouth, a torso, a tail. That said, the "Skullcrawlers" initially evoke the profile and look of Komodo Dragons, and that neatly harkens back to Cooper & Schoedsack's catalyst conceit for the original **KONG** (before they became aware of Willis O'Brien and stop-motion animation possibilities, the team entertained bringing live Komodo Dragons and a live gorilla into the fray as their "mon-stars"). Sure, I *could* pick the film apart (and a lot of people I respect *are*)—but to hell with that: I had too much fun with **KONG: SKULL ISLAND** to self-destruct my own enjoyment of it.

I'm happy to say that Kong comes through as a real character here—not as vividly as Willis O'Brien's original Kong, not as personable as he of Peter Jackson/Andy Serkis' **KING KONG** (2005, New Zealand/USA/Germany), but this newest KK actually comes across as a living, breathing being. The motion-capture performance was credited onscreen to two performers, Terry Notary and Toby Kebbell, and this Kong is a real beauty.

Best of all, he gets a moment—just a *moment*—while looking up at the night sky in wonderment and awe that offers us a glimpse at an inner emotional life which certain other elements of the film (no spoilers from me!) dance around.

I savored that particular moment. But **K:SI** wasn't *that* movie. It's *this* movie. It's a rock 'em, sock 'em war-monster movie!

Yes, I'd still love to see whatever **KONG** movie my compadre *wished* we'd been watching. I hope they make that movie soon enough for us to go together and enjoy it—but I suspect that, for my pal, **KK** '33 will remain the *only* Kong, forever and ever. And that's okay.

But **KONG: SKULL ISLAND** is something other than that. And for this monster-movie-addict, it was just jim-dandy.

(PS: Need I really say it? *Do not* leave the theater when the credits start. The end of the movie comes *after* the credits—though a certain trio of trademark notices in the credit crawl gave away any surprise I might have enjoyed there—but that's *all* I'm saying!)

WE BELONG DEAD

Now in its 25th year!

Welcome to a world where Karloff was the Frankenstein monster, where Christopher Lee was Dracula and Peter Cushing was the evil Baron Frankenstein. To a world where Lon Chaney Snr lurked beneath the Paris Opera House and Lon Chaney Jnr became a wolf when the wolfbane bloomed. Where Lugosi listened to the children of the night and Charles Laughton evoked our sympathy for the unfortunate bell ringer of Notre Dame. A long forgotten age when Kong ruled Skull Island and Vincent Price held sway at the Masque of the Red Death.

Once again marvel as Dracula rises from the grave, Frankenstein creates woman, the devil rides out, the House of Usher falls, the Wolfman meets Frankenstein and the zombies have a plague...
Welcome to WE BELONG DEAD!!!

Visit our website
unsunghorrors.co.uk
or contact us by email
wbdmagazine@yahoo.co.uk

Your History Lesson For Today

MONSTERS!
AN ILLUSTRATED MOVIE HISTORY

PART FOUR: THE SCREAMING SIXTIES

WORDS AND PICTURES BY ANDY ROSS

UTILIZING THE LURID TONES OF THE EASTMAN COLOR PROCESS, THE BRITISH, BRAY BASED HAMMER FILMS WAS TO RE-IGNITE INTEREST IN GOTHIC THEMED HORROR.

STARRING PETER CUSHING AS BARON FRANKENSTEIN AND CHRISTOPHER LEE AS THE CREATURE, CURSE OF FRANKENSTEIN WAS TO HERALD THE BEGINNING OF A FORMIDABLE ON-SCREEN PARTNERSHIP.

FOLLOWING THE FAVORABLE RESPONSE TO TERRENCE FISHER'S TAKE ON THE MARY SHELLEY TALE, HAMMER SOON TURNED TOWARDS DIRECTOR ROY WARD BAKER AND HIS SIMILARLY GORE-LADEN PRESENTATION OF HORROR OF DRACULA (1958).

A MAINSTAY THROUGHOUT THE 1960'S, THE EXAMPLE SET BY HAMMER FILMS (WHILST NEVER QUITE EQUALLED) WAS TO WITNESS AN EXPLOSION OF BRITISH MADE CREATURE FEATURES.

1

ADDING THE MUMMY (1959) AND CURSE OF THE WEREWOLF (1961) TO THEIR MONSTROUS ROLL-CALL, THE STUDIO WERE TO EMBRACE HITHERTO UNEXPLORED MONSTROSITIES BY MEANS OF BOTH THE GORGON (1964), AND THE REPTILE (1966)

WHILST HE MAJORITY OF HAMMER'S OUTPUT WAS SET AGAINST A STYLIZED, EARLY 19TH CENTURY MILIEU, 1966 WAS TO SEE THE RELEASE ONE OF THEIR MOST ENDURINGLY POPULAR MONSTER MOVIES.

UTILIZING THE STOP-MOTON EFFECTS WORK OF FORMER WILLIS O'BRIEN PROTEGE RAY HARRYHAUSEN ONE MILLION YEARS B.C, WAS TO WITNESS A VERY DIFFERENT KIND OF HAMMER HORROR.

MONSTER! BOOKSHELF

Fantastic Films of the Decades, Volume 1: The Silent Era
by Wayne Kinsey

(@ www.peverilpublishing.co.uk)

Last year in the *Monster!* Spring Special double issue (#28/29, April-May 2016), I reviewed Wayne Kinsey's *Fantastic Films of the Decades, Volume 2: The 1930s*, noting at the end of my review that, on the strength of *Vol.2*, I would be ordering *Vol.1: The Silent Era* (Peveril Publishing, 2015). Which I did indeed do. Now here's my review of it…

For starters, in contrast to *Vol.2*, *Vol.1* has a nice shiny-slick cover! Now, any book covering the silent era of film in general would of course be obliged to provide a *lot* of Lon Chaney coverage, so any book specifically covering horror and fantasy movie fare from that period would out of necessity be dominated by his sinisterly looming presence. Unlike beginning in the 1930s, which saw a whole procession of genre stars (such as Lugosi, Karloff, Lorre, Chaney, Jr., and others) rising to the fore, it was Chaney, Sr. who undoubtedly dominated the Silent Era as "The Man of a Thousand Faces", horror star to an entire generation of adoring moviegoers. His influence was so strong that those who came after him were either compared to him or else dubbed "the new Chaney", or some such thing. Therefore, it is most refreshing indeed that *Fantastic Films of the Decades, Volume 1* is not wholly dominated by Chaney, although he nevertheless does understandably put in a strong showing both within. *And without*, as, indeed, fully three of his most-famous roles are featured right on the book's photomontage

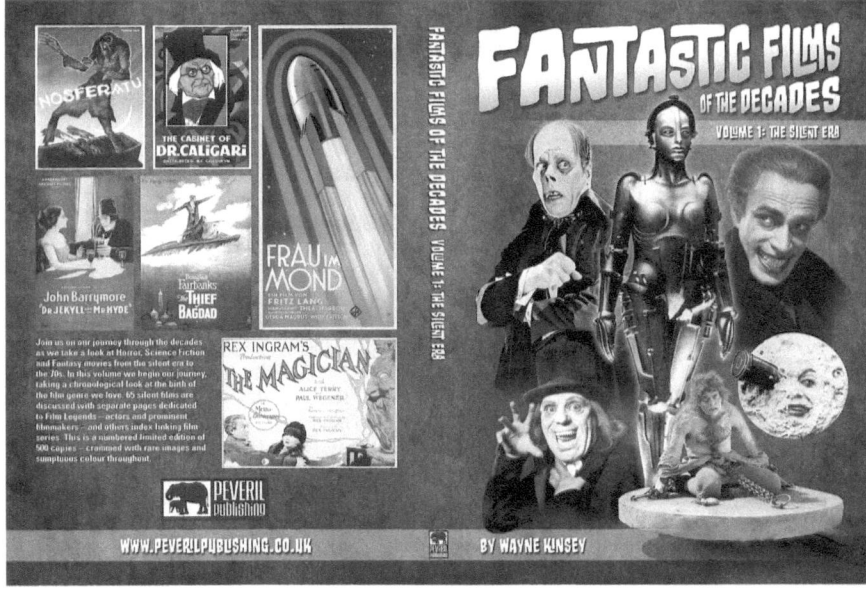

cover: Erik from **THE PHANTOM OF THE OPERA** (1925, USA, Ds: Rupert Julian, Lon Chaney), Quasimodo from **THE HUNCHBACK OF NOTRE DAME** (1923, USA, D: Wallace Worsley) and "The Man in the Beaver Hat" from the long-lost **LONDON AFTER MIDNIGHT** (1927, USA, D: Tod Browning [see p.109]). The "star" of the front cover, so to speak, is Brigitte Helm in her hugely iconic role as the robot Maria from **METROPOLIS** (1927, Germany, D: Fritz Lang), who is flanked thereon by Conrad Veidt as the forever-grinning Gwynplaine from **THE MAN WHO LAUGHS** (1928, USA, D: Paul Leni) and the space-rocket-stuck-in-the-moon's-eye from French filmic fantasist Georges Méliès' SF progenitor *A Trip to the Moon* (*Le voyage dans la lune*, France, 1902).

As this is the first in a proposed whole series of books, those that come after it will follow the same format. Thus, as per format herein, we get coverage of various "Legends" interspersed throughout the book: Georges Méliès, Paul Wegener, Herbert M. Dawley, Willis O'Brien, Conrad Veidt, The Barrymores, F.W. Murnau, Karl Freund, Lon Chaney, Fritz Lang, The Westmores, Paul Leni, Tod Browning, Alfred Hitchcock, Jack P. Pierce, Michael Curtiz and Anton Grot. I had not even heard of some of the lesser-known names in this list before, so had to look-up extra details on them; as usual, Kinsey's biographical detailing is top-notch, which helps immensely. We also have special categories called "Series Links" too, which cover both the Silent Era and the Talkies: *Frankenstein*, *She*, *Dr. Jekyll and Mr. Hyde*, "Edgar Allan Poe Films", "Mummy Films", "Supernatural Films", *Dracula*, *The Hunchback of Notre Dame*, "Dinosaur Films", *The Phantom of the Opera*, "10 Chaney / Browning Films" and, finally, "Vampire Films". Other individual features to be had herein are "The Origins of Film", "Universal Pictures", "Birth of the Hollywood Majors" (covering Paramount, MGM, 20th Century-Fox, First National, Warner Brothers, RKO, United Artists and Columbia, giving a brief biographical history of those companies); "Universal Luminaries" (i.e., Charles D. Hall, Maurice Pivar and Vera West), plus another feature entitled "Transition to Sound" to span the two eras.

Then, spread-out over the remainder of the book, we have a list of 67 films—numbering both short subjects and full-length features—which reads like a veritable "Who's Who" of fantastic films (all films are of American origin, unless otherwise noted): the aforementioned *A Trip to the Moon* (1902, France), *Frankenstein* (1910), **DANTE'S INFERNO** (*L'Inferno*, 1911, Italy), *She* (1911), *Dr. Jekyll and Mr. Hyde* (1912; with James Cruze as J/H), *Dr. Jekyll and Mr. Hyde* (1913; with King Baggot as J/H), **A MESSAGE FROM MARS** (1913, UK), **THE STUDENT OF PRAGUE** (*Der Student von Prag*, 1913, Germany), **THE AVENGING CONSCIENCE** (1913), **LIFE WITHOUT SOUL** (1915), **SNOW WHITE** (1916), **20,000 LEAGUES UNDER THE SEA** (1916), **THE EYES OF THE MUMMY** (*Die Augen der Mumie Ma*, 1918, Germany), *The Ghost of Slumber Mountain* (1918), **THE CABINET OF DR. CALIGARI** (*Das Cabinet des Dr. Caligari*, 1919, Germany), **EERIE TALES** (*Unheimliche Geschichten*, 1919, Germany), **DR. JEKYLL AND MR. HYDE** (1920, with John Barrymore as J/H), *Dr. Jekyll and Mr. Hyde* (1920, with Sheldon Lewis as J/H), **GO AND GET IT** (1920), **THE GOLEM** (*Der Golem, wie er in die Welt kam*, 1920, Germany), *Haunted Spooks* (1920), **THE HEAD OF JANUS** (*Der Januskopf*, 1920, Germany), **THE PENALTY** (1920), **DESTINY** (1920), **THE HAUNTED CASTLE** (*Schloß Vogelöd*, 1921, Germany), *The Haunted House* (1921), **THE PHANTOM CARRIAGE** (*Körkarlen*, 1921, Sweden), **A BLIND BARGAIN** (1922), **HÄXAN: WITCHCRAFT THROUGH THE AGES** (*Häxan*, 1922, Sweden), **THE HEADLESS HORSEMAN** (1922), **NOSFERATU** (*Nosferatu, eine Symphonie des Grauens*, 1922, Germany), **ONE EXCITING NIGHT** (1922), **THE HUNCHBACK OF NOTRE DAME** (1923), **THE HANDS OF ORLAC** (*Orlacs Hände*, 1924, Austria/Germany), **DIE NIBELUNGEN PART 1: SIEGFRIED** (*Die Nibelungen: Siegfrieds Tod*, 1924, Germany), **DIE NIBELUNGEN PART 2: KRIEMHILD'S REVENGE** (*Kriemhilds Rache – Der 2. Nibelungenfilm*, 1924, Germany), **THE THIEF OF BAGDAD** (1924), **WAXWORKS** (*Das Wachsfigurenkabinett*, 1924, Germany), **THE LOST WORLD** (1924), **THE MONSTER** (1925), **THE PHANTOM OF THE OPERA** (1925/1930), **SHE** (1925), **THE UNHOLY THREE** (1925), **THE BAT** (1926), **FAUST** (*Faust: Eine deutsche Volkssage*, 1926, Germany), **THE MAGICIAN** (1926), **MIDNIGHT FACES** (1926), **THE SORROWS OF SATAN** (1926), **THE STUDENT OF PRAGUE** (*Der Student von Prag*, a.k.a. **THE MAN WHO CHEATED LIFE**, 1926, Germany), **THE CAT AND THE CANARY** (1927), **THE GORILLA** (1927), **THE LODGER: A STORY OF THE LONDON FOG** (1927, UK), **LONDON AFTER MIDNIGHT** (1927), **METROPOLIS** (1927, Germany), **THE UNKNOWN** (1927), **THE WIZARD** (1927), **ALRAUNE** (1928), *Fall of the House of Usher* (1928, France), **THE MAN WHO LAUGHS** (1928), **NOAH'S ARK** (1928), **WEST OF ZANZIBAR** (1928), **THE LAST WARNING** (1929),

THE MYSTERIOUS ISLAND (1929), SEVEN FOOTPRINTS TO SATAN (1929), WOMAN IN THE MOON (*Frau im Mond*, 1929, Germany) and two early talkie mysteries with horror elements, THE TERROR (1928) and THE THIRTEENTH CHAIR (1929).

Each of these films' individual listings comes complete with a whole host of facts, plotlines and other pertinent details, elevating these early classics out of the archive and making the reader wish that they were all still available (although a great many of them *are*, in one form or other). The trouble with the Silent Era as a whole is the fact that so many films from that time now no longer exist. To cite one of the most famous examples, 1927's Lon Chaney vehicle **LONDON AFTER MIDNIGHT** (see p.109), which *did* still exist up until 1967, when a fire at the MGM vault in Culver City, California saw the only remaining print destroyed. Since then it has been eagerly sought-after, largely (I would conjecture) due to all the tantalizing promotional stills of Chaney in full "vampire" makeup that were distributed at the time of its production, of which a great many are still extant to this day. Flash-fires combined with the instability of nitrate-based film stock, along with the simple junking of many older films when the Sound Era began to take off also contributed greatly to the loss of silent film prints, which were rendered "obsolescent" overnight due to the sudden dramatic shift in cinema technology. According to Martin Scorsese's Film Foundation, more than 90% of all American Films made before 1929 are now no longer unavailable, while the Library of Congress states that 75% of all silents have been irretrievably lost *forever*! Therefore, a book such as this is a welcome addition to any library, because it not only contains in-depth information on each title discussed, it also has an abundance of wonderful stills along with a whole host of reproduced promotional materials for many of the films that are covered. (Though one cannot guarantee how correct their listing is, Wikipedia has posted a list of lost films [@ https://en.wikipedia.org/wiki/List_of_lost_films], which makes for interesting reading).

With this work, Wayne Kinsey has paid the finest homage to cinema's Silent Era, and has succeeded in breathing new life into an often-neglected and overlooked period, from which, more often than not, a mere few films have been raised to near-mythic status whilst so many others got left languishing in the shade.

I wholeheartedly give *Fantastic Films of the Decades, Volume 1: The Silent Era* a full and well-deserved 10-out-of-10!

~ **Matthew E. Banks** © 2017

The Hammer Dracula Scrapbook
by Wayne Kinsey

(@ *www.peverilpublishing.co.uk*)

For cinema audiences up until the mid-to-late 1950s, just one actor and one actor alone stood out as *the* portrayer of Count Dracula, and that was…Béla Lugosi. To the public at large, Lugosi *was* Dracula and Dracula *was* Lugosi! But that would all change on May 8th (in the USA) and May 22nd (UK) of 1958, when, as a follow-up to their smash-hit horror franchise reboot **THE CURSE OF FRANKENSTEIN** (1957), Hammer Films released **DRACULA** (a.k.a. **HORROR OF DRACULA**, 1958, both UK, D: Terence Fisher), which swiftly became another box-office blockbuster for the studio.

For the first time ever, not only were audiences finally able to actually *see* all the fangs, neck-biting, stakings, violence and gore, but they were able to view the whole lot in gorious *[sic]* Technicolor, yet! Fisher's **DRACULA** was the first color Drac film ever, and audiences worldwide rushed out in droves to see it. It made international stars/household names of Peter Cushing and Christopher Lee, firmly establishing Hammer Films as *THE* new studio for horror films, a genre which it dominated with very little competition for the next decade-and-a-half. In fact, the antiquated image of The Count as a powderpuff-complexioned, lipstick-lipped—and conspicuously *fangless*!—vampire was utterly obliterated by Lee's intensely physical performance as the vicious-but-charismatic vampire lord as he announced "I am Dracula" before bounding down the stairs to greet Jonathan Harker. *[Although, to be fair, Germán Robles had sported fangs first the year prior as Count Duval in Fernando Méndez's THE VAMPIRE (El vampiro, 1957, Mexico), albeit only in glorious B&W – SF.]* Cushing's performance as Van Helsing also obliterated the former image of the bookish, aged scholar by instead turning him into a man of action. I would actually go so far as to say that **DRACULA**.'58 redefined the Horror genre as a whole, just as Lugosi's **DRACULA** '31 (see p.107) had defined it 27 years previously.

In regards to Hammer Films, over the years there have been numerous books and magazines published which covered both the actors/

personnel and the studio itself, so, quite frankly, one wonders what more could possibly be said about the studio and its productions. Then along comes Wayne Kinsey—author of six books on Hammer, plus 24 issues of the fanzine *The House That Hammer Built* (a number of back issues of which are still available from the same publisher/website)—with a new idea/concept which will lead into a whole series of books. As Kinsey himself explains in his introduction: *"[...]* Hammer fans grew restless. Mutterings were heard on Facebook of an idea I had toyed with for a series of Hammer scrapbooks, similar in tone to the successful *Peter Cushing Scrapbook"*. What Kinsey wants to do with this new series is to share his sizable collection of Hammer-related visual materials and other ephemera with the world, and to not be one of those selfish collectors who hoard their stuff away without sharing it…and I commend him most highly for doing so!

Each volume in this proposed new series will (quote) "celebrate films under a key theme"; other forthcoming—if-at-present-only-tentative—titles should (hopefully!) eventually include:

"The Hammer Frankenstein Scrapbook"
"The Hammer Vampire Scrapbook"
"The Hammer Monster Scrapbook"
"The Hammer Sci-Fi Scrapbook"
"The Hammer Horror Scrapbook"

Issue #4 (1997) of author Wayne Kinsey's long-running Hammer zine (cover art by him)

"The Hammer Fantasy Scrapbook"
"The Hammer Thriller Scrapbook"
"The Hammer Adventure Scrapbook"

So, let's take a look at the kickoff volume in this potentially expansive series: *The Hammer Dracula Scrapbook*. It is a meaty 335 pages in length and covers Lee's total of seven *Dracula* films in chronological order: **DRACULA** (1958), **DRACULA – PRINCE OF DARKNESS** (1965), **DRACULA HAS RISEN FROM THE GRAVE** (1968), **TASTE THE BLOOD OF DRACULA** (1970), **THE SCARS OF DRACULA** (1970), **DRACULA A.D. 1972** (1972) and, finally, **THE SATANIC RITES OF DRACULA** (1974). Each franchise entry has its own separate chapter, of varying lengths, each of which, for ease of reference, are color-coded by different-colored page-surrounds: hence, the chapter on **DRACULA** #1 is 82 pages long—tellingly, the longest chapter in the book by far—with a red-and-pink surround; **PRINCE OF DARKNESS**' chapter is 41 pages, with an orange surround; **RISEN FROM THE GRAVE** totals 39 pages, with a pink surround; the 51-page **TASTE THE BLOOD** chapter has a mauve surround; the **SCARS** section runs 49 pages, with a yellow surround; **A.D. 1972** is 35 pages, with a green surround; and, finally, **SATANIC RITES**, the shortest chapter at a "mere" 28 pages in length, comes with a tasteful purple surround. All in all, the attractiveness of the packaging contributes greatly to the overall presentation.

Steve Kirkham's design is top-notch, as always, and the images—which are numerously scattered throughout—are often amazing; many of which I have never come across before. Unlike most books of this type, for this series Kinsey has taken a different tack, as he explains: "The books are divided into chapters on the individual films, with each page exploring a certain theme. They are meant to be 'light-read' pictorial coffee table books *[...]*". In the chapter on the first *Dracula* outing, we have brief biographies on performers Lee, Cushing, Valerie Gaunt ("Vampire Woman"), John Van Eyssen ("Jonathan"), Michael Gough ("Arthur"), Melissa Stribling ("Mina"), Carol Marsh ("Lucy"), child actress Janina Faye ("Tania"), as well as many of the minor character players and some of their hiring agreements. Opening the chapter, we have details on the film, including cast and crew, opening day details, plus much, much more.

More importantly than this though is the reproduction in-part of Christopher Lee's personal annotated copy of the shooting script. In

still another welcome addition, we also get a good gander at the spectacular climactic sequence of **DRAC '58**, wherein Van Helsing and The Count have their violent confrontation with each other at Castle Dracula. Further on into this revealing chapter we are shown some of Bernard Robinson's production designs, showing the revamping of the internal sets (with illustration-to-photograph comparisons), reproductions from Cushing's annotated version of Stoker's *Dracula*…in fact, there is *SO* much covered in the first 65-odd pages that one wonders what could be left to fill its final 11 pages; in which we are treated to sharp repros of the various posters and lobby cards for that production, all presented in spectacular color, like the film itself. If anything, this chapter really whets one's appetite for the next chapter.

1965's **DRACULA – PRINCE OF DARKNESS** saw Lee reprising his Dracula role for the first time in eight years. This chapter runs only half the length of the first chapter, but follows the same pattern, with biographies of the principal players. It is beautifully illustrated with both off-set and on-set stills; especially interesting is the final "drowning" sequence, as well as some Techniscope test shots, production designs and Bray sets, et cetera. In fact, throughout the book, the behind-the-scenes photographs add greater depth to the films in question, allowing us deeper insights into these classic productions about which we thought we knew so much already. Later chapters include shooting schedules, censors' notes, and—*yes indeed!*—still more besides. In addition, each movie has its own "trailer breakdown", showing screen captures of frames from same, plus notes to guide the reader.

My favorite Hammer *Dracula*, 1970's **TASTE THE BLOOD**, is the longest chapter after the one for the '58 series founder, and there are some awesome treats to be found in it: such as some of Scott MacGregor's beautiful set designs, and Lee's disdainful comments regarding his dialogue as Drac; and not only that, but other little excerpts taken from conversations with Lee back whilst Hammer were attempting to entice him into appearing in more of the *Dracula* series are hilarious!

I have gone on before about how easy-on-the-eye and full of fresh information Kinsey's books are, and this one is certainly no exception. It is a lavish tome, chock-a-block with rare images (I reiterate, such as posters, lobby cards and other printed advertising materials, set-design drawings, script pages, schedules, plus various documents, contracts and other assorted ephemera). Although

it *is* a "scrapbook" after all, so you'd perhaps expect it to be more pictorially-based, there are guiding notes, although I personally would have liked a little more information…but, to be fair, I'm just *greedy*!

Boasting around a whopping 1800 images in total, I certainly can't quibble about the sheer quantity of often-long-unseen visual material that this volume contains aplenty, and I am keenly looking forward to Kinsey's planned *The Hammer Frankenstein Scrapbook*. As with all Peveril publications, *The Hammer Dracula Scrapbook* has a limited print-run of just 600 copies; each volume is numbered and signed by Mr. Kinsey (my copy being #508!). At the time of this writing, the book had sold-out, so if you want to get your hands on a copy, I suggest you check on eBay or Amazon.

I give this volume a 9-out-of-10 rating. On its very last page, there is a "coming soon" teaser which promises more Kinsey/Peveril projects: *Fantastic Films of the Decades, Volume 3: The 1940s, A Portrait of SHE: An Exclusive Photofile of the Hammer Classic*, and aforementioned *The Hammer Frankenstein Scrapbook*—so keep an eye out for 'em! (Better yet, *two* eyes!!)

~ **Matthew E. Banks** © 2017

NOTE: As with all Peveril titles, they are available solely through their website (@ *peverilpublishing.co.uk*).

MONSTER! #32 MOVIE CHECKLIST

MONSTER! Public Service posting: Title availability of films reviewed or mentioned in this issue of MONSTER!
Information dug up and presented by Steve Fenton and Tim Paxton.

Miscellaneous Stuff to Be Gotten Out of the Way First, Before We Get to the Main "Meat" of the Matter:

Jean Rollin Movies (spanning 1968-2010) *[pp.154-216]* |– Considering the quite high profile he's well-deservedly getting in this ish, we might as well start things off on the right footing here with our entry about him, beginning with a purely gratuitous quote from that truly singular-of-vision and sorely-missed *Artiste/Cinéaste Extraordinaire*, Jean Rollin (taken from his interview with Caroline Vié in *Fangoria* #202 [2001]): *"I don't put naked girls in my films because it's cheaper! ...I only use them when it's needed in the script."* As mentioned some 16 years past in that very same *Fango* piece about him just quoted from, Jean Rollin's official website, long endorsed by him while he was still physically alive—rather than "merely" being very much still with us in a spiritual sense (if you happen to believe in that sort of thing!)—is (*was?*) Shocking Images (@ shockingimages.com). This site has apparently since "morphed" into the one called Film Fanaddict (which is at the same web addy just-cited, for those who might wanna pop in for a visit); the latter covers a lot more than just Rollin material, with a strong emphasis on "cult" fare of Euro origin, accent on the sleazier/gorier kinds. As for the broad swathe of M. Rollin's cinematic canon covered this issue, since we have already so vastly over-extended our page limit in *M!* #32 (you can pretty much guarantee that the next one will be even THICKER, if we ye eds gots any say in the matter, which we very much do!), we've had to limit our vid info (henceforth sometimes to be referred to by the acronym "V.I.") somewhat to save on space (talk about closing the stable door after the horse has bolted!). Simply because the main focus of writer J.P. Checkett's expansive *Rollinade* overview/retrospective is the series of topnotch-quality Blu-ray editions of the bulk of JR's most-seminal films recently put out by Redemption/Kino Lorber (see pp.160-171, 175-181 & 185-196) and they presently stand as the absolute optimum (*ultimate?*) ways to go quality-wise, we shan't be spending any time whatsoever hereunder itemizing all the *MANY* different video versions of his works (be they of monstrous themes or otherwise) which have been released all across the globe over the course of recent decades in all the various usual media formats. Instead, as a kind of "pictorial wish-list", if you will, we shall be collectively running mostly-non-captioned/

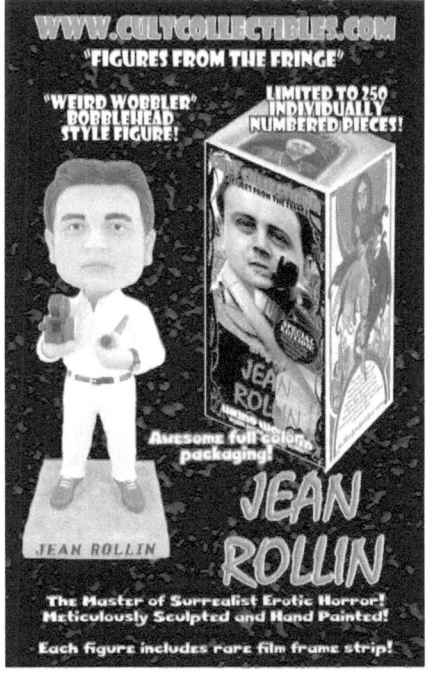

speak-for-themselves (as in "A picture is worth a thousand words") reproductions of assorted international video covers for JR movies on the following two pages; this in order to give the more hardcore Rollin enthusiast—and there's absolutely NO reason why you shouldn't become one, assuming you're not already!—at least some idea of the plethora of versions of his collected filmic works that are out there. What with all the many handy leads we've provided this ish to point you in the right directions, the rest is up to *you*, Dear Readers! ☺ (*...Next!—*)

Recent Indian Monster Movies (c.2011-2017) *[pp.120-135]* |– It seems that none of the films reviewed are available on home video in India, except for the **EVIL DEAD** rip-off **BACH KE ZARAA** *[p.130]*, which is only available as a VCD from Priya Video or via a rip of it uploaded on YouTube. The remaining titles were discovered either on YT and/or from various Indian satellite streaming sites, while some of the older titles may have been on DVD, but, as of this writing,

Above: *Dinosaurs & Spaceships?!* 1970s French "*Film Super 8 120-mètres*" box. Despite the central image in its cover art being a still of Jacqueline Sieger in JR's **THE RAPE OF THE VAMPIRE** (p.160), according to one—erroneous?—source we saw online (@ www.bd-cine.com), this is actually (?) the box-top to a '70s French 77-meter (roughly 250-ft.) Super 8/sound cutdown reel of **BLOOD OF THE VAMPIRE** (1958, UK, D: Henry Cass), retitled *Les Expériences du Docteur Callistratus*

we could track down no record of them being available thus (either dubbed or otherwise). ~**TP** There now follows a short list of just some of the titles Tim P. covers within his article, all of which we randomly searched for on YouTube (those interested in finding other titles in the article there that are not listed here can always do a YT search easy enough using the information given elsewhere). As of this writing, the following titles were posted in either full-length or separately-segmented uploads at the site. Data pertaining to accessing them is listed in point-form hereunder: The film known numerically only as **6** *[p.125]* (@ *https://www.youtube.com/watch?v=VL1iE3vX-4el*); **MIRUTHAN** *[p.122]* (@ *https://www.youtube.com/watch?v=xRb6FB5BWOY*); **BACH KE ZARAA** *[p.130]* (@ *https://www.youtube.com/watch?v=x19GSu4Omo4*); **2014 FEAR OF THE YEAR** *[p.133]* (@ *https://www.youtube.com/watch?v=s4d4urawLjk*); uploaded in 2 parts, there's also **BHAYANAK ATMA** *[p.133]* (Pt.1 is @ *https://www.youtube.com/watch?v=II08e3trrtI*); and **KAUNRI KANYA 3D** *[p.132]* (@ *https://www.youtube.com/watch?v=o2VC3pszJ-PI*), in 2D; and, albeit only in a flat (and really CRAP quality!) 2D version, there's also a 5-part upload of **MITA BASICHI MU BHUTA SATHIRE 3D** *[p.132]* (Pt.1 is @ *https://www.youtube.com/watch?v=dIhCjGKpW8w*); **KALPANA HOUSE** (கல்பனா ஹவுஸ் [@ *https://www.youtube.com/watch?v=eiDBXm-vIVI*]) is the Tamil dub of **NAGAVALLI** *[p.129]*, whereas the film under that exact same title (@ *https://www.youtube.com/watch?v=fTGo5qc9Gg0*) more commonly found on the internet is in actuality P. Vasu's Telugu remake/sequel to his own 2010 Kannada movie, **APTHARAKSHAKA** (@ *https://www.youtube.com/watch?v=W1HiTACvdFs*), that itself was a remake of uni-named Malayalam director Fazil's 1993 psychological horror thriller **MANICHITHRATHAZHU** (@ *https://www.youtube.com/watch?v=F0P1RzIlRMM*), which is considered one of the more important films—of any genre—ever to be made in the Indian state of Kerala. Sound insane? Well, it *IS*! Additionally, **DARLING** *[p.134]* is available for purchase or rent VOD on YT for $3.99 Canadian, with English subs (@ *https://www.youtube.com/watch?v=QRstFK9WwyQ*), while, split into 3 parts, **DARLING 2** *[p.134]* can be seen gratis there (Pt.1 is @ *https://www.youtube.com/watch?v=JCLUzsulmro*), with Portuguese subs only (but that's a lot closer to English than Odia or Hindi is! ☺). Judging by what we saw of the film while we were there—(Not much! Too damn *busy* to stick around!)—however, it looks like it might be more of a psycho/slasher-type flick than a monster one, if possibly with some ghostly possession elements in the mix too.

Facing Page, Top Right to Bottom Left: The so-called American Video's 1980s French VHS jacket for one of Rollin's most-popular vampire flicks, plus a half-dozen assorted international DVD covers for other JR releases, including Terminal Video's Italian edition of **SHIVER** *[dead-center]* and Another World's Danish release of **REQUIEM** *[bottom right]*. **Right:** The striking cover designs (art unsigned) for three official if now ultra-rare mid-'80s French-Canadian (i.e., from Québec) Rollin releases on Beta/VHS tape, all from the Vidéo Lazer company. *[Scans c/o The Michael Ferguson Foundation]*

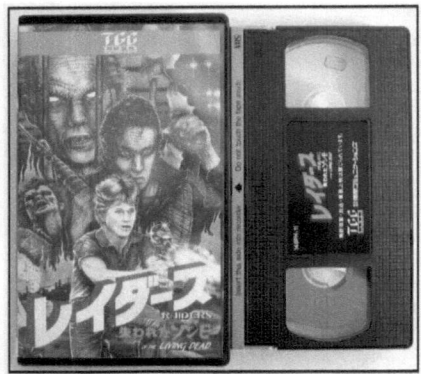

Japanese VHS tape of **RAIDERS OF THE LIVING DEAD** (see p.29)

Brett Piper Movies (c.1982-) *[pp.6-40]* |– As for the Piper films which *M!*'s resident—and yes, this is his *official* title here at the mag, by the way!— Pop-Cultural Paleontologist *nonpareil et par excellence* Stephen R. Bissette and Mr. Piper himself discuss in the interview/article devoted to the latter, since Steve has already included much about the few-and-far-between international video releases of BP's back-catalogue in his main text and captions anyway, we shan't be covering any of the titles they discuss hereunder. Just to let you know in advance, any major additions V.I.-wise shall all be collectively corralled together when the author compiles the complete BP filmography he has promised *Monster!* which we will be running with the final instalment of his epic Piper piece (which *may* run in 6 parts, or maybe less). *[And now, on to the separately-titled V.I. entries proper...]*

BLOOD OF THE VIRGINS (1967) *[p.264]* |– If you (us included [but not Martín Núñez! ☺]) happen to require a copy that comes with an Anglo translation of the original Argentine-Spanish dialogue, your best bet to date would undoubtedly be Mondo Macabro's now-long-since-out-of-print domestic All-Region DVD edition from 2004.

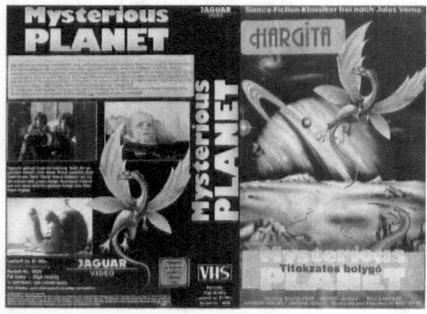

German-Hungarian VHS jacket (see p.16)

More recently (a decade later in 2014), **BOTV** was put out as another regionless DVD stateside by Cheezy Flicks (part of whose cover-hype reads: *"A Blood-Drenched Vampire Epic! Argentina's Very First Vampire Film!"*), complete with English soft-subs. While we can't say for sure sight-unseen, this may simply be a port-over of Mondo's prior release version (?). For those either fairly or fully fluent *en español*, there is a very decent-quality, native-dialogue-only rip of the erstwhile domestic Argentinean videocassette version of this film on YouTube at the page "Sangre de Virgenes 1967 AR VHSRip" (@ *https://www.youtube.com/watch?v=_dBH2B27RHY*), presented at a "full-screen" 1.33:1 aspect ratio which is pretty close to its original (?) theatrical one of 1.37:1. Also on YT, other than for the fact that it's been matted/vertically-cropped down from its just-cited original aspect ratio to make it appear a lot more widescreen than it actually ever was, as is so typical/predictable of uploaders on such sites who naïvely believe they'll be exempt from claims of copyright infringement if they simply alter a movie's audiovisual aspects, at Gothic Te@m (Rodos)'s channel (@ *https://www.youtube.com/watch?v=Uy29E6HjGIw*), there's a pretty nice copy of this flick posted at said site under the Greek title **AΊΜΑ ΠΑΡΘΈΝΩΝ** (a simple translation of the movie's original Spanish and English titles). It's *en español*, with its original audio track, but comes with Hellenic subtitles (Attn: Christos Mouroukis! ☺). PS. For another opinion of **BOTV**, check out the review at the cool bloodsucker-themed blog Taliesin Meets the Vampires (@ *http://taliesinttlg.blogspot.ca/2009/04/blood-of-virgins-review.html*).

Incidentally, on a directly related note, those interested in checking-out an uninterrupted string of cool Argentinean movie previews which directly pertains to Emilio Vieyra's filmography might do well to check out the YT link titled "Trailers Cine Explotación Argentino" (@ *https://www.youtube.com/watch?v=Sn4Iv33wsU0*), which, despite its generic-sounding group heading, actually consists completely of—and nothing *but*!—Vieyra movies, if not all (just roughly half) of them falling into the monster/horror genre. Clocking-in at a solid 25½ minutes and for the most part of highly-tolerable picture quality indeed, this most welcome, smoothly-edited compilation—with an accent on the more lurid, trashier kinds of product—opens with trailers for both the present film (onscreen blurb: *"¡... una tremenda pesadilla de horror...!"* ["A terrible nightmare of horror!"]), plus several more for others of its director's mostly (s)exploitation efforts too, including: 1971's man-becomes-monster (or *does* he...?) sexy shocker **LA BESTIA DESNUDA** (*"¡Una historia increíble converti-*

da in tremenda realidad! ... ¡¡¡Drogas!!! ¡Sexo! ..." ["An incredible story becomes a sensational reality! ...Drugs! Sex!..."]); Something Weird Video's—duly credited—watermarked US export trailer for 1967's **THE DEADLY ORGAN** (*Placer sangriento*, a.k.a. **FEAST OF FLESH** [Anglo voiceover: *"It will blow your mind! ...Needing more and more, getting in deeper and deeper, until it's too late—and they're hooked by the fiend behind the mask! It's a nightmare in psychedelic suspense!"*]); plus another Anglo one (*"One man seeks to experiment with the sexes to satisfy his science and his sick curiosity!"*) via SWV for 1968's **THE CURIOUS DR. HUMPP** (*La venganza del sexo* [some of the aptly-named Dr. Humpp's quoted dialogue therein: "Sex dominates the world, and now, *I* dominate *sex*!"]), whose trailer includes the surefire ticket-selling line *"From every act of pleasure comes an equal act of perversion"*, which—presumably just in case we might have missed it the first and second times—is uttered fully thrice in a row! Presented over the first third of the comp in rapid-fire order one-after-the-other and spanning just over eight minutes in total, these trailers for Vieyra's horror fare then segue into ones for other, non-horror movies made by the same director, including: his 1970 musical melodrama **GITANO** ([*"Gypsy"*], starring the hunky local pop-singing sensation known only as "Sandro" [r.n. Roberto Sánchez {1945-2010}] and co-starring Vieyra's frequent casting choice Ricardo Bauleo, from **BOTV** [etc.]); plus there's another spot for Vieyra's pseudo-spaghetti western spoof **LOS IRROMPIBLES** (1975), which was heavily influenced by—if a whole lot more *violent* than!—Terence Hill & Bud Spencer's Italoater comedy *Trinity* duology, which spawned scads of rip-offs from both Italy and the rest of the world over (it even actually reuses verbatim the familiar "spaghetti" gunshot sound effect heard in just about every "authentic" SW ever made!); then there's also theatrical previews for Vieyra's bullet-riddled, tongue-in-cheek Bondian espionage actioner **LA GRAN AVENTURA** (*"The Great Adventure"*, 1974) and his Bronson/*Death Wish* franchise-influenced crime drama **OBSESIÓN DE VENGANZA** (*"Obsessed with Revenge"*, 1987), which is further described in a link on YT as "*El Charles Bronson argentino!*"; rounding-out this well-worth-watching comp, which moves along at a nice brisk pace, is a trailer for the self-explanatorily-titled serious social drama **EL PODER DE LA CENSURA** ("The Power of Censorship", 1983)—which likely amounts to one of EV's most "respectable" and upwardly-mobile efforts—dealing with the various forms of censorial restraint forcibly applied by society (i.e., both its authorities and its citizens) on those who dwell within it. Yes indeed, its themes are every bit as pertinent today as ever (especially here in upper North America), as the would-be authoritarian/totalitarian censorious quashers of Freedom of Expression seem to be EVERYWHERE among us right now! (Okay, potential extended political rant over! ☺ *Monster!* most definitely ain't the forum in which to be talking politics anyway. We got way too much better stuff to fill our precious pages with than waste space on that "real world" shit!)

THE BRAINIAC (1961) *[pp.229-256]* |– Adline: *"Fiend From Beyond Time!"* By far the nicest version yet released of this cult super-classic of world cinema in any format is Casa Negra Entertainment / Panik House's now-OOP 2006 Region 1 DVD edition, which came with both the original Spanish dialogue track and optional soft-subs, as well as with an English track which contained the audio of the K. Gordon Murray dubbed version which was imported into the US for television consumption in 1963. When interviewed by Bill "*Keep Watching the Skies!*" Kelley way back in *Video Watchdog* #2 (1990), KGM's head dubbing director/voice-dubber Paul Nagel/"Nagle" accurately referred to **THE BRAINIAC** as "probably the grossest of the Mexican horror films". Nagel further opined to Kelley how he believed that its more gruesome scenes basically only made it uncut onto *gringo* TV because the film was shot in B&W rather than color. It appears as though,

Sinister Film's Italian DVD edition of **BLOOD OF THE VIRGINS**, in their prolific *Horror D'Essai* series; presented in its original Spanish, with Italo subs

Front Row Entertainment's awesomely garish Canadian cover art (artist unknown) really made their cheapo (5 bucks Canuck!) edition of this ultramegasuper-classic leap off the shelf into my hand; but I'd still have snapped-up a copy even if it came in a plain brown wrapper... but then Casa Negra's optimal disc release came along and left this edition in its dust! ~ **SF**

judging by some as-yet-unsubstantiated reports/rumors, that on its initial airings (starting sometime in '63), AIP-TV's original broadcast version was evidently a full-length, entirely uncut print. However, due to complaints from various viewers about the gruesomeness/grisliness of certain scenes, it was at some point or other censored here and there for subsequent broadcasts, presumably only on a local/regional basis (?). However, the longest known version (@ 77 minutes) has long been available on both videotape and DVD. In terms of picture quality, while it's a tad on the darkish side and somewhat short on pixel definition (its "master" evidently having simply been struck from an old videotape transfer print [possibly even Sinister Cinema's old VHS version?]), the sell-through DVD edition put out by the *el cheapo* Toronto label Front Row Entertainment in the mid-'00s is highly watchable indeed; and not only that, but it came in some pretty cool (if garishly trashy/tacky!) all-new original cover art to boot. A lustrum (i.e., 5 years) or so earlier in the year 2000, it was also put out by another cut-price company, the New York-based fly-by-night operation Beverly Wilshire Filmworks/Telefilms International, along with a more-than-welcome whole slew of other K. Gordon Murray anglicized dub-jobs of Mexi-horror flicks (one o' these days, we'll have to put together a complete list in this here section). However, due to some sort of cease-and-desist order filed by those films' original Mexican copyrights-holder (I do believe the plaintiff in the suit may have been producer's son/Mexican cinema archivist/historian Rogelio Agrasanchez, Jr. [?]), the whole BWF/TI run of titles—roughly a dozen in all (maybe 15, tops)—was yanked from circulation within a year or two after their release...those that weren't already long-since sold off, that is. Smart shoppers like me (i.e., SF) snapped-up copies of 'em while we could, because they didn't stick around long. According to what Dennis Capicik tells me—it was him who was kind enough to pick me up copies of a goodly number of said discs on his travels back and forth to/from the USA from/to Canada at that time (bless 'im!)—many of those bootleg releases (which, to give BWF/TI the benefit of the doubt in the matter, were presumably simply misperceived by them as being in the public domain?) now command quite dear prices on eBay and via other online outlets. I have around ten of 'em, and I was glad to get every last one!

Okay, back to **THE BRAINIAC**... As has so frequently been pointed out by reviewers (it *is* pretty noticeable, after all!), the titular critter's oversized head tends to throb and pulsate a lot; looking rather as though (at least to me, anyway!) he's desperately trying to either inhale or exhale through his nostrils, only his sinuses get so plugged-up with something—possibly other people's residual brain matter, perchance?—that he can't get any air either into or out of his head. But other than for that possible if highly unlikely reason, I can't see why it pulsates and throbs quite so damn much! Unless it's just a brainiac's way of expressing its intense excitement, that is. He also has the—some might say dubious—power to dematerialize men's clothing clear off their bodies then rematerialize them onto his own instead (sure saves dressing/undressing time, that's for sure! But who'd ever wanna matter-transmit themselves into some other guys' gotchies, FFS?!). In addition, rather than bothering taking the time to belly-up to the bar in a nightclub by actually strolling over to it, he simply up and appears right alongside it from right out of thin air, really giving nice'n'sleazy/easy pick-up Ariadna Welter quite the start, although she's so tipsy she doesn't know whether it's just her eyes playing tricks on her or not. When the spirit takes him, he can even go full invisible, if needs be; though presumably he prefers to remain on full view for the most part for the simple reason that he gets such a huge kick out of freaking people out with his frighteningly grotesque appearance. So

far as I can deduce, having seen this movie quite a few times over the decades since I first gratefully laid my disbelievingly goggling eyeballs on it back in the late '80s, it actually appears as though barely a single solitary exterior shot (if any) was taken, as apparently all (or at least most) of the "outdoors" settings were actually lensed on indoor sets, sometimes with greatly-blown-up two-dimensional photographs serving as backgrounds; a tactic which is sometimes quite glaringly obvious, but at other times so subtly seamless it's tough to tell whether the actors are moving out and about in the real world or staying strictly with Urueta's manufactured in-studio alternate reality or not. Case in point during the suitably lurid nighttime scene when Baron Vitelius is boldly and brassily approached by a mature, "MILF"-type hooker on a brightly-lit urban street, for instance. Just when you're almost feeling convinced that said footage was indeed shot out on an actual street in the open air, star Salazar accidentally just happens to move too close to the backdrop, and, down in the lower right-hand corner of the screen, we briefly (right at around the 34.20 mark in Casa Negra's DVD) espy his shadow falling upon it in a manner which would totally defy the laws of physics if he happened to really be moving in a three-dimensional space... but then again, he *is* El Brainiac, possessed of all sorts of mind-boggling abilities, after all, so who can say for sure what's going on! All joking aside (for now!), the crisp, sharp clarity of the Casa disc edition is what makes this momentary "shattering of the illusion" all the more visible than it may have been in the past, and it probably wouldn't be quite so apparent in poorer-quality copies (for instance, I don't remember spotting it in my old Front Row version). While presumably primarily done in this manner for economical purposes, this "indoor-outdoor" technique at times enhances the film's sense of claustrophobia and gives the action a dreamlike (and sometimes nightmarish!) quality. The at times outrageous script oftentimes adds greatly to the overall surreality generated; although, contrary to what often happens during the redubbing process when foreign films are dubbed into the vernacular for release into different markets, KGM's chief dubber Nagel actually makes his cast of voice actors (which included he himself, voicing Salazar's Baron Brainiac part, no less!) mouth English translations which for the most part aren't all that far removed from what's in the original Spanish version. For instance, compare the following series of subtitles with the dialogue excerpt (beginning right at the 27:36 mark in Casa's DVD; for the sake of comparison, simply switch on the English subs while the Anglo-dubbed version is playing) from the KGM dub transcribed at the start of Mongo's write-up

on page 234: "In all the years I have worked in this place, I had never encountered something like this. These two victims' skulls were perforated by a drill, maybe an electrical one. I say it because of the skill, the mastery with which the orifices were made. And the most incredible thing, gentlemen, is that the encephalic masses were completely extracted". Other differences/similarities abound in this regard too. In further example, when, while they are on their lunchbreak, head detective Silva reveals to his skittish/squeamish partner (addressed as "Benny" in the US version [played by director Federico Curiel]) about the murder victims' "drastically de-brained" (my words!) condition; casually remarking to him, in subtitle on the Spanish version, about their "Total absence of encephalic mass" (whereas, in the Anglo dub he puts it a lot more tactlessly by blurting out, "And as usual, Benny, *his brains have been sucked out!*"). Adding to the already considerable queasy feeling in poor Benny's belly, this moment occurs right before their waitress strolls up and plonks down his preordered plateful of grub. "Here are the brain tacos", she matter-of-factly announces in the subbed Spanish version, alternately nonchalantly saying "Your order of calves' brains, sir" on the *gringo* audio track. Needless to say, her customer no longer has any appetite left whatsoever by this point! (Better if Benny had ordered Eggs Benedict instead, perhaps. Come to think of it, sloppy as

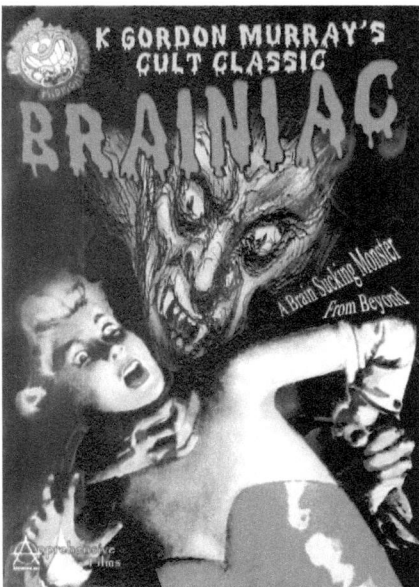

Sans the "**THE**", Apprehensive Films' currently-on-offer **BRAINAC** DVD-R appears to be a shady "grey" market release...cool if crude (stolen) artwork, though! ☺

they are, that might not go down too well on an upset stomach either!) And speaking of eating, of the notorious scenes wherein the character for whom he provided an American voice eagerly spoons cerebral tissue into his trap like it's pudding, Nagel remarked in the same *VW* interview quoted above, "It reminded me of someone eating tapioca". *Mmmmm, YUM!*

Starting in 2013, someone calling themselves Apprehensive Films began offering **THE BRAINIAC** on burned-to-order DVD-R. Online retail sources for that disc include Techno Outlet (@ *www.technooutlet.com*), and our uneducated guess would be that it's merely a booted dupe of a pre-existing edition, quite possibly (?) even Casa Negra's most-optimal one to date from '06. As of this writing, there was a copy of AF's edition (loudly hyped as *"K. Gordon Murray's Cult Classic"*) on offer at eBay for just $6.95, boasting some pretty cool pulp mag-style cover art which appears to have been cobbled-together from a couple of different pre-existing sources. Also, the film was even more recently picked-up for the purposes of streaming online by Netflix USA. And, not that anyone in their right mind—or even their *wrong* one, for that matter—would ever wish to subject themselves to the torture of it thanks to these flippin' friggin' smart-alecky/never-STFU Philistines, this is also available to stream in a fucked-with/vandalized version allegedly (quote) "Made Funny *[sic!* ☺ *– SF.]* By Rifftrax" (their words; most definitely *not* mine!). By all means AVOID that masochistic non-experience at all costs! And speaking of masochism, not that we (generally speaking!) like to judge a book or video by either its cover or title, from the little we've seen and heard about the sub-indie no-budget monster flick **BRAINIAC** (2004, USA, D: Terry Michael King), it sucks in all sorts of ways…just not the *right* one. And no, despite its title, it definitely *isn't* even an attempt at any sort of remake/reboot, so you can breathe easy on that score! However, if one of our regular contribbers feels so inclined (Attn: Paging Christos Mouroukis! ☺), we'll gladly run your write-up of it in a future issue. But by all means give it a fair shake, okay? Cuz that's just the way we roll (mostly).

CHUDAIL STORY (2016) *[p.308]* |– Whether legitimately or not (who can say for sure?), there's a real nice HD (i.e., 720p rez), letterboxed and—*BONUS!*—English-soft-subbed upload of **CS** at the Bolly Kick – Hindi Movies channel on YouTube (@ *https://www.youtube.com/watch?v=DL4zYN1ebhc*), whose crisply crystal-clear upload was evidently taken from one of the numerous online streaming sites whereon the movie is concurrently streamable. At SPL Pictures' YT channel, there's even a trailer available there in all the same formats too. Although, surprisingly enough, **CS** hasn't yet been made available on disc

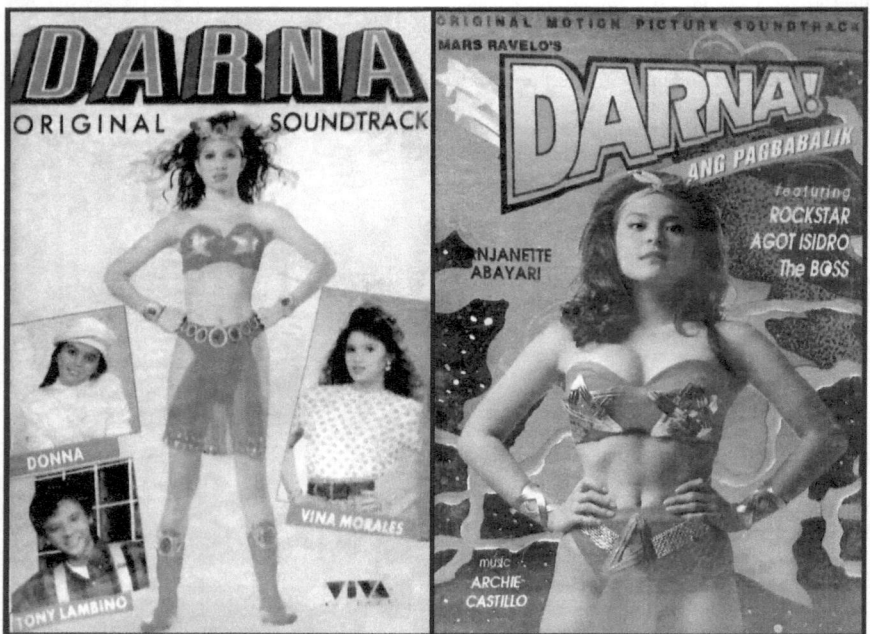

Darna movie soundtrack audio cassettes, featuring then-"hot" Pinoy/Pinay pop singers

in its country of origin (nor anywhere else either, most likely), judging by the "place-holder" ordering page that's up at India's Induna retail website (@ www.induna.com), an All-Region DVD release is imminently planned. Those who want it badly enough despite Kinshuk Gaur's far-from-flattering review of it herein can simply click on the "email notification" button thereat and be notified via their inbox whenever the disc becomes available. No price is given at said site as-yet.

THE CROSS OF SEVEN JEWELS (1987) *[p.298]* |– Virtually unreleased anywhere, Marco Antonio Andolfi's cheapskate "werewolf" (?) flick first premiered on Japanese VHS videotape back in '87 courtesy of that now-highly-collectible label, Sony Video Software (released in conjunction with Mount Light Home Video as part of their so-called EXc!t!ng *[sic]* line). Adorned with typically eye-popping cover art, their edition of the film came both in English and nicely letterboxed, albeit with the customary burned-in Japanese subtitles, of course. Oh yes, and all genital nudity/pubic hair is digitally censored, as per the usual norm, by a blurry "mosaic tile" pattern which obscures the offending naughty bits (quite severely in some scenes; you'll know them when you see 'em!). As a bonus, the film is preceded by an English-language trailer for Larry Ludman (a.k.a. Fabrizio de Angelis)'s cheesy shot-in-Manila "Karate Kid" rip-off **KARATE WARRIOR** (*Il ragazzo dal kimono d'oro*, a.k.a. **FIST OF POWER**, 1987, Italy). Also, under its slightly different alternate title **CROSS OF THE SEVEN JEWELS**, it was released in a limited edition on VHS in Germany in 1998 by Incredibly Strange Visions (ISV), presented in its English-dubbed format, but with German hard-subs. ~ **Dennis Capicik**. To round out this entry in not-so-fine style, check out the following bunch of user comments we plucked from the IMDb, which unanimously tear **TCOSJ** several new assholes with their bare teeth: *"Entertainingly Inept Vanity Project... Unbelievably ridiculous—thoroughly bad but enjoyable... The Rape of Cinema! ...Easily one of the worst Italian horror movies of 80's (3 naked werewolves out of 10)... Mind-numblingly awful... A really dreadful and unintentionally funny mess of an Italian werewolf horror flick... A werewolf movie so bad, I don't even know where to start!"* (There! After that lot, now you just *know* you won't be able to resist checking it out! ☺)

DARNA movie series (1965-94) *[pp.88-105]* |– Just to let the record show, we here at *M!* (as with most any other title detailed hereabouts, unless we specifically single one [or more] out for an especially glowing endorsement just because

Alternate Indonesian VCD covers for one of the local *Darna* knockoffs. That *"Stop Pembajakan!!!!"* blurb pasted atop the bottom pic is an anti-piracy notice. BTW, the website at the addy also added to the image above has since expired, so it's a no-go zone

we think it deserving) are not necessarily officially endorsing the products we cover in this section, merely throwing the info out there for people to use (or *not*) as they see fit. So, especially when it comes to dubious deals like the following one appears to potentially be—but then again, by the same token, it might be more than acceptable, for all we know—you pays your money and you takes your chances! While it seems to be a pretty shady grey (more like jet-*black*!) market operation, for a total of $59.95 US, a package deal (*"8 Rare Darna Films!"*) simply entitled the *Darna Collection (1965-94)* is available—if only in DVD-R format—via the retail site Rare Movie Collector (@ *https://raremoviecollector.com/shop/ultimate-darna-collection-1965-94/*). Included in this unofficial "box set", in Tagalog only, are: **DARNA AT ANG BABAENG TUOD** (1964) *[p.92]*, **DARNA AND**

THE GIANTS (1973) *[p.93]*, DARNA AT DING (1980) *[p.97]*, and DARNA (1991) *[p.98]*; in Tagalog with English subs are: DARNA VS. THE PLANET WOMEN (1975) *[p.96]*, DARNA, KUNO...? (1979) *[p.105]*, and DARNA! ANG PAGBABALIK (1994) *[p.99]*. Sold individually as well as *en masse*, each of these titles can be purchased separately for $12.95 apiece. Those who purchase all 7 discs together get a "bonus" eighth film, BIRA! DARNA, BIRA! (1979) *[p.105]*. Presented only with its original Tagalog dialogue track, *sans* English, B!DB! is (quote) "only available when the entire 8-disc set is purchased for $59.95, and is not sold separately". Hype for the set's aforementioned copy of DARNA AND THE GIANTS claims it is "totally uncut, with an extra 10 minutes of footage added which is missing from all other prints". As for the included spoof DARNA, KUNO...?, starring the domestically phenomenally popular Pinoy comic Dolphy—who's rather akin to the local version of Italian superstar Totò—it contains some pretty funky Filipino folkloric content that includes both *Tikbalang*s ("horse demons"; half-equine/half-human) and that popular favorite kind of *Aswang*, the self-segmenting winged "semi"-vampire known as the *Manananggal* (in this particular instance a trio of female ones, who suck Dolphy's blood—through a drinking straw, yet!—only to spit it out in disgust when they realize he isn't a virgin anymore!). The above group offer, or else one highly similar to it, is also available at the Super Strange Video site (@ *www.superstrangevideo.com*). This same source also offers the full 2009-10 *Darna* teleseries, sold as a set of 14 DVD-R's (for $59.95, with free shipping in the USA). Also, containing the same capsule plot breakdowns given at the first source listed above, the retail website iOffer (@ *http://www.ioffer.com/i/darna-collection-482865507*) is also flogging a *Darna Collection* of much the same package... albeit for a higher total price of $91.04 ([!!] Canadian) and sans the offer of a bonus copy of BIRA! DARNA, BIRA! when you purchase the entire set. By the way, there used to be a whole bunch of Darna flicks up on YouTube, but the supply seems to have dwindled drastically since I first downloaded personal copies from there a year or two ago. As of this writing, the following were the only ones we could still find up there, so pickings have gotten decidedly slim: DARNA AND THE GIANTS (@ *https://www.youtube.com/watch?v=apd7vvd9P_g*), DARNA (@ *https://www.youtube.com/watch?v=f_ZdB60y-JIM*), and DARNA! ANG PAGBABALIK (@ *https://www.youtube.com/watch?v=PBwX7ge_kPc*). CAPTAIN BARBELL *[p.105]*, one of the films listed in our Darna filmography in which the heroine makes a cameo appearance is also up on

YT (@ *https://www.youtube.com/watch?v=MX-zUrNkm3G8*). Uploaded broken-up into 10 segments of around nine minutes apiece at the site is a rather scrappy if nonetheless welcome copy of the wacky Indonesian/Darnanian imitation DARNA AJAIB *[p.105]* (Pt.1 is @ *https://www.youtube.com/watch?v=2fBDlzipkis*), whose various cheap thrills include a hideous snake-woman and a *kapre*-like giant (albeit sans any cigar, such as that hirsute, tree-dwelling big dude is said by Filipinos to smoke). Once you surf the algorithmic waves into the "Darna" zone of YT, there are all sorts of clips and related links to click on there to keep you busy for ages!

DRACULA (1931) *[p.108]* |– *[Note: To save time, the following entry is reprinted virtually verbatim from* Monster! *#25 – eds.]* Not that most *M!* readers presumably need to be told, but this iconic "Golden Age of Horror" title has been made available through Universal Pictures Home Entertainment (and its various subsidiaries/umbrella companies) in about a trillion-gazillion different formats and editions over the decades since Uni's home movie merchandising wing Castle Films first issued it in truncated form on 8mm and 16mm film back circa the early '60s, and it—as with much of their most popular Universal Monsters series—has been kept available in whatever state-of-the-art medium ever since, from Regular and Super 8 on through RCA SelectaVision CED, Betamax/VHS videocassette, laserdisc, and currently on DVD and Blu-ray. You've sure come a long way, Béla baby! ☺

DRÁCULA (1931) *[p.115]* |– As for the simultaneously-shot, much longer Spanish-language version of the '31 Lugosi film, it's been commercially available for home video consumption for a good deal less time than the original has, naturally enough, since it only first ever became re-available again *circa* the late '80s (?) after being previously presumed lost for many decades; it's also currently (and till Hell freezes over too, no doubt!) from Universal Pictures Home Entertainment in various digital formats. Speaking personally, I (i.e., SF) totally LOVE both versions all to bits ("When I say I'm in love, you best believe I'm in *love*, L-U-V! [to quote the New York Dolls' frontman David Johansen's trash-talkin' intro to their glam-rock classic "Looking for a Kiss"]), sometimes for much the same and at other times for totally different reasons; but as far as I'm concerned, they totally complement one another ideally, and the world would be a far lesser place without either of them... or, worse yet, *both*! In my opinion, Troy Howarth does a fine, even-handed job this ish of "leveling the playing field" fairly in regards to both films, although I think I perhaps do appre-

ciate the Spanish version quite a bit more than he does. But to each their own, as the old saying goes! Incidentally, while we do generally favor fonder write-ups of fave fare from our contributors rather than needlessly mean-spirited trashings of things which they can't find even a single positive thing whatsoever to say about—*NO* movie is ever *that* totally bad, surely?!—*Monster!* provides a forum in which writers may express their honest opinions of monstrous media fare freely and as they see fit. Unless politics pertain directly to the subject, please try to keep any *heavy* politicking OUT of it, though, if you will (identity politics—one of *THE* very *WORST* kinds—especially); that's what personal blogs and social media are for, and we'd really rather not sully our precious pages with such depressing "real world" twaddle, especially if it's being spouted from an entirely one-sided viewpoint with zero objectivity and even less sense. (Okay, impromptu sermon over! *Next!*—)

ISLAND OF TERROR (1966) *[p.257]* |– For the simple reason that this Brit monster classic is due to be released on domestic Region A Blu-ray by Shout! Factory very soon (on June 20th, 2017) and their edition shall likely trump (<<< *Oops!* Pardon the potential trigger-word there! ☺) all others, we're not even gonna bother listing any of its earlier releases here, simply because none of 'em will even come close to S!F's impending version, we reckon. (*There!* How's that for an excuse not to bother?! But we really have maxed-out our pagecount this ish, so we're desperately trying to save space wherever we can, without actually cutting any corners to do so.)

KONG: SKULL ISLAND (2017) *[p.309]* |– Still actively packing 'em into theaters even as we went to press, **K:SI** is not surprisingly unavailable on domestic disc of either format yet.

KRAA! THE SEA MONSTER (1997) *[p.305]* |– Initially released on domestic DVD by Full Moon, it was subsequently (in 2003) issued in the same format by Shadow Entertainment. According to reports, **K!** incorporates some "previously enjoyed" footage from its lesser predecessor, **ZARKORR! THE INVADER** (see separate entry below). Trivia Time: While **K!**'s titular critter bears more than a passing resemblance to certain—some more than others'—Marvel Comics artists' interpretations of the fishy humanoid superantihero character Manphibian (a member of Marvel's Legion of Monsters), other than in-name-only he bears no resemblance whatsoever to another comic creation called Kraa, which/who was a monstrous creature adopted as the living idol of primitive tribespeople in the African bush; in actuality a former hu-man

Top: Derann's '80s Greek VHS jacket for **ISLAND OF TERROR** (art unsigned).
Above: The spectacular Chinese DVD cover for **KRAAI** *[sic!]* **THE SEA MONSTER**

who had been irradiated by irresponsible commie A-bomb tests on the Dark Continent, thus turning him into a big, brutish bluish-greyish *thing* which has vowed vengeance on everyone in the so-called civilized world (word balloon, transcribed as-is: "OH NO! **NO!** IT--IT **ISN'T** A STATUE!! IT'S A **LIVING BEING!!** KRAA IS ALIVE!! **ALIVE!!**"); however, a twist ending proves it/him to be not such a mean mother-effer of a monster

after all. First seen in Marvel's *Tales of Suspense* comic book #18 (June 1961; cover and story art by Jack Kirby), his tale "Kraa the Unhuman!" was reprinted by them eleven years later in *Where Monsters Dwell* #15 (May 1972; with new cover art by John Severin). As for the present Kraa, if he looks nothing like the same-named monster just discussed, he bears even *less* of a resemblance still (if that's even possible!) to the heroic giant eagle character by that name found in Belgian comics illustrator Benoît "*Inspector Canardo*" Sokal's "alternate world western" series, *Kraa*. See all this wonderful (if useless) trivia we treat you guys to?!

LAKE OF DRACULA (1968) *[p.261]* |– Along with a number other Japanese *kaiju* and *kaidan eiga*, **LOD** first quite unexpectedly turned up stateside on VHS tape from Paramount Home Video all the way back in 1994, and we were happy as pigs in shit to have it, even though copies of the pre-record were duped at the incredibly stingy, cost-cutting EP ("extended play" a.k.a. SLP / "super-long-play") mode; however, considering it only went for an average price of around ten bucks both north and south of the US border and the print contained was more than presentable anyway (barring the occasional video tracking problem, that is), if you think we hard-up Asian horror freaks were bitchin' about it one bit, you'd be dreaming! (Well, okay, maybe a *little*...) More recently, it was issued on British DVD/VHS by Artsmagic (2002), and copies of that now-OOP edition can be found used at various sources online (*Amazon.com* included). At the present time, an All-Region DVD(-R?) version of this film is available at the Amazon link entitled "LAKE OF DRACULA (1971) Michio Yamamoto / English subtitles DVD".

MAJIN series (1966) *[pp.68-87]* |– Either singly or collectively, the entire trilogy is available domestically on Region A Blu-ray and Region 1 DVD from Mill Creek Entertainment (a typically cheapozoid outfit who are really starting to come up in the world quality-wise, so it seems). Versions have also recently been released in both the same disc formats in their country of origin, in their original Japanese without English subs. Following its rousing inaugural appearance in **DAIMAJIN**, the stroppy stone idol that seldom stayed bone idle stomped again that very same year in **RETURN OF DAIMAJIN**, hotly followed by his third and final appearance—as angry as (if not even *angrier* than) ever!—in **WRATH OF DAIMAJIN**. While Mike Hauss already gave all three Majin movies some myghty fyne and ample coverage in his article proper elsewhere this ish, being as it is the lesser-seen and least-discussed of the trio, we just wanted to put in our own two (or three) cents' worth here, so here goes... As an old VHS ad-line for #3 exclaimed, "*A Wave of Evil Has Been Unleashed! Now the land must be cleansed!*" Evidently in hopes of attracting a younger audience, the third and final entry, **WOD**, stars not only a quartet of juvenile Japanese actors in the main heroic roles—Tsurukichi (Hideki Ninomiya), Kinta (Masahide Iizuka), Daisaku (Shinji Hori), and the "momma's boy" runt of the group, Sugimatsu, nicknamed "Sukebo" (Muneyuki Nagatomo)—but, while there is still plentiful fervent praying going on here too at times, it also largely dispenses with the far preachier, religious-heavy tone of the first two instalments. Unfortunately, at the same time, they place so much of a focus on the four boy protagonists' efforts to get where they're headed cross-country (turning it into a sort of off-road "road" movie) that the title character rather gets lost in the shuffle. Although, adding a novel bit of interest, the scowling/glaring god-monster does have a personal familiar in the form of a "watch-hawk" in this entry. In a memorable scene, said bird of prey swoops down out of the heavens like a miniature Rodan to bloodily dispatch a trio of musket-toting warriors before plummeting to the earth like a dead duck after being plugged by a stray bullet, and the bird's death in defense of the juvie heroes serves as the catalyst to Majin's reawakening this time out. It isn't until just before we hit the 65th minute that the po-faced Shino puts his green "bad face" on to become Majin once again, however. In keeping with this entry's "gunpowder plot", the most firepower seen in the entire trilogy (includ-

The glorious modern Japanese DVD artwork (by Koga) for **LAKE OF DRACULA**

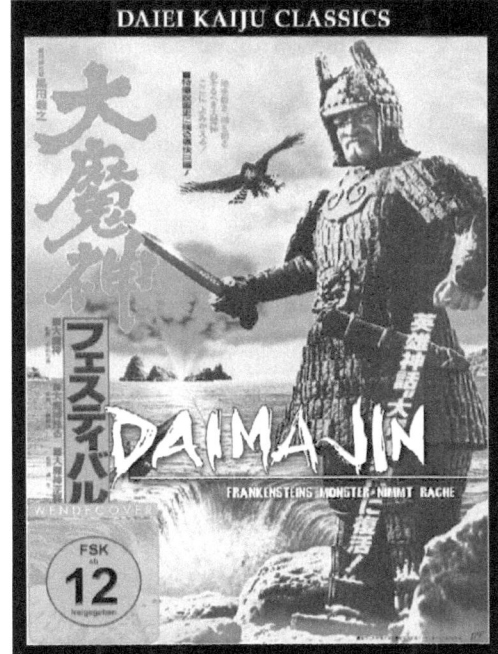

German DVD cover (see also above left)

Daimajin soundtrack CD set
(Tokuma TKCA-30295)

Limited edition T-shirt from Japan
(available @ *https://www.atpress.
ne.jp/news/119033*)

Color-Xeroxed cover to a $2.00 Toronto Chinatown bootleg (taken from the Hong Kong release) DVD-R—"courtesy" of the Triads!—for **MAREBITO**. The only way that this artwork differs from the original official HK release is that a special new product number has been added at the base of the spine, as with all such releases I ever saw (and bought!) ~ **SF**

actors, yet, while they have the familiar guttural intonation of their mother tongue down pat even while speaking ours, the effect comes across as equally phony as any number of Godzilla/Gamera movies done by Anglo dubbers faking stereotypically "Asian" accents! Of related interest because Majin is such a key focal point of it, according to Kara Dennison at Crunchyroll (*www.crunchyroll.com*), a Japanese-only 496-pp. softcover text anthology—which comes with a supplemental CD (also only in Japanese, natch)—of unreleased audio drama scripts and story treatments by the influential writer/composer/actor Yasutaka Tsutsui was recently published (in February 2017), also containing all-new illustrations by the contemporary manga artists Hiroaki "*Blade of the Immortal*" Samura and Terada "*The Monkey King*" Katsuya, along with vintage (c.1960s) reprinted ones by Nagatachi Karasawa and Yoshito Sugawara. Entitled 大魔神 筒井康隆全戯曲4 (*"Daimajin: The Complete Dramas of Yasutaka Tsutsui – Vol. 4"* [the final volume in the series]), it is available to order via the Japanese retail website *Fukkan.com* (@ the URL addy *http://www.fukkan.com/fk/CartSearchDetail?i_no=68325355*). The cost at Fukkan is 3,996 ¥ ("yen"), which sounds like a lot more than it actually is; although, even when converted to US bucks, it's still a pretty tidy sum (around $360.00, at today's rate of inflation; either that, or the Google online currency converter done made a boo-boo).

MAREBITO (2004) *[p.150]* |– Some years ago down in Toronto's Chinatown, in its Hong Kong incarnation, complete with English subs, I (SF) was more than happy to snap-up a Triad pirate DVD-R copy (the average price of which—complete with box and color laser copy of the jacket—was a mere 2 bucks Canuck) of this excellently creepy flick, but if I'd known what a great movie it was, I would definitely have snapped-up a "legit" copy every bit as readily for probably as much as ten times the price, so it all evens out. This film was also put out on British PAL All-Region DVD in 2007 by Tartan Asia Extreme. It's also been made available at different times on PAL Region 2 DVD, both in Italy (by Cecchi Gori Home Video; in Japanese, with Italian subs) under its original anglicized/transliterated Japanese title given here, as well as in the same disc format in Greece as ΣΚΙΩΔΗ ΠΛΑΣΜΑΤΑ (*"Shadow Creatures"*) from Audio Visual Enterprises. Surprisingly enough for a French release (which usually seem to go out of their way *not* to include English subtitles! [Blame it on Wellington kicking Napoleon's *derrière* at Waterloo! ☺]), the R-1 DVD edition released in France (?) by Warner Bros./Seville in 2005 actually comes complete with subs both in *français* and *anglais*. Hold that

ing volleys of matchlock musketry and a broadside of cannons) is unleashed against the striding stone tromper-stomper. At one point hefting a whole log in each gauntleted fist as effortlessly as if they were baguettes, once he finally gets going though, if anything the mighty man of masonry (rubber suit worn by human powerhouse Riki Hashimoto herein) trashes more stuff here than in both the first two movies combined. Adding a novel touch, this time it all goes down during a fierce snowstorm in which fire and ice vie against one another as fiercely as men battle the monster. While opinions on the matter tend to differ, I personally think the climax of **WOD** is the most spectacular and exciting of the series (and that's sure saying something, because they all end with quite the bang). And, judging from the sounds of things, my guess would be that Pt. III was dubbed into English at a much later date than the first two (?). There is just something "different"-sounding about the audio track on this one that sets it apart from Pts. I and II (and not in a good way, although it serves its purpose functionally enough). Something about some of the terminology used smacks of being more modern (e.g., the phrase "you guys" is heard spoken more than once). Ironically enough, it seems to have been dubbed by actual English-speaking Japanese voice

thought! Actually, come to think of it, from what I can tell, said edition may actually have originated a lot closer to home in French Canada (i.e., Québec) rather than back in Mother France; if so, those bilingual subs aren't *quite* so surprising, although many a PLQ-supporting Québécois (pronounced "kebekwa") Separatist might not approve of them, mind you!

MARK OF THE VAMPIRE (1935) *[p.116]* |– After for the longest time being considered lost then being rediscovered lying in the vaults sometime during the early/mid-'80s (?), **MOTV** was first made available on domestic Betamax/VHS videocassette from MGM/UA back in 1987. Because the rights have since switched to Warner Brothers, it is now available on DVD through them. Disc releases of theirs including it are: the six-pack "Hollywood Legends of Horror Collection" (from 2006), which also comes with the five following other classics (running [ad-quote] *"the gamut from classic vampirism to baroque romanticism"*), that are all well-worth-having for classic monster/horror movie buffs: **MOTV** director Tod Browning's own **THE DEVIL DOLL** (1936), **DOCTOR X** (1932, D: Michael Curtiz) and its in-name-only, Humphrey Bogart-starring sequel **THE RETURN OF DOCTOR X** (1939, D: Vincent Sherman), along with **MAD LOVE** (1935, D: Karl Freund), plus, last but by no means least, **THE MASK OF FU MANCHU** (1932, Ds: Charles Brabin, Charles Vidor). The set comes with special commentaries by "those-in-the-know" for half the films, plus theatrical trailers for all of them. **MOTV** is also available via Warners in a Double Feature deal as part of the same series, doubled-up with that lattermost title just cited in the sentence before last. On a related note, Béla Lugosi's co-star Carroll Borland got a whole LOT of mileage out of her archetypal portrayal of the "dark angel" Luna in the film, exploiting it to the max/milking it for all it was worth for literally decades and decades after the fact—and who can blame her?—as a regular fixture of horror conventions and the like. We'd like to say she was cashing-in even further than she'd done already when she wrote her novel, entitled *Countess Dracula*; only thing is, it was actually written in 1929, some half-dozen years *before* the film which cemented her as a pop culture icon ever even made it to the screen. More than 60 years after it was written, the work was finally published in 1995 by MagicImage Filmbooks (a 2015 digital edition from BearManor Media is currently still available in Kindle format via Amazon Digital Services for a mere $7.55 US). Not bad for a "vampire" girl who in actuality (i.e., as per within the movie's context) *wasn't* really one at all (as for in real life though,

who knows)! So far as **MOTV** is concerned, this wonderfully ambient *faux* vampire movie is still quite the entertaining slice of "old school" (mock-) monster cinema anyway, its pre-"*Scooby-Doo*" letdown ending notwithstanding. And in our considered opinion, it does still fit in this here mag regardless of its groan-inducing-to-some anticlimactic "big reveal". Why? Simply because, whether "actually real" or not, vampires *are* still monsters, after all (even when they're—*uh*—not really).

MATANGO (1963) *[p.140]* |– Due to the fact that, in a not-too-distant issue, we're planning (or at least *hoping*) to have a special **MATANGO** "roundtable"—not to jinx it or anything, but hopefully with cover art by that great monster mag cover illustrator Bob "*FM*" Eggleton (who gave us the fab Majin portrait on p.85)—we're gonna reserve the bulk of this film's quite lengthy home video history till then. Suffice to say for now though that it has long (i.e., since 2005) been extant on domestic Region 1 DVD from Media Blasters / Tokyo Shock, so copies are by no means hard to track down online for them that want them.

THE MAZE (1953) *[p.276]* |– Up for grabs as a made-to-order DVD-R from Sinister Cinema, it

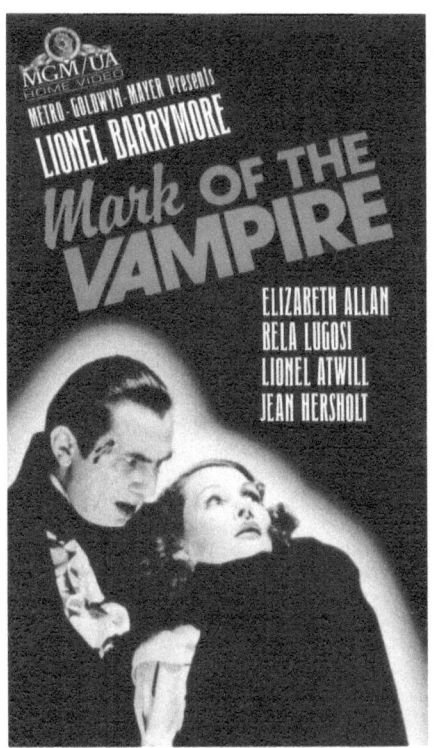

MGM/UA's domestic '87 VHS

Tokyo Shock's US DVD edition (2005)

seems odd to us that this moody favorite of Hollywood Gothic isn't more widely available. Beginning with a superimposed "TV G" rating (for "General" audiences) logo which lets us know it was ripped from an airing on American telly, there is a murky if endurable enough upload of this film on YouTube (@ https://www.youtube.com/watch?v=Cp_6Bw_uHBc) that's been up at the site for over two years now without being taken down yet, so chances are it's there to stay. Oh yes, and for real hardcore fans of this fine flick, as of today (March 24th, 2017), there was an unusual and exceedingly rare item of original paper material pertaining to the film—namely, a promotional folded card with a die-cut "pop-up" insert—being offered on *Amazon.com* (at the page titled "The Maze Pop-up 1953") for "just" $234.00! There are many, many sources all across the web via which to obtain various-condition used copies of Maurice Sandoz's 1945 source novel *The Maze* (featuring a total of 11 illustrations by Salvador Dalí [1904-1989]; see p.279). For instance, as of right now, Amazon had a number of copies of the '45 and '46 hardcover editions on offer for from between $30-$50. Concurrently on eBay, a first edition of Doubleday, Doran & Co.'s '45 US version was being sold with an asking price of US $112.49. The British booksellers' site *Abebooks.co.uk* has no less 26 copies for sale (mostly of the '45/'46 edition) by various vendors, ranging in price (in pounds sterling) from as low as £24.69 to as high as £332.77; their costliest copy by far being a first printing/

edition with an asking price of £1,500.00, boasting a title page personally-autographed/inscribed by illustrator Dalí himself (dated 1968). The first Brit edition was published by London's Guilford Press in '53, the same year that the film adaptation was produced (presumably as a tie-in that coincided with its UK release?). Providing further food for thought as we bring this entry to an end, according to Wikipedia, "The story is somewhat influenced by the monster of Glamis Castle, a legend in Scottish folklore".

MOONLIGHT MASK (1958-59) *[pp.40-67]* |– We haven't been able to deduce for sure whether the entire 130-episode (some sources say there are one more than that) *Gekkō Kamen* TV series has been made available on disc—assuming (?) that the whole lot of them are even still *in esse* (their simple vintage makes the loss of some seem highly plausible [?]), but we can reliably report that their original producer/current rights holder, the advertising media conglomerate Senkosha, have issued (in conjunction with Humming) a bunch of them—totaling three (?) volumes in all—on domestic Japanese DVD, albeit sans any English titles (for ordering info, see the Humming website [@ http://humming.ne.jp/business/dvd/gekko_kamen/index.html]). As for the movie spinoffs based on the teleserials, all of those are concurrently extant in the same digital format from Toei Video (Toei being their originating studio), also minus *gaijin*-friendly subs, so best you bone-up on your Nipponese! For anyone interested in seeing **THE MOON MASK RIDER** (月光仮面 / *Gekkō Kamen*, 1981, D: Yukihiro Sawada) the failed theatrical feature from the forestalled relaunch of the *GK* movie franchise, go to the following link at one Jeffry Vazquez's YT channel (@ https://www.youtube.com/watch?v=mvHq3oib8wM). It doesn't come with any English—nor any monsters either, just so's you know!—but is at least fully widescreen and of passably decent picture quality to be worth a look-see. In that movie just mentioned, amusingly enough, the Moon Mask Riders, a 6-piece musical combo (consisting of fully three guitarists, a bassist, keyboardist and drummer), all sporting identical MMR costumes, appear "live in concert" performing an energetic if super-schlocky funk-rock/power pop anthem glorifying the title hero for the benefit of an audience of frantically boogalooing 20something "teenyboppers"! Now, if it had instead been done in a cool spacey surf style, with a heavy accent on the tremolo bar/wah-wah pedal/phase shifter/fuzzbox and other classically "psychedelic" audio FX, that might've really been something. Lastly, those wishing to either dip their toe into

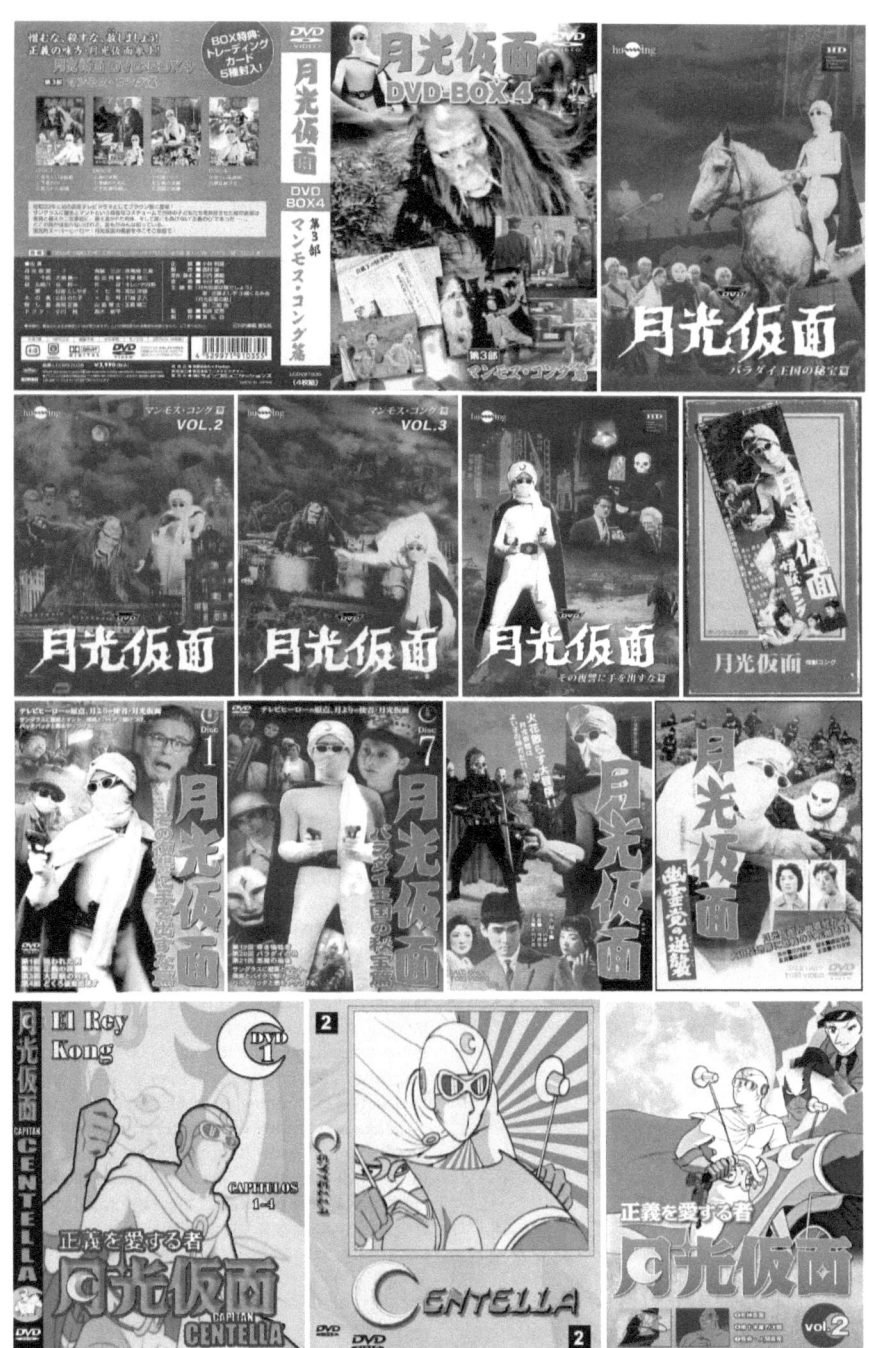

Above, Top 2 Rows: Assorted covers for Humming/Senkosha's Japanese DVD releases of the *Gekkō Kamen* TV serials. **3rd Row:** Four more native DVD covers, this time for some of Toei's cinematic spinoff features. **Above:** A pair of (fan-made?) Hispanic DVD jackets for the '72 anime show *[left & center]*, plus a Japanese one for same

the *GK* mythos (see filmography on p.353) to test the water or even dive into it headfirst without checking whether they'll be plunging in way out of their depth or not will have no trouble whatsoever turning up absolutely *OODLES* of stuff pertaining to the long-standing, much-merchandised franchise: manga, videos, records, toys, Menko (counting game) cards, masks—you name it! For further reading on *GK/MM*—the articles are all in Japanese, but Google Translate will convert everything into some sometimes surprisingly quite legible English for you, if needed—visit these following online addies:
http://fujiskya.web.fc2.com/ks30.htm
http://www.senkosha.net/column/05.html
http://humming.ne.jp/business/dvd/gekko_kamen/story.html
http://humming.ne.jp/business/dvd/gekko_kamen/tokuten.html

THE SEVENTH CURSE (1986) *[p.282]* ⊢ Okay, this here's Les Moore speaking, taking over for this entry, for better or worse. I expressly asked *[Begged and pleaded, you mean!* ☺ *– eds.]* Steve and Tim if I could come up with the vid info about this title for the simple reason that, much like this ish's reviewer of same Jeff Goodhartz, as well as Messrs. Paxton & Fenton too, it's one of my absolute *faverinomundo* Asiatic creature features of all; which means that this entry will most likely turn into more of a glowingly gilded endorsement of 7ᵀᴴ C rather than merely being a dry listing of the various video sources for it, but what can ya do? *C'est la vie!* (Besides, there aren't really very many video sources for it that I know of which come with English anyway, so I gotta fill up my allotted space somehow, right? *[Sure, Les, but do try to bring it in at around or under 1,000 words, will ya? Remember that old saying about how "Less is more"! Considering your birth name, you could at least try to live up to it somewhat. – SF].*) Okay, on with the show... True to trope, spoiled brat rich kid/budding photojournalist Tsai-hung (Maggie Cheung; whose character is dubbed "Rainbow" in some versions) insists on tagging along for the big jungle adventure they all go off on together, whether the guys like it or not (they *don't*), as per that old trope that's so old it's got whiskers on top of its whiskers. A real high-maintenance drama queen prone to throwing shrill, screechy temper tantrums whenever it suits her (shades of seemingly more real-life females than ever before these days! ☺), in one scene, our bespectacled, bookish if by no means wimpy secondary hero Dr. Yuan Chen-hsieh (Siu-ho Chin) threatens—thanks to a typically wonky subtitle—to spank her "without pants" (we can only assume he meant hers, not his). Later, having been made their captive by the baddies and become enslaved by a black magic spell, Ms. Cheung (quote) "goes berserk and is herculean" to run amok while swinging a machete at anyone who comes within range; although, being a girl ("☺"), she doesn't actually succeed in hitting anyone with it, so no worries. The much more demure—and about 10,000 dB *quieter*—secondary heroine played by the *[clears throat exaggeratedly]* "well-put-together" Sau-lai Tsui is a tribal maiden who is identified by the Anglo subs as Betsy (yeah, right! A Southeast Asian jungle girl named "Betsy", my eye! Although the Cantonese dialogue seems to be referring to her as "Bahtsi" [sic?] or some such similar thing), who treats us to several candid scenes involving what Bart Simpson once erroneously if pricelessly termed "nakidity" (including an infamous scene which once again reconfirms how razor-sharp knives and nipples should *never* be shown in such close proximity to one another). With his headbanger-long, Goth-black hair and matching nail-polish, while frequently cackling in a shrill, glasscutter falsetto only an octave or two lower-pitched than Witchie-Poo's, Elvis Tsui as the head heavy, an androgynous evil-ass sorcerer/fanatical pagan cult leader and self-styled godly avenger named Aquala ("You've blasphemed Old Ancestor... I'll punish you on behalf of God!"), really gets into his part with some gleeful gusto, and we can be most thankful for that indeed. Putting in little more than a glorified cameo, when he isn't puffing on

Hong Kong DVD cover for **THE SEVENTH CURSE**

his XL gran'pappy pipe, Chow—playing a sort of almond-eyed, olive-skinned Van Helsing—sure knows his supernatural shit, such as a surefire cure-all for the dreaded Little Ghosts spell, for instance ("Get a pregnant cow at once", he orders curtly with proper professional detachment and an air of imperialistic authority which the hop-to-it-chop-chop natives simply can't ignore. "Slaughter it, and get her placenta out. Also, kill a black dog and get its blood". No sooner said than done, they promptly rustle-up all the requested [=demanded!] ingredients on the spot).

Shot against a huge, booby-trap-filled prop Buddha statue, the sequence wherein the heroes, Indy-style, clamber up it via hanging lianas to get at the purifying golden-glowing diadems secreted within its stone eyeballs (containing the special curative seeds needed to free Doc Yuan of his full-strength, ultimately fatal #7 blood curse) harkens all the way back to a spectacular scene involving Sabu in **THE THIEF OF BAGDAD** (1940, USA). Although the Great Buddha gives-up his all-seeing orbs gladly when he realizes it's for a good cause, he loses his head in the process and, as it topples all-too-convincingly off his stone shoulders, this prompts a blatant—if equally well-done—retread of the "giant rolling boulder" scene from **RAIDERS OF THE LOST ARK**. In terms of creepy cuteness, the vicious Little Ghosts demon—animated by the angry souls of no less than five-score mass-murdered dead babies (*egad*)!—rather reminded me of a combination of the parasitical mock-"symbiote" Elmer the Aylmer from **BRAIN DAMAGE** (1988, USA, D: Frank Henenlotter) and the title anal-dwelling (!), subconsciously-summoned, revenge-killing imp of **BAD MILO** (2013, USA, D: Jacob Vaughan). Another even scarier killer kritter is the hyper-energetic/aggressive stubby-winged, Mahar-like flying reptile which Old Master climactically transforms into to go on a no-holds-barred/all-holes-bared killing spree, making for a memorably manic and viciously murderous monstrosity indeed and rounding-out this keeper on the grandest of high notes. Sure it's gory and gets good 'n' gooey sometimes, but the spiritedly enthusiastic FX work is so outré in its energy and extreme exaggeration that the effect is at times rather akin to a live-action Asiatic version of a Tex Avery cartoon (or words to that effect). In addition, there are requisite amounts of high-caliber gun fu to go along with 7^{TH} C's equally-mandatory martial arts action sequences, and during one particularly crazed scene, an incidental extra (trained stuntman? [We can only hope!]) playing a cultist gets smucked head-on by an incoming airborne Range Rover; a moment that ideally illustrates the reckless, devil-may-care attitude towards stunt-work which was so prevalent in HK action flicks during the '70s, '80s and beyond. And all this craziness is crammed into a mere 77½-minute running time, yet! Oh yeah, and before I forget in all the excitement, 7^{TH} C has been made available numerous times—largely in Asia—initially on videocassette, then again more recently in the digital versatile disc format. (Unfortunately, there's no Blu-ray of it in sight yet, however deserving of one it might be [and indeed very much *is*!].) So far as its more legit Chinese DVD incarnations—as opposed to all the bootlegs (including pirate videotape dupes) which have variously circulated both back in the day and now—are concerned, these include a version issued in 2001 both in HK and stateside by Tai Seng Entertainment, and another edition that was released (in 2008) as part of Fortune Star (FS)'s expansive "Legendary Collection" (FS also put it out on HK video compact disc via DeltaMac [DM], and there was another Chinese VCD issued by Mei Ah Laser Disc Co., Ltd.); both FS versions came with English subtitles, but are currently OOP (?), although there are of course copies still in circulation for those wishing to track one down online (be warned that some "deep-Googling" might be required to come up with a copy!). In a rare instance where the film actually received a legit Anglo video release, it was put out on VHS tape in Australia by Siren Entertainment in 1998. The VHS edition put out in the UK on the Mia label as part of their "Hong Kong Classics" line in 1999 was slightly cut by the ever-watchful BBFC; this not unexpectedly during the scene when Betsy slices her breast open with a curved blade (see pics on p.283) in order to perform some "life-saving titty magic"—which is about as good a term for it as any!—on the accursed and ailing hero. For its French DVD release (via FS/Metropolitan Filmexport) known as **LA 7ÈME MALÉDICTION**, it was hyped with the catch-all "*Quand Indiana Jones rencontre Evil Dead!* / When Indiana Jones Meets the Evil Dead!" If anybody's ever gonna get around to releasing it in a state-of-the-art medium today, it'll likely be either its long-time rights holders Fortune Star themselves, or else some licensee specialist video (or online streaming source?) from elsewhere in the world. While most prints seem to run just over 77 minutes, I saw at least one source online which gave an indeterminate DVD edition of the film an 81-minute runtime. Considering its well-deserved cult popularity with HK horror fans, just so long as the world doesn't suddenly blip out of existence one of these days in the not-so-distant future, it seems pretty much inevitable that a deluxe BD edition will eventually materialize from somewhere. (Come to think of it, all you power-hungry politico control freaks, PLEASE don't

blow up the planet until at least *after* 7ᵀᴴ **C** comes out on Blu—and I've had a chance to see it—so I can at least die happily and without any regrets!) ~ **Les Moore** *[Editor's Note: The pirate DVD-R copy I found of this baby down in TO's Chinatown back in about 2005 (thanks, Triads, you evil S.O.B.'s!) was duped from the legal HK edition put out by Universe Laser & Video Co., Ltd./MediaAsia Distribution Ltd., which came both properly widescreen and with English soft-subs. I still have that very same copy in my possession, just in case anyone wants to sic the FBI or the RCMP on me!* ☺ *– SF.]*

THE SNAKE WOMAN (1961) *[p.271]* |– Video sources for this long-little-seen obscuriosity (which is at-best of only marginal interest to most *M!* readers, quite likely, as any "monster" content is decidedly lame indeed) are decidedly sparse on the ground, to say the least, but, for what it's worth, it is thankfully out there in some form for them that might want it. For instance, if you key-in "The Snake Woman (1961 'B' Cult Horror Film on DVD)" at *eBay.com*, a link to a DVD-R version of the movie—on offer for a mere $5.99 US there—will pop up at the head of the queue; whose "master" may or may not (?) have been struck from this following edition we're about to mention… As for more above-board sources, **TSW** is included—its poster tellingly depicted *dead-last* in the cover art, indicating its lowly place in the pecking order of both the DVD billing and in the great scheme of things—as part of MGM's domestic "Movies 4 You" quartet entitled *Timeless Horror*, collectively packaged along with another real rarity, Wm. "One-Shot" Beaudine's John Carradine starrer **THE FACE OF MARBLE** (1946 [whose poster is tactically depicted first]), plus Albert Band's long-easy-to-find **I BURY THE LIVING** (1958) and Edward L. Cahn's once-exceedingly-difficult-to-see-but-now-nowhere-near-so-much **THE FOUR SKULLS OF JONATHAN DRAKE** (1959, all USA); both the latter of which have been extant on disc via MGM as part of their "Midnite Madness" series for quite some time now, while neither **TSW** nor **TFOM** were previously available in any non-bootleg form that we know of. As well as being the only non-American title included in said MGM 4-pak, **TSW** is the sole one therein that is presented at a widescreen aspect ratio (**TFOM** having originally been shot "fullscreen" [@ 1.33:1], as per the norm for the time, with **IBTL** and **TFSOJD** both at 1.85:1 [although, according to a customer testimonial we saw on eBay, both are reportedly rendered fullscreen herein], as was **TSW**, judging by all appearances [or was its original maybe at 1:66.1, perhaps? Hard to say for sure!]). As of right now (i.e., @ 4:29 a.m. on March 20ᵗʰ, 2017), there is an evidently full-length (68-minute) rip uploaded to YouTube (@ *https://www.youtube.com/watch?v=LYK0Tq6idgo*) on the Vulture channel, more than likely—*um*—"borrowed without permission" from MGM's disc version, but what can you do.

There's also a pretty cool narrated American trailer (see our transcription of same on p.271) up for view at Vulture's sister channel Vulture Graffix (who post plentiful content of interest to not only monster movie mavens but trash / cult / psychotronic fans in general, so by all means why not become a subscriber there!). Elsewhere, attesting to at least some sort of minor following for **TSW**, not only has the same Anglo trailer just cited above been posted at a Russian channel (where we learn that the title translates to "Женщина-змея" in that language), but at still another channel someone has posted an 11½-minute, audio-only file of a number of the film's eeriest isolated soundtrack excerpts—complete with all the original special sound effects, but no dialogue—at the link entitled "The Snake Woman (1961) music by Buxton Orr". What with its eerie pipe-fluting and all, this spookily evocative Orr score might have better fit a far superior shocker than it ultimately got saddled with… but it is what it is, so it's nice that even such a largely below-average production has proven to be still very much with us rather than gotten inadvertently or intentionally flushed down the plop-cultural shitter for keeps. Which reminds me: the image quality (in actual *widescreen*, yet, rather than that phony-baloney "artificially-stretched" format that we see all over YT at so many hack-job video postings of the copy of **TSW** posted at Vulture is exceedingly fine, which once again leads me to suspect that the channel likely ripped-off their rip from MGM's current DVD release. Whatever's the case, those with any sort of YouTube downloader software might wanna d-load their own personal copy for their archives, as things like this have a distinct tendency to vanish from YT without a trace at some point. ;-)

TREPANATOR (1992) *[p.217]* |– Back cover blurb to the ultra-rare French VHS release: *"Plus 'Gore'…t'es mort!"* (tr: "More 'Gore'…you're dead!"). **T**'s main—indeed, pretty much *sole*—driving force was D.I.Y. basement moviemaker "N.G. Mount"/Norbert Moutier (or, as some linguistically-challenged movie nerd at a video review of one of his movies on YT hilariously roughly mispronounces it, "Norrburtt Mottiyurr" [!?]). A highly interesting fellow indeed, his website, Monster Bis – Le Site officiel de Norbert Moutier (@ *http://monsterbis.free.fr/index.php?p=bio_monsterbis*), is well worth a browse for those interested in finding

out more about this virtual one-*homme* homemade "movie-love" (my term) cottage industry, who is so much more than merely a maker of no-budget filmic fare. As for the present selection from his filmography, according to the French blog Nanarland (@ *http://forum.nanarland.com/viewtopic. php?f=17&t=15038*), only a single domestic—as in France—VHS edition of this fabulously flaky flick was ever issued by its maker Moutier's self-owned prodco (=read: *him alone!*) N.M International, and is now virtually impossible to find copies of. Thus, for your viewing pleasure—judging by all that Mongo McGillicutty says about it this ish, it should be right at the very top of your "Must-See" list!—there is a highly-watchable-quality upload of this hard-to-find horror hootenanny ripped to YT at the link called "Trepanator (1992) [Sub. Español]" (@ *https://www.youtube.com/watch?v=y-CgzjDV6Vcc*). Although it doesn't come with any English subs—for why *should* it? (What are ya, one of those intolerantly unilingual "*Speak English or die!*"-type xenomorphs or something?! ☺)—it does come with Spanish ones. So if you're in any way vaguely versed (as am I [SF]) in either *français* and/or its close kissin' *cousin* (<<< dat's "cousin" in French ;-) *español*, you should have little trouble (as did neither I nor Mongo) figuring out the bulk of what's going on, even if some of the subtler details might well zoom way over your head like a flying frog (much as they did with ours at times). Moutier, the long-time owner/operator of a tiny, seedy "hole-in-the-wall" Parisian *vidéoclub*-cum-bookstore known as the Librairie B.D.-Ciné, has not only produced and directed a total of 9 homemade movies in his time, but also (back in March 1979), he launched the lastingly popular local fanzine, *Monster Bis* (latter word pronounced "Beece"; no, I'm not sure what it means [possibly some Gallic colloquialism?]). For a homey/folksy guided tour conducted by Moutier himself through a bunch of back issues of his zine (albeit revealing only their covers whilst he verbalizes some of their contents *au français*), visit the post at 1Kult's channel on Vimeo titled "Monster Bis // Norbert Moutier (Juin 2010)" (@ *https://vimeo.com/13339827*). Along distinctly similar lines, dating from 2008, there is a four-minute, French-language-only on-camera interview with the highly-personable and most articulate NM on YT (@ *https://www.youtube.com/watch?v=HGsXK0jrqr8*), shot as before at his aforementioned shop before shelves lined wall-to-wall with assorted books and cult videos of all genres (including his own most-"famous" offering, the incrapulously craptastic slasher/zombie splatter schlocker **OGROFF**). Also, this one dated February 2nd, 1995, at the French website Ina (@ *http://www.ina.fr/video/I16237730*), there is a 3½-minute video featurette entitled "Portrait Norbert Mouti-

Norbert "**TREPANATOR**" Moutier in his Paris shop, plugging his long-running zine *Monster Bis*—begun in 1979, and still going strong!—in a 2010 Vimeo vid (see web addy at left)

er", which features a short chat with him and shows some of the FX used in his films. And speaking of which, let's not forget a memorable moment in the present one which Mongo—who *is* brainless, after all, so he might easily be excused for his over-

Cover (artwork by Grégory Lê @ *www.gengiskahn-artwork.com*) for The Ecstasy of Films' 2015 native PAL All-Region DVD release of the French documentary a.k.a. **JEAN ROLLIN: THE STRAY DREAMER** (2011, France, Ds: Damien Dupont, Yvan Pierre-Kaiser)

sight—somehow managed to miss mentioning: in it, guest star Jean Rollin (sporting his stick-on "Groucho" upper lip-warmer) is seen shooting a hypodermic needle from a little plastic "Cupid" bow, like an arrow. *'Nuff said!*

UNHUMAN (2004) *[p.286]* |– As of this writing, Region 3 DVD copies (with English subs!) were on offer at the (quote) "Online Thai Entertainment Store", eThaiCD.com (@ *http://www.ethaicd.com/show.php?pid=14641&asso=10013*). Now, there *used* to be—accent on the past tense—an Indian version dubbed into Tamil on YouTube which I was going to suggest you should have a look at beforehand to decide whether you wanted to track down a legit copy of the film or not, but said upload has since been removed due to copyright infringement (Thai production companies tend to keep strict controls over that sort of thing), although there are quite a number of old horror/monster/fantasy flicks from Thailand (typically dating from the '80s) for those willing to take the time to surf/scour YT in search for some; do bear in mind though that they are usually identified solely by their titles in Thai symbols (which are notoriously "flexible" when being transliterated into Roman characters anyway, so there's quite a bit of variation to be found in transliterations). If you can Google-up an odd Thai title or two and copy-and-paste them over into YT's search field, that will take you into the loose general "Thai section" of the site, where you can try your luck by simply checking out thumbnails and clicking on links till you hit the jackpot; it's all very hit-and-miss, but sometimes you do strike gold. Also, do keep in mind that only relatively few movie uploaders from Thailand at YT, at least when it comes to more recent releases, bother including English subs (although in recent years during the T-horror "renaissance" of sorts that's been going on since The Pang Brothers first started gaining international acclaim in horror film circles while largely working out of Bangkok on their Asian co-productions, DVD releases do typically seem to include them almost automatically, or so it appears). If you visit the highly informative and helpful website Thai World View (@ *www.thaiworldview.com*), there's a page entitled "Thai Sci-Fi Movies" (@ *http://www.thaiworldview.com/tv/tv22.php*) which includes in-English coverage of a number of movies in that genre, including the present one. In addition to other genres, the site also covers plenty of horror movies (and other aspects common to Thai culture) too, and the handy thing is that they always include movie titles in the original Thai language,

Gracefully aging horny hepcat Toranong Srichua in a combo video promo for the filmmaker's **UNHUMAN** + Big Love brand—*um*—"hard-on helper", as seen on Thailand's erotically-inclined TV station Love Channel, c.2009ish

which greatly expedites things while Googling! Using TWV as your central database should prove to be a real boon on YT. It certainly was for me as, using their resource, I've (i.e., SF [*again*]) turned-up many an exotic rarity thereat.

As far as the present title is concerned, at the (former?) Thai YT link entitled "อมนุษย์ (Amanut) - ทรนง ศรีเชื้อ เฉพาะหนัง R ผ่าฉาก X Tape 2 Part3"—which, so far as I can tell, has since vanished from the site without a trace, so I'm glad I downloaded the video at it while I had the chance before this happened (BTW, if anyone wants an mp4 copy c/o *M!*, hit us up, and we'll Dropbox you one)—was posted a quarter-hour section of a TV program which originally aired on Thailand's Love Channel, featuring **UNHUMAN**'s director, Toranong Srichua, front and center. Said piece opens with "his" infamous commercial for the (*aptly enough!*) all-organic Big Love-brand male sex organ enhancer (see p.297 for more dirty details!), which said channel was actively hawking during commercial breaks; this whilst, evidently in some sort of symbiotic arrangement, the filmmaker pitched his own wares too. In the ad, the then-60ish Srichua, having parked and dismounted his sleek high-end mo'sickle out in the middle of nowhere, proceeds to sweep-up into his arms his vastly-younger, scantily-clad "mama" (played by willowy *Maxim* model Amie "I Gots the Biggest Fake Boobies in Thailand" Sirikittirat [evidently having not yet gotten "them" augmented to their maximum mammarian massiveness yet, even if here she already is pretty dang busty, with melonial sweater puppies to do Angel "Darna" Locsin right proud!]). Trying real hard to make it appear as though he isn't straining under her lissome-yet-in-some-key-areas-quite buxom body weight, ready to collapse at any moment, he then frantically scurries off the road with Amie into the surrounding bush to bust-off a lightning-swift quickie with her in the long grass! Crude, choppy editing only adds to the frantic tone and pace and, adding to the overall cheeseball effect, mellow tinkly classical piano music accompanies the lovers' fitful off-road tryst (which doesn't reveal a lick of anything even resembling nudity, by the way; unless you're one of those puritans who think that a woman's unabashedly-bared *navel*—even such a highly-pronounced and pertly protruberant "outie" as hers is—constitutes a naughty bit!). This whole opening montage flies by in mere seconds, then it's all over (howzat for "wham-bam-thank-you-ma'am"!), rather leaving us wondering whether premature ejaculation may well have resulted due to his all-fired over-eagerness to put his synthetically-hypercharged manhood to its intended use (but don't worry, proving that the makers exercised at least some restraint, they thankfully don't show us even a slight lump in his pants, let alone his actual woody! ☺). After a job well-done, while "basking in the afterglow" (so to speak!) seated sidesaddle at a rakish tilt on his mount (the non-human, two-wheeled, motorized one!), speaking directly into the camera, Srichua then proceeds to deliver Big Love's all-important sales pitch (i.e., both figuratively and literally gives us the "hard"-sell! [See p.297 for an English translation of what he's saying]). Perhaps intended for stylistic/aesthetic "real-time" effect, the entire thing looks like it didn't take much longer to shoot than its actual total running time takes to play out, that's what a rushed air the ad-spot has (his section is dispensed with in roughly 1½ minutes). Better yet, the same TV featurette also includes some movie excerpts, behind-the-scenes stuff and interview clips—spoken in his untranslated native tongue, natch—with Srichua the filmmaker (as opposed to his rakishly randy, bike-and-bimbo-riding/stay-hard senior stud muffin counterpart; a role for which, quite frankly, he's getting a bit too long-in-the-tooth to pull off with any real conviction, it must be said). So far as I can glean, the greying-long-haired, sunshades-wearing aging cool cat evidently mainly just did the herbal hard-on meds ad-spot for the Love Channel in exchange for some promo time for **UNHUMAN**, which is all well and good, I suppose (anything to get the job done [no pun intended]!). Over the course of his lengthy, uninterrupted monologues about the film, he conspicuously repeats its admittedly catchy title literally *scores* of times throughout to ensure people won't forget it (talk about "subliminal advertising"!). Because the piece, which dates from the late Pre-'Teens, by my estimation, was aired on a station whose main bread-and-butter is (non-XXX?) erotica, the film clips shown reveal absolutely every last single shred of—highly limited—skin that **UNHUMAN** has to offer (including comely co-star Suthita Ketanont's bare-bummed late-night wade in a woodland pool, plus a quickie insert shot of a busty starlet's main claims to fame when one of the horny unhumans rips her top off; but then, in his homeland, Srichua is primarily known as a director of "erotic" fare, after all). A longish, tit-filled excerpt from the same filmmaker's mockbuster disaster epic **DEATHWAVE** (*2022 Tsunami*, 2009) is also included therein. Oh, and by the by, as of this writing there was a quite decent-quality upload of that film on YouTube (@ *https://www.youtube.com/watch?v=2xbP8kHWJps*), with English soft-subs, yet; it's also available on domestic disc from Entertainment One ("eOne") Distribution. Incidentally, mere days after we copied-and-pasted it over from there to reprint as-is (on p.297) in this

here mag you be holdin', a trash news item at the Coconuts Bangkok site about Srichua's notorious Big Love commercial got "mysteriously" taken down. If you try and use the link we gave to it there now, the following message pops up in place of the article: *"404. PAGE NOT FOUND. We're sorry but the page you're looking for does not exist. Please return to the homepage or search Coconuts below."* This leads me to believe that some sort of legal reason may well have been the cause for its sudden disappearance. Minor point anyway! We just thought we should mention it in case any of our more curious readers actually took the time to carefully key-in that addy (which, we reiterate, is [uh, make that *was*] @ *http://bangkok.coconuts.co/2013/05/03/viral-video-thailand%E2%80%99s-weirdest-erectile-dysfunction-ad-ever*), only to be left wondering why there was nothing at the other end of it. To be honest, while totally harmless, the ad *is* pretty tasteless—if mainly only in the excess amount of über-tacky schmaltz involved, more than anything else!—and was likely an embarrassment to all concerned (probably the two people in front of the camera most of all; their "passionate necking" seems painfully self-conscious, mostly on poor Amie's side!). Due to these disappearances offline of both the video and news item discussed above, I'm starting to wonder if maybe somebody is trying to erase their tracks as best they can!

ZARKORR! THE INVADER (1996) *[p.303]* |– US promo hype: *"A Starlog Group Exclusive!*

185 Feet Tall... 300 Tons... and Angry! ...The first US-made, city-crushing, giant monster movie in decades! ...Feed Your Massive Monster Mania! Order One of the Creature Collections from the Zarkorr Store and Own a Piece of Monster Island!" For a mere $39.95 (US), Monster Island Entertainment/Amazing Fantasy Entertainment (an offshoot of Full Moon)'s special edition Big Box VHS release came complete with a full set of eight limited edition mock-lobby cards, plus a set of eight **Z!** trading cards, too…oh yeah, and let's not forget a tape of the movie, too. For a few dollars more (*10*, actually), an even-more-deluxe edition called "The ZARKORR! Humongous Haul" was also released simultaneously. It contained all the same goodies from the Big Box edition, as well as a hard copy of the movie's script and a "Massive 6-FOOT TALL Collector's Poster!" (depicting the same artwork seen on the **Z!** vidbox). Or, if you weren't interested in all the bells and whistles, you could snap-up the tape alone for just a nickel shy of 20 bucks. Known in Japan as 巨大怪獣ザルコー / "Huge Monster Zaruko", it was released on home videotape there by CAM Video, dubbed—ironically enough, really *badly*, by all reports (now there's a switch!)—into Japanese. Apparently, some footage from this (not surprisingly, considering Full Moon's habit of cannibalizing from its own productions to pad-out new ones) subsequently turned up in their other mock (*very* mock!)-Daikaiju effort, **KRAA! THE SEA MONSTER** (see separate entry above).

IN MEMORIAM: BILL PAXTON
(May 17th, 1955 to February 25th, 2017)

"Fish heads / Fish heads / Roly-poly fish heads / Fish heads / Fish heads / Eat them up / Yum!" Remember that *bizarro* experimental new wave song and attendant short film by Barnes & Barnes from 1980 called "Fish Heads", which we just quoted the famous chorus from? If you'd long since forgotten it, chances are (assuming you're even old enough to remember) that those unforgettably kooky'n'catchy lyrics will bring it all flooding back to you on a wave of nostalgia and sappy sentimentality! Originally appearing as the A-side to a 7" 45rpm single (put out by them on their own Lumania Records label) from 1978, it was subsequently included by B&B on their '80 debut vinyl LP, *Voobaha*. At the time of the song's initial release as the soundtrack to a short (roughly 4¾-minute in its full-length form) film of the same name back in 1980—right around when '70s so-called "second wave" punk rock was just starting to turn into so-called "New Wave" weirdo pop—the toon became an oft-replayed (and then some!) mega-hit on LA's hugely popular underground music-oriented *Dr. Demento Radio Show* (1970-2011), for most of its early years aired on the FM station KMET, which specialized in oddball novelty/comedy songs. B&B were "actually" (*not!*) Art & Artie Barnes (who were *actually*-actually musicians Bill[y] Mumy and Robert Haimer, respectively; both of whom also put in uncredited onscreen appearances during "FH" the film itself). Long-partnered with Haimer in their comedic rock duo (B&B made a total of nine albums together), Mumy—yes, the very same one from such TV classics as *The Twilight Zone*'s "It's a Good Life" episode (1961) and the entire run of the sci-fi series *Lost in Space* (1965-68) himself!—whipped-up wacky audio creations together D.I.Y.-style on their 4-track tape recorder, with "FH"—one of whose numerous strange aspects is its off-kilter "Chipmunks"-style vocal chorus—amounting to their greatest and most enduring hit of all. Well, you see, not only did then likeably/confidently cocky young punker/aspiring actor Bill(y) Paxton (the Texan-born not-too-distant cousin of *M!*'s own Tim, no less) direct it, but he also appeared in it as well. At that time, Mr. Paxton—an ex-set dresser at Rog Corman's New World Pictures who made his unbilled professional screen acting debut in Jonathan Demme's distaff gangster flick **CRAZY MAMA** (1975, USA)—was just dipping his boot-toe into future Hollywood superstardom, and his memorable co-star or character turns in so many great movies were yet to be. Of all his canon, most

As shot by future rock vid-maker Rocky Schenk, above are just three of the many wacked-out images to be seen in the late Bill Paxton's short film "Fish Heads"!

Monster! readers will likely remember (and *love!*) him best in two of his most iconic roles of all: as jittery-if-gung-ho "bug"-hunting grunt Private Hudson in James Cameron's **ALIENS** (1986, USA/UK), and as the crazed vampire punk Severen the following year in Kathryn Bigelow's cult bloodsucker shocker **NEAR DARK** (1987, USA). Prior to these roles, he had played the way-too-hyper, gap-toothed/spiky-blue-fauxhawked leader of a gang of punk rockers whom Schwarzenegger

"I think this guy's a couple cans short of a six-pack!"

"Stop your grinnin' an' drop your linen!"

Top & Above: Bill Paxton as the #1 punker in James Cameron's **THE TERMINATOR** (1984), and as Colonial Marine Private Hudson in the same director's **ALIENS** (1986)

as the title humanoid killing machine—*um*—"puts in their place" during Cameron's **THE TERMINATOR** (1984, USA); a role which well-established the kinds of hotheaded and sometimes all-out mentally unstable characters he was so often—to such great effect—cast as.

As for "FH", as well as directing it, Bill Paxton (at one point rather distinctly evoking a young Christian Slater) also starred in it anonymously, too; not that there's any dialogue, of course, the entirety of the audio track being dominated by B&B's title song. Shot (by DP and future prolific rock video director Rocky Schenk) on both Super 8 and with a hand-cranked 16-mill Bolex, it features out-to-lunch, artsy-fartsy-styled costumes (by Joan Farber, Haimer's then-girlfriend) and imagery straight out of a pretentious Euro "Art Film", plus so much more wonderful wackiness besides! In an on-camera video reminiscence from c.2014 posted on YouTube (@ *https://www.youtube.com/watch?v=4IrWJbANIdU*), its co-songwriter Mumy openly admits regarding "Fish Heads"' runaway success: "All credit goes to Billy Paxton. What a *go-getter*! Completely enthusiastic, would not take no for an answer, took his own money, flew to New York... He said to us, 'I'm gonna get 'Fish Heads' on *Saturday Night Live*'!" Which he did. It played on *SNL* twice (i.e., once again the following week too), thereafter became entered in various film fests, got—and still gets—scads of radio/TV airplay, and still endures as a popular favorite to this day (hell, even my ol' Mum remembers it fondly, even if it *does* kinda creep her out some!), with B&B still seeing some pretty decent residuals from monies generated by the song. All this said, I guess what I'm ultimately getting to here is that, upon—as my personal tribute on the day of his death—re-watching (and of course re-*listening* to) "Fish Heads" after however many years had passed since I last saw/heard it (*too many!*), it actually brought a lump to my throat and a tear to my eye seeing Billy, then in his mid-20s—all punked-up/modded-out in his dark glasses, snazzy blazer, skintight black slacks and *nuevo wavo* booties—looking so vibrantly and cocksuredly very much ALIVE, relishing and reveling in the full bloom of his youth and all its energy (since I'm only a few years younger than he was, I can well remember the exciting times in which "FH" was made). In fact, I'm coming over all lumpy-throated and teary-eyed even as I type these words here, I freely admit. (But anyway, this *ain't* about me, it's ALL about Bill.) As of this writing—precisely one month to the day after his passing—his family, friends and fans are no doubt still sorely feeling the loss of him, but there are *oodles* of ways in which we can continue to keep him alive in our hearts and minds, such is the fine legacy he left behind him. Speaking for myself, in his honor later today, I'm planning on watching **ALIENS** one more time again (for the umpteenth time since I saw it first-run on its original Canadian theatrical release); cuz, when it gets right down to it, *that's* the one movie of his which totally solidified him in my memory for as long as I'm alive, and even if he'd never made another one it'd be more than enough to do me. So—R.I.P., Bill Paxton! ☹ Wherever it is you've gone to most likely beats this messed-up world all to hell! ☺ ~SF

MOONLIGHT MASK / GEKKŌ KAMEN
APPENDIX + ADDENDUM:
Or, How To Tell the Difference(s) Between the TV Show & the Theatrical Features! ~
by Dan Ross & SF (with an invaluable assist from Wikizilla/Wikipedia/IMDb)

Above: Perhaps feeling constrained by the small screen, Koichi Ōse *[left]* as Gekkō Kamen's TV incarnation fought crime using more modest hardware than his theatrical series counterpart Fumitake "Takeshi" Ōmura, whose own version of GK was a Rikuo/Smith & Wesson *[right insets]* brand-loyalist; both actors are here seen in their "Clark Kent" modes

The TV Show:- Senkosha's small-screen B&W series of five serials premiered on the KRT network ("TBS TV") on February 24th, 1958, ending on July 5th, 1959. Totaling 130 (or maybe 131?) episodes in all, these were spread-out across five distinct story arcs. It starred Koichi Ōse (大瀬康一) as Juro Iwai (祝 十郎 / Iwai Juro), a.k.a. *Gekkō Kamen* ("Moonlight Mask"), who bombed from point A to point B on a white 1957 Honda Dream C70 (250cc). GK's TV incarnation used twin Browning 1910 9mm automatic pistols as required; which, while being little more than glorified derringers caliber-wise, usually do the trick well enough; in fact, they are the gats of choice of just about everybody in the show, be they goodie or baddie! Indeed, the sheer prevalence of said brand seems to point to the Browning firm perhaps being a major sponsor. Regardless of all this seemingly quite blatant product placement, the quintet of tele-serials (each broken-up into their own individual episodes) is as follows:

1. *Skull Mask* (どくろ仮面 / *Dokuro Kamen*, in 72 episodes [#1-72, from February 24th to May 17th, 1958]; adapted to the big screen in 2 parts)
2. *The Secret Treasure of Baradai Kingdom* (バ ラダイ王国の秘宝 / *Baradai Ōkoku no Himitsu*, in 21 episodes [#73-93, from May 25th to October 12th, 1958])
3. *Mammoth Kong* (マンモスコング / *Manmosu Kongu*, in 11 episodes [#94-104, from October 19th to December 26th, 1958])
4. *The Ghost Party Strikes Back* (幽霊党の逆襲 / *Yureitō no Gyakushū*, in 13 episodes [#105-117, from January 4th to March 29th, 1959])
5. *Don't Toy With Revenge* [or Don't Turn Your Hand to Revenge] (その復讐に手を出すな / *Sono Fukushū ni Te wo Dasu na*, in 14 episodes [#118-131, from April 5th to July 5th, 1959]).

The Official Spinoff Toei Movie Series:- These cinematic features—"reimaginings" of the source teleplays, still lensed in monochrome, yet with the added dimension of ToeiScope (=widescreen)—trailed behind each original television story arc by a few months (their respective theatrical release dates are given below). They all starred Fumitake "Takeshi" Ōmura (proper name 大村文武) as Juro Iwai, who here instead rode a big, rumbling Rikuo RQ750 (thus besting his TV counterpart by a good 500cc's!), that came c/o the Rikuo Internal Combustion Company (陸王 / *Rikuō Nainenki Kabushiki Kaisha*); which, although technically

of only *747* cc's despite its name, was *far* from "Jap crap" *[sic!]*, as some diehard, closed-minded H-D enthusiast still harboring resentment about Pearl Harbor might claim. Upping not just his horsepower considerably but also his firepower a tad too, the movie GK wielded a matching pair of (arguably) harder-hitting snub-nose Smith & Wesson .38 Special revolvers…although firearm experts are divided on which handgun's projectile packs the hardest punch, so it's rather like arguing apples and apples anyway. Weaponry aside though, the six cinema features are:

1. **MOONLIGHT MASK** (月光仮面 / *Gekkō Kamen*) |- Release date: July 30th, 1958 (source: the *Skull Mask* story [Part 1])
2. **MOONLIGHT MASK – DUEL TO THE DEATH IN DANGEROUS WATERS** (月光仮面 - 絶海の死斗 / *Gekkō Kamen – Zekkai no Shitō*) |- Release date: August 6th, 1958 (source: the *Skull Mask* story [Part 2])
3. **MOONLIGHT MASK – SATAN'S CLAW** (月光仮面 - 魔人〈サタン〉の爪 / *Gekkō Kamen – Satan no Tsume*) |- Release date: December 22nd, 1958 (source: the *Baradai Kingdom* story)
4. **MOONLIGHT MASK – THE MONSTER KONG** (月光仮面 - 怪獣コング / *Gekkō Kamen – Kaijū Kongu*) |- Release date: April 1st, 1959 (source: the *Mammoth Kong* story; albeit a considerably downsized version)
5. **MOONLIGHT MASK – THE GHOST PARTY STRIKES BACK** (月光仮面 - 幽霊党の逆襲 / *Gekkō Kamen – Yureitō no Gyakushū*) |- Release date: July 28th, 1959 (source: *The Ghost Party Strikes Back* story)
6. **MOONLIGHT MASK – THE LAST OF THE DEVIL** (月光仮面 - 悪魔の最後 / *Gekkō Kamen – Akuma no Saigo*) |- Release date: August 4th, 1959 (source: the *Don't Toy with Revenge* story).

NOTE: Incidentally, Daisuke Kuwahara (桑原大輔) took over the role of Detective Juro in the belated 1981 theatrical reboot, which, due to its poor box-office reception, didn't do much to advance the careers of anybody involved.

Small-Screen GK: Native *Mammoth Kong* DVD cover

Big-Screen GK: Native **MONSTER KONG** B1 poster/DVD cover

NEXT ISSUE: Over 300 pages of more amazing cool stuff!

MONSTER! contains photos, drawings, and illustrations included for the purpose of criticism and documentation. All pictures copyrighted by respective authors, production companies, and/or copyright holders.

BERNIE WRIGHTSON:
A *MONSTER!* EULOGY TO THE MASTER

(1948-2017)

The late, great Bernie (a.k.a. "Berni") Wrightson, in his younger days, from The Studio era of the 1970s; that's the signature of Bernie's Studio partner Jeff (later Catherine) Jones visible on the display items *[above right]*

We mourn our own.

The world is mourning the passing of Jimmy Breslin and Chuck Berry; *we're* mourning the passing of Bernie Wrightson.

On Friday, March 17th, Bernie Wrightson was in this world with us.

By Sunday, March 19th, Bernie had left us. He passed at about 8 p.m. on March 18th, Texas time.

Bernie's wife Liz posted on March 19th, on Bernie's official website:

"It is with great sorrow that I must announce the passing of my beloved husband, Bernie. We thank you for all the years of love and support. His obituary is below:

After a long battle with brain cancer, legendary artist Bernie Wrightson has passed away.

Bernie "Berni" Wrightson (born October 27, 1948, Baltimore, Maryland, USA) was an American artist known for his horror illustrations and comic books. He received training in art from reading comics, particularly those of EC, as well as through a correspondence course from the Famous Artists School. In 1966, Wrightson began working for The Baltimore Sun newspaper as an illustrator. The following year, after meeting artist Frank Frazetta at a comic-book convention in New York City, he was inspired to produce his own stories. In 1968, he showed copies of his sequential art to DC Comics editor Dick Giordano and was given a freelance assignment. Wrightson began spelling his name "Berni" in his professional work to distinguish himself from an Olympic diver named Bernie Wrightson, but later restored the final E to his name...."[1]

[1] Liz Wrightson (@ http://berniewrightson.com/a-message-from-liz-wrightson/)

Bernie's mastery of pen, brush and ink and his dramatic use of lighting and deep shadows were evident from the beginning, as in this, one of the earliest published *Frankenstein* pieces of his long, illustrious career. "Berni" was 19 years old when he did this 1967 drawing, which was reprinted in the retrospective volume *Berni Wrightson: A Look Back* (The Land of Enchantment, 1979)

Then, the career highlights—Bernie's first published comicbook work: his mainstream comics debut in DC Comics' *House of Mystery* #179 in 1968, a short EC Comics horror parody called "Ghastly Horror Comix" (which Bernie signed with the penname "Nauseous") in the underground tabloid *Gothic Blimp Works* #6 in 1969. Amid a steady flow of horror stories and art for DC and Marvel Comics, Len Wein wrote and Bernie drew the award-winning one-shot story "Swamp Thing" in *House of Secrets* #92 (June/July, 1971), which prompted such positive reader response that editor Joe Orlando contracted Len and Bernie to revise and expand that self-contained story into a new comicbook series, *Swamp Thing*—and the rest is history! While freelancing for DC, Bernie also co-created Destiny, later to elevated to a key position in the DC universe via Neil Gaiman's revisionist *Sandman*, but this was before DC's creator royalty program or character creation programs were in existence, so Bernie earned *nothing*—save for occasional reprint payments—for this body of work over the years.

Bernie also collaborated with his pal Vaughn Bode on "Purple Pictography", painted erotic comics for the adult newsstand magazine *Swank* (from 1971-72), and had some wild work in the pages of *National Lampoon*. By the mid-1970s, Bernie was producing an extraordinary body of solo and collaborative work for Warren Publishing's newsstand B&W horror-comics magazines *Creepy*, *Eerie*, and *Vampirella*; he also joined forces with his friends and artistic peers Jeff (later Catherine) Jones, Michael Kaluta, and Barry Windsor-Smith to form "The Studio", a shared creative space in a Manhattan loft where they each produced creator-owned masterworks—paintings, portfolios, prints, etc.—free of the legal, contractual, editorial, and creative straitjackets that they'd all dealt with as freelancers. Amid this explosion of innovative work, Bernie fulfilled a lifelong dream of fully illustrating his all-time favorite novel, Mary Shelley's *Frankenstein* (1818), a seven-year project that yielded almost 50 extraordinary pen-and-ink drawings in a classical inking style.

Bernie's multimedia work included working with first wife Michele Brand Wrightson on a

full-color trade paperback adaptation of George Romero/Stephen King's 1982 portmanteau film **CREEPSHOW**, spawning a series of Wrightson-illustrated projects with King: the novella *Cycle of the Werewolf* (Westland, MI: The Land of Enchantment, 1983), the restored, unexpurgated original draft of King's 1978 apocalyptic horror epic *The Stand* ([New York, NY: Doubleday, 1990] published thanks to an original manuscript that had been gifted to, kept, and later rediscovered by the late, great Rick Hautala), illustrated limited hardcover editions of *From a Buick 8* (Baltimore, MD: Cemetery Dance Publications, 2002) and *The Dark Tower V: Wolves of the Calla* (New York, NY: Donald M. Grant/Scribner, 2003). Bernie also did album cover art (including for Meat Loaf), conceptual art for movies like **GHOSTBUSTERS** (1994) **THE FACULTY** (1998), **GALAXY QUEST** (1999), **SPIDER-MAN** (2002), Romero's **LAND OF THE DEAD** (2005), Frank Darabont's adaptation of Stephen King's **THE MIST** (2007), and many films that never saw light of day (among them Stuart Gordon's pre-**DAGON** [2001] proposed Lovecraft adaptation "THE SHADOW OVER INNSMOUTH", which makeup legend Dick Smith also worked on).

Bernie wrote and drew for *Heavy Metal* magazine a hilarious one-shot "Captain Sternn" story (*HM*, June 1980) that was adapted for the animated film **HEAVY METAL** (1981), then, in the early 1990s, spun-off into its own series, *Captain Sternn: Running Out of Time* (1993), for Kevin Eastman's Tundra Publishing, in collaboration with Bernie's pal Jim Starlin. Bernie later returned to the DC and Marvel Comics folds, drawing lavish covers and pages and even a graphic novel or two, doing his spin on the likes of The Hulk, The Thing, Spiderman, Batman, The Punisher, and others; cover art for DC/Vertigo's *Nevermore* (2003) and *Toe Tags* (2004-05), and more. Mutual friend and vet comics writer Steve Niles (*30 Days of Night* [2002]) rallied Bernie to collaborate on what stands as the best comics work of his final years: *Dead She Said* (2008), *The Ghoul* (2009-10), *Doc Macabre* (2010-11), and the exquisite *Frankenstein Alive, Alive!* (2012-13, all IDW Publishing).

But that's Bernie's work; he was so much *more* than that...

Bernie was a man, a friend, a lover, a husband, a father, and he was making his way in this crazy world amid his own steps and missteps, and many of us loved Bernie fiercely, however and whenever we encountered him.

Bernie's work was a *constant* in my life, it seems, though, looking back, it was a drawing in a fan column in one of the Warren magazines (*Creepy* #9,

Len Wein/Berni Wrightson's instant classic "Swamp Thing" was the cover story in *The House of Secrets* #92 (June/July 1971); Louise Jones (now Louise Simonson) posed for Wrightson's stunning cover art. Reader and industry response was unanimously positive, prompting editor (and former EC Comics artist) Joe Orlando to reunite the team for the remarkable 10-issue run by Wein & Wrightson, beginning with *Swamp Thing* #1 (November 1972)

Bernie's lifelong love for Mary Shelley's *Frankenstein* (1818) yielded one of his most ambitious undertakings, completing almost 50 original pen-and-ink illustrations for Shelley's classic novel; the completed volume was initially published by Marvel Comics (their only Marvel Illustrated Novel) in 1983, with an introduction by Stephen King

June 1966, p.33), *Castle of Frankenstein* (a full story, "A Case of Conscience", in *CoF* #16, June 1971, but obviously written/drawn/submitted years before), a clutch of DC comics (including his issues of *Nightmaster* for *Showcase* [#'s 83/84, June-August 1969]) and his first solo anthology collection *Badtime Stories* (Graphic Masters, 1971) that I'd studied closely to figure out who *this* was, what *this* work was, how it might have been realized...

Little did I know then how my high school years would be illuminated by Bernie's best work for DC—those ten issues of *Swamp Thing* (1972-74), of course!—my college years bettered by Bernie's eye-popping/mind-blowing work for Warren's *Creepy, Eerie, Vampirella* (the *best* artworks in some issues were Bernie's inside-front-cover portraits of the horror host).

Little did I know I'd meet and befriend John Totleben when we were both students at the Joe Kubert School of Cartoon and Graphic Art, and thus meet a Wrightson fan/scholar whose love for Bernie's work and for *Swamp Thing* would outstrip that which the rest of us had nurtured. Like Bernie, John was a genius artist; little did I know John would become such a great friend, much less that I'd get to work with John closely in realizing our own "take" on *Swamp Thing* (1983-86)[2] in the brightest arc of my own professional mainstream career as a cartoonist.

During those Kubert School years, our classmate Ben Ruiz (who was much older than any of us) once told us about being at that convention in 1968, when this kid named Bernie Wrightson showed up and showed his portfolio to Dick Giordano and whoever else was also standing around, and how mind-blowing it was seeing Bernie's brush-and-ink and pen-and-ink work even at that stage. Ben's vivid account still burns in my memory—and as my pal Rick Veitch said to me this past weekend, what momentous changes Bernie brought with him to all of comics, just by being who he has, doing what he did, and showing up when he did.

Little did I know I'd get to meet Bernie, briefly, at a Kubert School outing (our only "class trip", if I remember correctly) with John and Rick Veitch and all our classmates piling into a tiny Pennsylvania museum to see an exhibition of Frank Frazetta paintings; and Bernie was there, and so was Burne Hogarth, who targeted the opportunity and Bernie's presence to gather us all into a room and lecture us for well over an hour on the "death wave" sweeping our culture, and our position in it, and our pivotal role in it, and I'll never forget the look on Bernie's face, defiant even as he absorbed Burne's stern words, even as he was working on his magnificent *Frankenstein* (1983) illustration project...

Little did I know over the years what a friend Bernie would be to all of us, in his way. Ever open to conversation, ever-attentive, ever-cordial and warm and funny; we were all on a *Swamp Thing* and a horror comics panel together at Ithacon NY, and our families got to dine together that night. I got to ship a box of my publication *Taboo 1* (1988) to Bernie to distribute at a Halloween party he and Michele hosted in their upper-NY-State home, and got to have a couple phone conversations about what we were doing, and Bernie patiently explained why *Taboo* wasn't for him: "But you guys know what you're doing, and it's *necessary*".

2 As for our run with *Saga of the Swamp Thing* (#16-50, most issues, 1983-1986), we had many "fill-in" issues by others, but it's *complicated* (#16-27, 29-31, 34-44, 46, 48, 50+, 1983-1986+), but John worked on issues I didn't, and vice-versa. ~ **SRB**

We'd get to chat in the Tundra offices in the early 1990s, as Bernie worked with Kevin Eastman and editor Gregory Scott Baisden on expanding his *Heavy Metal* SF-ode-to-Warner-Bros.-cartoons into a series (the aforesaid *Captain Sternn: Running Out of Time*), and I think that's where I got to know Bernie a bit—just a *little*—blown-away by what a kind, soft-spoken, sharp, funny, and wry man he was at all times.

This was when Bernie explained, at some point, why he'd had to abandon working with his beloved brush-and-ink; it turned out *his tools had turned on him.* He had developed an allergy to the farrel of the brushes, which would cause his fingertips to swell, split, with considerable pain, and he simply couldn't work with gloves on and maintain the quality of work he demanded of himself and most enjoyed creating. Thus, his switching to pencils and other drawing tools, a transition that left long-time fans scratching their heads and bemoaning what once-had-been—but Bernie never stopped drawing through it all.

At some point in all this, when asked about *Frankenstein* and those magnificent drawings, Bernie patiently explained that whenever he made a mistake on one of those illustrations, he'd scrap the entire drawing and start over, because every one of them had to be perfect—no errors, no white out, no corrections. *Perfection* was what he sought, *and* created.

Little did any of us know that Bernie meant it when he said he'd been reading our work on his character; that when he showed me, with some regret, unfinished *Swamp Thing* pages for a new project he and Len Wein had begun and which Bernie had terminated, patiently telling me "I can't do it anymore. I realized that you guys had changed the character completely", and I found myself choking-up as he spoke; that when DC in its benevolence sent Bernie a bonus check out of the blue, Bernie would split-up that bonus check and mail checks to Alan Moore, John Totleben, Rick Veitch, and me, and when asked what for, he laughed, saying, "*I* didn't earn this. I know this bonus was because of what you guys did on the character, but don't tell anyone about this, because you don't want DC to have a reason not to send another check!"

It's important to remember, as I noted earlier, that Bernie was of a generation who did *not* benefit from earning royalties or co-creator revenue streams for all the work he'd done prior to he, Jones, Kaluta, and Windsor-Smith founding The Studio. This wasn't a "weakness"

on the part of creators like Bernie: the offer simply wasn't on the table, it wasn't available, it simply wasn't how business was done. *One* page rate, paid *once*, and that was *it*: the work then belonged lock, stock, and barrel to the publisher. Creator royalties and character-creator-shares simply didn't exist at DC Comics or Marvel Comics prior to the 1980s (and barely ever did at Marvel, *ever*), so aside from the occasional benevolent "manna-from-heaven" bonus check like the one just cited, Bernie didn't earn a share from all his 1960s and 1970s work which earned—and continues to earn—for his former publishers. Warren not only didn't pay royalties, but according to Bernie, Warren had a trick: he only paid you for your *last* job when you turned in a *new* job. Thus, Warren was always ahead of the game, in his mind, and the Warren reprints paid nothing to the writers and artists; it was one-time-payment *only*. And as the license for that material has since moved through multiple hands, it earns nothing, or precious little (again, dependent upon the benevolence—or need for a new cover or illustration—by current reprint packagers/publishers) for Bernie, for his family. All these reprint editions of *Creepy, Eerie, Vampirella*? NOTHING for Bernie, or his heirs!

Wrightson and King reunited for an original novella, *Cycle of the Werewolf*, initially published as a limited-edition hardcover (The Land of Enchantment, 1983) two years before a mass-market version hit bookstores (Signet, 1985), the same year the film adaptation **SILVER BULLET** hit theaters

Bernie gave us all so, so much. He carved-out a career, and he earned what he earned doing so, but don't think for a moment that he was reaping the benefits which creators since the hard-fought creator-rights battles of the 1980s have since enjoyed. Bernie was *old-school,* and his generation had a tougher path than we did.

There's more, so much more, but I've neither the wits nor the heart to share it right now *[Anytime you're feeling up to it later, man, go for it!* ☺ *– eds.]*; besides, I barely knew Bernie, not really, but I was lucky enough to have met him, to have had opportunities to talk with him from time to time over the years. I'll never, ever forget his face, his hands, that voice, his sense of humor, his generosity, the way his face lifted and his eyes glowed when he talked about something he loved…and those astonishingly expressive eyebrows of his!

I was luckiest of all to work on Bernie's and Len's character, and thus have a career in comics—that I owe *completely* to my mentor and "second father", Joe Kubert, to close friends like Rick Veitch and John Totleben and Tom Yeates, to the character(s) Bernie and Len co-created and which Len decided John and I were worthy of working with for a time.

Bernie was as much our "master", our mentor, as was Joe Kubert, though in such different ways, and on such a different path…

Much, *much* love and deepest condolences to Liz Wrightson, to Bernie's sons, John and Jeffrey (who sadly also lost their brilliant, talented, incredible mom, the great Michele Brand, on May 30th, 2015), and his stepson, Thomas Adamson, and to all in Bernie's circles, too.

On Friday, Bernie was with us.

On Sunday, Bernie had left us.

We mourn our own.

—Stephen R. Bissette
March 22nd, 2017,
Mountains of Madness, Vermont

An exquisite double-page spread from Bernie's final published Frankenstein project, and his final project with writer and friend Steve Niles, the National Cartoonist Society-award-winner, *Frankenstein Alive, Alive!* (IDW Publishing, 2014); from the third and final issue

ENDNOTE

How To Make Some Monsters: Preliminary rough digital demo layout concept art by Alex Wald for this very ish's spectacular wraparound cover artwork! (But don't you dare go tearing it off and framing it, mind you! If the demand is great enough, who knows, perhaps the creator might make special art prints of the work available for purchase [hint-hint!])

Front & Rear Cover Art: In its artist Alex Wald's own words: "Abel Salazar as Baron Vitelius, Iwa Moto as Valentina and Hideyo Amamoto as a transforming Matango".
Contents Page Art: Daimajin gets reawakened one more time by Jolyon Yates (see still more exclusive-to-*M!* original Majin art on pp.85+86!)

Other Original Art Contributions: Bob Eggleton (p.85), Christopher Martinez (p.86), Denis St. John (p.89), Andy Ross (p.279), Matt Bradshaw (pp.318-320)

Contributing Writers: Michael Hauss, Dan Ross, John-Paul Checkett, Cédric Monget, Eric McNaughton, Dennis Capicik, Kinshuk Gaur, Jeff Goodhartz, Christopher Martinez, Jonathan Clode, Andy Ross, Matt Bradshaw, Marcel Burel, Martín Núñez, Christopher J. Maurer, Louis Paul, Matthew E. Banks, Eric Messina, Troy Howarth, Stephen R. Bissette, Les Moore, Mongo McGillicutty, Brian Harris, Steve Fenton, and Tim Paxton

Timothy Paxton, Editor, Publisher & Design Demon
Steve Fenton, Editor & Info-wrangler
Tony Strauss, Edit-fiend
Brian Harris, El Publisher de Grand Poobah
Coffee/Whipping-Boy & General Scapegoat/Doormat: "Mongo" McGillicutty

MONSTER! is published bi-monthly...sort of. Subscriptions are NOT available. © 2017 Wildside Publishing / Kronos Productions, unless otherwise noted. All rights reserved. No part of this publication may be reproduced, distributed, or transmitted in any form or by any means, including photocopying, recording, or other electronic or mechanical methods, without the prior written permission of the publisher, except in the case of brief quotations embodied in critical reviews and certain other noncommercial uses permitted by copyright law. For permission requests, write to the publisher: "Attention: Permissions Coordinator," at: Tim Paxton, Saucerman Site Studios,
26 W. Vine St., Oberlin, OH 44074 • kronoscope@oberlin.net

www.ingramcontent.com/pod-product-compliance
Lightning Source LLC
Chambersburg PA
CBHW020853180526
45163CB00007B/2489